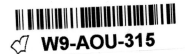

BRIDGE OF DREAMS

BRIDGE OF DREAMS

The Mary Griggs Burke Collection of Japanese Art

MIYEKO MURASE

THE METROPOLITAN MUSEUM OF ART, NEW YORK

Distributed by Harry N. Abrams, Inc., New York

This publication is issued in conjunction with the exhibition "The Art of Japan from the Mary Griggs Burke Collection," held at The Metropolitan Museum of Art, New York, March 28–June 25, 2000.

The exhibition catalogue is made possible through the generous support of The Dillon Fund.

Published by The Metropolitan Museum of Art, New York
John P. O'Neill, Editor in Chief
Emily Walter, Editor, with the assistance of Ellyn Childs Allison and Margaret Donovan
Bruce Campbell, Designer
Gwen Roginsky and Merantine Hens, Production
Minjee Cho, Desktop Publishing
Jayne Kuchna, Bibliographic Editor

The color photographs in this publication are by Bruce Schwarz, The Photograph Studio, The Metropolitan Museum of Art

Map by Anandaroop Roy

Typeset in Fournier and Centaur by Professional Graphics, Inc., Rockford, Illinois
Printed on Mitsubishi Deluxe Real Art, Matte, 157 gms
Color separations by Nissha Printing Co., Ltd., Kyoto
Printed and bound by Nissha Printing Co., Ltd., Kyoto

Jacket/Cover: Unidentified artist (early 17th century), *Women Contemplating Floating Fans* (detail, cat. no. 142). *Frontispiece*: Geiai (fl. ca. 1489), *Sparrows among Millet and Asters* (detail, cat. no. 58)

"History of the Collection," by Mary Griggs Burke, is reprinted, in modified form, from *A Selection of Japanese Art from the Mary and Jackson Burke Collection* (Tokyo, 1985), by permission of the Chunichi Shimbun. Sixty-nine catalogue entries originally published in *Japanese Art: Selections from the Mary and Jackson Burke Collection* (New York, 1975) are reprinted, in modified form, from the volume originally published by The Metropolitan Museum of Art. Thirty-nine entries originally published in *Jewel Rivers: Japanese Art from The Burke Collection* (Richmond, 1993) are reprinted, in modified form, by permission of the Mary and Jackson Burke Foundation.

Library of Congress Cataloging-in-Publication Data

Murase, Miyeko.
 Bridge of dreams: the Mary Griggs Burke collection of Japanese art / Miyeko Murase.
 p. cm.
 Includes bibliographical references and index.
 ISBN 0-87099-941-9—ISBN 0-87099-942-7 (pbk.: alk. paper)—ISBN
 0-8109-6551-8 (Abrams)
 1. Art, Japanese—Exhibitions. 2. Burke, Mary Griggs—Art collections—Exhibitions.
 I. Burke, Mary Griggs. II. Metropolitan Museum of Art (New York, N.Y.). III. Title.

N7352.M84 2000
709'.52'0747471—dc21 99-054465

Contents

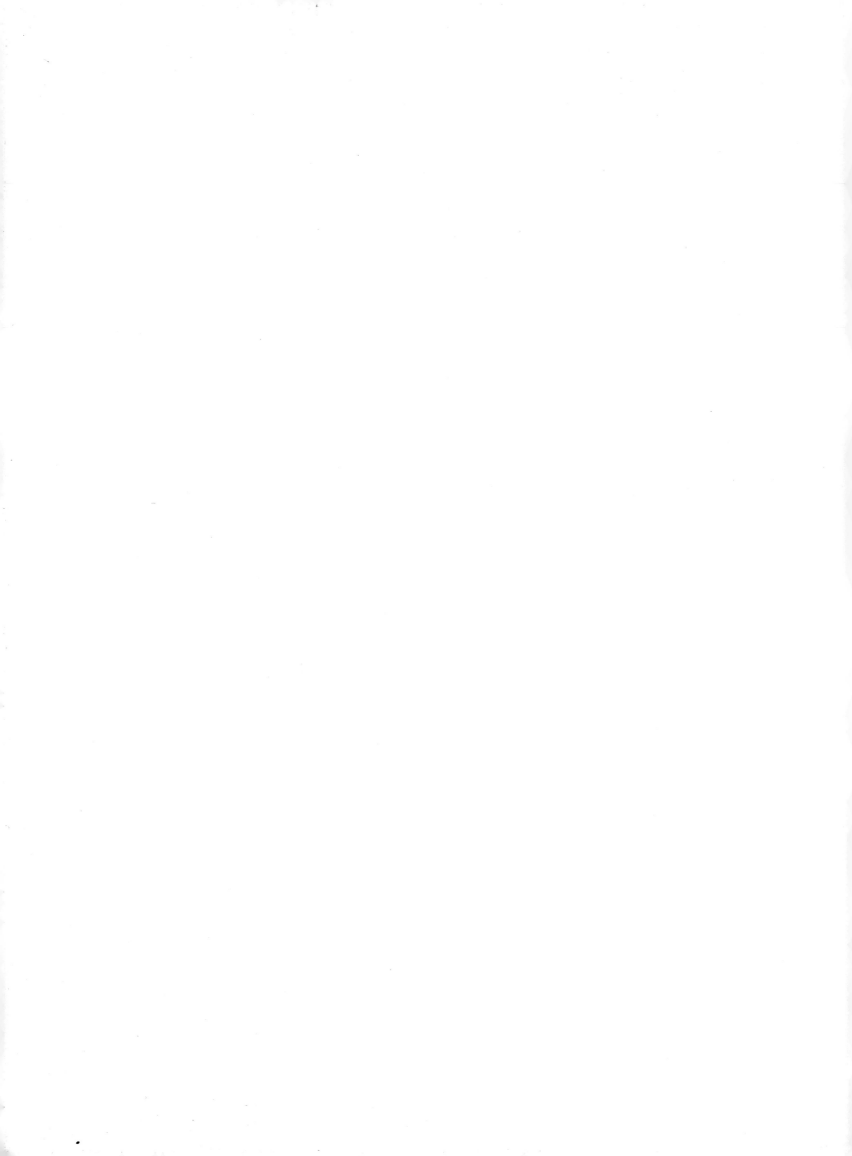

Director's Foreword

PHILIPPE DE MONTEBELLO

The Metropolitan Museum of Art is privileged to present the Mary Griggs Burke Collection of Japanese art, which represents highlights of Mrs. Burke's involvement with and collecting in the field of Japanese art over the thirty-seven-year period since 1963. The Museum's association with Mary Burke and with her late husband, Jackson, goes back to 1962, when they began their generous support of the program in Japanese art in the Department of Asian Art. Members of the department's Visiting Committee at its inception in 1969, the Burkes throughout the years donated funds for purchases, frequently lent works to be shown in the Japanese galleries, funded research on Japanese art in the Museum's collection, and contributed to the department's activities in more personal ways. Mrs. Burke's firm commitment to the Museum is further evidenced by her service since 1976 as a Trustee, and since September 1995 as a Trustee Emeritus; she has also served, since 1977, on the Museum's Acquisitions and Education Committees.

The Mary Griggs Burke Collection includes a comprehensive range of objects, from prehistoric earthenwares to refined lacquerwares, dramatic and brilliantly colored screens, and exquisite ink drawings. It is the largest and most encompassing private collection of Japanese art outside Japan. The culmination of nearly forty years' activity, it is a testimony to the seriousness, intensity, and selectivity of Mrs. Burke's collecting, guided by her discerning eye and deep affection for Japan. A selection of more than one hundred works was shown at the Metropolitan in 1975, and the present exhibition comprises some two hundred objects, including many acquired since then and never before seen by the public. The exhibition of the collection at the Tokyo National Museum in 1985 and the subsequent award to Mrs. Burke of the honorary medal of the Order of the Sacred Treasures, Gold and Silver Star, by the Japanese government in 1987 are signal marks of the high esteem in which Mrs. Burke is held by the Japanese nation for her activities in support not only of Japanese art but of all facets of Japanese culture. The exhibition of the Burke Collection in its latest form at the Metropolitan is an occasion to celebrate Mary Burke's longstanding commitment to the Museum, and ours to her. It also bespeaks the Museum's commitment to the field of Japanese art.

The exhibition and its accompanying catalogue also mark the collaboration over the past thirty-five years between Mary Burke and Dr. Miyeko Murase, Takeo and Itsuko Atsumi Professor Emerita, Columbia University, and currently Research Curator of Japanese Art at the Museum. Mrs. Burke and Dr. Murase have worked closely together to form the collection, and the latter has curated the present exhibition and is the author of its catalogue.

In closing, I wish to extend my sincere thanks to The Dillon Fund for its generous support toward the realization of this catalogue.

The Collection: A Personal History

MARY GRIGGS BURKE

The beauty of the Japanese aesthetic first struck me when I saw my mother's kimono, a padded winter garment of black silk displaying at the knee a bold design of twisted pine branches covered with snow. She had bought it in Japan as a young woman, just after the turn of the century, and she wore it with the slim grace of the Princess from the Land of Porcelain, in the painting by Whistler that hangs in the famous Peacock Room at the Freer Gallery of Art in Washington, D.C. Mother's taste in clothes was elegant, and the kimono attained its striking effects not through brilliant color or intricate pattern, but by its dramatic white-on-black design. I can remember putting it on and letting it trail behind me. It was then, I believe, that a future collector of Japanese art was born.

In considering this vivid memory of childhood, I realize that my taste has been influenced by a series of such family experiences associated with travel to and ideas from other countries. Cross-cultural currents shape the lives of many Americans. We look back to Europe, whence many of us come, but we turn also, with curiosity and expectation, to the East. In contemplating the activities of my immediate forebears, I have a sense of the movement, drive, and curiosity that linked them with cultures other than our own.

My maternal grandfather, Crawford Livingston, came from an old New York family.

Robert Livingston, the founder of the Livingston family in America, was a Scotsman. He arrived in this country in the early seventeenth century. He received a large land grant and the title Lord of the Manor from the British crown. Four generations later, Livingstons served in the American Revolution. They helped to draft and sign the Declaration of Independence and the Constitution, and they produced several eminent men in the fields of government, law, and commerce in the newly established United States of America.

Although he grew up in New York, Grandfather Livingston did not remain in the east. In 1870, he went west to Saint Paul, Minnesota, fourteen years after my paternal grandfather, Colonel Chauncy Griggs, had moved there from Connecticut. The Colonel had fought in the War Between the States on the Union side. The Griggs family, like the Livingstons, traced its roots in American history to the early seventeenth century. Both my grandfathers were men of their time. Ambitious and in search of promising business opportunities, each left the east coast, where he was born, to travel throughout the United States. Both married and raised large families in Saint Paul and established themselves in a variety of successful ventures, including lumber, railroading, and public utilities. Grandfather Livingston eventually returned to New York

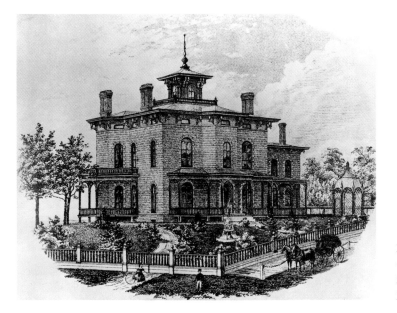

Figure 1. House of Crawford Livingston, Saint Paul, Minnesota. Engraving, 1867

to help his only surviving son form a banking firm, while Grandfather Griggs pressed on to the west coast to extend his lumbering interests in Tacoma, Washington.

While Grandfather Griggs attended to business, his wife and some of his children traveled abroad. Martha Ann Gallop Griggs, my grandmother, took two of her children—my father, Theodore, and a younger sister—to Germany. It was there that Father first studied art. He later made skillful black-and-white ink sketches of landscapes, animals, and people, delighting in caricatures of friends and relatives. His drawings contributed to my later admiration and empathy for the world of the great ink painters of Japan.

Grandfather Griggs's wife—an active, cultured person and a good amateur painter—was a woman of independent mind. She is purported to have made a number of trips to the Orient, including Japan, in the late nineteenth and early twentieth centuries. Unfortunately, I know little of these adventures except for a possibly apocryphal but evidently typical story concerning one of her departures from Tacoma. She was about to board ship when her houseman rushed onto the dock with the news that the house was on fire. Calmly she told him to return to the site and put out the fire; she meantime continued on her journey to Japan, with a single-mindedness worthy of a Zen priest.

One of her four sons, my uncle Everett Griggs—who succeeded his father, the Colonel, as head of the Saint Paul and Tacoma Lumber Company—visited Japan on a business trip after the great earthquake of 1923. While at Yale, Everett had become the friend of two Japanese classmates. He and his wife, Grace, evidently stayed with these gentlemen and their families in Japan. Soon after their return, the daughter of one of the Japanese friends came to visit them. She stayed, it is said, for two years and attended school in Tacoma. With her, she brought a splendid fourteenth-century painting of White-Robed Kannon as a gift to my aunt and uncle. This painting (cat. no. 49), which I had long admired,

I acquired in 1983 from the cousin to whom my aunt left it in her will.

My mother, Mary Livingston Griggs, was not the only member of her family to visit Japan. Accompanied by her mother, a sister, a brother, and two cousins, she went around the world in 1902. In Japan they stopped at Tokyo, Nikkō, and Kyoto, which she especially enjoyed. Mother went down the Kamo River to shoot the Hozu rapids. She watched cormorant fishing and attended a Nō play. Unfortunately, only her kimono remains to commemorate this early trip to Japan, but I believe that the beauty of the country and the spirit of the Japanese people deeply affected her. Certainly she loved its gardens. Many years later she built a rock garden with streams, rustic bridges, ferns, moss, and wildflowers in northern Wisconsin at the summer house that she inherited from her father, Crawford Livingston. This miniature garden inspired by Japan, along with Wisconsin's tall green pines and sparkling lakes, instilled in me a deep love of nature. The belief in the sanctity of nature in turn led me in my collecting to Zen Buddhist landscapes of the Muromachi period, so expressive of the essence of natural things and of man's harmony within the natural world. "Landscapes of the soul," they illustrate the quiet seclusion of a mountain retreat and were often used by Zen monks as aids in meditation (see cat. no. 62).

In Saint Paul, both my grandfathers acquired large Victorian houses situated on a hilltop boulevard with a commanding view of the Mississippi River. There exists a quaint 1867 print of Grandfather Livingston's house, built in 1862–63 by an entrepreneur of the riverboat and stagecoach industry (fig. 1). The print shows the house as a three-story gray-limestone mansion crowned by a low-pitched roof and wooden cupola. The bracketed cornice, round arched windows, and handsomely proportioned belvedere are typical of the villa style so popular in America between 1850 and 1870. Mother, the only one of Grandfather's children to remain in Saint Paul, eventually took it over. My parents were married in this house and I grew up there.

Throughout Mother's life she found much pleasure in collecting antiques, which on a large scale included complete eighteenth-century paneled European rooms, which were—cleverly and amazingly—installed in the Victorian house. By the time Mother had finished redoing it, the mid-nineteenth century house contained such a variety of styles and objects from different cultures, including a few Chinese ceramics, that it was like a museum. Living in such an environment undoubtedly helped me to develop a respect for rare, carefully crafted objects, and being surrounded by so many interesting things probably gave me an eclectic taste. Collecting was in my blood.

Like Father, Mother was artistically inclined. Late in life she took up painting. She greatly admired the work of the American painter Georgia O'Keeffe, and some of her own pictures resembled that artist's flower paintings. Miss O'Keeffe's exposure to Eastern art is manifested in her working process of executing a series of paintings on a single theme. Her deep awareness of the forces underlying nature and her adoption of a flat, decorative composition in strong colors also reflect this influence.

Mother was greatly drawn to Miss O'Keeffe's paintings, and in the 1940s she gave me one called *Black Place No. 1* (fig. 2). I believe this painting, more than any other single work of art, influenced the formation of my own taste.

Another painter who also had a profound influence on my growing aesthetic appreciation was Bradley Walker Tomlin, with whom I studied at Sarah Lawrence College. Tomlin was an Abstract Expressionist of the New York School. He taught me how to look at and really understand a picture. He rejected stereotypes and had the ability to grasp the inner meaning of all true art. Tomlin is purported to have studied Zen ink painting. He introduced me to the calligraphic line of the American Action Painters, whose brushstrokes resemble Chinese and Japanese calligraphy. Eventually, I acquired works by such artists as Maurice Utrillo and Aristide Maillol,

as well as a fine example of a Surrealist-Cubist painting by Tomlin himself (fig. 3).

I studied art history at home—at Sarah Lawrence in Bronxville, at Columbia University Graduate School, and at the Institute of Fine Arts—and abroad, in France and Italy, and became more appreciative of modernism in art. The use of shadowless space and unrealistic but strong, clear color had become familiar to me through my acquaintance with the work of both O'Keeffe and Tomlin, as well as through that of the other modern painters I had collected. When eventually I went to Japan, I was struck by certain similarities of approach between some of the traditional Japanese schools and schools of contemporary Western art. But what impressed me most in Japanese painting was the use of line. In *ukiyo-e* prints and paintings line serves as a border for areas of color, while in ink painting line is a kind of shorthand, a sensitive and suggestive way of presenting both form and content.

It was not until 1954, about thirty years after I coveted my mother's splendid kimono, that I made my first trip to Japan, at the suggestion of the architect Walter Gropius. Increasingly involved with the modern movement in painting and architecture, I had decided to build a contemporary open-plan house on the north shore of Long Island in Oyster Bay, New York (fig. 4). For the job I chose The Architects Collaborative, or TAC, in Cambridge, Massachusetts, a firm headed at that time by Gropius. He had just returned from a lecture tour in Japan and was full of enthusiasm for things Japanese. The kind of modernism he stood for had much in common with traditional Japanese architecture, epitomized by the Katsura Imperial Villa (fig. 46, page 249). Both Gropius and Ben Thompson, the TAC architect principally responsible for designing my house and its landscaping, thought that visiting the gardens of Japan would give me insight that might help them to create a perfect environment.

Through the International House of Japan, I met the architect Junzō Yoshimura and in his company visited most of the important gardens of Japan, both private and public. Mr. Yoshimura was of great help to me in deepening my understanding of Japanese aesthetics and architecture. We visited many of his buildings and those of other contempo-

rary architects, and we visited as well ancient temples and palaces. At the Katsura Imperial Villa, we sat on the bamboo moon-viewing platform and looked out over the stroll garden, with its lakes, winding paths, and teahouses. From this and other sites I brought back not only ideas that helped capture some of the spirit of Japan for my own garden but also a profound interest in the entire approach to the arts in that country.

In 1954 the countryside of Japan was still strikingly beautiful. Patterned rice paddies and neat tea plantations surrounded the villages on the plains, covered the low hills, and reached up to the craggy mountains. The old, dark, beautifully shaped farmhouses appeared to grow from the green fields, and the people who worked the fields in their dark blue clothes and broad straw hats evoked a sense of belonging and harmony. Art played a large part in the daily lives of the people. The distinction between craft and high art was not so sharply drawn as in the West. Art was a comprehensive whole that included lacquer, ceramics, paintings, textiles, and much more. The aesthetic sensitivity of the Japanese people showed not only in their architecture and masterpieces of sculpture and painting, but in what they wore, in the utensils they used for eating, even in the arrangement of food on a plate. Although modern development has done away with much of the picturesque quality of the scenery that I saw in 1954, this understanding of art as an all-embracing way of life still prevails in Japan to the present day.

It was during the 1954 trip that I fell in love with Japan, and I have continued to this day to admire the country, its people, and its art. Although I was profoundly moved by the beauty of the paintings and sculptures that I saw in museums and temples, I acquired at that time only a few souvenirs—some modern ceramics, including a large plate by Hamada, which I gave away as a present, and a number of Meiji prints.

I found my first large Japanese art object in the United States. In 1956, I bought at auction an Edo-period screen. It depicts six episodes from Murasaki Shikibu's *Tale of Genji*, which focus on chapter 7, "An Autumn Excursion," in which Genji and his great friend Tō no Chūjō dance the "Waves of the Blue Ocean." Although my interest in Japanese art was

growing, I had not yet read Lady Murasaki's great novel or I would certainly have tried to acquire the screen's mate, also offered at the auction. Eventually, the companion screen was bought by Frank Lloyd Wright and is now in Taliesin, his house in Spring Green, Wisconsin.

In 1955, the year before I bought the screen, I had married Jackson Burke. Having lived in California for most of his life, he also had an interest in the East. We used the Edo-period screen first in our TAC-built house, where it suffered from too much sunlight, and later moved it to our New York apartment. We then acquired some works of modern Japanese abstract calligraphy more appropriate for our modern house than old screens.

By this time, I was seriously studying Japanese art. I had joined both the Japan and Asia Societies in New York, and I was taking courses at the Institute of Fine Arts and at Columbia University. At Columbia, I met Professor Miyeko Murase, whose connoisseurship continues to be an invaluable source of inspiration and help to me in matters of understanding and collecting Japanese art. She has played a large role in the continuing growth of the collection and has written most of the catalogues for its many exhibitions.

Because of my husband's failing health, we began to spend some of our winters in Florida. In 1962 we attended an exhibition at the Society of Four Arts, in Palm Beach, which included paintings, but no prints, of the *ukiyo-e* school. We were captivated by the artists' use of pattern, strong color, and line. These paintings were mainly genre scenes and portraits of beauties of the Yoshiwara district (see cat. no. 146). On November 22, 1963, a date I well remember, as it was the day that President Kennedy was assassinated, we bought the entire collection of seventy works from the widow of Mr. Frank Hart, who had assembled them in Japan during the Occupation. These paintings were to form the nucleus of our future collection.

In the following two years we became more adventurous, and while we never completely stopped collecting *ukiyo-e*, we turned our attention to other areas of painting. We were fortunate to be able to purchase works by early Rinpa artists, most notably two charming album leaves with poems from the *Kokin wakashū*, done in Kōetsu's fluid calligraphy

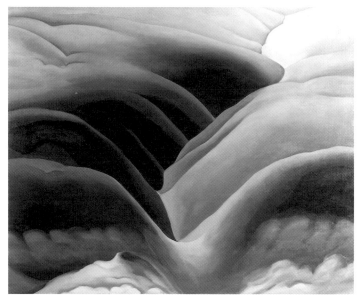

Figure 2. Georgia O'Keeffe (1887–1986), *Black Place No. 1*, 1945. Oil on canvas, 76 x 91 cm (29⅞ × 35⅞ in.). Collection Mary Griggs Burke, New York

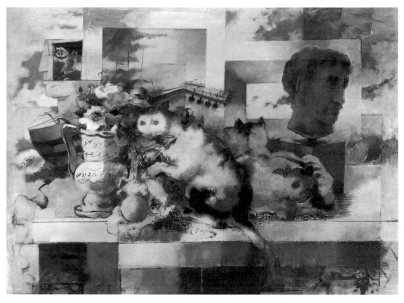

Figure 3. Bradley Walker Tomlin (1899–1953), *Still Life (Outward Preoccupation)*, 1939. Oil on canvas, 85.7 x 118 cm (33¾ × 46½ in.). Collection Mary Griggs Burke, New York

on Sōtatsu's decorated paper (cat. no. 84), and a Hotei portrayed with a few deft strokes and patches of black ink by Kōrin (cat. no. 133). Later we acquired other important works by these masters of painting and calligraphy (cat. nos. 83, 85). During these early years we also found sculpture, ceramics, sutras, and lacquers.

At the encouragement of Professor Murase, I had at last read *The Tale of Genji*. This great and intricate novel, which has had a pervasive effect on Japanese culture, touched me deeply. I became aware of how important both prose and poetry are to the Japanese and how closely they are bound to the visual arts of painting and calligraphy. The collection includes many works—screens, scrolls, albums, and other objects—that present episodes from *Genji* (cat. nos. 81, 82, 87, 109, 110, 126).

As full-fledged collectors, my husband and I had begun to become friendly with other collectors as well as with curators and directors of museums in the United States that had large holdings of Asian art. These included The Metropolitan Museum of Art, which in 1975 presented our collection in an exhibition that traveled to the Seattle Art Museum and the Minneapolis Institute of Arts. We had good relationships with the Art Institute of Chicago, the Museum of Fine Arts in Boston, the Fogg Art Museum of Harvard University, and in particular the Freer Gallery of Art in Washington, D.C., whose former director, Philip Stern, was most helpful in advising us

on some of our first purchases. When we began to collect in Japan, we were greatly helped by these friends, who introduced us to museum experts and noted scholars such as the late Tanaka Ichimatsu. We met many knowledgeable dealers in both America and Japan. The assistance we received from all these people is an important chapter in our collecting activities, but one too large to be covered in the present essay.

In 1965, my husband and I made a decision that gave me the incentive and encouragement to go to Japan for really serious collecting. As a printer and designer of books and eventually as director of typographic development for Mergenthaler Linotype Company in Brooklyn, Jackson Burke had a strong sense of design. He was well known as a designer of typefaces. A man of great taste and an inveterate collector himself, he built a library of rare books on printing. He realized that in order to display our treasures properly we needed not only more space but also properly designed space. In 1965, we acquired a separate apartment for the display of our collection. Here we could share with others these beautiful objects in a setting that would enhance the unique quality of each work. In our "mini-museum" we tried to approximate the simple and carefully proportioned space of a traditional Japanese house, where a limited number of functional and beautiful objects are always on view. While we did not produce a real Japanese living room, the Japanese

sculptor and designer Yasuhide Kobashi helped us create an architectural enframement in the Japanese style. This room of grass cloth and wood includes wall space for hanging scrolls, built-in platforms for screens, and a *tokonoma* for the display of scrolls and objects. Here my husband applied his fine sense of design and his training in graphic arts to put together small, exquisite exhibitions. In choosing objects, we tried to develop an ambience that would suit a particular season or would appeal to the taste of the guests who were to be entertained on a specific day.

Like the Japanese, we attempted to think in terms of the complete environment. We constantly changed and rearranged our objects to form different and complete harmonies. In the years from 1966 to 1975, Jackson Burke selected two hundred fifty groups of objects to display to more than sixteen hundred visitors, among them scholars, friends, and students. Their delight and their often sudden recognition of the beauty of an object in this ideal setting amply rewarded our efforts.

The completion in 1966 of our mini-museum was a stimulant to our collecting activities. We felt more secure in acquiring rare and beautiful objects to display in that environment, now with proper temperature and humidity control. When I would return from Japan with new art objects, Jackson Burke would catalogue them and organize them in the new space.

During the years 1966 through 1973, we added considerably to our collection and our

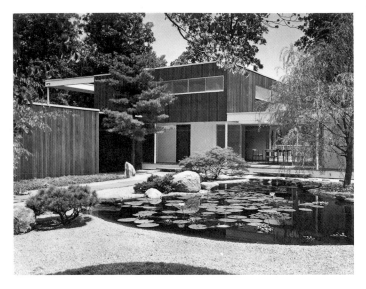

Figure 4. House of Mary Griggs Burke, Oyster Bay, New York. The Architects Collaborative (TAC), 1955

range of interest expanded to include all the categories represented in this exhibition. We continued to increase our holdings of Shinto and Buddhist sculpture and painting and began to collect in new categories, including early *yamato-e*, calligraphy, and ink painting. To the works we already owned of the Rinpa, Tosa, and *ukiyo-e* schools from the Momoyama, Edo, and Meiji periods, we added works from the Kano, Shijō, and *nanga* schools. We also acquired ceramics, lacquer, and metal objects from all periods. I cannot say that we made a conscious decision to amass examples from every area of Japanese art, because certain categories popular with many collectors, such as prints, *inrō*, *haniwa*, and decorative porcelains, are either completely absent or represented by only one example.

The factor of luck—being in the right place at the right time—accounts for the fact that about thirty percent of the collection consists of works from two Edo-period schools, *ukiyo-e* and *nanga*. We had acquired the Hart Collection of *ukiyo-e* in 1963, and a large number of *nanga* paintings in 1967 and 1968. These two categories of paintings made good foils for each other. The robust, colorful, town-oriented *ukiyo-e* we first admired found their complement in the Chinese-inspired, literary, and nature-celebrating *nanga* works. The collection includes a pair of screens by one of the most famous *nanga* artists—*The Gathering at the Orchid Pavilion* and *Autumn Festival*, by Taiga (cat. no. 159).

During the sixties and early seventies I was able to pick up bargains in both the United States and Japan, because at that time not only were there only a few serious collectors of Japanese art in America, there was a lull in the art market in Japan.

When my husband died, in 1975, I did not stop collecting. Although I missed both his good taste and his capacity for organization, there was something within me that could find release only through continuing to seek out the beautiful and enjoying it with others. Perhaps the need to collect and to share my treasures became even stronger after I lost him.

In 1979 it became necessary for the designer, Kobashi, to add another small gallery to the mini-museum, in order to display religious objects, sculpture, and painting—both Shinto and Buddhist. Again the aim was not to produce an authentic setting. Instead of a temple, Kobashi created an atmosphere of calm simplicity in which religious icons would look at home. He also built a tearoom.

Extra space was needed to accommodate not only the religious art, but also the significant growth in other categories of the collection. Fine Momoyama tea ceramics were being acquired, and in 1980 a more serious attempt to collect both calligraphy and lacquer was fostered by my then curator, Andrew Pekarik, who had taken over the care of the collection in 1973. Mr. Pekarik continued to help me maintain and expand the collection for ten years.

At the present time, the collection is cared for by two very knowledgeable women. Gratia Williams Nakahashi, Curator, and Stephanie Wada, Associate Curator, keep the collection in pristine condition, set up small exhibitions for visiting scholars and friends, and serve as registrars for objects on loan. They are invaluable.

Before concluding this essay, I would like to speak again of Professor Murase. I have known her during the more than thirty years she spent as a distinguished member of the Department of Art History and Archaeology at Columbia University, where she is Takeo and Itsuko Atsumi Professor Emerita, and we have enjoyed a long and fruitful relationship. Internationally published, she has curated exhibitions and written catalogues for collections other than mine, and several of her students have attained positions of prominence at museums and universities. Of enormous help to my husband and me was the fact that she frequently brought her students to see our collection and used it as a tool for teaching. In addition to offering us her knowledge and informed opinion of objects presented to us for purchase, she has introduced me to important scholars and to dealers in Japan. In short, she has been invaluable to the formation of my collection.

I would like to close by saying how proud and how pleased I am to have this exhibition at the great Metropolitan Museum, with its distinguished director, Philippe de Montebello. I have been amazed by the detailed and careful preparation that has gone into making it a beautiful and meaningful display, one in which Professor Murase has been involved with every facet, as she was in the exhibition held at the museum in 1975. My only disappointment is that my husband, Jackson Burke, did not live to participate in this splendid occasion.

I have been a member of the Metropolitan's Board of Trustees since 1976, and I have found every minute to be both interesting and rewarding. Both the Acquisitions and Education Committees, on which I serve, are highly stimulating. I have learned much about great art and about its history, and how it is best presented to the diverse museum audience of New York City. I owe a deep debt of gratitude to the other members of the Board of Trustees and to Philippe de Montebello for allowing me to be a part of this wonderful world. In the collection's future public use, I plan to remember the Museum in ways that will prove pleasing to all.

Acknowledgments

This exhibition and the accompanying catalogue represent the culmination of a long journey by Mary Burke and myself, assisted by many people, notably among them Dr. Wen Fong, without whose encouragement it would not have been possible.

Many people have contributed to the growth of the collection over the past twenty-five years, since it was first exhibited at this museum in 1975. Especially important have been those individuals in Japan who offered professional advice, information as to the availability of objects for purchase, and a willingness to assist Mrs. Burke in her quest for beautiful and important works of art.

In the preparation of this catalogue, a large number of people have given me invaluable and selfless assistance. Four authors, all associated with Columbia University, contributed to the catalogue: Gratia Williams Nakahashi, Gen Sakamoto, Stephanie Wada, and Masako Watanabe. In addition, Gen Sakamoto compiled the Bibliography of Selected Readings and Stephanie Wada prepared the Glossary. My special thanks are due also to Gratia and Stephanie in their capacity as the curators of the Burke Collection. They greatly facilitated this enormous undertaking, helping with photography sessions and during my examination of objects, and in countless other ways. At Mrs. Burke's, Noelle O'Connor and Elizabeth Corbo were always willing to help.

In the Department of Asian Art at the Metropolitan Museum, my deepest gratitude goes to Dr. Masako Watanabe, who was indispensable as a colleague and adviser, assisting and guiding me through the inner workings of the Museum. Dr. Maxwell Hearn was always generous with his knowledge of Chinese language and Chinese art. Dr. Barbara Ford helped me with her intimate knowledge of the Museum's holdings of Japanese art, and Joyce Denney offered her expertise in Japanese textiles. Dr. Denise Leidy gave ungrudgingly of her knowledge of Buddhism and Sanskrit; she was also forthcoming with valuable suggestions, as an experienced curator, in the preparation of the exhibition and in the creation of the CD-ROM, in which I played only a small part. That relatively new project was skillfully orchestrated by Elizabeth Hammer Munemura and Teresa Russo of the Education Department, assisted by Paul Caro, Clemence Delannoy, and Joseph Loh. My thanks also to Yoshinori Munemura and Kōichi Yanagi, who gave their time and expertise in helping us with a portion of the CD-ROM that concerns the tea ceremony.

In my research for the catalogue, I depended on the kindness and generosity of many librarians: Jack Jacoby of the Department of Asian Art and Linda Seckelson and Robert Cederberg of the Thomas J. Watson Library at the Metropolitan were especially helpful, as were Kenneth Harlin and Rongxiang Zhang of the Starr Library at Columbia University. Very special thanks go to Leighton and Rosemarie Longhi of New York, who graciously made available to me the large holdings of their private library. Tomoko Sakomura and Miwako Tezuka, both graduate students at Columbia University, and Ichiro Yuhara of the University of Chicago helped me in numerous ways, especially in dealing with computers. My special thanks go also to Dr. Stephen D. Allee, Research Specialist in Chinese Literature and History at the Freer Gallery of Art, Washington, D.C., who translated Chinese-style colophons.

The preparation of the catalogue, which involved more than three years' intensive work, also represents the close collaboration of many people. My deepest gratitude goes to Emily Walter, Senior Editor, whose patient editing of every word of manuscript ensured lucidity and readability. Her high standards, dedication, and conscience were matched by her team of equally dedicated and remarkably sharp-eyed assistants, editors Ellyn Allison and Margaret Donovan. Jayne Kuchna was the meticulous editor of the notes and bibliography. I shall be forever indebted to their careful scrutiny of details. To this talented group must be added Robert Palmer, who compiled the index. It was again a pleasure to work with Bruce Campbell, whose sensitive design recalls our earlier, happy collaboration. The book's beautiful appearance is the work also of the photographer Bruce Schwarz, and of the production team, headed by Gwen Roginsky, of Merantine Hens, Production Manager, and Minjee Cho, who was responsible for the desktop publishing. The high quality of the catalogue was due, needless to say, to the expert guidance of John O'Neill, Editor in Chief.

For the complex work on the exhibition, I am again deeply grateful to Masako Watanabe and Denise Leidy, and to the members of the Design Department, Michael Batista and Sue Koch, who have created a beautiful and memorable installation. I wish also to thank Aileen Chuk, Registrar, working with Hwai-ling Yeh-Lewis and Allyson Moss of the Department of Asian Art, as well as the Asian Art technicians Michael Rendina, assisted by Damien Auerbach and Beatrice Pinto. Takemitsu Oba and Sondra Castile, Conservators in Asian Art Conservation, have been deeply involved with the conservation and installation of the art objects. For the duration of this project, the staff of the Department of Asian Art has been most tolerant and patient with me. My first thanks go to Judith Smith, who guided me through the maze of officialdom and red tape. Nina Sweet, Joyce Sitzer, and Denise Vargas were always good natured, and helpful in countless ways. Last but not least, I offer my gratitude to Marvin Pertzik, secretary of the Mary and Jackson Burke Foundation, for his invaluable assistance and encouragement.

The execution of this exhibition is a tribute to the skill and professionalism of every person involved. To each one of them—experienced staff member and friend—I offer my deep and sincere thanks for their commitment and unstinting support.

Miyeko Murase

Chronology

Protoliterate Era	ca. 10,500 B.C.–A.D. 538
Jōmon Period	ca. 10,500 B.C.–ca. 300 B.C.
Yayoi Period	ca. 4th century B.C.–ca. 3rd century A.D.
Kofun Period	ca. 3rd century A.D.–538
Asuka Period	538–710
Nara Period	710–794
Early Heian Period	794–ca. 900
Late Heian Period	ca. 900–1185
Kamakura Period	1185–1333
Nanbokuchō Period	1336–1392
Muromachi Period	1392–1573
Momoyama Period	1573–1615
Edo Period	1615–1868

Key to Contributing Authors

GWN	Gratia Williams Nakahashi
GS	Gen Sakamoto
MW	Masako Watanabe
SW	Stephanie Wada

BRIDGE OF DREAMS

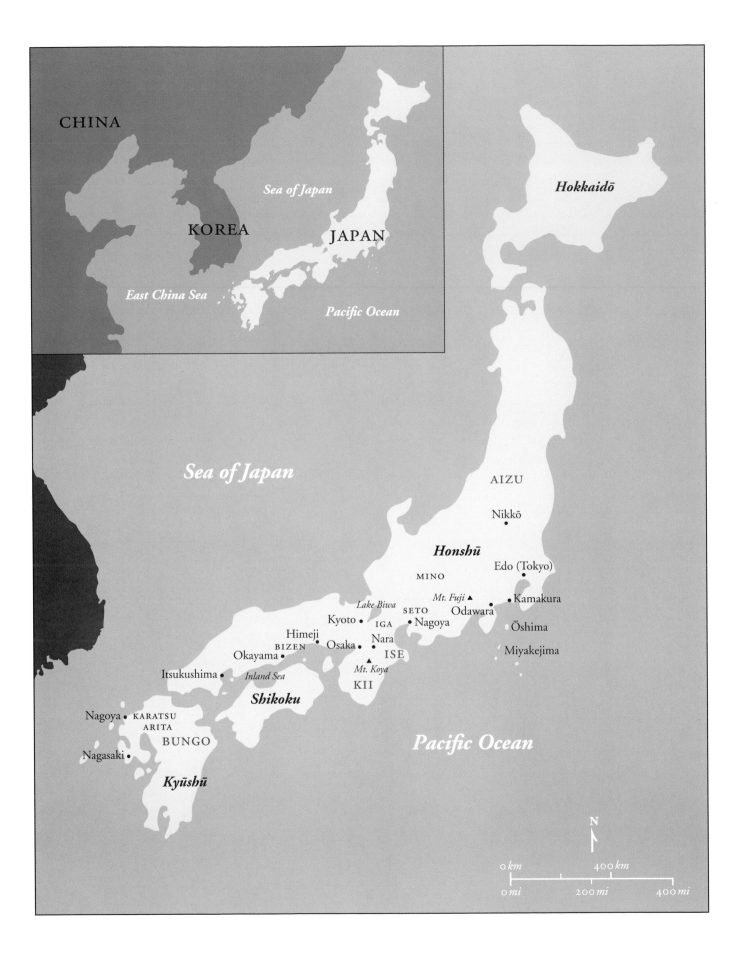

CHINA

Sea of Japan

KOREA

JAPAN

East China Sea

Pacific Ocean

Hokkaidō

Sea of Japan

AIZU

Nikkō •

Honshū

MINO

Edo (Tokyo) •

Mt. Fuji ▲ • Kamakura

Lake Biwa SETO Odawara •

Kyoto • IGA Nagoya • Ōshima •

Himeji Nara Miyakejima •

BIZEN • Osaka • ISE

Okayama • ▲

Itsukushima • *Inland Sea* *Mt. Koya*

KII

Shikoku

Nagoya • KARATSU

ARITA

BUNGO *Pacific Ocean*

Nagasaki •

Kyūshū

N

0 km 400 km

0 mi 200 mi 400 mi

Introduction

Japan is an elongated, crescent-shaped chain of islands that extends for about 2,800 kilometers (1,740 miles) off the Asian mainland. The name "Japan," by which the archipelago is known in the West, derives from "Riben," the Chinese reading of "Nihon" or "Nippon" (Where the Sun Rises), the name by which the Japanese people referred to their land.

Japan lies within a vast monsoon zone that promises regular seasonal winds—in summer from the tropical south, bringing heavy rainfall; in winter from northern Asia, causing heavy snowfall in Hokkaidō and the coastal areas facing the Sea of Japan. The warm currents that flow from southern China and Southeast Asia favor the southern areas and those on the Pacific coast with mild winters. Even in the temperate southern regions, however, life has never been easy for the inhabitants. Studded with mountains—many of them volcanic—only about one-sixth of the land is arable and thus lacks in natural resources.

Ethnological and linguistic studies indicate that the first settlers came either from the northern regions of the Asian continent or from Southeast Asia. Although these early immigrants could advance no farther, as they were blocked by the vast ocean that extended to the east, the four seas that surrounded them served to protect them from invasion. Before the Second World War, Japan was only twice threatened by a foreign power. In 1274 and again in 1281, a combined force of Chinese and Koreans was successfully repulsed, but only with the unexpected intervention of violent storms, subsequently venerated by the Japanese as the *kamikaze* (divine wind).

In this highly insulated nation, the attitude of the Japanese people toward their neighbors has swung like a pendulum. At times they withdrew into the comfortable cocoon of their island habitat, rejecting all contact with the outside world. At other times they were acutely aware of cultures beyond the seas that surrounded them and yearned to be part of the larger, international community. Three great waves of continental influence gave direction to the main cultural currents of Japan. The first was the introduction of Buddhism from Korea in the mid-sixth century. Thereafter, for hundreds of years, cultural models were drawn from China and Korea. Zen Buddhism arrived in the twelfth century, and with it the art of ink-monochrome painting. In the eighteenth century Japanese artists, again profoundly influenced by Chinese culture, emulated the Chinese literati concept of painting.

Without question, the intermittent influence of Chinese culture inspired the Japanese people. But no foreign culture has ever totally dominated them. Periods of intense borrowing from continental culture have always alternated with periods of retrenchment, when the Japanese would assimilate what they had borrowed from abroad, adapting it to their own needs and sensitivities and adjusting it to the indigenous environment. The vivid expression of a joyful response to nature and human affairs, for example, has distinguished the arts of Japan from those of China, which tend toward sober restraint and intellectualization. Nearly all aspects of Chinese art were explored in Japan, and in every case the result

was a rich and innovative variation. For this reason it is nearly always possible to distinguish Japanese copies from the Chinese originals. A particularly good example of this process is found in the art of book illustration. Boldly exploiting the handscroll's unique ability to suggest the passage of time as the paper is unrolled, Japanese painters have depicted human activities with an immediacy unrealized anywhere else before the advent of the cinema. The Japanese genius is also evident in the masterly application of vivid colors and gold and silver to create large, abstract patterns not unlike some twentieth-century art. Perhaps what distinguishes Japanese art most clearly from the art of China and Korea is the fast—almost frenzied—pace with which new styles evolved in the island culture. Even so, the presence of the past is always felt.

In our own time, the Japanese have turned once again to the outside world. Emerging from an entrenched feudal system in the late nineteenth century, they have eagerly assimilated Western technology and culture. Their achievements in art during the past hundred fifty years again illustrate their remarkable gift for absorbing new ideas while remaining true to their own spirit. Fascinating though it is to examine the evolution of the modern arts in Japan, that pleasure cannot be enjoyed here, as the Mary Griggs Burke Collection focuses exclusively on works dating to before 1868. It is hoped that those who read this catalogue and savor the works on which it is based will pursue their acquaintance with the art created in Japan through the twentieth century and beyond.

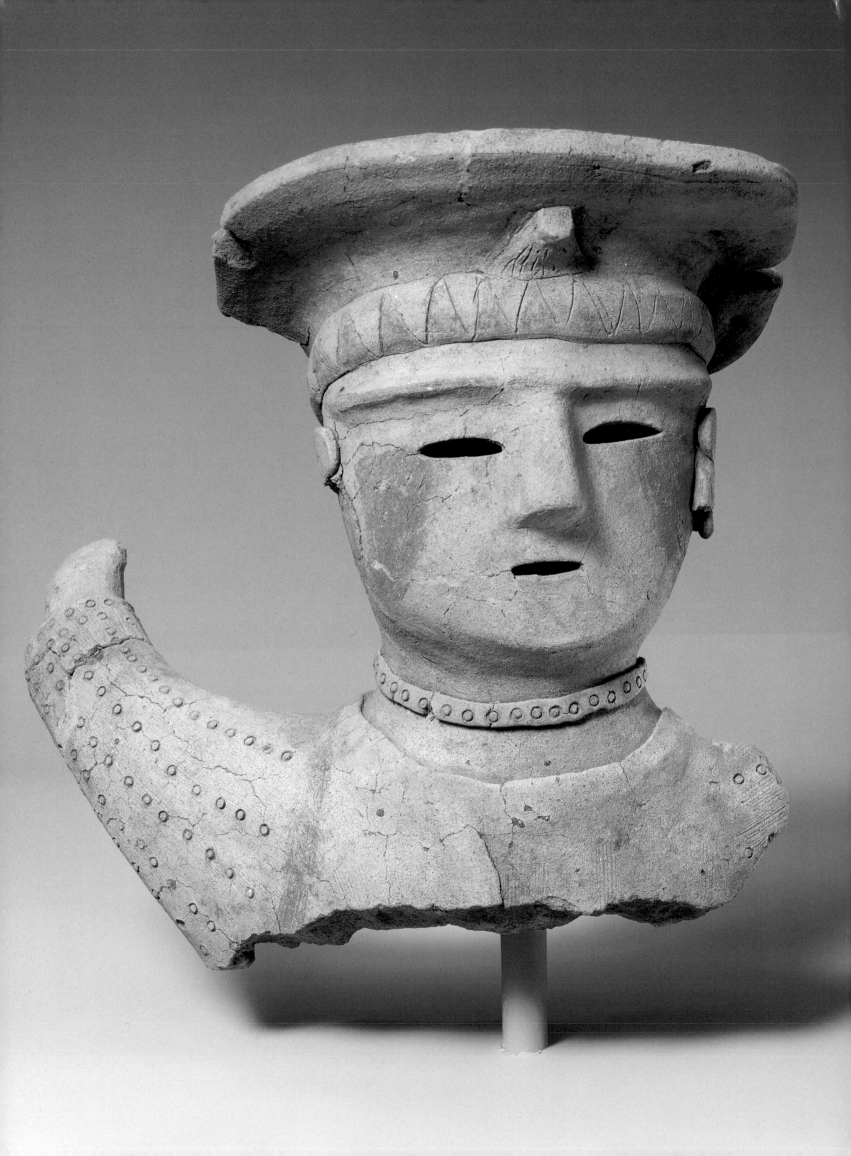

I. Protoliterate Era (ca. 10,500 B.C.–A.D. 538)

CATALOGUE NOS. 1–4

About eighteen thousand years ago, toward the end of the Ice Age, as the great glaciers began slowly to melt, the islands that now constitute the Japanese archipelago were separated from the Asian mainland. Japan's first pottery-making culture, the Jōmon, appeared sometime after this geological event. Carbon-14 testing of the oldest types of Jōmon vessels has yielded for their production the stunningly early date of about 10,500 B.C., but because this date falls outside the known chronology of pottery development elsewhere in the world, it is not generally accepted and remains provisional until further studies are made.

The Jōmon period (ca. 10,500 B.C.–ca. 300 B.C.) constitutes the first phase of Japan's protoliterate era; the others are the Yayoi period (ca. 4th century B.C.–ca. 3rd century A.D.) and the Kofun period (ca. 3rd century A.D.–538). The name Jōmon, which means "cord markings," was given to these ceramics because most of the clay vessels and figurines made in this culture bear the marks made by rough ropes wound around sticks that were pressed against the clay when it was still wet (fig. 5). Such marks are also combined with geometric designs formed of grooves and raised bands, which the potters made by dipping their fingers in water and running them over the clay body, leaving a vivid reminder of their presence. Excavations of Jōmon sites, most of which were discovered by chance, have increased in number since the end of the Second World War. While the many archaeological finds have added to our knowledge of specific artifacts, they have not helped to resolve certain fundamental questions concerning the people of the protoliterate era, such as their ethnic classification and the origin of their language. The resolution of such questions is crucial for understanding the succeeding culture.

Beginning about the fourth century B.C., Jōmon culture was gradually replaced by the more advanced Yayoi culture, which first appeared in western Japan, then spread east and north to Honshū Island. The Yayoi, farmers who enjoyed the benefits of living in per-manently settled communities, developed a culture that signaled a radical departure from the simple hunting life of the Jōmon. Some new aspects of their society evolved from the Jōmon, but more important to their development was the technique of wet-rice cultivation, which is thought to have been introduced to Japan from Korea or southeastern China.[1] Many dates for this momentous agricultural innovation—ranging from 1000 B.C. to the first century A.D.—have been proposed, and its adoption has been largely responsible for

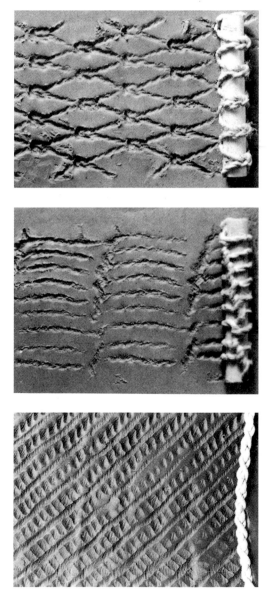

Figure 5. Cord-marking patterns on Jōmon pottery

Opposite: Cat. no. 3

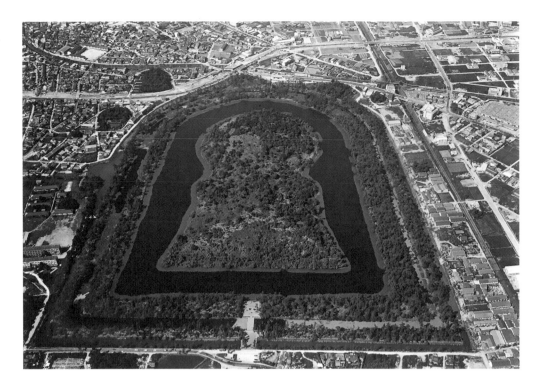

Figure 6. Tomb of Emperor Nintoku, Sakai, Osaka Prefecture. Protoliterate era (ca. 10,500 B.C.–A.D. 538), late 4th–early 5th century. Total area 458 acres

the political, economic, and cultural variations that characterize different regions of the archipelago. Thus the western region, which is better suited to rice cultivation, is culturally and economically more advanced than the hilly, colder northern region, which to this day remains less developed.

Yayoi vessels are the products of a society dependent on the cultivation of rice. As surpluses were stockpiled, increasing numbers of storage jars were needed. Indeed, storage jars constituted nearly half the vessels produced in the Yayoi culture. The Yayoi also made objects and tools in bronze and iron, as well as elegant, thin-walled pottery wares. (The name "Yayoi" is borrowed from a site in Tokyo, near the campus of Tokyo University, where this type of pottery was first discovered in 1884.) The great variety of shapes available for the cooking, storage, and serving of food suggests that the culture was an affluent one. The technical sophistication of their crafts clearly distinguishes the Yayoi people from the Jōmon and presupposes that their cultural advancement was not of indigenous origin but rather was brought to Japan from the Asian continent by successive waves of immigrants.

The people of the Yayoi culture lived in thatched houses clustered to form villages, and it was during this era that a class society began to emerge. Also significant was the introduction of metallurgy from the Asian continent, which made possible the production of bronze and iron implements. Over time, the Yayoi people grouped themselves into clan-nations, which by the first century numbered more than one hundred. Throughout the second and third centuries the clans fought among themselves. In the late fifth century power fell to the Yamato clan, which won control over much of Honshū Island and the northern half of Kyūshū.

The practice of building sepulchral mounds and burying treasures with the dead was transmitted to Japan from the Asian continent about the third century. The following three centuries are called the Kofun (also Tumuli) period because the culture of this era is studied mainly through artifacts found in or near burial mounds (*kofun*, old tombs). In the late fourth and the fifth century, mounds of monumental proportions were built in great numbers, symbolizing the increasingly unified power of the governing class (fig. 6).

1. Richard J. Pearson (in Pearson et al. 1991, p. 15) dates it to 1000 B.C. But in his most recent book (Pearson et al. 1992, p. 23) he dates it to ca. 400 B.C. Gina L. Barnes (in Pearson et al. 1991, p. 28) places it at about 350 B.C. Kinoshita Masashi (1982, introduction and p. 17) dates it to both the first century A.D. and the third to second century B.C. More recent scholarship holds that the beginning of the Yayoi culture did not necessarily coincide with the introduction of wet-rice cultivation, suggesting that it overlapped with the demise of Jōmon culture.

Jōmon Period (ca. 10,500 B.C.—ca. 300 B.C.)

CATALOGUE NO. 1

At the present time, the chronology of the Jōmon period is usually divided into the following six phases:

Incipient	ca. 10,500–8000 B.C.
Initial	8000–5000 B.C.
Early	5000–2500 B.C.
Middle	2500–1500 B.C.
Late	1500–1000 B.C.
Final	1000–300 B.C.

All Jōmon pots were made by hand, without the aid of a wheel, the potter building up the vessel from the bottom with coil upon coil of soft clay. The clay was mixed with a variety of adhesive materials, including mica, lead, fibers, and crushed shells. After the vessel was formed, tools were employed to smooth both the outer and the interior surfaces. When completely dry, it was fired in an outdoor bonfire at a temperature of no more than about 900 degrees centigrade. It is generally believed that the vessels were made by the women of a food-gathering society whose male kinfolk hunted and fished. In other parts of the world such food-gathering cultures evolved into food-producing cultures. By contrast, the Jōmon people—though they lived in settled communities, their pit dwellings arranged around a central open space—continued to follow their original life-style.

The earliest, most primitive pieces made in this culture were cooking vessels, the most common of which were pointed at the base so they could be pushed into the earth. Over the centuries, decorations were added. Initially,

small medallions or strips of clay were attached to the rim. Later, designs were incised into the clay. And finally, the *jōmon*, the cord markings, appeared (fig. 5, page 3). Beginning about midpoint in the Initial Phase, potters used not only rope but also shells and wooden sticks with engraved designs to impress decorations into the soft clay. Rims became irregular in profile as they were pinched, raised, or indented. In western Japan, mainly Kyūshū and the Nara–Kyoto area, flat-based vessels were produced. Indeed, at this time nearly all the characteristic features of Jōmon pottery emerged.

Excavation sites dating to the Middle Phase—the zenith of Jōmon culture—have been found in great numbers, suggesting a growth in the population, which now enjoyed a somewhat richer material life. Vessels dating to this era are more varied in shape, size—some measure 50 centimeters (nearly 20 in.) in height, others a mere 5 centimeters (2 in.)—and function. With their thicker bodies and flamboyant projections, Middle Phase pots are more profusely decorated, with designs executed in a wide range of techniques. The exuberant projections, which bear no apparent relationship to the function of the vessels, are unique to Japanese pottery culture. Some examples, like the vessel in the Burke Collection (cat. no. 1), are irregular in shape, with a boldly sculptured rim and three-dimensional protrusions. The primitive species—snakes and frogs—that sometimes adorn the surfaces suggest that vessels of this kind may

have had some ritual, rather than purely utilitarian, purpose.

During the Late Phase, mysterious figurines in clay, called *dogū* (earthen idols), representing humans—usually female—and animals, began to appear. They have been found at many sites, for the most part in eastern Japan. Cord patterns like those on the pots decorate their bodies and faces. The function of the *dogū* is not clear, though it was most likely based on some sort of ritualistic belief. Many female *dogū* have ample breasts and hips, which suggests that they may be fertility goddesses or benevolent spirits who assisted at childbirth. As many others have missing body parts, they may have been used in prayers for the recovery of the sick or to place a curse on an enemy.

Jōmon vessels were of interest to the Japanese of the early Edo period (1615–1868), but serious studies of the culture were not undertaken until the excavations in 1877 of shell mounds at Ōmori, south of Tokyo, by the American scholar Edward S. Morse (1838–1925). Our information concerning the evolution of Jōmon pottery remains inconclusive. Many scholars suggest connections with the Asian mainland; for example, the use of small, punched holes as well as *jōmon* on vessels from northern Japan is thought to derive from Siberian pottery.[1] Other scholars see the development of Jōmon pottery as the result of indigenous evolution.

1. Kobayashi Tatsuo 1979, figs. 19, 21, and 23.

1. Deep Bowl

Jōmon period (ca. 10,500 B.C.–ca. 300 B.C.)
Earthenware
Height 53.1 cm (20⅞ in.)

LITERATURE: Murase 1993, no. 55.

Like many Jōmon vessels of the same general shape, this pot is composed of two distinct parts: a tall, flat-based body that widens slightly toward the top and a flaring mouth that consists of four groups of abstract sculptural shapes. Made of coiled clay that encircles the top of the vessel, the flamboyant, forward-projecting decorations are pierced by large and small openings. Rims sculptured in this way are known as the fire-flame type, or Ka'en-shiki, as they resemble leaping flames (ka'en); they are the distinguishing feature of Jōmon vessels. Their meaning, origin, and function are not known, but they are vivid reminders of the malleability of the material from which the vessels were constructed.

Although most Jōmon wares are plain pots made for cooking, lavishly decorated pieces such as this one were probably used for preparing food at special religious ceremonies, their sculpted rims and large size making them unfit for everyday use. The soot that blackened the upper half of the body suggests that this vessel was placed over a vigorous fire that later died down.[1] Such pieces are far rarer than those that are smooth and plain-rimmed, and they are in a better state of preservation when excavated.

Jōmon vessels have been found at sites throughout the Japanese archipelago, but the most spectacular specimens are from sites concentrated in eastern Japan. It is generally agreed that Ka'en-shiki vessels were produced in the northeast, from the Japanese Alps to the area north of the Kantō Plain. The most dramatic examples come from the Shinano River basin in Niigata Prefecture, near the Sea of Japan. The bowl in the Burke Collection resembles pieces excavated in the areas around Fukushima, northeast of Tokyo.

The tentative chronology of Jōmon pottery culture suggests that Ka'en-shiki vessels first appeared in the Kantō region at the beginning of the Early Phase and reached the height of their development in the Middle Phase, during which the Burke bowl may have been made. In the Late Phase such strong plastic designs began to lose their energy and were supplanted by the more functional vessels of the Yayoi culture.

1. Richard J. Pearson in Pearson et al. 1991, p. 26. It is also suggested that some Jōmon vessels were used for the burial of human remains, and the small holes at the bottom were made as passages through which the deceased's soul could be released. See Harada Masayuki in Pearson et al. 1992, p. 103.

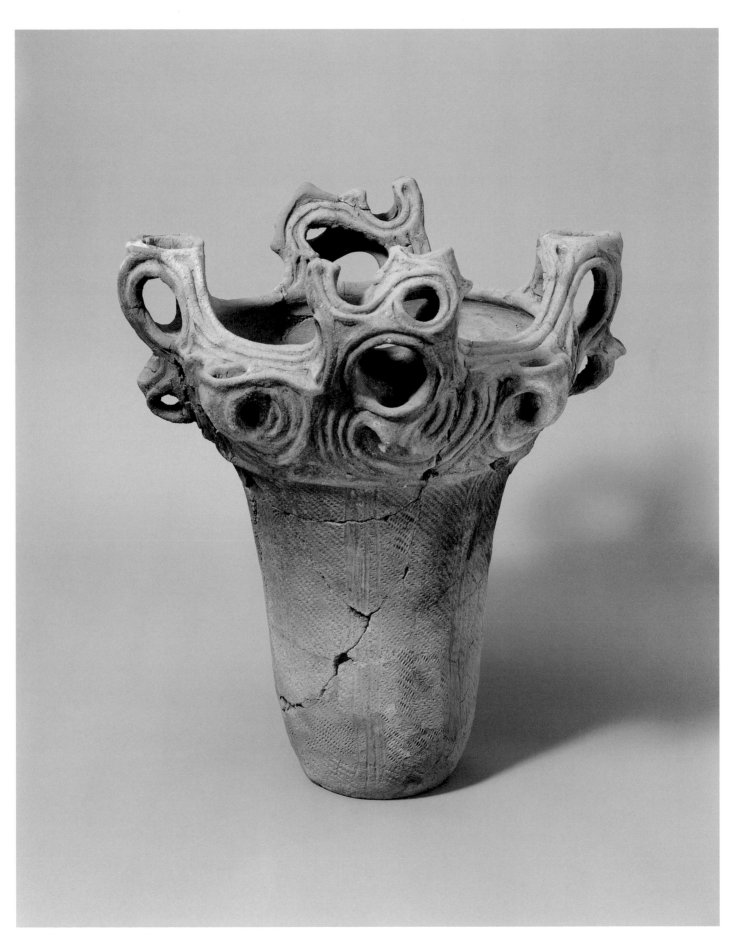

Yayoi Period (ca. 4th century B.C.—ca. 3rd century A.D.)

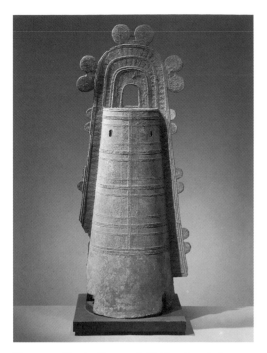

Figure 7. *Dōtaku* (bronze bell). Yayoi period (ca. 4th century B.C.—ca. 3rd century A.D.), 1st–2nd century A.D. Bronze, height 110.5 cm (43½ in.). The Metropolitan Museum of Art, New York. Rogers Fund, 1918 (18.68)

In striking contrast to Jōmon pottery, Yayoi vessels have clean, functional shapes. Nonetheless, the technical process of pottery-making remained essentially the same, and in all likelihood women using the coil method rather than the potter's wheel continued to be the primary producers. Two technical differences, however, are significant: the fine clay surfaces of Yayoi vessels were carefully smoothed, and clay slip was sometimes applied over the body to make it less porous.

Many Yayoi vessels resemble pots found in Korea, and some scholars have proposed that the Yayoi style originated in that land, arriving first in northern Kyūshū and gradually spreading northeast. Nevertheless, some pieces clearly show the influence of Jōmon ceramics, leading others to speculate that Yayoi wares were the product of an indigenous evolution from the less elaborate Jōmon wares of northern Kyūshū.[1] A compromise view is that the indigenous pottery tradition was modified by an influx of new technology from the continent in the last years of the Late Jōmon Phase.[2]

Although recent excavations in South Korea and Japan have brought to light an enormous amount of data concerning Yayoi vessels, there is still much to be learned. It is clear that new pottery shapes, which were functional as well as elegant and refined, spread across the archipelago, with the exception of Hokkaidō in the north and Okinawa in the south, and a variety of regional styles evolved. The most extensively decorated Yayoi vessels were produced in areas where the most elaborate Jōmon wares had been made, suggesting the lingering influence of the earlier pottery tradition. Nevertheless, the decorations are relatively scant, consisting primarily of grooves and hatched lines. In some cases simple designs of houses, animals, fish, and humans are scratched into the shoulders. Some Yayoi vessels with tall stems recall pieces from the Longshan culture of China (2500–1700 B.C.), while others have the perforated base characteristic of Korean pottery in the Three Kingdoms period (57 B.C.–A.D. 668).

Yayoi wares were fired at a higher temperature than Jōmon pottery, some parts polished to a high sheen and painted before firing. Although most Yayoi pots were intended for utilitarian purposes, some were apparently made for ritual use. The most unusual bronze object produced during this period was the *dōtaku*, a bell with a tubular body surmounted by a large handle that extends as a decorative flange along the sides of the body (fig. 7). The most common designs are hatched lines, triangles, spirals, and geometric patterns. Simple representations of domesticated animals, as well as scenes of fishing, harvesting, hunting, and fighting—all familiar activities in the lives of the ancient Japanese—also appear. Religious or ritual ceremonies do not seem to have been depicted. The continental prototype of the *dōtaku* has yet to be discovered.

1. Kuraku Yoshiyuki 1979, p. 6; Harunari Hideji 1990; and Tsuboi Kiyotari 1990, p. 86.
2. Kinoshita Masashi 1982, p. 20.

2. Red Jar with Flaring Mouth

Yayoi period (ca. 3rd century B.C.–ca. 3rd century A.D.), 3rd century A.D.
Earthenware
Height 40.5 cm (16 in.)

LITERATURE: Murase 1993, no. 56.

Devoid of the sense of dark mystery that pervades Jōmon pottery, this jar belongs to a new type of ceramic discovered in 1884 and named "Yayoi" for the culture that produced it. Yayoi pieces have complex profiles. This jar swells from a small base to a bulbous body and then narrows sharply to a neck that supports a boldly flaring mouth decorated simply with four sets of three parallel clay strips. The surface is smooth, and the bright red coloration was produced by the oxidized iron in the clay.

This smooth-walled vessel with its simple yet powerful shape was probably made as a storage jar for grains or liquids. A black scorch mark on the body, however, suggests that like many other storage jars it was placed over a cooking fire. The large hole at the base perhaps indicates its original use, since it is believed that such vessels were placed on tall stands atop tomb mounds (fig. 8, page 12) as precursors of the earliest *haniwa* (cat. no. 3).[1]

1. See Murai Iwao 1971, p. 84; Kuraku Yoshiyuki 1979, figs. 76, 85; and Kobayashi Yukio 1990, p. 122.

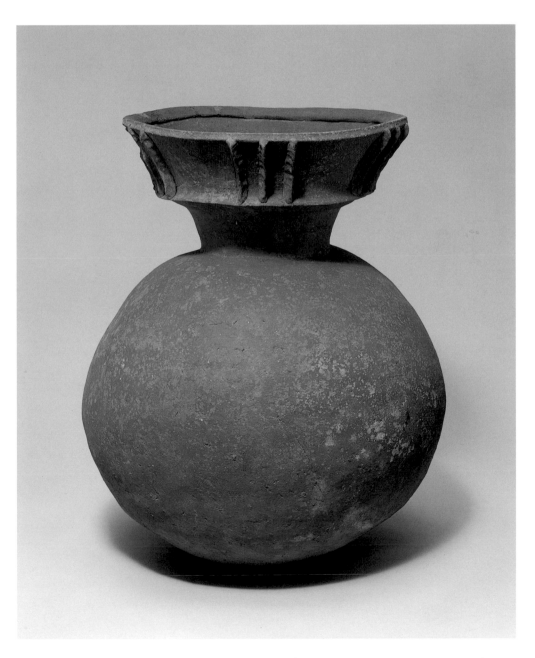

Kofun Period (ca. 3rd century A.D.–538)

CATALOGUE NOS. 3, 4

Several of the great tombs that gave this period its name are found in the vicinity of Osaka. The largest, believed to be that of Emperor Nintoku (313–399), measures in total 458 acres (fig. 6, page 6). The tomb is shaped like a keyhole. In front is a flat wedge-shaped mound intended for rituals, and behind it is a higher circular mound built over the burial chamber. The site is surrounded by three moats and ringed by a series of smaller burial mounds.

Burial chambers and sarcophagi in the early tombs are simple and unadorned. By the sixth century painted decorations begin to appear. The earliest, dating from the beginning of the century, are simple geometric patterns; later in the same century, painted representations of men and animals are found. The bodies of the dead were interred in large wooden coffins; burial goods—bronze mirrors, tools, weapons, personal ornaments, horse trappings, and clay vessels—accompanied the coffins in the tomb chambers.

The burial mounds were circled with stones. Packed in rows at the base, scattered on the crest of the knoll, or placed on the sloping sides of the mound were *haniwa* (clay cylinders). These hollow clay tubes served as stands for offering vessels, such as the Yayoi jar (cat. no. 2), when the tombs were the focus of community ritual.[1] Although most *haniwa* are unadorned, some have sculptures— among the most charming objects created in prehistoric Japan—at the top.

The first sculptural *haniwa* were miniature models of houses and ceremonial furnishings placed on the summit of the mounds, which were often surrounded by small replicas of arms and armor. Later, sculptures of birds, most likely meant as messengers of the gods, were added, together with figures of horses and priestesses. In the late fifth century solemn-faced aristocrats, warriors, peasants, and soothsayers join their ranks, as do boats and domesticated animals by the end of the century. Directly observed representations of things and people, *haniwa* offer a rare glimpse into the life of the ancient Japanese. With no

hint of mystery in their open expressions, these delightful sculptures were made with very little modeling; the eyes and mouth, for example, are mere perforations in the hollow tube, which allowed hot air to pass through the statue during the firing process. The simplicity of technique and form reflects the Japanese craftsman's sensitivity to the soft, malleable character of the clay, a sensitivity that may be observed as well in much later ceramic works.

Facing outward from the burial mounds, the *haniwa* could be seen from a great distance (fig. 8). Possibly they were used to mark a sacred site, or to protect the site from evil spirits; they were certainly not used as replacements for human sacrifices, as is often erroneously claimed. The disposition of the human *haniwa* on the mounds has been variously interpreted as representing a funeral march, prayers for the revival of the dead, or a transfer of power from one ruler to the next.[2]

Haniwa were made in large numbers, sometimes in the thousands. They were fired in kilns called anagama, at a low temperature of about 600 degrees centigrade. As a result, they

are, like the example in the Burke Collection (cat. no. 3), either reddish or buff-colored. When nearly identical figures are found in groups of two or three, they can be attributed to the same artisan; differences in regional styles have also been recognized.[3]

There is some dispute as to where *haniwa* originated, but we know that their production spread throughout the archipelago. After the initial stage of cylinder or pot-atop-cylinder, objects such as shields, boats, and houses were introduced, most likely in the second half of the fourth century. In the fifth century, these objects were replaced by representations of humans and later of animals. The human *haniwa* were especially popular in the Kantō region of eastern Japan. *Haniwa* production stopped in the Kinki area, in southern Honshū, in the late sixth century and in the rest of the country in the seventh century.

1. Kobayashi Yukio 1990, p. 122.
2. Kamei Masamichi 1995, p. 21.
3. Inokuma Kanekatsu 1979, pp. 15–18; and Kobayashi Yukio 1990, p. 101.

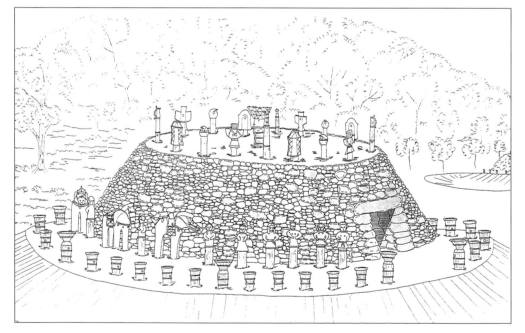

Figure 8. Reconstruction of *haniwa* on tumulus, Jimbo Shimojō, no. 2, Gunma Prefecture. Drawing by Migishima Kazuo and Iizuka Satoshi

3. Haniwa

Kofun period (ca. 3rd century A.D.–538),
6th century
Earthenware with traces of polychrome
Height 31.5 cm (12⅜ in.)

LITERATURE: Murase 1993, no. 57.

Burial mound figures, or *haniwa*, were the most important funerary furnishings of the Kofun period. Because male and female *haniwa* have similar faces, gender identification is difficult. Nevertheless, in most cases clothing and hairstyles serve to distinguish males from females. Men wear hats and helmets, their long hair tied in two ponytails. Women are shown with their hair piled high upon their heads. The special charm of these figures derives from their simple, abstracted forms, with no attempt made to model either face or body, and a disregard for realism, which gives them a vivid immediacy. It is doubtful

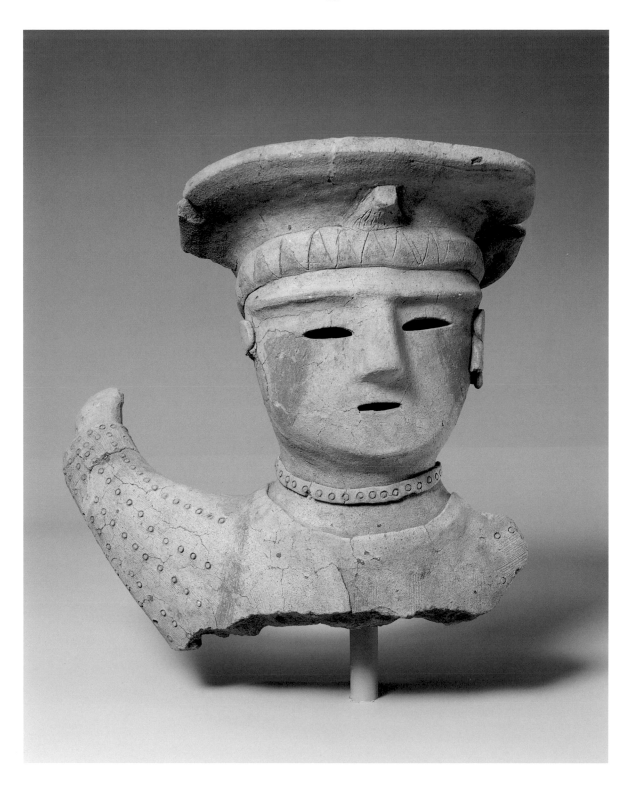

that the makers of these engaging figures intended to portray emotion; the perception of a particular mood is in the mind of the beholder. Indeed, depending on the position of the viewer, the facial expressions of *haniwa* seem to change.

This fragment of a *haniwa* figure with a guileless, childlike expression portrays a young woman, so identified by her imposing chignon, which resembles a mortarboard. The hair is tied in two parts by a ribbon that is visible when viewed from above; indentations detected from the underside of the disk show the parting of the hairknot. The coiffure is adorned with a comblike ornament and a band with a triangle pattern, partially painted red. Directly below the hairline is a long, straight ridge, also painted red, probably indi-cating eyebrows. The facial features, rendered with no attempt at modeling, are expressed by the simplest means—two almond-shaped slits for the eyes, a chunk of clay for the nose (partially restored), and a small opening for the mouth.

With festive rouge on her cheeks, the young woman wears a beaded necklace and earrings that cover her ears. She is dressed in a high-necked tunic with tight-fitting sleeves deco-rated with dots, suggesting deerskin. A shawl-like cloth covers her right shoulder. The raised right arm tapers off to an ill-defined, damaged hand. The left arm, now lost, may have held offerings or been raised in the same manner as her right. The torso is lost, but it is likely that the figure originally wore a flared jacket over a skirt that ended rather abruptly above the usual cylindrical base.

We do not know whether the figure por-trays a particular individual, nor do we know her station in society. It has been suggested that the rouge, earrings, and necklace identi-fy the figure as a participant in a funeral cere-mony.[1] Alternately, such adornments have been thought to indicate that the woman was a sorceress. It has also been proposed that the facial paint represents a tattoo.[2] Whatever the case, the consensus is that the color had a ceremonial significance. The figure may come from the Kantō region of eastern Japan, where many fine human-shaped *haniwa* were made in the sixth century.

1. Doi Takashi in Pearson et al. 1991, no. 56.
2. Kobayashi Yukio 1990, p. 100.

4. *Yokobe*

Kofun period (ca. 3rd century A.D.–538),
6th century A.D.
Sueki; earthernware
Height 37 cm (14⅞ in.); diameter 44 cm (17⅛ in.)

LITERATURE: Murase 1993, no. 58.

This large recumbent vessel, or *yokobe*, is impressive for its unusual watermelon shape, its tough, dark gray body, and the horizontal streaks of glaze that appear to have been blown across the surface by a high wind. The side opening is unique to this type of ware, which was first produced in the mid-fifth century. Known as Sueki—from *sueru* (to offer) and *ki* (ware)—it is usually made of blue-gray clay and is often thin-bodied and hard, having been fired at temperatures of roughly 1,100 to 1,200 degrees centigrade, a range similar to that used to produce modern stoneware and porcelain. Unlike earlier Jōmon or Yayoi pots, *yokobe* were fired in a Korean-style kiln called an anagama, a single tunnel-like chamber half buried in the ground along the slope of a hill. Such kilns were introduced to Japan sometime in the late fourth or early fifth century A.D.

The lineage of Sueki reaches back to the Longshan pottery of ancient China (ca. 2500–1700 B.C.), but its direct precursor is the grayware of the Three Kingdoms period (57 B.C.–A.D. 668) in Korea.[1] Technically more advanced than Jōmon and Yayoi pot-tery, or even a Kofun-era ware of a slightly later date called Hajiki, Sueki marks a turn-ing point in the history of Japanese ceramics. Here the wheel was used for the first time, though only to produce smaller pieces and to finish the shapes of larger vessels. Beginning in the second half of the seventh century, green glaze was intentionally applied to cere-monial objects. Natural ash glaze was often used to decorate wares intended for everyday use, such as the *yokobe* shown here.

Many Japanese settlements with kilns and kiln sites are named Suemura (Sue villages), but scholars generally agree that the first kilns to produce Sueki were probably located south of Osaka—the political and cultural heart of fifth-century Japan—where more than five hundred kiln sites have been discov-ered behind a cluster of tombs.[2] Initially the kilns must have been operated by immigrant Korean potters, since the earliest Sueki look very much like Korean wares. In their casual appearance and the asymmetrical placement of the neck on the body, they most closely resemble Korean pieces from the Kaya region, on the southern coast. From the end of the fifth through the early sixth century, the new technique spread to many other areas of Japan, and to date more than two thousand Sueki kiln sites have been discovered. After the decline of production at Suemura kilns in the Osaka area in the tenth century, Sueki kilns in other provinces continued to turn out pots as late as the fifteenth century.

In addition to the use of the wheel, Sueki manufacture also differed from that of the Jōmon and Yayoi wares in that it was the

product of an officially organized systematic effort that enjoyed court and temple patronage, and professional male workers were involved.[3] A great variety of shapes were created—for everyday use, for the ceremonial functions that evolved in the more complex and advanced society, and for burial of the dead. Sueki was adapted even to the needs of the newly introduced Buddhist ceremonies.

In use from the beginning of Sueki history,[4] a *yokobe* such as this one, a barrel-shaped recumbent bottle with the neck on the side, is the most basic type of storage jar for liquids such as sake. (It is shown here as it would have stood when not in use, so the liquid would not pour out.) Like many other *yokobe*, it was formed in sections by the coil method. The neck also was made separately and later attached to the opening on the side. Three disks were used to finish and close the aperture at one end. These may have been finished on a wheel, as they bear whirl lines left by a turning motion. The vessel itself was smoothed on both the exterior and the interior by being beaten with wood tools, with care taken to keep them from breaking through the relatively thin body. The exterior was further smoothed with another wood tool, carved with a checkered pattern, while the interior was finished with a tool carved with a wave pattern. The finished vessel was made to stand on its end in the kiln; the ashes from burning embers that fell on its surface during the firing created the random vitreous glaze that runs across the body, a technique that has continued into modern times.[5] This vessel, with its simple, well-formed body of iron-rich clay and stripes of natural green-brown glaze, vibrates with raw energy, its strangely vivid quality singularly appealing to modern taste.

1. Miwa Karoku in Pearson et al. 1991, p. 53.
2. Narasaki Shōichi 1990, p. 92.
3. Tanabe Shōzō 1989, p. 121.
4. Narasaki Shōichi 1990, p. 108.

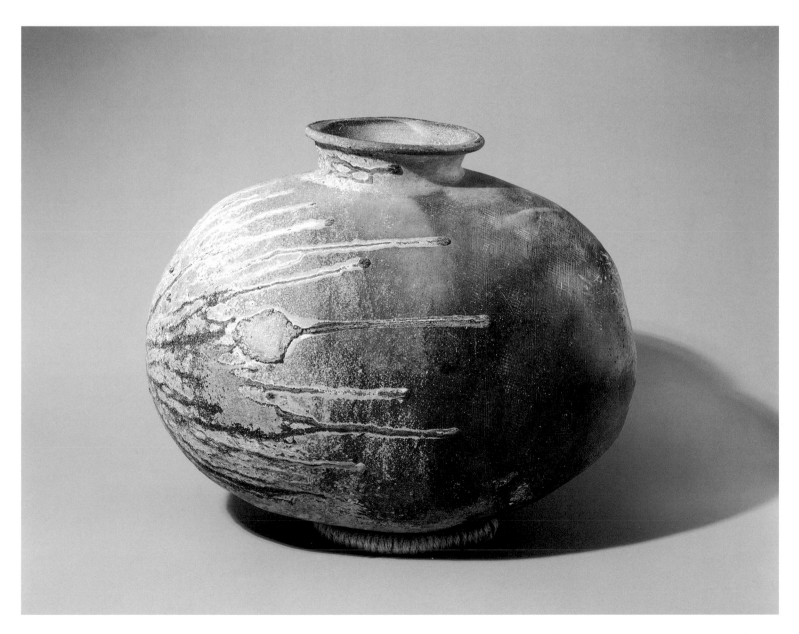

II. Asuka through Late Heian Period (538–1185)

The introduction of Buddhism to the Japanese archipelago in the sixth century was of momentous significance. The faith that has shaped the lives of millions of people in East and Southeast Asia originated in India. Its founder is thought to have been born in 563 B.C. The son of a king of the Shakya tribe, based in the Himalayan foothills of what is now Nepal, his given name was Siddhartha and his family name Gautama; he also came to be known as Shakyamuni (J: Shaka Nyorai), or Sage of the Shakyas. Raised in luxury as a royal prince, Siddhartha eventually became acutely aware of the abject miseries suffered by mankind, and at the age of twenty-nine he departed from home, renouncing the world to search for a solution to death and human suffering. He first studied yogic meditation under various teachers, but finding that it did not lead to the highest realization, he decided to follow his own path. After six years of spiritual discipline, he attained enlightenment while meditating under the sacred *bodhi* tree at Bodh Gaya. As the Buddha, or Enlightened One, he devoted himself to sharing with others the mysteries of the universe, teaching and establishing a community of monks and nuns, the *sangha*, to continue his work.

The Buddha taught that all existence is sorrow and that human suffering derives from attachment to the self and to the ephemeral delights of the senses. To rid oneself of suffering and to find release from reincarnation—the continual cycle of birth, death, and rebirth to which all sentient beings are destined—it is necessary to suppress the ego. Salvation, he discovered, is achieved by following the Eightfold Path: of right beliefs, right aspirations, right thoughts, right speech, right livelihood, right action, right effort, and right meditation. This code of living the Buddha proclaimed in his first sermon, to five ascetics at Sarnath, where he began to turn the Wheel of the Law. The five ascetics became his first disciples. According to tradition, the great teacher achieved transcendence, or *nirvana*, in his eightieth year and was liberated from the cycle of rebirth and suffering. After

his mortal death the Buddha resumed his place in paradise, to await the souls of the faithful through the ages.

Mahayana (Greater Vehicle) Buddhism, which developed in India during the Kusana era (ca. 1st–3rd century A.D.), was the form of the faith introduced into Japan. It is distinguished from the Theravada and related schools, known as Hinayana (Lesser Vehicle) Buddhism. The ideal of earlier Buddhists was the perfected saintly sage, the arhat, who attained liberation by purifying the self of all defilements and desires. The main philosophical tenet of Mahayana doctrine is that all things are empty, or devoid of self-nature. Its chief religious ideal is the bodhisattva, who supplanted the earlier ideal of the arhat and is distinguished from the latter by his vow to postpone his own entry into *nirvana* until all other sentient beings are saved. Shakyamuni, the historical Buddha, is regarded in Mahayana as the temporary manifestation of the eternal Buddha. Mahayana's belief in the intrinsic purity of consciousness generated the idea of the potential Buddhahood of all living beings.

Buddhism arrived in China about the first century A.D., via the deserts of ancient Gandhara (northern Afghanistan) and Central Asia. By the fourth century, the faith had amassed a great number of believers in Korea as well. In 538 (or 552, according to another tradition), the king of the Korean kingdom of Paekche (J: Kudara), an ardent believer, sent a message to the Japanese emperor Kinmei (r. 532–71) describing the Buddhist faith as "most excellent" and urging him to embrace it.

The decision to admit a foreign faith into their land signified that the Japanese would be joining the continental Buddhist community. It would necessitate adopting a new culture, which was essentially Chinese, and assuming a way of life fundamentally different from that to which they were accustomed. Chinese civilization, which was culturally and politically more sophisticated than their own, thus came to serve as a model for a new social order. The

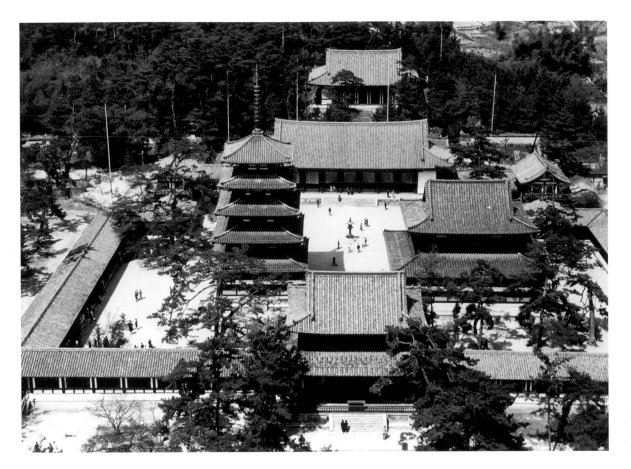

Figure 9. Hōryūji, Nara.
Asuka period (538–710),
rebuilt from 670

upper classes studied Chinese literature, phi-
losophy, art, science, and governance. Most
important, the introduction of the Chinese
system of writing revolutionized Japanese
life, since until that time the Japanese had had
no written language.

The adoption of Buddhism did not, how-
ever, lead to the abolition of Shinto, the
ancient native religion of Japan, which is
characterized by the observance of traditional
rituals and customs involving the reverence of
ancestors, the celebration of popular festivals,
and worshiping a host of beneficent deities.
Indeed, the early Japanese converts to Bud-
dhism learned to accommodate their own
gods to the new faith, and Shintoism has con-
tinued to dominate many traditional cere-
monies important to national life up to the
present day.

The introduction of Buddhism to Japan
marks the initiation of Japan's first historical
epoch, the Asuka period (538–710), named
for the area near Nara where the court resided
and where many edifices were built to honor

the new gods. Because the Japanese had no
knowledge of continental architecture, sculp-
ture, or painting, the construction of temples
and statues and the painting of icons were
supervised by artisans who had emigrated
from Korea.

The earliest Japanese Buddhist temples,
modeled on Chinese prototypes, which in turn
derived from Chinese secular buildings, were
multistructured compounds constructed on
level ground, the buildings laid out in a sym-
metrical plan with a southerly orientation,
considered auspicious in Chinese geomancy.
We know from literary sources that these
structures, built as re-creations of paradise on
earth, were dazzling in their lavish use of
space and the sensuousness of their colors.

Sadly, none of the ancient monasteries
survive. Hōryūji, established probably in 607
in the Asuka area, is the earliest surviving
Buddhist temple, and its several buildings
illustrate the first epoch of Japanese Buddhist
architecture (6th–8th century; fig. 9). Closely
associated with the enlightened statesman

Prince Shōtoku, regent of Japan from 593 to
622, Hōryūji is the oldest extant wooden struc-
ture in the world. With its wealth of architec-
tural and artistic styles, Hōryūji offers the
most comprehensive picture that we have
today of the arts in the Asuka period. The
extraordinarily large number of sculptures
that it houses are predominantly of gilt bronze
and modest in size, with iconographic features
specific to Buddhist imagery. Buddhas are
distinguished from bodhisattvas in that, as
a rule, they wear no personal ornaments. Bodhi-
sattvas are, by contrast, heavily bedecked with
jewels. Buddhas are also characterized by the
urna, a small protuberance on the forehead
that signifies superhuman wisdom, and the
ushnisha, a larger protuberance, like a top-
knot, on the head. The *urna* and *ushnisha* are
two of the *lakshana* (attributes) of the histor-
ical Buddha, physical characteristics that dis-
tinguish him from ordinary mortals. Buddhas
and bodhisattvas alike have unusually long
earlobes, reminders of Buddha's princely past
in India, where men wore heavy earrings. The

Figure 10. Great Buddha Hall, Tōdaiji, Nara. Nara period (710–94), 743–52. Rebuilt 17th century

Buddha is often shown making distinct hand gestures, called mudras, which represent such practices as teaching or meditating. Buddhist deities are, in general, without indication of gender, though a small number have been identified as goddesses by their gentle facial expressions or plump bodies.

Before the eighth century, a new capital city was founded and a new imperial palace constructed. This extravagant practice, which was followed every time a new emperor succeeded to the throne, grew out of the Shinto belief that death pollutes the environment in which it occurs. Thus, because the capital city and the imperial palace were meant to be temporary, for many generations they were fairly modest in size. Over time, the influx of foreign ideas and customs stimulated the emulation of the more sophisticated life-style that prevailed on the continent, from which increasing numbers of Japanese travelers returned with glowing reports of the magnificent capital at Chang'an (Xian) in northwestern China. The reorganization of

the Japanese court into a more complex system, together with a desire for a more centralized rule, led to the establishment of a permanent capital.

Nara was founded in 710. Located somewhat west of the commercial district of present-day Nara, the ancient capital was fashioned after Chang'an, facing south, though unlike the Chinese model, it was not enclosed within city walls. Efforts were made to establish Buddhism as the official religion of the state, and the city itself became the emblem of the new national policy. Along with the new government buildings erected within its confines, many Buddhist temples from the Asuka area were relocated to Nara. Thus, over the centuries, Nara became a mecca for Japanese Buddhists. Today it boasts more than thirty temple buildings, all of wood, that date back to the Nara period, a remarkable number of preserved structures, considering the fragility of the building material.

The city's most ambitious religious project in the Nara period was Tōdaiji (fig. 10), a tem-

ple commissioned in 743 by Emperor Shōmu (r. 724–49), a devout Buddhist, and its main icon, a colossal image of the Vairochana Buddha (J: Birushana Nyorai; fig. 11). In 741, Shōmu had further decreed that branch monasteries and convents be erected in each province in honor of the Shakyamuni Buddha. Shōmu's grandiose scheme, which was never fully realized, sought to achieve in religion the unity of a centralized political system modeled after that of the Tang imperial court. As the Buddha of Supreme Light, the ultimate source of the cosmos, the Vairochana Buddha served as a physical representative of Tōdaiji's supremacy over the provincial temples. Seated on a bronze lotus pedestal composed of forty-eight petals, each petal engraved with an image of the Shakyamuni Buddha, and surrounded by bodhisattvas and monks, he is also the religious counterpart to the reigning secular emperor.

The scale of Tōdaiji was beyond anything ever seen before in Japan. A monument of such grandeur was inconceivable in the

Figure 11. *Vairochana Buddha* (Buddha of Supreme Light), Tōdaiji, Nara. Nara period (710–94), 8th century; reconstructed 17th century. Cast bronze, height 147.3 m (48 ft. 4 in.)

mental to their chief patron, the imperial court. The Buddhist sects in Nara, such as Kegon, Gusha, and Ritsu, their temples built under royal patronage and their massive holdings of land donated by the court, were powerful and rich. Wielding great influence in matters of religion, the clergy became more aggressive in secular matters as well, taking an increasingly active part in national affairs—a situation that threatened the court's authority.

Only seventy-four years after Nara was created, the capital was moved again. In 784, construction began at a site thirty miles north of Nara, but the project was abandoned in favor of another site in 794. Nestled in a valley surrounded by low-lying, rolling hills to the north, east, and west, and open to the south, the new site was conveniently linked via land and waterways to the fertile plains of Nara and Osaka. Heiankyō (the capital of peace and tranquillity) was laid out, like Nara, in a rectangle, again following the plan of the Chinese city of Chang'an. It remained the nation's capital, albeit at times in name only, until 1868, when the capital of modern Japan was established at Edo, subsequently renamed Tokyo. In Heiankyō, the court enjoyed nearly four centuries of peace. The Heian period is usually divided into two eras, Early Heian, extending from 794 through the ninth century, and Late Heian, from the tenth century until 1185.

Heiankyō is today known as Kyoto (capital city). As a tourist mecca it is renowned for its Buddhist temples, which however date from periods later than the Heian. During the reign of Emperor Kanmu (r. 781–806), large-scale temple construction was forbidden within the city limits because the emperor, who had learned a bitter lesson at Nara, was determined to remain free from the influence of the Buddhist clergy. There were three exceptions to his prohibition: Saiji (Western Temple) and Tōji (Eastern Temple), both built in 796 on the southern border to guard the city, and Enryakuji, built to the northeast of the city, atop Mount Hiei, which was far removed from secular life and considered, according to the laws of Chinese geomancy, a propitious location. Enryakuji, which developed into a vast complex of three thousand temple buildings and became a center of learning and culture, was founded about 788 by a young monk

previous Asuka era, when the construction of temples, the worship of Buddhas, and the modeling of their images were matters reserved for individuals of privilege. During the Nara period, however, the practice of Buddhism was embraced by the entire population.

In this period, the Buddhist arts departed significantly from their Asuka predecessors. More complex and varied in their iconography, they adhered more strictly to Buddhist scriptures. Japanese monks who had journeyed to China returned with important Buddhist documents and introduced rituals that required an entirely new pantheon of images. Artists were organized into workshops affiliated with major temples, and soon

they acquired techniques enabling them to work in many different media and styles. The entire range of sculptural techniques and materials, including gilt bronze, unbaked clay, and dry lacquer, is represented at Tōdaiji alone. While a sizable number of statues have been preserved from this period, only a small number of paintings, made on fragile materials such as silk or paper, have survived. Embroidered images and paintings on wood give only a faint echo of what was once a magnificent tribute to the glorification of the Buddha of Supreme Light.

While Buddhism made immense contributions to Japanese culture, the institutions of the faith proved, paradoxically, to be detri-

named Saichō (posthumous title, Dengyō Daishi, 767–822), who had himself left Nara, rejecting the corruption of the monasteries there. In 804, he would be sent to China on an imperially sponsored mission. Saichō and another monk, Kūkai (posthumous title, Kōbō Daishi, 774–835), introduced a new faith called Mikkyō (Esoteric Buddhism) which profoundly affected the life and arts of the Japanese during the Early Heian period (on Mikkyō, see pages 34–36).

As the court withdrew its support, temple activities in Nara were sharply curtailed, and a slow decline of the ancient city set in. Many artists and craftsmen employed by its temple workshops were dismissed. Some returned to their homes in the provinces, but many became itinerant monk-artists, traveling from temple to temple in search of temporary employment. The style of Nara art was thus disseminated to many different parts of the country, as far north as the province of Mutsu (Iwate Prefecture) and as far south as the remote islands of Shikoku and Kyūshū. Without the support of Nara's well-organized temple studios, independent artists were forced to scale down their projects and to use materials that were more readily available and less costly. Clay, dry lacquer, and metal were replaced by wood, which was both plentiful and easily obtainable. Indeed, with the exception of a few bronze pieces created several centuries later in the Kamakura period, wood remained the predominant material for Buddhist sculpture. Dependence on this new material and altered working conditions inevitably influenced the type of work produced, as artists rejected official taste—vividly expressed in the noble, restrained realism of Nara sculpture—to adopt a more personal style.

While other monks, scholars, and traders continued to undertake the arduous journey across the sea to China in order to study or to reap handsome profits in commerce, the court began to evince a somewhat weary reluctance to maintain further official contacts with the Chinese. After a final mission in 838, no further effort was made to renew ties with China. Then, in 894, Sugawara Michizane (845–903; see cat. no. 34), a noted Confucian scholar and one of Japan's ranking statesmen, declined an appointment as ambassador to China, observing that political conditions in Tang China were so turbulent that any official assignment there would be extremely hazardous and without benefit. The court thus terminated official relations with China, which had enriched Japan for more than two centuries.

This historic decision denotes the self-confidence that had been acquired by the Japanese and their growing awareness of the differences that separated them from the Chinese, whom they had hitherto revered and emulated. The year 894 is thus commonly designated as the beginning of the Late Heian period, one of the seminal eras in the nation's cultural history, when the Japanese succeeded in adapting Chinese culture to their own sensibilities. Early in the tenth century the Fujiwaras, a powerful aristocratic family, emerged as the supreme political power. Arranged marriages to emperors helped to secure their preeminence as regents to generations of rulers. Indeed, the hegemony of the Fujiwaras led to the decline of imperial authority. Japanese emperors would strive to regain supremacy, but their efforts would ultimately prove futile.

The Fujiwaras immersed themselves in hedonistic pleasures and the cultivation of beauty. Eventually they controlled not only affairs of state and religion but matters of aesthetics as well, their refined, somewhat effeminate courtly tastes permeating the arts, attitudes toward life, and even religious faith.

By the second half of the twelfth century, domination by the Fujiwaras had waned and political power had shifted from the nobility in Kyoto (Heiankyō had been known by this name since the late eleventh century) to military landowners in the provinces. First, the Heike clan (known also as the Taira) triumphed over the rival Minamoto (or Genji) clan in the Hōgen Insurrection of 1156. The Heike amassed great wealth, especially under Kiyomori, a governor of the south, near Hiroshima, by dealing privately with Chinese traders. Kiyomori, however, fell prey to the attractions of the Kyoto court and began to emulate the hedonism of the Fujiwara family. The Heike were defeated in 1185 following a power struggle with the Minamotos. The latter subsequently instituted a government controlled by military generals, or shoguns, ushering in the feudal system that would shackle Japan until 1867. The year 1185 is thus considered to mark the end of the Late Heian period and the beginning of the Kamakura era.

While Mikkyō continued to thrive during the Late Heian period, courtiers increasingly devoted themselves to the cult of Amida Buddha (Skt: Amitabha), the Buddha of Boundless Light, who inspired in his followers the hope of eternal life in the Western Paradise, or the Pure Land.

5. Relief Tile with Buddhist Triad

Asuka period (538–710), 2nd half of 7th century
Earthenware with traces of polychrome
Height 24.5 cm (9⅝ in.); width 19.6 cm (7¾ in.);
depth 3.7 cm (1½ in.)

LITERATURE: Kim 1991, no. 38; Murase 1993,
no. 1.

Clay relief tiles with figures of the Buddha, known as *senbutsu* (clay-tile Buddhas), have been discovered in many regions of Japan, the excavation sites extending from as far east as Fukushima Prefecture in the Tōhoku region of Honshū to Ōita Prefecture on the westernmost island of Kyūshū. This example depicts the Buddha seated, with two attendant bodhisattvas, in front of the sacred *bodhi* tree, under which he received enlightenment.

Some of the most important discoveries of *senbutsu* have been made in the Asuka region, south of Nara, the ancient capital. Of particular significance is the 1974 excavation at Kawaradera in Asuka village, where *senbutsu*, fragments of clay statues, bronze statuettes, and metal ornaments were discovered in a large pit behind the foundations of the temple structure, the objects apparently buried after a fire that probably occurred in the early eighth century.[1] Directly opposite Kawaradera is Tachibanadera, to which the Burke *senbutsu* is attributed, as the raised rim is characteristic of tiles associated with this temple. Among the extant examples of *senbutsu*, those from Tachibanadera are believed to be the earliest.[2] The traditional dating for the establishment of Tachibanadera appears in the *Hōryūji ruki shizaichō* (Treasures of Hōryūji through the Ages), dated 747, which states that the temple was founded during the tenure of Shōtoku Taishi as prince regent (593–622). On the basis of dates established for the temple's stone foundations, however, scholars posit that Tachibanadera was established later, during the Tenchi era (662–72).[3]

The square tiles, which bore either triads or single figures and were variously decorated with gold leaf and pigments, are believed to have functioned as wall decorations in the main halls, lecture halls, and pagodas of the temple complexes. And although no temple that preserves this ancient method of ornamentation survives, some have speculated that the tiles were arranged side by side and affixed to walls with nails inserted through small holes, features visible on the Burke tile.[4]

Both the manufacture and the function of *senbutsu* have direct sources in the Chinese artistic tradition. Closely related though slightly smaller clay relief tiles were produced in China as private devotional plaques in the seventh century.[5]

Senbutsu were made by impressing clay in negative molds to produce an image in low relief. The unbaked tile was extracted from the mold by means of a material that would ease separation, possibly ash made from burned wood or straw, and then fired. Considering the substantial quantity of extant tiles, relatively few molds have survived, a result perhaps of repeated use for mass production. The manufacture of *senbutsu* is related to the production of gilt-copper repoussé Buddhist plaques (also produced in Tang China), known as *oshidashi* (pushed-out) *butsu*, for use in miniature shrines.[6] It has been suggested that some repoussé plaques (which were made by hammering sheets of copper over a positive metal matrix) and *senbutsu* were produced from common original molds, which may account for the striking similarity in the composition and style of many examples.[7]

A triad formation, as represented by the Burke tile, is a fundamental and pervasive grouping in the Buddhist pictorial tradition. Although details may vary, the basic compositional elements of both Chinese and Japanese triad tiles are similar. Each tile includes a figure of the Buddha seated with pendant legs on a high-backed throne and with hands held in the *jōin* mudra, which symbolizes a state of concentration. Flanking the Buddha, two standing bodhisattvas in prayer are supported by lotus pedestals that emanate beneath the Buddha from a single stem of the lotus blossom. Above the Buddha is an umbrella-like canopy with pendant jewels.[8] Japanese square *senbutsu* triads are further enhanced in the upper corners by figures of *hiten* (flying bodhisattvas), whose twisted postures suggest their descent from the heavens to attend the Buddha.

The iconographic scheme of Japanese *senbutsu* triads is ambiguous. In general, if a Buddha is depicted seated with pendant legs on a throne, he is identified as Miroku (Skt: Maitreya), the Buddha of the Future. Some triad fragments excavated at Kawaradera, however, are incised on the back with characters for the names of several other manifestations of the Buddha, including Shaka (Shakyamuni), the historical Buddha, and Amida (Amitabha), the Buddha of Boundless Light, as well as Miroku. This would suggest that the seated figure is a generic representation of multiple manifestations of the Buddha, a concept fundamental to Mahayana Buddhism. The attendant bodhisattvas have no attributes and cannot be specifically identified.

The stylistic features of *senbutsu* reveal aspects of an early Tang mode. The Buddha's fleshy upper torso, the form subtly implied through the thin folds of drapery rendered in delicate relief, reflects characteristics further developed slightly later in the Tang. This style is exemplified in larger scale by the famous early-eighth-century stone reliefs of Buddhist triads from Baojingsi in Xian.[9] In comparison with the Chinese examples, however, the Buddhas on Japanese tiles are less naturalistically con-

ceived. The composition is naively executed in split perspective: the upper parts of the bodies are represented from head to waist in a frontal position, whereas the lower parts (as well as the lotus pedestals) are tilted downward, which creates a diagonal perspective from above.[10] Given that both the Japanese and the Chinese tiles were manufactured in the seventh century and share comparable pictorial features, the adoption of this decorative technique in Japan must have occurred soon after the production of the Chinese prototypes. *Senbutsu* may have been introduced to Japan by immigrant artisans from the continent. It is also possible that Chinese *senbutsu* were brought to Japan by emissaries returning from imperially sponsored missions to China in the second half of the seventh century.[11]

In forming wall displays with square *senbutsu*, artisans attempted to provide a setting for the main sculptures in the temple hall that would be evocative of the Buddha's realm. What the Japanese were apparently trying to replicate with the tiles, albeit on a smaller scale, was the monumental splendor of the decorated interiors of Chinese Buddhist cave temples such as those at Dunhuang in northwestern Gansu Province and Yungang in northern China.[12]

Senbutsu were produced in Japan for a relatively short period extending from the second half of the seventh century to the early eighth century, after which this type of temple decoration declined in popularity and its production ceased. GWN

1. See Matsushita Takaaki 1977, p. 2; see also Nara National Museum 1976.
2. Kuno Takeshi 1976, p. 60.
3. Ibid.
4. For an artist's rendering of the manner in which *senbutsu* may have been displayed, see Hirata Yutaka 1989, pp. 60–61; see also Kuno Takeshi 1976, p. 49.
5. Kuno Takeshi 1976, pp. 63–65. This type of Chinese tile is associated with Daciensi, a temple in Xian built in 652; see Soper 1969, pp. 35–36.
6. See Kurata Bunsaku 1981, no. 5.
7. See Mitsumori Masashi 1985, pp. 1538–47; see also Ōwaki Kiyoshi 1986, pp. 4–25.
8. This attribute derives from descriptions of the Buddha's miraculous power to transform offerings of flowers, parasols, and other precious objects into a canopy; see Weinstein 1978, pp. 1–3.
9. Ōhashi Katsuaki 1980, p. 13.
10. Ibid., p. 17.
11. Ibid., p. 13.
12. See Dunhuang Research Institute 1981, no. 177; and Shinkai Taketarō and Nakagawa Tadayori 1921, pl. 190.

6. From the "Daihōkōbutsu kegongyō"

Nara period (710–94), ca. 744
Fragment of a handscroll, mounted as a hanging scroll, silver ink on indigo paper
24 × 55.6 cm (9½ × 21⅞ in.)
Ex coll.: Nigatsudō, Tōdaiji, Nara

LITERATURE: Kaufman 1985, fig. 9; Tokyo National Museum 1985a, no. 67; Schirn Kunsthalle Frankfurt 1990, no. 14.

A desire to preserve and transmit the teachings of the Buddha led to the writing of the first sacred texts, or sutras, around the beginning of the first century.[1] The copying of sutras—even the commissioning of copies—was therefore deemed a highly meritorious act. Sutras were copied at times of national disaster, and it was not uncommon for wealthy individuals facing personal crises to commission sutra copies.

Both the act of copying scriptures and the

copied texts themselves are known in Japan as *shakyō*. *Shakyō* was viewed as a written form of prayer and of such importance that an official Buddhist scriptorium was established, before 728, at the imperial palace in Nara. High-ranking scriptoria employed many specialists, including copyists and proofreaders, who collaborated in an assembly-line manner.[2] Elaborate sets of sutra scrolls were made, the most sumptuous of which are the renowned twelfth-century

Heike nōkyō (Sutras Donated by the Heike Clan), kept at the Itsukushima Shrine, near Hiroshima. Many other sutra scrolls, like the pieces included here (cat. nos. 15, 16), were written in gold and/or silver pigment on deep-indigo-colored paper, produced by repeatedly soaking the paper in dark blue dye to create a color suggestive of lapis lazuli—a precious mineral mentioned frequently in the sutras but not readily available in Japan.

This particular handscroll fragment, now mounted as a hanging scroll, was originally part of a sixty-scroll copy of the *Daihōkō-butsu kegongyō* (The Buddha Avatamsaka Sutra, or Garland Sutra), also known as the *Kegon Sutra* (*Kegongyō*), first translated from Sanskrit into Chinese between 418 and 420 by the Indian missionary Buddhabhadra (359–429). The twenty-eight lines quoted here are from the chapter titled "Nyūhokkai-bon," of the fifty-third volume.[3]

Setting forth the teachings of the Kegon sect of Buddhism, the sutra describes a sermon presented by the Buddha at Vulture Peak in response to a question posed by the bodhisattva Maitreya (J: Miroku) in which he explains the Six Ways (Skt: *Satparamita*) to conduct one's life in order to achieve enlightenment. These include the practice of charity, the following of holy precepts, perseverance, assiduousness, meditation, and wisdom.

The *Kegon Sutra* was chosen by Emperor Shōmu (r. 724–48) as the fundamental teachings of Tōdaiji. It is believed that this set of scrolls was donated to the temple in 744, when the *Kegon-e* (a ceremony dedicated to the *Kegon Sutra*) was instituted. The oldest extant example of a sutra inscribed in silver ink on dark blue paper, it is considered the finest example of calligraphy from the Nara period. The small Chinese characters in Tang-style *kaisho* (regular script) are written with restraint and control, a sense of balance and contrast being achieved through the combination of thin horizontal and thick vertical strokes applied with a subtly rhythmic movement of the brush.

The sutra has sustained considerable damage. In February 1667, torches used during the annual *Omizutori* (Drawing of the First Water of the Year) ceremony ignited a blaze that swept through the Nigatsudō (Hall of February), near the Great Buddha Hall, where the set of scrolls was stored. The salvaged remnants of the sutras came to be known as the *Yakegyō* (Burned Sutras). In most instances, the fire damage was sustained at the bottom of the text paper, though several scrolls are damaged at the top.[4] Interestingly, the luster of the ink was apparently enhanced by the fire, which reduced the oxides in the metallic pigment, restoring the silver to its original brilliance.

The sutras were repaired in 1678 but were later dispersed among various collections. Only two scrolls from the set have remained in the original handscroll format. One is now in the Nezu Institute of Fine Arts, Tokyo; the other is in a Japanese private collection. Of the scrolls that remained at Tōdaiji, many were cut into segments, measuring on the average from 55 to 60 centimeters in width (21⅝–23⅝ in.), and mounted on folding screens.[5] The fragment in the Burke Collection, which is 55.6 centimeters (21⅞ in.) wide, may be one of these. In 1979–80, in the most recent repair of the scrolls that remain at Tōdaiji, several segments were pieced back together. The number of handscrolls at Tōdaiji is now twenty.

1. Pal and Meech-Pekarik 1988.
2. Ōyama Ninkai and Takasaki Chokudō 1987.
3. *Daizōkyō* 1914–32, vol. 9, no. 278, pp. 733–34. See also Fontein 1967.
4. As in the Burke segment, most of the lines marking the upper and lower margins and columns were probably not visible even before the fire; they are, however, faintly visible on some fragments, such as that in the collection of Kimiko and John Powers, Aspen. Rosenfield and Shimada Shūjirō 1970, no. 5.
5. Ōyama Ninkai 1983, pp. 143–50.

7. Hyakuman-tō and Darani Scroll

Nara period (710–94), ca. 767
Hyakuman-tō: Japanese cypress (*hinoki*) and
Cleyera ochnacea (*sakaki*); *darani* scroll: ink printed
on paper
Hyakuman-tō: height 22 cm (8⅝ in.); *darani* scroll:
5.8 x 46.4 cm (2¼ x 18¼ in.)

LITERATURE: Kaufman 1985, fig. 6; Murase 1993,
no. 2.

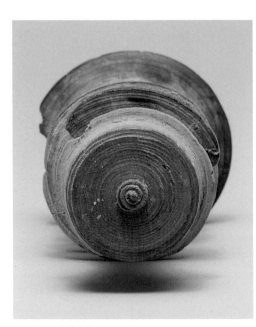

Bottom of finial

This miniature wooden pagoda is identical to
the thousands displayed today at the Treasure
House of Hōryūji in Nara.[1] These were
among the one million pagodas (*hyakuman-
tō*) produced in one of the most interesting
projects in the history of Japanese Buddhist
art; at the same time they serve as a vivid
reminder of an ignominious episode in
ancient Japan.

Historical information on the small pagodas
is found in two sources: the *Shoku Nihongi*
(History of Japan Continued, 797) and the
Tōdaiji yōroku (Chronicles of Tōdaiji, 1134).[2]
According to these documents, the project
was conceived by Empress Kōken, perhaps as
penance for grave misconduct. Kōken was
the daughter of Emperor Shōmu—one of
Japan's most devout rulers—and his equally
devout consort, Kōmyō. She was enthroned
twice, the first time as Kōken (r. 749–58), the
second as Shōtoku (r. 765–69). During her
second reign she allied herself with a notori-
ous Buddhist monk named Dōkyō, promot-
ing him to a series of politically powerful
positions—an unprecedented expression of
favor to bestow on a young monk. It was
widely rumored that Dōkyō was her lover.[3]
Shortly after an unsuccessful coup in 764 led
by her uncle, who objected to her conduct,
Empress Shōtoku commissioned one million
tiny scrolls printed with the magical Buddhist
incantations known as *darani* (Skt: *dharani*),
each one enshrined in a miniature pagoda. In
this way she perhaps hoped to appease the
ecclesiastical community. She may also have
been attempting to rival her father's commis-
sion of the monumental Tōdaiji and its great
bronze Buddha.[4]

Four *darani* were inscribed on the scrolls:
the *Konpon*, the *Jishin'in*, the *Sōrin*, and the
Rokuhara, all of them drawn from the *Muku-*

jōkō daidaranikyō (Skt: *Vimalanirbhasasutra*).[5]
This sutra promises aid in the expiation of sins,
the termination of strife, and the accumula-
tion of religious merit through the construc-
tion of pagodas and the copying of sutras.

The *darani* in the Burke Collection is com-
posed of thirty lines of text, printed either
from woodblocks or from metal plates and
arranged in columns of four or five charac-
ters, with intralineal glosses. It is one of the
thousands that have been dispersed to public
and private collections. Only some four
thousand remain at Hōryūji. Until fairly
recently they were believed to be the earliest
extant examples of printed text in the world.
In 1966, however, a printed scroll version of
the *Mukujōkō daidaranikyō* was discovered at
Pulguksa, a temple in Kyŏngju, South Korea,
in a stupa known to have been sealed in 751.[6]

There is no way to determine whether the
Burke *darani* was originally inside the pagoda
in which it is housed today, although when
rolled it fits perfectly inside the cavity pro-
vided in the base of the pagoda. Like most of
the miniature pagodas at Hōryūji, the Burke
pagoda has two sections, a three-storied base
made from *hinoki* (Japanese cypress) and a
five-ringed finial of *sakaki* (*Cleyera ochnacea*),
a wood better suited for fine detail.[7] Only
two of the Hōryūji pagodas are larger, one
having seven stories, the other thirteen.

The entire surface is coated with lead white,
and a brownish patina is faintly visible. Lead
white also coats the interior of the cavity.
The base was finished on a lathe, and five
chisel marks, made as the piece was fitted on
the lathe, are still visible. At the bottom of
the finial (at left) is a small "belly button,"
another trace of the lathe.

Many of the *hyakuman-tō* at Hōryūji have
the word "left" or "right" inscribed under

the white coating, either on the base or on the finial, suggesting that the craftsmen who produced them were organized into two groups. Other inscriptions include dates and the names of individuals. The exact location of the workshop where the pieces were created is not known, but it is thought to have been situated somewhere in Nara, where a number of apparently discarded pagodas have been unearthed. From the inscriptions the names of about two hundred and fifty persons, thought to have been temporary workers, have been identified. In all likelihood they were recruited for this project, for which they were probably paid by the number of pieces they completed. Approximately twelve hundred bases and an equal number of finials were made each day, not counting rejected pieces. The inscriptions also suggest that most of the pagodas were produced between 767 and 768.

The project was completed by the fourth month of 770, at which time one hundred thousand *darani* scrolls and pagodas were distributed to each of the ten major temples in Nara.[8] Surprisingly, only Hōryūji still houses these royal gifts.

The pagoda in the Burke Collection has no inscription, though it may have been made by an artisan from the "right" group, which appears to have used both chisel and lathe, most notably during the year 767. As the cavity in its base is painted with lead white, a practice that was abandoned after the eighth month of that year, its production may be safely dated to the early part of 767.

1. Hōryūji owns a total of 26,054 pagoda spires and 45,755 bases. See Hōryūji Shōwa Shizaichō Henshū Iinkai 1991, pp. 9–11. In the past it was erroneously reported that only one hundred miniature pagodas remain at the temple. This misunderstanding was due to the government's designation, in 1908, of one hundred of the pieces as Important Cultural Properties.
2. *Shoku Nihongi* 1986, pp. 635–770; and *Tōdaiji yōroku* 1944.
3. See Yiengpruksawan 1987, pp. 225–38.
4. Ibid., p. 233.

5. *Daizōkyō* 1914–32, vol. 19, no. 1024.
6. Chibbett 1977, p. 29.
7. For the method of construction, see Hōryūji Shōwa Shizaichō Henshū Iinkai 1991.

8. *Tōdaiji yōroku* (1944, pp. 25–26) lists them as Tōdaiji, Daianji, Gangōji, Kōfukuji, Gufukuji, Hōryūji, Shiten'noji, Sufukuji, Saidaiji, and Yakushiji.

8. Standing Taishakuten

Late Heian period (ca. 900–1185), 2nd half of
10th century
Japanese cypress (*hinoki*)
Height 175.5 cm (69⅛ in.)

LITERATURE: Murase 1975, no. 1; Sekine
Shun'ichi 1997, fig. 88.

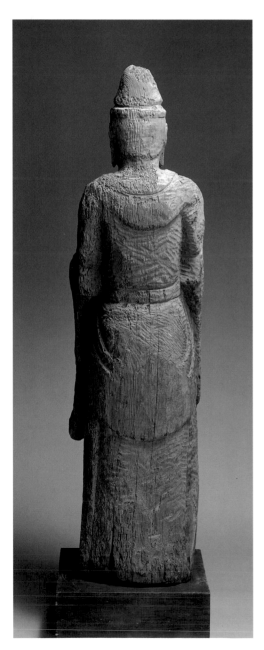

Simplicity and dignity mark this work, which is typical in many ways of Japanese wood sculpture of the tenth century. Although severely damaged by weather and insects— the entire right arm and the left forearm, the front portions of the feet, and the lotus pedestal are lost—this tall, majestic figure stands firm, with dignified tranquillity. The long hair is tied in a tall knot with a band, and a strand of hair crosses over one ear, forming a loose loop. The small, full face has sustained several losses: the eyelids and eyebrows are no longer discernible, and the once clearly defined nose ridge is marred. Fortunately, the cheeks, chin, and full lips still preserve their original softness and plasticity. The figure is dressed in a long-sleeved, belted, flowing gown, its low neckline ornamented with a narrow, scallop-edged frill; under the gown is armor that has a narrow collar edged with a dainty ribbon. This type of clothing is usually associated with two Buddhist guardians: Bonten (Skt: Brahma) and Taishakuten (Skt: Indra).

The suffix "ten" in the names Bonten and Taishakuten is the Japanese for Devas, who were Hindu gods before they were incorporated into the Buddhist pantheon as guardians against Buddha's adversaries. In Vedic India, Brahma was lord of heaven, supreme creator of the universe. In Japanese representations he is often paired with Taishakuten, god of the atmosphere and thunder (see cat. no. 48). Once they were assimilated into the Buddhist cosmology, they became part of the Twelve Guardian Deities (J: Jūniten), who are associated with elements of nature and the cardinal directions of the universe.

When they are represented in the Esoteric Buddhist pantheon (J: Mikkyō), Bonten and Taishakuten can be easily identified by their attributes. Taishakuten often rides a white elephant, his attribute from the pre-Buddhist period, while Bonten may be seen astride a goose or geese. Both guardians are endowed with a third eye and extra hands, among other attributes. No specific attributes were provided for Taishakuten and Bonten outside

Mikkyō theology. In their earliest appearances in Japan, they were represented in the unusual attire of armor and courtly robes. Distinctions between representations of the two deities are often blurred, but when they are shown together, it is usually only Taishakuten who wears armor.

This massive, solid statue was carved out of a large piece of wood in the *ichiboku ʒukuri* (single block) technique. The form, mass, and weight inherent in the original material are preserved in this sculpture. It is often difficult to determine the original surface condition of wood sculptures from this period.[1] Some statues that were decorated in colors have lost their pigment, while others that were unpainted appear to have been given a colorful finish in later centuries. On the back of the shawl this statue has slight traces of color, which may be original.

Such celebrated wood statues as the standing Yakushi Buddha, carved about the year 800, at Jingoji, Kyoto,[2] and similar works from the ninth century are oppressively massive, their facial expressions forbidding and frightening. The Burke Taishakuten exemplifies the transitional period between the powerful, imposing style of the ninth century and the gentler, more sophisticated mid-eleventh-century Late Heian style. The head is quite small in proportion to the tall body; the body is flat; the terrifying expression of ninth-century faces is absent; the upper eyelids are heavy and the eyes downcast, creating a benign, almost sleepy countenance. The folds of the long, soft robe are delineated simply, by a few lines in concentric curves. The *honpa* (rolling wave) treatment of the robe, in which rounded and sharp-edged folds alternate, is minimal, exposing the smooth surface of the thighs. The carving from a single block of wood with a solid interior, but with a separate lotus pedestal, points to a date in the second half of the tenth century.

1. Kuno Takeshi 1972, pp. 94–104.
2. Mizuno Keizaburō, Kon'no Toshifumi, and Suzuki Kakichi 1992, pls. 4–6.

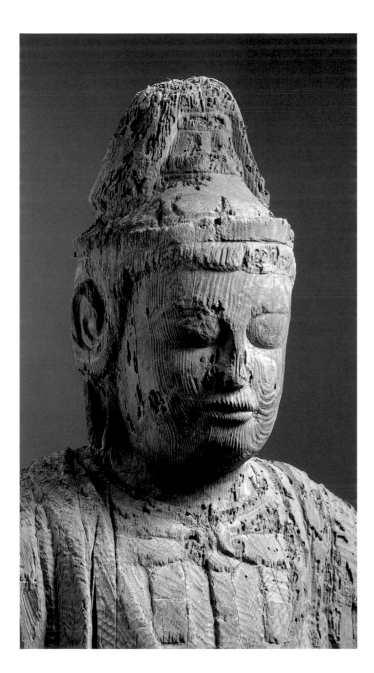

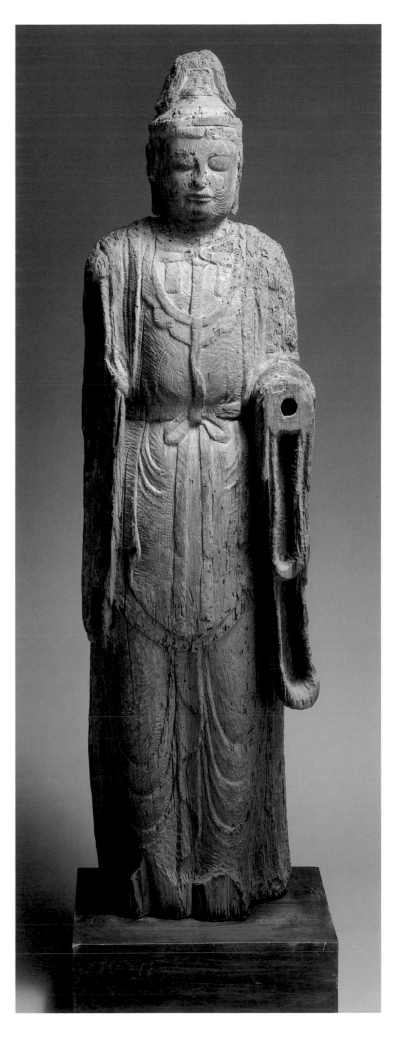

9. Standing Tobatsu Bishamonten

Late Heian period (ca. 900–1185), late 10th–
early 11th century
Polychromed *keyaki* wood (*Zelkova serrata*)
Height 125 cm (49¼ in.)
Ex coll.: Howard C. Hollis, New York; Haramoto
Torao, Tokyo; Rishō Gokokuji, Wakayama.

LITERATURE: Ikawa Kazuko 1963, figs. 12–14;
Mayuyama Junkichi 1966, no. 18; Rosenfield 1967,
no. 3; Murase 1975, no. 2; Mayuyama Junkichi 1976,
no. 330; Kurata Bunsaku 1980, no. 57.

Bishamonten (also known as Tamonten) is
the Japanese equivalent of Vaishravana,
Guardian King of the North. Characteristi-
cally, he is dressed in the armor of a military
general and holds aloft a weapon and a minia-
ture stupa. The Tobatsu Bishamonten is one
of the god's several manifestations (see also
cat. no. 23). Unlike Bishamonten, who is usu-
ally included in a group of the Shiten'nō
(Skt: Lokapalas), the guardians of the four
quarters of the universe, the Tobatsu Bisha-
monten is always shown as an independent
deity, supported by the earth goddess Jiten
(Skt: Prthivi).[1] Jiten is usually, but not
always, flanked by two squirming dwarf-
demons—Niranba and Biranba—who are
also the conventional vehicles supporting all
Shiten'nō.

Although the origin of the name Tobatsu
is unknown,[2] several Central Asian tales
associated with Bishamonten help to identify
the iconographic features by which he is dis-
tinguished. One legend, which can be traced

back to the folklore of Khotan, is recorded
in the celebrated travelogue by the monk
Xuanzang, the *Xiyouji* (Buddhist Records
of the Western World).[3] The story, which
echoes the birth of the goddess Athena in
Greek mythology, relates how in the desert
of Khotan a king prayed to a statue of the
protector Bishamonten that he might become
the father of a child. Instantly, an infant boy
sprang from the idol's forehead. To provide
milk for the newborn, Bishamonten made the
earth in front of him swell up in the form of
a breast, and from the breast the child eagerly
drew forth nourishment.

Another fantastic tale, which also suggests
Bishamonten's association with Central Asia,
is taken from one of the major scriptural
sources, the *Bishamon giki* (Rules for the
Worship of Bishamonten). This story relates
how Bishamonten appeared on the northern
gate of Kutcha when the city was surrounded
in 742 by enemy forces. At Bishamonten's
command, golden mice suddenly emerged

Figure 12. Infrared photography
of crown *a*. Front *b*. Left side

a

b

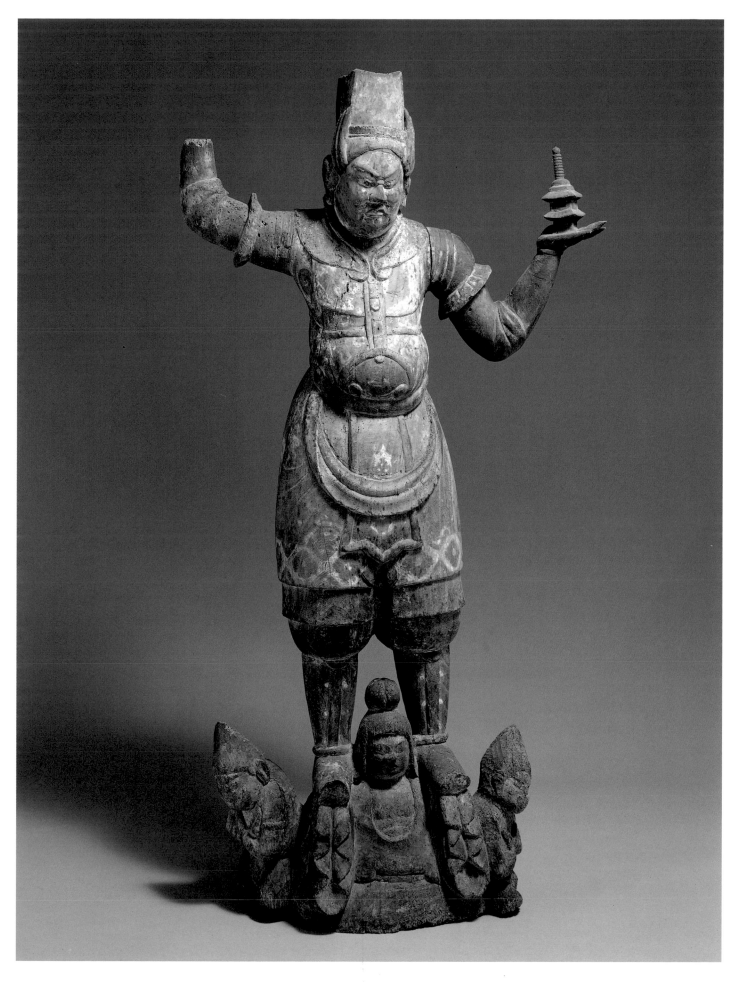

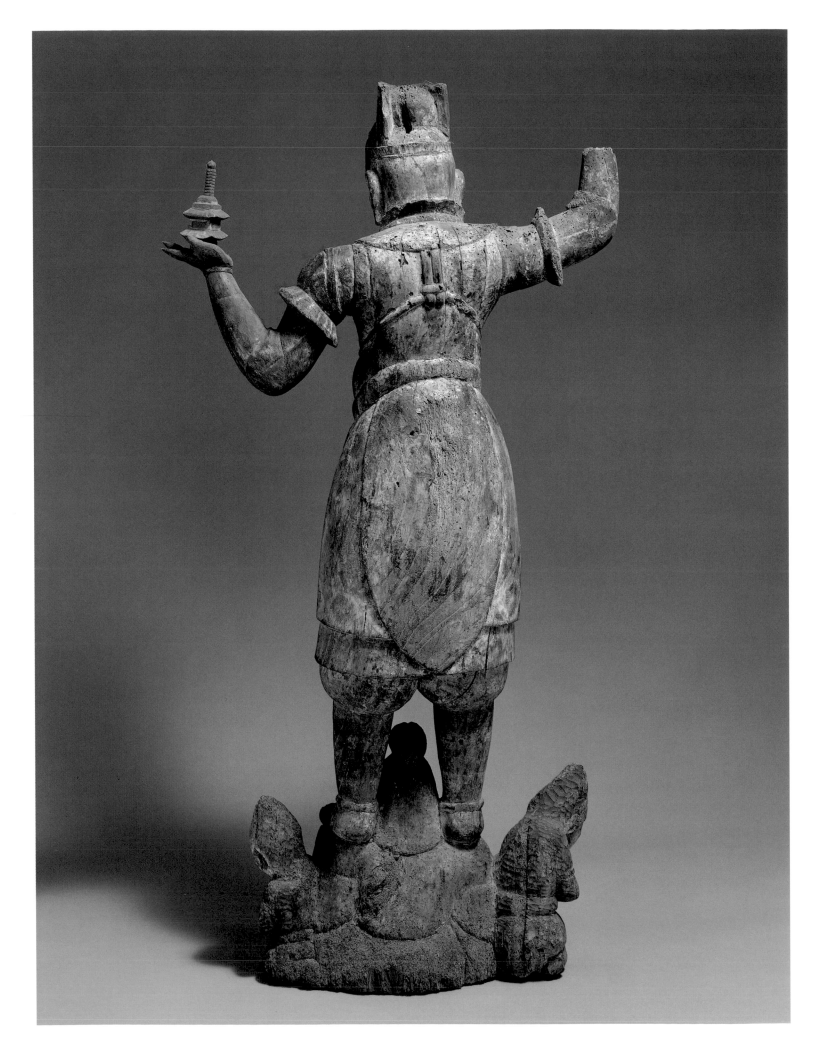

and chewed on the bowstrings of the enemy soldiers, destroying their weapons and incapacitating them.[4] This legend must have been familiar to the Japanese, since the oldest Tobatsu Bishamonten in Japan, a Chinese sculpture at Tōji, Kyoto, dating to the early tenth century, is associated with an identical story, reported in the *Tōbōki*, a history of Tōji by the monk Gōhō (1306–1362).[5] The statue of Tobatsu at Tōji, according to this source, was originally the guardian deity of the capital city of Kyoto, and it stood at Rashōmon, the most important gate at the city's southern border. Both Tobatsu and ordinary Bishamonten are guardians of the north, which in India and East Asia is traditionally considered the source of evil forces.

Another feature of Tobatsu that may reflect a foreign influence is their attire. Tobatsu Bishamonten from both China and Japan are often shown wearing tall, tubular crowns embellished with the design of a phoenix or some other bird. This attribute is mentioned in a twelfth-century collection of iconographic drawings, the *Asaba shō*, which traces its origin to Sassanian Persia.[6]

The Tobatsu Bishamonten at Tōji is dressed in a Central Asian type of armor: a long, tight-fitting coat of mail with narrow sleeves. In the past, this armor was regarded as the only attribute differentiating Tobatsu Bishamonten from other Bishamonten images. While this seems to hold true for early representations in China and Japan, later depictions are not necessarily restricted to this type of armor, and East Asian armors,

sometimes with flowing sleeves, coexist with Central Asian types.[7] The East Asian costume is worn by many other guardian deities in Japan, and thus cannot be used as a criterion in distinguishing Tobatsu Bishamonten from other forms of Bishamonten or from other guardian kings. Tobatsu's only identifying element is the earth goddess Jiten, who supports the guardian god.

The Burke Tobatsu Bishamonten stands over a triad of Jiten and two earth demons. With knit brows, glowering eyes, and pursed lips, he looks downward with a threatening expression. The small, full torso with bulging midriff is tightly enclosed in Chinese armor, originally decorated with bold color patterns. With the exception of Tobatsu's arms, the figural group is carved, in the *ichiboku* technique, from a single block of wood. The raised right arm most likely held a weapon, probably a small *vajra* (thunderbolt), with which to ward off evil forces. When the statue was published in 1963 and 1966, it had a modern right forearm, which has since been removed.[8] The left arm is a recent replacement. The tall crown bears faint traces of ink drawings, now badly worn but revealed by infrared photography (fig. 12): on the front, five seated Buddhas, a feature that is unique to this statue, and on the left the figure of a small child dressed in a courtly costume. Although rare in Japanese representations of the Tobatsu, Central Asian and Chinese examples often include the figure of a small child, a reference to the Khotanese birth myth.

The display of power and flamboyant movement typical of Bishamonten is suppressed here in favor of the evocation of quiet energy. The half-naked dwarf-demons, their arms crossed in obeisance, are carved in a direct, blunt manner, the chisel marks still visible on their backs and hair. And while the sophisticated taste of the court is reflected in the tightly formed body of the deity and in the childlike face of Jiten, the simple execution of the humorous earth demons suggests that the provenance of this work may be found outside the orbit of court workshops.

The statue is dated by Kurata Bunsaku to the tenth century, and by Ikawa Kazuko to the first half of the eleventh.[9]

1. Because the presence of Jiten seems to be the only identifying element of images of this deity, he is also known as Bishamonten Supported by Jiten; see Tanaka Shigehisa 1966, pp. 92–110.
2. For research on the origin of the name Tobatsu, see Minamoto Toyomune 1930, pp. 40–55; *Daizōkyō zuzō* 1932–34, vol. 9, p. 418; Matsumoto Eiichi 1937, pp. 417ff.; and Matsumoto Bunzaburō 1944, pp. 273ff. Matsuura Masaaki (1992, p. 55) interprets the armor as of the Western type.
3. *Daizōkyō* 1914–32, vol. 51, no. 2087, p. 943; and Soper 1959, p. 240. For an English translation of the *Xiyouji*, see Xuanzang 1958.
4. *Daizōkyō* 1914–32, vol. 21, no. 1249, p. 228.
5. *Gunsho ruijū* 1906–9, vol. 12, p. 21.
6. Matsumoto Eiichi 1937, pp. 434–37.
7. Ikawa Kazuko 1963.
8. Ibid., figs. 12–14; and Mayuyama Junkichi 1966, no. 18.
9. Kurata Bunsaku 1980, no. 57; and Ikawa Kazuko 1963, p. 62.

The Art of Esoteric Buddhism

CATALOGUE NOS. 10, 11

Among the great leaders of Buddhist influence on Japanese society and culture during the Early Heian Period were two monks, Saichō and Kūkai, who were untouched by the institutional corruption that had brought about the downfall of the Buddhist religious establishment in Nara. Both founded new schools, and both infused the faith with insights gained from their study of Buddhism in China.

Saichō had established Enryakuji on Mount Hiei in 788. In 804 he journeyed to China, where he studied mainly at the monastery of Tientai, at which the doctrines of the *Lotus Sutra* (Skt: *Saddharmapundarikasutra* J: *Myōhōrengekyō*,

or *Hokekyō*, for short) were propagated. Considered by its adherents the supreme Buddhist text, it is surely one of the most important religious texts in the world. Written in India sometime in the first century, it teaches that all men should attempt to realize the Buddha-nature that exists in every sentient being. While in China, Saichō also undertook the study of Esoteric Buddhism, known in Japan as Mikkyō, and on his return to Japan in 805 he conducted the first Mikkyō rituals to be held in the land. Saichō founded the Tendai sect, which came to have considerable influence during the Late Heian period.

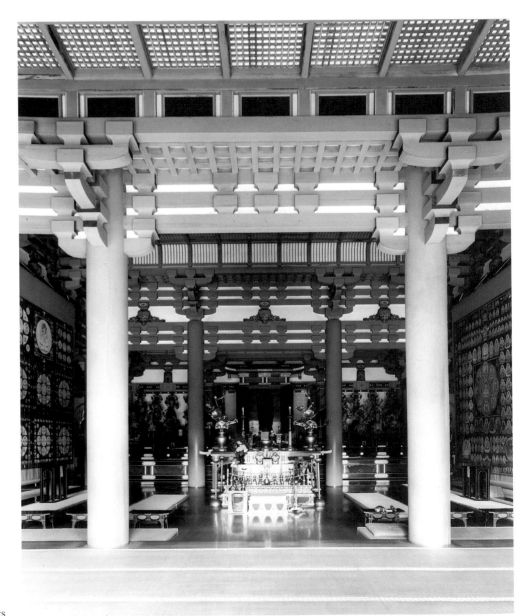

Figure 13. Mikkyō Hall, Jingoji, Kyoto, showing mandalas on side walls and altar with ritual objects

Saichō's teachings and importance, however, were superseded by those of the other great teacher of Buddhism in Japan, the monk Kūkai. Kūkai traveled to China at the same time as Saichō, studying with various Buddhist masters before returning to Japan in 806. The teaching he was most influenced by was Mikkyō. The focus of this school was not the lessons of the historical Buddha Shakyamuni but a primordial and central divinity, the Buddha Vairochana, the Great Illuminator (J: Dainichi)—inherent in all phenomena of the universe, in every thought, deed, and word—of which all other Buddhas and bodhisattvas are manifestations. Kūkai's sect was called Shingon, or True Word Buddhism, a name derived from the Japanese word for the Sanskrit term *mantra*, a mystical doctrine or formula. In the teaching of Shingon, the cosmic world is the body of Dainichi. It is composed of six elements. The first five—earth, water, fire, air, and ether—are matter. The sixth—consciousness—is mind. The body, speech, and mind of Dainichi constitute the Three Mysteries of the life of the universe, and they in turn correspond to body, speech, and mind in the human realm. The goal of Shingon practice is to unite the two realms of the human and the divine.

In this most occult of all Buddhist sects (thus the Japanese term *mikkyō*, secret teachings), the timeless teachings of Dainichi are revealed to aspirants by masters initiated into the secrets of an elaborate liturgy. Aspirants attain enlightenment through the practice of ritual actions that correspond to the Three Mysteries, faculties possessed by every human being. The ritual actions of the body include mudras (the formation of gestures with one's hands in accordance with the Buddha or bodhisattva invoked), the postures of meditation, the incantation of spells, and the burning of wood inscribed with magical formulas. The actions of speech include the recitation of mantras, or "true words." And the actions of the mind are focused on mandalas, schematic representations of the cosmos. The Esoteric liturgy was designed to induce a trancelike

state that would enable mystical union with the cosmic Buddha. In its occult practices and rituals and in its assimilation of native Japanese Shinto, Mikkyō appealed to the Heian nobility. It promised happiness and success on earth—in love and in work.

In the *Go shōrai mokuroku*, the catalogue compiled by Kūkai to describe the objects he had brought back from China and presented at court, visual imagery is emphasized as a way to convey the meaning of the abstruse doctrines of Shingon:

Since the Esoteric Buddhist teachings are so profound as to defy expression in writing, they are revealed through the medium of painting to those who are yet to be enlightened. The various postures and mudras [depicted in mandalas] are products of the great compassion of the Buddha; the sight of them may well enable one to attain Buddhahood. The secrets of all the sutras and commentaries are for the most part depicted in the paintings, and all the essentials of the Esoteric Buddhist doctrines are, in reality, set forth therein.[1]

Painted images thus became a means of transmission and an important aspect of Mikkyō teaching.

The central image of Mikkyō worship is the mandala (fig. 13).[2] Originally meaning "that which possesses (*la*) essence and totality (*manda*)," the word later came to signify the place in which this perfection could be realized, where the rituals aimed at attaining the goal of enlightenment were conducted. In India, this was a sand platform on which a diagram of Buddhist images was drawn and around which believers would sit. Sand platforms used for initiation and ordination rites were only temporary, to be destroyed after the ceremonies were conducted. Still later, the word came to mean any visual representation of the Buddhist pantheon. The most comprehensive mandalas are the *Taizōkai* (Skt: *Gargbhakoshadhatu*, or Womb World mandala) and the *Kongōkai* (Skt: *Vajradhatu*, or Diamond World mandala). In the Womb World

mandala, which symbolizes Dainichi's immutable or potential aspect, the deity is depicted forming the mudra of deep contemplation and surrounded by the Buddhas of the four regions. In the Diamond World mandala, which represents the deity's immanence in all manifestations, he sits with the mudra of "knowledge first." The two are believed to have been paired in China in the late eighth century: these symbols of softness and flexibility (the Womb World) and stability and hardness (the Diamond World) were placed together to represent the entire Mikkyō cosmos.

Esoteric Buddhism offered rituals to defeat evil forces, achieve prosperity and longevity, and gain love and affection. Mandalas that focused on these objectives, called *besson* mandalas, invoked specific deities chosen from the multitude of gods in the Womb World and Diamond World mandalas. Many *besson* mandalas were brought to Japan from China during the ninth century.

Few Mikkyō paintings survive from the Early Heian period (794–ca. 900), most of them having been destroyed or severely damaged by repeated use. Nevertheless, following Kūkai's dictum that monks should practice the arts, particularly painting, acolytes copied painted images owned by their teachers, and in this way the continuity of iconographic standards was preserved. Copies were occasionally made in color, but as monochromatic images were believed to present fewer distractions, more commonly they were made in ink, and to these, color notations were sometimes added. They also recorded their own perceptions of the deities, with specific notations for colors and other details.

Known as *zuzō*, these iconographic drawings were assembled in the twelfth century. The systematic study of *zuzō* that ensued provided the opportunity for monks to interpret, preserve, and perpetuate certain types of iconic imagery. The majority of *zuzō* that survive date to the eleventh century or later (cat. nos. 10, 11).

In 816, Kūkai founded the monastery of Kongōbuji on Mount Kōya, south of Osaka,

on a site granted him by the court, and as Mount Hiei was the center of the Tendai sect, so Mount Kōya became the headquarters of Shingon. All but inaccessible until the mid-twentieth century, Kongōbuji stands on a precipice in a primordial forest. The plan of the monastery, which symbolizes Shingon ideology in its pairing of the two worlds of *Taizōkai* and *Kongōkai*, became the model for other Mikkyō temples.

Kūkai actively sought the court's support in spreading Shingon teaching. In 823, the court turned over to him the task of completing Tōji (officially renamed Kyōō Gokokuji, or King's Counselor–Nation's Protector Temple),

which had been under construction for nearly thirty years. Situated in Kyoto, the temple preserves the Nara tradition of a symmetrical plan, while the statues and paintings exemplify Kūkai's efforts to convey through visual means the essence of Esoteric teachings and Buddhist ideology. Work on Tōji was continued after Kūkai's death by his disciples, who attempted to implement the master's ideas in their choice and grouping of statuary. The group of twenty-one deities that crowd the central platform of the Lecture Hall, arranged in mandala form with the central position occupied by Dainichi, became a paradigm of Mikkyō iconography.

Mikkyō temples are found throughout

remote regions of Japan. Steep mountain slopes and narrow terraces required the builders of Mikkyō sanctuaries to design structures adapted to the special features of such sites, and because sites on these mountaintops were often squeezed into narrow clearings between hills, symmetrical plans like those of Nara temples were not feasible. The temples are thus nestled in the mountains and woods, blending harmoniously with the surrounding landscape.

1. Kūkai 1972, pp. 145–46.
2. Grotenhuis 1999.

10. Aizen Mandala

Late Heian period (ca. 900–1185), 1107
Hanging scroll, ink on paper, 58.4 × 53.4 cm
(23 × 21 in.)
Ex coll.: Shōren'in, Kyoto

LITERATURE: Yanagisawa Taka 1965, pt. 1, fig. 3 (detail); Rosenfield and Grotenhuis 1979, no. 19; Yanagisawa Taka 1980, no. 90; Shinbo Tōru 1985, pls. 130–32; Tokyo National Museum 1985a, no. 1; Schirn Kunsthalle Frankfurt 1990, no. 10; Goepper 1993, pp. 71–72; Nedachi Kensuke 1997, figs. 32 (detail), 118; Grotenhuis 1999, fig. 71.

Notations on reverse

The tradition of making iconographic drawings, called *zuzō*, began in Japan during the ninth century. By the twelfth century *zuzō* were being assembled and classified by monks, which led to the standardization of many images. Based on Chinese iconographic drawings, *zuzō* exerted a profound influence on Japanese Buddhist art. Mandalas were copied in *zuzō*, and many depicting individual deities or a small number of deities—known as *besson* mandalas—were imported to Japan from China during the ninth century.[1]

The central image of the present *zuzō*, which depicts seven deities and two symbolic objects, is that of the fierce Aizen Myōō (Skt: Ragaraja). Like many other gods in the pantheon of Esoteric Buddhism, Aizen is an avatar of Dainichi.[2] His name means "the Great Passion," and he epitomizes the dual nature that characterizes many Mikkyō deities. As his name suggests—"ai" (*raga*; love) and "zen" (*raj*; to dye)—Aizen is the god of love, both sacred and profane, and it is he who transforms carnal desire into sacred devotion. Because his name is a homophone for *aizen* (*ai*, indigo; *zen*, to dye), he is also traditionally regarded as the protector of textile dyers.

Aizen's physical appearance—his body is

the color of the sun—and attributes are given in the *Yugikyō*, which is believed to have been translated into Chinese by the Indian monk Vajrabodhi (J: Kongōchi, 671–741).[3] In the Burke mandala, Aizen has three fierce eyes and wears a lion's-head crown. His attributes are the *vajra* (thunderbolt), the lotus, and a bow and arrow, signifying his assault on the forces of evil. In one of his left hands he holds a human spirit in the form of a man's head. An inscribed notation states that his flesh should be a deep red, signifying his primary function as the god of love.

Beneath Aizen is Kannon (Skt: Avalokiteshvara), identified by a notation that specifies white as his body color, and above him is the figure of Miroku (Skt: Maitreya), whose inscription indicates that the color of his face should be "flesh white." At the right is a jeweled pennant, symbol of good luck, and at the left a dragon wrapped around a sword, symbolic of Fudō Myōō (Skt: Achala), represented below. At the upper left corner is a twelve-armed "red-colored" Daishō Kongō, an avatar of Dainichi, and at the upper right is a two-headed Aizen—one face with a fierce expression, the other smiling—seated against a mandorla meant to be "angry red"

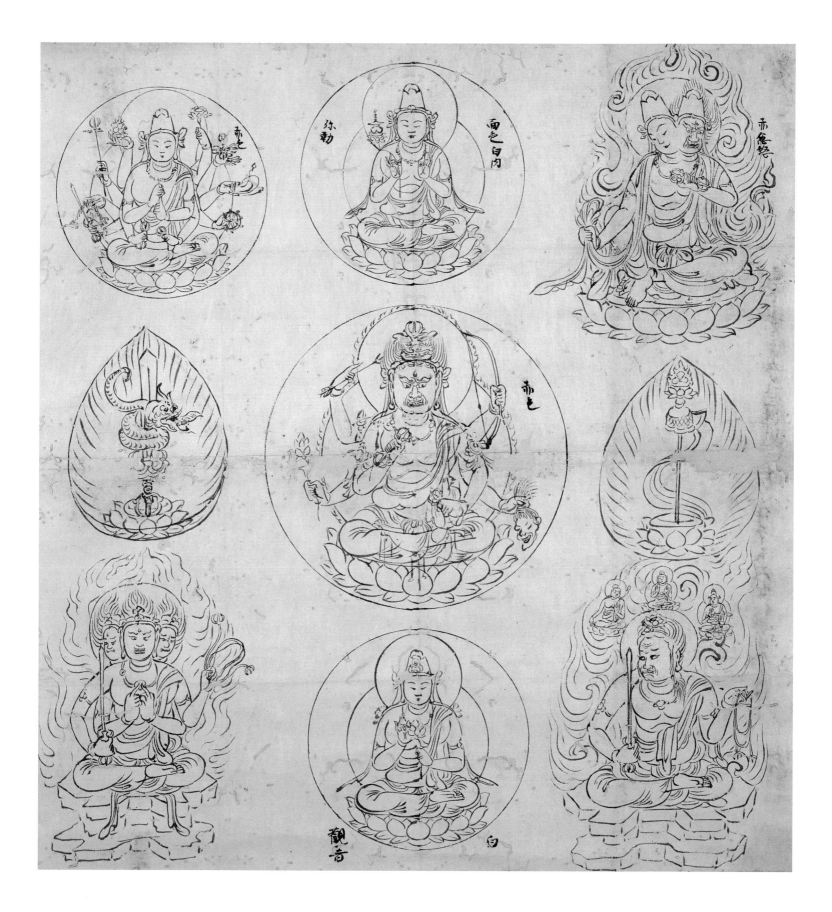

in hue. In the lower corners are, at left, a three-headed Daiitoku (Skt: Yamantaka), the lasso and sword in his hands symbolizing victory over mortality, and, at right, Fudō in an unusual representation that features Shakyamuni and the bodhisattvas Monju and Kongōshu seated within a flame mandorla.

Worship of Aizen was introduced to Japan in the ninth century, most likely by Kūkai, initially to benefit and to promote national prosperity. Literary references to Aizen increased dramatically during the second half of the eleventh century, as Fujiwara courtiers invoked the deity's intervention in the untangling of their complicated love affairs. This shift in the Late Heian period led to a noticeable increase in the production of Aizen paintings and sculpture. The expression of the deity's more personal meaning is reflected in the Burke mandala by such themes as the union of complementary forces, especially male and female, alluded to by a two-headed Aizen. In addition, the presence of the man's head held by Aizen suggests that the mandala was used in a ritual to help a woman secure a man's affection.[4]

The *Chūyūki*, a record of court activities kept by the courtier Fujiwara Munetada between 1087 and 1138, refers to rituals dedicated to Aizen that involved more than one hundred larger-than-life statues of the deity.[5] None of these are extant. The drawing in the Burke Collection is one of the few images of Aizen from this period to have survived.

The drawing was at one time folded lengthwise in the center. Brief notations on the reverse (page 36) identify some of the deities depicted,[6] while the inscription, dated the fifth day of the third month, the second year of the Kashō era (1107), states that it was copied from a model inherited by a certain Sanmai Ajari Ryōyū from his teacher Chōen (1016–1081), a noted Mikkyō scholar of the Tendai school and a renowned prelate at Ōhara.

Because representations of Aizen generally follow iconographic details prescribed in the *Yugikyō*, the original model for the work owned by Chōen may have been a copy of a Chinese drawing. Most likely it resembled drawings from the Diamond World mandala scroll, formerly in Shōren'in, Kyoto, and now in The Metropolitan Museum of Art. It is

dated 1083 and identified as a copy of a Chinese work brought to Japan by Saichō.[7] It is notable that the Burke mandala was in the Shōren'in collection when the temple was situated on Mount Hiei and served as the headquarters of the Tendai sect.[8]

Although no finished painting resembling the Burke mandala is known, it is nearly identical to an Edo-period ink drawing of 1706 in the MOA Museum of Art, Atami.[9] The few differences between them, however, are significant and suggest that they were based on different models.

1. Hameda Takashi 1980, pp. 85–87; and Shinbo Tōru 1985.
2. On this deity, see Goepper 1993, on which the present discussion is based.
3. *Kongōbu rōkaku issai yuka yugikyō*, in *Daizōkyō* 1914–32, vol. 18, no. 867.
4. Goepper 1993, p. 74.
5. Fujiwara Munetada 1965.
6. These notations are written in a calligraphic style which differs from that in the drawing itself.
7. Yanagisawa Taka 1965, pts. 1, 2.
8. Shōren'in was founded by Gyōgen (1097–1155), a pupil of the monk Ryōyū; see Rosenfield and Grotenhuis 1979, p. 90.
9. Kyoto National Museum 1981, p. 226.

ATTRIBUTED TO TAKUMA TAMETŌ (FL. CA. 1132–74)

11. *Page from the "Kontai butsugajō"*

Late Heian period (ca. 900–1185)
Ink and color on paper
25 × 12.8 cm (9⅞ × 5 in.)

LITERATURE: Ōmura Seigai 1921; Murase 1975, no. 14; Yanagisawa Taka 1980, no. 86; Kaufman 1985, fig. 4; Tokyo National Museum 1985a, no. 2; Schirn Kunsthalle Frankfurt 1990, no. 11.

A serene bodhisattva wearing an elaborate golden crown sits on a large lotus pedestal. His body is light pink. His left hand rests on his thigh, while in his right he holds a *vajra* attached to a long staff. Scarves loosely drape his torso, their ends fluttering behind him. His name, Dai Shōjin Bosatsu, is inscribed at the bottom right, and his secret name, Futai Kongō, at the bottom left. The word *sam'maiyagyō* (attribute) and Bosatsu's "seed" letter, which signifies his nature and function, are written on either side of the *vajra*.

This small painting, which is now mounted on the back of an old, unrelated sutra, was

originally part of a book of iconographic drawings representing the Buddhas and bodhisattvas of the *Kongōkai* mandala. Commonly known as the *Kontai butsugajō* (Book of Buddhist Deities from the *Kongōkai* and *Taizōkai* mandalas), the book had an extraordinary history. According to a vivid personal account by Tanaka Ichimatsu, a small book of 112 pages of drawings and text was "discovered" in 1927 at Ganjōji, Kumamoto Prefecture.[1] In fact, the book was fairly well known before that time, since a facsimile edition had been published in 1921.[2] From the moment of its so-called discovery, the book was disassembled, its pages cut

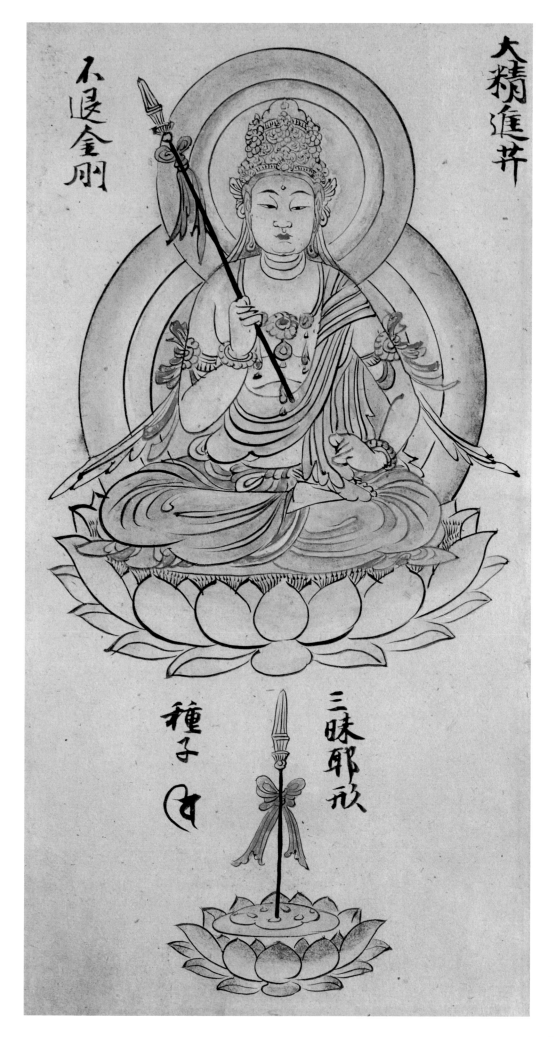

大精進幷

不退金剛

三昧耶形

種子

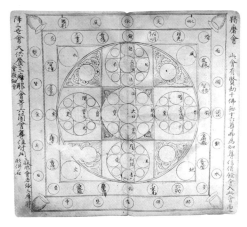

Figure 14. Attributed to Takuma Tametō (fl. ca. 1132–74). Schematic diagrams of the Diamond World mandala. Page from the *Kontai butsugajō*. Ink on paper, 25 × 27.7 cm (9⅞ × 10⅞ in.). Private collection, Kyoto

apart and distributed among various collections—the fate of many books and scroll paintings before 1929, when the government issued restrictions concerning the preservation of works of art. Twelve pages are now in the Museum Yamato Bunkakan, Nara, eighteen in the collection of Kososhi Bunkichi, Kyoto, and at least five in collections in the United States.[3]

In its original arrangement, the book opened with five schematic diagrams of the Diamond World mandala (fig. 14). These were followed by a brief description of the mandala and by illustrations of ninety-five deities. With the exception of the last twenty-two figures, each deity was accompanied by an inscription with his name, a secret name, a "seed" letter, and his attribute. In addition, notations for each of the first thirty-eight figures indicate the deity's color, mudra, and name in Sanskrit.

The fragment in the Burke Collection represents the forty-third figure, Dai Shōjin Bosatsu, known also as Yūmō Bosatsu (Skt: Shauraya Bodhisattva), all these names referring to his unswerving faith. He is one of sixteen guardian deities of the Diamond World mandala known collectively as the Gengō Jūroku Son.

At the end of the book were three inscriptions concerning its history. According to the earliest inscription, dated to the fifteenth day of the first month, the twenty-seventh year of the Ōei era (1420), the book was given to the monk Kōshin by the monk Chōson, a transaction that took place at Kōdaiin on Mount Kōya, the headquarters of Shingon Buddhism. The second inscription, written in the seventh month of the fifth year of the Kyōroku era (1532) by Shinson, the eighth abbot of Ganjōji, furnishes the title of the book and attributes its authorship to the Buddhist painter Takuma Tametō (fl. ca. 1132–74). The third inscription, dated to the third month of the sixteenth year of the Kan'ei era (1639), states that by a "miraculous connection," the book came into the possession of Gyōshin, sixteenth abbot of Ganjōji, and there it remained for nearly three hundred years.

In his commentary to the facsimile edition, Ōmura Seigai states that the second inscription was not originally in the book but was among those he discovered in the massive temple records preserved at Ganjōji. On the basis of the calligraphy, however, Tanaka argues that this is a modern copy of the sixteenth-century inscription and that its contents are authentic. Several facts suggest that there may indeed have been a "miraculous connection" between the temples of Mount Kōya and those of Ganjōji. Most obvious, the name Shinson (the author of the second inscription) is a composite of the second syllables of the names Kōshin and Chōson, the monks mentioned in the first inscription. Second, the subtemple Dai Dempōin on Mount Kōya once housed mandala paintings made on pillars in 1131 by Tametō, the artist named in the second inscription. That temple's founder, the reformer Kakuban (1095–1143), was believed to have established in 1140 the small temple in Wakayama, near Mount Kōya, that later expanded to become Negorodera. Negorodera maintained close ties with Dai Dempōin long after Kakuban's death, as well as with Ganjōji, founded in 1233, which was apparently under the theological jurisdiction of the Dai Dempōin group. Negorodera was destroyed in 1585 by Toyotomi Hideyoshi. At that time, one of its high-ranking monks, Seishin, escaped to Ganjōji, taking with him temple treasures and important sutras. Eventually he became the thirteenth abbot of Gangōji. If the date of the second inscription—1532—is accurate, Seishin's departure to Ganjōji would have occurred after the transfer of the *Kontai butsugajō* to Kyūshū, but it suggests that the book was taken there earlier by monks from Mount Kōya.

While the accuracy of the attribution to Takuma Tametō would seem to rest on the validity of the second inscription, stylistic evidence suggests that the paintings were made by a professional Buddhist painter of the twelfth century. The bodhisattvas' full, oblong faces, long torsos, relaxed poses, and brightly colored ornaments, as well as the smoothly flowing ink outlines, are all characteristic of twelfth-century Buddhist works. There is, however, no painting that can be even remotely connected to Tametō.[4]

The book's title suggests that it may have been part of a larger set that included both the *Kongōkai* and *Taizōkai* mandalas. In fact, Ōmura included in his facsimile edition a set of two small books with representations of deities from the *Taizōkai* mandala. In his account of 1966, Tanaka states that he saw this book in 1924 but that its present whereabouts are unknown. His recollections after more than forty years are understandably sketchy, but he recalled that the books were about the same size.[5] The schematic formats of the deities were reportedly identical, and the drawings were stylistically of the same period, if not by the same hand. Iconographically, the deities were complementary.[6]

Among the hundreds of drawings made for iconographic studies, the *Kontai butsugajō* is unique. The drawings are not the usual hasty sketches in ink monochrome made by monks as notes for their personal use. Rather, they are finished works, and as such they are important examples of Buddhist paintings of the Late Heian period.

1. Tanaka Ichimatsu 1953, pp. 22–27.
2. Ōmura Seigai 1921.
3. Four of these are reproduced in Rosenfield 1967, nos. 5a–d.
4. Tanaka Ichimatsu 1966, pp. 115–16.
5. Ibid., p. 109.
6. Naitō Tōichirō 1932, fig. 21.

The Embodiment of Shinto Gods

CATALOGUE NO. 12

The ancient Japanese had no organized religion. The popular faith, known as Shinto (*kami no michi*; the way of the spirits), claims no founder, no sacred books, no teachers or saints, and no well-defined pantheon of gods. It never developed a moral system or a hierarchical priesthood, nor did it offer salvation after death. For the ancient Japanese, nature itself was the manifestation of divine presence. Rivers, trees, and rocks were marked by *kami*, shadowy apparitions dwelling in dim, undefined spaces.

Shinto ceremonies were the natural outgrowth of an agrarian society. Worship took place outside, at sacred sites. Over time, however, structures were built to honor the gods (though not to house their images). In plan and style Shinto architecture, which was apparently quite similar to secular architecture, reflected the Japanese reverence for

nature. Shrines were usually built in the mountains, often on ground that was not level, without a symmetrical plan (fig. 15).

Shinto was profoundly affected by the advent of Buddhism, which by the eighth century had infiltrated Japanese culture. At the beginning of the ninth century, the mystical beliefs of Mikkyō were widely proselytized by groups of *shugenja*, ascetics who followed the rigorous practice of the religious order Shugendō and whose harsh, nomadic lifestyle required that they travel through rugged mountainous regions in search of sites for Buddhist temples. Often they discovered that the sites they chose had already been claimed as the domain of Shinto deities. It was thus early recognized that the assimilation of Buddhism and Shinto would be mutually advantageous, the more highly structured system of Buddhism absorbing the more inchoate devotion of Shinto. The amalgamation of a native faith with a foreign religion was not peculiar to Japan; indeed, similar attempts had been made in China to syncretize Daoist spirits with Buddhist deities.

In Japan anthropomorphic representations of gods were unknown before the spread of Buddhism, although deities were symbolically associated with sacred objects, such as mirrors, swords, and jewels that became imperial insignia. Following the advent of the new religion, Shintoists began to make images. The form of worship, however, did not change, as images of gods were hidden away in the inner sanctuary of the Shinto shrine, adherents demonstrating their faith—at the entrance— simply by clapping their hands. In similar vein Mikkyō, with its all-encompassing view of the universe, was able to establish a theoretical basis, known as *honji suijaku*, or *shinbutsu shūgō*, for including indigenous gods within its pantheon. In a rather curious theological transformation, Buddhist identities were assigned to Shinto gods, in the belief that these unseen spirits of nature sought enlightenment and salvation.

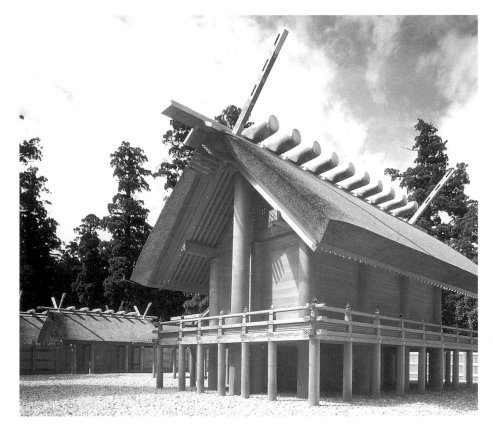

Figure 15. Ise Shrine, Mie Prefecture. Protoliterate era (ca. 10,500 B.C.–A.D. 538), 3rd century A.D.; since late 7th century, razed and rebuilt every twenty years

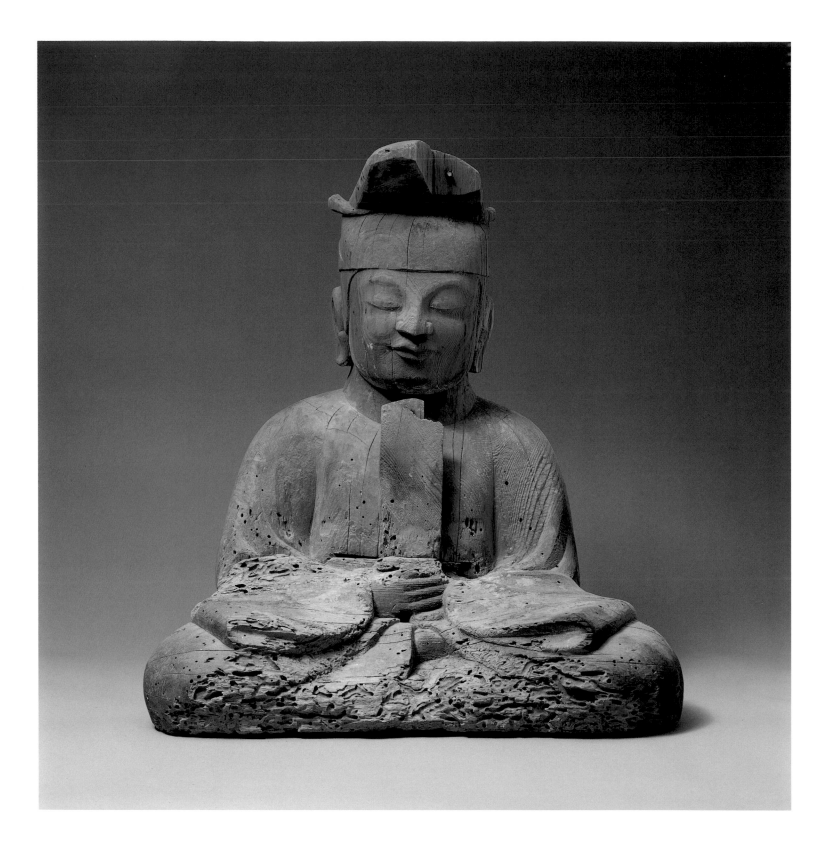

12. Seated Shinto God and Goddess

Late Heian period (ca. 900–1185), 10th century
Japanese cypress (*hinoki*), with traces of color
Height, each 52.5 cm (20⅝ in.)

LITERATURE: Murata Seiko 1983, pp. 21–31;
Kanda 1985, pls. 42, 43.

These small yet dignified deities, in the guise of court nobles, are early examples of the anthropomorphizing of Shinto gods. The figures sit Buddha-like, their legs folded beneath them. The god wears a tall headpiece and holds a scepter, symbol of secular authority. The goddess, her hair fastened in a tall chignon, rests her right hand on her knee. Her left hand, which may have held an object, is now lost. The figures were originally part of a larger group of five statuettes—two male and three female—said to have been removed from the Shinto shrine of Usa Hachimangū, on northern Kyūshū. Another

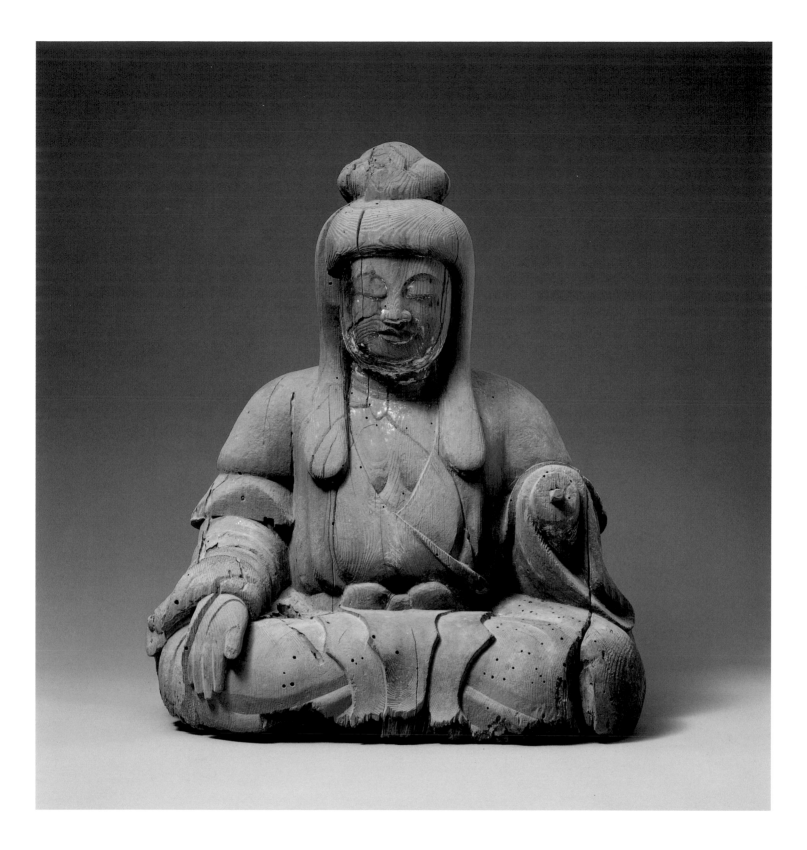

male and female pair are now in the Cleveland Museum of Art, and a third female figure is in the Museum Yamato Bunkakan, Nara (figs. 16, 17).¹ The female figures in Cleveland and Nara each have one knee raised, suggesting that in the original arrangement these two female deities flanked the other three

figures, with the Cleveland goddess at the left and the Nara figure at the right. We do not know whether or not this type of symmetrical placement was intended, however, as early Shinto statues were not accessible for public viewing.

The visual representation in Shinto of *kami*

(or spirits) was inspired by the imagery of Buddhist art. The spirit ancestors of many aristocratic Japanese families were given official recognition by the court in the ninth century, as a reward for the families' political and cultural contributions. Represented in human form, these syncretic images, which

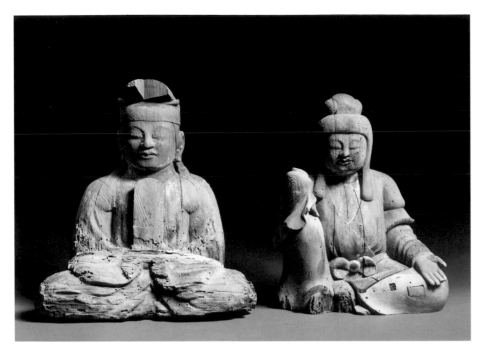

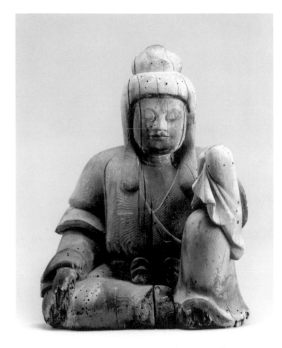

Figure 16. *Shinto God and Goddess*. Late Heian period (ca. 900–1185), 10th century. Wood, approx. height 52 cm (20½ in.). The Cleveland Museum of Art. Purchase, Leonard C. Hanna, Jr., Bequest Fund

Figure 17. *Shinto Goddess*. Late Heian period (ca. 900–1185), 10th century. Wood, height 50 cm (19¾ in.). Museum Yamato Bunkakan, Nara

incorporated elements of Buddhist—specifi-cally Mikkyō—iconography, included female Shinto deities rendered as court ladies, ini-tially in Tang-style Chinese robes and later garbed in the many-layered courtly dresses of the Heian period. Male deities were repre-sented as court noblemen, with tall caps and scepters, or sometimes as soldiers or Buddhist monks. Without inscriptions, the identities of many of these figures cannot be determined.

Shinto statues are usually made of wood, probably from old trees revered as the dwell-ing places of the *kami*. The original group to which the Burke figures belonged is carved primarily in the *ichiboku zukuri* (single block) technique, though many parts of the sculp-tures are fashioned from separate pieces of wood. The knees of the gods in the Burke and Cleveland collections, for example, were

made from individual pieces, and their hats must also have had separate parts. Deep cracks are visible on the face and body of the goddess in the Burke Collection, giving the false impression that it is made of several pieces of wood. All five statuettes have suffered insect damage, and the pigment that originally covered the bodies and robes has flaked off.

The massive, blocklike body of the Burke goddess is covered by a robe with simple but deeply cut folds, arranged on the forearm in a manner reminiscent of *honpa* (rolling waves), a technique that characterizes wood sculp-tures of the late ninth and the tenth century. Most likely the figural group was carved by a sculptor who worked in the Buddhist tradi-tion, modifying the hairstyles and robes to suit the specific requirements of Shinto icons.

The style of carving used to delineate face and draperies and the treatment of the solid, weighty bodies, with their broad shoulders and squarish faces, bear a strong resemblance to those typical of Buddhist sculpture of the late ninth century. The sculptures have been dated variously from the early tenth to the twelfth century.[2] Here, they are tentatively dated to the early tenth on the basis of the squarish faces, blocklike bodies, and the deeply cut drapery folds on the goddess, all of which reflect characteristics still prevalent in sculpture of the ninth century.

1. All five figures are reproduced in Murata Seiko 1983 and in Kanda 1985, pls. 40–45.
2. Murata Seiko (1983, p. 31) dates them to the first half of the eleventh century, Kanda (1985, pls. 42, 43) to the twelfth. See also Kurata Bunsaku 1980, no. 84 (as early tenth century).

In Praise of Amida Buddha

CATALOGUE NOS. 13–17

Thanks to the efforts of monks such as Kūya (903–972) and Genshin (942–1017), Pure Land Buddhism, as the Amida cult is known, underwent a phenomenal expansion during the late tenth century. Even today it claims more adherents than any other religious sect in Japan. Genshin, in particular, played a decisive role in popularizing the dogma of *raigō*, the descent of Amida to welcome new souls to the Western Paradise.

The Amida cult offered the easiest path to salvation of any Buddhist sect. In the concept of salvation implied in *raigō*, Amida does not merely await the arrival of the faithful in the Pure Land, but descends to earth to greet them and to escort them to his realm. The only demands made of the devotee are an unwavering faith and the recitation of the *nenbutsu*, a prayer invoking the name of Amida Buddha. The prospect of salvation without laborious spiritual practice was very appealing. The beatific vision of the Western Paradise as described in countless Amida sutras and in the *Ōjōyōshū* (Essentials of Pure Land Rebirth, 985)—a highly popular book by Genshin, who had an especially fertile visual imagination—influenced the religious as well as the secular life of the nobility.[1] To the all-powerful

Fujiwaras, convinced that only death was beyond their control, Amidism offered at the end a new beginning, the eternal expression of exquisite beauty. To re-create Amida's paradise on earth, the Fujiwaras built great palaces and great temples.

Fujiwara Michinaga (966–1028), patriarch of the Fujiwara clan and perhaps the most extravagant spendthrift Japan has ever known, built Hōjōji, Heiankyō, as a tangible manifestation of his faith in Amida Buddha. Dedicated in 1022, Hōjōji was the most magnificent religious monument of its time. Eloquent testimony to the political and economic power of the Fujiwaras, the temple exemplified the aesthetic vision of the Fujiwaras—the integration of architecture, sculpture, painting, decorative arts, and landscape design into a beautifully balanced ensemble. Hōjōji was destroyed by fire in 1058, but its sumptuous beauty is vividly described in the major chronicle of the time, the *Eiga monogatari* (Tale of Flowering Fortunes).[2] Also narrated is Michinaga's death inside the Amidadō, or Amida Hall, in 1028 while holding a strand of five-colored silken cords attached to the hands of the Amida statue.

Although now reduced in size, the celebrated

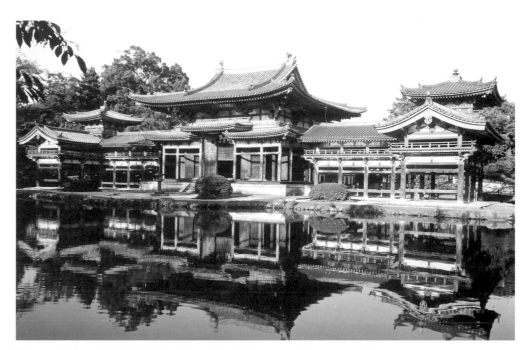

Figure 18. Phoenix Hall, Byōdōin, Kyoto. Late Heian period (ca. 900–1185), 1052

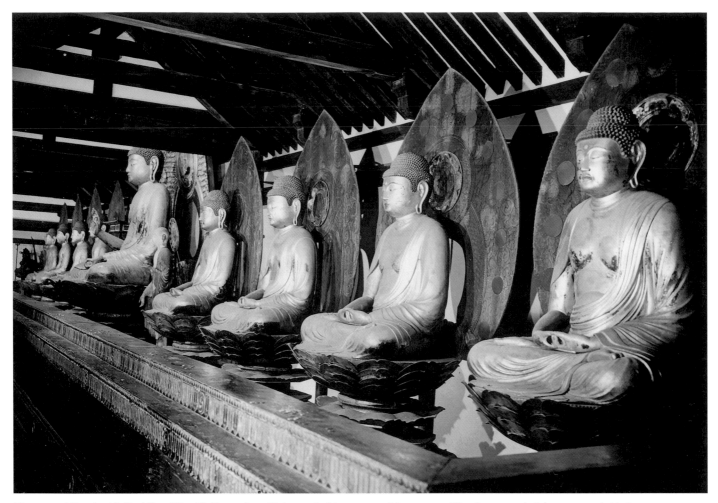

Figure 19. Nine Amida Buddhas, Jōruriji, Kyoto. Late Heian period (ca. 900–1185), ca. 1107. Wood, average height 142.1 cm (56 in.)

Byōdōin, on the Uji River, in a suburb south-east of Kyoto, nevertheless echoes Michinaga's glorious monument. Originally a summer estate, Byōdōin was inherited by Michinaga's son Yorimichi. In 1052, Yorimichi converted the residence into a temple, a visionary replica of the Western Paradise and a symbol of resurrection and immortality. It was named Hōōdō, or Phoenix Hall, for the two bronze phoenixes that stand sentinel atop the central roof (fig. 18). The entire building, with wings at each side and a projecting "tail," is also a representation of the mythological bird. Because it was converted from a villa, Hōōdō reflects features of domestic architecture popular at that time, known as *shinden ʒukuri* (bedchamber style), in which spacious rooms separated by sliding partitions are connected by narrow galleries. The graceful proportions of the Hōōdō and the use of tall stilts to support the covered corridors fuse harmoniously with the natural setting, and the building demonstrates the influence of indigenous

taste on Buddhist architecture, as the impressive, if ponderous, style borrowed from China is here transformed into an airy lightness and elegance hitherto unknown in Japanese Buddhist architecture.

In the central hall is a large gilt-wood statue of Amida Buddha carved by the master sculptor Jōchō (d. 1057). The ceiling and the pillars of the hall are richly decorated with paintings, metal inlay, and mother-of-pearl, while statuettes of bodhisattvas and monks in various attitudes of prayer or playing musical instruments adorn the upper walls. On the wall space below, painted *raigō* scenes depict Amida and his attendants flying over mountains and rivers that are reminiscent of the actual landscape surrounding Heiankyō.

Jōchō's Amida set the standard for all the Amida statues made from the second half of the eleventh century through the end of the twelfth. His face is circular, like a full moon, and his eyes are half closed, as though he is meditating; the brows are long arcs, the lips

small but full, and the hair delicate curls. The broad, flat shoulders, narrow waist, and long legs—the last providing a wide base for the body—are covered by a thin robe with regular folds.

The Buddha's quiet composure and the shallow relief carving reflect the taste of the time and the vogue for *yosegi ʒukuri* (assembled blocks), a technique perfected by Jōchō in which the statue was constructed of small carved blocks of wood, leaving the interior hollow. The blocks were then covered with lacquer and gold.[3] The technique proved to be ideal for retarding deterioration in wood sculptures, as it makes them less susceptible to the changes in weather that cause solid wood to crack. Because they were hollow, *yosegi ʒukuri* sculptures were light and easy to handle, and several craftsmen could collaborate on one piece, each one working on a different section. The hollow was often filled with objects of various kinds—sutras, precious beads, and dedicatory documents. The artist's

signature was sometimes inscribed on the interior (see cat. no. 21).

Michinaga's Hōjōji housed a large number of statues carved by Jōchō and his assistants. Among them was a set of nine Amida Buddhas, each representing one level of *raigō*, according to the nine classes of merits that a devotee could accumulate in his lifetime. The nine Amidas were destroyed along with the temple that housed them, but a later, similar set—the only complete one to survive—can be seen at Jōruriji, south of Kyoto (fig. 19). The nine Amidas—the central figure is the largest—were carved about 1107 and installed against the western wall of the temple. The two *hiten* (Skt: *apsaras*; bodhisattvas who attend the Buddha) in the Burke Collection (cat. no. 14) are believed to have adorned the mandorla that once backed the central Buddha.

The exquisite delicacy that characterized contemporary Buddhist icons can perhaps be attributed in part to the fact that women played an important role in setting artistic standards during the Late Heian period. Indeed, women have probably never had as prominent a part in the cultural affairs of Japan either before or since. Their active involvement in the arts was the result both of the influential political positions they gained when they married into the imperial family and of the encouragement they received in their literary pursuits (see, in particular, cat. no. 20). But certainly as important, the *Lotus Sutra* attracted women to the arts by its promise—offered not only to men but to women as well—of salvation.

1. Andrews 1973.
2. *Tale of Flowering Fortunes* 1980.
3. Nishikawa Kyōtarō 1983.

13. Seated Amida

Late Heian period (ca. 900–1185), early 12th century
Polychromed Japanese cypress (*hinoki*)
Statue: height 49.3 cm (19⅜ in.); pedestal: height
31.2 cm (12¼ in.)

LITERATURE: Kuno Takeshi 1963, pp. 77–79;
Rosenfield 1967, no. 27; Murase 1975, no. 3;
Mayuyama Junkichi 1976, no. 339; Kurata Bunsaku
1980, no. 12; Kaufman 1985, fig. 1; Schirn Kunst-
halle Frankfurt 1990, no. 1.

Amida, the Buddha of the Western Paradise,
is the most popular Buddha in East Asia. His
Japanese name derives from the two Sanskrit
names by which he is known in India, Amitabha
(Boundless Light) and Amitayus (Limitless
Life). In the second century, sutras that
describe him and his heavenly residence
became available to the Chinese.[1] Visual rep-
resentations can be traced to the mid-fourth
century in China, and by the seventh century
worship of Amida dominated Buddhism in
China.[2] By mid-century his popularity in
China was reflected in his increasing pres-
ence in Japan—for example, the now-lost
paintings at Hōryūji—and over the next
three hundred years devotion to him devel-
oped into a cult.

The present work, a benign Amida dating
to the early twelfth century, belongs to this
tradition. Seated in quiet concentration with
eyes downcast, he signals his welcome to the
devotees by gently joining his thumbs and
index fingers in the *jōbon geshō,* a mudra seen
in many depictions of Amida toward the end
of the Late Heian period.

Made in the *yosegi zukuri* (assembled
block) technique, the statue is hollow inside.[3]
The figure originally had an *urna,* a small
protrusion on his forehead that signifies the
Buddha's wisdom, and both face and torso
were covered with gold leaf, most of which
has flaked off. The left hand, right arm and
hand, and tip of the skirt are later replace-
ments. The red garment with black window-
pane patterns is loosely draped in regular,
low-relief folds; the red and black patterns
are later replacements. The broad lotus petals
arranged in alternating rows on the large,
low pedestal appear to have been introduced
from another statue, and the painted designs
on the petals are also later additions.

The Amida is attributed by Kuno Takeshi
to a workshop in Nara, which, like all others
of the period, was influenced by the model
established by Jōchō's Amida in the Hōōdō
while it retains some of the ancient Nara tra-
ditions.[4] The workshop favored several fea-
tures seen on this statue that deviate from
Jōchō's formula. The modeling of the facial
features, for example, is softer and fleshier
than the sharp, linear representations of
Jōchō's works. In this respect, the statue is
linked to other sculptures from the Nara area
that date from the late eleventh to the early
twelfth century.[5]

1. *Daizōkyō* 1914–32, vol. 12, no. 361.
2. Ōmura Seigai 1915, p. 598; and Soper 1959, p. 14.
3. For *yosegi zukuri,* see Nishikawa Kyōtarō 1983.
4. Kuno Takeshi 1963, pp. 78–79.
5. See, for example, the Yakushi Buddhas at Saimyōji,
 Kyoto (1047), and at Reizanji, Nara (1066), the latter
 dated by inscription to 1185. Reproduced in *Chōkoku*
 1972, nos. 154, 279, respectively.

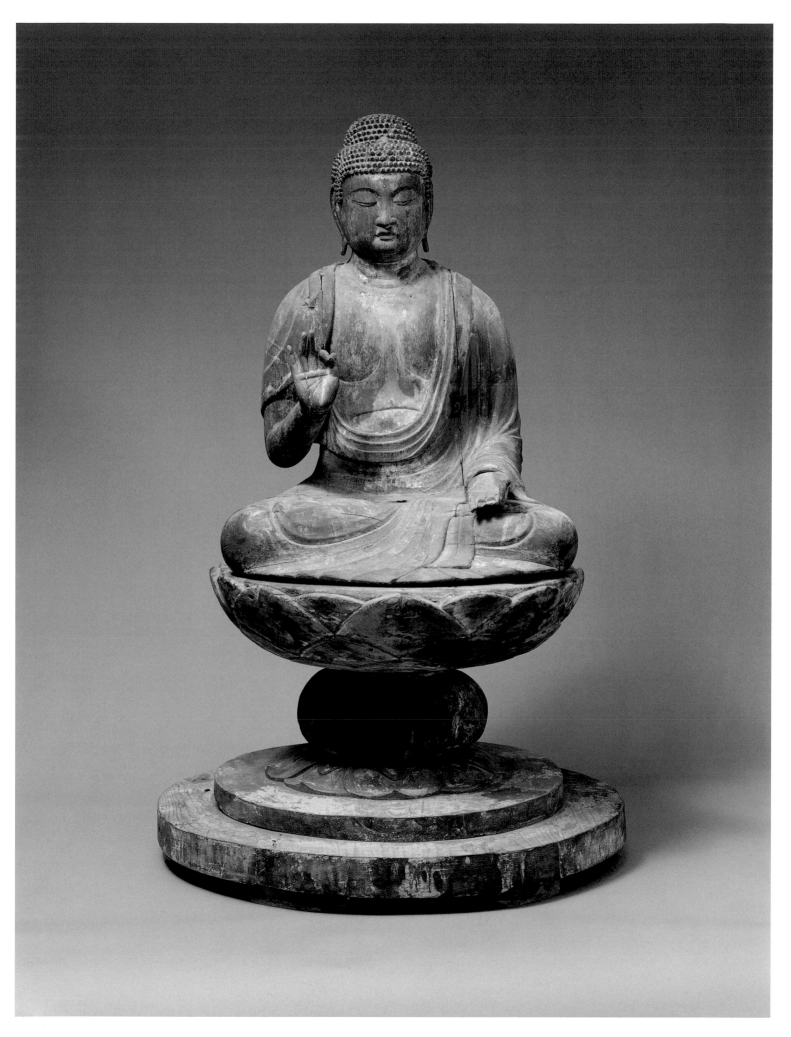

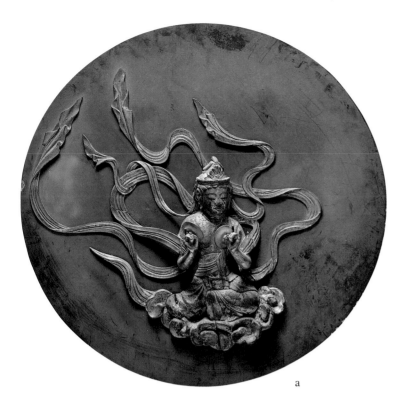

a

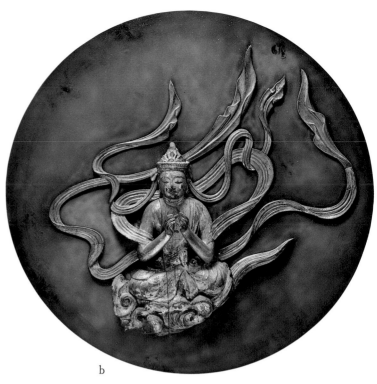

b

14. Two Hiten

Late Heian period (ca. 900–1185), late 11th–
early 12th century
Lacquered and gilded Japanese cypress (*hinoki*)
a: Height 28 cm (11 in.)
b: Height 27.5 cm (10⅞ in.)
Ex coll.: Koizumi Sakutarō; Mohr, Germany

LITERATURE: Koizumi Sakutarō 1926, pls. 29
(*hiten b*), 30 (*hiten a*); Murase 1993, no. 3; Burke
1996b, p. 45.

These disks display two *hiten* (Skt: *apsaras*),
bodhisattvas who fly on clouds around the
Buddha. Also known in Japan as *unchū kuyō
bosatsu* (Bodhisattvas among the Clouds in
Adoration of the Buddha), they are often
depicted playing musical instruments.

Hiten are important elements in the repre-
sentation of the Buddha and his realm.
They appear on the rim of mandorlas behind
statues of the Buddha and on the walls of
Buddha halls, and they are often present in
painted images. Examples can be cited from
the earliest periods of Buddhist art in Japan
(cat. no. 5), Korea, and China. East Asian
hiten are wingless, whereas those from India
and Central Asia tend to be winged, and in
this respect the latter may be associated with
the angels of Christian art, who perhaps
evolved from the winged deities of ancient
Iran.[1] Unlike angels, *hiten* seem never to have
acquired a spiritual function, nor is their
iconography or genealogy clearly understood.
The most well known winged deity of the
Buddhist world, which looks exactly like a
Christian angel, is found in a cave painting
in Miran, Central Asia.[2] In its pre-Buddhist
incarnation in India, it is thought to have been
the goddess of water, the wife of Gandharva,

a guardian deity and celestial musician repre-
sented as a hybrid of a human and a bird.

In China, Daoist immortals were some-
times depicted with feathery wings amid
fantastic cloud formations that evoked the
celestial regions, but Buddhist incarnations
of the airborne deities are in most instances
wingless, their ability to fly suggested by
their fluttering scarves, their body postures,
and their placement in the Buddha's realm.

Hiten appeared in Japan soon after the in-
troduction of Buddhism in the sixth century.
Among the most famous examples are
those at Hōryūji, Nara, where they adorn
the Golden Hall (*kondō*). The cast-bronze
Shaka Triad of 623, the central icon in the
Golden Hall, is backed by a large mandorla
that originally bore a group of *hiten* on its
rim, and small *hiten* with musical instruments
also adorn the canopies that hang above.

Bodhisattvas are often shown with the
Amida Buddha in representations of *raigō*,
though the iconographic connection, if
any, between the bodhisattvas of *raigō* and
early *hiten* is unclear. Like *hiten*, the Amida's
bodhisattvas ride on cloud formations; some
play musical instruments; others are shown
in attitudes of adoration. The most famous

examples of such bodhisattvas can be found in the Phoenix Hall of Byōdōin, of 1052, where they hover on the walls above the Amida carved by Jōchō and on the large mandorla behind him. Just as Jōchō's Amida provided the model for later generations of Buddhist sculptors, the decoration of the mandorla in the Phoenix Hall became the standard in the eleventh and twelfth centuries. The decorative scheme for this leaf-shaped mandorla, thought to have been perfected by Jōchō and known as *hiten kō* (short for *hiten kōhai*, mandorla with *hiten*), usually includes a statuette of Dainichi at the top, seated among swirling clouds and flanked by a group of twelve or fourteen *hiten*.

The Burke *hiten* were first published in 1926, in the catalogue of the collection of Koizumi Sakutarō (Sanshin Koji, 1872−1937), an influential politician and writer of the late Meiji and Taishō periods.[3] Both statuettes were identified in the catalogue as originally having been attached to the central figure of the Amida Buddha in the temple of Jōruriji, south of Kyoto, and dated on stylistic grounds

from the late eleventh to the twelfth century. The temple is famous for its unusual display of nine statues of the Amida (fig. 19, page 46), representing the nine levels of *raigō*. Temple records state that a new building to house the statues was built in 1107.[4] The Amida, the largest of the group—24.5 meters (96¼ in.) in height, placed on a pedestal 11.5 meters (45⅜ in.) high—is an outstanding example of a sculpture based on Jōchō's model in the Phoenix Hall (fig. 20). Backed by a great mandorla adorned with four *hiten*, the statue on its pedestal is imposing in scale—36 meters (nearly 12 ft.) in height—making the *hiten* appear quite small. In the late 1950s it was proposed that the mandorla had been adorned with a statuette of Dainichi and either twelve or fourteen *hiten*, of which all but four were lost.[5] More recent studies suggest that the mandorla is largely a replacement, dating to 1688, while the four remaining *hiten* are contemporary with the Amida.[6]

If the Jōruriji Amida and its four *hiten* were indeed made about 1107, as suggested by temple records,[7] it is possible that the

Burke *hiten*, dated on stylistic grounds to the same period, originated with this sculptural group. Like the Burke *hiten*, the four at Jōruriji are made of lacquered and gilded cypress (*hinoki*) and they are seated on cloud vehicles. The dimensions of the four surviving *hiten* are commensurate with those in the Burke Collection. The *hiten* at the top right measures 33.3 centimeters (13⅛ in.), the figure at the lower right 32.1 centimeters (12⅝ in.); measurements of the other two are not available.[8] It is possible that *hiten b*— whose cloud formation suggests a leftward movement—was originally at the viewer's right, below the two remaining *hiten* and a lost third. Burke *hiten a*, which turns its head slightly toward the right, may have been the fourth *hiten* at the left.

The Burke *hiten* are carved in high relief, their heads rendered almost completely in the round. The disks and the rather fussy ribbons that create the suggestion of movement are later additions. Both figures have sustained noticeable damage on the torsos.

The Burke *hiten* were separated for many years. *Hiten a* was acquired by the Burke Collection in 1987, and was reunited in 1992 with *hiten b*, which had been in a private collection in Germany.

1. Nagahiro Toshio 1949; see also Hamada Takashi et al. 1989.
2. Stein 1921, vol. 4, pls. 40, 41.
3. Koizumi Sakutarō 1926, pls. 29, 30.
4. *Ruki no koto* (Records of Temple History), in Ōta Hirotarō et al. 1978, p. 64.
5. Inoue Tadashi 1958, p. 47.
6. Ōta Hirotarō et al. 1978, p. 85; and Nishikawa Kyōtarō et al. 1984, vol. 5.
7. Inoue Tadashi (1963, pp. 7−20) favors 1047 as the date for the central Amida.
8. I am grateful to Mr. Tada Tsuguo, of the Iwanami Shoten, who helped me to acquire this information.

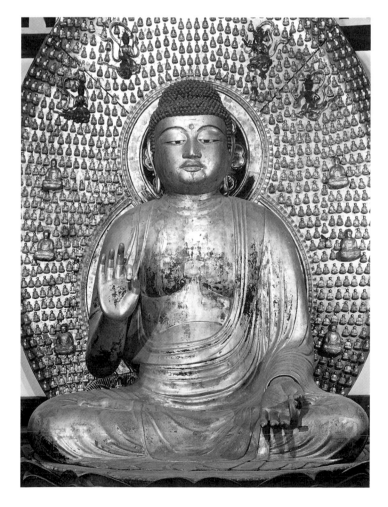

Figure 20. Amida Buddha and mandorla with *apsaras*, Jōruriji, Kyoto. Late Heian period (ca. 900−1185), ca. 1107. Wood, height 24.5 m (96¼ in.)

15. Scroll of the "Daihan'nya haramittakyō"

Late Heian period (ca. 900–1185), 12th century
Gold and silver ink on indigo paper
Frontispiece: 25.9 × 21.3 cm (10¼ × 8⅜ in.)

LITERATURE: Murase 1975, no. 10; Mayuyama Junkichi 1976, no. 354.

The cover of this sutra gives the title, *Daihan'nya haramittakyō* (Skt: *Mahaprajnaparamitasutra*; Greater Sutra of the Perfection of Wisdom), and the chapter number, seventy-eight. The decoration on the sutra conforms to a type popular during the Late Heian period.[1] Of the thousands of sutras copied, most were on paper of a deep indigo color, the text written in silver ink and the frontispiece drawings executed in gold and silver ink. As was common for sutra frontispieces, a bird-shaped hill representing Vulture Peak, near Rajagriha, where Shakyamuni preached, looms in the distance. The Buddha is shown seated on a tall lotus pedestal flanked by bodhisattvas and monks. In front of him are an offering table with an incense burner and four monks and three noblemen with their backs to the viewer.

The *Daihan'nya haramittakyō* (*Daihan'nyakyō* for short) is the opening sutra of the *Tripitaka*, the compendium of Buddhist scriptures. One of the most important canonical sources for Mahayanists, it includes sixteen metaphysical discourses delivered by the Buddha. In this part of the first discourse, the Buddha answers a series of questions posed by the noblemen, who are seeking enlightenment. Throughout the sermon, absolute truth is equated to void or emptiness, and wisdom is praised as the best means of attaining enlightenment.

A short version of the *Daihan'nyakyō* was translated into Chinese from Sanskrit in the early fifth century, and a full translation comprising six hundred scrolls was made by the Chinese monk Xuanzang (596–664) between 659 and 663. The sutra was introduced to Japan soon thereafter. The earliest known Japanese copy dates from 712, and it was frequently copied for use in the liturgy dedicated to prayers for the protection of the nation against evil.

Although laborious, the task of copying sutras was nevertheless appealing, as there was spiritual merit to be gained. Indeed, the patient act of copying was considered "a kind of down payment toward a felicitous rebirth in the next life."[2] The official scriptoria, which had employed professional scribes, were probably abolished at the end of the eighth century, when the court moved from Nara to Kyoto. With the waning of imperial support for Buddhist temples, fewer sutras were produced during the Early Heian period. The copying of sutras regained popularity in the tenth century, however, especially among the Buddhist nobility. The copying of such scrolls was especially prolific in the twelfth century, and the deep veneration for the activity is reflected in the large numbers still preserved in Japan and abroad.

Many frontispieces depict dramatic narrative scenes. Others, like this one, are characteristically hieratic, with the Buddha, surrounded by a host of bodhisattvas and devotees, at the center of the composition.

大般若經卷第七十八

Cover

大般若波羅蜜多経巻第七十八

初分天帝品第廿二之二

三蔵法師玄奘奉　詔譯

Frontispiece

The drawings also tend to be stylistically uniform, the figures of the Buddha and his host assuming the appearance of charming, innocent children. Quickly applied brushstrokes define the essential details of the figures, and the landscape is delineated in broad bands of gold and silver. The monks' round heads are rendered with two brushstrokes applied in opposite directions, a convention that suggests a Buddhist painter was responsible for the work. Indeed, this drawing is in every respect typical of decorated sutras dating from the twelfth century. The cover of the scroll is also decorated in the standard manner, with large, stylized floral motifs in gold and silver ink.

The copying of a large set of sutras was sometimes done by ambitious amateur calligraphers, but the stylistic similarities in the calligraphy of the text and in the frontispiece decorations found in most sutras suggest that they were generally produced in workshops.

1. *Daizōkyō* 1914–32, vol. 5, no. 220. For a detailed discussion of this sutra, see Rosenfield and Shimada Shūjirō 1970, pp. 80–81.

2. Pal and Meech-Pekarik 1988, p. 276.

16. Scroll of the "Jingoji Sutras"

Late Heian period (ca. 900–1185), before 1156–1185
Gold and silver ink on indigo paper
Frontispiece: 25.6 × 21.8 (10⅛ × 8⅝ in.)
Seal: *Jingoji*
Ex coll.: Jingoji, Kyoto

LITERATURE: Murase 1975, no. 11; Kaufman 1985, fig. 11; Tokyo National Museum 1985a, no. 68; Pal and Meech-Pekarik 1988, pl. 82; Schirn Kunsthalle Frankfurt 1990, no. 15; Kim 1991, no. 46.

The compositions on this sutra cover and frontispiece closely resemble those on the *Daihan'nyakyō* (cat. no. 15), but they are simpler. Here, too, the Buddha is shown at Vulture Peak, but he is flanked only by two monks and two bodhisattvas. The rectangular red seal of Jingoji is placed between the frontispiece and the first line of text.

The scroll was at one time part of a set of the *Tripitaka* preserved at Jingoji that came to be known as the *Jingoji Sutras*. According to the *Jingoji ryakki*, a history of Jingoji, the *Tripitaka* was begun under the auspices of the retired emperor Toba (r. 1107–23) just before his death in 1156 and completed in 1185 under his son Go-Shirakawa, who lived at the temple after he abdicated in 1158.[1] The original set likely included about 5,000 scrolls, since the temple inventory of 1794 lists 4,722 as still there.[2] In the nineteenth century, several scrolls were stolen and probably hundreds more were sold to finance repairs of the temple buildings. Today only 2,273 scrolls remain.

Cover

如是我聞一時佛在王舍城鷲峯山中興

大方廣佛華嚴経後慈分一巻

三藏法師提雲般若等奉制譯

神護寺

Frontispiece

The present scroll, the *Daihōkōbutsu kegon-gyō shujibun*, was translated from Sanskrit into Chinese in 692 by a Central Asian monk from Khotan who was known in China by the name Tiezhi.[3] In the sutra, the Shakya-muni Buddha, in response to a question posed by the bodhisattva Maitreya (J: Miroku), discourses on the Six Ways (see cat. no. 6), the fundamental moral virtues that must be practiced along the path to enlightenment.

1. *Jishi sōsho* 1915, p. 115; see also Rosenfield and Shimada Shūjirō 1970, no. 33.
2. Tanaka Kaidō 1942, p. 355.
3. *Daizōkyō* 1914–32, vol. 10, no. 306.

17. Sutra Cover

Late Heian period (ca. 900–1185), before 1149
Silk brocade, bamboo, brass, and mica
31.4 × 44 cm (12⅜ × 17⅜ in.)
Ex coll.: Jingoji, Kyoto

LITERATURE: Murase 1975, no. 111; Pal and
Meech-Pekarik 1988, pl. 83.

Sumptuously decorated sutra scrolls that constitute the entire text of the *Tripitaka* (the compendium of Buddhist scriptures) were not meant for daily use. Once copying of the texts was completed, they were stored in boxes and placed in sutra depositories, to be taken out only for special occasions. The *Jingoji Sutras*, from Jingoji, Kyoto, are believed originally to have numbered about five thousand scrolls (see cat. no. 16). This massive work, donated to the temple in 1185 by the retired emperor Go-Shirakawa, was divided into groups of about ten scrolls, each wrapped in a beautiful bamboo cover like the example shown here. Nearly five hundred similar covers were likely produced, of which 202 are still preserved in the temple.

Covers such as this one were made of nearly three hundred thin strips of bamboo, dyed black and fastened together with nine interwoven bands, alternately narrow and broad, of colorful threads. The resulting mat was then framed with a border of silk brocade. Two brass studs in the shape of butterflies secured a braided silk ribbon; a longer ribbon, now lost, was attached to a third butterfly, also lost. The small wood tag once fastened to the ribbon has survived, and its inscription, hand carved and filled in with gold, reads "Maka Sōgi Ritsu, 2" (Rules and Laws on the Lives of Monks and Nuns) on one side and "Shōjō Ritsu, 58" (Rules and Laws for Monks and Nuns) on the other.

The mat is lined on the back with silk brocade. When the cover was first made, a sheet of lustrous mica was inserted between the bamboo strips and the brocade lining, not only to create a shimmering effect but also to protect the scrolls from moisture. Fragments of the mica that still adhere to the silk are visible through the screen of the bamboo strips.

One of the strips from another *Jingoji Sutra* cover bears the date 1149.[1] It is generally believed that all the wrappers were produced about this time and that the *Jingoji Sutras*, including the present work, were begun sometime before.

Sutra covers of this type were most likely introduced from China. Many are preserved in the Shōsōin Treasury, Nara.[2] Dating to the mid-eighth century, these examples suggest that the technique of making sutra covers changed very little over four centuries. In contrast to the large number of textiles preserved from the Nara period, as well as from the much later Momoyama and Edo periods, only a small number from the Heian through the Muromachi periods are extant. The *Jingoji Sutra* cover is a rare survivor from the twelfth century. It is evidence of the sophistication of brocading and weaving techniques, and it reflects as well the aesthetic consideration given to even the smallest details of such consecrated objects—objects that clearly testify to their donors' religious fervor and devotion.

1. Kirihata Ken 1983, p. 74.
2. Nara National Museum 1979, no. 4.

18. Poems from the "Kokin wakashū"

Late Heian period (ca. 900–1185), 2nd half of
11th century
Page from an album, mounted as a hanging
scroll, ink on paper
20.3 × 13.8 cm (8 × 5⅜ in.)
Ex coll.: Araki Sōhaku

LITERATURE: Komatsu Shigemi 1985b, vol. 1,
p. 55; Tokyo National Museum 1985a, no. 71;
Schirn Kunsthalle Frankfurt 1990, no. 26.

The three poems inscribed on this sheet are
from a version of the *Kokin wakashū* (A
Collection of Poems Ancient and Modern).
Presented in the year 905, the original work
was the first imperially sponsored anthology
of Japanese poetry. The appearance of this
work, known also as the *Kokinshū*, signals
official acceptance of Japanese verse as
literature.

The book from which this page was sepa-
rated is called the *Araki gire* (Araki Fragment),
having once belonged to the calligrapher
Araki Sohaku (1600–1685). The calligraphy,
traditionally ascribed both to Fujiwara
Yukinari (Kōzei, 972–1027) and to Fugiwara
Kintō (966–1041), is now attributed to an
anonymous artist from the latter half of the
eleventh century. It is characterized by tightly
formed, rounded characters rendered in a
fluent, continuous line that inclines to the
right, the brush seldom lifted from the paper;
the entire second line from the right, for
example, was written in one continuous sweep.
A lively sense of movement and spontaneity
is created by the spaces left between the titles
and the poets' names.

The paper is known as *kumogami* (cloud
paper), as the indigo dye, combined with the
paper pulp, produces blue cloudlike patterns
on the sheet. In its original format the *Araki
gire* was composed of a variety of papers,
including pages made from imported Chinese
paper with mica-printed designs and other
decorated surfaces.

The page includes three poems and, in
two cases, the titles and names of the poets.
The first (reading from right to left) is by
Takamuko no Toshiharu (fl. ca. 890–930).
Its title, "Hanging Moss," and the name of
the author are missing, as they were inscribed
on the facing, right-hand page. The author of
the second poem, "Long-Jointed Bamboo,"

is Ariwara no Shigeharu (died ca. 905), the
son of Ariwara no Narihira (825–880), a
colorful literary figure of the Early Heian
period. And the author of "Mushroom" is
Kagenori no Ōkimi (fl. late 9th century).

450
Sagarigoke
Hana no iro wa tada hito sakari kokeredomo
kaesu gaesu zo tsuyu wa some keru

Hanging Moss
Only briefly do the autumn grasses
display their beauties,
yet each night the dew has come
to dye the petals deeper colors.

451
Nigatake
Inochi tote tsuyu o tanomu ni katakereba
mono wabi shira ni naku nobe no mushi

Long-Jointed Bamboo
Difficult it is to depend upon sips of dew
to sustain one's life,
so anxiously they pipe long
lonely hours, insects of the fields.

452
Kawatake
Sayo fuke te nakabatake yuku hisakata no
tsuki fukikaese aki no yamakaze

Mushroom
Already the moon has half climbed
the celestial dome
as night grows old—oh autumn wind
from the peaks
blows it backward on its course.[1]

1. *Kokinshū* 1984.

荒のうろてゝうちつゝうわさけろ

うつゑうつひらあきけろ

てうつも

うみのちわれくつねさうのもろつうけれ

のものわひ―らううすれへけむし

うくすけ

うきのりのうき

さしふもくそうのそけ

つきらようろ稲桁の山うせ

CALLIGRAPHY BY FUJIWARA SADANOBU (1088–1156)

19. Page from the "Tsurayukishū"

Late Heian Period (ca. 900–1185), ca. 1112
Page from a book, mounted as a hanging scroll,
ink on decorated paper
20.2 × 16 cm (8 × 6¼ in.)
Ex coll.: Nishi Honganji, Kyoto

LITERATURE: Pekarik 1985a, fig. 3; Tokyo
National Museum 1985a, no. 70; Schirn Kunsthalle
Frankfurt 1990, no. 25.

This sheet was originally part of the *Tsura-yukishū*, an anthology of poetry by Ki no Tsurayuki (ca. 872–945), one of the most revered poets of classical Japan. That volume was in turn part of a set of thirty-eight, the *Sanjūrokuninshū* (Collection of the Thirty-six Immortal Poets). Transcribed in the early twelfth century, the version of the anthology from which the Burke page is taken is the oldest known copy. It was part

of the imperial collection until 1549, when Emperor Go-Nara (r. 1526–57) presented it as a gift to the monk Shōnyo (1516–1554), who lived at Honganji, a temple then located at Ishiyama, the present site of Osaka Castle. The books dropped out of sight until 1896, when they turned up in a storehouse of Nishi Honganji, Kyoto. In 1929 two volumes, the *Iseshū* (cat. no. 20) and the volume from which this sheet comes (vol. 2 of the *Tsurayukishū*),

were separated from the set and sold to various public and private collections to finance the founding of a women's college. The two volumes came to be known as the *Ishiyama gire* (Ishiyama Fragment), recalling Emperor Go-Nara's gift to the monk at Ishiyama.

The *Sanjūrokuninshū* appears to have been commissioned as a gift for the retired emperor Shirakawa (r. 1073–87), a staunch supporter of poetry and the sponsor of many celebrated poetry contests, on the occasion of his sixtieth birthday in 1112.[1] Approximately fifty artists and craftsmen labored to produce the more than two thousand sheets, creating papers embellished with paintings, printed designs, multicolor torn-paper collages, *suminagashi* (flowing-ink patterns), and other decorations.[2] The books are also fine examples of *detchō* binding, in which each sheet is folded in half and then glued to the following page along the folded edge.

The calligraphy, generally regarded as some of the finest early writing in the flowing Japanese *kana* script, has been attributed to twenty different hands, though only one, the calligrapher of volume 2 of the *Tsurayukishū*, has been firmly identified.

Fujiwara Sadanobu (1088–1156) was the grandson of Fujiwara Yukinari (Kōzei, 972–1027), one of the greatest calligraphers of Japan, and the son of Sadazane (1063–ca. 1131), to whose hand several volumes from the same set are attributed.[3] He is known for having copied single-handedly onto nearly six hundred scrolls the entire *Issaikyō*, the Chinese translation of the *Tripitaka*, a task that spanned twenty-seven years. His efforts literally went up in smoke a few years later, when the temple to which he had donated the work, a building in the Tōdaiji complex in Nara, was destroyed by fire.

The Burke page is decorated with a mica-printed design of stylized lions and vine scrolls, onto which motifs of birds and plants are stamped in silver. Over this delicate yet lively ornamented surface, Sadanobu, who was only about twenty-five at the time, inscribed the verses of Tsurayuki in quick, fluid brushstrokes that vary noticeably in size and width. The result is a calligraphy that is fresh, spontaneous, and overflowing with youthful vigor. Another page from the same volume, in the Seattle Art Museum, is stylistically comparable.[4]

The first poem reads as follows:

Tōku yuku hito no tame niwa waga sode no namida no tamamo oshikara naku ni

Seeing someone off to a faraway place, no regrets to wet my sleeves with so many teardrops.

The second poem is also about departure and loss. As described in the headnote, it expresses the thoughts of one Hyoe no suke Kanesuke as he bids farewell to his friend Miharu no Arisuke, an officer of the Left Guard, on the banks of the Kamo River:

Kimi oshimu namida ochi masu kono kawa no migiwa masarite nagaru tsura nari

My tears, which mourn your departure, make the river swell. It overflows its banks.

The last line on the sheet, which reads "Composed while seeing someone off who is departing with a gift to see a mutual friend," refers to the poem inscribed on the following page.

1. On this set, see Kyūsoshin Noboru 1966.
2. Egami Yasushi 1972, pp. 11–18. On paper decorations, see Tanaka Shinbi 1950.
3. Kinoshita Masao 1980, p. 25.
4. Y. Shimizu and Rosenfield 1984, no. 9.

20. Poems from the "Iseshū"

Late Heian period (ca. 900–1185), 12th century
Page from a book, mounted as a hanging scroll,
ink on decorated paper
20.1 × 15.8 cm (7⅞ × 6¼ in.)
Ex coll.: Osaragi Jirō; Nishi Honganji, Kyoto

LITERATURE: Rosenfield 1967, no. 37d; Murase 1975, no. 19; Mayuyama Junkichi 1976, no. 510; Tokyo National Museum 1978, no. 114; Kita Haruchiyo 1985, p. 85; Pekarik 1985a, fig. 2; Tokyo National Museum 1985a, no. 69; Schirn Kunsthalle Frankfurt 1990, no. 24.

The man came and stood at her gate. Hearing a cuckoo singing in a flowering orange tree, he composed the following verse and sent it in to the lady:

*To ni tateru ware ya kanashiki hototogisu
hanatachibana no eda ni ite naku*

*Standing at your gate
forlorn am I as the mournful
cuckoo that sings my sadness
from his perch among the branches
of your blossoming orange tree.*

To this she replied:

*Nanika ton kimi oba shiraji hototogisu
kinagara nakuwa sagoni ya wa aranu*

*Hardly can he know
what errand brings you here,
the cuckoo in my tree—
is it not his tuneful nature
thus to come and sing?*[1]

In addition to the two poems and short prose introductions on this fragment, a line at the extreme right reads: "irozo fukaku narinuru" (the color has deepened). These are the last words of the poem on the preceding sheet.

The author of this poetic exchange is Ise no Go (ca. 877–940), a poet of the Fujiwara clan active in the Late Heian period and named one of the Thirty-six Immortal Poets, or Sanjūrokkasen, in the eleventh-century listing compiled by Fujiwara Kintō. Ise's unhappy love affairs as a young woman and her life at court in service to Empress Onshi, consort of Emperor Uda (r. 887–97), are briefly summarized in the introduction to her major poetic work, the *Iseshū*, an anthology of approximately five hundred poems. Ise's life was early shadowed by the death in infancy of the son she bore the emperor. She later married Uda's fourth son and gave birth to a daughter, Nakatsukasa, who also became one of the Thirty-six Immortals.

Lady Ise's poems reflect the period of cultural transition in Japan at the beginning of the tenth century. After official ties with Tang China were severed in 894, Japanese literature began slowly to shed the ponderous influence of Chinese literary forms. *Waka*, an indigenous Japanese verse in thirty-one syllables, was developed during Ise's lifetime, and Ise herself is considered one of the pioneers of this literary form. Twenty-two of Lady Ise's poems are included in the *Kokinshū* (A Collection of Poems Ancient and Modern), completed about 905.

The Burke page is a fragment from the *Iseshū*, which was in turn included in the *Sanjūrokuninshū* (Collection of the Thirty-six Immortal Poets). It is embellished with floral patterns and peacocks, printed in mica and overlaid with printed silver designs of pine branches and birds. The delicate beauty of the sheet contrasts sharply with the robust calligraphy and designs that characterize the *Tsurayukishū*. One volume of that work is coupled with the volume to which this sheet belongs, the two together referred to as the *Ishiyama gire* (see cat. no. 19). The small, elegant characters have a certain uniformity, but within each character is a subtle flourish that creates a sense of lively energy. Also attributed to this calligrapher, who remains unidentified, are the *Tomonorishū* and the *Saigū no Nyōgoshū*.[2]

Two additional pages from the same book are in the Philadelphia Museum of Art and in the Arthur M. Sackler Museum, Harvard University Art Museums, respectively.[3]

1. Translations by Edwin A. Cranston and Fumiko Cranston in Rosenfield 1967, no. 37d.
2. Kinoshita Masao 1980, p. 58; Komatsu Shigemi (1985b, vol. 2, pp. 78–83) attributes these three books to Fujiwara Kintō (966–1041).
3. Y. Shimizu and Rosenfield 1984, nos. 10, 11.

III. Kamakura and Nanbokuchō Periods (1185–1392)

CATALOGUE NOS. 21–47

The Kamakura period, spanning roughly the century and a half between the triumph of the Minamoto warriors in 1185 and the abortive Kenmu Restoration of 1333, was a time of dramatic transformation in the politics, society, and culture of Japan. *Bakufu* (tent governments), or government by shoguns (warrior chieftains) or their regents, controlled the country from Kamakura, headquarters of the Minamoto forces and center of the de facto national administration, approximately forty-five kilometers (28 miles) southwest of modern Tokyo. Thus began a binary system of government, under which emperors reigned but shoguns ruled. It lasted for nearly seven centuries, until 1867.

For some time prior to 1185, two rival clans, the Minamoto (also known as the Genji) and the Heike (Taira), had been quietly reinforcing their power bases outside the capital city of Kyoto: the Minamoto in the eastern regions and the Heike in the western provinces along the Inland Sea. In two civil conflicts, known as the Hōgen Insurrection (1156) and the Heiji Insurrection (1159), the clans had allied themselves with opposing factions in the imperial court for the purpose of overthrowing the entrenched Fujiwara regime. In the wake of these upheavals the Fujiwara court finally lost its supremacy, first—but only briefly—to the Heike, and subsequently to the Minamoto under their leader, Minamoto Yoritomo (r. 1192–99; fig. 22).

Although a brilliant general and an astute politician, Yoritomo was blessed with neither longevity nor competent progeny, and because he had eliminated as potential rivals many able relatives, the fall from a horse that killed him at age fifty-two virtually ended Minamoto hegemony in Kamakura. Yoritomo's sons Yoriie (r. 1202–3) and Sanetomo (r. 1203–19), who succeeded him as second and third shogun, respectively, were inadequate as rulers, and both were murdered young. Power passed to the Hōjō clan, led by Tokimasa, Yoritomo's father-in-law, who had been regent from 1203 to 1205. It was not until the closing years of the thirteenth century that the strength of the Hōjō regency began to wane. Invasions by the combined forces of the Mongols and Koreans, along with years of costly military preparedness against the threat of another attack, caused severe economic hardship and strained the loyalty of the hard-pressed and meagerly rewarded warrior class.

Further complicating Kamakura's difficulties, the Hōjō regency became entangled in disputes over the imperial succession. In 1333, a coalition of supporters of Emperor Go-Daigo (r. 1318–39) and the warrior chieftain Ashikaga Takauji (r. 1338–58) toppled the Kamakura regime in an attempt to restore direct imperial rule that has come to be known as the Kenmu Restoration. Soon, however, the erstwhile allies were at odds. In 1336, Takauji drove Go-Daigo from Kyoto, and there, in 1338, he established the Ashikaga shogunate. Ashikaga hegemony would last until the late sixteenth century. Go-Daigo took refuge in Yoshino, south of Kyoto, and set up the Southern Court, rivaling Takauji's Northern Court in Kyoto. For a rare moment in the history of Japan, two imperial houses coexisted. The era of strife that resulted, from 1336 to 1392, is known as the Nanbokuchō

Figure 22. Unidentified artist (13th century), *Minamoto Yoritomo*. Hanging scroll, color on silk, 143 × 112.8 cm (56¼ × 44⅛ in.). Jingoji, Kyoto

period, or the period of the Northern and Southern Courts.

The Kamakura and Nanbokuchō periods were remarkable for the shift that occurred during this time in the Japanese aesthetic. The new patrons of the arts had no patience with the precious sentiments so highly prized by the ousted aristocracy. A commentary by the courtier-turned-recluse Kamo no Chōmei (1155–1216), entitled *Hōjōki* (The Ten-Foot-Square Hut), exemplifies the spirit of the new age.[1] In this work, Chōmei gives a detailed account of the famine of 1181 (in only two months of that year, those dead of starvation in the capital numbered more than 42,300). His documentation of even the most pitiful and repellent aspects of reality reflects the warrior's outlook on life. In keeping with this outlook, the warrior class favored artists who treated their subjects with a direct honesty and virile energy that matched their own. What followed, then, was an age of realism unparalleled before the late eighteenth century.

Paradoxically, the destructive wars between the Heike and the Minamoto gave impetus to the new style. Yoritomo's troops were aided by a populous army of well-trained, well-equipped monk-soldiers from Kōfukuji and Tōdaiji, Nara's two most powerful temples. Overcome, the Heike army retreated in 1180, setting fire to the two temples and reducing them to rubble. As a token of his gratitude for the monks' support, Yoritomo ordered that the temples be rebuilt the following year. Under the energetic supervision of the monk Shunjōbō Chōgen (1121–1206), the most dynamic talents were mobilized for the reconstruction project, and for a time the city of Nara was the artistic center of Japan.

The creation of the many sculptures that had to be replaced was entrusted to a group known collectively as the Kei school, which was under the direction of two young sculptors, Unkei (1151–1223) and his older colleague Kaikei (cat. no. 21). The first generation of the Kei school had settled in Nara in the eleventh century, working mainly on the repair and restoration of statues in Nara temples. Kei-school training was therefore based on an older sculptural tradition, particularly that of the Nara period. Although one Kyoto critic

called their work "uncouth,"[2] the dominance of the Kei school in the reconstruction projects of the early Kamakura period led to a revival of the Nara aesthetic.

This renascence was not limited to art. Religious movements experienced a similar resurgence, and reform and counterreform currents animated and transmuted Kamakura Buddhism. Among the courtly and warrior elites, Heian traditions of Amida worship and Esoteric Buddhism were perpetuated, but for the first time in its history Japanese Buddhism evinced a deep commitment to the salvation of the masses. The monks Hōnen (1133–1212), Shinran (1173–1263), and Ippen (1239–1289) all broke with tradition to found new sects that had as their primary goal the spiritual welfare of the underprivileged. And monks such as Myōe (1173–1232) attempted to reform and revive older sects, emphasizing worship of Shakyamuni, the historical Buddha, which was the fundamental doctrine of Buddhism in the Nara period. Evidence of their efforts includes the large number of copies made of the *Kako genzai e-ingakyō* (Illustrated Sutra of Cause and Effect; cat. no. 24), an eighth-century painted handscroll depicting scenes from the life of Shakyamuni.

In 1274 and 1281, the combined forces of Korean and Yuan (Mongol) Chinese forces invaded northern Kyūshū. Although repelled by *kamikaze* (divine winds, or typhoons), they nevertheless left vast destruction in their wake. In the aftermath of the ensuing national crisis, the native Shinto gods received the same official recognition accorded Buddhist deities. Shinto beliefs came to be codified and affiliated with Buddhism in the syncretic system known as *honji suijaku* (see cat. nos. 31–33, 35). And in the final years of the Kamakura period, Zen Buddhism exerted a strong influence on the warrior class, becoming the dominant faith of the succeeding Muromachi era.

The binary system of government—the crown reigning while the shogun ruled—was reflected in the arts as well. At the outset of the Kamakura regime, the warriors were on the whole poorly educated and ill prepared to handle civil administration. To carry out the business of government and, more important,

to act as go-betweens with the imperial court, the *bakufu* needed to attract to Kamakura educated noblemen and monks. And to lend themselves an aura of social and political legitimacy, warrior leaders had to acquire the intellectual skills and cultural refinements previously possessed only by members of the court and clergy. Eventually, activities such as poetry gatherings and competitions, quintessential symbols of aristocratic culture, became popular even among Kamakura's lesser warriors. Hōjō regents repeatedly had to exhort their vassals to cherish military rather than civilian arts, thus demonstrating how strongly Kamakura's warriors were drawn to Kyoto culture. And the court lost no opportunity to assert its cultural superiority by perpetuating courtly traditions. It was in this atmosphere that, in 1201, the retired emperor Go-Toba (r. 1183–98) established the Bureau of Poetry, the Wakadokoro, and commissioned the compilation of the twenty-volume anthology *Shin kokin wakashū* (New Collection of Poems Ancient and Modern), or *Shin kokinshū* for short.[3] Numerous critical essays on poetics also appeared, inspired by the court's determination to preserve and promote ancient traditions.

In the turbulent years of the late twelfth century the historical moment was also felt. Men such as the essayist Kamo no Chōmei showed a keen awareness that their time was one of sociopolitical transition, a sense that they were witnessing history in the making. Many books and essays offering critical interpretations of historical events were written during this period, and heroic tales of battle—the *Hōgen*, *Heiji* (cat. no. 38), and *Heike* (cat. no. 111) *monogatari*—were illustrated in painting.

It is not surprising that this era, with its interest in history and human experience, should have witnessed the development of biographical painting. Handscrolls in this genre depicted the lives and deeds of saints, sages, and founders of religious sects (cat. no. 27). Illustrated histories of Buddhist temples and Shinto shrines were inspired by a similar interest in recording the past (cat. no. 34). *Emaki* were also indispensable as proselytizing aids. Patronage of such paintings was

undertaken not only as an expression of reverence for the founders or institutions depicted but in the expectation of accruing merit toward salvation—merit that accrued also to the artists.

And indeed, the Kamakura period was a golden age of portraiture, of both sacred and secular subjects executed in both painting and sculpture. A telling anecdote reveals how attitudes toward this art form changed, allowing new developments in the genre to emerge. An entry in the *Gyokuyō*, the diary of the courtier Kujō Kanezane (1149–1207),[4] chief adviser to Yoritomo, relates that in 1173 a group portrait (now lost) was painted on the walls of Saishōkōin, the Buddhist temple built by the consort of the retired emperor Go-Shirakawa (r. 1155–58). The portraits were found to be "unrefined," and the building was locked so they would be inaccessible. Kanezane, however, had a chance to inspect the work. To his dismay he found that the noblemen and attendants had been depicted as they looked "in reality." Evidently, the "outrageous" portraits departed from the earlier, idealizing tradition. Such realistic portrayals, taken directly from life, were called *nise-e* (likeness pictures).

The highly popular paintings known as *kasen-e*—imaginary portraits of the Immortal Poets (cat. nos. 39–41, 137)—represent a synthesis of the many currents that characterize Kamakura culture: classical revival, historical awareness, and interest in day-to-day reality.

Strictly speaking, they are not true portraits, having been painted long after their subjects had died. But most are portraitlike, with individualized features and physical characteristics.

Many innovative works in Buddhist sculpture of the Kamakura period portray minor gods rather than Buddhas or bodhisattvas. Sculptors regarded lesser gods, such as guardians, as affording an opportunity to depict more naturalistic body movements, and technical innovations such as the inlaying of eyes with crystal and other materials served to enhance lifelike representation. This approach also liberated Buddhist statuary from strict frontality, a corollary of their function as devotional objects. For the first time, statues filled a three-dimensional space. Another manifestation of the trend toward realism was the dressing of statues in clothing. This practice, which had the unfortunate result of reducing icons to the level of popular idols, marks the decline of Buddhist sculpture in Japan. Because sculpture was rarely used to represent secular subjects in East Asia, the decline of religious sculpture meant the decline of sculpture as a whole. The trend accelerated in the late Kamakura period with the advent of Zen Buddhism, which used far fewer sculpted icons in its temples than did traditional places of worship.

Zen (Ch: Chan) adherents, who had been gaining in numbers since the beginning of the thirteenth century, received unexpected encouragement from the Chinese who had fled their homeland in the wake of the Mongol invasion in 1260. Chan prelates who emigrated to Japan, particularly monks from the south, were warmly welcomed as they settled and began to proselytize. Among the immigrants were the noted monk-scholars Lanqi Daolong (known in Japan as Rankei Dōryū, 1213–1278), Wuxue Zuyuan (Mugaku Sogen, 1226–1286), and Yishan Yining (Issan Ichinei, 1247–1317). With support from the *bakufu*, two of these men established important Zen temples in Kamakura: Kenchōji, under Rankei in 1253, and Enkakuji, under Mugaku in 1282. The Chan prelates, educated in the classical traditions of China, were highly effective in introducing to the Japanese an appreciation for Chinese calligraphy and ink-monochrome painting. Thus, through the vehicle of religion, Chinese literature, calligraphy, and painting again served to inspire the educated elite to pursue new directions and to aspire to new goals. Such works as *The Ten Ox-Herding Songs* (cat. no. 42) and two examples of early ink monochrome (cat. nos. 43, 44) are harbingers of the Zen-inspired works that would dominate the art of the Muromachi period.

1. Kamo no Chōmei 1907, pp. 14–15.
2. Fujiwara Tadachika 1965, p. 83, entry for the twenty-ninth day, ninth month, third year of the Hōgen era (1158).
3. *Shin kokinshū* 1970.
4. Kujō Kanezane 1993.

21. Standing Jizō Bosatsu

Kamakura period (1185–1333), ca. 1202
Lacquered Japanese cypress (*hinoki*), color, gold, and *kirikane*, inlaid with crystal
Statue: height 51.2 cm (20⅛ in.); pedestal: height 4.8 cm (1⅞ in.)

LITERATURE: Kaufman 1985, figs. 7, 8; Tokyo National Museum 1985a, no. 82; Schirn Kunsthalle Frankfurt 1990, no. 2; Kaneko Hiroaki 1991, pl. 61; Mizuno Keizaburō, Kudō Yoshiaki, and Miyake Hisao 1991, fig. 12.

This small figure of Jizō Bosatsu (Skt: Kshitigarbha; Womb of the Earth) grasps a staff in his right hand; the fingers of the left hand, curled as though cupping a small object, must originally have held a wish-granting jewel.[1] His shaved head and the long staff topped with metal rings give him the appearance of a monk rather than a bodhisattva, and like a monk he wears three robes, the outermost of which is a surplice suspended from the left shoulder. Nevertheless, his exalted status in the Buddhist pantheon is clearly indicated by the *urna* on his forehead and by his long earlobes. In the tradition of bodhisattva figures, he may have worn a necklace.

Like many Buddhist deities, Jizō was originally a Hindu god, incorporated into the Buddhist pantheon in India. While he never gained a large following there, his popularity grew in China, especially after three important sutras on Jizō worship were translated into Chinese during the Tang dynasty (618–907).[2] Known as *Jizō's Three Sutras*, these teachings established Jizō's place in the Buddhist hierarchy as a savior who appears during the tenebrous period between the passing of Shaka and the coming of Miroku.

One of the sutras describes his journey through the Six Realms of Reincarnation (J: *rokudō*), into which all sentient beings are destined to be born. More than ten Jizō sutras are preserved at Shōsōin, Nara, indicating that Japanese interest in Jizō dates at least to the mid-eighth century.

The *Ōjōyōshū* (Essentials of Pure Land Rebirth), a text written in 985 by the monk Genshin (942–1017), stimulated the growth of Jizō's popularity by emphasizing the deity's role as a savior in the Six Realms of Reincarnation.[3] The long staff sometimes held by this deity, as here, most likely alludes to his travels through the Six Realms; Buddhist monks carried similar staffs when they collected alms. Occasionally, Jizō is depicted wearing shoes, also an allusion to his travels. He appears as well in the entourage of Amida Buddha in *raigō* paintings, accompanying the Amida as he descends to earth to welcome the dying into the Western Paradise.

The Burke Jizō is carved from several blocks of Japanese cypress (*hinoki*) joined in the *yosegi zukuri* (multiple block) technique. The figure is hollow, and the crystal eyes are inlaid from the inside of the head. During a

Figure 23. Inscriptions on interior

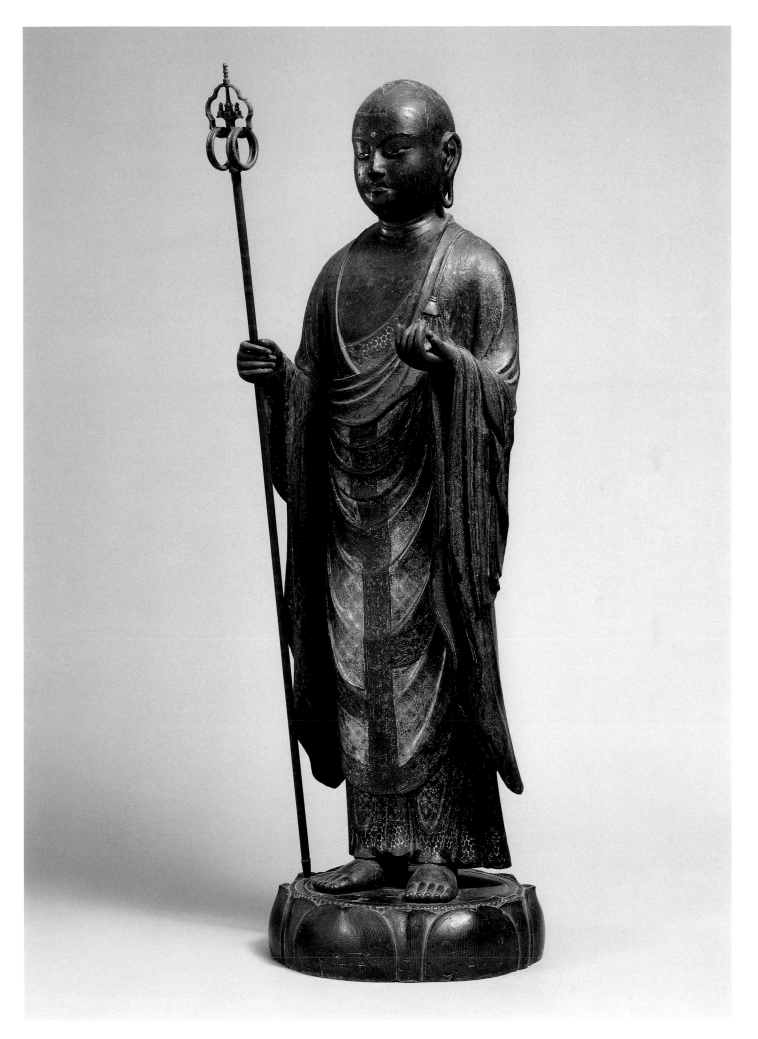

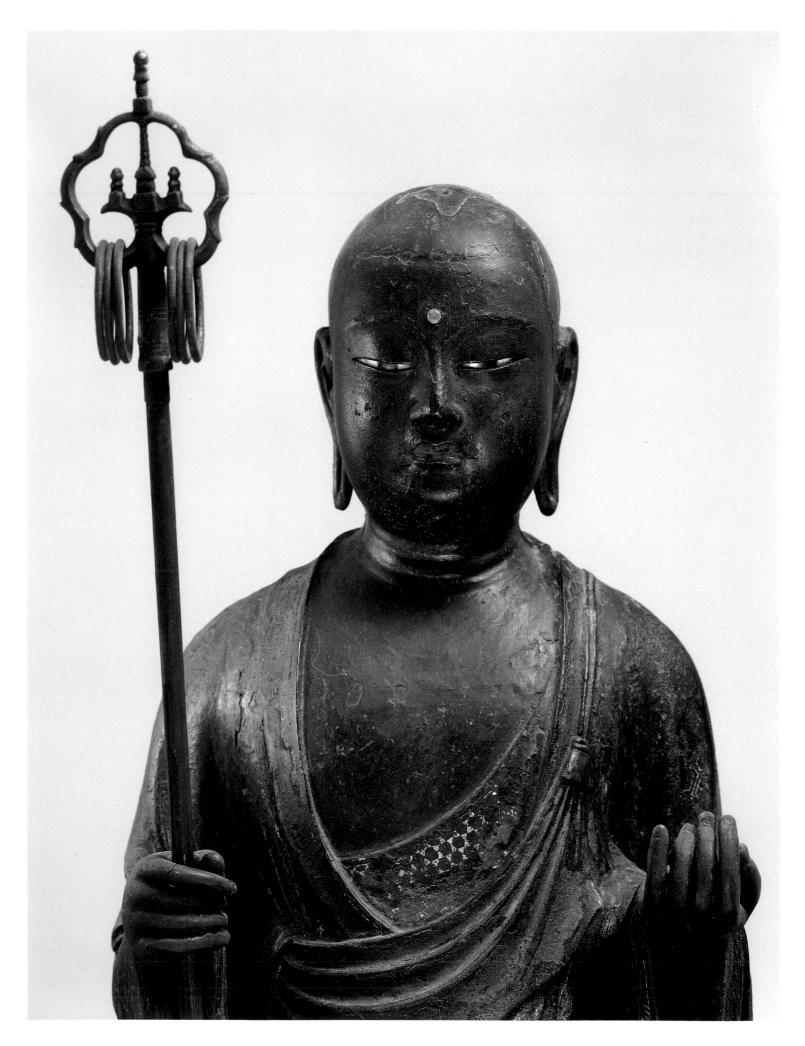

recent restoration, several inscriptions were discovered on the interior, including the names Shinkai, En Amida Butsu, and Ryō Amida Butsu (fig. 23). In the middle of these names are the characters for "An [a syllable signifying Amida Buddha] Amida Butsu," the name used by the sculptor Kaikei (fl. ca. 1183–1223).[4] Of the other three names, two are those of the same sculptor—Shinkai, who seems to have called himself En Amida Butsu and who is thought to have been Kaikei's principal associate. Shinkai's name appears on a number of Kaikei's works.[5] The name Ryō Amida Butsu, evidently that of another of Kaikei's close associates, is also found on works by Kaikei.[6]

Kaikei was one of the two leading sculptors of the early Kamakura period. The other was Unkei (1151–1223), with whom Kaikei collaborated on sculptural projects commissioned for the monumental reconstruction in Nara of Tōdaiji and Kōfukuji. Kaikei, who is thought to have been a pupil of Kōkei, Unkei's father, and to have been slightly older than Unkei, was atypical in that, unlike most Japanese sculptors of the premodern era, he signed many of his works. Of the forty or so that survive, at least twenty-three are signed; many are also dated by inscription. It is therefore possible to establish a chronology for the evolution of his style.

Three phases of stylistic development in Kaikei's work have been identified.[7] The first phase lasted from 1189 (possibly earlier) until 1192. A sculpture of Miroku in the Museum of Fine Arts, Boston, is signed "Busshi Kaikei" (Buddhist Sculptor Kaikei) and dated 1189.[8] This youthful and vigorous work was strongly influenced by Kōkei, whose own style was based on the naturalism of the Nara period. The Boston Miroku and other early works by Kaikei display a markedly naturalistic modeling of the body, along with deeply cut drapery folds that form lively, complex patterns. The second phase of Kaikei's career began in 1192, when he started

to sign his works "Kōshō An Amida Butsu" (Craftsman An Amida Buddha), the name he continued to use until sometime before 1208. This was Kaikei's most productive period, in which he received numerous commissions for Tōdaiji and Kōfukuji, tasks that occupied him from the late 1190s until shortly after 1203. During these years he seems to have come under the influence of the monk Shunjōbō Chōgen (1121–1206), overseer of the reconstruction project at both temples. Chōgen had traveled to China three times and was familiar with current continental styles of Buddhist architecture, sculpture, and painting. No doubt inspired by Chōgen's knowledge, Kaikei incorporated Song-dynasty elements into his work. His sculptures from this period, including the Burke Jizō, exhibit well-modulated, calm countenances, a balanced modeling of the body, and a more linear, simplified arrangement of the drapery folds, which are fewer in number than those of his earlier works. This pleasing blend of naturalism and refinement was well received, and came to be known as the An Ami style.

The choice of the name An Amida Butsu was no doubt due to the influence of Chōgen, who called himself Namu Amida Butsu and encouraged his followers in turn to incorporate "Amida" into their own names. Recent studies indicate that Kaikei's religious contacts extended beyond Chōgen's circle. Even before Chōgen's death, in 1206, Kaikei was in close touch with aristocratic monks deeply involved with the Jōdo sect, a cult of Amida Buddha founded by Hōnen (1133–1212),[9] and an aristocratic elegance characterizes many of the sculptures from this phase of his career. Shortly after 1203, when Kaikei was made an honorary priest and given the title hōkkyō, he began signing his name "Kōshō Hōkkyō Kaikei."

During the third and final phase, from about 1209, when he was promoted to the rank of hōgen, to about 1231, Kaikei included

his new title on many small statues of the Amida. The faces of these late figures lack vitality and have a somewhat detached expression, though the drapery folds have regained their earlier complexity.

That Kaikei inscribed his name on many works, a practice unprecedented in the history of Japanese sculpture, reflects the general awareness of the worth of the individual that was characteristic of the Kamakura period. In Kaikei's case it may have been even more strongly influenced by his deep devotion to Amida Buddha—evident from the names that he adopted as an artist.

The Burke Jizō, which can be dated to about 1202, exhibits the vigorous, youthful appearance of Kaikei's early works. At the same time, the solid, naturally posed body is clad in robes with realistic, elegantly arranged folds. Gold paint and kirikane (thin strips of gold leaf) have been used to decorate the garments with a variety of designs, among them floral motifs, tortoiseshell patterns, and linked octagons.

1. Both the hands and the staff are later replacements, as are the toes and the lotus pedestal.
2. The Daijō daishū Jizō jūringyō, the Jizō Bosatsu hongangyō, and the Sensatsu zen'aku gohōkyō. See Daizōkyō 1914–32, vol. 13, nos. 411, 412, and vol. 17, no. 839, respectively.
3. Andrews 1973.
4. Mōri Hisashi 1961, p. 125; and Matsushima Ken 1985, pp. 97–99.
5. Mōri Hisashi 1969, p. 28. Among these works are the Amida at Kengōin, Kyoto (1194–99); the Fudō at Sanbōin, Daigoji, Kyoto (1203); and the Monju at Monjuin, Nara (1203). See Mizuno Keizaburō, Kudō Yoshiaki, and Miyake Hisao 1991, figs. 7, 28, and 31, respectively.
6. See, for example, Hachiman in the Guise of a Monk (1201), at Tōdaiji, Nara; Mizuno Keizaburō, Kudō Yoshiaki, and Miyake Hisao 1991, pl. 46, as well as the Monju at Monjuin (1203), also in Nara.
7. Mōri Hisashi 1961, pp. 125ff.
8. Mizuno Keizaburō, Kudō Yoshiaki, and Miyake Hisao 1991, fig. 4.
9. Miyake Hisao 1986, pp. 135–39; and Aoki Jun 1992, pp. 654–56.

22. Seated Fudō Myōō

Kamakura period (1185–1333), early 13th century
Lacquered Japanese cypress (*hinoki*), color, gold,
and *kirikane*, inlaid with crystal
Height 51.5 cm (20¼ in.)

LITERATURE: Dallas Museum of Fine Arts 1969,
no. 18; Murase 1975, no. 7; Kurata Bunsaku 1980,
no. 70; Kaufman 1985, fig. 5; Tokyo National
Museum 1985a, no. 80; Schirn Kunsthalle Frankfurt
1990, no. 3; Mizuno Keizaburō, Kudō Yoshiaki, and
Miyake Hisao 1991, fig. 30; A. N. Morse and S. C.
Morse 1995, no. 36; A. N. Morse and S. C. Morse
1996, fig. 12.

This ferocious-looking deity, Fudō Myōō, is known in India as Achala or Achalanatha. He is one of the many manifestations of Shiva, the Hindu god of destruction and reincarnation.[1] Both his Sanskrit and Japanese names mean "the unshakable or immovable one," and true to his name, he came to be considered the indomitable and militant protector of Buddha's Law. Originally a pagan deity, Fudō converted to Buddhism and was assigned a lowly position as a servant and messenger of Buddha. Gradually he achieved higher status. In Esoteric Buddhism he became the emissary of the supreme god Dainichi (Skt: Vairochana), and still later he was promoted to the rank of Guardian, subjugator of Buddha's enemies. Finally he became a manifestation of Dainichi's own power and virtues. In this capacity, he is depicted in Mikkyō temples as the central figure in the group of the Five Guardian Kings (J: Go Dai Myōō; Skt: Vidyaraja).

That he originated in India is universally acknowledged, although no representation of Achala has been found in the arts of Hindu India. Nor are there many extant examples from Central Asia or pre-Tang China. The scriptural sources citing him are Tang (618–907) or later translations.[2] His iconography is outlined in the *Dainichi Sutra*, the basic sutra for Esoteric Buddhism, which was translated into Chinese in the year 725.[3] According to the descriptions in these sutras, the body of Achala is stocky and black or dark blue, symbolic of his role as subjugator of Buddha's adversaries. He has a terrible face: his eyes bulge in anger, and the left eye is either closed or smaller than the right; protruding fangs bite his lower lip. These features are in sharp contrast to the aristocratic appearance of bodhisattvas, and they reflect his original, lowly status as well as his late acceptance into the Buddhist pantheon.

Fudō's tenacious commitment to the protection of Buddha's Law is symbolized by the adamantine rock formation on which he is usually shown either seated or standing. In his left hand he holds a lasso for pulling reluctant beings toward the path of salvation, and in his right is a sword for demolishing evil forces. His long hair is gathered at the left side of his face in several knots—as many knots as there are incarnations through which he will serve as the faithful servant of his master. On his head he often bears a small, six-petaled flower or a lotus blossom, signifying his determination to uphold Buddha's Law. Terrible gods are often depicted in violent movement, but Fudō is usually motionless, in keeping with the belief that the mightiest power is best expressed in such a state.

After the prescribed rituals for Fudō worship were introduced by Kūkai (774–835) in the early ninth century, Fudō became one of the most popular and enduring Mikkyō deities in Japan. Although there are variations—he may appear in a group representation with his child attendants, Kongara and Seitaka, or he may be shown with multiple arms—the basic iconography set forth in the sutras continued to be observed.[4]

This representation of Fudō adheres stylistically to the iconography established in the Early Heian period. In most Japanese examples he is shown with large, bulging eyes; here the effect is achieved with crystal inlays. The statue is carved from several pieces of Japanese cypress (*hinoki*), assembled in the *yosegi zukuri* (multiple block) technique; the interior is hollow. The surface was first covered with coarse linen, over which a heavy coating of black lacquer was applied. The dhoti was originally decorated with colors and gold strips in the *kirikane* technique, though most of this is now flaked off. The metal jewelry may be original,[5] but the attributes that the deity holds are later replacements, as is the right hand. The rock-shaped pedestal on which he was seated is lost.

The Burke Fudō is nearly identical to a statue signed by Kaikei and dated 1203. It is housed at Sanbōin, a subtemple of Daigoji, Kyoto.[6] While both works are remarkably similar in iconographic details and size—the Sanbōin version is 59.4 centimeters (23⅜ in.) high—there are subtle stylistic differences. The Burke Fudō has a stronger sense of three dimensionality, with a more exaggerated modeling of the fleshy face, a more forward thrust of the arms, and greater complexity in the deeply cut drapery folds. Above all, while the Sanbōin version appears soft and

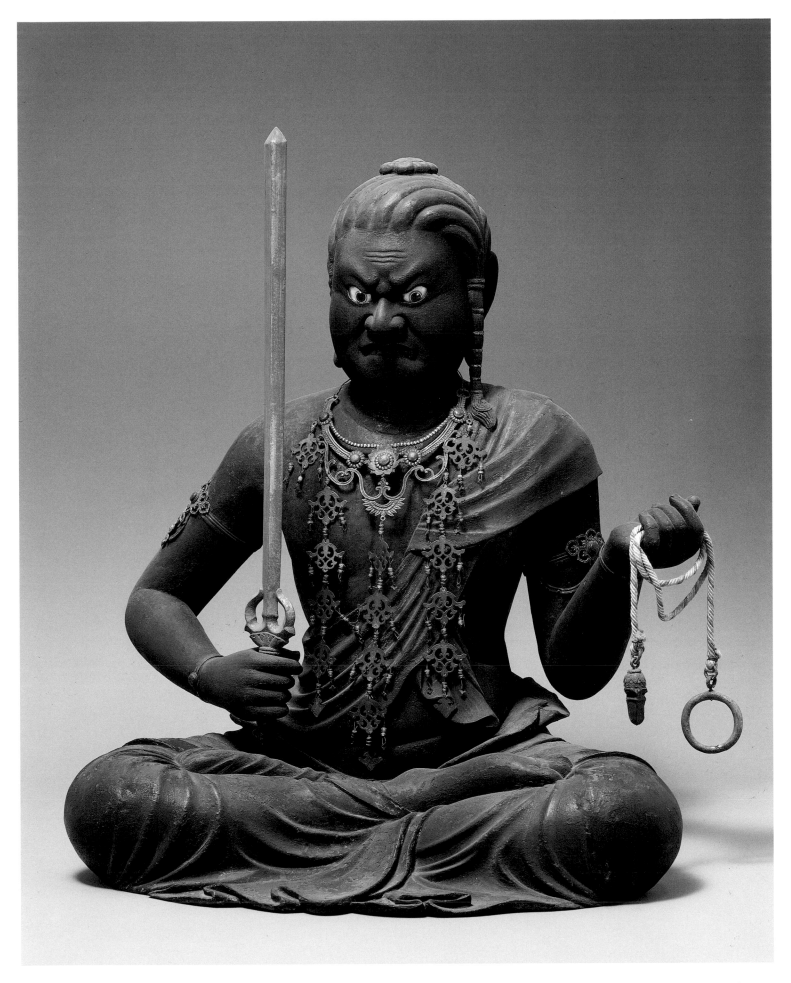

supple, the Burke version is noticeably harder in its modeling; the former has the unformed softness of a child, while the latter has a more mature look.[7] Although unconfirmed, the Burke Fudō is thought to have been in the collection of Shōren'in, Kyoto. Kaikei had close ties with this temple and with its aristocratic abbot, Shinshō, through whose efforts he obtained commissions at other temples.[8] Kaikei worked at Shōren'in at various times; his services there in 1210 and 1216 are recorded in the *Mon'yōki*, the official record of the temple.[9] There is,

however, no reference in the record to a statue of Fudō.

Kaikei, an unusually prolific artist, had a large group of able assistants. It is possible that the Burke Fudō was made by one of these disciples, perhaps Shinkai, who assisted Kaikei in producing the Burke Jizō Bosatsu (cat. no. 21) and the Fudō at Sanbōin.[10]

1. On this deity, see Sawa Ryūken 1960, pp. 40–46; for Japanese representations, see Nakano Genzo 1986.
2. For example, the *Amoghapashakalparajasutra* (J: *Fukūkensaku shinpen shingongyō*), which was

translated into Chinese in 709 by an Indian named Bodhiruchi. See *Daizōkyō* 1914–32, vol. 20, no. 1092.
3. For the *Dai birushana jōbutsu shinpen kajikyō*, or *Dainichikyō*, see ibid., vol. 18, no. 848.
4. Kyoto National Museum 1981.
5. The beaded pendants are believed to be later.
6. Mizuno Keizaburō, Kudō Yoshiaki, and Miyake Hisao 1991, fig. 28.
7. In their unpublished report, the group of sculpture specialists working under the auspices of the Tokyo National Research Institute of Cultural Properties attribute the Burke version to a follower of Kaikei.
8. Mōri Hisashi 1961, pp. 55–57.
9. *Daizōkyō zuzō* 1932–34, vols. 11, 12.
10. Mōri Hisashi 1969, p. 28.

23. *Standing Bishamonten*

Kamakura period (1185–1333), 1st half of 13th century
Polychromed Japanese cypress (*hinoki*) and *kirikane*, inlaid with crystal
Height 42 cm (16½ in.)

LITERATURE: Murase 1975, no. 8; Tokyo National Museum 1985a, no. 81; Schirn Kunsthalle Frankfurt 1990, no. 4a.

The guardians of the four cardinal points, the Shiten'nō (Skt: Lokapalas), were originally Hindu gods.[1] They seem to have been adopted into the Buddhist pantheon as protectors of Buddha's Law quite early in the history of Indian Buddhism, and their names appear in many sutras in connection with various aspects of Buddha's life. At Bharhut they trample upon squirming earth demons, an act that is symbolic of their role as subjugators of Buddha's enemies. Throughout Central and East Asia, by contrast, the emphasis is on their military aspect: they wear armor, carry weapons, and often convey rage through their fierce expressions and physical gestures. The four guardians—Jikokuten (Skt: Dhrtarashtra) of the east, Kōmokuten (Virupaksha) of the west, Zōchōten (Virudhaka) of the south, and Bishamonten or Tamonten (Vaishravana) of the north—were absorbed into the Mikkyō pantheon, in which, with eight other fierce kings, they constitute the Twelve Devas (J: Jūniten), eight of whom protect the four cardinal points and the points between them, while four symbolize heaven, earth, sun, and moon.

Detailed descriptions of the guardians' functions, appearance, and attributes are given in many sutras, such as the *Konkōmyō Saishōōkyō* (Skt: *Suvarnaprabhasattamarajasutra*; Sutra of the Golden Light), or *Konkōmyōkyō* for short.[2] In Hindu mythology, the Lokapalas are believed to have their sumptu-

ous palaces at four sides of the cosmic mountain, Sumeru. In accordance with this ancient belief, Buddhist temple halls are provided with a large platform symbolizing Mount Sumeru. Statues of Buddhas and bodhisattvas are placed in the center of the platform, the corners of which are protected by the four guardians. Normally, the Shiten'nō are subservient to Buddhas and bodhisattvas in the Buddhist pantheon and in Buddhist temple halls. In the early history of Japanese Buddhism, however, the four acquired a special status as protectors of the nation. In the year 593, Shiten'nōji, a temple dedicated to them, was built in Osaka by Prince Shōtoku (574–622) as an expression of gratitude for the Shiten'nō's assistance during his campaign against indigenous anti-Buddhist forces (the present building is a modern reconstruction).

Of the four kings, Bishamonten is regarded as the most powerful, evidently because in India and East Asia the north, Bishamonten's domain, has traditionally been considered a source of danger.[3] He is said to have three sumptuous palaces, and he alone is given the honor of being represented as an independent deity, especially in times of military strife. In group representations he is usually identified by the miniature stupa—both a symbol of Buddha's Law and a special treasure granted him by the Buddha—that he holds in his right hand. Because of this attribute, Bishamonten was later worshiped

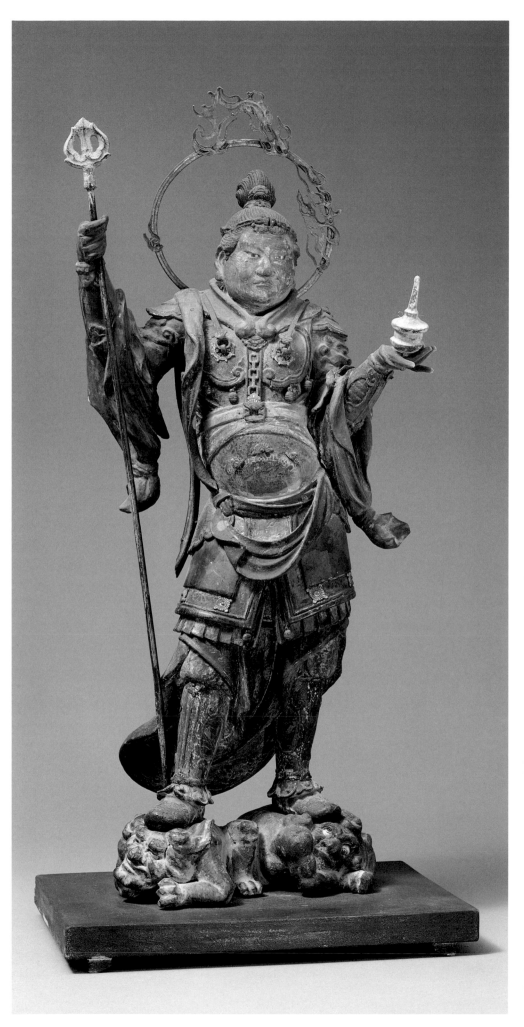

as a guardian of wealth, and in folk religion he is known as one of the Shichifukujin, or Seven Gods of Good Fortune. Various sutras dedicated to Bishamonten refer to his family. In a complex process that includes an exchange of identity, he is believed to be capable of transforming himself into an infant boy, Zen'nishi (Skt: Janavasabha), who is also his son. In a triad arrangement, Bishamonten and the female deity Kichijōten (Skt: Mahashri) may flank Shakya as husband and wife, but more frequently Bishamonten is the central figure, with his wife and son at either side. Bishamonten is also said to have had several more sons, who were sometimes included in a large family portrait.[4]

The small, youthful, but stern Bishamonten here stands firmly on two scowling demons, Niranba and Biranba. His miniature stupa is supported on his left palm, while in his right hand he grasps a long lance. The shift of the stupa from the right to the left hand when Bishamonten is represented alone seems to have been introduced in Mikkyō mandalas at the beginning of the ninth century, establishing a new canon. The present statue was originally brightly colored, with floral and geometric patterns in paint and *kirikane* covering the layers of robes and armor; dark blue was used for the hair and buff for the body. The small, shining eyes are inlaid.[5] The sculpture is made of several pieces of wood, and its interior is hollowed out. The demon on the right, with large, bulging inlaid eyes, looks up in amazement. His body was originally painted green and his hair gold. The other demon, who squirms beneath the pressure of his conqueror's foot, was originally painted bright red.

Bishamonten's full-cheeked face is small but carefully modeled, with a fleshy nose; his short neck is almost buried in his heavy shoulders. These features are reminiscent of the Bishamonten statues conceived by Unkei (1151–1223), one of the master sculptors of the Kamakura period, such as the Bishamonten he made in 1186 for Ganjōjuin, Shizuoka, near Kamakura.[6] In this piece, however, a slightly forced contrapposto and a distinct lateral thrust of the arms create a two-dimensional effect, and the small facial features impart a quiet and restrained mood, thereby softening the raw dynamism that

marks Unkei's work. Such control of tension without neglect of stylistic details is characteristic of Tankei (1173–1256), the eldest of Unkei's six sons, all of whom assisted their father in major projects. Stylistically, the piece especially resembles the triad of Bishamonten, Kichijōten, and Zen'nishi made by Tankei for Sekkeiji, Kōchi Prefecture, Shikoku Island,[7] and may therefore be attributed to an artist who closely followed Tankei's style or model in the first half of the thirteenth century.

1. For this group, see Soper 1959, pp. 231ff.
2. *Daizōkyō* 1914–32, vol. 16, no. 665.
3. For Japanese examples of Bishamonten, see Matsuura Masaaki 1992.
4. *Daizōkyō* 1914–32, vol. 16, no. 665, p. 431.
5. Later replacements are Bishamonten's right forearm, including the lance and sleeve; his left hand, including the stupa and the tip of the sleeve; his halo; and the base.
6. Reproduced in Mizuno Keizaburō, Kudō Yoshiaki, and Miyake Hisao 1991, pl. 25.
7. Reproduced in ibid., pl. 75.

24. From the "Kako genzai e-ingakyō"

Kamakura period (1185–1333), late 13th century
Handscroll, 27.7 × 156.4 cm (10⅞ × 61⅝ in.)
Ex coll.: Setsuda; Matsunaga Yasuzaemon, Tokyo

LITERATURE: Tanaka Ichimatsu et al. 1959, illus.; Maruyama Masatake 1963, pp. 144–47; Tanaka Ichimatsu 1965a, p. 24; Murase 1975, no. 12; Pal et al. 1984, no. 47.

The *Kako genzai ingakyō* (Sutra of Cause and Effect), known also by its abbreviated title *Ingakyō*, is generally believed to have originated in India in the third century.[1] The sutra is in the form of a story told by the Buddha in response to questions posed by his followers. He describes one of his former incarnations, his life as the young prince Siddhartha, and his attainment of enlightenment. He closes by explaining that one's life is determined by past deeds and one's future by present actions.

The Sanskrit original of this sutra no longer exists, but its Chinese translation, attributed to the Indian monk Gunabhadra, who completed it perhaps in the first half of the fifth century, is still in use. When first translated, the sutra apparently comprised four or five handscrolls with text. Later, as illustrations were added, they were placed above the text, diminishing the space originally allocated to the words and allowing both pictures and text to flow together from right to left. Thus, illustrated versions of the *Ingakyō* usually had eight scrolls or sometimes ten, an arrangement that had become popular by the Tang dynasty (618–907). A number of Tang Buddhist scrolls and books with this arrangement have been recovered from the Dunhuang caves in northwestern China. In Japan many copies of the *Ingakyō*, with and without illustrations, were made during the eighth century. The oldest extant examples of the illustrated version are divided among Japanese and American collections, notably at Jōbon Rendaiji, Kyoto; Hōon'in, a subtemple of Daigoji, Kyoto; and the MOA Museum of Art, Atami. None of these scrolls are from the same set, and all were painted at different times by different hands. In addition to the Nara-period scrolls, two Heian versions, dating to the early ninth century, also exist.[2]

The *Ingakyō* seems to have fallen into disuse after the ninth century, when Esoteric Buddhism and the worship of Amida dominated Japanese Buddhism. During the Kamakura period, however, the increased popularity of Shakya worship led to a revival of interest in the sutra teachings, and a number of new versions were produced. The reemergence of the *Ingakyō* also reflects an important artistic trend of the period, the revival of classical traditions. Just as in the twelfth century the art of Unkei and his followers was influenced by sculpture of the Asuka and Nara periods (see page 68), monk-painters and patrons of the Kamakura period revisited the *Ingakyō* with fresh appreciation.

The earliest known Kamakura version of the *Ingakyō* is dated to 1254; another copy was made before the end of the thirteenth century. The late-thirteenth-century version, known only in a few fragments of the fifth scroll from the set of eight, belonged at one time to the Matsunaga collection and is now dispersed. The large fragment in the Burke Collection comes from this version.[3] A third, slightly later version, which was also cut apart and dispersed, once belonged to Shōriji, Nagoya.

The Burke fragment, which illustrates the temptation of Prince Siddhartha, came toward the end of the original handscroll. In this fantastic scene, the demon king Mara and an army of his men try to distract the prince as he meditates. Mara is shown seated to the right at the beginning of the scroll, grasping the pommel of his sword as if to draw it. An array of weapon-wielding demonic figures, many of them composites of various weird and terrifying beasts, converge on the prince. Two of Mara's young sisters appear bearing skulls. The demons try to frighten the prince, not only with their grotesque faces and fearsome weapons but also by creating storms, earthquakes, fires, and tornadoes. The supernatural power of the prince, however, repels all threats. Huge boulders meant to be cast at him will not move; flying swords and arrows are arrested in midair; thunder, lightning, rain, and fire are transformed into multicolored flowers; the poisonous breath of dragons becomes a fragrant breeze. In the midst of this mayhem the prince sits unperturbed until at the left a heavenly voice (represented as a figure emerging from clouds) announces that Mara, now seated with his sword drawn, has been defeated and that the demons must disperse.

Both the eighth-century fragment of the illustrated *Ingakyō* owned by the Hōon'in of Daigoji and a ninth-century version formerly in the Masuda collection preserve the same temptation scene, and the two versions are very much alike. Similarly, because the late Kamakura Shōriji version of the scene is extremely close to the Burke fragment from the Matsunaga version, it is possible that the latter served as a model for the Shōriji scroll or that both copies derive from a common model, one probably made earlier in the Kamakura period after a Nara or Heian work. The two Kamakura copies, while basically similar in composition to the Hōon'in and Masuda versions, share modifications that distinguish them from the two earlier scrolls, making it unlikely that either of these was the prototype.

In the eighth- and ninth-century scrolls, regularly placed hills or buildings are used to separate the episodes, providing a stagelike setting for the protagonists. Most Kamakura scrolls are free of these devices, thus allowing a continuous flow of events from right to left. A certain vitality also distinguishes the illustrated *Ingakyō* of the Kamakura period. The temptation scene, the most theatrical and action-filled in the entire sutra, is more dramatic in the Kamakura copies, and the devils and demons are more grotesque. In contrast to the carefully drawn lines of the earlier scrolls, the brushwork here is sure and quick, and the colors sometimes extend beyond their inked boundaries. In this scroll, spontaneity, energy, and motion—the vital elements of the art of this period—are translated into colorful visual form.

1. *Daizōkyō* 1914–32, vol. 3, no. 189; see also Tanaka Ichimatsu et al. 1959, p. 13.
2. These are reproduced in Tanaka Ichimatsu et al. 1959.
3. Two other fragments from this version are in the collection of Kimiko and John Powers, Aspen. See Rosenfield and Shimada Shūjirō 1970, nos. 42, 43.

25. Shaka Triad and the Sixteen Rakan

Late Kamakura–early Nanbokuchō period,
14th century
Hanging scroll, ink, color, and gold on silk
143 × 75.5 cm (56¼ × 29¾ in.)

LITERATURE: Miyama Susumu 1988, fig. 69;
Schirn Kunsthalle Frankfurt 1990, no. 7; Murase
1993, no. 6.

This hanging scroll focuses on the triad of
Shaka and two *bosatsu*, Fugen (Skt: Saman-
tabhadra) on an elephant and Monju (Man-
jushri) on a lion. Below the triad are the
Sixteen Rakan (Skt: *arhat*; Ch: *luohan*),
advanced disciples of the Buddha. The
theme of the picture can be interpreted as a
gathering of devotees around the Buddha,
who is shown preaching at Vulture Peak,
which rises in the background among swirl-
ing clouds. As depicted here, this famous site
in northern India appears to be a variant on
literal renderings of the landscape in which
the peak is given the form of a bird's head,
its perceived shape and hence the source of
its name.[1] An unusual feature is the inclusion
of two additional figures at the bottom of
the composition: on the left Shōtoku Taishi
(574–622), prince regent during the reign of
the empress Suiko (r. 593–628), and on the
right the monk Kūkai (774–835), the founder
of Shingon Buddhism.

Many early Buddhist figure paintings have
traditionally been attributed to painters of
the Takuma school of *e-busshi* (artists who
specialized in Buddhist painting), who were
active in Kyoto and Kamakura in the Late
Heian and Kamakura periods. Takuma artists
were noted for incorporating Song and Yuan
styles into their work. Landscape elements in
this painting, such as the precipitous rocks
delineated in texture strokes and the use of
modulating lines for the robes of the rakan,
reflect some of the features that Japanese
artists absorbed from Chinese ink paintings
brought to Japan by Zen monks as early as
the thirteenth century. The connection
between Takuma artists and Zen temples is
further substantiated by the inscriptions of
Zen monks on paintings attributed to the
Takuma school.[2] Although it is not possible
to ascribe the Burke painting definitively to a

Figure 26. Kasuga Shrine, Nara. Nara period (710–94), 768; present structure 1863

such mandalas often functioned as general guides during the periodic reconstruction of shrine buildings.

Names of painters are seldom attached to Kasuga Shrine mandalas, though it is generally believed that the mandalas were painted by artists from workshops in Nara, especially those active at Kōfukuji. Although they mainly produced Buddhist icons for temples, they also made secular works, such as pictorial histories of temples and illustrated biographies of famous monks. They may also have produced purely secular landscapes, such as *meisho-e* (pictures of famous views).[3] Some of these may have resembled the Burke mandala in its rendering of a gentle landscape—low-lying hillocks bathed in the golden light of a full moon, flowering trees partly hidden by mist, and darkly silhouetted mountains in the distance.

This small but elegant painting was most likely commissioned—as were most Kasuga Shrine mandalas—by an aristocrat from Kyoto, the capital city. In the absence of extant *yamato-e*, or Japanese-style, landscape paintings from the Heian and Kamakura periods, Kasuga Shrine mandalas such as this one serve as vivid reminders of the lost splendors of secular landscape imagery. The bandlike fingers of mist (*suyari gasumi*) and the depiction of Mount Mikasa with patches of forest are reminiscent of features found in other paintings of the mountain dating to the beginning of the fourteenth century. We would therefore posit a date for the Burke mandala shortly after the standard composition for Kasuga Shrine mandalas was firmly established at the end of the thirteenth century.[4]

no Koyane. This building, also known as the Wakamiya, is shown in the painting to the right of the shrine complex.

Kasuga Shrine mandalas are testimonials to the efforts made by both Buddhists and Shintoists to reconcile the two religions in order to ensure mutual survival and prosperity. The first references to paintings depicting the Kasuga Shrine precinct appeared in courtiers' journals in the early 1180s.[1] Apparently, such paintings were worshiped in the homes of aristocrats as a substitute for visiting the site. An ostensibly realistic view of the precinct, with vegetation, buildings, and sacred deer—intermediaries between gods and humans—was thus requisite. Paintings of such scenes were displayed in a special ceremony held at the shrine on May 21 of each year.

The Kasuga gods were regarded as potent protectors of Kōfukuji and its deities. As the Fujiwara clan turned increasingly to the Buddhist Pure Land sect in the twelfth century, they viewed the sacred mountains beyond the shrine and the area around Kasuga as a Shinto paradise on earth, paralleling the Pure Land of Amida Buddha.[2] Just as Buddhist Pure Land paintings showed Buddhas and bodhisattvas in their beautiful residences, Shinto mandalas were viewed as depictions of places where native gods dwelled. This tolerant, even conciliatory attitude on the part of Buddhists toward Shintoism no doubt contributed to the development of *honji suijaku*, the concept by which Shinto gods were regarded as manifestations of Buddhist deities. In Shinto shrine mandalas the two faiths coexisted, and the native reverence for nature was used to appeal to adherents and to deepen their faith in indigenous gods.

Although they are known as mandalas, Shinto shrine paintings such as this example differ from the rigidly schematized mandalas of Buddhism. Kasuga Shrine mandalas represent a bird's-eye view, allowing more space for the natural environment than for the shrine structures. While the latter are not rendered in a highly realistic manner, with every architectural detail reproduced, their general appearance corresponds to that of the actual buildings as they have existed since 1179. The nucleus of the compound faces south (to the right), while the Wakamiya in its own precinct faces west. Indeed,

1. A ritual involving Kasuga paintings performed in May 1184 is described in the *Gyokuyō*, a journal kept by the courtier Kujō Kanezane (1149–1207); see Kujō Kanezane 1993. See also Kawamura Tomoyuki 1981, pp. 92ff.

2. For a comparison between paintings of the Buddhist Pure Land and Shinto shrine mandalas, see Gyōtoku Shin'ichirō 1994, p. 244.

3. Ibid., pp. 240–57.

4. Ibid., pp. 242–43. Some scholars attribute this painting to a secular artist. See Sasaki Kōzō and Okumura Hideo 1979, no. 149.

32. Wakamiya of the Kasuga Shrine

Nanbokuchō period (1336–92), early 14th century
Hanging scroll, ink, color, gold, and *kirikane* on silk
76.1 × 48.4 cm (30 × 19 in.)
Promised Gift of the Mary and Jackson Burke
Foundation Inc., and Purchase, Lila Acheson
Wallace Gift, 1997

LITERATURE: Murase 1997, p. 91; Fukui
Rikichirō 1999, fig. 38.

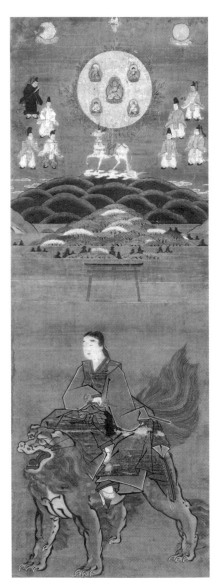

Figure 27. Unidentified artist (14th–
15th century), *The Legend of the Kasuga
Wakamiya Shrine at Nara*. Hanging
scroll, ink and color on paper, 95.4 ×
34.2 cm (37½ × 13½ in.). Sansō Collection,
Peter F. and Doris Drucker, California

A large sphere outlined in luminous, thinly
cut gold leaf (*kirikane*) appears to be suspended, weightless, in an otherwise empty
space, the figure within materializing like an
apparition from the surrounding darkness.
Although he is seated on a pink-and-white
lotus pedestal in the manner of a Buddhist
deity, his garb is that of a layperson. Wearing
a kimono and a long sleeveless jacket bearing
designs of cherry blossoms, butterflies, and
swallows, and with his hair parted in the middle and tied above his ears, he epitomizes a
youth of noble birth. The only jarring note is
the long sword that he holds in his hands.

The portrait, a conflation of Buddhist and
secular images, represents Wakamiya (young
[*waka*] shrine, or prince [*miya*]), the god
enshrined at Kasuga. The youthful deity first
revealed his presence at Kasuga in 1003, and
in 1135 was installed at the Wakamiya Shrine,
in the southern section of the Kasuga precinct.
His *honji*, or Buddhist equivalent, is identified either as Monju (Skt: Manjushri) or
Jūichimen (Eleven-Headed) Kannon (Ekadashamukha).[1] Monju, the Buddhist god of
wisdom, is often represented as a youthful
figure, to symbolize the deity's immaculate
thoughts; as a princely deity, Wakamiya was
regarded as having a similarly pure nature.
More important, in the agrarian society within which the Kasuga cult was formulated,
youth signified the cyclical resurgence of
energy and vitality in the natural world.[2]

It is not known when the representation of
Wakamiya was incorporated into the imagery
of the Kasuga cult. Only a small number of
Wakamiya paintings are extant, each iconographically unique. This would suggest that
a strict iconographic type for the god never
really developed. The earliest known example depicts the youthful Monju manifesting
himself as Wakamiya;[3] it serves as the frontispiece of the *Kongō han'nya haramitsukyō*
(Skt: *Vajracchedikaprajnaparamitasutra*),
which was found in the cavity of a wooden
sculpture of Monju riding a lion and escorted
by four attendants.[4] According to the dedicatory message on one of the twelve documents
found within the statue,[5] it was commissioned
by the monk Kyōgen of Kōfukuji from Kōen
(1207–ca. 1285), a grandson of Unkei, the
leading sculptor of the early Kamakura period.
Kyōgen, who also copied out the accompany-

ing text of the *Kongō han'nya haramitsukyō* in
August 1273, noted in his dedicatory essay
that he had been visited in a dream by an
apparition of the young Wakamiya, among
cherry blossoms in the fields of Kasuga; the
god looked about fourteen or fifteen years
old and was attended by three Shinto priests.
The frontispiece, which includes the figure of
Kyōgen and is in an unusually fine state of
preservation, shows Wakamiya standing amid
the lush Kasuga foliage dressed in courtly
robes and surrounded by white cherry blossoms, just as he must have appeared in
Kyōgen's dream.

The fact that Kyōgen intended the painting to represent the vision from his dream
indicates that he was dissatisfied with existing
Kasuga iconography and wanted something
new and different. A visually appealing
dream seems to have been a convenient
device for effecting change. Images available
as models must have resembled the late
Kamakura painting formerly in the Nakamura
Gakuryō collection, Zushi,[6] that depicts the
young Monju astride a lion, the Kasuga
precinct visible in the background. Because
the frontispiece was meant to be placed inside
a Monju-and-lion sculpture, Kyōgen may
have wanted to avoid repetition by using an
entirely new pictorial presentation of the
deity. His dream image of Wakamiya in the
guise of a young courtier was the answer.

A much later work, in the collection of
Peter and Doris Drucker (fig. 27), reflects an
effort to conflate a number of diverse elements: the sun and moon; the Deer mandala
of the Kasuga Shrine (cat. no. 33); the eight
Shinto gods enshrined in the Kasuga area;
Mount Mikasa, with its five Kasuga Shrine
buildings; and the shrine's *torii* gate. Set
against this complex background is the figure
of the child-god riding a lion.[7]

A copy of a painting made by Tosa Mitsuteru in 1893 suggests the existence of yet
another iconic representation of Wakamiya.[8]
It depicts the deity dressed as a nobleman and
riding a deer under flowering branches of
wisteria (J: *fuji*), an obvious allusion to the
Fujiwara clan, founders of the Kasuga Shrine.

The Burke painting, by eliminating all
narrative elements, focuses on the ethereal
form of Wakamiya, emphasizing the sanctity
of the childlike figure. Only the designs on

the garments—the cherry blossoms from Kyōgen's dream and the butterflies and swallows suggestive of the Elysian fields of Kasuga—recall the more descriptive representations of the deity. A strong Buddhist influence may have helped to produce this special type of iconography. An iconographic type of the Buddhist holy man Kūkai (774–835), founder of the Shingon branch of Esoteric Buddhism, is nearly identical in composition to the Burke painting: there, the child monk, enclosed within a golden disk, seems also to float in space.

The circle that frames the figure of Wakamiya can be variously interpreted. In traditional religious iconography, its most prevalent use is as a halo placed behind the head of an icon. Buddhist and Shinto deities in Japan are sometimes shown within a circular format to identify them as heavenly beings, remote from the ordinary world. At other times a circle may symbolize a mirror, which reflects the true image. The circle was also used in Zen art as a symbol of the primary Zen principle of perfection and completion (see cat. no. 42).

1. The Jūichimen Kannon is depicted in the Kasuga Shrine mandala (cat. no. 31); Monju is represented in the Kasuga Deer mandala (cat. no. 33).
2. Kageyama Haruki 1975, p. 9.
3. Kaneko Hiroaki 1992, fig. 8.
4. The sculpture is one of a group originally from Kōfukuji, Nara; it is now in the Tokyo National Museum. See ibid., fig. 6.
5. Gotoh Museum 1964, no. 21.
6. Nara National Museum 1964a, no. 19.
7. Kawai Masatomo 1986, no. 3.
8. Kyoto Municipal University of the Arts Archives 1993, no. 100.

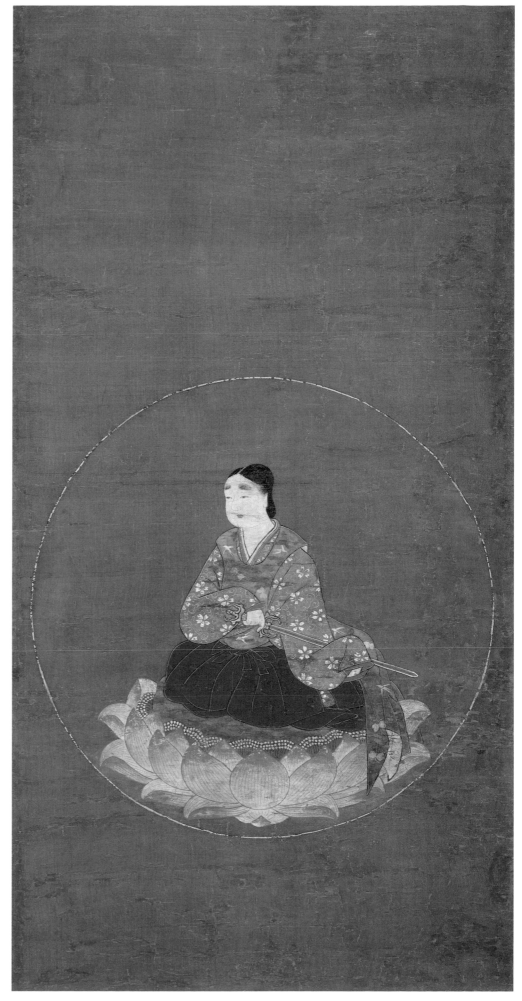

33. Deer Mandala of the Kasuga Shrine

Nanbokuchō period (1336–92), late 14th century
Hanging scroll, ink, color, and gold on silk
85.7 × 35.6 cm (33¾ × 14 in.)

A spotted brown deer, bedecked in a sumptuously decorated saddle and gold pendants dangling from a vermilion harness, looks back over its shoulder, as if interrupting its cloud-borne flight. The saddle supports an upright branch of the sacred *sakaki* tree, entwined with wisteria blossoms and hanging ornaments, which in turn supports a golden disk. Within the disk, whose glow pierces the darkness of the night sky, are five figures of buddhas and bodhisattvas.

Deer were apparently regarded as sacred in prehistoric and ancient Japan. They were represented by *haniwa* (see cat. no. 3) as early as the fifth or sixth century, and in time they acquired a special status as messengers of the Shinto gods. It is believed that the Fujiwara clan, whose ancestors had served the court as diviners, used deer scapulae as oracle bones, suggesting that deer were accorded a special place.[1] And beginning in the Muromachi period, deer became protected animals in the Kasuga area.

According to tradition, in 768 Takemikazuchi no Kami, the god of the Kashima Shrine (northeast of modern Tokyo), flew to Mount Mikasa on the back of a white deer. Upon his arrival he was installed as god of the First Shrine at Kasuga. Later, three more deities arrived and took up residence at three other buildings, completing the main complex of the Kasuga Shrine.[2] A small number of extant paintings depict Takemikazuchi, sometimes accompanied by other deities or by attendants, on his way to Kasuga. The Deer mandala of the Kasuga Shrine (*Kasuga shika mandara*) most likely evolved from such images. About thirty Deer mandalas are known today.[3] Several display the deer within the Kasuga precinct, against the backdrop of Mount Mikasa, with shrine buildings in the foreground. Most of them, however, like this one, represent the deer alone, bearing the sacred tree that supports a disk or the sacred mirror.

Paintings such as these were the products of the syncretic interaction between Buddhism and Shinto. This evolution, which allowed the two religions to coexist in harmony, led in turn to *honji suijaku*, the belief that Shinto gods were manifestations of Buddhist deities. Thus, each god of the Kasuga Shrine was given a Buddhist identity, called *honji butsu* (Buddhas of the Original Land). Icons used in the service of *honji suijaku* gained popularity in the late thirteenth century. It has been suggested that the movement was spurred by the invasions of Japan by the combined forces of China and Korea in 1274 and again in 1281. On both occasions, prayers were offered nationwide to invoke the assistance of Shinto gods.[4] This came, miraculously, in the form of *kamikaze* (divine winds, or typhoons).

It would appear that standards for the production of Deer mandalas and rules regarding their worship were established by the end of the thirteenth century.[5] According to one tradition, the general composition of the mandalas was based on an apparition that appeared to one Fugenji Motomichi sometime during the reign of Emperor Antoku (1180–85).[6] And they seem to have been worshiped as the principal icons of the Kasugakō, a lecture-ceremony conducted periodically at the Kasuga Shrine.

The Buddhist deities enclosed in the golden disk of the Burke mandala are Shaka (Skt: Shakyamuni), center, residing at the First Shrine; Yakushi (Bhaishajyaguru), top right, holding a medicine jar and residing at the Second Shrine; Jizō (Kshitigarbha), top left, holding a jewel and a staff, residing at the Third Shrine; Monju (Manjushri), lower right, residing at the Wakamiya (see cat. no. 32), and Kannon (Avalokiteshvara), bottom left, residing at the Fourth Shrine. Below the disk and the *sakaki* branch supporting it, the deer's taut body and sharp gaze convey a sense of the mystical power with which the animal is endowed. The tense pose, with forelegs spread wide, suggests a sudden arresting of movement. In contrast, the cloud with trailing vapor creates an impression of flowing motion.

It is believed that most Deer mandalas were produced in the Nara region, primarily by artists attached to large, powerful Buddhist temple workshops, such as those at Kōfukuji and Tōdaiji. This particular work may be dated to the late fourteenth century.

Kasuga Shrine and Deer mandalas increased in popularity during the Kamakura period, when the realistic depiction of nature became prevalent in the visual arts and there was a new desire to endow devotional images with a sense of both the real and the divine.

1. Nagashima Fukutarō 1944, pp. 9ff.
2. *Ko shaki* (Records of Old Shrines), in *Kasuga* 1985, pp. 3–15.
3. Listed in Gyōtoku Shin'ichirō 1993, p. 17.
4. Ibid., p. 8.
5. *Kasugasha shiki* (Private Records of the Kasuga Shrine) by Nijō Norinaga, in *Kasuga* 1985.
6. Nara National Museum 1964b, p. 24.

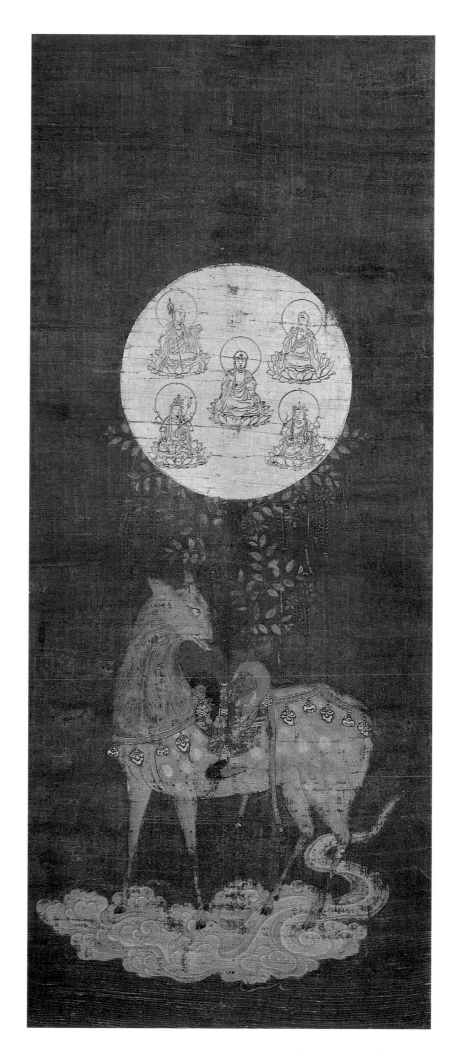

34. From the "Kitano Tenjin engi emaki"

Kamakura period (1185–1333), ca. 1300
Handscroll, ink on paper
28.1 × 117.9 cm (11⅛ × 46⅜ in.)
Ex coll.: Matsumi Tatsuo; Kimura Teizō, Nagoya;
Kishi Kōkei

LITERATURE: Mizoguchi Teijirō et al. 1942,
pp. 87–89, 105–6; Shimada Shūjirō 1969, vol. 1,
p. 79; Umezu Jirō 1970, p. 149; Murase 1975, no. 22;
Akiyama Terukazu 1980a, no. 68; Tokyo National
Museum 1985a, no. 7; Schirn Kunsthalle Frankfurt
1990, no. 21; Shinbo Tōru 1990, fig. 5 (detail), pl. 9.

Kitano Tenjin, Kyoto, is one of the most influential Shinto shrines in Japan, with connections to more than four thousand ancillary shrines in the nation. The *Kitano Tenjin engi* (History of the Kitano Tenjin Shrine), or *Tenjin engi* for short, tells the early history of the shrine in a dramatic combination of historical fact and miraculous wonders. It is typical of the religious literature popular in medieval Japan.

Compiled shortly before 1194 by a still undetermined author, the *Tenjin engi* is usually divided into three parts. The first is based on the life of Sugawara Michizane (845–903), a noted man of letters and one of the most brilliant statesmen of the Heian period. The story begins with the sudden appearance of Michizane as a precocious child endowed with extraordinary literary talent. His rapid rise to prominence at court and his position of favor with the emperor invited the jealousy of his rivals, particularly the leading member of the powerful Fujiwara clan, Tokihira. Michizane ultimately fell victim to Tokihira's intrigues: he was ban-ished from the capital and sent into exile on Kyūshū, where he died in lonely sorrow. The second part of the story centers around a series of unusual events in the capital. The imperial palace was subject to an onslaught of floods and fires, and Michizane's onetime adversaries successively met with violent deaths or suffered from bizarre ailments. Eventually, it became clear that the angry spirit of the deceased Michizane, bent on revenge, had inflicted these calamities. Nor would his wrath be tempered short of his deification as Tenjin (from the word for "heavenly deity"). Thus, a shrine was dedicated to him and honors were posthumously conferred. The first Kitano Shrine was erected in 942, and the third part of the *Tenjin engi* tells of its development into a prosperous Shinto establishment. Included in this section are a number of proselytizing tales of favors awarded to Tenjin's devotees.

Long before Michizane's time the *tenjin* were associated with natural phenomena, and in the agricultural communities of ancient Japan many Shinto shrines were dedicated to

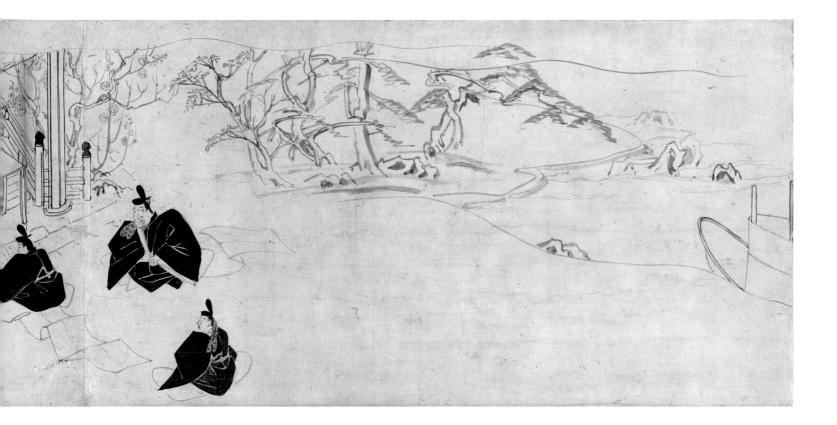

them. The thunder god, who calls forth rain, was especially powerful and much feared. When Michizane's vengeful ghost became Tenjin, he acquired the attributes of those deities, but his metamorphosis was not complete until he regained the distinction he had enjoyed as a scholar and man of letters. As the god of learning and calligraphy, Tenjin is the most venerated Shinto deity in Japan, especially popular today with students preparing for entrance examinations.

All available evidence suggests that the first illustrations for this dramatic tale were made before 1194, that is, soon after the three-part narrative was completed. The many Tenjin shrines in Japan, eager to establish connections with Michizane—either real or fictitious—created an enormous demand for illustrated copies of the scroll, and more than thirty such scrolls—ranging in date from the thirteenth to the nineteenth century—are extant.

Most illustrated *Tenjin engi* are composed of three scrolls, one for each part of the tale. The fragment in the Burke Collection was

originally part of a scroll that was the third in such a set. The scroll, which included ten episodes, was intact until 1943; it was divided up shortly after that date.[1]

In the Burke fragment, picture is followed by text because of a recent error in mounting. The reverse order is the correct *emaki* format, the text preparing the reader for the next episode to be illustrated. Here the illustration is of the fourth episode in part three, in which the frightened court attempts to placate Michizane's angry spirit. On August 20, 993, the imperial messenger, Sugawara Narimasa, arrived at Anrakuji, Michizane's mortuary temple, to report his posthumous promotion to Great Minister of the Left, Junior First Rank. But Michizane was not pacified and sent an angry protest in the form of a poem. The emperor, Ichijō (r. 986–1011), was profoundly disturbed but did not respond until the following year, when he bestowed on Michizane the highest possible civilian title, Prime Minister, Senior First Rank. This time Michizane was satisfied, and he acknowledged his acceptance with an appropriately

happy poem. A postscript at the end of the episode promises that those who recite Michizane's poem once will be given his protection seven times a day.

In the present composition, the messenger is seated in front of Anrakuji, reading the imperial edict. He is accompanied by two courtiers. The background elements—the shore lined with pine trees and the odd-looking boat moored on the bank—are standard features of the second episode, which is separated from the Anrakuji scene by several others. The composition here was no doubt copied from an unknown model in which some sheets had been mounted incorrectly, leading to errors in matching the pictorial components with the texts of the different episodes. In other respects, the Burke painting closely resembles the same scene in a *Tenjin engi* scroll in the Metropolitan Museum.[2]

The Burke fragment is executed in the *hakubyō* (white drawing) technique, in which ink is used without color, though an occasional touch of red may be added to such details as lips. Large patches of dark ink—

for example, a woman's long, trailing hair or, as here, the noblemen's voluminous garments—create abstract decorative patterns that contrast with the white paper and the areas of delicate line drawing. This type of work is usually executed with fine, regular brushstrokes rather than with the undulating line associated with the ink-monochrome technique used in Chinese-style painting. Although the fragment typifies the *hakubyō* genre of the late Kamakura period, this rendering appears more spontaneous than most *hakubyō* works (see, for example, cat. no. 109), adding a sense of drama and movement to the scene.

1. Umezu Jirō 1970, p. 147. Four other fragments are in the Philadelphia Museum of Art, the Honolulu Academy of Arts (Shimada Shūjirō 1969, vol. 1, p. 93), the Brooklyn Museum of Art, and the Art Institute of Chicago. The two other scrolls in the set have not yet been traced.
 A small piece of paper bearing the title *Kitano honji* was pasted at the beginning of the scroll when it was still intact. The word *honji* refers to *honji suijaku*, the term used to describe the syncretization of Shintoism and Buddhism. During the Muromachi period the word was frequently incorporated into the titles of religious literature, even when the text was an established legend of a temple or shrine. Often it meant that changes had been made to existing text. The present *Kitano honji* scroll is an early example of the use of the word in a title; its text, however, strictly adheres to that of the traditional *Tenjin engi* formulated in the Kamakura period.
2. Reproduced in Shimada Shūjirō 1981, pp. 1–16.

35. Seiryū Gongen

Nanbokuchō period (1336–92), mid-14th century
Hanging scroll, ink and color on silk
91 × 44.7 cm (35⅞ × 17⅝ in.)
Ex coll.: Maeyama Hisakichi

LITERATURE: Museum of Fine Arts, Boston 1936, no. 45; Kyoto National Museum 1974, pl. 69; Murase 1975, no. 18; Tokyo National Museum 1985a, no. 4; Burke 1996b, p. 44.

The goddess Seiryū Gongen is shown here as a full-cheeked, voluptuous woman wearing elaborate hair ornaments and courtly silk garments of white, blue, and green. Supporting a wish-granting jewel (Skt: *cintamani*) in her right hand, she stands majestically in a doorway facing a little girl who holds a book, the *Kōyaku no shirushi bumi* (Records of Miraculous Medicine), which the goddess has just given her. Although the painting is considerably damaged and has darkened with age, it is still possible to discern the delicate designs on the goddess's upper garment and details of a landscape painting on the sliding panel at the left—white cherry blossoms in full bloom and small water birds—which indicate that the season is spring.

The name "Seiryū Gongen" can be written in two ways: depending on the characters used, *seiryū* means either "pure waterfall" or "blue dragon"; *gongen* can mean "god" or "goddess." The goddess was believed originally to have been the titulary deity at Qinglongsi (Blue Dragon Temple) in Chang'an (modern Xian), China. She is said to have been introduced to Japan by the monk Kūkai (774–835) and was later adopted as the protector deity of Shingon Buddhism at Jingoji, Kyoto. Seiryū Gongen was believed to be a manifestation of the deity Zen'nyo Ryūō, daughter of the Dragon King Sagara, whose enlightenment at age eight is described in the *Lotus Sutra*. Because of her association with the dragon, Seiryū Gongen had a dual mission as rainmaker and protector against floods. She was later introduced to Daigoji, Kyoto, and other Esoteric Buddhist temples, where her nature underwent a complex metamorphosis through the process of *honji suijaku* (see cat. nos. 31–33). As conceived for this doctrine, Seiryū Gongen was believed to be the avatar of two Mikkyō deities: Nyoirin Kannon (Skt: Cintamanichakra), an alleviator of suffering, and Juntei Kannon (Cundi), a deity associated with fecundity.

The cult of Seiryū Gongen does not appear to have attained great popularity. Only two images of the goddess are known today, this painting and an earlier work now in the Hatakeyama Memorial Museum of Fine Art, Tokyo.[1] The earliest known reference to such an image, recorded in a document at Daigoji, dates only to the late eleventh century. In 1088, the monk Shōkaku (1057–1129) of Daigoji, while searching for a site for a shrine in which to house an image of Seiryū Gongen, had a vision in which the goddess appeared to him looking exactly like Kichijōten (Mahashri), the goddess of beauty and fecundity.[2] She was dressed as a court lady in a long-sleeved silk garment and held a *cintamani* in her left hand. Shōkaku commissioned two paintings to record his dream. When completed, these were stored in the sutra hall

of Sanbōin, the subtemple of Daigoji that he had founded. Unfortunately, the fate of these paintings is unknown.

The Seiryū Gongen in Tokyo bears two inscriptions. One refers to the goddess's appearance in an unnamed person's dream on the nineteenth day of the fourth month of the first year of the Genkyū era (1204–5). The other was written in 1262 by the monk Seishin of Daigoji, who dedicated the painting. Another document preserved at Daigoji refers to a painting of Seiryū Gongen made by the monk Shinken (1179–1261), also of Daigoji.[3] One evening Shinken dreamed of Seiryū Gongen, and he painted her image as she had appeared to him—dressed in layers of silk, holding a *cintamani* in her right hand, and having just given the *Kōyaku no shirushi bumi* to a little girl. The description corresponds closely to the Hatakeyama painting. This work was at Daigoji until 1895, when it was sold to the industrialist and noted collector Hara Tomitarō, and it is sometimes identified as the painting made by Shinken.[4] These stories of heavenly apparitions follow the typical pattern of medieval Japanese myths concerning the origin of portraits, secular as well as religious. Painted images of Seiryū Gongen were no doubt extremely rare, perhaps even nonexistent, before Shōkaku glimpsed her in his dream of 1088. Thus, in the absence of prototypes, the first image of her was very much influenced by the traditional representation of Kichijōten, a goddess frequently shown as a voluptuous court lady of the Tang dynasty.

Except for the fact that it lacks an inscription, the Burke Seiryū Gongen resembles the Hatakeyama version in every other respect, and it too may have been connected with Daigoji. Stylistically, however, it seems to have been painted considerably later than the earlier picture, which may indeed have served as its model. Such features as the stiff brushstrokes and the generally rigid delineation of landscape details indicate a date in the mid-fourteenth century.

1. Reproduced in Tanabe Saburōsuke 1989, p. 142, fig. 19.
2. For literary sources, see Akamatsu Shunshū 1951, pp. 1–26.
3. Ibid., p. 4.
4. Ibid., p. 14.

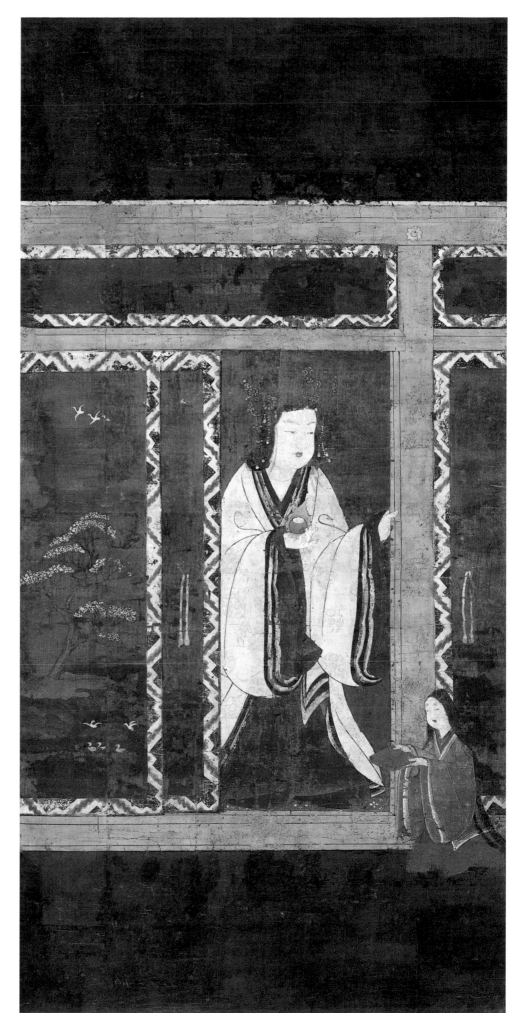

a

36. Pair of Guardian Lion Dogs

Kamakura period (1185–1333), mid-13th century
Lacquer, gold leaf, and polychrome on Japanese
cypress (*hinoki*)
a: height 42.4 cm (16¾ in.)
b: height 45.8 cm (18 in.)

LITERATURE: Schirn Kunsthalle Frankfurt 1990,
no. 6; Murase 1993, no. 4.

Traditionally, a pair of lion dogs, or *komainu*, is placed within or at the entrance to the sanctuary of a Shinto shrine or shrine complex to ward off evil. The lions depicted in stone or bronze reliefs as temple decorations in the Nara period belong to a sculptural tradition that can be traced back to the Buddhist art of India and China, where images of the seated Buddha often included lions at his right and left, both to underscore his majesty and to protect him. The basic connection between guardian lions and *komainu* is obvious, though the latter did not appear in Japanese art until the Heian period.[1]

The term *komainu* has ambiguous and complex roots. The literal translation is "Korean dog," which would indicate a Korean prototype;[2] in visual terms, however, these images appear to derive primarily from Chinese sources. The term was first used in early shrine and temple records of lion masks (generally identified as Chinese), musical instruments, and other items related to the ancient court dance Bugaku, which incorporated various continental Asian elements,

including dance forms from India, China, Korea, and Central and Southeast Asia.[3] The 780 registry of Saidaiji, Nara, lists a lion head with a horn, which suggests that this iconographic detail appeared on Bugaku masks as early as the Nara period.[4] And one lion mask from a Late Heian pair in Hōryūji, near Nara, does indeed feature a short horn on the top of the head.

By the Early Heian period, images of lions and horned lion dogs were paired and standardized under the general term *komainu*. A twelfth-century handscroll, the *Shinzei kogaku zu* (Shinzei's Illustrations of Ancient Music), depicts masked performers dressed as a creature that resembles the lion dog with an open mouth and others costumed as a horned lion with a closed mouth; both may have appeared together in the same performance.[5] No document, however, offers a specific explanation for combining a leonine head with a canine body, the basic characteristic of *komainu* sculptures. In various Heian, Kamakura, and Nanbokuchō examples, a single or split horn is found on one animal of

b

the pair, an attribute that recalls the horned lion mask mentioned in the registry of Saidaiji. Although this feature is missing from the Burke pair, the presence of a small oval outline on the head of the closed-mouth animal suggests that a horn may once have been attached.[6] A consistent aspect of *komainu* iconography is the placement of the *a gyō* (open-mouth) lion dog on the right with the *un gyō* (closed-mouth) counterpart on the left. It is the *un gyō* lion dog that always bears the horn. These features were perhaps inspired by *niō*, Buddhist guardian figures whose mouths can also be open or closed. It might be noted that the "a" in *a gyō* represents the first letter of the Sanskrit alphabet, the "un" in *un gyō* the last; together these characters symbolize the alpha and omega—the beginning and ultimate end of all things.

There is evidence in Heian-period literature that small metal sculptures of lion dogs were used as weights to secure standing screens in private palace apartments and may also have functioned as guardians. The eleventh-century *Eiga monogatari* (Tale of Flowering Fortunes), a history of the Fujiwara family, describes *komainu* weights as follows: "The Fujitsubo [palace apartment] was now supplied with a dining bench, as well as a Korean dog and lion in front of the curtain-dais—appurtenances that made a splendid sight."[7] Because much of what took place at the imperial court had a major influence on Shinto ceremonies and customs, the practice of employing *komainu* as guardian images within the palace may have been extended to Shinto shrines.

The method used for manufacturing the Burke sculptures is *yosegi zukuri* (assembled wood-block construction). On the closed-mouth *komainu* a tenon is exposed at the point where the right rear leg, now missing, was attached, illustrating this type of joinery. Both sculptures were originally covered with polychrome as well as gold leaf applied over lacquer; only traces of these materials remain. The heads of the animals, whose abundant manes add to their powerful appearance, have roots in early Chinese depictions of imaginary lions, while their sturdy, massive bodies and frontal poses represent a continuation of the Heian conception of lion dogs. These late examples, however, with their heads slightly turned, are more expressive than their Heian prototypes and reflect aspects of Nara-period naturalism, which was being revived at this time.

GWN

1. Itō Shirō 1989; and Kyoto National Museum 1990.
2. Related to the notion of a Korean connection is the legend that dogs were used in the third century to lead the empress Jingū's military expedition to Korea. See Kageyama Haruki 1973, pp. 62–63.
3. Nishikawa Kyōtarō 1978, p. 20.
4. Itō Shirō 1989, p. 44.
5. *Shinzei kogaku zu* 1927, n.p.; and Kyoto National Museum 1990, pp. 21–22.
6. For possible Chinese and Japanese precedents of images of horned animals used as guardian figures, see Dien et al. 1987, p. 116; and Itō Shirō 1989, pp. 27, 45.
7. *Tale of Flowering Fortunes* 1980, vol. 1, p. 225; and Itō Shirō 1989, p. 46.

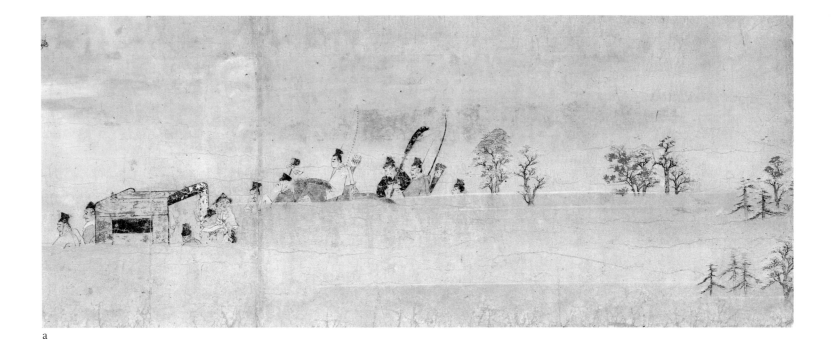

a

37. From the "Sumiyoshi monogatari emaki"

Kamakura period (1185–1333), late 13th century
Fragments of a handscroll, mounted as two
hanging scrolls
a: Ink and color on paper, 31.1 × 71.5 cm
(12¼ × 28⅛ in.)
b: Ink on paper, 30.5 × 8.4 cm (12 × 3¼ in.)
Ex coll.: Masuda Tarō, Kanagawa Prefecture;
Momiyama Hanzaburō; Yoshida Tanzaemon

LITERATURE: *Taishikai zuroku* 1912, pl. 30;
Murase 1975, no. 21; Murase 1980a, pp. 118–19;
Murase 1985, fig. 1; Tokyo National Museum
1985a, no. 5; Schirn Kunsthalle Frankfurt 1990,
no. 20; Tokyo National Museum 1993, no. 19.

The *Sumiyoshi monogatari* (The Tale of Sumi-
yoshi) is the story of two lovers who after a
long separation are reunited in Sumiyoshi, a
small fishing village near modern Osaka.[1] It
tells of an unfortunate stepdaughter—a pop-
ular theme in Heian and Kamakura litera-
ture—and has a Cinderella-like ending.

The beautiful young princess Himegimi
loses her mother at an early age and is reared
by a stepmother who has two daughters of
her own, Naka no Kimi and San no Kimi.
When the well-born Chūjō falls in love with
Himegimi, the stepmother tricks him into
marrying her younger daughter. After the
stepmother frustrates her husband's attempts
to make a suitable match for Himegimi, the
despondent Himegimi flees to Sumiyoshi,
where her deceased mother's wet nurse is liv-
ing as a nun. After prayer and fasting, Chūjō
searches for and finds her there. The young
lovers are married, and after several days'
celebration return to Kyoto.

Still wary of the wicked stepmother, the
couple conceal Himegimi's true identity for
seven years. During this period, she gives
birth to a son and a daughter. On the happy
occasion of the ceremony when one of their
children is clothed in a new skirt (usually
between the ages of three and seven), Hime-
gimi's father is invited to the ceremony and
learns about his daughter's marriage and
return. Chūjō and Himegimi live happily
ever after, while the evil stepmother ends her
days in poverty and disgrace.

The work of an unidentified author, the
Sumiyoshi monogatari was probably written
in the mid-tenth century, predating by about
half a century Lady Murasaki's *Genji mono-
gatari* (cat. nos. 81, 82, 87, 109, 110, 126),
which is generally recognized as the world's
first romantic novel. The influence of the
Sumiyoshi monogatari on Lady Murasaki is
widely acknowledged. In another Late
Heian work, *Makura no sōshi* (The Pillow
Book), the author, Sei Shōnagon, praises
the *Sumiyoshi monogatari* as one of the great
romantic novels of Japan.[2] It has, however,
suffered many misfortunes. The original
manuscript is lost, and the story as we know
it appears to have been based on a version
extensively modified in the Kamakura peri-
od. A small portion of the Heian original
can, however, be reconstructed with the
help of seven poems and their prose pref-
aces by the courtier-poet Nakatomi
Yoshinobu (921–991).[3]

The *Sumiyoshi monogatari* was in an unfin-
ished state at the end of the tenth century,
when Yoshinobu was asked to compose his
poems, the story having progressed only as
far as Chūjō's finding Himegimi in Sumi-
yoshi.[4] In all likelihood the original story was
quite different from that of the extant text, in
which the lovers marry at this point. In his
brief introduction, Yoshinobu explains that
he was asked to write poems about the paint-
ings for the *Sumiyoshi monogatari* "because
the poems that should have accompanied

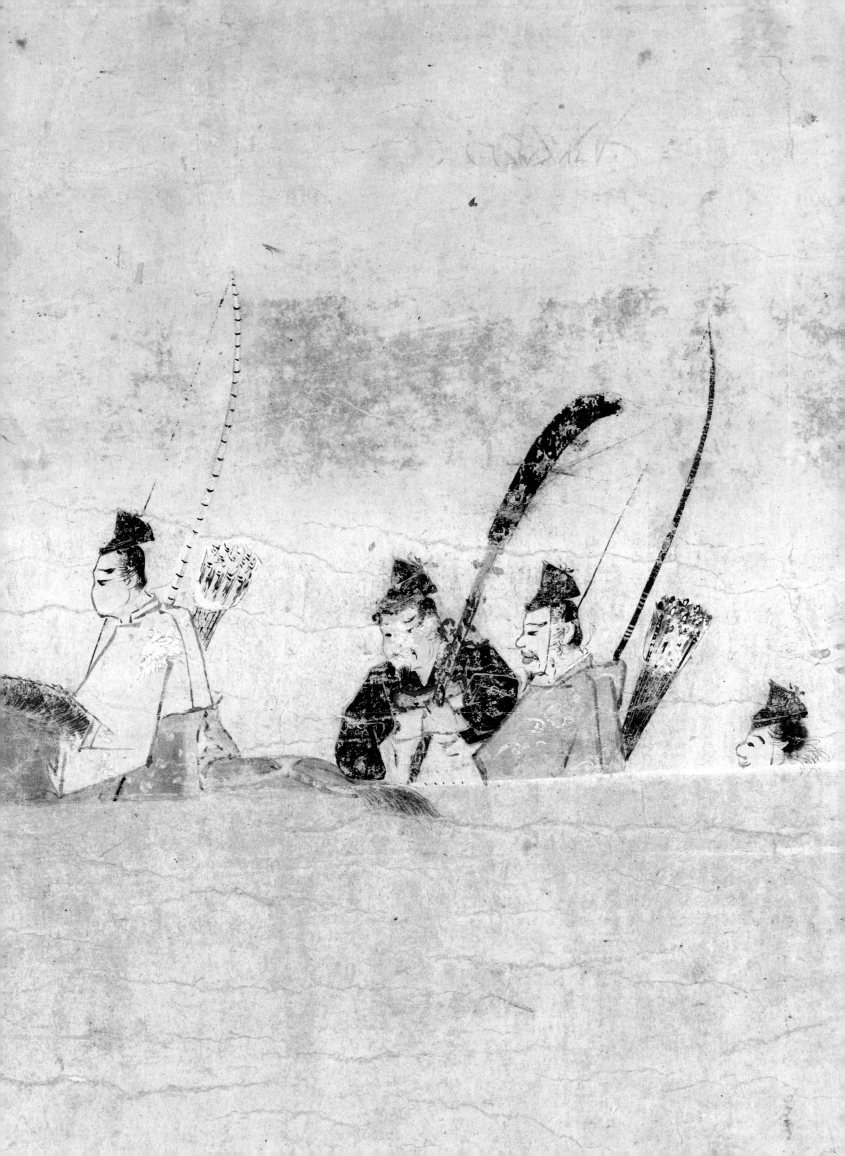

b

some of the scenes . . . were still not there."[5] A short prose description precedes each of the seven poems and identifies the subject of that scene.

Yoshinobu's poems are interesting for what they reveal about the literary practices of the Late Heian period. Apparently a novel might be read by a number of people, and even illustrated with paintings, before it had been completed. Poems were then composed to accompany the illustrations. Thus, the three elements of Japanese fiction—prose, painting, and poetry—came together in a process that depended on their mutual enrichment.

Although *Sumiyoshi* illustrations existed by the late tenth century, the oldest extant example of a *Sumiyoshi monogatari emaki* (Illustrated Tale of Sumiyoshi) is a late Kamakura work, of which only a few frag-ments are preserved. The largest of these is in the Tokyo National Museum;[6] several smaller sections, including the Burke frag-ments, are in private hands. The fragment in Tokyo illustrates the episode in which the villagers of Sumiyoshi have gathered at the seashore to celebrate the marriage of Chūjō and Himegimi.[7] This scene continues on the Burke fragment (*a*), in which Chūjō and his bride are shown in their carriage, accompa-nied by friends on horseback, as they set off for the capital.

Here crimson maple leaves brighten the country road on a clear autumn day. A group of soldiers marches to the left behind the car-riage. A light mist seems to rise from the ground, and the figures gradually fade from view. The following scene, now in the Man'no Art Museum, Osaka, shows Chūjō and Himegimi continuing their journey by boat.

Little remains of the text that originally accompanied the illustrations. A fragment of three lines (*b*) that relates the arrival of Chūjō and Himegimi at the capital (also in the Burke Collection) is the only known sur-vival. It reads:

Then they arrived in the capital and went to the mansion of Chūjō's father, who was upset about his son's secret marriage to an unknown country girl. Nevertheless, he built a special wing of the house for them and there established the newlyweds.

The text suggests that the scroll went on to illustrate the later events of the story, up to the reunion of Himegimi with her father.[8] The original *emaki* set seems to have com-prised at least two or three scrolls. Most of it was lost before 1848, when Sumiyoshi Sada-nobu, an artist who is otherwise unknown, made a copy of the scrolls.[9] This copy, which is now in a private collection in Japan, appears to be a faithful replica; the only section of text that it includes is the Burke fragment.

The Tokyo fragment and its companion pieces are traditionally attributed to Tosa Nagataka, who was active sometime during the thirteenth century but of whom nothing more is known.[10] All the stylistic features point to a date at the end of the thirteenth century: the agitated facial expressions of the soldiers, the stiff, angular lines of the gar-ments, the rock defined by broad brush-strokes, and the short, gnarled trees with bent branches. These characteristics are shared by other *emaki* from the same period, such as the *Obusuma Saburō ekotoba* of 1295 and the *San'nō reigenki* of about 1288.[11]

Although the *Sumiyoshi monogatari* was read and copied frequently during the Kamakura period, when its romantic theme was again in vogue, most of the illustrated versions of the tale have been lost. In fact, aside from the fragments discussed here, only one other *Sumiyoshi emaki* from the period is known. This scroll, now owned by the Seikadō Bunko Art Museum, Tokyo, dates to the early fourteenth century, but it too is severely damaged and incomplete.[12] The *Sumiyoshi* tale continued to enjoy considerable popularity throughout the Muromachi, Momoyama, and Edo periods, and was often illustrated in scrolls and books. Extensively modified, however, these later versions bear little relationship to the illustra-tions produced in the Kamakura period.

1. "Sumiyoshi monogatari" 1901.
2. Sei Shōnagon 1958, p. 249.
3. Reprinted in Hashimoto Fumio 1970, pp. 105–6, 110–12. The poems were first discussed in Horibe Seiji 1943.
4. Tamagami Takuya 1943, pp. 1–20.
5. Horibe Seiji 1943, pp. 45–50.
6. Murase 1983a, no. 12.
7. The Tokyo fragment was recently reunited with a fragment that was formerly in the Dōmoto Art Museum, Kyoto; see Umezu Jirō 1970, pp. 44–45.
8. For the reconstruction of the original sequence of these fragments, see Murase 1980a, pp. 118–19.
9. Umezu Jirō 1970, pp. 46–47.
10. Kurokawa Harumura 1885–1901, vol. 7, p. 2.
11. See, respectively, Komatsu Shigemi 1978b and Komatsu Shigemi 1984a.
12. Komatsu Shigemi 1978c, pp. 2–37.

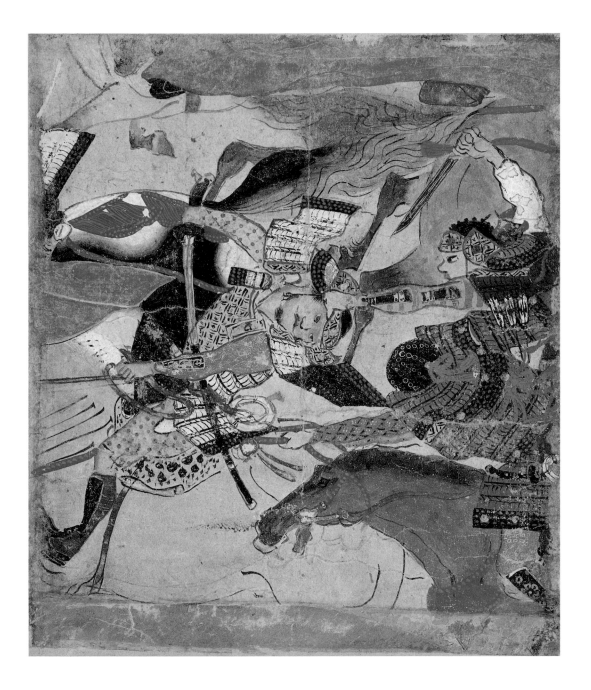

38. *From the "Heiji monogatari emaki"*

Kamakura period (1185–1333), 1st quarter of
14th century
Fragment of a handscroll, mounted as a hanging
scroll, ink and color on paper
17.4 × 14.8 cm (6⅞ × 5⅞ in.)
Ex coll.: Okamoto Ryōhei

LITERATURE: Akiyama Terukazu 1952, pl. 9, fig. 10;
Murase 1967, fig. 13; Shimada Shūjirō 1969, vol. 1,
pl. 54; Matsushita Takaaki 1975, pl. 43; Murase 1975,
no. 23; Komatsu Shigemi 1977a, fig. 10; Akiyama
Terukazu 1980a, no. 9; Meech-Pekarik 1985, pl. VI;
Tokyo National Museum 1985a, no. 6; Schirn
Kunsthalle Frankfurt 1990, no. 19.

With their vivid accounts of the men who
shaped the nation's destiny, tales of the
Hōgen (1156) and Heiji (1159) insurrections
captured the medieval imagination. The sto-
ries told of the clashes between two rival
military clans, the Minamoto (also called the
Genji) and the Heike (Taira), which signaled
the collapse of the long-held Fujiwara con-
trol over the court and marked the beginning
of autocratic rule by generations of several
warrior clans. Stories of Hōgen and Heiji
battles,[1] together with another popular war
romance, the *Heike monogatari* (The Tale of
the Heike; cat. no. 111), are renowned in the
military literature of Japan.

Over an extended period of time the two
great clans quietly built up their forces in the
provinces. By the mid-twelfth century, they
were allied with opposing factions of the
imperial court. Both the Hōgen and the Heiji
incidents represented power struggles between
members of the imperial family and the Fuji-
wara. In 1158, a dispute over the succession
to the throne erupted. When battle lines were
drawn, the Minamoto and the Heike support-
ed rival factions. The Heiji struggle began in
December 1159, when a force led by Mina-
moto Yoshitomo (1123–1160) attacked Sanjō
Palace, the residence of the retired emperor
Go-Shirakawa (r. 1155–58); it ended a few

Figure 28. Unidentified artist, *Heiji monogatari*. Detail from an Edo-period copy. Ink on paper, overall 42.4 × 971.1 cm (16¾ in. × 31 ft. 6¾ in.).
Tokyo National Museum

weeks later with a Heike victory, though not, as it turned out, a conclusive one.

It is likely that illustrations for these tales were made shortly after the texts were compiled, in the late thirteenth century. The tales were popular subjects for *emaki* and were often painted, usually in sets of many scrolls. A fifteenth-century royal diary, the *Kanmon gyoki* (Record of Things Seen and Heard), refers, for example, to a fifteen-scroll set of the Hōgen *emaki*.[2] Although no scrolls of the Hōgen story painted in the Kamakura period are extant, their lost compositions can be surmised from later works, such as an early-seventeenth-century pair of screens now in the Metropolitan Museum[3] or fans painted by Sōtatsu (cat. nos. 83–87) dating to the same period.[4] Fortunately, late Kamakura scrolls illustrating the Heiji Insurrection have survived. Of these, the opening event in the war, the burning of Sanjō Palace, is depicted in a masterpiece now in the Museum of Fine Arts, Boston. The Seikadō Bunko Art Museum, Tokyo, owns a scroll illustrating the death of Fujiwara Shinzei, a leader of the defeated faction. And a scroll in the Tokyo National Museum shows the dramatic flight of the reigning emperor, Nijō (r. 1158–65), to his estate in Rokuhara. In addition, fourteen small fragments of a scroll depicting the ensuing battle at Rokuhara are now in private

collections; the present painting is one of them.[5] A subsequent battle, at Taikenmon, is recorded in a late copy, and other scrolls illustrate the final episode of the Heiji story—the tragic fate of Tokiwa, the wife of a defeated general, and her small children.[6]

With the exception of the Tokiwa scrolls, the Heiji scrolls and fragments share distinctive stylistic features, though it has not yet been determined if these paintings once belonged to the same set.[7]

Documentary evidence indicates that the Rokuhara battle scroll was intact at least until 1617.[8] We also know that it was damaged sometime during the eighteenth century, and the surviving portion was then cut into fourteen pictures that were mounted as hanging scrolls and sold separately.[9] An Edo-period copy of this scroll, complete with text and illustrations, is in the collection of the Tokyo National Museum (fig. 28). From this copy the original sequence of the fourteen fragments can be reconstructed.[10]

The fragment in the Burke Collection, placed tenth in the sequence, forms part of the climax of the battle narrative. In a crowded, chaotic combat scene, two Heike warriors on horseback close in on a Minamoto soldier, one of them grabbing his helmet. Drawing his sword, the Minamoto rider clings to his horse in a desperate attempt to escape.

Some traces of retouching are visible, for example on the hand and arms of the Heike warrior at the upper right and around the muzzle of the dun horse at the lower right. A strip of dark green was painted at the bottom of the picture, perhaps to conceal some damage, and a small piece of paper, also painted green, was added at the lower left corner to create a regular rectangular shape. The dark green repair is a serendipitous complement to the red banner of the Heike forces floating at the top of the composition.

1. *Hōgen monogatari* 1971; and *Early Japanese Literature* 1951, pp. 375–457.
2. *Kanmon gyoki* 1944, p. 387, in the entry for the thirtieth day of the fifth month of the eighth year of the Eikyō era (1436).
3. Kajihara Masaaki and Meech-Pekarik 1987.
4. Yamane Yūzō 1977–80, vol. 1.
5. All these *Heiji* scrolls are reproduced in Komatsu Shigemi 1977a. A small fragment of the text is known to have been in existence until quite recently; see Tamura Etsuko 1967, pp. 13–31.
6. The scroll of the Tokiwa episode is reproduced in Komatsu Shigemi 1983, pp. 57–105.
7. Suzuki Keizō (1952, pp. 309–16) posits that all the known Heiji pictures were made at different times.
8. Akiyama Terukazu 1952, p. 2.
9. Fukui Rikichirō 1944, p. 84.
10. Akiyama Terukazu 1952, pp. 1–11.

During the Heian period, one mode of literary expression popular among the nobility was the *waka*, or "Japanese poem" in a thirty-one-syllable five-line form. The ability to compose *waka* extempore was an essential element of aristocratic deportment, and ambitious courtiers, both men and women, found such a skill indispensable to recognition and promotion in the capital.

Courtly pastimes of the Heian period included a variety of competitions in nearly every artistic endeavor, including painting. Poetry contests, or *uta awase*, were also a vital component of patrician life. Although it is not known exactly when the first *uta awase* took place, the custom can be traced back to the 880s and the games played by women of the court.[1] (Aristocratic women were the first to adopt *waka* as a major mode of literary expression, at a time when their male counterparts still followed the traditional Chinese style.) In a classic poetry match, contestants were divided into two groups, the "left" and the "right."

It is traditionally believed that the renowned scholar, critic, and poet Fujiwara Kintō (966–1041) and the poet and critic Prince Rokujō Tomohira (964–1009) differed in their choice of the greatest *waka* poet.[2] Kintō nominated Ki no Tsurayuki (ca. 868–945); Tomohira preferred Kakinomoto no Hitomaro (fl. 685–705). To buttress his opinion, Kintō selected thirty-six poets of the Nara and Heian periods and asked other *waka* connoisseurs to evaluate them. The majority awarded the highest honors to Hitomaro. It then became popular to make lists of great poets, usually numbering thirty-six, with Hitomaro in first place. When Kintō selected the thirty-six masters, soon to be known as *kasen* (Immortal Poets), he also chose representative verses of each, 150 poems altogether.

It is difficult to determine exactly when the first group portrait of *kasen* was made, but several timely developments appear to have contributed to the formation of a pictorial iconography. Taking a cue from the Chinese, the Japanese, for didactic purposes, decorated their palaces with portraits of sages, scholars, and wise (or sometimes wicked) rulers. In a similar vein, Buddhist temples commissioned portraits of patriarchs as objects of veneration. By 1050 it had become customary to paint portraits of celebrated poets, divided into the "left" and "right" groups and accompanied by examples of their best-known compositions.[3]

The *kasen* theme as a subject for painting may also have been inspired by an earlier tradition of paying homage to the painted image of Hitomaro. The ceremony in which Hitomaro's portrait was venerated as an icon is said to have been initiated in 1118, when a newly made portrait was displayed, with flowers and offerings placed before it.[4] The poet was portrayed as an aged man, informally clad, with a sheaf of writing paper in his left hand and a brush in his right. The image was traditionally believed to have been based on Hitomaro's appearance in a dream to one Sanuki no Kami Kanefusa, an aficionado of *waka* who aspired to greatness as a poet.[5] The morning following his dream, Kanefusa called for an artist to render the dream figure in a painting, intending to use it as an icon for worship. Thereafter Kanefusa's poetry showed great improvement, and the miraculous portrait was willed to the emperor Shirakawa (r. 1073–87). Many copies of the painting were made and used in the ceremony dedicated to the "holy man" of *waka* poetry. The ritual veneration of Hitomaro's portrait, a practice that lasted for centuries, was obviously inspired by the Chinese custom of paying homage to images of Confucian sages.

The oldest extant *kasen-e*, paintings of the Immortal Poets, are the two scrolls of a mid-thirteenth-century set known as the Satake Version (*Satakebon*) of the *Sanjūrokkasen emaki* (Illustrated Handscroll of the Thirty-six Immortal Poets). Originally part of the Satake collection, they were divided in 1919 among various other collections.

The production of *kasen-e*, based either on the Satake Version or on variations of it, reached its peak during the Kamakura period. Several factors contributed to the popularity of this genre: the fierce determination of the politically enfeebled Kyoto court to assert aristocratic cultural traditions; a new interest in history and historical figures; and the growing appeal of portrait paintings, known as *nise-e* (likeness pictures). Although *kasen-e* are renderings of men and women who lived long before the paintings were made, the creation of individualized portraits is very much an expression of the Kamakura spirit.

The diversity of Kamakura *kasen-e* reflects a growing tendency to produce art that deviated from the Kintō model. The *kasen-e* tradition continued through the Muromachi period and later, generating innovative variations on the poet-portrait theme while retaining the vigor of its beginnings.[6] For all their deceptively simple content, *kasen-e*—in their uniting of the three high arts of literature, calligraphy, and painting—express the quintessential Japanese reverence for the power of word and image.

1. Minegishi Yoshiaki 1958, p. 13.
2. For literary records of this dispute, see Hasegawa Nobuyoshi 1979, pp. 40–44.
3. See the section on the *e-awase* of the fifth year of the Eijō era (1050), in *Kokon chomonjū* 1968, p. 313.
4. *Kakinomoto eiguki* (Record of Offerings Made to Kakinomoto's Portrait), edited by Fujiwara Atsumitsu (1061–1144), in *Gunsho ruijū* 1928–37, vol. 13, p. 53.
5. For the record of this dream, see the *Jikkinshō*, a 1252 collection of old tales (1982, pp. 118–19).
6. For later variations, see Murase 1986, nos. 12–16.

39. Fujiwara Teika: From the "Ikkasen isshubon"

Kamakura period (1185–1333), early 14th century
Fragment of a handscroll, mounted as a hanging scroll, ink and color on paper
28.7 × 37.5 cm (11¼ × 14¾ in.)
Ex coll.: Sekido Akihiko, Nagoya

LITERATURE: Mori Tōru 1965, fig. 8; Murase 1975, no. 20; Mori Tōru 1978, p. 99, fig. 7; Tokyo National Museum 1985a, no. 9; Wheelwright 1989, no. 3; Schirn Kunsthalle Frankfurt 1990, no. 23.

A nobleman, formally dressed in a voluminous court robe and tall hat, is shown seated and facing in the direction of the poem inscribed on the right. His face is rendered in thin, even lines, and the hairline is painstakingly executed in minute strokes. The angular black mass of his garments, defined by broadly brushed contours, creates a sense of monochromatic solidity relieved only by traces of red pigment on his lips and a pinkish brown tone at the edge of his belt. His face, inclined slightly downward, with eyes fixed to one side, suggests concentrated scrutiny of the lines of verse:

Hitori nuru
yamadori no o no
shidario ni
shimo oki mayou
toko no tsukikage

Frost has formed
on the trailing tail
of a solitary sleeping pheasant,
its bed illuminated
by a cold autumn moon.

The portrait represents Fujiwara Teika (1162–1241), the great medieval poet, scholar, and critic, and the poem is one of his compositions from the Shin kokinshū (New Collection of Poems Ancient and Modern). Teika was the most celebrated literary figure of his day, and the Shin kokinshū is one of the great anthologies of Japanese poetry. It was compiled by order of the retired emperor Go-Toba (r. 1183–98) by a group of four scholar-poets headed by Teika and was completed about 1206. In 1232, Teika was commissioned by Emperor Go-Horikawa (r. 1221–32) to compile another anthology, the Shin chokusenshū (New Imperial Collection). Teika also wrote essays on poetry and collated texts for such classics as the Genji monogatari. His diary, the Meigetsuki (Journal of the Full Moon), which covers his life from 1180 to 1235, is an indispensable document for the study of the Kamakura period.[1]

About a dozen fragments of the handscroll to which this portrait belonged are extant.[2] Each includes a poem inscribed either to the left or to the right of the poet's portrait; several give the poet's name. Some of the poets had lived in the recent past (that is, in the

final century of the Heian period) and, as members of Go-Toba's selected "group of one hundred poets," were included in the *Shin kokinshū*. In this compilation in the form of an imaginary competition, the contending poets are divided into "right" and "left" groups. The original scroll was thought, therefore, to have been a version of the genre called *Jidai fudō uta awase* (Competition of Poets of Different Periods; cat. no. 40). All the extant fragments, however, lack the usual attributes of poetry-competition pictures: each poet is represented by one poem instead of by several, and there are no references to the various rounds associated with a poetry match or to the two opposing teams. This group of portraits is, in fact, more closely related to traditional *kasen-e* than to poetry-competition scrolls, and a separate designation has been proposed for it: *Ikkasen isshubon* (One Poem One Poet Version).[3]

Stylistic features of the painting, such as the tight, stiff brushstrokes, are characteristic of works datable to the early fourteenth century. The round seal partly visible in the lower right corner is probably that of a collector.

1. *Meigetsuki* 1977.
2. For other fragments from the same scroll, see Mori Tōru 1965, pp. 25–29.
3. Suntory Museum of Art 1986, no. 71.

40. The Poets Henjō and Jichin: From the "Mokuhitsu jidai fudō uta awase-e"

Nanbokuchō period (1336–92), mid-14th century
Fragment of a handscroll, mounted as a hanging scroll, ink on paper
31.2 × 52.8 cm (12¼ × 20¾ in.)
Ex coll.: Mori collection

LITERATURE: Mori Tōru 1965, suppl., fig. 6; Mori Tōru 1978, pl. 32; Murase 1993, no. 34.

The basis of Fujiwara Kintō's selection of the Sanjūrokkasen (the Thirty-six Immortal Poets; see page 109) was a *jidai fudō*, or listing of poets of different eras. A later selection, in a work known as the *Jidai fudō uta awase* (Competition of Poets of Different Periods), differs from Kintō's in presenting one hundred poets as paired, competing rivals. This anthology of poets, each represented by three works, is generally accepted as having been commissioned by the retired emperor Go-Toba (r. 1183–98).[1] Believed to have been completed between 1232 and 1235, it sets up an imaginary contest between the one hundred poets, who are evenly divided into "left" and "right" teams. The "left" team is made up of poets represented in the three earliest imperial anthologies: the *Kokinshū* (A Collection of Poems Ancient and Modern, ca. 905), the *Gosenshū* (Later Collection, ca. 951–ca. 966), and the *Shūishū* (Collection of Gleanings, ca. 996–1007). The "right" team is drawn from later authors represented in the five subsequent anthologies: the *Go shūishū* (Later Collection of Gleanings, 1086), the *Kin'yōshū* (Collection of Golden Leaves, ca. 1124–27), the *Senzaishū* (Collection of a Thousand Years, ca. 1188), the *Shikashū* (Collection of Verbal Flowers, 1151–54), and the *Shin kokinshū* (New Collection of Poems Ancient and Modern, ca. 1206).

According to tradition, Go-Toba commissioned a Kyoto artist to depict the one hundred poets in an illustrated version of the *Jidai fudō uta awase*. The story cannot be verified, but the many extant paintings of Go-Toba's one hundred poets, dating mostly from the mid-Kamakura through the Muromachi period, attest to the enormous popularity of his concept. Unfortunately, only fragments of these paintings exist, except for several copies and images made during the Edo period.[2]

Some of the established characteristics of the pictures of the *Jidai fudō uta awase* can, nevertheless, be determined from what survives. The poets are portrayed in competing pairs, their respective teams and the round in the competition identified. Members of the "left" team are shown at the right, and members of the "right" team are shown at the left. With the notable exception of Hitomaro, the poets in these paintings, in appearance and pose, are unlike their counterparts in traditional *kasen-e*, which may indicate a deliberate attempt to create a new iconographic tradition.

The present painting depicts two Buddhist monks, Henjō (816–890) on the right and Jichin (the posthumous name of Jien, 1155–1225) on the left. The six poems that were composed in rounds sixteen through eighteen of the competition are written in pairs within the areas marked off above. Each of these areas is decorated with underdrawings of landscapes or flowers, creating the effect of a *shikishi* (decorated poem sheet). In the rectangular spaces behind the poets, their names are inscribed. The poems are written in an unusual style that combines *kana* with *man'yōgana*, the first Japanese system, in which Chinese characters were used to

represent Japanese sounds. The practice is believed to have come into vogue in the late Kamakura period.[3]

The two poets are dressed in monks' habits, which are drawn with a flat wood stylus called a *mokuhitsu*—hence the title of the original scroll, *Mokuhitsu jidai fudō uta awase-e* (Stylus-Illustrated Competition of Poets of Different Periods). This implement creates thread-thin parallel lines that reveal the white of the paper between the lines, producing an effect known as *hihaku* (flying white). Introduced from China as early as the mid-eighth century, the technique seems to have later become closely associated with the Shingon sect of Esoteric Buddhism.[4] Attempts to individualize the poets' features are evident: Henjō is represented as a youngish monk, while Jichin appears as an older man with an unusually prominent nose. He seems to be on a winning streak, for his younger rival looks at him in consternation.

The handscroll from which this fragment was taken once belonged to the Mori collection, and it listed at the beginning the names of all one hundred contestants.[5] However, the box that housed the scroll bears an inscription dated 1725, indicating that even at that time the scroll was incomplete, as the box is large enough for only one *emaki*. The scroll included the first forty-eight poets, with the exception of the forty-third and the forty-fifth, who were missing.[6] Another fragment is now in the collection of the Asian Art Museum of San Francisco,[7] but its calligraphy differs from that of the Burke and other fragments. More than one calligrapher may thus have been involved in this daunting undertaking—the copying of three hundred poems.

The six poems of this fragment read as follows:

16th Round, Left
*Cherry trees on Mount Furu at Iso no Kami
are as old as the mountain.
No one knows who planted them there.*[8]

16th Round, Right
*The leaves have turned, yet linger
still in the valley.
Autumn showers deepen their colors—
the tenth month of the year.*[9]

17th Round, Left
*Everyone again is garbed
in hues of springtime blossoms.
Oh, tear-stained sleeves,
will you now become dry?*[10]

17th Round, Right
*Vainglorious though I may be,
I yearn to protect, under my priestly sleeves,
the people of this woeful world.*[11]

18th Round, Left
*Mist on the tips of the leaves,
dew at the roots of the tree,
sooner or later all will vanish.*[12]

18th Round, Right
*Oh, that I may linger
on this darkened path,
that it may brighten with
the Buddha's Law.*[13]

1. Mori Tōru 1978, pp. 153ff.
2. For reproductions of these later examples, see ibid., figs. 33–35.
3. Ibid., p. 167, no. 3.
4. Shōsōin Office 1968, p. 153.
5. Mori Tōru 1978, fig. 22.
6. Ibid., p. 106, no. 1.
7. Y. Shimizu and Rosenfield 1984, no. 38.
8. *Gosenshū*, no. 49.
9. *Shugyokushū*, no. 6107. Unlike the other poems quoted in the colophon, this verse is taken not from one of the imperial anthologies but from a collection of Jichin's poetry compiled from 1328 to 1346.
10. *Kokinshū*, no. 847.
11. *Senzaishū*, no. 1134.
12. *Shin kokinshū*, no. 757.
13. Ibid., no. 931.

41. Koōgimi: From the "Fujifusabon Sanjūrokkasen emaki"

Muromachi period (1392–1573), 1st half of
15th century
Fragment of a handscroll, mounted as a
hanging scroll, ink and color on paper
29 × 41.2 cm (11⅜ × 16¼ in.)
Ex coll.: Mrs. John D. Rockefeller III

LITERATURE: Mori Tōru 1978, pl. 11-3;
Mori Tōru 1979, pl. 100.

The seated woman depicted with her back to
the viewer is identified in the accompanying
inscription as the poet Koōgimi (Kodai no
kimi, late 10th–early 11th century). The
inscription also informs us that she was lady-
in-waiting first to Emperor Ichijō (r. 986–
1011) and then to Emperor Sanjō (r. 1011–16)
when he was still crown prince. At that time,
she held the title of *sakon*, which the inscrip-
tion gives as *ukon*—an error that was cor-
rected in the margin by a later hand. It is also
known that Koōgimi was the wife of Prince
Shigeakira, a direct descendant of Emperor
Daigo (r. 897–930).

A poem selected from an anthology of
her work, the *Koōgimishū*, is included in the
inscription:

Iwabashi no yoru no chigiri mo
taenu beshi
akuru wabishiki
Katsuragi no yama

Nightly visits across Iwabashi stopped.
When morning came, sadness surrounded
Katsuragi Mountain.[1]

Koōgimi's voluminous court dress is deco-
rated with small floral patterns in white and
touches of red and green on the sleeves. The

drawing is particularly animated in describ-
ing the undulating flow of her gorgeous long
black hair. The exaggerated nailhead brush-
strokes and the squat characters of the inscrip-
tion suggest a date in the early Muromachi
period, during the first half of the fifteenth
century.

The handscroll from which the portrait
was separated is known as the *Fujifusabon*,
or Fujifusa Version of the *Sanjūrokkasen
emaki* (Illustrated Handscroll of the Thirty-
six Immortal Poets), as it was presumably
edited by Fujiwara Fujifusa (Madenokōji
Fujifusa, b. 1295). Some ten additional frag-
ments from the scroll are extant.[2] Fortunately,
the original sequence can be reconstructed
with the aid of a copy once in the possession
of the *nanga* master Tani Bunchō (cat. no. 168)
and now in the collection of the Jingū Mu-
seum of Antiquities, Kuratayama.[3] The
placement of the biographical notes beside
the portraits, the content of the biographies,
and the poems selected indicate that a distant
model for the Fujifusa Version may have
been the *Satakebon*, the oldest extant hand-
scroll on the theme of the Thirty-six Immor-
tal Poets. The lively figures in the Fujifusa
Version, however, probably more directly
reflect the influence of the *Narikanebon*, a
late-thirteenth-century handscroll that

b

a

f

e

弘安戊寅仲秋之後一日書干
十牛圖後
義□

Inscription

j

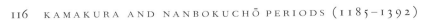

i

住鼎州梁山廓庵和尚十牛圖

夫諸佛真源衆生本有因迷也流淪
三界由悟也頓出四生所以有諸佛
而可成有衆生而可作是故先賢悲
憫廣設多途理出偏圓教興頓漸
從麁及細自淺至深末後目瞬青蓮
引得頭陀微笑正法眼藏自此流通
天上人間此方他界得其理也超宗
越格如鳥道而無蹤得其事也滯句
迷言若靈龜而拽尾間有清居禪師
觀衆生之根器應病施方作牧牛以
為圖隨機設教初從漸白顯力量之
未充次至純真表根機之漸熟乃到
人牛不見故標心法雙亡其理也已
盡根源其法亦尚存襃笠遂使淺根
疑誤中下紛紜或疑之落空亡或愛
作墮常見今觀則公禪師擬前賢之
模範出自己之胸襟十頌佳篇交光
相映初從失處終至還源善牽羣機
如救飢渴慈遠是以採尋妙義採拾
玄微如水母以蝦為目
初自尋牛終至入鄽旋起波瀾橫生
頭角尚無心而可覓何有牛而可尋
泊至入鄽是何魔魅況是祖祢不了
狄及兒孫不揆荒唐試為提唱

Preface

d

c

h

g

43. *Wagtail on a Rock*

Nanbokuchō period (1336–92)
Hanging scroll, ink on silk
83.1 × 35 cm (32¾ × 13¾ in.)
Signature: *Taikyo-sō*
Inscription by Taikyo Genju
Seals: [two indecipherable seals]

LITERATURE: Matsushita Takaaki 1960, no. 14;
Kamakura Kokuhōkan 1962, fig. 2; Matsushita
Takaaki 1967, fig. 136; Kanagawa Prefectural
Museum of Cultural History 1972, fig. 16; Murase
1975, no. 26; Shimada Shūjirō 1979, no. 12; Tokyo
National Museum 1980, fig. 100; Ford 1985, fig. 3;
Tokyo National Museum 1985a, no. 11; Shimada
Shūjirō and Iriya Yoshitaka 1987, no. 148; Schirn
Kunsthalle Frankfurt 1990, no. 30; Brinker and
Kanazawa Hiroshi 1996, fig. 29.

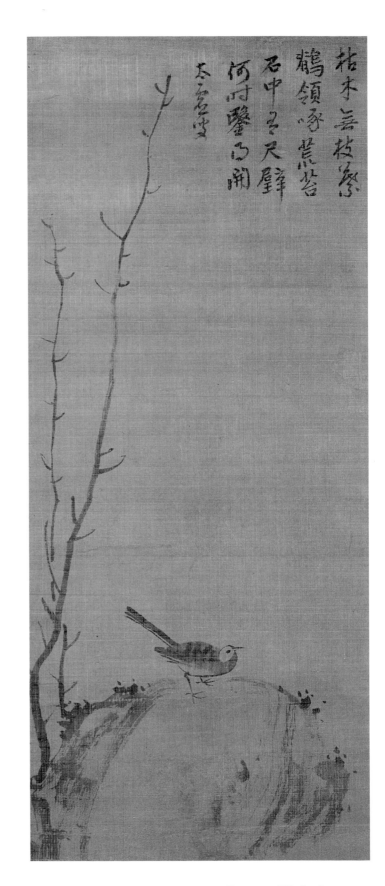

The theme of this simple composition—a
depiction of a wagtail on a rock, with two
bare tree branches—is Zen training. In the
inscription, the wagtail's pecking at the rock
is compared to a monk in search of truth—
the monk, no doubt, who signed it:

*The branches of the withered tree
are without leaves.
The wagtail pecks at the moss-covered rock
inhabited by the jade of truth.
When will he be able to open it?*

—*Taikyo-sō*

Taikyo Genju, who composed and in-
scribed the colophon, is known to have stud-
ied with the famous Zen master Yakuō
Tokken (1244–1319), who worked mainly in
Kamakura. In 1328 he went to China, where
he continued his studies with many leading
Chan masters. After returning to Japan about
1330, he lived for a while at Fukugonji, near
Kōbe. He returned to Kamakura in 1374.[1]

A painting of a wagtail on a rock—
though without a colophon—in the Yale
University Art Gallery, New Haven, is very
similar to this one.[2] In each work, the com-
position is asymmetrical; the dry, broken
strokes of the rock create a sense of rough
surface, and a wetter ink and finer delin-
eation are used for the branches and the
bird's plumage. Very possibly Taikyo Genju
was the artist responsible for both composi-
tions. No other works attributable to him
have yet come to light.

1. Tamamura Takeji 1983, pp. 394–95.
2. "Art of Asia" 1966–67, fig. 61; and Brinker
and Kanazawa Hiroshi 1996, fig. 30.

44. Orchids, Bamboo, Brambles, and Rocks

Nanbokuchō period (1336–92), mid-14th century
Hanging scroll, ink on paper
72.2 × 37 cm (28⅜ × 14⅝ in.)
Inscription by Tesshū Tokusai
Seal: *Tesshū*
Ex coll.: Fukuoka Kōtei

LITERATURE: Nakamura Tanio 1973, pp. 65–66;
Tanaka Ichimatsu 1974, pl. 16; Murase 1975, no. 27;
Murase 1977, p. 86; Shimada Shūjirō 1979, p. 113;
Ford 1985, fig. 4; Tokyo National Museum 1985a,
no. 12; Schirn Kunsthalle Frankfurt 1990, no. 31.

From ancient times in China, wild orchid
blossoms were associated with the virtues
regarded as proper to the nobility—selfless
modesty and moral purity. A similar symbol-
ism was attached to bamboo, its graceful
resilience linked with the virtuous rectitude
of the scholar-gentleman. Paintings of
orchids and bamboo were a specialty of Chi-
nese literati artists of the fourteenth century,
and many of the finest paintings of orchids
are the work of Chan and Zen monks.

The master of the genre was the Chinese
artist Puming (fl. 1340–50), renowned as the
greatest orchid painter of the Yuan dynasty.[1]
(Puming eventually lost favor in China; most
of his extant works are preserved today in
Japan.) The genre was introduced to Japan
by monk-painters—including Tesshū
Tokusai—who traveled to China in the four-
teenth century. It remained popular with
artists working in ink until it was superseded
by landscape in the fifteenth century.

Although unconfirmed, Tesshū is believed
to have studied painting with Puming when
he was in China, and indeed a conceptual and
stylistic affinity with Puming's work is evi-
dent here. The surface texture of the rocks,
rendered in dry brushstrokes, for example,
and the delineation of the bamboo leaves in
short, dark strokes both recall the Chinese
master's style. Tesshū's paintings, however,
are more gentle and cultivated in ambience.

Tesshū was born in the province of
Shimotsuke, north of Tokyo. At an unknown
date he moved to Kyoto, where he studied
with the great Zen master Mukyoku Shigen

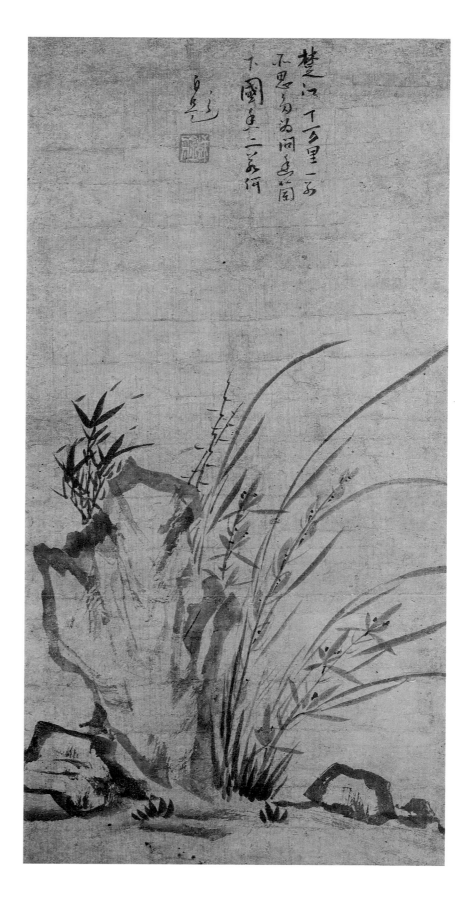

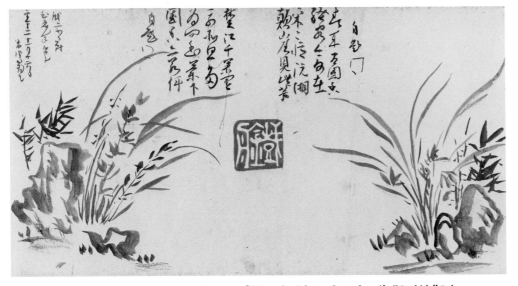

Figure 30. Kano Tsunenobu (1636–1713), *Copy of Diptych with Tesshū Tokusai's "Orchids."* Ink on paper. Tokyo National Museum

(1282–1359) at Tenryūji. While in China, Tesshū received instruction from some of the most respected Chan monks of the period and was received by Emperor Shun-tsung (r. 1333–68), who bestowed upon him an honorary title. After returning to Japan about 1342, he continued his Zen studies with Musō Soseki (d. 1351) and became close friends with Gidō Shūshin (1325–1388), the teacher of Gyokuen Bonpō (cat. no. 51); the *Kūgeshū*, a collection of poems by Gidō, includes a number of verses in praise of Tesshū's orchid paintings.[2] Tesshū served at Manjuji and other famous temples in Kyoto. He retired in 1363 to Ryūkōin, the subtemple that he founded at Tenryūji, in Saga, a suburb of Kyoto. He died there in 1366.

Tesshū is said to have painted orchids nearly every day, with a kind of religious fervor. This scroll is especially important to the study of his work, as it is one of the few paintings with poetry inscribed in his hand. It reads as follows:

Since leaving the rivers of Chu
thousands of miles away,
Unceasingly have I longed for them.
Below the fragrant orchids I ask,
What would a second national
fragrance be like?[3]

Orchids were long associated with the Chinese poet-statesman Qu Yuan (343–277 B.C.), who was wrongly accused and exiled to the northern marshlands. Despondent, he drowned himself in the Miluo River.

Undoubtedly, Tesshū was referring to Qu's *Elegies of Chu* when he wrote these lines.[4]

Kano Tsunenobu (1636–1713) made a copy of the Burke painting when it was still paired with a second scroll as a diptych (fig. 30).[5] That painting, now in a private collection in Japan,[6] depicts the orchids swaying to the left, that is, toward the Burke scroll, in which they move in the opposite direction.[7]

1. Li 1962, pp. 49–76.
2. *Kūgeshū*, in Kamimura Kankō 1936, vol. 2, pp. 468, 575, 735–36.
3. "National fragrance" is a reference to the orchid.
4. *Songs of the South* 1985, pp. 273–74. The *Enbushū*, a collection of Tesshū's poems, includes other colophons that he wrote on his paintings. Curiously, while many of these are concerned with a wide range of subjects—animals, flowers, grapes, and landscapes—in none does the artist refer to his paintings of orchids. See *Daizōkyō* 1914–32, vol. 80, no. 2557.
5. Nakamura Tanio 1959c, p. 22; Nakamura Tanio 1972; and Nakamura Tanio 1973, pp. 65–66.
6. Nara Prefectural Museum of Art 1994, no. 42.
7. The Burke painting appears to have been trimmed slightly (about 1 cm [⅜ in.] on the right and left sides), resulting in the loss of the tips of the leaves on the right and a corner of the rock on the left.

Lacquerware

CATALOGUE NOS. 45, 46

Lacquer, a viscous substance obtained from a type of sumac known as the lacquer tree (*Rhus verniciflua*) in central and southern China and Japan, has long been used in those countries as a protective coating and as an adhesive. In prehistoric times, lacquer was combined with pigments while still in a liquid state, which helped enhance the aesthetic effect of painting and inlay. Many ancient lacquer-decorated Chinese objects in wood, metal, and textile have been excavated in recent years.[1]

The greatest Japanese contribution to the art of lacquer was the refining of the time-consuming and exacting technique known as *maki-e*, in which minuscule flakes of gold and silver foil are sprinkled (*maki* or *maku*) on the lacquered surface to create effects similar to painting (*e*). Where a decorative pattern is desired, it is first indicated in the lacquer, and finely ground metallic dust or pigment is then sprinkled on the lacquered surface before it hardens. In the oldest and most difficult *maki-e* technique, which produces the most durable wares, several coats of black lacquer are applied over the gold- or silver-filled areas of the design, and then charcoal is used gently and slowly to lift off these layers of lacquer until the "sprinkled picture" reappears. Finally, a protective coating of clear lacquer is applied over the entire surface.

The technique was probably imported from China, but Japanese lacquerers developed it to its most sophisticated level and exploited its physical properties. The Japanese applied the *maki-e* technique not only to small personal belongings but also to the interior walls of palaces. The *Taketori monogatari* (The Tale of the Bamboo Cutter), dating to between the early ninth and the tenth century, describes a sumptuous house decorated in *maki-e*.[2] Later documentary sources indicate that *maki-e* was a popular lacquering technique that enriched the everyday life of the Heian aristocracy in the tenth century.[3] Gifts of *maki-e*–ornamented Japanese lacquers were soon coveted by the Chinese and Korean courts of the late tenth and eleventh centuries.[4] During the Kamakura period, the technique was further advanced when methods were developed to grind gold into a finer dust, which produces a more lustrous glow.

In the late sixteenth century, when the Portuguese and Spanish began trading in Japan, Japanese lacquer became an export item as important as ceramics. In 1610, a company was established in Amsterdam to handle lacquer imports.[5] The use of the term "japanning" for varnish imitating Japanese or Chinese lacquer is evidence of the enormous popularity that lacquer, especially Japanese lacquer with *maki-e* designs, once enjoyed in Europe.

1. For a general introduction to lacquer, see Watt and Ford 1991, pp. 1–11.
2. "Tale of the Bamboo Cutter" 1956, p. 341.
3. See, for example, *Tales of Ise* 1968, episode no. 78, p. 122; and Arakawa Hirokazu 1969, p. 48.
4. Arakawa Hirokazu 1969, p. 48.
5. Tsuji Nobuo, Kōno Motoaki, and Yabe Yoshiaki 1991, p. 188.

45. *Kōgō with Pines and Plovers*

Kamakura period (1185–1333), early 14th century
Black lacquer with gold *maki-e* on gold *nashiji*
ground
3.9 × 9.4 × 6.9 cm (1½ × 3¾ × 2¾ in.)

LITERATURE: Lee 1961, no. 40; Murase 1975,
no. 102; Tokyo National Museum 1985a, no. 104;
Schirn Kunsthalle Frankfurt 1990, no. 106.

46. *Kōgō with Autumn Grasses*

Muromachi period (1392–1573), 15th century
Black lacquer with gold *maki-e* on gold *nashiji*
ground
3.3 × 8.4 × 6.4 cm (1¼ × 3¼ × 2½ in.)

LITERATURE: Murase 1975, no. 102; Tokyo
National Museum 1985a, no. 106; Schirn Kunsthalle
Frankfurt 1990, no. 107.

These rectangular boxes, known as *kōgō*,
have rounded corners and fitted lids that are
very slightly raised and curved at the sides.
Thin metal rims encircle both the mouth of
the lid and the base. Originally, such boxes
held articles used to blacken the teeth with a
liquid known as *haguro*, which was obtained
from a mixture of iron and other minerals.
An important cosmetic for both men and
women in ancient Japan, it seems to have
been in common use even before the Nara
period; it was regarded during the Heian
period as a sign of sophistication and gentil-
ity. Male aristocrats at the court of Kyoto
continued to use *haguro* throughout the Edo
period; women did so until the late nine-
teenth century. Its application formed an
important part of the symbolism associated
with the initiation ceremony for boys and
girls at the age of nine. Young women, how-
ever, applied *haguro* on their teeth only after
matrimony, as it was a mark of fidelity.

These two boxes are distinguished from
other types of toiletry containers by their
rectangular shape. A complete cosmetic set
usually consisted of a larger box that held
two each of three differently shaped contain-
ers: square for face powder, round for incense,
and rectangular for *haguro*. The boxes were

Cat. no. 45

Cat. no. 46

frequently separated from the sets to which
they once belonged for later use in *chanoyu*
(the tea ceremony). Before the late sixteenth
century, when the Japanese began making
small pottery boxes designed specifically for
incense, such lacquer containers were often
substituted for the rare and expensive Chinese
ceramic imports that were then in vogue.

Except for the bottom surface, the back-
ground of each box is covered evenly with
fine gold speckles, producing an effect called
nashiji (pear skin), as it resembles the spotted
skin of Japanese pears. The seascape design
on one *kōgō* (cat. no. 45), with its gnarled
pines and plovers in flight, continues from
the top onto the four sides and the interiors

of both top and bottom. The slightly sharp
curve of the top dates this piece to the early
fourteenth century, during the Kamakura
period;[1] so too does the decorative motif,
which in its intricacy and power is worthy of a
much larger object.

The *nashiji* on the other *kōgō* (cat. no. 46)
is slightly denser. The top and sides, together
with the interiors of the top and bottom, are
decorated with a design of pampas grass,
gentian, and other wild plants. The more
flamboyant design suggests a date in the
fifteenth century, during the Muromachi
period.

1. Arakawa Hirokazu 1969, p. 64.

47. Jar with Chrysanthemums

Kamakura period (1185–1333), late 13th–early
14th century
Ko Seto ware; earthenware
Height 24.8 cm (9¾ in.)

LITERATURE: Murase 1975, add. no. 113; Pekarik
1978, no. 5; Tokyo National Museum 1985a, no. 86;
Schirn Kunsthalle Frankfurt 1990, no. 128.

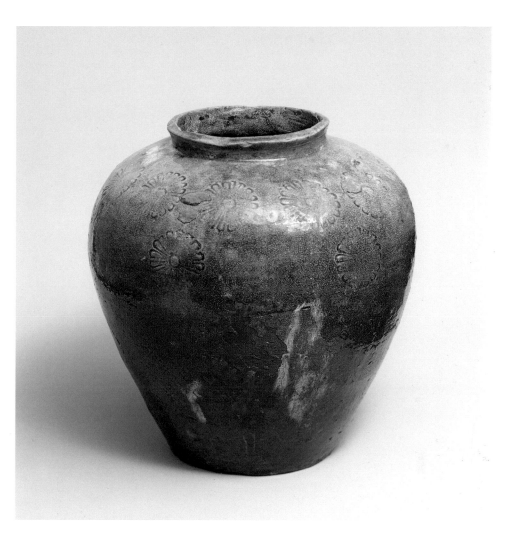

The Seto region, northeast of Nagoya, holds a distinguished place in the history of the ceramics industry in Japan. More than five hundred kiln sites are located just outside the city of Seto, where potters' kilns have been active since the Heian period in the late tenth century, when they produced Sueki (cat. no. 4). So successfully have these kilns functioned over the centuries that in eastern Japan the word "Seto" has become synonymous with ceramics, which are even today referred to as *Seto mono* (Seto things).

It was long believed that in 1223 a certain Katō Tōshirō accompanied the venerable Zen Buddhist monk Dōgen (1200–1253) to China, where he spent five years studying the art of the potter. Several years after his return, in 1243, he is said to have found in Seto a clay particularly suited to forming complex shapes. This story is generally discredited today, though it is undeniable that Seto kilns experienced a burst of activity in the thirteenth century, when they began producing new wares, based on Chinese prototypes, that were innovative in shape and glazing techniques. It has been speculated that the Kamakura *bakufu* may have played a role in this revitalization.[1]

Among the new wares produced were Japan's first high-fired, intentionally glazed earthenwares. These were further enriched by a variety of decorative designs, including appliqués and stamped or engraved patterns, so different from the haphazard ornamentation sometimes found on Heian-period wares. The new ceramics were among the most elegant and sophisticated works produced by the so-called Six Old Kilns of the medieval period: Seto, Bizen, Echizen, Shigaraki,

Tanba, and Tokoname.[2] Seto wares of the Kamakura through the early Edo period are usually called Ko Seto (Old Seto), to distinguish them from later products.

This jar, though probably made for storage, may have been used as a funerary vessel. Many similar ceramic pieces have been found in tombs, where they served as containers for the bones of the deceased. The Burke jar has a wide, slightly flared mouth and a flat base. The shape, which is broad and almost bulbous at the shoulder and tapers toward the bottom in a slow, graceful curve, imparts an overall sense of stability and solidity. The yellow-green glaze reflects the refinement of Japanese glazing techniques that were developed at the end of the thirteenth century.[3] Chrysanthemum motifs are stamped over the entire surface, although the impressions on

the lower half are not easily visible because the glaze has darkened over time. Streaks and spots of dark blue—in this instance, accidentally formed natural-ash glaze—create dramatic variations of color.

Ceramic vessels with wide mouths first appeared in the late thirteenth century. This characteristic, as well as the stamped designs, indicates that the piece was made at the height of Ko Seto production. It therefore dates to sometime between the late thirteenth and the early fourteenth century.[4]

1. Tokyo National Museum 1985b, p. 116.
2. This designation is no longer used, as other major kilns have been identified in recent excavations.
3. Tokyo National Museum 1985b, p. 117.
4. Fujisawa Yoshisuke 1982, pp. 29–56.

IV. Muromachi Period (1392–1573)

CATALOGUE NOS. 48–74

In 1390 the third Ashikaga shogun, Yoshimitsu (r. 1369–95), brought an end to the era of the Northern and Southern courts and established the shogunal headquarters in the Muromachi district of Kyoto, from which the period from 1392 to 1573 takes its name. Despite the intermittent warfare that would continue to plague Japan during this period, Kyoto regained its status as the seat of political power under the Ashikaga shoguns, and cultural activities flourished, especially with the encouragement of Yoshimitsu and the eighth Ashikaga shogun, Yoshimasa (r. 1449–74). Their private villas, Rokuonji (popularly known as Kinkakuji, or the Golden Pavilion), built in 1397 by Yoshimitsu, and Jishōji (Ginkakuji, or the Silver Pavilion; fig. 31), completed in 1489 by Yoshimasa, served as elegant settings for the pursuit of art and culture. Contact with China had been resumed in the Kamakura period, and once again Japanese aesthetics were enriched and transformed by influences from China, particularly the art of the Song and Yuan dynasties (960–1368). As in preceding centuries Buddhism was pervasive, and a new doctrine, Zen, was enthusiastically embraced by the military class and went on to have a profound impact on all aspects of national life, from government and commerce to the arts and education.

Zen (Skt: *dhyana*; Ch: *Chan*), contemplative meditation, without recourse to the promise of salvation offered by Buddhas and bodhisattvas, was a practice that originated in India. According to tradition, Bodhidharma (J: Daruma), a princely monk from South India, introduced the concept of meditation to China in the early sixth century. He is said to have sailed up the Yangzi River on two fragile reeds and to have spent nine years meditating before a rock wall. His teachings, which evolved in China, emphasized self-reliance and mental self-discipline and encouraged adherents to discard traditional rituals and step-by-step approaches to truth and enlightenment. Two practices assisted in breaking the chains of conventional thinking and attaining a deeper awareness of reality: *zazen*, sitting in meditation—an intellectual and physical discipline—and *kōan*, questions and answers of an enigmatic or paradoxical nature. According to a popularly held misconception, Zen is iconoclastic. Indeed, in its pristine form it has no need of scriptures, temples, icons, or the paraphernalia of religious institutions. In practice, however, various arts flourished in its name. The basic outlook of Zen, which emphasizes spontaneity and simplicity, became the guiding principle of its aesthetic doctrine. Architecture provided havens for solitary meditation, and paintings in ink monochrome illustrated dogma or recorded the state of mind in moments of enlightenment. The concept that less is more was certainly not invented by Japanese Zen adherents, but it was central to the arts inspired by Zen.

That Zen was essentially pragmatic and of this world—as opposed to the salvific orientation of Esoteric Buddhism—can be seen in the prominence that Zen ecclesiastics came to attain in the affairs of state, since their familiarity with Chinese Confucianism, the philosophical basis of government, meant that their views and advice were frequently sought by military governors. Zen monks were in turn able to enlist the assistance of feudal landholders in their evangelical works. Zen temples, which maintained direct contacts with their counterparts on the mainland, at least until the Mongol invasions of China in 1260, became active partners in commercial transactions with China, thereby strengthening their own economic power. The frequent travel of Chinese and Japanese monks between the two countries led to cultural interchange, and the monasteries in Japan became centers of Chinese learning and Chinese-inspired arts. Zen flourished under Yoshimitsu, whose love of culture led to extravagant spending sprees, surpassing all but those of Fujiwara Michinaga almost four hundred years earlier. Many of the now-famous Zen monasteries in Kyoto were constructed during his regime.

Yoshimitsu's aesthetic pursuits were matched by those of Yoshimasa, whose mismanagement of government is often cited as

Opposite: Detail of cat. no. 59

Figure 31. Silver Pavilion, Jishōji, Kyoto. Muromachi period (1392–1573), 1489

the direct cause of the decline of Ashikaga authority. Like Yoshimitsu, Yoshimasa spent enormous sums on building projects. One of his major architectural endeavors was the construction of his private retreat at Higashiyama (the eastern hills), which was converted into the temple Jishōji after his death in 1490. One of the buildings on the estate, the Tōgudō, completed in 1483, was a light, graceful structure with a small, square room called the Dōjinsai. Measuring 4½ tatami mats—in Japan the dimensions of a chamber are set by the standard size of a floor mat, or tatami, about 183 by 91 centimeters (6 × 3 ft.)—it is the oldest extant example of the *shoin* (study) style of architecture. The highly ritualized etiquette of succeeding centuries—centered in the *shoin* of residential buildings—had its source in *chanoyu*, the tea ceremony, which was conducted in such simple, unpretentious settings.

In receiving friends for tea at the Dōjinsai, Yoshimasa helped to raise this form of social gathering to a fine art. The tea used in the ceremony, a deep green powdery substance that is whipped, not steeped like English black tea, was introduced from China by Zen monks, who first employed it for medicinal purposes and as a stimulant during the long hours of meditation. In the fifteenth century, at the court of Yoshimasa, a small coterie of highly cultivated men, influenced by Zen ideals, developed the basic principles of the tea aesthetic. Murata Shukō (Jukō, 1423–1502), Yoshimasa's instructor in the art of *chanoyu*, exalted the virtues of simplicity and quiet refinement. He also promoted the paradoxical aesthetic principle of imperfection. As a full moon is more beautiful in a sky shadowed by clouds, a blemish in something that is otherwise perfect enhances its beauty. Thus, what is

imperfect or irregular or fragile is prized, an aesthetic denoted by such terms as *wabi* and *sabi*, two words that are difficult to translate but can be rendered as "forlorn" and "rustic" beauty, respectively.

At its highest level, *chanoyu* involves an appreciation of garden design, architecture, interior design, calligraphy, painting, flower arranging, the decorative arts, and the preparation and serving of food. It is practiced and experienced within the small room in which tea is served. The participant must be relaxed and in a state of mind that will enable attunement to the beauty of the environment. From Yoshimasa's time the accoutrements of tea, as well as such ancillary activities as flower arranging, were systematized and elevated to the level of independent arts. The aesthetic tradition thus established has pervaded Japanese culture since that time.

Chanoyu gave impetus to the development of various crafts during the Muromachi period. Because different utensils were needed for serving both the tea and the light meal (*kaiseki*) that preceded it, many articles were designed especially for this purpose in ceramic, lacquer, wood, bamboo, and metal. The Japanese also delighted in adapting objects originally intended for other purposes to *chanoyu* and *kaiseki*. Negoro ewers, for example—vessels used in temples for pouring water or other liquids—were later employed to serve sake and water at *kaiseki* dinners.

The Nō dance-drama, a subtle, slow-moving stage performance featuring masked and elaborately costumed actors, was also influenced by Zen teachings. Although the Nō theater originated in simple dances performed at Buddhist temples and Shinto shrines, it evolved in the fourteenth century into an extremely refined dramatic art under the patronage of Yoshimitsu.

Among Zen-inspired arts, ink monochrome, or *suibokuga* (picture of water and ink), succinctly expresses a basic tenet of Zen: the achievement of maximum effect with minimum means. In this difficult art form, artists execute the first, and final, version of a work on paper or silk using only black ink and a brush with a pointed tip. Although light washes of color are often added, these paintings are

generally conceived in ink alone. Thus, every pictorial element—form, modeling, tonality, and perspective—is conveyed through brushstrokes and ink wash. The painting may be elaborated through a slow additive process, but once the artist applies the brush, execution is rapid.

During the fifteenth century, the practitioners of *suibokuga* were Zen monks, most of them working for the temples; others painted purely for their own enjoyment or for friends. It should be noted that the works produced in the temples were not intended as religious icons in the traditional sense. At least in theory, painting was regarded as an aid to meditation or a statement of the artist's understanding of truth. The act of painting itself was viewed as a discipline that would assist in the attainment of enlightenment. In this connection, well-known historical and legendary tales from the lives of Zen patriarchs figure importantly in the ink-painting repertory.

Ink paintings of Buddhist deities contrast starkly with traditional treatments of Buddhist subjects, which were brightly colored and often embellished with gold. Kannon, for example, undergoes a radical metamorphosis in the Zen context. No longer the compassionate savior of traditional Buddhist iconography, he becomes a remote, meditative figure (cat. no. 49). Some early ink painters, such as Reisai (cat. no. 54), who were trained in traditional Buddhist painting, either switched to ink monochrome or worked occasionally in the new genre. Most of the painters who worked in both styles, polychrome and ink monochrome, were employed at Tōfuku-ji, an important Zen temple in Kyoto. Tōfuku-ji must have had a sizable collection of Chinese paintings, which Reisai, his teacher Kichizan Minchō (1352–1431), and his slightly older colleague Sekkyakushi (cat. no. 53) no doubt had occasion to study.

Very different from the Tōfukuji painters were the erudite monk-painters, who maintained close communication with their Chinese counterparts. This enabled them to acquire a firmer grasp of Zen doctrine and the principles of ink monochrome than did the members of the Tōfukuji group. The social

background and education of these monks were also considerably superior, and, in turn, their paintings manifest an intimate knowledge and better understanding of Yuan Chinese prototypes, which were executed in a free, spontaneous style. Among the older generation of monk-painters, Kaō and Mokuan Reien (both fl. early 14th century) had both studied Zen in China, and like other scholarly monks trained in Zen and Chinese literature they composed poems in the Chinese style, which they inscribed on their paintings of birds, plum blossoms, orchids, and bamboo.

A turning point in the history of Japanese ink painting occurred at the beginning of the fifteenth century, when landscape itself became the most prominent subject. Inspired by Southern Song Chinese prototypes, artists began to paint romantic, idealized landscapes, with heavy mists and evocative spaces. The evolution of this type of painting closely paralleled the development of the art of Shūbun (see cat. no. 61), a monk at Shōkokuji, where he also served as controller and as the Ashikaga shogun's official artist.

To Shūbun are attributed many *shigajiku*, vertical scrolls with a landscape or birds and flowers painted at the bottom and, inscribed at the top, in the Chinese style, with poems by erudite monks. Learned monk-scholars of this time, many of them prominent abbots at notable Zen temples, emulated the example set by Chinese scholar-officials. As the scholar-officials had done for centuries before them, they too aspired to escape the worlds of the court and of the cities and to take up instead a life of meditation in the peaceful surroundings of nature. They commissioned artists to paint images that would evoke the state of enlightenment or, meeting with friends at poetry gatherings, they would inscribe poetry on paintings and extol the virtues of the contemplative life.

The earliest *shigajiku* allow considerably more space to the inscribed verses than to the painted image, which was often squeezed in at the bottom of the scroll. This imbalance is indicative of the distinction between the scholarly monks and the monk-painters. In all but a few cases, those who composed the verses

were eminent and highly educated men who occupied important posts, while the painters, of modest circumstances with little formal education, were unknown and hence accorded little space; indeed, their names are seldom mentioned in official records.

The next phase in the development of ink painting coincides with the life and oeuvre of the great master Sesshū Tōyō (1420–1506), who expanded Shūbun's efforts in landscape painting. By the late fifteenth century Ashikaga power was in decline, and with that decline Kyoto's prestige as Japan's cultural center faded. In Sesshū's time, the art of ink painting spread to the provinces of the north and south, in some instances leading to the establishment of schools with a distinctly local style. Artists from eastern Japan, with the center in Kamakura, are now being accorded long-deserved recognition, and are grouped under the rubric of the Kantō (eastern Japan) school. Among the most prominent artists of this school is Sesson (cat. nos. 67–69).

The last phase of ink painting saw the rise of the Kano school, which endured without interruption for four hundred years. Its founder, Kano Masanobu (1434–1530), was the last official painter to be engaged by the Ashikaga shoguns. Masanobu appears to have come from Kantō, and his background differs considerably from that of his predecessors at Shōkokuji. He had little schooling in Zen, but was trained as a painter of traditional Buddhist icons and portraits in the colorful polychrome style. Masanobu's versatile talents and flexibility supplied the key to the success of the Kano school. After the Ashikagas lost their supremacy, political power shifted from faction to faction, but Masanobu managed to maintain his preeminence, serving a succession of powerful warlords.

The legacy of the Ashikaga shogunate was the pervasive influence of Zen in Japanese culture. Without Zen, such ancillary arts as *chanoyu*, flower arranging, the Nō dance-drama, and the code of conventions and formal etiquette that characterizes modern life in Japan either would not have come into existence or would have taken very different forms from those that prevail today.

48. Mandala of Han'nya Bosatsu

Muromachi period (1392–1573)
Hanging scroll, ink, color, and gold on silk
Overall, with painted mounting, 211.4 × 146.6 cm
(83¼ × 57¾ in.); image 163.9 × 123.6 cm (64½ × 48⅝ in.)

Figure 32. Diamond World and Womb World mandalas, 2nd half of 9th century. Hanging scrolls, ink and color on silk. Tōji, Kyoto a. 185.5 × 164.2 cm (73 × 64⅝ in.) b. 183.6 × 163 cm (72¼ × 64⅛ in.)

The iconography of Esoteric Buddhism is the most elaborate and complex in the Buddhist tradition. The rich multitude of its icons and deities is most comprehensively represented in two mandalas, the Womb World (*Taizōkai*) and the Diamond World (*Kongōkai*), which together are the fundamental manifestation of the cosmic world. The earliest extant pair in Japan, which are characteristic of the type, in Tōji (Kyōō Gokokuji), Kyoto, are believed to be a ninth-century copy of a late Tang Chinese original (figs. 32).[1]

Han'nya Bosatsu (Skt: Prajnaparamita), the embodiment of transcendental knowledge and perfect wisdom, appears with six arms in the Womb World mandala in the *jimyōin* (Hall of Vidyadhara), below the central section of the *hachiyōin* (eight-petaled lotus).[2] The principal icon in this section, Han'nya Bosatsu is flanked by two figures on each side: on the right by Gōzanze Myōō (Vajrahumkara) and Fudō Myōō (Achala), and on the left by Daiitoku Myōō (Yamantaka) and Shōzanze Myōō (Trailokyavijaya).

In the Burke mandala, a two-armed Han'nya Bosatsu is the central icon of the entire painting.[3] Attended by Bonten (Brahma) and Taishakuten (Indra), originally two of the three highest-ranking gods of Hinduism,

he is enshrined as if on an altar. In accordance with iconographic descriptions of Han'nya Bosatsu in the *Darani Jukkyō Sutra* (Collection of Magical Spells), the bodhisattva's Sixteen Protectors (J: Jūroku Zenshin) appear within the surrounding register, the Demonic Guardians (J: Kijin) in the outer register.[4] Heavenly music-making *hiten* are shown at the top, and Chinese-style dragons and a phoenix along the outer borders serve to protect this abstract, yet highly representational, realm. The directional gates provide entrance from the secular to the sacred precinct. The outer borders, painted in red with floral decoration, recall the borders of the Womb World mandala at Tōji.

The meditative containment of the three central figures enhances the devotional quality of the image. The painting is rendered in intense malachite green and azurite blue, to which has been applied patterns in cut-gold foil (*kirikane*). The ritual implements, gates, and robes are richly represented in gold pigment over areas raised by a buildup of red-colored shell powder (*moriage*). These technical features are characteristic of mandalas of the Muromachi period.

The Bosatsu is portrayed seated on a lotus pedestal on the back of a lion. In his left

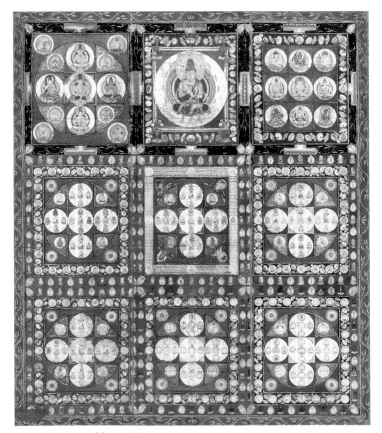

a. Diamond World mandala

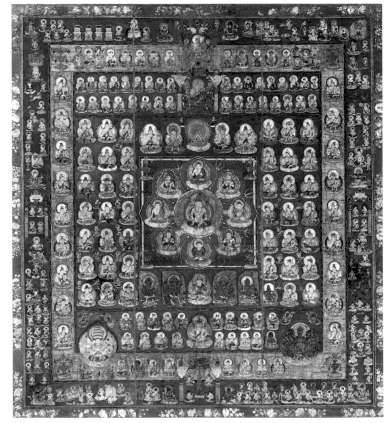

b. Womb World mandala

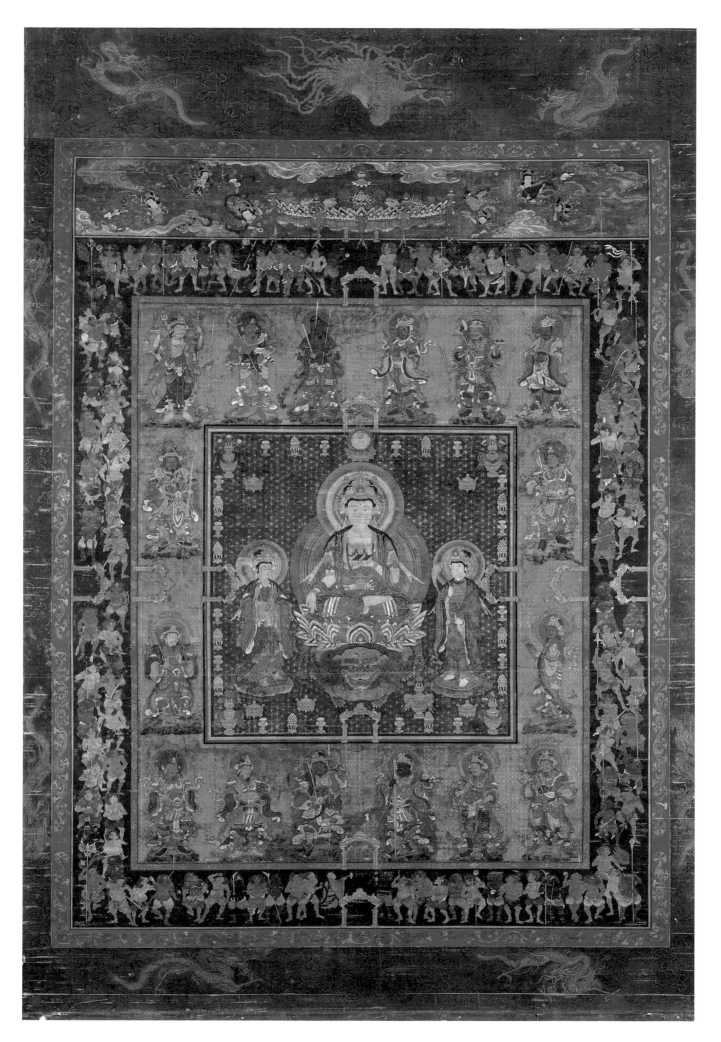

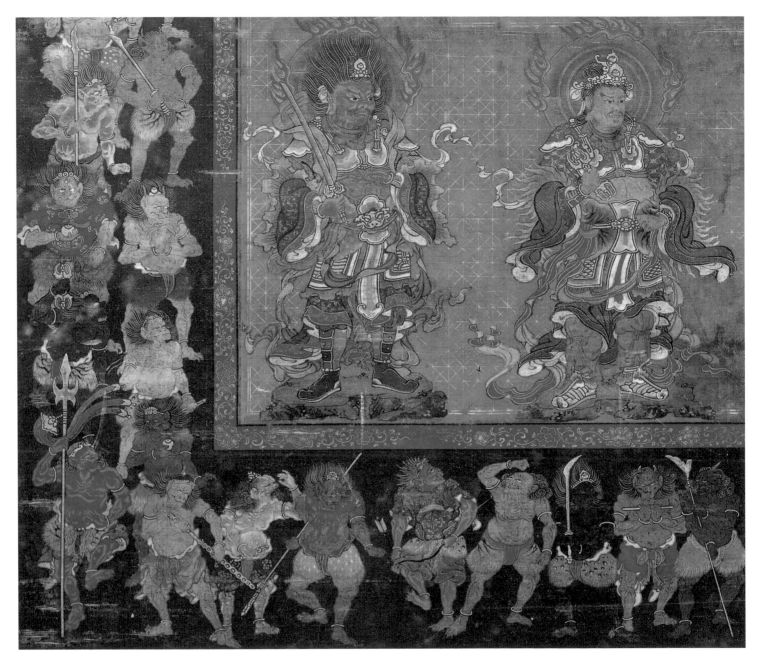

Detail of cat. no. 48

hand is a sutra box, while his right hand is held in the *seganin* mudra, sign of the fulfilling of the vow. Following the description in the *Darani Jukkyō*, he has a white body and wears a jeweled crown; the text does not mention the flaming jewel above his head. The text refers to the Bosatsu as Mother of All Buddhas (Han'nya Butsumo), and the description is that of a heavenly female.[5] It is often difficult in Japanese mandalas to discern whether Han'nya Bosatsu is male or female, in contrast to the explicit manifestations of the bodhisattva in the Indian and Tibetan Tantric traditions. The iconography of Bonten and Taishakuten in the present work is similarly faithful to the descriptions in the *Darani Jukkyō*.

The Sixteen Protectors are identified by their descriptions in the *Han'nya shugo jūroku zenjinnō gyōtai* (Iconographic Manual of the Appearance of the Sixteen Protectors for the Perfection of Wisdom).[6] They comprise the Four Guardian Kings—Kōmokuten, Tamonten, Jikokuten, and Zōchōten—who guard the west gate, the front gate of the central altar at the bottom of the central square—and twelve additional Protectors, four each guarding the north, east, and south gates. Their names and distinctive iconographic features are listed below in a clockwise sequence, beginning with the Protector at the left of the west gate.[7]

Daitorada Zenjin, also known as Jikokuten, with greenish blue body, large sword, and spear.

Birurokusha Zenjin, also known as Zōchōten, with *vajra* (thunderbolt) and left fist at hip.

Saifuku Dokugai Zenjin (Subjugator of Evil Impediments), with red body, three-pronged sword, hair standing on end, and left hand at chest.

Zōyaki Zenjin (Increaser of Merit or Bestower of Merit), with four arms, three-pronged sword, crescent moon, willow branch, and wheel disk.

Kanki Zenjin (Great Joy), with green body, peacock headdress, halberd, and left fist at hip.

Jo Issai Shōnan Zenjin (Eliminator of Obstacles), with six arms, three-pronged halberd, three-pronged staff, sutra text, stupa, red lotus flower, and conch.

Batsujo Zaiku Zenjin (Remover of Defilements), with red body, five-pronged staff, and right fist at head.

Nōnin Zenjin (Excellence in Endurance), with blue body, hood on head, three-pronged sword, and spear.

Yumō Shinchi Zenshin (Wellspring Ground of Fierce Courage), with mudra *gebaku ken-in* (outer-bonded fist), in which palms join with fingers interlocked.[8]

Shishi Imō Zenjin (Leonine Awe-Inspiring Majesty), with four arms with axes, lion-headed crown, sword, sutra box, and trident.

Nōku Shou Zenjin (Able to Save the Myriad Existences), with mudra of worship (*koshin gasshō*, Clasp of the Empty Heart).[9]

Shōfuku Shoma Zenjin (Subjugator of the Myriad Evils), with hair standing on end, three-pronged sword, and left hand open.

Kugo Issai Zenjin (Savior and Protector of All Sentient Beings), with mudra of worship and red lotus flower.

Ri Issai Fui Zenjin (Free of All Fear), with three-pronged skull on head, single-pronged *vajra*, and left fist at hip.

Birubakusha Zenjin, also known as Kōmokuten, with brush and scroll.

Beshiramanu Zenjin, also known as Tamonten, with bluish body, *vajra* staff, and stupa.

The compositional structure of the mandala describes a gradual shift in the degree of iconic divinity from the center to the outer registers. The symmetrically arranged triad at the center inhabits the most sacred precinct. The Sixteen Protectors are more loosely distributed and their poses are more natural, reflecting their closeness to the secular realm. The seven thousand Demonic Guardians that protect each of the Sixteen Protectors inhabit the outermost register; profane creatures, they are far from the center of divinity. At the bottom center of the outermost register is the figure of a monk at worship, evoking the physical world of time and space. Thus the hierarchical structure of the world of Han'nya Bosatsu. MW

1. Yanagisawa Taka 1982, pp. 123–33.
2. Another manifestation of Han'nya Bosatsu appears in the Diamond World mandala, where the deity is known as Han'nya Butsumo (Mother of All Buddhas). See Sawa Ryūken 1962, pp. 97–98; and Ueda Reijō 1989, pp. 463–65.
3. Hayashi On (1988, pp. 75–95) suggests that the two-armed Han'nya Bosatsu was used for the *Han'nya Shingyōhō*, the ceremonial recitation of the *Han'nya Shingyō* (Heart Sutra), while the six-armed Han'nya Bosatsu was the main icon for the *Han'nya Bosatsuhō* (Han'nya Bosatsu Rites). The Burke painting is perhaps an indication of the continuation of the *Han'nya Shingyōhō* in the Muromachi period.
4. *Daizōkyō* 1914–32, vol. 18, no. 901, pp. 804–12.
5. In the Indian and Tibetan Buddhist traditions, Prajnaparamita (Han'nya Bosatsu) is a goddess. See Bhattacharyya 1924, pp. 84–86; and Saraswati 1977, pp. L–LI. I wish to thank Dr. Steven Kossak, of the Metropolitan Museum, for providing me with this particular iconography.
6. *Daizōkyō* 1914–32, vol. 21, no. 1293, p. 378.
7. A twelfth-century compilation of iconographic drawings, *Besson zakki*, represents an almost identical iconography of the Sixteen Protectors. *Daizōkyō zuzō* 1932–34, vol. 3, pp. 311–27. I am indebted to Dr. Frederic Kotas, Asian Studies, Cornell University, for translations of the names of the Sixteen Protectors.
8. Saunders 1985, p. 119.
9. Ibid., pp. 40, 72, 78.

49. White-Robed Kannon

Muromachi period (1392–1573), early 15th century
Hanging scroll, ink on silk
114.6 × 53.2 cm (45⅛ × 21 in.)
Ex coll.: Chauncy Griggs, Tacoma, Washington

LITERATURE: Ford 1985, fig. 1; Tokyo National Museum 1985a, no. 19; Schirn Kunsthalle Frankfurt 1990, no. 35.

Surviving the general expulsion of a vast number of orthodox icons from the pantheon of Buddhist images following the introduction of Zen Buddhism in the late Kamakura period, White-Robed Kannon (Skt: Pandaravasini) emerged as one of the most popular figures of Zen-inspired Japanese ink painting. Precisely how Kannon (Skt: Avalokiteshvara), the bodhisattva of compassion, came to be represented in his most human manifestation as white-robed is not known, although the scriptural source can be identified as the Gandavyuha chapter (J: Nyūhokkaibon) in the *Daihōkōbutsu kegongyō*, the principal text of the Kegon (Skt: Avatamsaka) sect. This describes the deity as seated on a rock in the "pristine" environment of Mount Potalaka (J: Fudarakusan), the mythical peak at the southern tip of India.[1]

Kannon is known in many manifestations. Endowed with a large, moonlike halo, he is usually identified as Suigetsu, or Water Moon, Kannon. If a branch of the medicinal weeping willow is shown beside the deity or in his hand, he is known as Yōryū, or Weeping Willow, Kannon. The Byakusho, or White Place, Kannon of Esoteric Buddhism makes reference to Kannon's abode, a pure and pristine—that is, white—place. Byakue, or White-Robed, Kannon seems to have evolved together with these other forms, and it is often difficult to distinguish one from the other, since their attributes are not always clearly defined and the scriptural description is brief.[2] The depiction of Byakue Kannon in ink probably became popular not long after the ink-monochrome technique developed into the major mode of artistic expression in China, in the tenth century. The earliest example of White-Robed Kannon in ink monochrome is associated with the Chinese literati painter Li Gonglin (ca. 1041–1106) and is preserved only in the form of a stone rubbing in the Liuheta (Pagoda of Six Harmonies) at Hangzhou, in South China.[3] The scriptural description of Suigetsu Kannon does not include many standard elements found in his pictorial representation, such as bamboo, pine trees, a waterfall, and relaxed pose. These elements, which later supplied a source for the representation of

Suigetsu-Byakue Kannon, seem to have originated in Chinese depictions of Daoist immortals and scholar recluses.[4]

The earliest extant image of Byakue Kannon and by far the greatest representation in ink is by the Chinese Chan monk-painter Muqi, who was active from the late thirteenth to the early fourteenth century. Muqi's painting, now in Daitokuji, Kyoto, depicts Kannon seated on a rock in a white gown and absorbed in deep meditation. The setting is suggested by expanses of ink wash. Beside the bodhisattva is a small willow branch in a vase, and before him waves beat against the rocky shore. Overhanging vegetation closes off the narrow, ravinelike space.[5] This contemplative image, in which the bodhisattva's human nature outweighs his divinity, was especially meaningful for monks pursuing the path to enlightenment, and Muqi's composition inspired countless paintings on the same theme by Zen artists in Japan.

The White-Robed Kannon in the Burke Collection is shown seated on a large rock near a vase containing a willow branch. A waterfall can be discerned through the bodhisattva's moonlike halo. Tree branches arch above the still figure, and waves lap at his feet. Kannon's head is uncovered here and his pose is strictly frontal, but in all other respects the composition follows Muqi's model. Broad ink washes loosely define the setting and highlight the long, sharp folds of drapery. The lively plashings of the waves upon the rock counterbalance the quiet, inward mood of contemplation.

There is neither a signature nor an artist's seal on this painting, although an inscription on the box ascribes it to a late-thirteenth-century Chinese artist named Yuehu, to whom many Japanese paintings depicting Byakue Kannon have been attributed.[6]

A number of stylistic features suggest that the painter of this scroll may have been associated with Ryōzen of Tōfukuji, a professional Buddhist painter active from 1348 to 1355. A depiction by Ryōzen of Byakue Kannon at Myōkōji, Ichinomiya (Aichi Prefecture), also shows the subject in the strictly frontal, iconic pose of the traditional Buddhist images.[7] In both paintings, too, the

folds of the drapery are clearly defined by linear brushstrokes, the shore extends like tapering fingers into the water, and the swelling waves have rough crests.[8]

The Burke Kannon may be tentatively dated to the early fifteenth century, shortly before landscape became the most popular subject for ink painting in Japan. Perhaps trained, like Ryōzen, as a Buddhist painter, the artist may have been experimenting here with ink monochrome, a medium only recently introduced from China.

1. *Daihōkōbutsu kegongyō*, in *Daizōkyō* 1914–32, vol. 10, no. 279.
2. An image engraved on a bronze mirror found inside the statue popularly known as Seiryoji Shaka, dating to before 985, at Seiryoji, Kyoto, is often cited as the earliest extant example of Byakue Kannon, since Chōnen, who commissioned the work from Chinese sculptors, so identified it on the document of his commission. It is, in fact, a representation of Suigetsu Kannon. See Maruo Shōzaburō 1966, vol. 1, p. 58, for the document, and vol. 2, pl. 55, for the mirror.
3. Tokiwa Daijō and Sekino Tei 1975, p. 52.
4. Yamamoto Yōko 1989, pp. 22–38.
5. Y. Shimizu and Wheelwright 1976, fig. 50.
6. *Kundaikan sōchōki*, in *Sadō koten zenshū* 1967, vol. 2.
7. Y. Shimizu and Wheelwright 1976, fig. 5.
8. For other examples of Byakue Kannon from the Tōfukuji school, see Kyoto National Museum 1986.

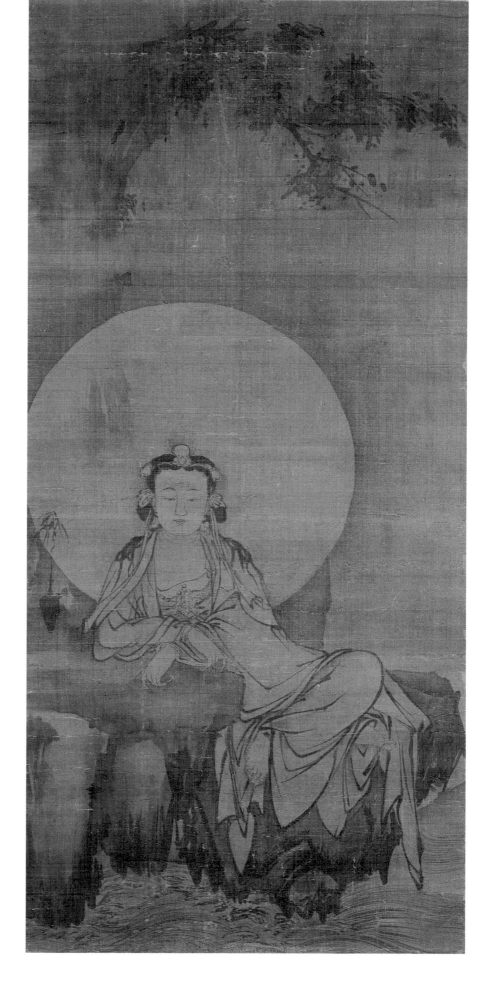

50. Geese and Reeds

Muromachi period (1392–1573), late 14th century
Hanging scroll, ink on paper
49.9 × 29 cm (19⅝ × 11⅜ in.)

LITERATURE: Etō Shun 1969a, pp. 83–84; Murase 1975, no. 25; Y. Shimizu and Wheelwright 1976, no. 29; Brinker and Kanazawa Hiroshi 1996, fig. 124.

Paintings of geese and reeds allude not only to the seasonal change from late autumn to early winter, when water reeds reach the end of their growing season and geese fly south, but also to the passage of time on a larger scale, from the past to the future. The theme of geese and reeds in painting is believed to have originated in South China, in the provinces of Zhejiang and Hunan,[1] an area of lakes and rivers where waterbirds have long been a favorite subject for painting. Legend has it that the Indian monk Bodhidharma, sailed down the Yangzi River on a pair of reeds to spread Chan Buddhism in China, and perhaps for this reason paintings of reeds, together with the geese that inhabited them, were regarded as essential decoration in Chan temples. Early Chinese representations of the theme were executed in polychrome, but beginning in the eleventh century such scenes were increasingly depicted in ink monochrome.

A catalogue of the Hōjō family collection of Chinese treasures indicates that Chinese paintings of geese and reeds had reached Japan by the early fourteenth century,[2] and about the same time the theme was introduced into the repertory of Japanese painting in the form of monochrome-ink decoration on screens represented in Buddhist paintings and handscrolls. Shortly thereafter, Tesshū Tokusai (cat. no. 44) painted the first known Japanese renditions of this subject in ink monochrome.

In the present painting, three geese are seen sheltering among stalks of reeds near the edge of a lake. One has tucked its head into its feathers for warmth, while the other two crane their long necks, beaks open, as though attracted by some movement in the sky. The unknown artist displays a highly sophisticated understanding of the genre. The soft, watery brushstrokes that define the plumage, the bank of the lake, and the rocks are executed with a confidence that imparts a tactile impression of moist earth and feather

down. The reeds are drawn in dry, sketchy lines to emphasize their brittle fragility. It has been suggested that the scroll may originally have had greater height and may have included an inscription.[3] In keeping with the practice popular at the time, it may also have been paired with another scroll, which would have depicted the geese in flight, bringing the seasonal cycle to completion.

The scene is painted on a paper that is imprinted in the upper right corner with a graceful bouquet of lotus flowers and orchids. The wax-based technique used to create the design was popular in China during the Song and Yuan dynasties (960–1368), and paper decorated in this manner has always been considered Chinese. Because of its greater technical virtuosity when compared with other early ink paintings, such as *Wagtail on a Rock* (cat. no. 43), the Burke scroll was once considered Chinese.[4] In the last twenty-five years, however, many works of the early Muromachi period have been uncovered, enabling a better understanding of the ink monochrome of this period and the reattribution of a number of works to Japan. A Japanese painting in the Gunma Museum of Modern Art, Takasaki, one of a pair, bears a very close compositional similarity to the present work.[5] Both paintings of the pair include colophons by Yishan Yining, a Chinese Chan Buddhist monk who died in Japan in 1317. The paintings in the Burke and Nakamura collections may have been based on a common model, possibly Chinese. A highly refined and technically advanced work, the Burke scroll may be dated to the late fourteenth century.

1. See Y. Shimizu and Wheelwright 1976, no. 29, for a discussion of the theme and its history in China.
2. They are listed in the *Butsunichian kumotsu mokuroku*; see Kamakura-shi Shi Hensan Iinkai 1956.
3. Y. Shimizu and Wheelwright 1976, p. 218.
4. Etō Shun 1969a, p. 84; and Murase 1975, no. 25.
5. Ebine Toshio 1994, pl. 41. This pair is also painted on imported Chinese paper.

51. Orchids, Bamboo, and Brambles

Muromachi period (1392–1573), after 1413
Pair of hanging scrolls, ink on paper
Each scroll 89.4 × 31.9 cm (35¼ × 12½ in.)
Signature: *Gyokuenshi hitsui* [on the scroll at right]
Seal: *Gyokuen* [on each scroll]

LITERATURE: Nakamura Tanio 1966, pp. 105–8; Shimada Shūjirō 1969, vol. 1, p. 102; Asia Society 1970, pp. 128–29; Murase 1975, no. 28; Kinoshita Masao 1979, figs. 163, 164; Ford 1985, fig. 6; Schirn Kunsthalle Frankfurt 1990, no. 32.

Wild orchids growing in quiet mountain settings came to symbolize for the Japanese the morally upright scholars of ancient China who resided in remote mountain dwellings. In these scrolls painted by Gyokuen Bonpō (ca. 1348–ca. 1420), long orchid fronds surround young sprigs of bamboo, and the flying-white technique (*hihaku*), in which the white paper shows through the strokes made by the spreading bristles of the brush, is employed to create a kind of vase at the base of the plant to hold the floral arrangement. The staccato rhythm of the prickly thorns is echoed in the ebony patches of moss on the rocks and in the tiny black centers of the orchid blossoms. The strong asymmetry of the composition, produced by the movement of the leaves in opposite directions, suggests that the scrolls were painted as a diptych.[1] The artist's signature appears on the scroll at the right, just above the seal; the scroll at the left bears only a seal.

We know from descriptions of bamboo and orchid paintings in such works as the *Kūgeshū*, an anthology of poems by the fourteenth-century Zen monk-poet Gidō Shūshin (1325–1388), that similar compositions were quite common for the diptych format.[2] Bonpō's composition is not dissimilar to those of his older contemporary Tesshū Tokusai (cat. no 44), a Zen monk-painter who may have directly influenced his work.

Bonpō appears to have specialized in the genre of wild orchid painting; other subjects are seldom associated with his name. The persistent repetition of one subject—orchids by Bonpō and Tesshū Tokusai, and birds by Taikyo Genju (cat. nos. 43, 44)—was likely perceived as a kind of spiritual discipline, parallel to the attempt to discover truth through prolonged and repeated meditation. Bonpō's devotion to the subject spans nearly half a century. More than twenty of his orchid paintings are known today; one of these he painted at the age of twenty-six for his ailing teacher, Gidō Shūshin.[3] It is widely accepted that although he never traveled to China, his work is indebted to the orchid paintings of the mid-fourteenth-century Chinese monk Puming, generally acclaimed as the greatest of all orchid painters, whose

paintings he may have seen in Japanese collections.[4] Bonpō's style is perhaps more directly related to that of Tesshū, as it tends to move away from the naturalism of Chinese paintings toward a more pronounced decorative patterning.

Bonpō was renowned in his lifetime as a monk, a poet, and a painter.[5] He was sent, at the age of about ten, to study Zen with the great master Shun'oku Myōha (1311–1388) at Tenryūji, Kyoto. Gidō Shūshin, his teacher of literature, refers to him in his diary about 1370, when the young monk was twenty-two and working under the religious name Gyokkei at Tōshōji, Kamakura.[6] Some three years later Bonpō changed his name to Gyokuen, which he used for the rest of his life. When Gidō Shūshin left Kamakura for Kyoto in 1380 to become abbot of Ken'ninji, Bonpō appears to have accompanied him. Prompted, perhaps, by the death of both his teachers, Shun'oku Myōha and Gidō Shūshin, in 1388, Bonpō departed the capital shortly thereafter, taking up the post of abbot of Eikōji, on the southern tip of Honshū Island. He later transferred to Kyūshū to become abbot of Manjuji.

Bonpō must have returned to Kyoto at the beginning of the fifteenth century, when his name begins to appear frequently in colophons inscribed on *shigajiku* (hanging scrolls with poetry and painting), together with the names of other eminent monk-poets in the capital. In fact, nearly all the extant *shigajiku* of the early fifteenth century—only about a dozen—bear inscriptions by Bonpō. With only a few exceptions, the paintings are not by Bonpō, but attributed traditionally to such artists as Josetsu, Minchō, and Shūbun, pioneers of landscape painting in the early Muromachi period. The *Saimon shingetsu zu* (New Moon over the Thatched Gate), dated 1405 in the Fujita Museum, Osaka, is the earliest extant *shigajiku* that bears a colophon by Bonpō;[7] the last dates to about 1420.

Bonpō prospered during the first years of the early fifteenth century in Kyoto, where he served as the abbot of two of the most prestigious Zen temples in Japan: Ken'ninji until 1409, and Nanzenji in 1413. Apparently, he retired soon after 1413, when he moved to Chisokuken, a small subtemple within the

Ryūgein of Nanzenji. A Bonpō seal bearing the name Chisokuken, which appears on paintings with many of the artist's inscriptions, indicates that he was still at Nanzenji in 1418.

Bonpō briefly enjoyed the friendship and patronage of the fourth Ashikaga shogun, Yoshimochi (r. 1395–1423) and was for a period his instructor in Zen, but for some unknown reason, he aroused the shogun's displeasure and was forced to take refuge in a small temple in nearby Ōmi Province (Shiga Prefecture). The only record of his last days, a short letter he wrote to a friend in 1420, states that having provoked Yoshimochi's anger he has decided to withdraw to a small temple, and as he is seventy-three years old he does not expect to live much longer. Bonpō died, probably in Ōmi, most likely soon after 1420.

All of Bonpō's inscriptions on the *shigajiku* include both his full name and his seal, which reads "Gyokuen." Occasionally, additional seals also appear. In 1413, he changed the character for "en" in "Gyokuen."[8] Although he adopted the new spelling for both his signature and his seal on the *shigajiku*, he seems to have retained the old spelling of the signature on his paintings of orchids, thus clearly distinguishing the works he made for official functions from those he did for his own pleasure. This pair of orchid paintings date to the post–1413 group, in which the seal is written in the new way, while the signature retains the old spelling.

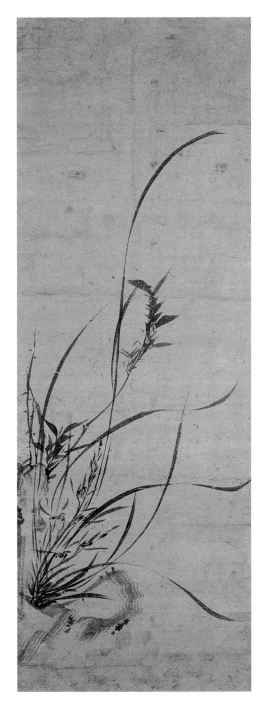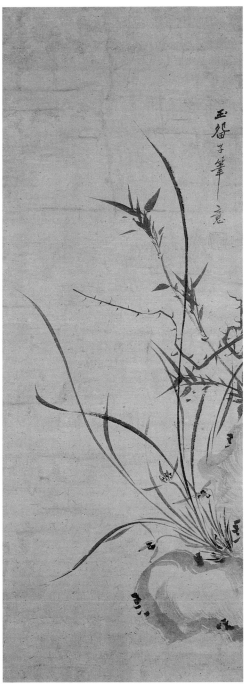

1. Nakamura Tanio 1966, pp. 105–8.
2. *Kūgeshū*, in Kamimura Kankō 1936, vol. 2, p. 594.
3. Ca. 1373, *Kūgeshū*, in ibid., p. 723.
4. Gidō Shūshin mentions Puming's orchid painting in 1385. See his *Kūge rōshi nichiyō kufū ryakushū*, in *Shiseki shūran* 1917–30, vol. 2, p. 260.
5. For biographical data on Bonpō, see Kumagai Nobuo 1933, pp. 95–113; Hoshiyama Shin'ya 1976, pp. 33–57; and Y. Shimizu and Wheelwright 1976, no. 34.
6. *Kūge rōshi nichiyō kufu ryakushu*, in *Shiseki shūran* 1917–30, vol. 3, pp. 55, 57, and 104.
7. Matsushita Takaaki and Tamamura Takeji 1974, pl. 2, fig. 1.
8. Usui Nobuyoshi 1961, pp. 36–39; see also Hoshiyama Shin'ya 1976, p. 44.

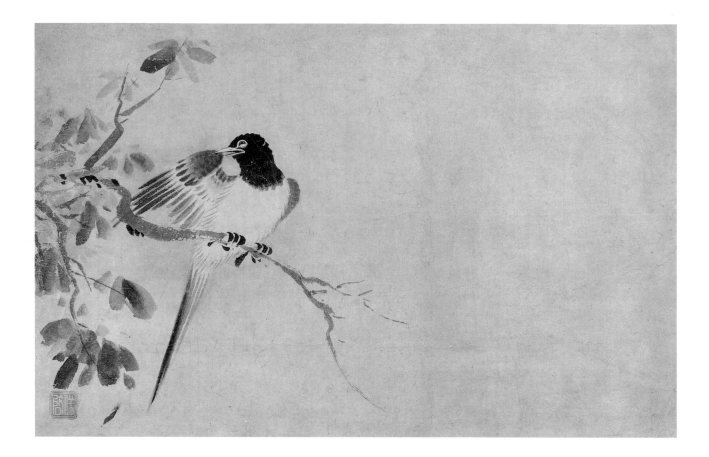

KENKŌ SHŌKEI (FL. CA.1470–CA.1518)

52. *Pair of Wagtails*

Muromachi period (1392–1573)
Pair of hanging scrolls, ink on paper
Each scroll 38.5 × 58 cm (15⅛ × 22⅞ in.)
Seal: *Shōkei* [on each scroll]

LITERATURE: Kanagawa Prefectural Museum of
Cultural History 1972, fig. 62; Murase 1975, no. 37;
Etō Shun 1979, no. 67; Nakamura Tanio 1985,
p. 131; Tochigi Prefectural Museum and Kanagawa
Prefectural Museum of Cultural History 1998,
p. 181, fig. 20.

Two wagtails, captured by Kenkō Shōkei
(fl. ca. 1470–ca. 1518) in a moment of lively
animation, perch on bare tree limbs that ex-
tend into empty space. The pictorial elements
in these two paintings are beautifully and
subtly contrasted. In the scroll at the right the
branch turns sharply upward, the wagtail, its
body nimbly twisted, poised to swoop down on
some unseen prey, while in the scroll at the
left the bird is shown upright on a downward-
bending limb. The eye is directed both verti-
cally and horizontally, from the narrow,
pointed leaves and old gnarled stump at the
right to the broad leaves of the young tree at
the left, and from the bird perched in cheer-
ful repose to the bird craned in sharp-eyed
readiness.

The exclusive use of the *mokkotsu* (bone-
less) method, a style of painting that employs
broad, supple brushstrokes without ink out-
lines, occurs only rarely in Shōkei's oeuvre.
His bird-and-flower paintings, in particular,
are usually executed in the minutely detailed
polychrome style characteristic of the Impe-
rial Painting Academy of Song China.

A triptych by Keison, one of Shōkei's
pupils (see cat. no. 65), which depicts Huineng

(J: Enō), the sixth Chan patriarch, includes
in the side panels wagtails that duplicate,
with postures reversed, those in the Burke
diptych.[1] The format of the Keison scrolls
suggests that the Shōkei paintings may origi-
nally have been intended as a triptych with
a center scroll representing a Zen subject.
The present, horizontal format is most likely
the result of remounting, perhaps to adapt the
panels for hanging in a large, palatial setting.
Each scroll shows a seam about 35.6 centime-
ters (14 in.) from the outer edge, to which
another sheet of the same paper is joined.
This would suggest that the two paintings
were originally vertical scrolls with a large
empty space above the image. In remounting,
the paper at the top was cut away and re-
placed at the sides, forming a horizontal. The
triptych format, with the central scroll illus-
trating a Zen theme, could explain Shōkei's
departure from his usual manner for the secu-
lar bird-and-flower genre in favor of ink
monochrome and rapid-brush technique, a
style more appropriate to the expression of
Zen inspiration. The Burke scrolls are stylis-
tically among the most sophisticated of
Shōkei's bird-and-flower paintings;[2] they are

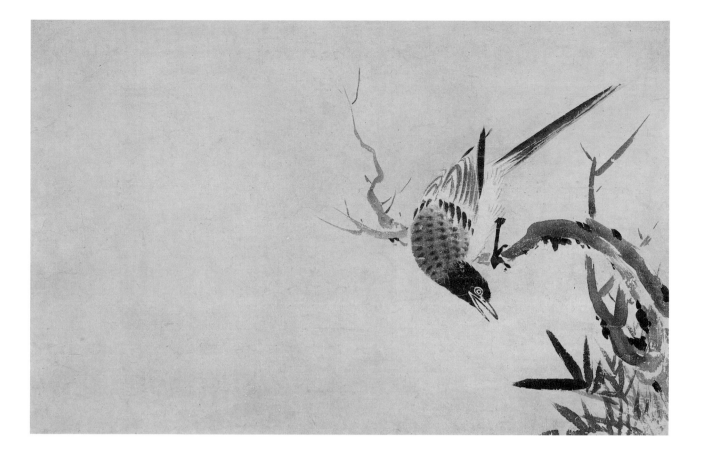

dated, for this reason, to the late period in his career.[3]

Like all ink painters of the Muromachi period, Shōkei was a Zen monk. He worked as a *shoki*, or scribe, at Kenchōji, Kamakura; Keishoki, the more familiar name by which he is known, combines the "kei" of his own name with that of his position, *shoki*. Shōkei may have studied at Kenchōji with Chūan Shinkō (fl. ca. 1444–57), a leading master of ink monochrome in the Kamakura region, who held a high position at that temple. The turning point in Shōkei's career was a three-year sojourn in Kyoto. In 1478 he traveled to the capital, where he came under the tutelage of Geiami (1431–1485), an artist and cultural adviser to the Ashikaga shoguns as well as the curator of their painting collection. Impressed by Shōkei's artistic talent, Geiami invited the young painter to copy all the Chinese paintings in the shogunal collection.[4] In 1480, when Shōkei was preparing to return to Kamakura, Geiami presented him with one of his own paintings, *Waterfall Viewing*, now in the Nezu Institute of Fine Arts, Tokyo. The presentation of a painting by a master to his pupil was in effect the conferring of a cer-

tificate attesting to the successful completion of study, and in fact an inscription on Geiami's painting by Ōsen Keisan (1429–1493) describes the presentation as such.

Shōkei perhaps decided to return to Kamakura with the idea of revitalizing art in that city. In cultural, political, and religious affairs Kamakura had enjoyed a period of dominance over Kyoto in the thirteenth and fourteenth centuries, but in the late fifteenth century the city was in decline. Although few documents survive to shed light on his activities after his return, it would appear that Shōkei established an atelier where he had a number of students, as the names of many painters from the Kamakura region include the "kei" of Shōkei's name. Works by these artists also reflect Shōkei's influence, and he is often said to have developed a distinctive local style of ink monochrome. Shōkei returned to Kyoto in 1493 and established a studio, the Hinraku-sai (Joy in Poverty Studio). He lived there until his death.

1. "Keison hitsu Rokuso" 1927, p. 77.
2. Etō Shun 1979, p. 119.
3. Shimada Shūjirō and Iriya Yoshitaka 1987, p. 270.
4. *Kanrin koroshū*, by Keijo Shūrin (1440–1518), in

53. Ox and Herdsman

Muromachi period (1392–1573)
Hanging scroll, ink on paper
53.6 × 29.6 cm (21⅛ × 11⅝ in.)
Seal: *Sekkyakushi*
Ex coll.: Nakamura Tanio, Kanagawa Prefecture

LITERATURE: "Bokudō zu" 1894, p. 187; *Sekai bijutsu zenshū* 1928, pl. 113; Iizuka Beiu 1931, pl. 18; Nakamura Tanio 1959a, pl. 42; Yonezawa Yoshiho 1959, pp. 17–19; Shimada Shūjirō 1969, vol. 1, p. 103; Fontein and Hickman 1970, no. 45; Nakamura Tanio 1970, pp. 98–99; Tanaka Ichimatsu and Yonezawa Yoshiho 1970, pl. 40; Matsushita Takaaki and Tamamura Takeji 1974; Tanaka Ichimatsu 1974, pl. 106; Murase 1975, no. 30; Mayuyama Junkichi 1976, no. 398; Y. Shimizu and Wheelwright 1976, no. 4; Kanazawa Hiroshi 1977, pl. 50; Kinoshita Masao 1979, fig. 175; Shimada Shūjirō 1979, no. 18; Tokyo National Museum 1985a, no. 13; Schirn Kunsthalle Frankfurt 1990, no. 37; Yamaguchi Prefectural Museum of Art 1998, no. 9.

On a grassy slope a tousled herdsman tends a large ox. The principal subject of the painting, the gentle beast, impressive in its mighty bulk, is described with infinite care. Broad strokes define the contours of the body, and long hairline strokes delineate the patches of furry softness. Light and dark ink are contrasted to create a sense of volume and to accentuate individual features.

It has been suggested that the Burke scroll was originally part of a set of ten that illustrated the Ten Ox-Herding Songs (cat. no. 42), most likely the fifth episode, "Herding the Ox."[1] A painting in the Kumita collection in Tokyo, which may be part of the same set, depicts a herdsman grappling with a recalcitrant ox,[2] a struggle that recalls the fourth parable of the series. In contrast, the calm that pervades the Burke painting is the essence of the fifth parable. While the Kumita work is slightly smaller than the Burke painting, it is believed to have been trimmed in recent remountings. Harder to explain are certain stylistic distinctions and the fact that they have different seals.[3]

Very little is known about the painter Sekkyakushi, whose seal is imprinted on the Burke piece, except that he was active in the first half of the fifteenth century. A painting by Sekkyakushi in the Musée Guimet, Paris, that shows Monju Bosatsu (the bodhisattva of wisdom) dressed in a robe of braided grass has a dated inscription of 1418.[4] Like many ink painters of the early Muromachi period, this artist remains an obscure figure because his career was overshadowed by the great fame of his contemporary Kichizan Minchō (1352–1431). "Sekkyakushi" was at one time thought to be another name for the monk-painter Reisai (cat. no. 54), who is himself often confused with Minchō. The distinct stylistic similarities between the work of these three artists suggests a possible master-pupil relationship. Indeed, a painting of White-Robed Kannon by Sekkyakushi in Rokuonji, Kyoto, is closely modeled after a work by Minchō in Tōfukuji in the same city.[5] Another interesting link between the three artists is that the names they chose for their seals commonly refer to the theme of feet or sandals. One of Minchō's seals includes the characters for "torn sandals"; the first two characters in Reisai's seal refer to legs; and the name Sekkyakushi means "the barefoot one."

The stylistic similarities in their work also seem to reflect a common background. If Sekkyakushi was in fact a pupil of Minchō, he must have been drawn into the orbit of the monks at Tōfukuji, where Minchō lived and worked. In contrast to their more progressive, avant-garde contemporaries—Shūbun, for example, or Bonpō—the Tōfukuji painters followed the tradition of Buddhist figure painting. No flower or bird paintings by these artists are known. Viewed in this context, it is unlikely that the Burke scroll was intended purely for aesthetic appreciation. Indeed, everything we know of Sekkyakushi points to its representing one of the Ox-Herding Songs.

1. Nakamura Tanio 1970, p. 99; and Tanaka Ichimatsu and Yonezawa Yoshiho 1970, p. 172.
2. Ibid.
3. Tanaka Ichimatsu and Yonezawa Yoshiho 1970, p. 98.
4. Shimada Shūjirō 1969, vol. 1, p. 105.
5. Shimada Shūjirō and Iriya Yoshitaka 1987, no. 11.

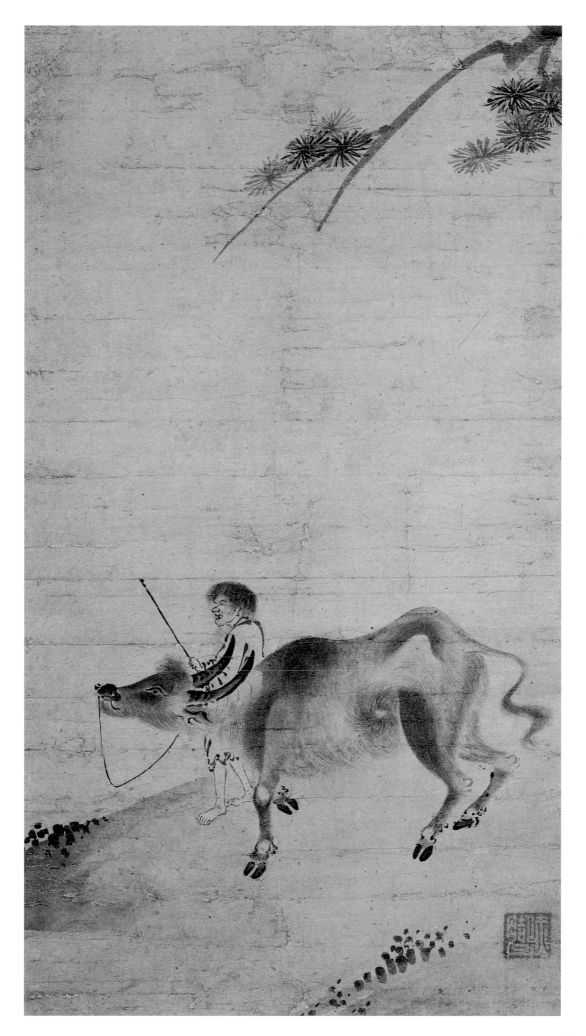

54. Bukan, Kanzan, and Jittoku

Muromachi period (1392–1573)
Pair of hanging scrolls, ink and light color on paper
Each scroll 96.5 × 34.6 cm (38 × 13⅝ in.)
Ex coll.: Satsuma Jihei

LITERATURE: Iizuka Beiu 1931, pl. 14; Shimada
Shūjirō 1969, vol. 1, pls. 8, 9; Tanaka Ichimatsu
1974, pl. 39; Murase 1975, no. 31; Y. Shimizu and
Wheelwright 1976, no. 5; Murase 1977, p. 89
(details of *Bukan*); Shimada Shūjirō 1979, nos. 21,
22; Tokyo National Museum 1980, fig. 106; Tokyo
National Museum 1985a, no. 15; Schirn Kunsthalle
Frankfurt 1990, no. 38; Yamaguchi Prefectural
Museum of Art 1998, p. 178, no. 8.

The bizarre shapes of vaporous clouds form
the backdrop of this unusual diptych. In the
left scroll two unkempt men stand on a hill-
side. The one with his back turned to the
viewer and a bamboo bucket in his left hand
is Kanzan (Ch: Hanshan; Cold Mountain).
The bucket is Kanzan's attribute, and with it
he is supposed to have collected leftover food
from temple kitchens. His animated compan-
ion is Jittoku (Ch: Shide; The Foundling),
who holds the broom suggestive of the menial
tasks he performed around temples. The
right scroll represents Bukan (Ch: Fenggan),
their elder mentor, who is always accom-
panied by his pet tiger. Only the face of this
docile creature is visible as he snatches a cat-
nap in the shadow of the rock on which his
master is seated. Bukan stares ahead, his
attention riveted on the abyss. The setting is
probably the Icy Cliff at Tientai, the moun-
tain in South China that is the abode of these
three legendary, quasi-historical characters.

Favorite subjects of ink monochrome by
Zen monks both in China and in Japan, the
three are believed to have lived during the
Tang dynasty (618–907), between the late
eighth and the early ninth century.[1] The life
of Kanzan is the best documented, as three
hundred poems are attributed to him. These
poems suggest that Kanzan, born of a farmer's
family, was an unsociable man whose only
enjoyment in life was reading books. Though
harmless, this hobby led to his being rejected
even by his own wife. So he left his village to
live at Icy Cliff. His poems suggest little of
the eccentricity usually associated with his
behavior; his reputation probably derives
from a description in the preface to a collec-
tion of his poems, the *Hanshanzi shiji*.[2] The
preface is traditionally attributed to Luqiu
Yin, a prefect in the Taizhou area who lived
during the Tang dynasty. In it, Luqiu describes
his visit to Bukan in his search for enlighten-
ment. Bukan, in turn, referred him to Kanzan
and Jittoku, whom he described as the per-
sonifications of two bodhisattvas, Monju and
Fugen. When Luqiu made the proper obei-
sance to them, the two men shouted and
laughed and said, "[Bukan] has a long tongue.
You did not recognize [him as Miroku, the
Buddha of the Future]. Why are you making

obeisance to us now?"[3] Whereupon they
joined hands and fled to neighboring moun-
tains. In the Burke diptych Kanzan and
Jittoku point to the valley, either in reference
to the futility of Luqiu's search or to the
nature of truth as being as vaporous as the
rising mist. It is possible that the space above
the clouds was reserved for inscriptions that
would have provided a narrative for the scene.

The subject enjoyed enormous popularity
in Japan beginning in the early fifteenth cen-
tury, as documented in the *Gyobutsu gyoga
mokuroku*, an early-fifteenth-century cata-
logue of the Ashikaga collection of Chinese
paintings.[4] While later versions of the sub-
ject usually do not seem to have specific nar-
rative content, the Burke scrolls suggest a
particular episode of the legend. A Kano-
school copy of a painting by Liang Kai
(fl. 1st half of 13th century), now in the
Tokyo National Museum, is nearly a mirror
image of the left scroll and thus perhaps
served as a model. It is not unlikely that
another work by Liang Kai, depicting Bukan
and his tiger, also served the same purpose.[5]

The scrolls, save for light washes of orange
red and brown, are monochrome, which
varies in subtly graded tones from coal black
to the lightest gray. The pervasive ice-cold
atmosphere and cutting edge of Jittoku's
laughter are relieved only by the contented,
dozing tiger. Brushstrokes that delineate the
folds of the robes begin thickly and deliber-
ately, creating exaggerated nailheads and
turns in each line. A similar angularity char-
acterizes the rocks in the foreground. Other
features of Reisai's style are the application
of ink over broad areas and the absence of
texture strokes on rocks and ground.

The Burke diptych was traditionally
attributed to Kichizan Minchō (1352–1431),
an ink painter active at Tōfukuji, Kyoto.[6] It
was reattributed in 1969 on stylistic grounds
to Reisai (fl. 1430–50), a younger contempo-
rary.[7] Ultraviolet examination of the left
scroll has since revealed the trace of a square
seal at the upper right corner that appears to
have the same dimensions as Reisai's other
known seals. And the artist's signature has
been detected on the right scroll.[8]

In addition to stylistic similarities in their

work, Reisai and Minchō may have belonged to the same circle of painters based at Tōfuku-ji. Reisai's somewhat old-fashioned use of gold not only in his rendering of jewelry and clothing but for his signature as well, as in a painting of Monju in the Tokyo National Museum,[9] may also provide a link to the artistic tradition of the workshop at Tōfuku-ji. The practice recalls the work of Ryōzen (fl. 1348–55), an artist active at the temple a century earlier, who painted traditional Buddhist figures and Zen-inspired subjects and who also signed his name in gold ink. Reisai too seems to have painted only Buddhist subjects.

Reisai's artistic activity covered at least thirty years. In 1435 he painted a large Nirvana picture, now in Daizōkyōji, Yamanashi Prefecture.[10] It is accompanied by an 1821 copy of the original colophon, which states that the painting was executed by "Monk Reisai" in 1435 for Jōkyōji, in Shizuoka, near Kamakura. The picture was modeled closely after an older work of the same subject in the collection of Enkakuji, Kamakura. This historical date allows us to postulate that Reisai may have come from the east, possibly from around Kamakura, where he received his early training in traditional Buddhist pictures. He later moved to Kyoto, where he became acquainted with Zen monks, some of whom wrote inscriptions on his paintings. It was perhaps through this connection that Reisai, in 1463, came to accompany a trade mission to Korea. There he presented a painting of White-Robed Kannon to Sejo, the reigning king.[11]

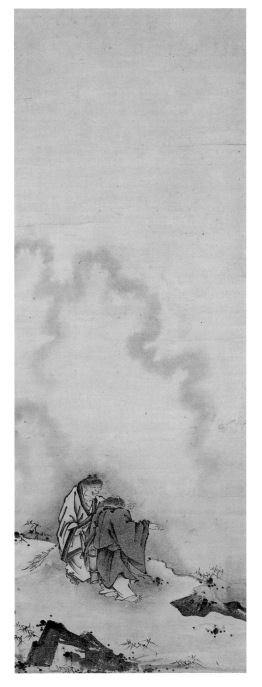
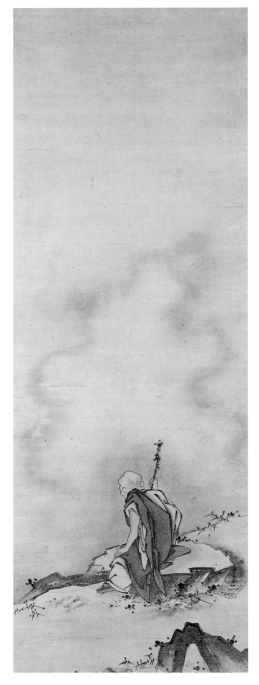

1. Wu Chi-yu 1957, p. 393; see also Hanshan 1970, p. 10; and Brinker and Kanazawa Hiroshi 1996, pp. 142–48.
2. Wu Chi-yu 1957, pp. 411–14; and Tochigi Prefectural Museum 1994.
3. Ibid., p. 414.
4. Tani Shin'ichi 1936, pp. 439–47.
5. Y. Shimizu and Wheelwright 1976, fig. 29; and Shimada Shūjirō 1979, nos. 21, 22.
6. Kano Tan'yū's certificate of attribution to Minchō is still preserved with the painting.
7. Etō Shun in Shimada Shūjirō 1969, vol. 1, p. 104.
8. Tanaka Ichimatsu 1974, p. 111; and Y. Shimizu and Wheelwright 1976, p. 71, n. 4.
9. Tanaka Ichimatsu 1974, pl. 111.
10. Ibid., pl. 113.
11. *Chosŏn wangjo sillok* 1955–58, vol. 7, p. 583.

55. *Su Shi on a Donkey*

Muromachi period (1392–1573)
Hanging scroll, ink and gold on paper
57 × 26 cm (22½ × 10¼ in.)
Seal: *Bokudō*

LITERATURE: Murase 1993, no. 11.

The setting in this hanging scroll is minimally described. A few dry brushstrokes merely suggest the shape of the rocky bluff and the rough terrain, while the darker ink spots that define the trees and bamboo leaves on the ground accent the otherwise pale landscape. Attention is focused on the figure of a man on a donkey as he journeys on a path below the cliff. Here, too, details are minimal, a few lines defining the rider's face and robe, darker ink washes shaping his large hat and the beast's body. In this stark depiction, the thin gold lines that trace the hat and headcloth, the bridle bit, and other details give an unexpected sense of luxury.

The image of a man riding on a donkey, a poor man's conveyance, symbolized the eremitic life of a scholar-poet and became a favorite subject among the ink painters of the Muromachi period. The riders that appear in such paintings are variously identified, often as Du Fu or Su Shi but sometimes as other poets of China. The Tang-dynasty poet Du Fu (712–770) was a favorite in fourteenth-century Japan. Later, his popularity was overshadowed by that of Su Shi (Su Dongpo, 1037–1101), a Song-dynasty poet whose work found an appreciative audience among Zen monks in the fifteenth century.[1]

In this painting the rider's large hat, its windswept ribbons, and the forlorn look of the landscape suggest that the poet is traveling through rain. If so, the painting may belong to a special iconographic type in which Su Shi is represented wearing a rain hat and wooden clogs, as he is in a scroll attributed to Tenshō Shūbun (fl. 1414–before 1463) in The Metropolitan Museum of Art.[2] The scroll illustrates an incident that took place while Su Shi was in exile at the end of his life, on Hainan Island, off South China. As he took leave of a friend he was visiting, it began to rain and Su Shi borrowed a bamboo hat and wooden clogs from a farmer. The strange sight of a scholar-official from the city plodding through the rain dressed in a humble farmer's outfit startled the women and children whom he met along the way and made them laugh.

Bokudō Sōjun (1373–1459), the painter of the Burke scroll, was a Zen monk at Tenryūji, Kyoto, a center of learning and home to many scholarly monk-poets, who wrote poetic colophons on a large number of paintings. One of the monks at Tenrūyji, Zuikei Shūhō (1391–1473), mentions in his diary a visit made by Bokudō to the temple, noting that the painter excelled in images of Fudō Myōō (Skt: Achala) and other ferocious guardian deities.[3] It is not unlikely that these paintings were also highlighted in gold, just like the figure of the poet in the present painting. The use of gold outlines in otherwise austere Buddhist images was a practice particularly favored by the professional painters of the late fourteenth and the fifteenth century, painters such as Minchō, Ryōzen, and Reisai, who were closely associated with Tōfukuji. It is not unlikely that Bokudō learned this technique from the paintings in the Tōfukuji collection.

1. Haga Kōshirō 1981, pp. 284–85; and Shimada Shūjirō and Iriya Yoshitaka 1987, p. 162.
2. Reproduced in Shimada Shūjirō 1969, vol. 1, pl. 78. Another painting attributed to Shūbun depicting the poet walking in the rain wearing a hat and wooden clogs is reproduced in Watanabe Hajime 1985, fig. 61. For Tani Bunchō's copies of similar works, see "Honchō gasan" 1939, p. 204.
3. *Guan nikkenroku* (Chronicle of Guan), in *Shiseki shūran* 1967–68, vol. 3.

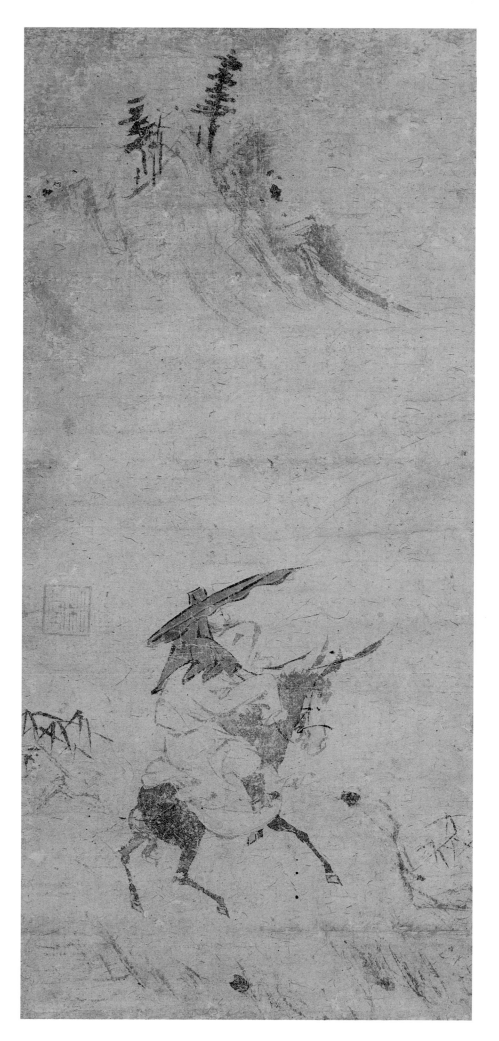

56. Water Buffalo and Herdboy

Muromachi period (1392–1573), late 15th century
Folding fan mounted on hanging scroll, ink on
gilded paper
18.2 × 47.1 cm (7⅛ × 18½ in.)
Seal: *Masanobu*[?]

LITERATURE: Murase 1993, no. 12; Kyoto
National Museum 1996, no. 17.

Although its worn vertical creases attest to frequent use, this gilded fan still provides a sumptuous setting for the illustration of a humble herdboy returning home on the back of a water buffalo after a day's work in the rice paddies. With the help of his switch, the herdboy urges the buffalo to wade through the shallow water. Short stubbles of rice plants suggest that the time is late spring or early summer. A small patch of land with a growth of bamboo at the lower left serves as a foreground. Gentle hills with a thick growth of trees close off the distant view. A shimmer of gold enhances the background and lends a poetic note.

Bulls and water buffalo had a special place in Chinese symbolism, both secular and religious. An emblem of spring and agriculture, the water buffalo was by extension regarded as a water god and symbol of the earth's fertility. Chinese Daoists saw the water buffalo as representing the honest, bucolic life, and the theme of the herdboy and buffalo as signifying the cyclical rhythms of nature. In Chan Buddhism, the relationship of the buffalo to its master and the act of herding itself assumed a spiritual significance suggesting the quest for enlightenment, as in the parables of the Ten Ox-Herding Songs (cat. nos. 42, 53).[1]

Many Chinese paintings of oxen or water

buffalo are recorded in the catalogues of the shogunal collections.[2] A small round fan-shaped painting of the theme attributed to the Chinese painter Xia Gui (fl. ca. 1195–1230) and now in the Tokyo National Museum (fig. 33), which must have been imported to Japan at least before the end of the fifteenth century,[3] appears to have been the model for several late-fifteenth-century Japanese paintings,[4] among them the Burke fan, dated to about the same time. Here, the buffalo and the herdboy are depicted from a closer vantage point than in the Chinese model, and a second buffalo is eliminated. Otherwise, the paintings are nearly identical, even in such details as the configuration of the shoreline and rice paddies, the posture and costume of the herdboy, and the ax-cut strokes that delineate the hills in the background. That the painting is most likely in the secular tradition and unconnected to Zen allegory is suggested by the clear indication of the season and the implication that the beast and its master have performed their task in the rice fields.

A large seal in the shape of a cauldron with a tall neck and bulbous body is impressed at the lower right, though the characters are not clear enough to decipher. Its shape is similar to that found in a group of seals thought to have been used by Kano

Figure 33. Attributed to
Xia Gui (fl. ca. 1195–1230),
Water Buffalo and Herdboy.
Fan, ink and color on silk,
23.3 × 25.2 cm (9⅛ × 9⅞ in.).
Tokyo National Museum

Masanobu (1434–1530). Masanobu, the first nonpractitioner of Zen to be appointed official painter to the Ashikaga shoguns, laid the foundations of the Kano school, which was to influence the course of Japanese painting for more than three hundred years. While the biography of this important artist is slowly emerging, only a small number of paintings are accepted as genuine.[5]

Masanobu is thought to have been born in eastern Japan, either in Kazusa or Izu Province (Chiba and Shizuoka Prefectures, respectively). Nothing is known about his early training or about how he came to receive commissions from the prominent temples of the Gozan (Five Mountains) system in Kyoto. His first such commission was realized in 1463. Nearly twenty years later, he is believed to have succeeded Oguri Sōtan (1413–1481) as official painter to the shogun, the most august position a painter could attain. Once he was appointed, his projects are recorded in detail.[6]

Painters who worked for the shoguns often used Chinese paintings in the shogunal collection as models. The Burke fan painting, which closely resembles the Xia Gui, may have been a direct copy, unlike other similar works, which seem to be one step removed from the original. It has not yet been firmly established that the Xia Gui was in the shogunal collection, but most likely it was in an important collection that Masanobu would have had access to.

Folding fans were made by court artists as gifts and presented annually by the painters themselves to the shoguns who employed them and to members of the imperial court; they were also popular export items in China and Korea. A courtier named Sanjōnishi Sanetaka refers in his diary, the *Sanetakakō ki* in the year 1529, to fans presented by the court artists as Edokoro fans (after the Edokoro, or Imperial Court Office of Painting); those presented by the Kano artists he terms Kano fans.[7] Because Masanobu was the leading Kano artist of the time, it is most likely that he himself presented them.

The Burke fan is heavily embellished with gold leaf, which suggests that it may have been made as one of the annual gifts. If the seal on this fan can be read as "Masanobu," and if the painting can be safely attributed to him, it should be dated sometime after 1491, when Masanobu adopted this sobriquet.

Folding fans, indispensable during the summer heat, were usually discarded at the end of a season. Those that were treasured for their painted decorations or for other, perhaps personal, reasons were often preserved in albums or on folding screens. The present fan may have survived in this manner and was later remounted as a hanging scroll.

1. Schafer 1963, p. 73; and Ho et al. 1980, no. 41.
2. For the *Butsunichian kumotsu mokuroku* and the *Kundaikan sōchōki*, see Kamakura-shi Shi Hensan Iinkai 1956; and *Sadō koten ẓenshū* 1967, vol. 2.
3. "Kakei hitsu Hōgyū zu" 1904, p. 182; and Kyoto National Museum 1996, fig. 7.
4. For a painting by Sekijō (fl. late 15th century) destroyed in the Tokyo earthquake of 1923, see Watanabe Hajime 1985, p. 120, fig. 31. Another, indirect copy is reproduced on p. 131, fig. 64.
5. For the life of Masanobu, see ibid., pp. 165–226; for documentary material (*shiryō*), pp. 192–216; and for seals (*inpu*), pp. 215–16. For additional information on Masanobu's life, see Yamaoka Taizō 1978; Ueno Kenji 1986, pp. 114–24; and Kawai Masatomo 1988, pp. 167–80.
6. Watanabe Hajime 1985, pp. 192–216.
7. Sanjōnishi Sanetaka 1979, entries for the twelfth day of the eighth month of the second year of the Kyōroku era (1529), and the first day of the fifth month of the fifth year of the same era (1532), which refers only to the Kano fans.

BOKURIN GUAN (FL. 15TH CENTURY)

57. *Cicada on a Grapevine*

Muromachi period (1392–1573)
Hanging scroll, ink on paper
64.4 × 30.8 cm (25⅜ × 12⅛ in.)
Seals: *Guan* and *Bokurin Guan*
Ex coll.: Watanabe Kazan

LITERATURE: Matsushita Takaaki 1960, no. 101; Murase 1975, add. no. 107; Shimada Shūjirō 1979, no. 14; Ford 1985, fig. 5; Tokyo National Museum 1985a, no. 17; Schirn Kunsthalle Frankfurt 1990, no. 33; Brinker and Kanazawa Hiroshi 1996, fig. 128.

It is the end of summer. The leaves of the grapevine have withered, fruits are ripe, and a solitary cicada clings to the vine. In this exquisite depiction of a small corner of the natural world, the artist has lovingly captured one of the familiar sights of seasonal change in soft, watery ink. Subtle gradations of wash define both front and back of the lacy, tattered leaves, while curving, hooked lines delineate vines and tendrils. The small globular fruits, delicately outlined with soft gray strokes, barely intrude upon our vision. The darkest ink is reserved for the lone insect, and the finest, thread-thin lines for its gossamer wings.

Many ink paintings of common vegetables and fruits—turnips, cabbages, persimmons, chestnuts—are associated with famous Zen monk-artists. These staples in the vegetarian diet of Buddhist communities were latecomers in the artistic repertory of ink-monochrome painters. Their depiction was perhaps an expression of the Zen belief that all phenomena, however mundane, possess an element of Buddhanature and have the potential for enlightenment.

The paintings of grapes most familiar in the Muromachi period were the vigorous examples associated with the thirteenth-century Chinese master Riguan (fl. ca. 1230), who treated the subject as a vehicle for bravura displays of brush technique.[1] Riguan's work doubtless inspired early Japanese practitioners of the genre, such as Gukei Yūe

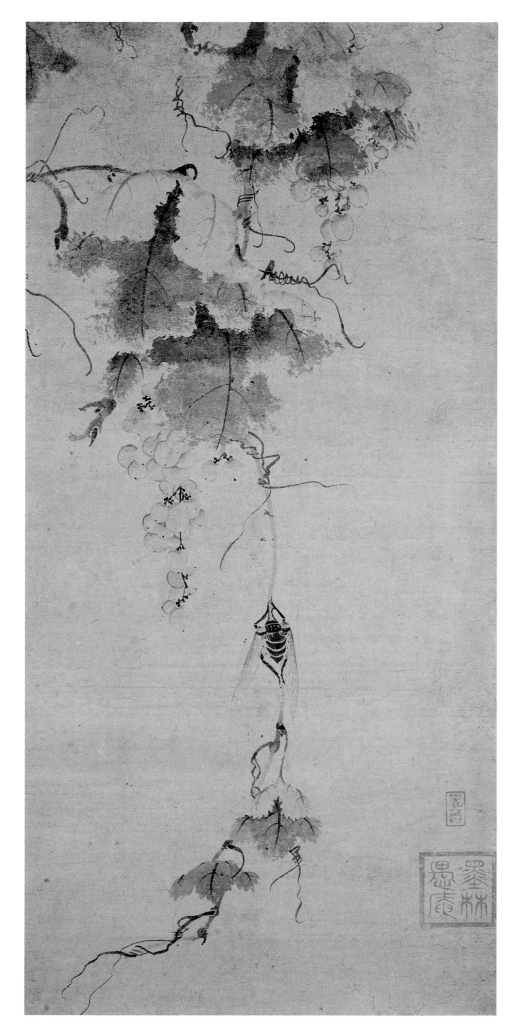

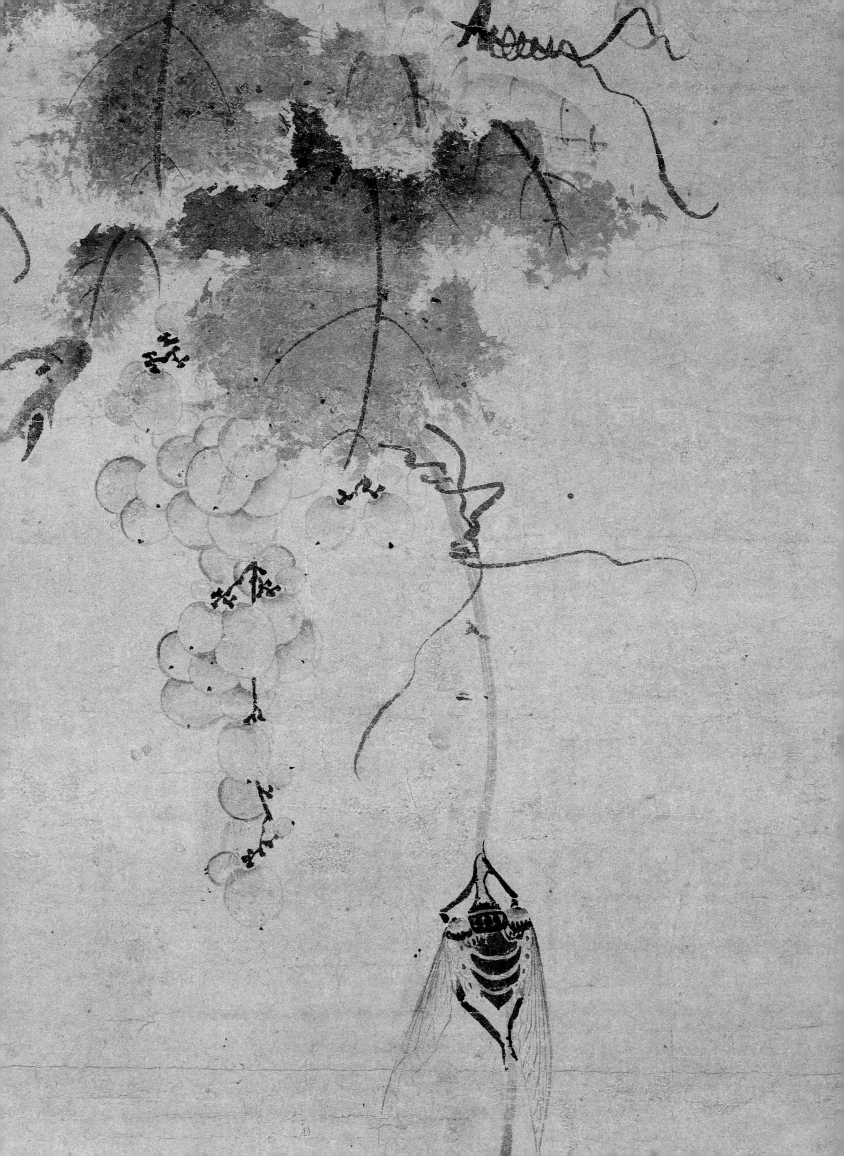

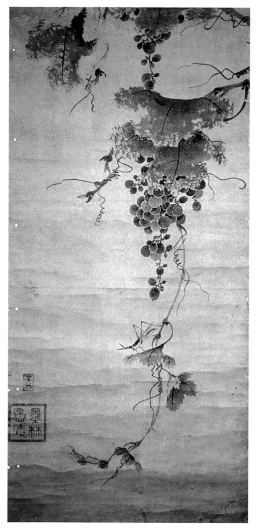

Figure 34. Bokurin Guan (fl. 15th century), *Insect on a Grapevine*. Hanging scroll, ink on paper, 64.6 × 30.9 cm (25⅜ × 12⅛ in.). Honpōji, Kyoto

(fl. mid-14th century), whose paintings usually feature a horizontal arrangement of vine stems, and Bokurin Guan, the painter of the Burke scroll. Guan's vertical compositions, with their more naturalistic details, may indicate a familiarity with either Korean or Chinese grape paintings, perhaps those associated with the Yuan master Ren Renfa (1255–1328)[2] and those of the Ming-dynasty painter Wang Liangzhen (fl. 15th century), who is today known only through one composition now in the Freer Gallery of Art, Washington, D.C., a painting of grapevines briskly swaying in the wind.[3] Guan's depiction may be placed somewhere between these two Chinese representations.

Guan's *Cicada on a Grapevine*, which shows nature in a state of near-frozen stillness, is the companion piece to a painting at Honpōji, Kyoto (fig. 34), in which swaying vines convey a lively sense of movement. The Honpōji scroll, which would have been placed at the left, suggests the summer season, with a grasshopper, fresher leaves, and darker fruits of a plant at its peak of ripeness.

The artist displays an exquisite control of the brush, a keen eye for the most minute details of nature, and a representational ability that is infused with poetry. Who he was, however, remains something of a mystery. Two seals are impressed on each of the paintings. The smaller seal reads "Guan," and the larger, "Bokurin Guan." Listed in an Edo history of Japanese painting is a monk-artist named Guan Shichi (fl. late 15th century–early 16th century), who excelled in painting monkeys in the manner of the Southern Song artist Muqi (fl. late 13th–early 14th century).[4] Examples are also given of his seal, "Guan," and of his signature, "Guan Shichi."[5] This "Guan" seal, however, differs from the seals impressed on the scrolls in the Burke and Honpōji collections, and the name Shichi is not found on any known painting. That Bokurin Guan was a Zen monk can be deduced from

the Zen-like names he chose for himself: Bokurin means "Ink Forest," and Guan, "Fool's Hut."

The use of two seals, one small and one much larger, recalls the practice of the monk-painter Kaō Ninga, who lived in the mid-fourteenth century. It has been suggested that those artists whose activities were primarily confined to the temple may have used only one seal and a less official name (*dōgō*) on their paintings.[6] Those who divided their activities between painting and clerical duties may have used two seals, comprising both the *dōgō* and the official name (*hōki*). While this theory is far from conclusive, it is persuasive. It may also be that the group who divided their activities received professional training as artists, and that Bokurin Guan belonged to this circle. His mastery of the ink medium far outstrips that of Tesshū and Bonpō (cat. nos. 44, 51), two of the most prominent figures in the Zen community of fourteenth-century Japan. Tesshū and Bonpō were both literati, for whom painting was pursued for personal pleasure or as an exercise in Zen training. The absence of documentation on Bokurin Guan may be the result of his relatively minor status in Zen circles. At present, the existence of a monk-artist who used the name Bokurin Guan is confirmed only by these two graceful depictions of grapevines. The marked naturalism and sophistication that characterize his work suggest a fifteenth-century date.

An inscription on the box containing the Burke scroll states that it once belonged to the late-Edo realist painter Watanabe Kazan (1793–1841).

1. For the symbolism of grapes, see Shimada Shūjirō 1993, pp. 136–51; Watsky 1994, pp. 145–49; and Tsang 1996, pp. 85–94.
2. Tokyo National Museum 1998, no. 149.
3. Toda Teisuke 1991, pl. 2.
4. Kano Einō 1985, p. 302.
5. Ibid., p. 485.
6. Yokota Tadashi 1976, pp. 33–40.

58. Sparrows among Millet and Asters

Muromachi period (1392–1573)
Hanging scroll, ink on paper
83.1 × 46.2 cm (32¾ × 18¼ in.)
Seal: *Geiai*

LITERATURE: Murase 1993, no. 13.

Five lively sparrows frolic around asters and a spear of millet. Heavy with grain, the millet can barely withstand the weight of the small birds. The animated capering of the sparrows has stirred the asters nearby, and a sense of open space under a crisp autumnal sky permeates all. The sparrow-and-millet subject was very popular and would later be standard in the repertory of Kano-school artists. In sharp contrast to the two bird-and-flower paintings of Shikibu Terutada and Uto Gyoshi (cat. nos. 59, 60), this work by Geiai in ink monochrome relies largely on *mokkotsu*, the soft, boneless technique that creates an airy lightness and sophisticated charm. Lines are limited to small details—feathers, the veins of leaves, the outlines of petals. Small ink dots delineate individual grains.

Several ink paintings of birds and plants bear the "Geiai" seal.[1] They not only share like dimensions, but are executed in a similar style. The birds and flowers are depicted with lively movement, long, arching blades of grass or tree branches bend in opposite directions, and pearl-gray washes lend a graceful refinement. To these ink paintings may be added a group of works in poly-

chrome, which may eventually be traced to a Chinese model of the Ming dynasty.

None of the ink-monochrome paintings impressed with "Geiai" seals bear the artist's signature. Furthermore, the seals show slight variations, which suggests that at least two different "Geiai" seals may have been used. Some of the paintings bear an additional seal that reads "Tonshu."[2] The only clue we have to the time of his activity is an underdrawing, in ink and gold, of a vivacious bird among flowers, which bears the "Geiai" seal and a date corresponding to 1489.[3]

Geiai's paintings have traditionally been confused with those by artists of the elusive Oguri school, active in the fifteenth and sixteenth century.[4] However, it is undeniable that some Geiai paintings combine the clear outlining of the academy technique with a painterly style based on soft, boneless ink washes, the technique closely associated with Sōami (Shinsō, d. 1525), the leading ink painter of the early sixteenth century.[5] In this connection, one might ask whether "Geiai" derives from the name of Sōami's father, Geiami (Shingei, 1431–1485).

Whoever Geiai really was, the paintings that bear his seal exhibit a wide range of brush techniques, reflecting a trend dominant among late-fifteenth-century artists active in the Kyoto area.

1. Shimada Shūjirō 1969, vol. 1, no. 98; Matsushita Takaaki and Tamamura Takeji 1974, pls. 91, 92; and Shimada Shūjirō 1979, no. 77.
2. This seal, which means "to bow to pay one's respect," is found on only a few paintings by Geiai, and it is always impressed upside down; see, for example, Matsushita Takaaki 1960, no. 102.
3. Matsushita Takaaki and Tamamura Takeji 1974, fig. 25; and Tamamushi Satoko 1991, fig. 16.
4. Kawai Masatomo 1988, pp. 167–80; see also Y. Shimizu and Wheelwright 1976, p. 116, n. 3.
5. See, for example, Matsushita Takaaki 1960, no. 102.

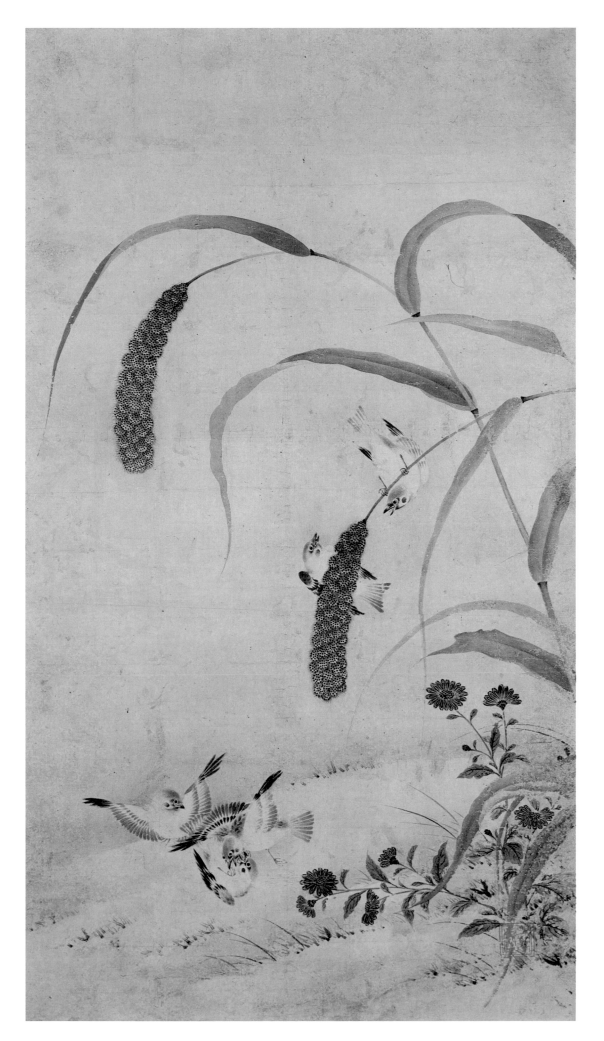

59. Birds and Flowers of Summer and Autumn

Muromachi period (1392–1573)
Pair of hanging scrolls, ink and color on paper
Each scroll 95.6 × 44.8 cm (37⅝ × 17⅝ in.)
Seal: *Shikibu* [on each scroll]
Ex coll.: Murayama Ryūhei, Kobe

LITERATURE: "Ryūkyō hitsu Kachō zu kai" 1929, pp. 95, 100–105; Nakajima Junji 1968, fig. 23 (left scroll); Kanazawa Hiroshi and Kawai Masatomo 1982, p. 145; Yamashita Yūji 1985, fig. 11; Tokyo Metropolitan Teien Art Museum 1986, pl. 44; Murase 1993, no. 17.

Like many other masters of the Muromachi period, the painter of this polychrome diptych has long been incorrectly identified or confused with other artists, and the difficulty of deciphering his seals has even prevented agreement on his name. Until recently, he was referred to as Shikibu Ryūkyō. Today, however, he is generally known as Shikibu Terutada.

The confusion over his identity is surprising, given that he often impressed two seals on even very small works, such as fan-shaped paintings, and that his fairly large oeuvre includes four pairs of folding screens as well as hanging scrolls and fans in both polychrome and ink monochrome.[1] The following account of his life owes a great deal to the research of Yamashita Yūji.[2]

At present, only two works by the artist have yielded clues for the dating of his career. The first is a set of eight hanging scrolls with eight views of Mount Fuji, one of which bears an inscription written by the monk Jōan Ryūsū, who died in 1536.[3] The other is *Li Bo Viewing a Waterfall*, in the Nezu Institute of Fine Arts, Tokyo, which bears an inscription by the monk Keikin Genkō, who is believed to have died in the southern part of the Kantō region in 1575.[4] Shikibu's life span thus probably extended from the middle to the latter part of the sixteenth century.

The artist's identity was confused as early as the late seventeenth century, when the painter Kano Ikkei (1599–1662), who wrote the first known book of biographies of Japanese painters, the *Tansei jakubokushū*,[5] deciphered one of Shikibu's seals as "Ryūkyō" and identified it as an artistic name used by Kenkō Shōkei (cat. no. 52), an artist who worked at Kenchōji, Kamakura. More than a century and a half later, Hiyama Tansai (1774–1842), in his *Kōchō meiga shūi* (Selected Masterpieces of Japanese Painting), of 1819, determined that the name "Ryūkyō" belonged to yet another painter in Kamakura, Chūan Shinkō (fl. ca. 1444–57), who is believed to have been Shōkei's teacher.[6] It was only in 1905, in the *Koga bikō* (Notes on Old Painters), that "Ryūkyō" was finally recognized as an independent artist, and his two

seals were read as "Terutada" and "Shikibu."[7] Nevertheless, this new reading has not been universally accepted and disputes over Shikibu's names and the larger question of his artistic identity persist.

Despite confusion over the seals, there has long been general agreement that Shikibu's art is closely connected with the Kamakura region in eastern Japan, and with Shōkei in particular. Yet Shikibu's paintings also reveal stylistic traits that set them apart from the more insular style of other Kamakura-based artists.[8]

Stylistic connections have also been noted between works by Shikibu and those of another rather obscure artist who used a seal reading "Uto Gyoshi" (cat. no. 60). Uto Gyoshi is believed to have been a student of Kano Motonobu and to have come from Odawara, near Kamakura, where this Kano master's painting style had a loyal following. Motonobu's pupils in Odawara are sometimes referred to as the Odawara Kano school, to distinguish them from his pupils in Kyoto. Odawara, now a slumbering provincial town east of better-known Hakone, enjoyed a brief period of cultural effervescence during the sixteenth century, when it served as the seat of the military government ruled by the family that adopted the name of Hōjō. This family is often called Go-Hōjō (the Later Hōjō) to distinguish it from an earlier family of the same name, whose members served as regents to the Minamoto shogunate during the Kamakura period in the thirteenth century.[9] Under the new administration, established in 1495, merchants, craftsmen, and artists poured into Odawara and made it a bustling town.

A succession of Go-Hōjō rulers, who eventually controlled a large part of the Kantō region, showed a strong interest in cultural matters. Zen monks were invited from Daitokuji, Kyoto, and with them came the masters of various arts—*chanoyu*, *renga*, *waka*, and Nō. The Go-Hōjōs were also aggressive collectors of both Japanese and Chinese art, and this no doubt attracted painters such as Sesson, who most likely went to Odawara to study the Chinese paintings in their collection (cat. nos. 67–69). Other painters from the Kyoto area migrated to Odawara as well. Its heyday was brief. In

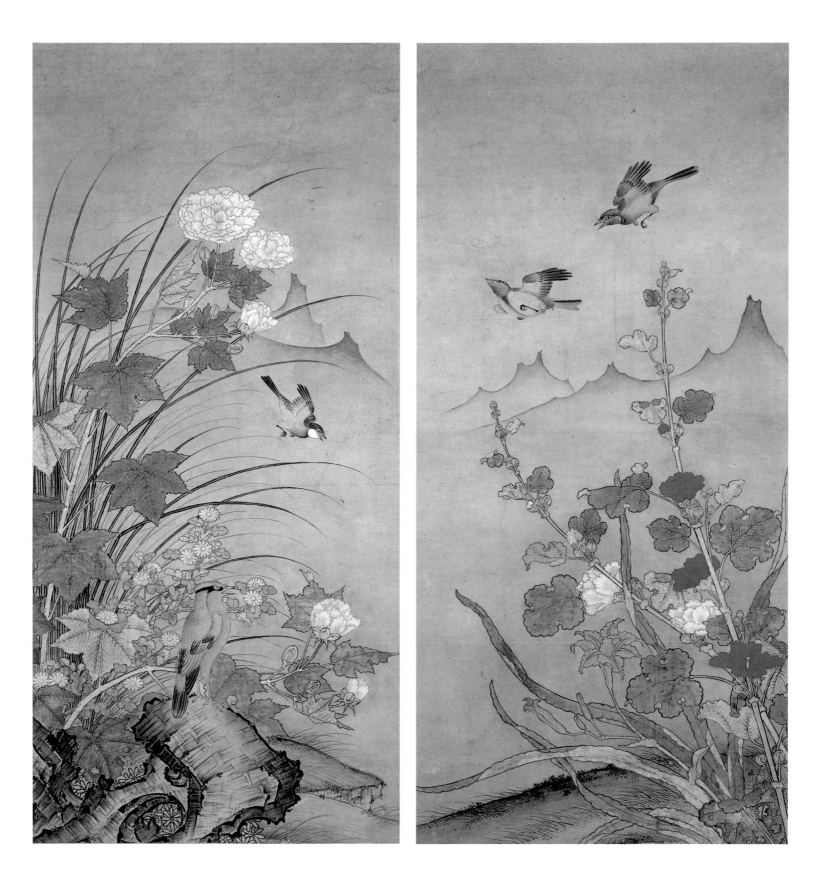

1590, the castle was attacked by Toyotomi Hideyoshi and Hōjō rule collapsed. The art collections of the Hōjōs were subsequently dispersed.

Like so many other painters, Shikibu seems to have found his way to Odawara and Hōjō patronage.[10] His activities, however, may have extended beyond eastern Japan and warrior patronage; one of the paintings of Mount Fuji bears a colophon written by a monk from Kyoto.[11] Shikibu's mature paintings reflect the assimilation of the styles of Kano Motonobu and Kenkō Shōkei (cat. nos. 71, 52). This synthesis is best demonstrated in *Monkeys on Rocks and Trees*, a pair of screens in the Kyoto National Museum that reveal a strong dependence on Motonobu's soft, watery style and the unmistakable residue of the Shōkei style,[12] the combination of which resulted in the formation of Shikibu's own highly idiosyncratic mode.[13]

The right scroll of the Burke diptych depicts red and white hibiscus and a lily, plants of summer whose stalks are gathered in the lower-right corner. The groundline is set low, creating an impression of open space beyond, though the tallest stalk in effect negates the sense of distance as it seems to tower above the rhythmically repeated concave profiles of the distant hills. Two jays, soaring high above, heighten the verticality of the composition as they respond to the call of their companion in the scroll at the left. There, hibiscus and late summer flowers thrive—chrysanthemums and eulalia grasses—while a bull-headed shrike perches on a solid, shell-like rock. The sense of density is even stronger in this composition, as the pictorial elements are packed

in the lower left. The profusion of detail is a distinct feature of Shikibu's art, one that became even more pronounced in his later, large-scale compositions.

Compositional structure, the negation of distance, and profusion of detail are all stylistic features that reveal Shikibu's close dependence on the work of Shōkei. As in Shōkei's paintings, the rocks are outlined in dark, clearly articulated brushstrokes and the surface has a brittle hardness, the parallel strokes regularly interrupted by short strokes that meet them at right angles. The density of the brushwork and the pronounced concavity of the distant hills also appear in many works by Shōkei's followers from the Kamakura area.

The diptych may have been modeled on the bird-and-flower paintings of Shōkei, such as the one in the Kyoto National Museum.[14] The authoritative shrike is an obvious derivation. Certain technical features, such as the rendering of the leaves and flowers by dark outlines filled in with solid colors, reflect the manner of the Imperial Academy of the Southern Song dynasty (1127–1279). This convention may have been adopted by Shōkei when, as a young man, he made copies in Kyoto of the Chinese paintings in the collection of the Ashikaga shogun. The strong ink line eventually became popular among his followers.[15]

Unlike the majority of Shikibu's paintings, the panels of this diptych bear only one seal each. Both read "Shikibu," but they are nearly lost in the densely packed corners of the composition. Shikibu's earliest datable paintings also bear only one seal. His large-scale paintings, screens, and later small paintings

are impressed with two seals, "Shikibu" and "Terutada." It is possible that he used the two only in his mature years.

1. For works by Shikibu in collections in the United States, see Shimada Shūjirō 1969, vol. 1, pls. 99, 100; and Rosenfield 1979, no. 20.
2. Yamashita Yūji 1985.
3. Ibid., figs. 16–21.
4. Kawai Masatomo 1992, no. 57; see also Yamashita Yūji 1985, fig. 13.
5. This essay is reprinted in Sakazaki Shizuka 1917, pp. 923–50.
6. *Kōchō meiga shūi*, unpublished. See Yamashita Yūji 1985, p. 11.
7. Asaoka Okisada 1905 (1912 ed.), pp. 795–99.
8. Yamashita Yūji 1985, p. 23.
9. For a summary of the Go-Hōjō rule and its art patronage, see Kanagawa Prefectural Museum of Cultural History 1989.
10. Yamashita Yūji 1985, p. 23.
11. *Li Bo Viewing a Waterfall* bears an inscription written by a monk from Kyoto who died in the Kamakura area, which suggests that Shikibu may have befriended him there, rather than in Kyoto.
12. M. R. Cunningham et al. 1991, no. 14.
13. Yamashita Yūji 1985, p. 26.
14. Tokyo Metropolitan Teien Art Museum 1986, pl. 10.
15. Yamashita Yūji 1985, p. 21.

60. Musk Cat

Muromachi period (1392–1573)
Hanging scroll, ink and color on paper
76.1 × 46.5 cm (30 × 18¼ in.)
Seal: *Uto Gyoshi no in*

LITERATURE: Murase 1993, no. 16; Kyoto
National Museum 1996, no. 119; G. Sakamoto
1997, figs. 1, 2; Tochigi Prefectural Museum and
Kanagawa Prefectural Museum of Cultural
History 1998, p. 167, fig. 3.

The animal shown here, with a long snout,
black-and-white fur, and bushy tail, is known
in Japanese as a *jakō neko*, or musk cat, and in
China is considered an auspicious creature
endowed with both male and female sexuality;
perfume extracted from the glands of the
musk cat was once popular among the
European aristocracy. Perched on a pendu-
lous branch, an agitated titmouse, as if
attracted by the scent, chirps busily in its
direction. Clear, strong brushstrokes in dark
ink define the slender willow boughs, the
leaves and flowers of the camellia, and details
of the foreground—the small tufts of bam-
boo and grass and the rocky ground. The
physical features of the musk cat and its fur
are meticulously rendered in fine brush lines.
The artist's seal, which reads "Uto Gyoshi
no in" (Seal of Uto Gyoshi), appears at the
lower right corner.

The name "Uto Gyoshi" sounds more like
an official rank than a personal name. And, in
fact, it is the Chinese term for an associate-
censor-in-chief (*youdu yushi*) at the
Censorate established by the first emperor of
the Ming dynasty in 1382. However, there is

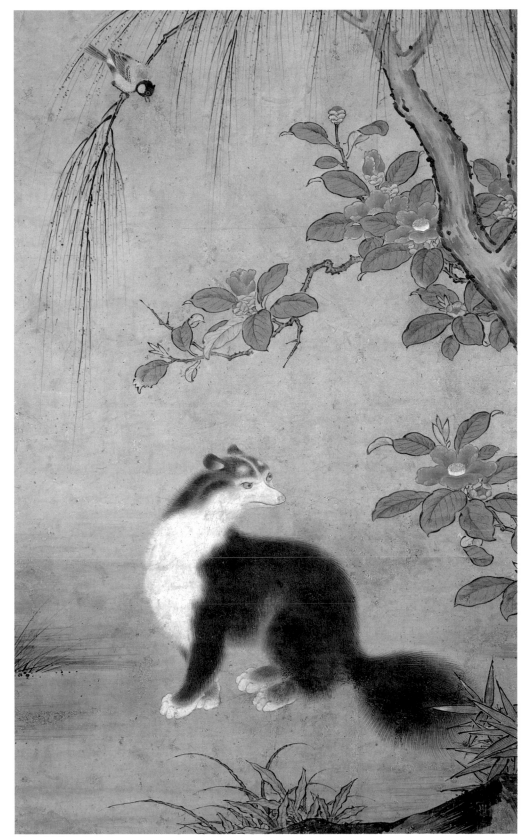

no record that this rank or office ever existed in Japan, nor is it known why this artist came to choose such an unusual-sounding name. Indeed, his very identity is shrouded in mystery. Uto Gyoshi's name, like that of Shikibu Terutada (cat. no. 59), has been confused with those of other artists, including Shikibu. The following discussion summarizes a recent study by Gen Sakamoto that attempts to unravel the scholarly tangle enmeshing this artistic personality.[1]

Uto Gyoshi's name does not appear in the earliest book on Japanese artists, the *Tansei jakubokushū*, by Kano Ikkei (1599–1662), but in 1672, the anonymous author of the *Bengyokushū* initiated the practice of including Uto Gyoshi's seal under the name of the artist Kano Gyokuraku, yet another obscure painter.[2]

Kano Gyokuraku had been included in Ikkei's book, and he is described in all later Edo sources on painters as a student and a nephew (or a niece) of Motonobu's (cat. no. 71), the august leader of the Kano clan. According to Ikkei, Gyokuraku served under Hōjō Ujimasa (1538–1590), the fourth ruler of the Go-Hōjō clan in Odawara, near Kamakura. Uto Gyoshi was thus possibly a member of the Odawara Kano school (as distinct from the metropolitan Kano school, active in Kyoto). In the sixteenth century, Odawara was the seat of Go-Hōjō power and the epicenter of cultural activity in eastern Japan (see cat. no. 59).[3] Some Kano documents claim that the main branch of the family came from nearby Izu Province (Shizuoka Prefecture) and that Motonobu's branch came from farther east, in Kazusa Province (Chiba Prefecture). Both regions were under Go-Hōjō control.[4]

In his *Honchō gashi* of 1678, Kano Einō (1631–1697) caused even more confusion: he quoted Kano Tan'yū (1602–1674), the most powerful leader of the Edo-period Kano

school, as having said that Gyokuraku used the sobriquet Maejima Sōyū.[5] Thus, three names—Uto Gyoshi, Kano Gyokuraku, and Maejima Sōyū—came to be identified with one and the same artist. Muddying the waters still further, Einō noted that Gyokuraku paintings without seals were easily mistaken for works by Motonobu.[6] Some modern scholars claim that Motonobu's painting style was transmitted to the Odawara area and that it was closely reflected in the work of Gyokuraku.[7] Unfortunately, these statements were made before even a single painting with Gyokuraku's identifying marks had been discovered, except for one bearing a doubtful signature.[8] Stylistic analysis of paintings that bear the seal of Maejima Sōyū reveals that his works differ considerably from those with the "Uto Gyoshi" seal, and these two artists should therefore be treated as separate entities. It is perhaps best, at this point, to consider all three names as belonging to different individuals and to establish a stylistic oeuvre for each one.

The majority of paintings bearing the "Uto Gyoshi" seal are in ink monochrome with the bird-and-flower theme. They are executed in bold, clearly defined brushstrokes, sometimes combined with a soft, painterly ink wash. Pictorial elements are arranged in a strongly asymmetrical manner, and they reflect the unmistakable influence of the Shōkei school, which dominated the Odawara area where artists such as Shikibu Terutada were active. Certain technical features—for example, the meticulous application of colors within the carefully drawn outline of petals and foliage—recall the work of Shōkei and of Shikibu. Two other paintings of musk cats should be mentioned here: a diptych of hanging scrolls in the Tokugawa Art Museum in Nagoya,[9] and a single hanging scroll in the Museum of Fine Arts, Boston.[10] As examples of the bird-and-

flower genre by Uto Gyoshi, these works are unusual in that, like the present painting, they are polychrome and more detailed and meticulously executed than this artist's work in ink monochrome.

The *jakō neko*, though not a species native to Japan, was nevertheless known among the Japanese as early as the Kamakura period through imported Chinese paintings by such Southern Song masters as Mao Yi (fl. 2nd half of 12th century),[11] and the subject became popular with Kano artists. As is also true of the work of Shikibu Terutada, polychrome paintings by Uto Gyoshi combine the style of Motonobu with the influence of Shōkei in such details as clearly outlined foliage and flowers carefully filled in with saturated pigments. Although Uto Gyoshi's identity remains uncertain, it appears that he belonged to a group of Kantō artists who combined the techniques of these two artists, as did members of the so-called Odawara Kano school.[12]

1. G. Sakamoto 1992.
2. For *Tansei jakubokushū*, see Sakazaki Shizuka 1917, pp. 923–50; *Bengyokushū* is not published.
3. On the Go-Hōjō family and its cultural activities, see Kanagawa Prefectural Museum of Cultural History 1989.
4. Ueno Kenji 1986, pp. 114–24.
5. For *Honchō gashi*, see Kano Einō 1985, p. 393; see also Nakamura Tanio 1968, pp. 38–46.
6. Kano Einō 1985, p. 336.
7. For example, Yamashita Yūji 1985, p. 26.
8. Nakamura Tanio 1971, fig. 139.
9. Tanaka Ichimatsu et al. 1962, no. 13; and Nakamura Tanio 1971, pl. 22, fig. 138.
10. Tokyo National Museum and Kyoto National Museum 1983, pl. 41.
11. Mao Yi's paintings of this subject are listed in early catalogues of Chinese imports. For the *Butsunichian kumotsu mokuroku*, see Kamakura-shi Shi Hensan Iinkai 1956; *Kundaikan sōchōki*, in *Sadō koten zenshū* 1967, vol. 2; and *Inryōken nichiroku*, in *Dai Nihon Bukkyō zensho* 1970–73, vols. 75–78, the entry for the thirtieth day of the fifth month of the eighth year of the Eikyō era (1436).
12. Tokyo Metropolitan Teien Art Museum 1986, p. 57.

61. *Landscape after Xia Gui*

Muromachi period (1392–1573)
Six-panel folding screen, ink and light color
on paper
153.9 × 274.8 cm (5 ft. ⅜ in. × 9 ft. ¼ in.)

LITERATURE: Tanaka Ichimatsu and Nakamura Tanio 1973, fig. 6; Murase 1975, no. 32; Osaka Municipal Museum of Art 1979, no. 31; Ford 1985, fig. 9; Shimao Arata 1989, fig. 16 (detail); Yamashita Yūji 1993, p. 814, fig. 10.

The two greatest masters of Japanese ink monochrome are Tenshō Shūbun (fl. 1414–before 1463) and Sesshū Tōyō (1420–1506). But while Sesshū's life and artistic achievement have been extensively recorded and analyzed, Shūbun appears in few literary sources and his paintings are only sketchily documented.[1] What we know of his activity is that he studied with the master Josetsu (fl. late 14th–early 15th century) and that two of his pupils were Sesshū and Oguri Sōtan (1413–1481). He served as chief painter to the Ashikaga shogunate and appears to have belonged to the Ashikaga family's private temple, Tōjiji. The brief accounts of his life emphasize his talent in sculpture and in the decorative arts but only touch on his skills as a painter of Buddhist subjects and of polychrome screens. Documentation on his commissions suggests that artists employed by the shogunate were responsible for making works in a variety of media, much like artists at the Chinese court. Shūbun received commissions for both carvings and paintings. A statue of Daruma in Darumadera, Nara, to which Shūbun applied pigment is the only extant work with a certain attribution,[2] though we also know that he helped to complete a large Amida triad for Ungoji, Kyoto, now lost. In 1423, Shūbun joined an official party of monks and businessmen who went to Korea in search of a printed set of the *Tripitaka*, the compendium of Buddhist scriptures. It is not unlikely that he had a chance while there to study Korean paintings, as his name appears in the Korean court record.[3] Shūbun probably died before 1463; temple records for that year indicate that his stipend was given to an artist named Sōtan, and Shūbun's name does not appear again in contemporary literature.

Even more difficult than reconstructing Shūbun's life and career is identifying stylistic criteria for his oeuvre. While nearly all extant paintings presently attributed to him are landscapes, early literary references mention only his Buddhist and bird-and-flower paintings. They are executed in a variety of styles, and although some bear his signature and seals, none is unanimously accepted as genuine. If the attributions are correct,

however, Shūbun may be considered the first Japanese ink painter to treat landscape as a major subject for ink monochrome.

Most Japanese landscapes of Shūbun's era are ink paintings of the type known as *shigajiku* (hanging scrolls with poetry and painting). The *shigajiku* format is tall and narrow, with more surface space devoted to the poetic inscriptions at the top than to the imaginary landscapes in ink monochrome at the bottom. The inscriptions were usually composed and written by the painter's contemporaries, monk-poets whose official position, education, and social status were superior to those of the painters. *Shigajiku* are characterized by a high viewpoint into the distance and a strongly asymmetrical arrangement of pictorial elements. Development of this distinctive type of composition has been attributed to Shūbun and may reflect Korean influence.[4] These features can also be observed in several *byōbu* (folding screens) associated with Shūbun that appear to be composed of several small vertical scenes transposed from hanging scrolls and rearranged on the wider surface to form a new and larger composition. Their method of construction would suggest that at this time screen composition was still in a formative stage. One distinct feature of the landscape screens thought to be by Shūbun is the subtle hint of seasonal change from spring to winter.

The present screen, the left half of a pair of *byōbu*, is attributed to Shūbun. It is a copy of a small section of a handscroll ascribed to Xia Gui (fl. ca. 1195–1230), a Chinese painter of the Southern Song dynasty whose style is reflected in many works believed to be by Shūbun. Xia Gui's *Streams and Mountains, Pure and Remote* was copied many times by many artists, and several versions are known today. One is in the collection of the National Palace Museum, Taipei; another version, which differs slightly from the Taipei scroll, is a fragment in the Hatakeyama Memorial Museum of Fine Art, Tokyo (fig. 35).[5] The Burke screen includes nearly the entire composition in the Hatakeyama fragment, with only minor changes such as the elimination of a bridge and the addition of a massive cliff at the left that provides a strong vertical presence and defines the spatial continuity.

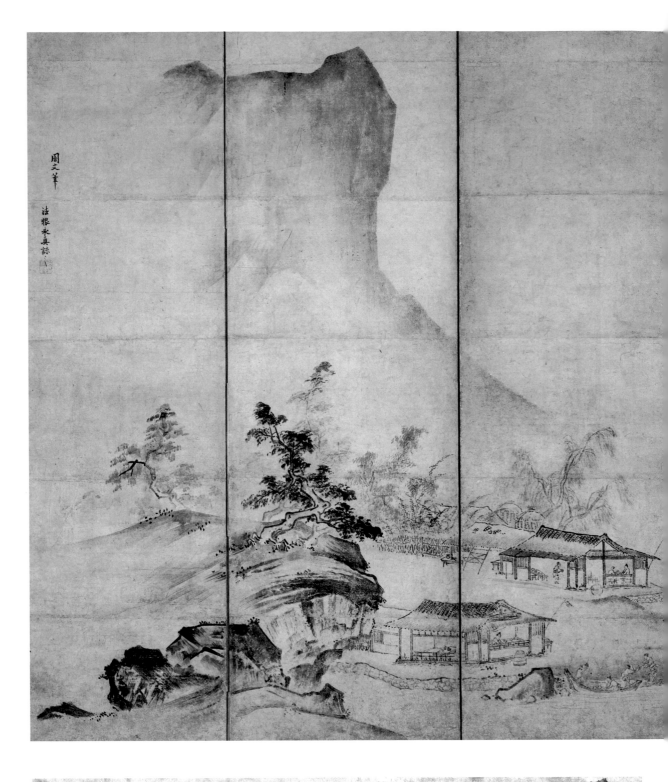

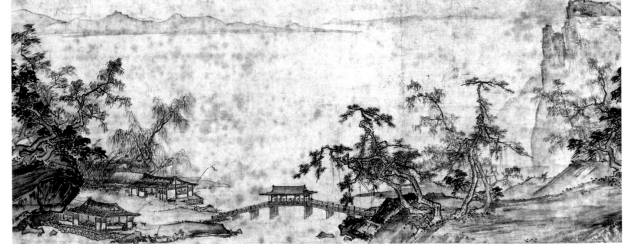

Figure 35. Unidentified artist (early 16th century), *Copy of Xia Gui's "Streams and Mountains, Pure and Remote."* Hanging scroll, ink on paper, 44.4 × 107.8 cm (17½ × 42½ in.). Hatakeyama Memorial Museum of Fine Art, Tokyo

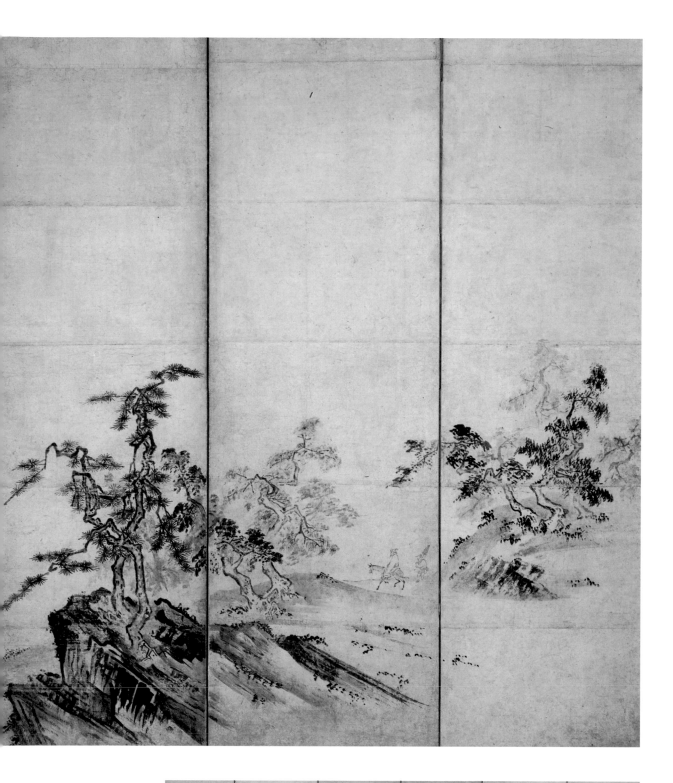

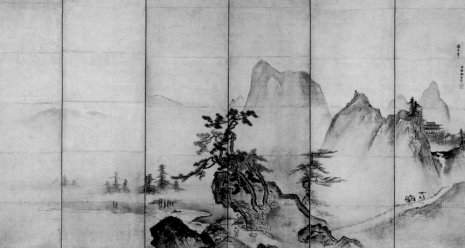

Figure 36. Follower of Tenshō Shūbun (fl. 1414–before 1463), right screen of *Landscape after Xia Gui*, early 16th century. Six-panel folding screen, ink and color on paper, 153.9 × 274.8 cm (5 ft. ⅝ in. × 9 ft. ¼ in.). Mary and Jackson Burke Foundation, New York

The screen depicts a small, peaceful village nestled beside a stream at the foot of the cliff. In the left foreground men unload goods from a boat. Two wineshops are identified by the white flags fluttering in the doorways. In one shop two gentlemen are served cups of wine; beyond them houses and haystacks are visible. At the right, a gentleman riding on a donkey and accompanied by a servant carrying an umbrella approaches the village through a mountain pass. The right screen (fig. 36), whose composition is unrelated to that of the Xia Gui, is obviously a later work, executed—perhaps as a replacement—by an early-sixteenth-century follower of Shūbun.

While the screens bear no signature or seal that would suggest Shūbun's authorship, both were authenticated by Kano Yasunobu (1613–1685), who placed the certificate of attribution and his own name and *hōgen* seals on each one. That Yasunobu's calligraphic style on the two screens is the same suggests that they formed a pair when he examined them.

Artists of the Muromachi period generally relied on Chinese models, especially the works of Southern Song painters like Xia Gui. Indeed, scholars have always recognized in the paintings associated with Shūbun's name the notable influence of the Xia Gui style, and there is certainly evidence in support of that contention for the Burke landscape.

1. On the life of Shūbun, see Tanaka Ichimatsu 1972; and Watanabe Hajime 1985. For documentation, see Watanabe Hajime 1985, pp. 92–94; for an English summary, see Y. Shimizu and Wheelwright 1976, p. 116, n. 11. For other documentation, see *Kanmon gyoki* 1944; *Inryōken nichiroku* 1978–79; and Watanabe Hajime 1985, pp. 95–109.
2. Miyajima Shin'ichi 1994, p. 79.
3. *Chosŏn wangjo sillok* 1955–58, vol. 2, pp. 575–77.
4. Matsushita Takaaki and Tamamura Takeji 1974, pp. 41–44.
5. For the Taipei version, see Fong and Watt 1996, pl. 87.

HIDEMORI (SHŪSEI, FL. 1ST HALF OF 15TH CENTURY)

62. *Early Spring Landscape*

Muromachi period (1392–1573)
Hanging scroll, ink and light color on paper
74.5 × 27.7 cm (29⅛ × 10⅞ in.)
Inscription by Sesshin Tōhaku (d. 1459)
Seals: *Hidemori*; *Sesshin*; and [illegible]

LITERATURE: Matsushita Takaaki 1960, no. 29; Matsushita Takaaki 1968, illus.; Matsushita Takaaki and Tamamura Takeji 1974, pl. 64; Murase 1975, no. 33; Matsushita Takaaki 1979, fig. 78; Shimada Shūjirō 1979, no. 62; Ford 1985, fig. 8; Tokyo National Museum 1985a, no. 14; Schirn Kunsthalle Frankfurt 1990, no. 40; Kanazawa Hiroshi 1994, fig. 69.

The poem inscribed at the upper left describes the simple landscape represented beneath it:

South of the river, north of the river,
 the snow is clearing.
Mountains spew forth rosy clouds,
 springtime colors are fresh.
Travelers remove their shoes, though
 the going still is rough.
Beside the open window, seated guests
 enjoy the splendid view.
Water flowing beneath the bridge rings
 like chimes of jade.
At the eaves, the wind in the pines
 tunes its stringless lute.
But why is that leaf of a boat moored
 beside the cliff?
Perhaps it is for wandering ten thousand
 miles away.[1]
 —*Chōsetsushi*

Inside a pavilion built over a river, two gentlemen sit looking out across the water, where two fishermen are seen in a boat. In the lower right corner, two figures meet on a path along the river's edge, near to where a second boat is moored. Beyond a small wood bridge in the distance, mountain peaks are enveloped in a gentle gray mist.

Two seals are impressed at the beginning and end of the verse, which is signed Chōsetsushi (Fisherman in the Snow). The rectangular seal is not legible, but the round seal has been deciphered as "Sesshin."[2] The name Sesshin, sometimes written "Sesshin Tōhaku," appears in several fifteenth-century documents, where it refers to a scholarly Zen monk of the period. In 1446, Sesshin is reported to have been appointed forty-ninth abbot of Shōkokuji, Kyoto, the official temple of the Ashikaga shoguns. Shortly thereafter, he was appointed the 129th abbot of Tenryūji, also in the capital. His age in 1459, when he died, was reported as seventy or seventy-seven.

A round seal reading "Sesshin" was also used by a man who went by the name Dokuchōshi (Lone Angler). His signature appears in an inscription on an ink-monochrome landscape, now in the Tokiwayama collection in Kamakura, which like the Burke landscape is attributed to Hidemori.[3] Although the seal on the Tokiwayama painting is not identical to the round seal seen here, the calligraphic styles of the two inscriptions are very close. And because "Dokuchōshi" and "Chōsetsushi" refer to fishing, it is not unlikely that they are pseudonyms for the same person.

Both paintings are in the *shigajiku* tradition.

The format is tall and narrow, and a poem that fills the greater portion of the scroll is inscribed above a small landscape painting. The strong asymmetry is characteristic of *shigajiku* landscapes, and the brush technique recalls that of the style ascribed to the elusive master of the genre, Shūbun (cat. no. 61). In the present painting the large rock, pavilion, and tree are darkly outlined and rendered in wet strokes of varying ink hues, while broad washes define the low-lying shore, the mountains, and the trees half hidden in hazy mist.

The background of the artist Hidemori (Shūsei), whose seal is impressed on the rock at the right, is completely unknown, though several paintings bearing this seal exist. Matsushita Takaaki has suggested that the Hidemori seal was used by Sesshin Tōhaku.[4] And although the seal is not found on the painting in the Tokiwayama collection, stylistically the painting closely resembles other pictures that bear it. Two of the six paintings with this seal have colophons written by Sesshin Tōhaku, the only colophon writer known to have collaborated with Hidemori. Conversely, it is possible that Sesshin Tōhaku not only composed the colophon and inscribed it but also executed the painting, in the tradition of such fourteenth-century monks as Taikyo Genju and Tesshū Tokusai (cat. nos. 43, 44). Sesshin's tenure at Shōkokuji coincided with Shūbun's period of activity there as the shogun's chief painter, which may explain the close stylistic similarities between the works of the two artists.

1. Translation after Stephen D. Allee, Research Specialist in Chinese Literature and History, Freer Gallery of Art, Arthur M. Sackler Gallery, Washington, D.C.
2. Matsushita Takaaki 1960, no. 29.
3. Sugahara Hisao 1967, no. 15.
4. Matsushita Takaaki 1968, pp. 135–43.

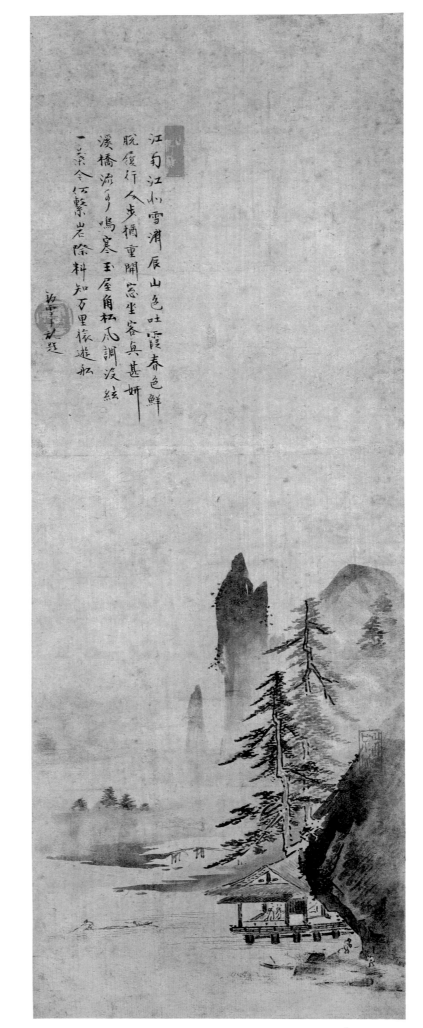

63. *Early Spring Landscape*

Muromachi period (1392–1573)
Hanging scroll, ink and light color on paper
71.1 × 40.6 cm (28 × 16 in.)
Inscriptions by Yōkoku Kentō (d. 1533) and
Teihō Shōchū (fl. ca. 1538)
Seals: *Yō* [?]*koku*; *Shōchū*; and *Shūtoku*

LITERATURE: Matsushita Takaaki 1967, fig. 88;
Tanaka Ichimatsu and Nakamura Tanio 1973,
pl. 80; Murase 1975, no. 39; Y. Shimizu and Wheel-
wright 1976, no. 21; Kawai Masatomo 1978, fig. 31;
Shimada Shūjirō 1979, no. 60; Akazawa Eiji 1980,
fig. 46; Kanazawa Hiroshi 1983, fig. 54; Tokyo
National Museum 1985a, no. 22; Shimada Shūjirō
and Iriya Yoshitaka 1987, no. 126; Schirn Kunsthalle
Frankfurt 1990, no. 43; Fukushima Tsunenori 1993,
fig. 31.

*The boat is moored in the west. Spring has
 arrived, and the water is high.
Outside the gate to the Emerald Xiang,
 he rolls up the cabin blinds.
Should the easterly winds look favorably
 on this fine young man,
He will sail at night in the silver moon
 to the distant frosts of Wu.*
 Kakyō Kansho Dōjin Kentō
 Yō [?]*koku*

*Springtime waters swell to heaven,
 the houses seem to float.
My boat is moored; I sleep; what do
 I seek in this life?
My days I give to paddling in
 wind and stream.
The mountains are like beautiful women,
 the river a silver gull.*[1]
 Zen Fukuzan Shōchū
 Shōchū

Steep cliffs tower above a pavilion near the
edge of a river. A boat is moored on the
banks, and from behind a craggy rock with a
few tenacious pines, a waterfall gushes forth.
Across the water a bridge joins two low-
lying promontories, and in the distance the
hills are enveloped in mist. The blue on
mountains, foliage, and rocks hints of early
spring. The asymmetry of the composition
and the poetic inscriptions at the top recall
fifteenth-century *shigajiku*, such as those
attributed to Shūbun. And the architectonic
composition, the strong contrast of light
and dark, and the jagged edges of rocks and
trees are reminiscent of the work of Sesshū,
another great landscape artist of the late
fifteenth century.

Both colophon writers served as abbot at
Kenchōji, Kamakura. Yōkoku Kentō, who
signed the first poem, was the 169th abbot, and

upon his death in 1533 he was succeeded by the
writer of the second poem, Teihō Shōchū.

An artist called Shūtoku is mentioned in a
number of Edo-period histories.[2] Most likely
he was a monk-painter, originally either
from Utsunomiya, north of Tokyo, or from
Suō Province (Yamaguchi Prefecture) in
western Japan. A pupil of Sesshū's, he inher-
ited his master's studio, Unkoku-an, after the
latter's death in 1506.[3] From 1539 to 1541 he
may have been a member of a trade mission
to China organized by the Ōuchi family and
led by the monk Sakugen (1501–1579).[4]

Extant paintings and literary records attest
that a painter named Shūtoku was active in
the 1530s and 1540s. The Shūtoku who trav-
eled to China in 1539 used a different second
character in his name than did Shūtoku the
painter. About ten extant paintings bear the
"Shūtoku" seal. The Burke landscape is also
impressed with this seal, but it includes an
archaic form of the character for *toku*, and
for this reason has been attributed to yet
another Shūtoku.[5] But it is not inconceivable
that the same artist used two different forms
of the character. Furthermore, the painting
reflects the unmistakable influence of Sesshū,
especially in the architectonic nature of the
composition and the clearly defined brush-
work. It would seem quite reasonable then to
posit that the two names, spelled with only a
slight variation, refer to one and the same
person, a monk-painter and close follower of
the master Sesshū.

1. Translations after Stephen D. Allee.
2. For these references, see Y. Shimizu and Wheel-
 wright 1976, pp. 166–69.
3. Tanaka Kisaku 1936, pp. 236–42.
4. Makita Tairyō 1955, p. 179; and Tanaka Ichimatsu
 and Nakamura Tanio 1973, pl. 80.
5. Shimada Shūjirō and Iriya Yoshitaka 1987, p. 376.

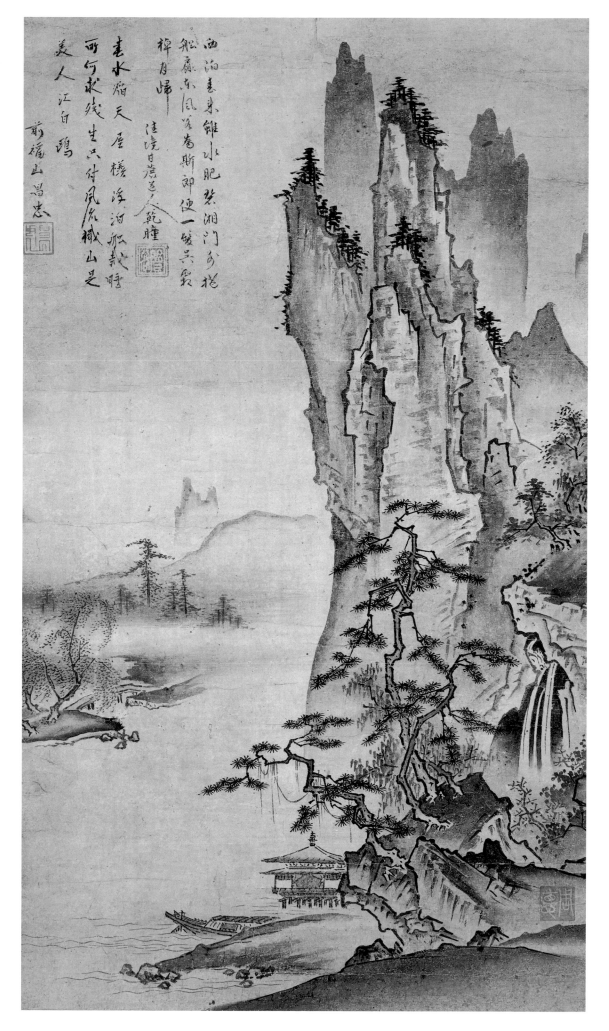

64. *Two Views from the Eight Views of the Xiao and Xiang Rivers*

Muromachi period (1392–1573)
Pair of hanging scrolls, ink and light color on paper
Right scroll 46 × 30.1 cm (18⅛ × 11⅞ in.); left scroll
47.6 × 30.1 cm (18¾ × 11⅞ in.)
Seal: *Kantei* [on each scroll]
Ex coll.: Kusaba Akira, Tokyo; Hachisuka
Yoshiaki, Tokyo

LITERATURE: "Kantei hitsu Sansui zu" 1898,
pp. 167, 169; Tajima Shiichi 1902, no. 22; Iizuka
Beiu 1931, pl. 155; Hasumi Shigeyasu 1935, pp. 1–7;
Matsushita Takaaki 1960, no. 35; Muraki Chii 1960,
fig. 4; Matsushita Takaaki 1967, fig. 121; Shimada
Shūjirō 1969, vol. 1, p. 121; Stanley-Baker 1974,
fig. 17; Murase 1975, no. 34; Y. Shimizu and Wheel-
wright 1976, no. 15; Shimada Shūjirō 1979, no. 63;
Tokyo National Museum 1985a, no. 16; Schirn
Kunsthalle Frankfurt 1990, no. 39.

In the scroll at the right, a gentleman traveler on a donkey and his attendant following on foot approach the bend of a path beneath an overhanging cliff. Beyond a small bridge rises an imposing city gate, and a full harvest moon glows over trees shrouded in mist. In the scroll at the left, snow-covered mountains tower behind a forested village. A farmer, riding backward on a water buffalo, returns home after a day in the fields. The bent branches of a naked willow repeat the formation of a flock of geese flying into the distance.

The scrolls depict two scenes from the Eight Views of the Xiao and Xiang Rivers (J: Shōshō Hakkei), one of the most popular subjects in traditional Chinese poetry and landscape painting. The setting is a region of South China that includes the provinces of Hunan and Jiangxi and the mountains of northern Guangxi.[1] With low-lying hills often shrouded in clouds, the area was the source of a rich tradition in literature and the locus of ancient myths, popular lore, and historical tales. In spite of its natural beauty, however, Chinese scholar-officials apparently disliked being posted there and considered it a place of exile.

The Northern Song painter Song Di (fl. 11th century), who retreated there after his abrupt dismissal from court in 1074, is the first artist reported to have painted views of the region in groups of eight. Although this cannot be verified, it was certainly about this time that the Eight Views entered into the iconography of Chinese landscape painting. The group provided painters with a formula to represent not only mountains and rivers but the appearance of the landscape in the seasons of the year, at different times of day, and in changing weather and shifting light. Song Di apparently painted the series several times over, most likely in a handscroll for-mat, though not a single work has survived. The general appearance of the paintings, however, can be gleaned from the poems they inspired.[2] The literary evidence suggests that Song Di's paintings did not necessarily depict the actual views but rather portrayed scenery that was suggestive of mood and impression.

The eight scenes came to be known by the following titles:

Mountain Market, Clearing Mist
Sails Returning from a Distant Shore
Sunset over a Fishing Village
Evening Bell from a Mist-Shrouded Temple
Night Rain on the Xiao and Xiang Rivers
Wild Geese Descending on a Sandbank
Autumn Moon over Dongting
River and Sky in Evening Snow

As a subject for paintings, they lost favor in China after the fall of the Southern Song dynasty in 1279, but the theme appealed to Japanese sensibilities and has enjoyed a last-ing popularity in Japan. The subject was introduced to Japan, perhaps as early as 1299, by Yishan Yining (died 1317 in Japan), a Chinese monk whose inscription appears on *Wild Geese Descending*, a rather weak interpretation of the sixth View, now in a private collection in Japan, by an early-fourteenth-century Japanese ink painter named Shikan (Shitan).[3] Chinese representa-tions of this subject were also imported to Japan. They came to be highly treasured and were frequently copied. The third Ashikaga shogun, Yoshimitsu (r. 1369–95), owned two famous versions in handscroll form by the Southern Song Chan masters Yujian (fl. mid-13th century) and Muqi (fl. late 13th–early 14th century). He had the hand-scroll by Yujian cut into eight sections and mounted, each as a hanging scroll. Seven of Muqi's Views have survived, but only three of Yujian's.[4] As each of Yujian's scenes includes a titled poem, the themes can be identified—as *Mountain Market, Sails Returning*, and *Wild Geese Descending*.

Later generations of Japanese artists took the Muqi and Yujian Eight Views as models, painting them on hanging scrolls and hand-scrolls, and arranging them in horizontal sequence across sliding and folding screens—a format to which they were ideally suited. Emulating Muqi and Yujian and following the nature of the landscape itself, Japanese artists have tended to represent the Eight Views in the washy, nonlinear technique known as *haboku* (splashed ink), in which outlines are

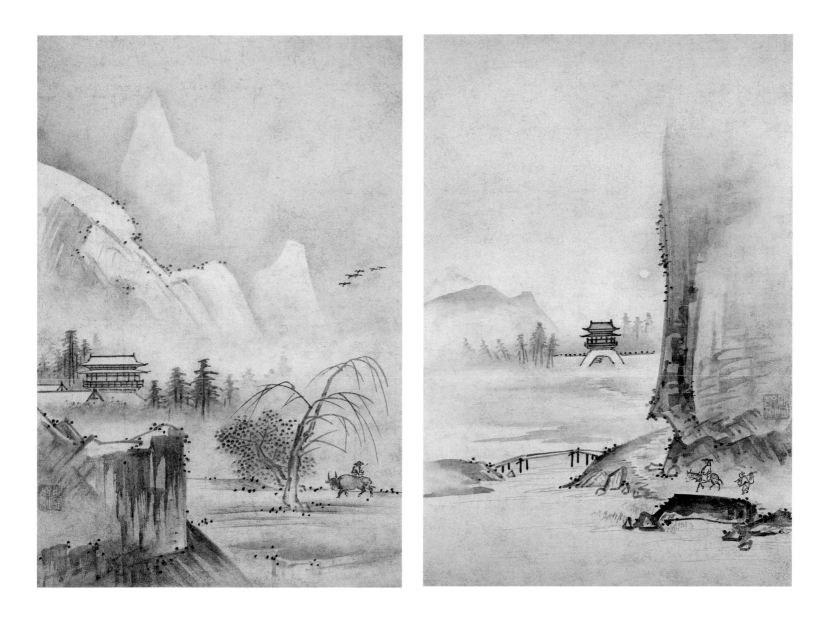

replaced by a soft, painterly wash and then accented in a darker, drier ink applied before the wash is completely dried.

The imagery of the Burke scrolls is quite conventional, though ambiguities exist that invite different interpretations. The scroll at the right, with a lake and a full moon rising, may illustrate *Autumn Moon over Lake Dongting*. But the gate and crenellated city gate, which may have been introduced merely to counterbalance the cliff at the right, suggest the presence of a Buddhist temple within—in which case *Evening Bell from a Mist-Shrouded Temple* may be the main theme or a subtheme. The scroll at the left, with wild geese and snow-covered mountains, also includes motifs from two of the Eight Views: *Wild Geese Descending on a Sandbank* and *River and Sky in Evening Snow*.[5] The scenes on each of the scrolls have also been given different interpretations.[6]

The numerals 4 and 6 are written—perhaps by a later hand—on the back of the right and left scrolls, respectively, directly behind the artist's seal. Three other paintings by Kantei have numerals written on the reverse in the same manner.[7] It has been suggested that each of these five paintings may once have been accompanied by a poem written on a separate sheet of paper and at some

later date were mounted together on a screen.[8]

Kantei, like many Japanese painters of the fifteenth century, is known today only through his work. His biography was not recorded until the Edo period, and there he is linked with Tōshōdaiji, Nara. This temple may have honored the artist in his lifetime with the title *Nara hōgen*, and indeed there is a painting with Kantei's seal in the Tōshōdai-ji collection.[9] Beyond this, any connection he may have had with this ancient Nara temple remains speculative. In the Edo period, Kantei was identified with the monk-painter Bokkei (Hyōbu, d. 1478). Bokkei was closely associated with the eccentric Zen monk Ikkyū Sōjun (1394–1481), who took up residence at Daitokuji, Kyoto, in 1474, having lived previously at Shūon'an, a temple near Nara. A connection between Kantei and Daitokuji is possible if Kantei lived in Nara and was acquainted with Ikkyū before the latter moved to the temple.

Kantei may be associated with Daitokuji in an artistic sense as well. His paintings are often described as showing an affinity with the work of Soga Jasoku (fl. 15th century), who painted the screens at Shinjuan, a subtemple of Daitokuji. However, the Burke scrolls bear a closer resemblance to the work of Sesshū (1420–1506). Especially noticeable

is an allusion in the right scroll to Sesshū's *Winter Landscape*, now in the Tokyo National Museum, where a precipice is counterbalanced by the horizontality of a city wall.[10] The emphatic outlines, broad ax-cut strokes, and architectonic structuring of pictorial elements by overlapping planes, which characterize the styles of both Sesshū and Kantei, may ultimately be traced to the twelfth-century Southern Song master Xia Gui.[11]

1. On the theme of the Eight Views, see Shimada Shūjirō 1941, pp. 6–13; Suzuki Kei 1964, pp. 79–92; Stanley-Baker 1974, pp. 284–303; Watanabe Akiyoshi 1976; Murck 1984, pp. 213–235; and Murck 1996, pp. 113–44.
2. Murck 1984.
3. Reproduced in Tanaka Ichimatsu and Yonezawa Yoshiho 1978, pl. 6.
4. For the listing of the extant paintings, see Ikeda Toshiko 1996, pp. 530–35.
5. Y. Shimizu and Wheelwright 1976, pp. 132–37.
6. Shimada Shūjirō 1979, no. 63.
7. The three paintings are in the Tokyo National Museum, Tokyo National University of Fine Arts and Music, and on loan to the Princeton Art Museum. See Shimada Shūjirō 1969, vol. 1, p. 121; and Y. Shimizu and Wheelwright 1976, figs. 45, 46.
8. Y. Shimizu and Wheelwright 1976, p. 135.
9. Ishida Mosaku 1955, pl. 54, fig. 4.
10. Y. Shimizu and Wheelwright 1976, p. 136.
11. Stanley-Baker 1974, p. 287.

KEISON (FL. LATE 15TH–EARLY 16TH CENTURY)

65. *Landscapes of the Four Seasons*

Muromachi period (1392–1573)
Pair of hanging scrolls, ink on paper
Each scroll 97.5 × 50 cm (38⅜ × 19¾ in.)
Seals: *Hōgen* and *Keison* [on each scroll]

LITERATURE: Murase 1975, no. 38; Etō Shun 1979, pl. 71; Tokyo National Museum 1985a, no. 21; Tokyo Metropolitan Teien Art Museum 1986, p. 112; Schirn Kunsthalle Frankfurt 1990, no. 42; Tochigi Prefectural Museum and Kanagawa Prefectural Museum of Cultural History 1998, p. 175, fig. 2.

The scroll at the left depicts a cold moon suspended over flying geese. In the distance bare trees on the mountains are weighted by winter snow, while in the foreground leafless branches extend over the water. The elements of autumn and winter are concentrated on the left side, leaving an open view of water on the right. The composition, except for two tall pines in the center, is mirrored in the companion scroll, creating a vista of water between the land masses when the two are hung together.

Two large seals of Keison, the artist who

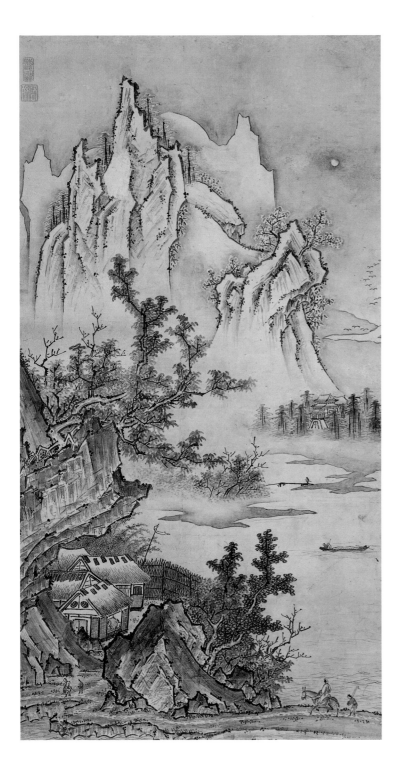

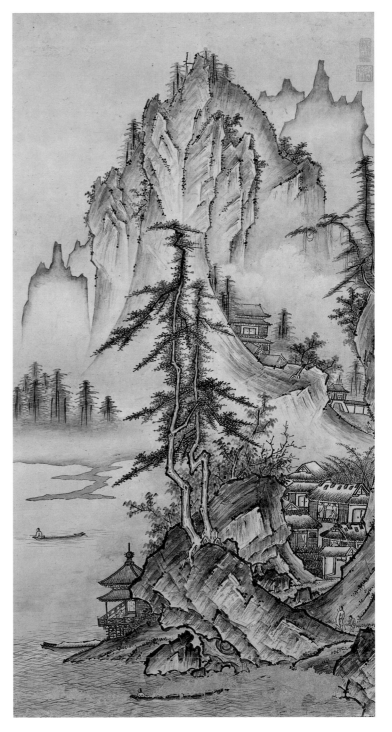

painted the landscapes, are impressed at the top left corner of the left scroll and at the top right corner of the right scroll. The balanced juxtaposition of both the seals and the two compositions suggest that the scrolls, which were acquired by the Burke Collection in two separate purchases several years apart, may originally have been a diptych. If this is the case, the scroll at the right, though it has no obvious seasonal imagery, must have been intended as an allusion to spring and summer.

On the other hand, it is possible the scrolls were part of a triptych. Keison painted a sty-listically similar ink-monochrome triptych that is now in the Tochigi Prefectural Museum, Utsunomiya. The central panel illustrates an old Chinese fable, the Three Laughers of Tiger Valley (Kokei Sanshō); the side panels show landscapes that are nearly identical to these two, except that they lack seasonal references.[1] Japanese paintings of Buddhist deities often were flanked by subjects taken from nature. The most famous example of this tradition is a triptych by the Southern Song painter Muqi (fl. late 13th–early 14th century) now in Daitokuji, Kyoto.

The central panel represents White-Robed Guanyin, the side panels, monkeys and a crane. The earliest Japanese example is a fourteenth-century White-Robed Kannon (Yamato Bunkakan, Nara) flanked by two landscapes (private collection, Japan) painted by Gukei Yūe (fl. mid-14th century).[2] A triptych by Keison formerly in the collection of Marquis Shimazu depicts a Chan patriarch in the center panel flanked by side panels with birds.[3]

The Burke landscapes are firmly united by stylistic consistencies. Rocks, mountains,

trees, and houses are sharply outlined, and forms are clearly defined by bold, angular brushstrokes and by the juxtaposition of dark and light inks. The rocky hills and houses convey a sense of solid mass, and the mountains in the background have a crystalline hardness. There is little sense of depth in these highly structured, crowded compositions. These features reflect the artist's dependence on a formula established by Kenkō Shōkei (cat. no. 52), one that became

popular in the region of Kamakura. And indeed, Keison was a faithful follower of the master. As the first part of his name suggests, he was in fact Shōkei's pupil. He became associated with Shōkei perhaps after 1480, when the latter returned to Kamakura after completing his studies with Geiami (1431–1485) in Kyoto. No documents concerning Keison's life have yet been found, but paintings with his seals suggest that he was a versatile artist, comfortable with land-

scape, figure painting, and the bird-and-flower genre. While he sometimes painted in the soft *haboku* (splashed ink) style, he was equally adept in the strong, hard manner of these landscapes.

1. Tochigi Prefectural Museum and Kanagawa Prefectural Museum of Cultural History 1998, nos. 9, 105.
2. Fontein and Hickman 1970, nos. 35, 36.
3. Tochigi Prefectural Museum and Kanagawa Prefectural Museum of Cultural History 1998, fig. 37.

BOKUSHŌ SHŪSHŌ (FL. LATE 15TH–EARLY 16TH CENTURY)

66. *Splashed-Ink Landscape*

Muromachi period (1392-1573)
Hanging scroll, ink on paper
80 × 33.9 cm (31½ × 13⅜ in.)
Seal: *Bokushō*
Ex coll.: Umezawa Kinenkan Museum, Tokyo; Moriya Kōzō, Kyoto

LITERATURE: "Bokushō hitsu Sansui zu" 1942, pl. 7; Matsushita Takaaki 1960, no. 43; Hanshin Department Store 1971, pl. 24; Murase 1975, no. 35; Y. Shimizu and Wheelwright 1976, no. 19; Shimada Shūjirō 1979, no. 56; Akazawa Eiji 1980, fig. 45; Tokyo National Museum 1985a, no. 20; Schirn Kunsthalle Frankfurt 1990, no. 41.

With broad strokes of wet ink and a few dot-like strokes of darkest ink accentuating an otherwise muted surface, Bokushō creates an intimate, evocative composition. A precipice hangs precariously over a river valley. Distant mountains enveloped in mist rise behind a lush growth of trees and a group of lightly sketched houses, the stillness broken only by two small figures, a traveler crossing a bridge in the foreground and at the right a man trudging up the mountain path.

The painting is a variation on a celebrated landscape in the *haboku* (splashed ink) technique by Sesshū (1420–1506), now in the Tokyo National Museum. In his use of *haboku*, Sesshū was himself paying homage to the work of the thirteenth-century Chinese master Yujian, whose landscape series Eight Views of the Xiao and Xiang Rivers was much admired in Muromachi Japan (see cat. no. 64). Sesshū's original was given by the master to his pupil Sōen as a farewell gift in 1495.

Bokushō's interpretation lacks the architectonic structure of Sesshū's composition, and it is more lyrical than other *haboku* paintings by followers of Sesshū. In these ways Bokushō looked back past Sesshū to Yujian. In his subtle realization of the *haboku* technique,

using neither contour lines nor explicit details, Bokushō captures the essence of the Zen spirit.

A noted scholar-poet of the late fifteenth–early sixteenth century, Bokushō Shūshō was a high-ranking Zen monk at Nanzenji and Shōkokuji, two of the most prestigious Zen temples in Kyoto. Late in his life he lived at Hōjuji (Yamaguchi Prefecture), at the western end of Honshū, where Sesshū also settled after leaving Kyoto. That the two men were close friends is documented by Bokushō's inscription on a painting by Sesshū now in the Ōhara collection, Okayama;[1] it is also possible that Bokushō studied painting with Sesshū.

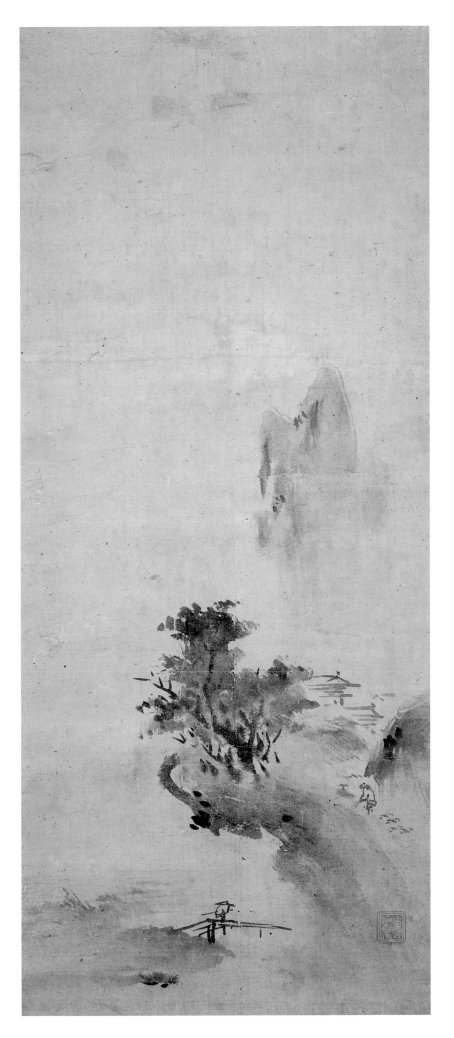

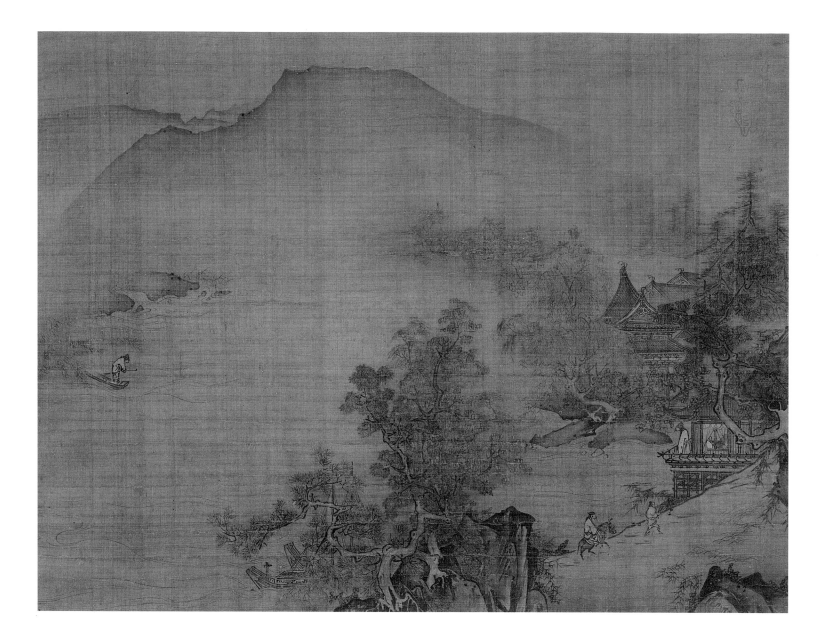

67. *Landscape with Pavilion*

Muromachi period (1392–1573)
Hanging scroll, ink and light color on silk
39.8 × 51.3 cm (15⅝ × 20¼ in.)
Seals (one cauldron shaped, one square): *Sesson*

LITERATURE: Matsushita Takaaki 1960, no. 70;
Nakamura Tanio 1971, fig. 24; Murase 1975, no. 40;
Shimada Shūjirō 1979, no. 88; Akazawa Eiji 1980,
fig. 68; Etō Shun 1982, pl. 6; Tokyo National
Museum 1985a, no. 23; Schirn Kunsthalle Frankfurt
1990, no. 44; Nakajima Junji 1994, fig. 69.

Sesson Shūkei (ca. 1504–ca. 1589) was a
Zen monk-painter who lived most of his life
in northeastern Japan. Although he was
never associated with the erudite Zen circles
of Kyoto, he was an ink painter of note
who, already in the *Honchō gashi* (1678) by
Kano Einō (1631–1697), was admired as an
"eccentric artist whose works evoke a strange
emotional response."[1]

Sesson was born, perhaps in 1504, in the
small town of Hetare in Hitachi Province
(Ibaraki Prefecture).[2] His father was a mem-
ber of the powerful Satake family, and
because he designated Sesson's half brother

as his heir, Sesson left home as a young man
to enter the Zen priesthood. Apparently, he
learned to paint in his early years and earned
his living for a time selling painted fans near
his hometown. By 1542 he had established his
reputation as a painter and had written a trea-
tise on painting, *Setsu monteishi*, in which he
discusses the study of nature, the copying of
old masters, and the expression of artistic
individuality.[3] He also proclaims his admira-
tion for Sesshū (1420–1506), the great master
he regretted never having met.

In 1542 Sesson was living in Hetare, but
he soon took up the life of a peripatetic monk-

painter, and his name begins to appear in various literary documents. By 1546 he had moved farther north, to Aizu Wakamatsu (Fukushima Prefecture), where he gave painting lessons to Ashina Moriuji (1521–1580), the governor of a large fief. At that time some of his paintings must have been acquired locally, as they are listed in regional records. Within a few years Sesson had moved south to Odawara, seat of the Go-Hōjō government, near Kamakura, and by 1550 he had a number of close relationships with important Zen monks in the area. In the summer of 1550, for example, he painted a *chinsō* (portrait of a Zen master) of Iten Sōsei (1472–1554), who had come from Daitokuji, Kyoto, to establish Sōunji in Odawara; the work is now in Hōshun'in, Daitokuji.[4] His painting *Myna Bird*, in the Tokiwayama collection, Kamakura,[5] must also date to that period, as it bears an inscription of 1555 written by the monk Keisho Shūzui (1476–1557), the 151st abbot of Enkakuji, Kamakura. Sesson's activity in the area was not confined to painting; he is also known to have instructed Hōjō Ujimasa (1538–1590), governor of Odawara, in the ways of Zen.

In Sesson's day, the eastern cities of Kamakura and Odawara formed a cultural center independent of Kyoto, with a distinctive regional style of ink monochrome. Sesson spent at least twelve years there, and through personal contacts must have gained access to the collections of Chinese and Japanese paintings belonging to the Go-Hōjō family and to local Zen temples. Sometime after 1561 he went north again, and when he was seventy he settled in the small town of Miharu, near his birthplace. He remained there until he was at least eighty years old. He may have lived to be eighty-six.

Although more than 150 paintings by Sesson are known today, it is difficult to trace the development of his oeuvre, as so few of his works bear dated inscriptions. With the exception of his portrait of the Zen master Iten Sōsei, Sesson did not sign his paintings in his early years.[6] Recent studies show that documented paintings are largely confined to his last twenty years, from the 1570s to his death about 1589;[7] indeed, not until he was in his seventies did he regularly sign his work, sometimes stating his age. A study by Tanaka Ichimatsu suggests that Sesson's eighteen

known seals and signature styles may be directly related to changes in his painting style.[8] Thus, it may eventually be possible to reconstruct a chronology.[9]

Landscape with Pavilion shows at the right a traveler on a donkey. With his servant leading the way, he progresses up a mountain path toward a cluster of lavishly appointed houses, where a gentleman surveys the calm expanse of water before him as he awaits the arrival of his guest. At the left a great mountain rises from the edge of the lake, and a lone fisherman casts his fishing rod.

The beauty of Sesson's painting is unfortunately somewhat diminished by the condition of the silk, darkened with age, but the superb brushwork and tightly structured composition can still be appreciated. The painting is essentially ink monochrome, though a spot of bright red on the donkey's saddle quickens the shades of the delicate foliage. The architectonic structure of the composition is seldom found in Sesson's landscapes, nor are the tightly controlled lines and the subtle changes in tonality—reflecting perhaps his emulation of painters of the Southern Song Academy, particularly Ma Yuan (fl. ca. 1190–1225). The division of the composition into two triangular areas by an invisible line running diagonally from the upper right to the lower left also reflects a knowledge of the Southern Song manner.

Although *Landscape with Pavilion* is not signed, it bears two seals, both of which read "Sesson." The same seals are found on other works without a signature, many of which are also painted on silk, with delicate brushstrokes and bright colors, in the manner of the Song and Ming Academies. The style, the absence of a signature, and the type of seals used all suggest that the painting is an early work, executed when Sesson was studying the great masters of the past. According to an inscription of 1655 on the box in which the painting was preserved, the scroll once belonged to a gentleman named Torii Jiun who lived in Tanakura, a small town in Fukushima Prefecture. It is possible that Sesson made the scroll for a local patron during his northward journey to Aizu, as the town of Tanakura is situated on the road connecting Hetare with this destination.[10]

1. Kano Einō 1985, p. 253.
2. On Sesson's life, see Ibaraki Prefectural Museum of History 1992. For pre-Meiji literary sources on Sesson, see Nakamura Tanio 1971, p. 19.
3. Kameda Tsutomu 1980, p. 121.
4. Reproduced in ibid., pl. 11.
5. Reproduced in ibid., pl. 67.
6. Tanaka Ichimatsu 1958, pp. 1–10.
7. Fukui Rikichirō 1935, pp. 131–34; Tanaka Ichimatsu 1958, pp. 1–10; and Ibaraki Prefectural Museum of History 1992.
8. Tanaka Ichimatsu 1958, pp. 1–10.
9. See Ford 1980.
10. Nakamura Tanio 1971, p. 31.

SESSON SHŪKEI (CA. 1504–CA. 1589)

68. *Landscape with Rocky Precipice*

Muromachi period (1392–1573)
Hanging scroll, ink and color on paper
30.3 × 46.8 cm (11⅞ × 18⅜ in.)
Signature: *Kei Sesson*
Seal: *Shūkei*
Ex coll.: Kumita Shōhei, Tokyo

LITERATURE: Honma Art Museum 1968, illus.;
Etō Shun 1969b, pp. 69–70; Nakamura Tanio 1971,
fig. 1; Tanaka Ichimatsu and Nakamura Tanio 1973,
pl. 102; Murase 1975, no. 42; Mayuyama Junkichi
1976, no. 410; Kameda Tsutomu 1980, pl. 10; Etō
Shun 1982, pl. 13; Tokyo National Museum 1985a,
no. 24; Schirn Kunsthalle Frankfurt 1990, no. 46;
Nakajima Junji 1994, fig. 111.

Unlike his *Landscape with Pavilion* and the
Seven Sages of the Bamboo Grove (cat. nos.
67, 69), Sesson's *Landscape with Rocky
Precipice* exhibits a stylistic idiosyncrasy
typical of the artist's later works. A strip of
land in the right foreground is connected by
a land bridge to a cluster of steeply rising
cliffs. At the far end of the bridge the path
shifts abruptly to the right, leading upward
to a building complex—perhaps country
inns—on the cliffs. Mountains gently
touched by mist rise directly behind, and a
fishing village lies nestled on the shore. The
scene is busy with human activity: a traveler
on a donkey, people crossing the bridge
engaging in lively conversation, passenger
boats bobbing on the river.

Sesson was able to produce an unusually
rich tonal variation of ink, from glistening
black to off-white, by using *gofun* (ground

seashells) as sizing for the paper.[1] The free, individualized brushstrokes create a sense of buoyancy. Lines turn at sharp angles, abruptly break off, then start again. The light ink applied to the surface of the rocks and cliffs in rhythmic, repetitive diagonals enhances their massiveness and height, and heavy black lines create strange concavities at the eroded base. It

is this idiosyncratic facture, which lends to the work a jangled, eccentric effect, that becomes characteristic in Sesson's late phase.

The painting is signed, an indication that it was done in the 1560s or later. And it bears only one seal, which reads "Shūkei." Sesson employed this seal on many of his late works, but when he was in his seventies and eighties

he used it in combination with other seals. The presence of the single seal together with the style of the painting would date the work to the artist's middle period, when he was in his sixties.

1. Hayashi Susumu 1984, p. 68.

SESSON SHŪKEI (CA. 1504–CA. 1589)

69. *The Seven Sages of the Bamboo Grove*

Muromachi period (1392–1573)
Hanging scroll, ink and light color on paper
102.6 × 51.8 cm (40⅜ × 20⅜ in.)
Seals: *Sesson* [cauldron shaped] and *Shūkei* [square]
Ex coll.: Sakata Yasorō; Fukuoka Kōtei; and Count Hijikata

LITERATURE: "Sesson hitsu Shichiken suibu zu" 1940, p. 40; Nakamura Tanio 1971, fig. 59; Murase 1975, no. 41; Mayuyama Junkichi 1976, no. 410; Shimada Shūjirō 1979, no. 91; Akazawa Eiji 1980, fig. 92; Kameda Tsutomu 1980, pl. 23; Etō Shun 1982, pl. 219; Hayashi Susumu 1982, fig. 1; Ford 1985, fig. 11; Tokyo National Museum 1985a, no. 25; Schirn Kunsthalle Frankfurt 1990, no. 45; Nakajima Jungi 1994, no. 110; Brown 1997, fig. 8.

In the right foreground of this lively scene, an old gentleman performs an impromptu dance to the tune of drums and flutes played by four of his companions. Beneath leafy bamboo branches, another man holding a wine pot and a cup in his outstretched arms dances along, unsteady on his feet. At the right a reveler, overcome with laughter, collapses on the ground. The antics of these carefree old men draw the attention of a group of women and children. The atmosphere is charged with energy, even the stalks of slender bamboo swaying in response.

In the later years of the Han dynasty (206 B.C.–A.D. 220) a Daoist-inspired pastime called *qingtan* (J: *seidan*), or pure conversation, became popular among bureaucrats and intellectuals in search of temporary release from the strict Confucian code of conduct that governed their lives. Participants would gather in some rural spot to relax and to engage in witty and sophisticated discussions of philosophical matters. On these occasions wine flowed freely and drunkenness was permissible, even expected. Culturally ambivalent behavior can serve as the inspiration of legend, and in China the quasi-historical *qingtan* group known as the Seven Sages of the Bamboo Grove (J: Chikurin Shichiken) became the subject of a popular theme.[1]

The members of the group lived after the fall of the Han dynasty. Ji Kang (A.D. 223–262), the founding member, was a musicologist and renowned player of the *qin* (a seven-stringed zitherlike instrument called a *koto* in Japanese). He is remembered particularly for an essay on the art of *qin* playing.[2] The other members were: Yuan Ji (210–263), Tao Shan (205–283), Yuan Xian (dates unknown),

Xian Xiu (221–ca. 300), Wang Rong (235–306), and Liu Ling (221–300). Escaping to the cool seclusion of Zhulin (Bamboo Grove), a famous summer resort north of the capital, these responsible men of superior education and high position would shed the trappings of their schooled conduct and immerse themselves in the pleasures of music and chess. They also read poetry and, most of all, they drank. When their spirits had been refreshed, they would return to their life of material comfort and politics, and to the decorum of the capital.

Exactly when the Seven Sages were first depicted in painting is not known.[3] One of the earliest extant examples is found on a set of relief-decorated tiles, recovered near the city of Nanjing in South China, that have been dated to the early Six Dynasties period (220–581).[4] The theme of releasing oneself from the strictures of court life must have

been highly appealing to the nobles of the Early Heian period, and Japanese paintings of this subject are reported as early as the late ninth century.[5]

Chinese renditions of the theme usually depict the Seven Sages engaged in music-making and singing, while Japanese representations tend to show them strolling quietly in a bamboo forest (cat. no. 70). Sesson's painting, in which the sages have abandoned themselves to drunken revelry, is a departure from the pictorial norms of both China and Japan. The inclusion of spectators—women, one nursing an infant, and several children—is also unusual.

The painting is in ink monochrome, with light washes of green and buff. A dark ink wash is used for the rocks in the lower left corner. The stalks and leaves of the bamboo are carefully outlined in smooth, deliberate strokes, reflecting Sesson's stylistic debt to the Ming Academy. Clothing is described in short, thick lines that frequently turn, forming sharp angles and nailheads. The tubelike sleeves that hang below the hands of the dancing sage are strangely tapered, and the ends have a curious, animated life of their own.

The painting is not signed, but it bears two seals, both of which appear on dated paintings by Sesson from the 1550s, while he was at Odawara (see cat. no. 67). The absence of a signature on the *Seven Sages* implies that it is from relatively early in the artist's career, before he made it a habit to sign his works. Its unusual stylistic features may be regarded as an intimation of the idiosyncrasies of Sesson's late style.

1. Spiro 1990; and Brown 1997.
2. Holzman 1957; and Gulik 1969.
3. For fourth- and fifth-century paintings on the theme, see Soper 1961, p. 85.
4. Nagahiro Toshio 1969.
5. Ienaga Saburō 1966a, p. 25.

70. *The Seven Sages of the Bamboo Grove*

Muromachi period (1392–1573)
Hanging scroll, ink on paper
31.2 × 53.7 cm (12¼ × 21⅛ in.)
Seal: [illegible]

LITERATURE: Tochigi Prefectural Museum
and Kanagawa Prefectural Museum of Cultural
History 1998, p. 170, fig. 6.

In a bamboo grove by a stream, four Chinese gentlemen-scholars, the Seven Sages of the Bamboo Grove (see cat. no. 69), engage in casual conversation while strolling toward their companions on the left. A waterfall is visible through a stand of bamboo, and farther to the left a fence suggests the presence of a recluse's hut. Engaging in spontaneous conversation and sharing in the appreciation of nature were pastimes that reflected the ideals of Zen Buddhism, and the theme of the Seven Sages became a popular subject for ink painting in sixteenth-century Japan. Many such works were produced for Zen temples and for the regional warlords who patronized the temples and were themselves collectors of things Chinese.

Formerly attributed to Kano Motonobu (cat. no. 71), the present scroll has been reattributed to an artist whose red seal in the shape of a two-handled vase has been detected in the lower left corner. Although the characters are not legible, stylistic features of the painting are similar to those found in works bearing a seal of the same shape whose characters have been read as both "Seikō" and "Rikō." The contour lines and garment folds seen here, for example, are depicted with dark, straight lines that open with a nailhead brushstroke applied over slightly wider lines in lighter ink, a characteristic of figure paintings with the "Seikō" seal, such as *The Seven Sages of the Bamboo Grove* in the Tokiwayama collection, Kamakura, and the depiction of the deity Hotei in the Tokyo National Museum.[1] Furthermore, the configuration of the sages' caps and, in particular, the facial features of the central figure in the group at the left correspond to the same elements in a painting of the Seven Sages with the "Seikō" seal, also in Kamakura.[2]

No biographical records exist for the artist

who used the "Seikō" seal. Not until the *Koga bikō* (Notes on Old Painters) was published, in 1905, was the seal listed; there it is included in a section devoted to unidentified seals and given a tentative reading of "Rikō." The published edition, of 1905, suggests a reading of "Seikō" and cites a triptych of landscape paintings attributed to the artist Nōami (1397–1471), of the Ami school, as a work bearing the seal.[3] Paintings impressed with the "Seikō" seal have also been attributed to two other artists of the Ami-school, Geiami (1431–1485) and Sōami (ca. 1485–1525), both of whom served as art consultants to the Ashikaga shoguns and advisers to the shogunal collection. One feature in particular of the present scroll points to the Ami school—the waterfall, unusual in representations of the Seven Sages but a common motif in Ami-school paintings.

It has been suggested that Seikō may have been an admirer of Sōami and painted landscapes in the Sōami style, viewing himself as an heir to the master's artistic lineage.[4] Two sets of the Eight Views of the Xiao and Xiang Rivers in the Tochigi Prefectural Museum are painted with the soft brushwork associated with Sōami; both bear the "Seikō" seal. And because the "Seikō" seal is vase shaped, like that of Sōami, it may reflect the artist's emulation of that particular Ami master.[5]

Nevertheless, Seikō did not devote himself solely to the Ami manner. His oeuvre also includes figure paintings with elements of the Kano style and landscapes reminiscent of works produced by followers of Shōkei in the Kantō region of eastern Japan during the sixteenth century (cat. no. 52).[6] One notable characteristic of ink paintings of the Kantō region that can be seen as well in works by

Seikō is the abundant use of ink wash, resulting in a dark, almost gloomy atmosphere. All this would lead us to believe that Seikō was an artist who worked in a style that derived from both the Ami and the Kano studios and who was active in the Kantō region during the latter half of the sixteenth century.

GS

1. For reproductions, see Tochigi Prefectural Museum and Kanagawa Prefectural Museum of Cultural History 1998, pls. 103, 130.
2. Matsushita Takaaki 1960, no. 132.
3. Asaoka Okisada 1905 (1912 ed.), p. 2044.
4. Hashimoto Shinji 1997, pp. 109–10.
5. Ibid., p. 110.
6. Ibid., p. 109.

ATTRIBUTED TO KANO MOTONOBU (CA. 1476–1559)

71. *Bo Ya Plays the Qin as Zhong Ziqi Listens*

Muromachi period (1392–1573)
Hanging scroll, ink and light color on paper
165.8 × 87.2 cm (65¼ × 34⅛ in.)
Ex coll.: Hara Tomitarō, Kanagawa Prefecture; Date Munemoto, Tokyo

LITERATURE: Tajima Shiichi 1903, illus.; "Ko Kano hitsu Hakuga dankin zu kai" 1937, p. 74; Takeuchi Shōji 1972, pls. 81, 82; Murase 1975, no. 43; Y. Shimizu and Wheelwright 1976, no. 28; Shimada Shūjirō 1979, no. 98; Ford 1985, fig. 10; Tokyo National Museum 1985a, no. 26; Schirn Kunsthalle Frankfurt 1990, no. 47; Tsuji Nobuo 1994, fig. 104; Kyoto National Museum 1996, fig. 16.

A story in the *Liezi*, a Daoist text dating to the third century, tells of Bo Ya and Zhong Ziqi, two gentlemen-scholars renowned for their close friendship and their fierce loyalty to each other. One day, when they were enjoying an outing at Taishan Mountain in Shandong Province, a sudden storm forced them to take refuge under a large rock. As they waited for the skies to clear, Bo Ya, an accomplished musician, began to play the *qin* for his companion. When his friend Zhong died, the bereaved Bo Ya broke his instrument, never to play it again.[1] The story was very popular in China, where playing the *qin* was considered the epitome of scholarly accomplishment and the unflagging loyalty of the two men to each other exemplified the highest standards of Confucian virtue.

In the Burke scroll Bo Ya, dressed in a flowing scholar's robe, is seen seated under a shallow rocky overhang, his *qin* on a table before him. Zhong Ziqi, seated a short distance away, listens attentively with his head slightly bowed. The reverent concentration of the two gentlemen is in marked contrast to the harsh mountain setting, with its crystalline rocks and violently twisted pine branches.

Although the painting has neither signature nor seal, it was attributed to Kano Motonobu (ca. 1476–1559) on stylistic grounds in 1935, when it was designated an Important Art Object, an honorary classification formerly used by the Japanese government. It bears a striking resemblance to *fusuma* (sliding screens) that once decorated six rooms in the Hōjō (abbot's quarters) of Daisen'in, a subtemple of Daitokuji, Kyoto.[2] Remounted as hanging scrolls, they are now divided between the National Museums of Kyoto and Tokyo. Thirty of the paintings have traditionally been attributed to Motonobu,[3] and the Burke scroll shares with them many features that reflect a reliance on painting of the Ming dynasty: strong outlines, the decorative use of surface texture, and a pronounced asymmetrical composition. Although it was never part of the Daisen'in group, which is preserved in its entirety, its relatively large dimensions and crowded composition suggest that it too may once have been part of a set of *fusuma* decorating a temple interior. A recent study shows that other paintings can be attributed to the painter of the Burke scroll, an artist who, if not Motonobu himself,

must have belonged to Motonobu's circle and worked closely with him.[4]

Kano Motonobu was the son of Kano Masanobu (1434–1530), the first member of a long line of Kano artists. In his groundbreaking study, published in 1966–70, Tsuji Nobuo identified and classified more than one hundred paintings associated with Motonobu,[5] an ambitious and successful artist who was engaged in a wide range of activities. Not only did he follow his father as the official painter for the Ashikaga shoguns but he secured for himself and for successive generations of Kano artists the patronage of the ruling military, court nobles, Zen monasteries, and the affluent merchants, who were emerging as a new class. To accomplish this awesome task, Motonobu wielded the two-edged sword of salesmanship and skillful public relations. It was also crucial to Motonobu's success that he was able to transform Zen-inspired ink painting into a decorative style that appealed to the taste of secular patrons. Motonobu is believed

to have married a woman from the Tosa family of artists, perhaps a daughter of the clan leader, Mitsunobu (fl. 1469–1523). This alliance reportedly enabled him to study the Japanese *yamato-e* style and to incorporate its techniques into ink monochrome.[6]

Motonobu's paintings apparently received some attention in China. In 1510, a Chinese named Zhengzi wrote a letter to Motonobu stating that Motonobu's paintings reminded him of works by two Chinese painters of the Song dynasty, Zhao Chang (fl. early 11th century) and Ma Yuan (fl. ca. 1190–1225). He also expressed his desire to study with the Japanese master.[7] In 1541, Motonobu was commissioned to paint three pairs of gold screens and one hundred folding fans—export items much prized in China—which were to be presented to the Ming emperor, Shizong, by a Japanese trade mission.[8] Motonobu's fame was well established in his own lifetime, and he was awarded the honorary priestly title of *hōgen* in his later years.

Bo Ya Plays the Qin includes all the basic elements of a successful Kano-school painting. The subtle tranquillity of earlier ink painting is replaced by a bold style that combines heavy ink outlines with color in a large, two-dimensional composition in a decorative polychrome formula that became the standard for generations of Kano artists and their followers over the next three hundred years.

1. *Liezi* 1960, pp. 109–10.
2. Takeuchi Shōji 1972, pp. 87–88.
3. Fontein and Hickman 1970, no. 63; and Tsuji Nobuo 1966–70, pt. 3 (1970), p. 43.
4. Kyoto National Museum 1996, no. 38.
5. Tsuji Nobuo 1966–70, pts. 1–5. See also Yamamoto Hideo 1994, pp. 363–71.
6. For an *emaki* by Motonobu in the *yamato-e* style, the *Kuramagaiji engi*, see Kurokawa Harumura 1885–1901, vol. 4, p. 21. For an *emaki* attributed to Motonobu, the *Shakadō engi* of 1515, see Murase 1983a, no. 34. For Masanobu's connection with the Tosa family, see *Jinson Daisōjōki*, diary of the Kōfukuji monk Jinson (1430–1508), for the twelfth month of the ninth year of the Bunmei era (1477).
7. Etō Shun 1961, pp. 72–74.
8. Tsuji Nobuo 1966–70, pt. 1, p. 23.

Negoro Lacquerware

CATALOGUE NOS. 72–74

The Japanese have long been keenly sensitive to the rustic beauty of everyday objects that have withstood years of handling. To many, Negoro lacquerware, admired for its lustrous cinnabar color and austere, functional form, embodies to perfection this particular aesthetic. The deep, warm red of most Negoro objects becomes worn with age and use and the thin coat of red lacquer almost translucent, allowing the undercoating of black lacquer to show through in random patterns reminiscent of abstract painting.[1] Although "Negoro" refers most often to objects of the type just described, with a base coat of black lacquer over which red is applied, the term is also loosely given to other lacquerware. These include wares of plain black lacquer, vessels painted with colored designs on black (cat. no. 72), and objects with carved decoration. The colors and shapes of Negoro pieces vary, but all are simple, sturdy, durable utensils used to serve food at communal meals and to hold ritual offerings in Shinto and Buddhist temples.

The earliest documentation concerning Negoro lacquers, which dates to the Edo period (1615–1868), includes an indiscriminate mix of fact and speculation concocted by tea masters and other cultural cognoscenti who were drawn to the stark simplicity of the objects. This type of ware is traditionally believed to have been made at Negorodera, a Shingon Buddhist temple in Wakayama, south of Nara, established in 1140. Negorodera enjoyed great prosperity—at the height of its glory it comprised more than two thousand subtemples and nearly six thousand monks. Tragically, the complex was savagely destroyed in 1585 during Toyotomi Hideyoshi's infamous campaign to subjugate the region.

The monks of Negorodera are said to have produced simple lacquerware both for their own use and for sale. Indeed, several early examples bear inscriptions with the names of Negorodera's numerous subtemples, and a recently discovered vessel clearly identifies Negorodera as the place of its manufacture.[2] With the near total destruction of the temple, however, only a few fragmentary remains have yielded evidence—tantalizing, if meager—of the once large-scale production.[3] Furthermore, certain objects that can clearly be designated as Negoro wares predate the founding of the temple, and others postdate its destruction. Adding to this confusing history are later designations, such as Kyō Negoro (Kyoto Negoro) and Yoshino Negoro, which suggest the production of Negoro-type wares at sites other than the Negorodera area. And in fact, the technique used for Negoro wares originated in ancient China, where lacquer objects were produced in red and in black, and in Japan of the Jōmon period. Heian documents mention red-and-black lacquerwares that may have been early prototypes.[4] Moreover, many handscrolls of the Late Heian and Kamakura periods depict red-and-black utensils, as well as saddles and armor in aristocratic interiors, that appear to be very much like Negoro ware. These sources indicate that the ware was reserved for use by the aristocracy and by religious institutions until the mid-Edo period, when it became more accessible to the general populace. In its current usage, the term "Negoro" thus refers to red-and-black lacquer objects made in various regions of Japan throughout its history.

1. Watt and Ford 1991, p. 3.
2. Arakawa Hirokazu 1958, p. 25; and Kawada Sadamu 1985, p. 284, pl. 169.
3. For excavations conducted in 1978 and 1979, see Wakayama ken Kyōiku Iinkai 1981.
4. Kawada Sadamu 1985, pp. 300–301.

72. Heishi with Design of Butterflies

Muromachi period (1392–1573)
Negoro ware; black-and-red lacquer with gold leaf
Height 32.5 cm (12¾ in.)

LITERATURE: Murase 1993, no. 74.

Negoro-ware sake bottles, or *heishi*, were often made in pairs and used in Shinto shrines to hold the sake, or rice wine, offered to native deities.[1]

Most Negoro utensils have a coat of red lacquer applied over a base coat of black lacquer. This example, however, has been covered with black lacquer and then decorated with designs and patterns in red. The raised chrysanthemum pattern that radiates from the spout, and, on the shoulders, the design of two facing butterflies are unusual ornamental features, as most *heishi* are undecorated. One butterfly is outlined in red lacquer and filled in with short strokes to represent patterns for the wings and body, while the contours of the other butterfly are defined simply by a field of red lacquer. Both designs are highlighted with gold leaf. The design of butterflies suggests that this *heishi*, which is lightweight and easily carried, may have been used in Bugaku, a type of courtly music and dance performance practiced in Japan since the Nara period, in which butterflies are a common motif. A character in one such work, known as *Kotokuraku*, is named Heishi-itori (Wine Bearer).[2]

The construction and design of this *heishi* are generally consistent with those of other Negoro sake vessels.[3] X-ray photography has revealed that the wood core is composed of two parts that have been cut and hollowed on a lathe and then joined at the shoulders (fig. 37). The spout was carved separately and inserted in the top. GWN

1. The mate to the Burke *heishi* is reproduced in Tanaka Hisao 1987, pp. 191, 233.
2. Nishikawa Kyōtarō 1978, pp. 44–45.
3. Kawada Sadamu 1985, p. 307.

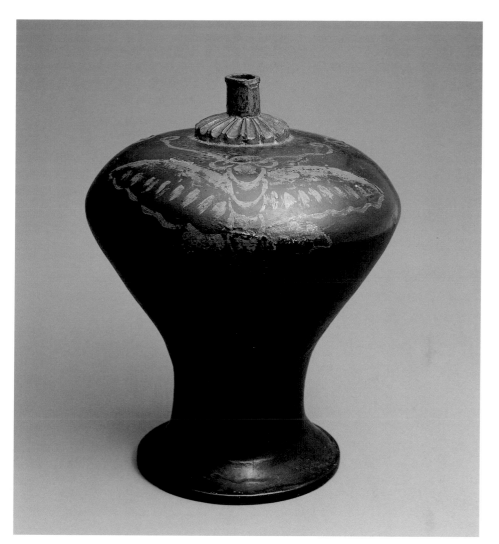

Figure 37. X-radiograph of *heishi*

Top of *heishi*

73. Heishi

Muromachi period (1392–1573)
Negoro ware; red-and-black lacquer
Height 38.5 cm (15⅛ in.)

LITERATURE: Murase 1975, no. 101; Tokyo
National Museum 1985a, no. 105; Schirn Kunsthalle
Frankfurt 1990, no. 108.

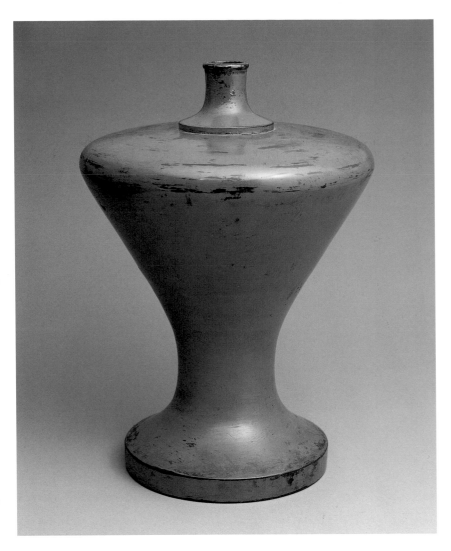

The clean, simple outlines of Negoro-ware
heishi are softened by the warm luster of red
lacquer; black patches, where the outer layer
of lacquer has worn away, serve as reminders
of contact with innumerable hands over many
years. The unique shape of the *heishi* features
a small spout at the top, a swelling shoulder,
and a body that narrows in a long, elegant
curve toward the bottom, where it widens
again to create a stable base. Throughout
the history of lacquer production in Japan,
craftsmen were influenced by the shapes
of Chinese metal and ceramic vessels; the
graceful proportions of *heishi* were proba-
bly inspired by the Song-dynasty porcelain
vases known as *meiping*.

The earliest record of a *heishi* of Japanese
manufacture appears in the *Engishiki* (Proce-
dures of the Engi Era), an early-tenth-century
compilation of governmental regulations
concerning court ceremonies and the accou-
trements connected with them.[1] Two pairs of
heishi are cited in the text, though it is not pos-
sible to determine whether they were made of
lacquer. It has been speculated that the pro-
duction of Negoro-ware *heishi* began early in
the Kamakura period (1185–1333),[2] when the
aesthetic of a red design on a black back-
ground—favored by the warrior class for
various types of lacquer utensils, including
swords, arrows, and saddles—was adopted
for the decoration of ceremonial vessels.[3]
This preference was perpetuated in the
Muromachi period.

1. *Engishiki* 1929, bk. 40, p. 211.
2. Kawada Sadamu 1985, p. 312.
3. Tanaka Hisao 1987, p. 233.

74. Tarai

Muromachi period (1392–1573)
Negoro ware; red-and-black lacquer with
exposed *keyaki* wood
Height 14.2 cm (5⅝ in.); diameter 35.7 cm (14 in.)

LITERATURE: Kawada Sadamu 1985, fig. 39;
Schirn Kunsthalle Frankfurt 1990, no. 109; Murase
1993, no. 75.

This Negoro-ware washbasin, or *tarai*, was
used to hold water for rinsing the hands in
preparation for the *fusatsu-e*, a Buddhist ritu-
al of self-purification held on the fifteenth
day of each month. The earliest dated exam-
ple of the type represented here is a basin
inscribed with the date 1352 and the subtem-
ple name Hōzōin.[1]

Apparently made as part of a set, the basin
is inscribed in red lacquer with a cyclical date
that corresponds to one of two years, either
1353 or 1413, and the name Sanshitsubō
(Cedar Room Quarters), which may indicate
the location in a particular temple where
the basin was used.[2] The elegant carving of
the legs and the design of the paired open
volutes in a boar's-eye pattern along the bot-
tom edge reflect Chinese influence. Another
handsome feature is the wide band with raised
edges, which is reminiscent of the strips of
metal or wood used to bind wood buckets and
barrels. The band is coated with a translucent
lacquer through which the natural grain of
the *keyaki* wood (*Zelkova serrata*) is visible, in
subtle contrast to the adjacent areas of red and
black lacquer.[3] GWN

1. Kawada Sadamu 1985, p. 322, pl. 170.
2. Ibid., pp. 323, 338.
3. Watt and Ford 1991, p. 183.

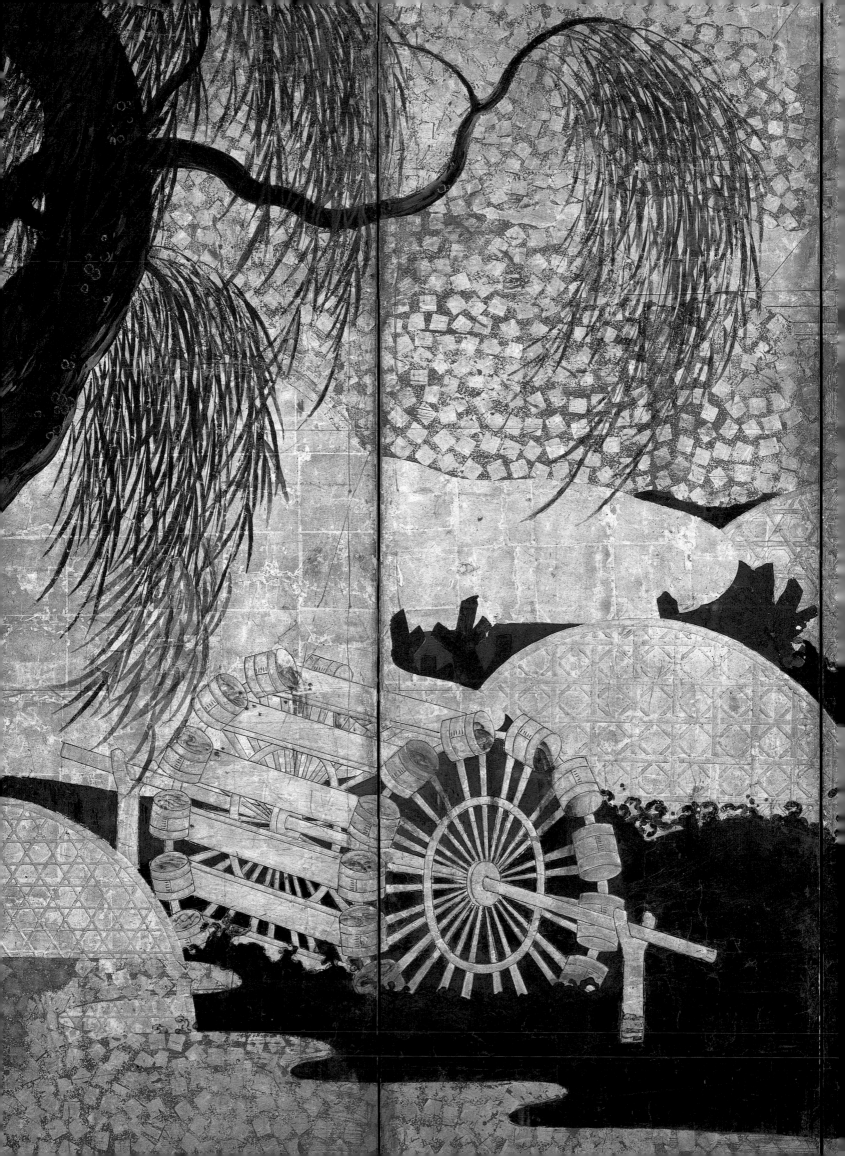

V. Momoyama Period (1573–1615)

With the decline of Ashikaga power in the 1560s, the feudal barons, or daimyos, began their struggle for control of Japan. The ensuing four decades of constant warfare are known as the Momoyama (Peach Hill) period. The name derives from the site, in a Kyoto suburb, of Toyotomi Hideyoshi's Fushimi Castle, whose grounds were turned into a peach (momo) orchard after the structure was demolished in 1622. During those forty turbulent years, the government changed hands three times. The official beginning of the Momoyama period is 1573, the year Oda Nobunaga (1534–1582) succeeded in wresting control of the government from the Ashikaga shoguns. Nobunaga subsequently committed suicide, after one of his own warriors attacked him. One of Nobunaga's generals, Toyotomi Hideyoshi (1536–1598), emerged as the new leader. But Toyotomi hegemony was also short-lived; it fell apart in 1615, when the clan's last stronghold, Osaka Castle, was overrun by the forces of another ally of Nobunaga, Tokugawa Ieyasu (r. 1603–5). A brilliant strategist and superb politician, Ieyasu established the Tokugawa shogunate, which was to last for more than two hundred fifty years, until 1868.

Although socially and politically the years 1573 and 1615 mark the beginning and end of the Momoyama period, those demarcations are unsatisfactory in terms of art history. The decorative style that is the hallmark of Momoyama art had its inception in the early sixteenth century and lasted well into the seventeenth. Thus, from an art-historical point of view, the Momoyama period extends from the mid-sixteenth to the mid-seventeenth century.

The war barons spent liberally to flaunt their newly acquired power. The art style of this period is characteristically robust, opulent, and dynamic, with gold lavishly applied to architecture, furnishings, paintings, and garments.

Unexpectedly, this age of bravura display saw the evolution of a counteraesthetic of simple rusticity. This highly sophisticated concept of "artful poverty" is best exemplified in the ideals of wabicha, the rustic tea ceremony, which developed around the great tea master Sen Rikyū (1522–1591). Extremely small tearooms, with floor space no greater than two mats—18.3 meters (6 ft.) square—came to express the canons of beauty advocated by the Muromachi tea master Murata Shukō (Jukō, 1423–1502) and perfected by Rikyū. The cottagelike tearoom was designed to create a secluded retreat within the metropolitan milieu. According to Rikyū, the smaller the space the more conducive it was to direct communication between the host and his guests. Such tearooms were constructed of simple materials, with the unpainted wood preserved in the natural state, sometimes left unplaned or even warped. Interior walls were often made of mud, with a coarse binding agent such as straw showing through the rough surfaces. Bathed in the soft, diffuse light that filtered through small windows, the slightly darkened interior, with a minimum of decoration—perhaps a single spray of flowers—provided a tranquil setting in which friends could enjoy one another's company and share an experience of aesthetic harmony.

Another important development during the Momoyama period was the rise of the merchant class. Relegated for centuries to the bottom rung of the social ladder in a country guided by Confucian principles of government and society, traders could not overtly exercise political power, though in fact they gained enormous influence over the shoguns, whose financial resources were perpetually being drained by warfare. The lives and aspirations of this emerging middle class became the subjects of a new mode of artistic expression, examples of which, from the succeeding Edo period, are discussed in the section devoted to genre painting (cat. nos. 139–43).

One historical incident in particular had an indirect but significant influence on the evolution of the arts during the Momoyama period: the arrival of a party of Portuguese in Japan. By the mid-sixteenth century Portuguese merchants and explorers, accompanied by missionaries engaged both in trade and in proselytizing, were traveling in India, southern

Opposite: Detail of cat. no. 80

Figure 38. Himeji Castle, Hyōgo Prefecture. Momoyama period (1573–1615), 1608

China, and the Southeast Asian islands. About 1543, en route to China, a group was shipwrecked on the southern coast of Japan, an event that marked the first contact between the Japanese and Europeans. The foreigners soon came to be called *nanban*, "barbarians from the south." The Japanese were intensely curious about Westerners—their appearance, their way of life, and the wares they were trading.

The shipwrecked Portuguese made an unwitting but highly significant contribution to the evolution of military accoutrements in Japan. The muskets they carried were immediately duplicated by the Japanese, and the introduction of these weapons substantially altered both the conduct of warfare (in which firearms had never before been used) and the nature of military architecture in Japan. Fortresses strong enough to withstand firepower

were now urgently needed. The warlords built defensive structures with moats and surrounded by heavy masonry walls—castles that served not only as fortifications but also as resplendent showpieces reflecting military strength and economic power (fig. 38). Chambers sparkled with latticed ceilings, gold-inlaid partitions, and gilded metal fittings. Gold was used freely as well on *fusuma* (sliding panels); this was the age of golden screens. Unfortunately, in defeat the warlords razed their castles (and often gallantly committed suicide inside them). Of those that survived, many were demolished in bombing raids during the Second World War. Although few remain, they can help us reconstruct what was a monumental architecture and splendid lost interiors.

The dark interiors of the huge chambers

demanded bright decorations clearly visible from a distance. Panels overlaid with gold leaf were ideal for this purpose, as they reflected sunlight during the day and the flicker of candles at night. Ornamenting such halls posed an exciting challenge to painters, who had previously decorated only the moderate-sized homes of court nobles or the modest living quarters of priests in Buddhist temples. The style established by many screen painters was pleasing to the self-made but unsophisticated men-at-arms: on large screens they painted simple compositions that could be easily understood. The leading artist of the time, Kano Eitoku (1543–1590), gained the favor of Nobunaga and many other warlords with heroic motifs—hawks and dragons, lions and tigers, pine trees, cypresses, peonies—as well as with figures from Chinese history and legend.

Many schools of painting competed for the prestigious commissions, and Japanese artists prospered more than ever before. Eitoku's descendants and the Kano school remained the leading members of the artistic community, but other schools also flourished, headed by such artists as Hasegawa Tōhaku (1539–1610), Kaihō Yūshō (cat. no. 77), Unkoku Tōgan (cat. no. 78), and Soga Chokuan (fl. 1596–1610).

The preferred style adopted by these painters was a synthesis of a Chinese-inspired ink technique and the colorful indigenous *yamato-e*. While the guardians of traditional Japanese painting, the Tosa artists (cat. nos. 80, 81), suffered a slow decline in such a milieu, a group of dynamic, innovative artists, who remain anonymous, managed to revitalize *yamato-e*. Such screen paintings as *Willows and Bridge* (cat. no. 80) were probably turned out by anonymous artists as ready-made pictures to satisfy a rising demand among the increasingly affluent merchant class. These artists, who worked in shops where ready-made pictures—on fans, handscrolls, screens—were offered for sale, probably received their training in one of the more popular schools, and they must have borrowed and combined many different styles to appeal to a broader clientele.

The Momoyama period was remarkable not only for its architecture and painting but also for the development of crafts—textiles, lacquerware, ceramics, and metalwork. The growing enthusiasm for *chanoyu* (the tea ceremony), the unprecedented prosperity of much of the population, and the new export trade with Europe are among the many factors that contributed to this development. As the shoguns and their financial supporters accumulated ever greater wealth and power, they demanded more elaborate wardrobes and accoutrements, which in turn spurred the creation of new designs. Technical advances in crafts also led to innovations in shapes and patterns, some inspired by European, others by Korean, art. With the encouragement of the feudal lords, communities in the areas surrounding castles and palaces established new light industries, which in turn laid the foundation for the enterprises that would flourish during the Edo period, many of which have survived into modern times.

The sixteenth century was also significant for the development of Japan's ceramics industry. Advanced technology introduced from Korea brought about many improvements at traditional kilns such as Seto and Bizen. The kilns, which until this time had produced either ceremonial or everyday utensils, began making tea wares according to the specifications provided by the tea masters.

Special mention must be made of two geniuses of the period, Hon'ami Kōetsu and Tawaraya Sōtatsu (cat. nos. 83–87), for the aesthetics of these two artists, who lived during the turbulent years of the Momoyama era, were barely affected by contemporary currents. Instead, they maintained an allegiance to the declining fortunes of the imperial court and to the courtly traditions of ancient Japan. Their art did not enjoy wide popularity during their lifetimes, but half a century later it inspired another genius, Ogata Kōrin (cat. nos. 132, 133), who brought about its revival. Later labeled the Rinpa school, this superbly decorative art steeped in *yamato-e* tradition, survived through the Edo period. (For further discussion of the Rinpa school, see pages 308–9.)

75. *Pheasants and Azaleas*
Golden Pheasants and a Loquat Tree

Late Muromachi–early Momoyama period, 1560s
Pair of hanging scrolls, ink and color on paper
Each scroll 101 × 49 cm (39¾ x 19¼ in.)
Seal: *Naonobu* [on each scroll]

LITERATURE: Takeda Tsuneo 1974, fig. 49;
Takeda Tsuneo 1977a, pls. 43, 44; Murase 1993,
no. 19.

Bird-and-flower painting flourished in the Chinese court during the Northern and Southern Song dynasties and was perpetuated by both court and professional artists during the Ming dynasty. In Japan such paintings were an important component of the Kano-school repertoire. During the turbulent years of the sixteenth century, birds that symbolized power and martial prowess (the hawk), longevity (the crane), and imperial elegance (the pheasant) were featured in paintings, together with similarly auspicious flowers and trees. Defined by strong ink brushstrokes, given brilliance by the application of vibrant colors, and set against the opulent background of gold leaf on folding or sliding screens, these images took on a heroic dimension. Their grandeur appealed to the wealthy and powerful members of Momoyama warrior society, as well as to the clergy of the more affluent Buddhist temples. Rendered in the hanging-scroll format, they remained impressive, if less monumental, symbols of status.

Although this pair of hanging scrolls was made just prior to the close of the Muromachi period, it represents a transition toward the boldly decorative compositional schemes associated with Momoyama-period taste. The arrangement of pictorial elements derives from the large-scale screens that were central to Kano-school work. The evergreen in the painting at the right and the loquat in the painting at the left extend their branches toward each other, serving as a frame for the stagelike setting. In the right scroll a pair of pheasants are shown in a narrow field bordered, in the foreground, by dandelions and violets of spring and, at the water's edge, by crimson azaleas of summer. In the left scroll golden pheasants perch on a craggy rock. Withered leaves on the loquat tree evoke autumn; the red-berried spearflowers are emblematic of winter. The pheasants are meticulously rendered, their wings and crests highlighted with fine, nearly invisible strokes of gold. The brushwork in both paintings is in keeping with the formal style of the Kano school which employed fluctuating contour lines, modeling with ax-cut strokes and washes, and wet ink dots applied to images

of rocks to indicate moss and other vegetation.

Each scroll bears the cauldron-shaped "Naonobu" seal of Kano Shōei (1519–1592), the third son of Motonobu (cat. no. 71) and a third-generation leader of the school. "Shōei" is the name by which the artist is most widely known today, but in fact it was the name he adopted when he took the tonsure in his later years. "Naonobu," his given name, appears on his seals, which are found on many of his extant works. The seal on the scroll at the right is impressed on the left side rather than on the right, inviting speculation that the works could once have been part of a triptych, in which case a third scroll would have been placed to the right of the present pair. However, the balance and symmetry of the two compositions make the existence of a third component unlikely.

Although his reputation was long overshadowed by the achievements of Motonobu, his illustrious father and mentor, and by the innovative genius of his own son Eitoku (1543–1590), Shōei has more recently been recognized for his own achievements. Highly regarded during his lifetime, he was given many important commissions by prestigious temples and Shinto shrines, as well as by the imperial court. Occasionally, he worked in concert with his celebrated son; the best known of the works they produced together are the ink-monochrome paintings created in 1566 for Jukōin, a subtemple of Daitokuji, Kyoto.[1]

Many of Shōei's extant paintings, on folding and sliding screens, hanging scrolls, and fans, feature bird-and-flower compositions—either in ink monochrome or in brilliant color—that hark back to models established

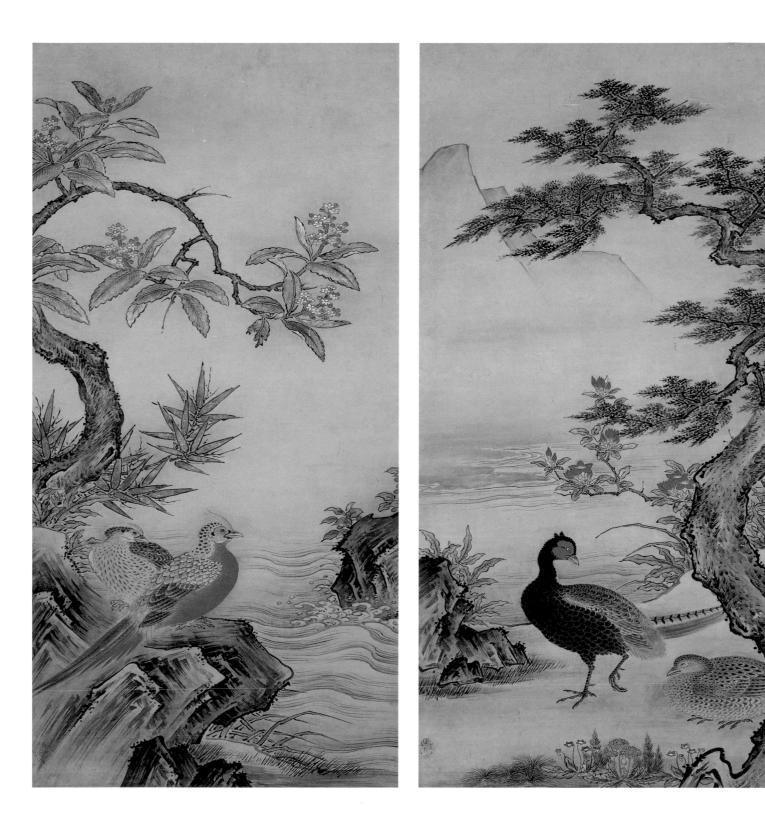

by his father. Recently rediscovered genre scenes, particularly those on a reduced scale, have spurred revision of the traditional assessment of Shōei as an artist less versatile than his father or his son.

While many of Shōei's paintings are executed in a soft brushwork (*gyō*) technique, this pair is in the formal style, reminiscent of a single six-panel folding screen entitled *Rooster and Pines*, also attributed to Shōei, in the Museum of Fine Arts, Boston.[2] Similarities of execution have been noted in one of the male birds in *Pheasants and Azaleas* and the pheasant that appears in the large hanging scroll of *nirvana* painted by Shōei for Daitokuji in 1563.[3] It is therefore possible that the Burke paintings were made during the early 1560s, before the artist embarked on his collaboration with Eitoku on decorating the interior of Jukōin.

sw

1. For the Jukōin screens, see Doi Tsugiyoshi 1978, pls. 8, 9.
2. Ibid., fig. 11.
3. Wheelwright 1981, pl. 72.

76. Seiōgyū and Ikuzanshu

Momoyama period (1573–1615)
Pair of hanging scrolls, ink on paper
Each scroll 111.8 × 47.4 cm (44 × 18⅝ in.)
Signature: *Naizen kore o zusu* [on the scroll at right]
Inscription by Takuan Sōhō [on each scroll]
Seals: *Ko* [Naizen's seal, on each scroll]; *Sōhō* and
Takuan [on each scroll]
Ex coll.: Nijō

LITERATURE: Tsuji Nobuo 1980, nos. 97, 98;
Narusawa Katsutsugu 1985, fig. 20 (*Seiōgyū*);
Tokyo National Museum 1985a, no. 32; Schirn
Kunsthalle Frankfurt 1990, no. 74.

Images of the two Zen patriarchs Seiōgyū (Ch: Zheng Huangniu; Zheng on the Yellow Ox) and Ikuzanshu (Ch: Yushanzhu; Master of Mount Yu), who were believed to possess mysterious powers, were popular among Zen adherents in both China and Japan. Often they were displayed together and, in many instances, were placed at either side of a central panel depicting the Indian monk Bodhidharma (J: Daruma), who had introduced Buddhism to China.[1]

Seiōgyū lived during the Northern Song dynasty (960–1127). Traditionally he was known for riding a yellow ox—a water bottle hanging from one of its horns—when he wandered the city streets or when he visited his friend, a local official in Zhejiang Province.[2] In this painting, however, the horn is decorated with a spray of peony, and the water bottle, a gourd, hangs from the lead rope.

Ikuzanshu (1121–1203) lived in Zhejiang Province during the Southern Song dynasty.[3]

Here, he rides a donkey; suspended from its harness are books and a fan. Only a cursory reference is made to a groundline and to the mountainous landscape setting, rendered in pale ink washes. Other pictorial elements, including the cloaks of the patriarchs, the plodding animals, and the incongruous peony ornamenting the ox's head, are executed in watery ink, in the *mokkotsu* (boneless) style. Dark ink, applied sporadically, enlivens these otherwise pale monochromatic works.

The poems on both scrolls were composed and inscribed by Takuan Sōhō (1573–1645), one of the most prominent Zen monks of his era. A prolific writer, a notable painter, and an energetic temple administrator, Takuan was known also for his loyalty to the imperial family, which in his lifetime was losing its authority to the increasingly powerful Tokugawa clan. Each poem, comprising four lines of seven characters each, is followed by Takuan's signature and by seals reading "Sōhō"

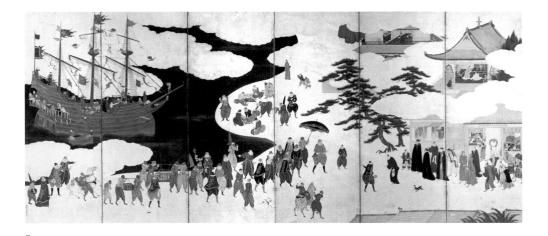

a

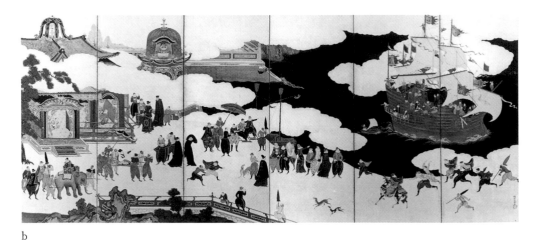

Figure 39. Kano Naizen (1570–1616), *Nanban byōbu*. Pair of six-panel folding screens, ink on paper, 154.5 × 363.2 cm (5 ft. ⅞ in. × 11 ft. 11 in.). Kōbe City Museum, Hyōgo Prefecture *a*. right screen *b*. left screen

b

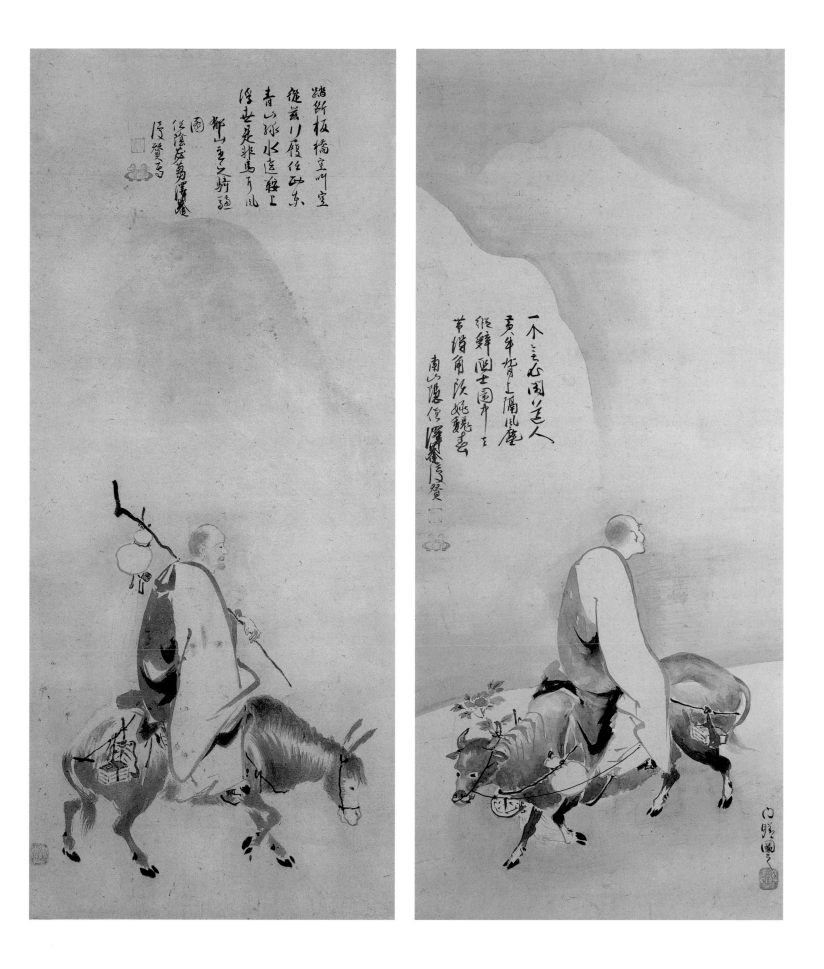

and "Takuan." The poem for Seiōgyū reads:

*A man of the Way sits leisurely without a concern
Astride a yellow ox, separated from the wind and
 dust [of this world].
He has left the hermitage of his garden,
And from the ox's horn hangs a sprig of peony
 from the Yao or Wei.*[4]

> Casually inscribed by the recluse monk
> of Nanzenji
> Takuan

The verse for Ikuzanshu reads:

*Breaking bridge planks as he treads,
 calling emptiness empty,
He strolls freely—to east, to west,
Surrounded by blue hills, green waters.
What is true, what is false, is but wind in a
 horse's ear.*

> Painting of the Master of Mount Yu
> Riding a Donkey, casually inscribed by
> Sokuin Hissū Takuan[5]

In contrast to the fame of Takuan, little is known about the painter of the two scrolls, Kano Naizen (1570–1616), although several pairs of folding screens bearing his signatures and/or seals are extant. The most famous of his screens, depicting the arrival of Portuguese traders in Nagasaki, are in the Museu Nacional de Arte Antiga, Lisbon, and in the Kōbe City Museum (fig. 39).[6] And his Hōkoku Festival screens of 1606 are in the Toyokuni Shrine, Kyoto.[7] Both the Kōbe and the Kyoto screens are executed in brilliant color, with careful attention given to detail, thus differing significantly from the monochromatic scrolls in the Burke Collection.

Another body of work by Naizen, in ink monochrome and depicting a variety of subjects—Chinese figures, landscapes, birds, animals[8]—exhibits stylistic similarities to paintings by two of his contemporaries, Kaihō Yūshō (cat. no. 77) and Unkoku Tōgan (cat. no. 78). The signatures and seals on these paintings are identical to those on the Burke pair; the signatures and seals on the polychrome screens are different.

A brief outline of Naizen's life can be reconstructed from an entry in the *Tansei jakubokushū*, a history of Japanese painting written by Naizen's son Kano Ikkei (1599–

1662).[9] Naizen is believed to have studied painting under Kano Shōei (cat. no. 75), the father of Eitoku, and his talent in painting is sometimes said to have been recognized by the great warrior statesman Toyotomi Hideyoshi. In 1591 he apparently accompanied Kano Mitsunobu (1562/65–1608), a son of Eitoku, to Nagoya, in northern Kyūshū, to decorate the interiors of the castle built for Hideyoshi. Naizen was not born to the Kano family but was allowed the use of this august name, which imparted great prestige and led to important commissions. After Hideyoshi's death in 1598, however, his fortunes declined with those of many other artists who were outside the Kano clan and who remained in Kyoto after members of the Kano family resettled in Edo, the new capital of the Tokugawa shoguns.

Naizen may have met Takuan Sōhō in the early 1600s. The illustrious monk was then living at Daitokuji, where in 1609 he served his infamous three-day tenure as its chief abbot.[10] His inscriptions on this pair of scrolls are thought to date, on stylistic grounds, to about 1615, shortly before Naizen's death.[11]

1. The best-known example of such a triptych is a Chinese work dating to the Southern Song dynasty (1127–1279) in the Tokugawa Art Museum, Nagoya. Tokugawa Art Museum 1983, no. 66.
2. See *Zenrin kujitsu konmeishū* (1715) by Kakuhō Jitsugai, in *Kokuyaku zengaku taisei* 1929–30, vol. 18, pp. 40–41, 59–60.
3. *Zoku dentō roku*, in *Daizōkyō* 1914–32, vol. 51, no. 2077, p. 689.
4. The Yao and Wei families of China were famous for their peonies.
5. Translations after Stephen D. Allee.
6. Sakamoto Mitsuru et al. 1982, pls. 50, 52, and 70–73.
7. Takeda Tsuneo 1980a, pls. 15, 16.
8. Okamoto Yoshitomo and Takamizawa Tadao 1970, pls. 2–7; and Narusawa Katsutsugu 1985, figs. 16, 17.
9. Tanaka Toyozō 1942. A portion of the note on Naizen seems to be missing, but it is reproduced in the *Koga bikō* (Notes on Old Painters); see Asaoka Okisada 1905 (1912 ed.), pp. 1765–66, 1769–70.
10. For Takuan's life, see Ichikawa Hakugen 1978; Haga Kōshirō 1979; Ogisu Jundō 1982; and Rosenfield and Cranston 1999, pp. 93–94.
11. Tsuji Nobuo 1980, pls. 97, 98. It has been suggested that Naizen's workshop was responsible for many of the extant ink paintings that bear his signature and seal, including the Burke pair. See Narusawa Katsutsugu 1985, pp. 10–11.

77. *River and Sky in Evening Snow, from Eight Views of the Xiao and Xiang Rivers*

Momoyama period (1573–1615), ca. 1602–3
Panel of a folding screen, mounted as a hanging scroll, ink and gold on paper
71.5 × 37.8 cm (28⅛ × 14⅞ in.)
Inscription by Seishō Shōtai (1548–1607)
Seals: *Yūshō* and *Seishō* [?]

LITERATURE: Kawai Masatomo 1966, fig. 4; Kawai Masatomo 1978, p. 108, fig. 19; Ōta Hirotarō, Yamane Yūzō, and Yonezawa Yoshiho 1990, pl. 23; Kawamoto Keiko 1991, pl. 30; Murase 1993, no. 21; Sugimoto Sonoko and Kawai Masatomo 1994, pl. 23; Burke 1996a, fig. 2.

Ten thousand miles of river and sky,
* ten thousand miles of my heart,*
Whirling, swirling flower catkins scatter
* through the level woods.*
Bridges blocked, roads closed off,
* my horse's hooves are slick.*
Again I say, at Indigo Gate one cannot go
* but in circles.*[1]

This poem describes the scene from the Eight Views of the Xiao and Xiang Rivers (J: *Shōshō hakkei*) known as *River and Sky in Evening Snow*. The five lines inscribed in dark ink seem to float in a vaporous void, defining the middle ground and separating far from near. A distant hill and snow-laden trees cling to the shoulder of the mountain, barely visible through the frozen haze. The large boulder supporting the trees in the foreground is the only solid form in view. A faint gold wash hints of light in this otherwise dim world of winter cold.

Of the many Chinese landscape subjects that have enjoyed lasting popularity among Japanese ink painters, the Eight Views stands apart from all others (see cat. no. 64). The Chinese representations of the theme that were imported to Japan in the early fourteenth century included two series in handscroll format by the thirteenth-century painters Yujian and Muqi done in the *haboku* (splashed ink) technique. Fragments from these series were often displayed at tea ceremonies in Muromachi society,[2] providing models for later generations of Japanese artists.

River and Sky in Evening Snow, by Kaihō Yūshō (1533–1615), was originally mounted on an eight-fold screen together with seven other paintings. Detached from the screen, they are now mounted as hanging scrolls and dispersed among various collections (fig. 40).[3] Although there is no way to ascertain the order in which the eight paintings were arranged, it is not unlikely that the Burke scroll was the last in the sequence. It is the only one that identifies the source of the poem, and it depicts a winter scene, which in Japanese paintings of the four seasons is traditionally the last and thus placed at the extreme left.

Each of the eight paintings bears the artist's seal and includes a poem, at times preceded by a title. The poems were composed and inscribed by seven renowned monk-poets (one monk wrote two poems) who lived in the culturally influential Gozan (Five Mountains) temples in Kyoto. The monk who composed and inscribed the poem on the Burke scroll, Seishō Shōtai (1548–1607), was appointed the ninety-second abbot of Shōkokuji in 1584 and was a confidant of the great general Toyotomi Hideyoshi and of Ieyasu, founder of the Tokugawa shogunate. Shōtai also was closely associated with poets at court.

It is quite possible that Yūshō had the opportunity to examine sections of the Yujian scroll. Like Yujian, he used an abbreviated brush technique, and there is a compositional similarity between some of his Eight Views and the surviving sections of the Yujian work.

Much of our knowledge concerning Yūshō's life is based on a colophon written in 1724 by his grandson Yūchiku (1654–1728) above a commemorative portrait of Yūshō and his wife, which in turn bears the seal of Yūshō's son Yūsetsu (1598–1677). Until 1573, when he turned forty, Yūshō lived at Tōfukuji, Kyoto. In that year Lord Asai, the master of Yūshō's samurai father, was killed in battle, together with all the members of Yūshō's family. Yūshō is believed to have returned to secular life in an attempt to reestablish the family line.

According to the painter and scholar Kano Einō (1631–1697), Yūshō studied the Kano style under the guidance of Eitoku (1543–1590), whom he often assisted on major commissions.[4] Most extant works by Yūshō date to his late period, when he was in his sixties and seventies. During these years, according to Einō, he perfected a distinctive personal style characterized by a rejection of the linear brushwork of the Kano school and a reliance on the use of ink washes. These he used to delineate form, planes, and volume, as is clearly exemplified in the Burke scroll. In moving steadily away from a representational mode and toward greater abstraction, Yūshō was obeying the ink painter's dictum, "Less is more," and at the same time achieving the spiritual objective to which, as a Zen Buddhist, he aspired. Many of Yūshō's paintings bear inscriptions by Zen monks, reflecting his close association with elite members of Kyoto's Zen community.

A letter from the courtier Konoe Nobutada (1565–1614)—an indication that Nobutada may have helped negotiate payment for the original screen—accompanied the work before it was dismantled. Circumstantial evidence dates the letter to sometime after 1599, which means that the paintings must have been executed around the turn of the century. Certainly they were made no later than 1603, for two of the monks whose inscriptions appear on the Eight Views died that year. There is also a close stylistic resemblance between the Burke scroll and two pairs of six-fold screens by Yūshō, one in the Tokyo National Museum and the other in the MOA Museum of Art, Atami, which are dated, respectively, 1602 and 1602–3.[5] It would thus seem safe to say that Yūshō painted the Eight Views as he approached his seventieth year.[6]

1. Translation after Stephen D. Allee.
2. See Nezu Institute of Fine Arts 1962; and *Sadō koten zenshū* 1967, vol. 9.
3. Kawai Masatomo 1966, pp. 96–97.
4. Kano Einō 1985, p. 356.
5. See Sugimoto Sonoko and Kawai Masatomo 1994, pp. 50–53.
6. Kawai Masatomo 1966, pp. 102–3.

Figure 40. Kaihō Yūshō (1533–1615), *Eight Views of the Xiao and Xiang Rivers*, ca. 1602–3. Panels of a folding screen, mounted as hanging scrolls, ink and gold on paper, each scroll approx. 71.5 × 37.8 cm (28¼ × 14⅞ in.). From top right:

a. *Mountain Market, Clearing Mist*. Private collection

b. *Sails Returning from a Distant Shore*. Gunma Museum of Modern Art, Takasaki, Gunma Prefecture

c. *Sunset over a Fishing Village*. Gunma Museum of Modern Art, Takasaki, Gunma Prefecture

d. *Evening Bell from a Mist-Shrouded Temple*. Private collection

e. *Night Rain on the Xiao and Xiang Rivers*. Private collection

f. *Wild Geese Descending on a Sandbank*. Private collection

g. *Autumn Moon over Lake Dongting*. Egawa Museum of Art, Nishinomiya, Hyōgo Prefecture

h. *River and Sky in Evening Snow* (cat. no. 77). Mary and Jackson Burke Foundation, New York

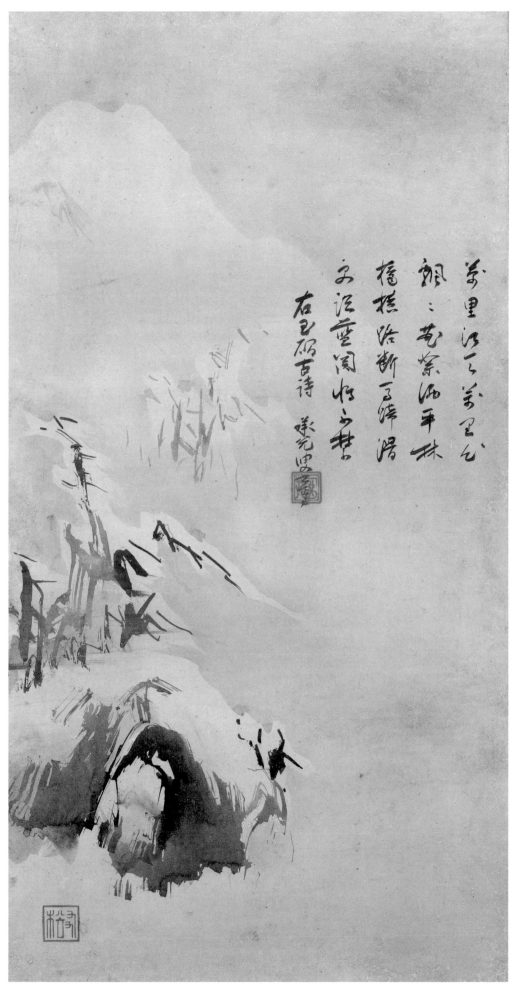

Cat. no. 77

UNKOKU TŌGAN (1547–1618)

78. Landscapes of the Four Seasons

Momoyama period (1573–1615)
Pair of six-panel folding screens, ink, color,
and gold dust on paper
Each screen 175.1 × 375.6 cm (5 ft. 9 in. ×
12 ft. 3⅝ in.)
Seals: *Unkoku* and *Tōgan* [on each screen]

LITERATURE: Murase 1971, no. 10.

The luxuriant foliage of spring and summer is depicted on the right in this pair of screens by Unkoku Tōgan (1547–1618). A land mass supports pavilions and a tall cliff, which rises above a promontory extending into the center of the screen. The scene is a busy one, with figures seen outdoors, in a pavilion, and inside houses. Boats are moored offshore, and in the distance a flock of geese fans out over a range of low-lying hills. The hills continue onto the screen at the left where, silhouetted against a dark sky they appear covered with snow. To the left, pictorial elements are brought up close to the viewer. A huge land mass dominates the scene. Nestled in the hills below is an uninhabited village, connected to the outside world by a narrow path in the foreground and a bridge at the extreme left. Four figures are visible in this otherwise desolate landscape: at the right a traveler riding a donkey and accompanied by a servant; in the center a fisherman seated cross-legged in his boat; and at the left a figure crossing the bridge.

The flight of geese and the moon on the screen at the right recall two scenes from the Eight Views of the Xiao and Xiang Rivers (cat. nos. 64, 77), a Chinese subject that by the late Muromachi period had become extremely popular among Japanese landscape painters.

Unkoku Tōgan impressed two of his seals on each of the screens. One of the major painters of the Momoyama period, Tōgan was also the founder of the Unkoku school, which thrived—particularly in western Japan—into the Meiji period. Before adopting his artistic name, Tōgan was known as Hara Naoharu. He may have been born into a branch of the Hara warrior clan, based in Hizen Province (Saga Prefecture), in northern Kyūshū. Tradition has it that his father, the head of the clan, was killed in battle in 1584 and that the family subsequently dispersed.[1] Naoharu seems to have gained the patronage of Lord Mōri of Hiroshima, the wealthiest and most powerful daimyo in western Japan. No work produced by Naoharu before 1592 has been identified; we know, however, that an important commission received in 1593 ensured his prominence as an ink painter. In that year Lord Mōri, the current owner of the famous *Long Scroll* by Sesshū Tōyō (1420–1506), asked the still unknown Naoharu to make a copy.[2] Upon the successful completion of the commission, Lord Mōri gave Naoharu the use of Sesshū's studio, Unkokuan (Studio of Clouds in the Valley). Naoharu then took the artistic name "Tōgan"—which uses the first character of "Tōyō"—and adopted "Unkoku" as his new family name.

The paintings by Tōgan that are strongly influenced by the work of Sesshū are customarily dated to after 1593, though he was probably acquainted with Sesshū's work before this date and may even have met some of his students. After he inherited Sesshū's studio, Tōgan's paintings became rather conservative. Nevertheless, he found ample patronage for his work in western Japan and in Kyoto. His screen paintings have been preserved in large numbers, many of them at subtemples of Daitokuji. These works represent Tōgan's excursions into the realm of monumental painting of the Momoyama period, including screens with gilded backgrounds. One pair attributed to him and now in the MOA Museum of Art, Atami, features genre scenes of cherry-blossom viewing and falconry, reflecting the wide range of his subjects and styles.[3]

Because so few of Tōgan's works are firmly dated, it has been difficult to establish a chronology for his paintings. In the 1980s, however, Yamamoto Hideo made an extended study of Tōgan's seal impressions.[4] He concluded that the artist most frequently used the square "Tōgan" seal in combination with a round seal reading "Unkoku." The lower part of the "Tōgan" seal seems to have been damaged sometime between

August 1604 and February 1611.[5] The artist later used a gourd-shaped "Unkoku" seal together with the damaged "Tōgan" seal. Thus the Burke screens, impressed with the round "Unkoku" seal and the undamaged "Tōgan" seal, may be safely assigned a date after 1593 but before 1611.

The ink landscape that extends across the Burke screens recalls many of Sesshū's works, including the *Long Scroll*, not only in the sharp, heavy outlines but in the shapes of the rocks, houses, figures, and boats, and in the precise, architectonic structuring of the landscape elements.[6] In one respect, however, it makes a significant departure. Most of the paired screen paintings traditionally attributed to Sesshū adhere to a compositional scheme used throughout the Muromachi period and perpetuated by Kano-school masters into the Momoyama era. In this scheme, pictorial elements are crowded into the outermost sides of paired screens, while the area where the screens meet is left relatively unfilled, creating a sense of open space and suggesting recession into distance. In the Burke screens, however, Tōgan breaks with this tradition. In the right screen part of the land mass on the right has floated toward the center to form a promontory; and the outcropping of

hills and mountains that overwhelms the left screen is connected precariously to the screen's left border by only a small bridge. A generous space is created at that juncture, allowing a view into the far distance, in contrast to the Muromachi scheme, in which this area is filled with close-up landscape elements. One screen attributed to Sesshū, in the Freer Gallery of Art, Washington, D.C., however, makes the same daring departure from the Muromachi formula, so it is difficult to attribute this innovation to Tōgan himself.[7] It should also be noted that Tōgan experimented with this new type of composition only during the early part of his career, while his "Tōgan" seal was still intact. After the seal was damaged, he apparently abandoned the new approach, and it was never taken up by his artistic heirs. The Burke screens thus testify to the achievements of the early, experimental stage of Tōgan's career.

1. Naoharu's name does not, however, appear in genealogical documents of the Hara family. See Kageyama Sumio 1984, p. 162.
2. Both Sesshū's original and Naoharu's copy are in the Hōfu Mōri Hōkōkai, Yamaguchi Prefecture, which was founded by Mōri's descendants. See Yamaguchi Prefectural Museum of Art 1984, p. 180, for Tōgan's explanatory colophon on Sesshū's scroll.
3. Kawai Masatomo 1978, pl. 41.
4. Yamamoto Hideo 1988, pp. 148–65.
5. Ibid., p. 151.
6. Tanaka Ichimatsu and Nakamura Tanio 1973, pp. 20–29, 103–9.
7. Ibid., pp. 94–95.

79. The Travels of the Monk Saigyō

Momoyama period (1573–1615), 16th century
Pair of six-panel folding screens, ink, color, gold, and silver on gilded paper
Each screen 152 × 353.8 cm (4 ft. 11⅞ in. × 11 ft. 7¼ in.)

LITERATURE: Shirahata Yoshi 1964, pp. 103–7; Murase 1971, no. 21; Yamane Yūzō et al. 1979, pls. 73, 74; Takeda Tsuneo 1980b, no. 95; L. Cunningham 1984, no. 2; Tokyo National Museum 1985a, no. 28.

Saigyō (1118–1190), a samurai turned monk-poet, is one of the great literary figures of Japan.[1] Born Satō Norikiyo to a family of minor courtiers, he became a promising junior officer at the imperial court. At the age of twenty-two, however, taking the name "Saigyō," he resigned his post and left his wife and small daughter in the hope of finding peace as a wandering monk. To abandon the secular world, enter the priesthood, and achieve union with nature and the divine spirit through solitary travel was the ideal of the educated gentleman of the Late Heian period; in reality, however, few even attempted to follow this arduous path. Saigyō was an exception, embracing the eremitic life with steadfast determination. He gained fame as a classical court poet in his own lifetime and was posthumously honored when ninety-four of his verses were included in the *Shin kokinshū* (New Collection of Poems Ancient and Modern), the imperially sponsored anthology of about 1206.[2]

Inevitably, the life of a man of such renown became a subject for painting. The earliest extant illustrated account of Saigyō's life, the *Saigyō monogatari emaki*, was created in the first years of the thirteenth century, not long after his death. The original work may have comprised four handscrolls, though only two have survived, one in the Tokugawa Art Museum, Nagoya, the other in the Man'no Art Museum, Osaka.[3] The subject remained a favorite with painters of later periods, and a number of copies of the thirteenth-century *emaki* still exist, along with variant versions. In 1500, an artist named Kaida Uneme made an illustrated handscroll on the life of Saigyō.

The original is lost, but many copies survive, the most important of which are two versions made about 1630 by Sōtatsu (cat. nos. 86, 87), one now in the Watanabe collection, the other, once in the Mōri collection and now in the Idemitsu Museum of Arts, Tokyo.[4]

The Burke screens are part of this long tradition of illustrating the wanderings of Saigyō. The screen at the right depicts an event that occurred on the first New Year's Day after the poet began his travels as a monk. At the left he is shown alone in a room, gazing at the white plum blossoms of early spring; in the adjoining quarters children and monks savor the quiet of the holiday.[5] These scenes are identical to images in the Man'no scroll.

In the screen at the left Saigyō travels to the region south of Nara in search of early cherry blossoms. On the mountain path from Yoshino to the pilgrimage sites at Kumano, he happens upon some beautiful cherry trees at the small mountain shrine of Yagami Ōji. The blossoms are fragile and lovely against the green leaves of the tree and the brilliant red of the Shinto shrine. Overcome with joy, the poet, who appears at the upper left, composes a poem and inscribes it on the red wood fence in front of the shrine:

Machi kitsuru Yagami
no sakura sakinikeri
araku orosuna mineno yamakaze

Long-awaited cherries of Yagami are in bloom.
Winds waft over the mountains and pines.
Do not disturb these fragile flowers.

In the lower portion of the screen is a scene of parting. Saigyō had befriended a group of mendicant monks and traveled with them for several days. Two of the monks are seen weeping as they bid Saigyō farewell and go their separate ways.

The painter of these screens must have had access either to the original thirteenth-century scroll now in the Man'no Museum or to an accurate copy, for he not only re-creates the images but captures their evocative, poetic quality. This quality in turn reflects the mood of many of Saigyō's poems, which celebrate the beauty and evanescence of the phenomenal world.

The landscape background of the original *emaki* has here been transformed into a much richer setting by the use of gold and silver in several forms—powdery dust, thin strips, and flakes—as well as by a sensitive handling of pigments. The dense green of the hills and the bright vermilion of the mountain shrine stand out vividly against the glitter of the golden clouds, and the sharp edges of gold foil are subtly camouflaged by a liberal sprinkling of small gold flakes, adding luster to the surface and lending to the clouds a vaporous delicacy. Additional decorative patterns are provided by small slivers of silver—oxidized

to different shades of gray—that are scattered on the ground in simulation of fallen pine needles. The rich surface treatment is suggestive of the delicate *maki-e* decorations on lacquerware of the period (cat. nos. 88–96). The unidentified artist of these screens either was trained in the use of metallic pigment or he collaborated with a craftsman who specialized in its application.

The tastefully lavish ornamentation of the Saigyō screens reflects a trend that began in the late Muromachi period and continued into the early Edo period. It is exemplified by such works as a pair of Muromachi screens, *Flowers and Birds of the Four Seasons with Sun and Moon*, in the Idemitsu Museum of Arts, Tokyo,[6] and by many others from the late Muromachi and early Momoyama periods. The Burke screens may thus be dated to the sixteenth century, in the Momoyama period.

1. For his life and poetry, see Saigyō 1991.
2. Ibid., p. 1.
3. Komatsu Shigemi 1979, pp. 1–59.
4. The Watanabe scroll is reproduced in ibid., and the Mōri version in Yamane Yūzō 1977–80, vol. 1, no. 28.
5. The first month of the old lunar calendar, during which New Year's Day was celebrated, was February—hence the plum blossoms of early spring.
6. Kuroda Taizō, M. Takeuchi, and Yamane Yūzō 1995, no. 1.

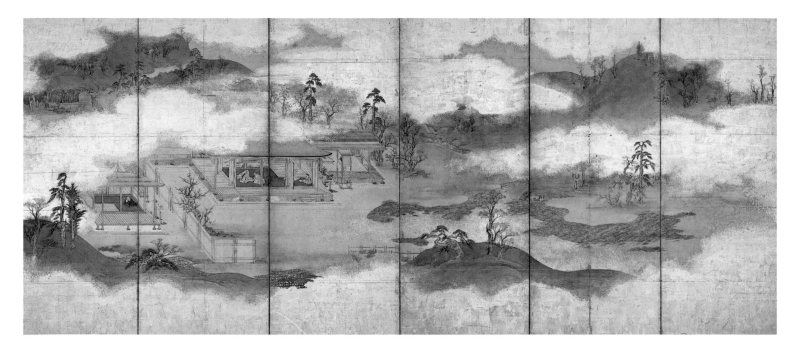

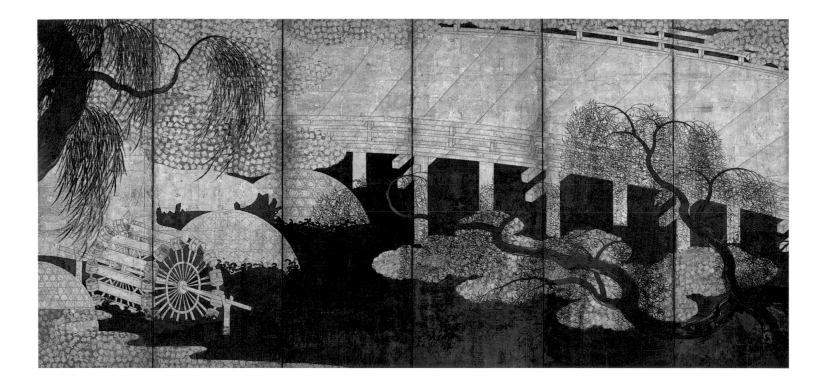

80. Willows and Bridge

Momoyama period (1573–1615)
Pair of six-panel folding screens, ink, color, gold,
and copper on gilded paper
Each screen 170.1 × 345.3 cm (5 ft. 7 in. × 11 ft. 4 in.)
Ex coll.: Marquis Maeda, Tokyo

LITERATURE: Murase 1971, no. 18; Murase 1975,
no. 46; Tokyo National Museum 1985a, no. 27;
Schirn Kunsthalle Frankfurt 1990, no. 50.

Under a moonlit sky, a golden bridge sweeps
upward in a strong diagonal from the right
screen to the left, spanning a view of water,
rocks, and trees. Three willows at the right,
middle, and left hint at the changing seasons;
the small, delicate leaves on the trees at the
right and center are signs of spring, while
the fuller, longer leaves at the left suggest
summer. Beyond the bridge, the glowing
moon—made of copper and attached to the
screen by small pegs—evokes the clear skies
of autumn. A large waterwheel turns in the
stream, and four stone-filled baskets (three
on the left screen and one on the right) pro-
tect the embankments. The irregularly shaped
clouds are formed of tiny square pieces of
gold leaf pasted onto a gold ground; the
gently lapping silver waves are tarnished with
age. With their contrasts of large dramatic

forms and brilliant metallic shimmer, the
Burke screens represent the zenith of the
Momoyama decorative style.

The paintings immediately evoke the
image of the bridge over the Uji River in
southeast Kyoto, a scenic view that has been
immortalized over the centuries by many
Japanese artists and poets.[1] Originating in
Lake Biwa, the river runs south across the
southern outskirts of Kyoto and eventually
empties into Osaka Bay. Its history as a
famous scenic spot (meisho) extends back to
the late eighth century, when its beauty was
celebrated in the Man'yōshū (Collection of
Ten Thousand Leaves).[2] Uji is also significant
in that it was represented in Japanese paint-
ings at a time when kara-e (Chinese-style
painting) was still dominant. A screen depict-
ing the Uji River in autumn, with crimson
maple leaves caught by fishing baskets in the
water, is described in literary sources as hav-
ing been installed at the beginning of the
ninth century in the Seiryōden, the living
quarters of the Imperial Palace, and from
that time forward it was an established part
of palace interiors.[3] The painting is often
cited as one of the first signs that yamato-e
(Japanese-style painting) had encroached
upon the kara-e tradition.[4] Throughout the
tenth century the scenery of Uji, usually
with autumnal imagery, was represented on

screens, which are now known only through
the poems that they inspired. Often the
imagery made only oblique reference to the
river, most often by the presence of maple
leaves and fishing baskets.

The iconography of the Uji theme as rep-
resented in the Burke screens has a long his-
tory; it began with the simplest symbolic
allusions and various other elements were
added over the years. Although no visual
image of the Uji theme from before the four-
teenth century survives, a rich store of liter-
ary references helps us to reconstruct its
iconographic evolution.[5]

A broad bridge, the essential element in
the later iconography, is believed to have
been constructed at Uji in 646; the several bat-
tles that were later fought in the area enriched
its historical associations. Beginning in the
eleventh century, waterwheels for irrigation
are frequently mentioned, as are baskets filled
with stones for water control and for the pro-
tection of the riverbanks. About the year 1010,
Lady Murasaki chose Uji as the setting for the
last ten chapters of the Genji monogatari (The
Tale of Genji), and a new element derived
from that text—boats carrying brushwood—
made its appearance in the iconography.[6]

About a half century later, the imagery
associated with Uji was further enhanced
by the addition of Byōdōin, originally the

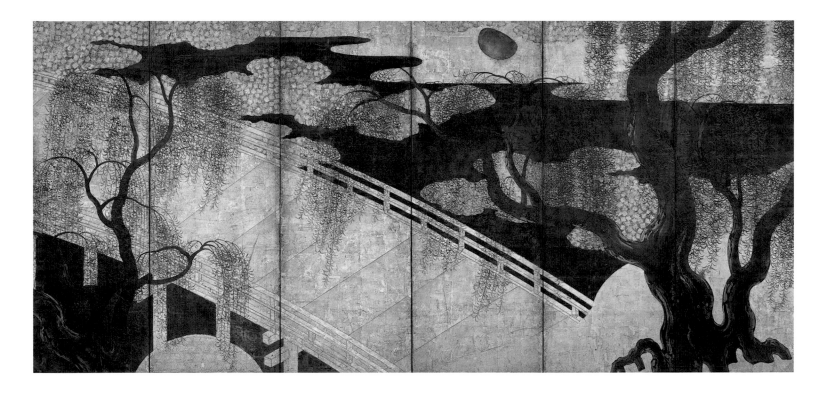

summer estate of the Fujiwara nobleman Yorimichi, who converted it, in 1052, into a Buddhist monastery dedicated to Amida Buddha. A small fan painting, formerly in the Sasama collection, Tokyo, and dated to the late fifteenth century, is the oldest known illustration of Uji to include Byōdōin.[7] Inscribed on the fan was a poem by Ranpa Keishi (d. 1501), who referred not only to boats carrying brushwood but to a scene of cloth bleaching, an industry believed to have begun at Uji in 1286. Willow trees were added to the iconography sometime before 1369, when a young retainer in a ceremonial procession to Byōdōin was described as wearing a robe that had on the right sleeve a design of the bridge and on the left a waterwheel, and possibly willows as well.[8]

The earliest extant example of Uji imagery is the fourteenth-century *Ishiyamadera engi emaki* (Illustrated History of Ishiyamadera). There, Uji is the setting for a miraculous Buddhist tale in which the bridge, waterwheel, and a boat carrying brushwood are represented.[9]

The Uji theme seems to have gone through one more stage before it evolved into the decorative composition exemplified by the Burke screens. This penultimate stage is well illustrated by two screens—each the right screen of a pair—one in the Yabumoto

collection, Osaka, the other in the Tokyo National Museum.[10] The bridge is shown in both works, but the composition is now dominated by seasonal references. In the Tokyo screen, for example, the hot sun of spring and summer blazes fiercely above the blossoming cherry trees and young willows.

A standard iconography for Uji screen representations seems to have been established by the late sixteenth century. By this time, too, the genre had received a name: *Ujibashi byōbu* (Screens of the Uji Bridge).[11]

That Uji screens remained popular in the early seventeenth century is indicated by their depiction in the Hōkoku Festival screens painted by Kano Naizen in 1606 (fig. 39, on page 190).[12] The composition was repeated many times into the early Edo period, with only minor variations in detail and quality. At least two versions bear the seals of Hasegawa Tōhaku (1539–1610), another the seal of his reputed son, Sōya. Although the present pair of screens bear neither seal nor signature, it is possible that they were painted by a member of the Hasegawa school.

A recent interpretation of the theme—according to which Uji Bridge represents a link to the Buddhist paradise[13]—is ingenious but unlikely, as no other Momoyama-period decorative screens have strong Buddhist overtones. More evident than Buddhist symbolism

are the reverberations of historical events and literary allusions. In the end, the setting lost its specific association with Uji Bridge and was reconstituted as an anonymous place, seen through the changing seasons of the year.

1. For a summary in English of the various interpretations of this theme, see M. Takeuchi 1995, pp. 30–53; for a detailed discussion of the theme, see also Asahi Misako 1984, pp. 35–78; Adachi Keiko 1990, pp. 7–22; and Takeuchi Misako 1990, pts. 1, 2.
2. *Man'yōshū* 1981.
3. Ienaga Saburō 1966b, pp. 29, 72.
4. Ibid., p. 73.
5. For a chronological compilation of literary records, see Adachi Keiko 1990, pp. 7–22; and Takeuchi Misako 1990, pt. 1, pp. 22, 28.
6. See Murasaki Shikibu 1976, pp. 751ff.
7. Narazaki Muneshige 1962, fig. 26.
8. Miyajima Shin'ichi 1980.
9. Komatsu Shigemi 1978a, scroll v, pp. 66–69.
10. Tokyo National Museum 1989b, nos. 39, 14.
11. A reference to *Ujibashi byōbu* is found in an entry for the eighth month of the twentieth year of the Tenshō era (1592), in the *Tamon'in nikki* (Chronicle of Tamon'in); see *Tamon'in nikki* 1967.
12. Takeda Tsuneo 1980a, pls. 15, 16.
13. Furuta Shōkin 1988, pp. 18–23.

Genji monogatari

CATALOGUE NOS. 81, 82, 87, 109, 110, 126

The *Genji monogatari* (The Tale of Genji), one of the world's earliest examples of romantic literature, is perhaps the work of Japanese literature best known outside Japan.[1] The author, Murasaki Shikibu (ca. 973–ca. 1015), was relatively young when she wrote it, and her extraordinary achievement is evident in the complexity of plot, keen observations of human psychology, descriptions of nature, and exquisite prose.

In a highly evocative literary style, the fifty-four-chapter novel traces the life and loves of the incomparable prince Shining Genji (Hikaru Genji) and two generations of his descendants. The events described span nearly three-quarters of a century and involve more than four hundred thirty characters. The first forty chapters recount the many romances of the protagonist, a man of high birth, rare beauty, sensitivity, and intellect—a paradigm of male virtue who is himself a passionate lover of beauty, both in women and in nature. The remaining chapters focus on the less illustrious careers of Niou, Genji's grandson, and Kaoru, who passes as Genji's son but is actually the child of a tragic liaison between Genji's young wife and the son of his best friend.

The novel, believed to have been modeled in part after the life of Michinaga (966–1028), the most powerful patriarch of the Fujiwara clan, vividly describes aspects of Late Heian court life and social mores, and is thus a valuable historical document as well as a great work of fiction. The book contains numerous references to art and to the aesthetics of court life, both of which are seldom mentioned in most other contemporary sources. These observations are particularly important because of what they reveal about aesthetic values at a time when the Japanese were becoming increasingly aware and proud of indigenous achievements in the visual arts.

Murasaki Shikibu, or Lady Murasaki as she is known to Western readers, was born about 973 into a minor branch of the august Fujiwara family. She married a kinsman of modest rank, many years her senior, who died in 1001.

The young widow was sent to serve as lady-in-waiting and instructor to Shōshi (d. 1074), the consort of Emperor Ichijō (r. 986–1011). It is not known exactly when she began her long novel, but the work must have been in progress, or was possibly finished, by 1008. In that year, according to her diary, she was addressed at court as Waka Murasaki (Young Murasaki) or Waga Murasaki (Our Murasaki), a reference to one of the heroines of the tale.[2] It is likely that she died about 1015, for her name ceased to appear in court records after this date.

The tradition of illustrating works of fiction and poetry was established in Japan sometime before the *Genji monogatari* was written. Illustrated versions of a mid-tenth-century romantic narrative, the *Sumiyoshi monogatari*, are dated to as early as 972 (cat. no. 37), and a number of illustrated novels are mentioned in the *Genji* itself; in addition to the *Sumiyoshi monogatari*, the *Ise monogatari* (cat. no. 86), *Utsubo monogatari*, and *Taketori monogatari* are named specifically.

Written more than one hundred years after the *Sumiyoshi monogatari*, the *Genji monogatari* may well have been illustrated shortly after its completion. Later novelists who tried to emulate the enormously successful *Genji* often noted that young women patiently copied out the text for their own reading pleasure, and some of these copies were no doubt accompanied by painted scenes. The earliest literary reference to illustrations of *Genji* is dated to 1119, about one hundred years after Lady Murasaki's death. In that year, according to the diary of Minamoto Morotoki (1077–1136), the retired emperor Shirakawa (r. 1073–87) and his consort asked Morotoki to procure paper on which to copy the tale, complete with pictures.[3] The status of the patron suggests that the earliest and finest extant *Genji* handscrolls, now fragmented and divided between the Tokugawa Art Museum, Nagoya, and the Gotoh Museum, Tokyo, are from that set.

Although the connection between the *Genji* scrolls in Nagoya and Tokyo and the set

commissioned in 1119 cannot be verified, the former can be dated, on stylistic grounds, to the first quarter of the twelfth century. Just as the tale is regarded as the pinnacle of Fujiwara-era literature, the nineteen extant fragments are considered among the finest examples of Japanese narrative illustration.[4] In his careful analysis of the nineteen paintings, Akiyama Terukazu estimates that the original scrolls included two or three illustrations per chapter and that the complete set comprised about ten handscrolls.[5] This would mean that only a small number of the original scrolls have survived. But Akiyama's estimate may in fact be too low, as the extant pictures were painted at a time when another illustrated version of the *Genji* was being made as a set of twenty handscrolls.[6] No other specific set of *Genji* pictures from before the late Kamakura period is known, and even the Kamakura examples consist of only a few fragments of ink drawings.

In spite of the rarity of early pictures, it is evident that the tale remained the most popular subject for narrative painting until the twentieth century. The iconography of each chapter was standardized in the late Muromachi period, but synopses and painting manuals were available as early as the fifteenth century. Among the most important of these are a sixteenth-century text owned by Osaka

Women's College and another, dating to the middle Edo period, in the Museum of the Imperial Collections, Tokyo.[7] These manuals include instructions, based on models approved by *Genji* connoisseurs, for depicting important episodes. In both manuals the sections of text drawn from the novel to represent each chapter are highly condensed, but the short, scenario-like directives provide descriptions of the pictorial scenes and their seasonal attributes along with the requirements for depicting the cast of characters and their actions.

Abundant examples of *Genji* illustrations from the Edo period, in book form, handscrolls, and screens, are available. In some instances they include pictures for all fifty-four chapters, with one painting allotted to each chapter. Another type, particularly popular after the eighteenth century, was the so-called dowry set, intended for young women about to be married. Enclosed in beautiful lacquer boxes, such sets usually comprised fifty-four books, one volume per chapter. The entire text of the novel was reproduced in these sets, while in all other versions it was customary to copy only selected passages.

All schools of painters—even artists of the strongly Chinese-influenced Kano school—painted themes or episodes from the *Genji monogatari*. Most were executed in brilliant

polychrome, but the delicate *hakubyō* (white drawing) technique was also popular (cat. no. 109). All *Genji* scenes reflect the classical conventions of figure painting developed during the Heian period. In most instances people are shown seated indoors, and there is little sense of movement. The identification of episodes, characters, and emotions depends largely on the treatment of the setting and its architectural and seasonal elements, or on the inclusion of plants and flowers specific to a particular chapter.

The Burke Collection is especially rich in *Genji* illustrations. Dating from the Muromachi era through the Edo period, these were produced by artists affiliated with different ateliers, including three generations of Tosa-school artists (cat. nos. 81, 82, 109) and the Sōtatsu or Rinpa school (cat. no. 87).

1. Murasaki Shikibu 1976.
2. Murasaki Shikibu 1982, p. 91.
3. *Chōshūki* 1965, p. 183. For other interpretations of the passage, see Komatsu Shigemi 1959, pp. 21–23.
4. The twentieth section is in the collection of the Tokyo National Museum, but it is too heavily overpainted to allow appreciation of its original beauty. See Akiyama Terukazu 1978, pp. 9–26.
5. Akiyama Terukazu 1976; and Murase 1983a, nos. 9, 10.
6. Inaga Keiji 1964, pp. 22–31; and Teramoto Naohiko 1964, pts. 1, 2.
7. See Shimizu Yoshiko 1960, pp. 1–14; Meech-Pekarik 1982, pp. 189–95; and Murase 1983b.

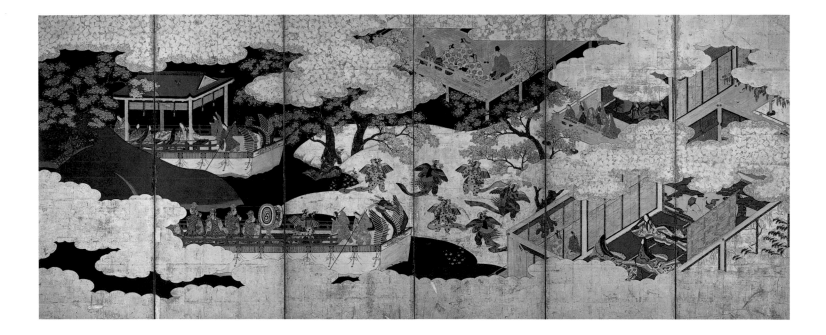

81. *Genji monogatari: "Kochō"*

Momoyama period (1573–1615)
Six-panel folding screen, ink, color, and gold
on gilded paper
148 × 359 cm (4 ft. 10¼ in. × 11 ft. 9⅜ in.)

LITERATURE: Murase 1985, fig. 7 (detail); Tokyo
National Museum 1985a, no. 30; Miyajima Shin'ichi
1986, fig. 63 (detail); Akiyama Ken and Taguchi
Eiichi 1988, pp. 122–27; Schirn Kunsthalle Frank-
furt 1990, no. 65; *Genji no ishō* 1998, pp. 56–57.

The scene that appears on this screen illus-
trates an episode from "Kochō" (Butterflies),
the twenty-fourth chapter of the *Genji mono-
gatari*. Spring festivities have been organized
for the gardens of Genji's residence, Rokujō
Palace. Dragon and phoenix boats, "bril-
liantly decorated in the Chinese fashion"[1]
and bearing ladies dressed in their most ele-
gant clothes, are launched on the lake;
another boat carries the male musicians. The
following day, a sutra reading is hosted by
Empress Akikonomu. Guests don formal
attire. Murasaki, Genji's favorite consort,
dresses several of her prettiest young atten-
dants as birds and butterflies, and sends them
to dance in front of Akikonomu's quarters:

The birds brought cherry blossoms in silver vases,
 the butterflies yamabuki in gold vases.
In wonderfully rich and full bloom, they
 completed a perfect picture.[2]

The screen painting conflates these events of
two consecutive days into a single scene. The
empress's residence is depicted at the lower
right; above, other sections of the palace are
shown filled with people watching the dancers.

Small squares of tissue-thin gold leaf,
scattered over the cloud forms that hover
above the palace chambers, create a golden
mist. Except in the areas screened by clouds,
interiors are exposed, with rooftops eliminat-
ed, in the pictorial convention known as *fuk-
inuki yatai* (room with roof blown away).
Cherry trees laden with pink blossoms set off
the deep green of the hillocks and the inky
blue of the lake. The warm tones of red and
pink that dominate the costumes stand out in
relief against the shimmering gold of the
ground and clouds. The entire image is suf-
fused with the warmth of a spring day and
the joy of the festivities.

The screen is generally accepted as the
work of Tosa Mitsuyoshi (1539–1613), a
hitherto neglected artist of the Tosa school.
The family had long served as official

painters to the imperial court, but their for-
tunes fell during the sixteenth century along
with those of their patrons, the Ashikaga
shoguns. At the close of the Muromachi
period the leader of the Tosa school, Mitsu-
moto (ca. 1530–1569), was in service to the
powerful warlords Oda Nobunaga (1534–
1582) and Toyotomi Hideyoshi (1536–1598).
When Mitsumoto was killed in battle, his
three children were left in the care of a pupil
named Genji, who may have later changed
his name to Mitsuyoshi.[3] Mitsuyoshi inherit-
ed the family's estate and documents, as well
as painting models and other materials. He
later moved to Sakai, then a thriving port city
south of Osaka, and sometime before 1593
took the tonsure and the priestly name
"Kyūyoku."[4] Various members of the Kano
family in Kyoto wrote to Genji urging him to
return to the capital, but he chose to remain
in Sakai.[5] About 1599, Kano Takanobu (1571–
1618) assumed the position of official painter
to the court, thus ending the preeminence of
the Tosa school.[6]

Scholars are slowly beginning to identify
Mitsuyoshi's oeuvre. Most works depict
events from the *Genji monogatari*. Among the
firmly attributed works are two *Genji* albums,
one in the Kyoto National Museum, the other

in the Kubosō Memorial Museum of Arts, south of Osaka.[7] Both albums bear the seal "Tosa Kyūyoku," Mitsuyoshi's priestly name. A leaf separated from a folding screen and now in the Burke Collection has also been assigned to Mitsuyoshi's hand.[8] All the *Genji* paintings are small, delicately drawn, and richly colored. In addition, several large-scale *Genji* screen paintings have been accepted as the work of Mitsuyoshi on purely stylistic grounds, although they contain neither seal nor signature. A pair of four-fold screens in The Metropolitan Museum of Art are regarded as the earliest of Mitsuyoshi's large-scale works, with the Burke screen slightly later but still from his early period.[9] The two *Genji* albums, on the other hand, have been dated to the last years of his life. The Kubosō album has been assigned to 1613, the year of Mitsuyoshi's death; the Kyoto album is viewed as incomplete, a work in progress at his death.[10] The album leaf in the Burke Collection has also been dated to his late period, as it bears a "Kyūyoku" seal.

The years that separate the small from the large-scale paintings, as well as the difference in their sizes, make it difficult to attribute the Burke screen paintings to Mitsuyoshi on purely stylistic grounds. Some small features, however, are useful markers for stylistic comparison, such as the small chins and large eyes of the bearded male figures that appear in both the Burke screen and the Metropolitan screens. Other details—the screens-within-screens, the rocks highlighted with gold, the use of fine ink lines for texture—also indicate a clear connection.

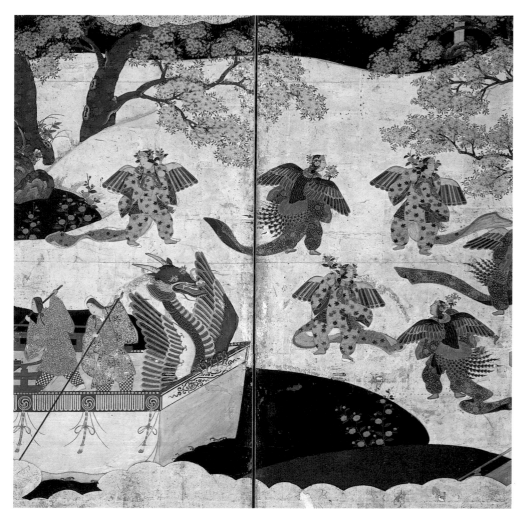

1. Murasaki Shikibu 1976, p. 418.
2. Ibid., pp. 422–23.
3. Some scholars do not believe that Genji and Mitsuyoshi were the same person; see Iwama Kaoru 1986, p. 168.
4. Miyajima Shin'ichi 1986, p. 76.
5. The *Tosa-ke monjo* (Tosa Family Documents), handed down in the Tosa clan, are now in the collection of the Kyoto Municipal University of the Arts.
6. Miyajima Shin'ichi 1986, p. 76.
7. See, respectively, Takeda Tsuneo 1976, pp. 3–40; and Narazaki Muneshige 1953. For color reproductions, see Akiyama Ken and Taguchi Eiichi 1988.
8. Tokyo National Museum 1985a, no. 37.
9. Miyajima Shin'ichi 1986, p. 57.
10. Akiyama Terakazu 1976, p. 66.

82. *Genji monogatari: "Tamakazura"*

Momoyama period (1573–1615)
Album leaves, mounted as a pair of hanging scrolls, ink, gold, silver, and color on paper
Each leaf 24.1 × 21.4 cm (9½ × 8⅜ in.)

LITERATURE: Tokyo National Museum 1985a, no. 38; Schirn Kunsthalle Frankfurt 1990, no. 67.

Toward the end of the year, the time approaches for the distribution of the New Year's robes to the ladies of Genji's household. "We must see that they are divided so that no one has a right to feel slighted."[1] Beautiful garments are sorted and put into chests and wardrobes, to be allocated among the women in question.

This episode, illustrated in the small album-leaf painting format, is from "Tamakazura" (The Jeweled Chaplet), the twenty-second chapter of the *Genji monogatari*. Genji is shown seated near Murasaki, as the women put colorful garments into black lacquered boxes. Outside is a snow-covered garden where mandarin ducks, symbols of winter and marital harmony, can be seen on the water. The scene is jewel-like in its miniaturistic detail, a signature of Tosa-school narrative painting. Accompanying the picture is a sheet of the same size with eight lines of text and the chapter title at the extreme right.

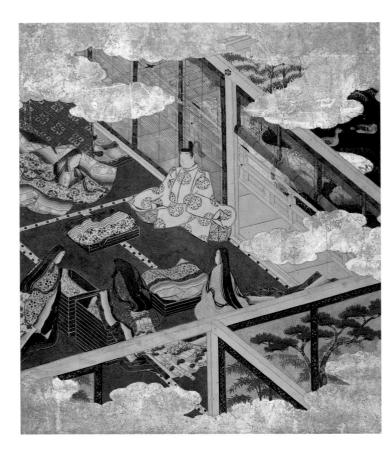

The sheets were originally pasted into an album, facing each other, with the text on the right side, the picture on the left.

To create a landscape and enhance the beauty of the text page, the artist used paper stencils to sprinkle tiny flakes of gold and silver on the surface. A shoreline appears in the foreground and a hill at the center, with a cloud pattern above. Larger areas of gold and silver foil further enrich the image. Close scrutiny reveals small, delicate trees on the distant hill. Reeds line the shore, and a roofed boat sails past. The silver ink has oxidized, darkening the waves in the foreground and obscuring the text.

The *Kimiyori-kō ki* (Records of Lord Kimiyori) and other documents note that painters of the Tosa school used decorated paper as a ground for calligraphy, a tradition dating back to the Heian period (cat. nos. 19, 20).[2] These decorative motifs, more prevalent later, in the Momoyama and Edo periods, were small and delicate, in contrast to the large-pattern designs for paper created by Sōtatsu in the seventeenth century (cat. nos. 83, 84).

The small painting seen here is nearly identical to a scene from a *Genji* album now in the Kyoto National Museum, a collaborative effort by Tosa Mitsuyoshi (cat. no. 81), the Tosa artist Chōjirō (fl. early 17th century), and an unidentified painter of the same school.[3] Although once attributed to Chōjirō,[4] it differs stylistically from the paintings in the Kyoto album. The figures have smaller, narrower faces, and the pine trees depicted on the sliding panels appear more three dimensional than the crisply outlined, flattened versions in the Kyoto album. This painting can thus be attributed to an unidentified painter who, like Chōjirō, was strongly influenced by Mitsuyoshi's miniaturist style.

1. Murasaki Shikibu 1976, p. 406.
2. The entry for the twenty-ninth day of the second month of the eighth year of the Daiei era (1528) in the *Kimiyori-kō ki*, unpublished. See Miyajima Shin'ichi 1986, p. 78.
3. Takeda Tsuneo 1976, pp. 11–40. Takeda believes that the anonymous paintings are also by Chōjirō. For a color reproduction, see Akiyama Ken and Taguchi Eiichi 1988, p. 117.
4. Tokyo National Museum 1985a, no. 38.

CALLIGRAPHY BY HON'AMI KŌETSU (1558–1637)
DESIGNS BY TAWARAYA SŌTATSU (DIED CA. 1640)

83. Two Poems from the "Kokin wakashū"

Momoyama period (1573–1615), shortly before
1615
Two album leaves, mounted as hanging scrolls, ink
and gold on paper
Each leaf 18.3 × 16.3 cm (7¼ × 6⅜ in.)
Ex coll.: Ōkura

LITERATURE: Murase 1975, no. 48; *Kōetsu sho
Sōtatsu kingindei-e* 1978, figs. 77, 78; Schirn Kunst-
halle Frankfurt 1990, no. 52.

Hon'ami Kōetsu (1558–1637) is a protean
figure in Japanese art history, admired for his
aesthetic vision as well as for his contribu-
tions to the arts of calligraphy, lacquer and
metalwork design, pottery making, *chanoyu*,
and the Nō theater. The earliest discussion of
Kōetsu and his family is found in the *Hon'ami
gyōjōki* (Activities of the Hon'ami Family),
a biography begun by his adopted son Kōsa
(d. 1637) and completed by his grandson
Kōho (1601–1682).[1] A more objective account
appeared in the *Nigiwai gusa* of 1682, a col-
lection of essays by the tea master Sano
Shōeki (Haiya Shōeki, 1610–1691).[2] Also
extant are nearly three hundred letters from
Kōetsu to his friends; the earliest of these,
in the collection of the Tokyo National Mu-
seum, is dated to 1585, when the artist was
twenty-seven.[3] While this correspondence,
particularly treasured in tea circles, provides
insight into Kōetsu's daily affairs, it seldom
mentions his artistic activities, save for refer-
ences to *chanoyu* and an occasional mention
of pottery making. Unfortunately, not a sin-
gle letter mentions Sōtatsu, his frequent and
close collaborator.

Kōetsu was born to a family whose trade
was the cleaning, polishing, and appraising
of swords. It is likely that his ancestors were
craftsmen who, in the fourteenth century,
became followers of the Jishū sect of Bud-
dhism, adopting "ami" (a reference to
Amida Buddha) as part of their surname.
Having established a reputation with the
warrior class, they acquired a privileged
status that they retained until Kōetsu's time.
Their clients included the leading warriors
of the day, Oda Nobunaga (1534–1582) and
Tokugawa Ieyasu (r. 1603–5), as well as
members of the imperial court. Kōetsu
apparently enjoyed the leisurely life of a cul-
tivated and wealthy man. *Chanoyu* seems to
have been his principal interest, and he was
regarded as a great disciple of the tea master
Furuta Oribe (see cat. no. 104).

The source of Kōetsu's unique calligraph-
ic style—rich, dynamic, and sensuous at its
best—has been sought in the work of vari-
ous calligraphy schools active during his
youth, in particular the group led by Prince
Shōren'in Sonchō (1536–1597). But there is
little evidence that the Shōren'in school

served as the major inspiration for Kōetsu's art. The most probable source, discovered by Itō Toshiko in the 1960s, is somewhat unexpected.[4] The Kanze school of Nō performers, led by Kokusetsu (1566–1626) and members of Kyoto's elite, practiced the same calligraphic style as Kōetsu. Indeed, many of their librettos have traditionally been attributed to Kōetsu. It is more likely, however, that these books, the earliest of which (with Kokusetsu's performance notations) dates to 1599, exemplify a germinating style of calligraphy that Kōetsu would perfect in later years.

Like many calligraphers at this time, Kōetsu deeply admired the classical aesthetics of the Heian period, and he was an enthusiastic collector of calligraphy from that era. His own political sympathies, which were with the imperial court and the cultural heritage it represented, may have influenced his move to Takagamine, northwest of Kyoto. In 1615, when the last stronghold of the Toyotomi regime, Osaka Castle, fell to Tokugawa forces, Tokugawa Ieyasu became the undisputed military leader of Japan. In the same year, Ieyasu ordered Furuta Oribe to commit *seppuku* (ritual suicide), because of suspicions concerning his loyalty. At the same time, however, he granted Kōetsu a tract of land at Takagamine. It has been speculated that what seemed an act of generosity may in fact have been an act of banishment. Certainly, the romantic notion that Kōetsu moved to Takagamine to establish an art colony lacks credence, as his subsequent activities focused on his commitment to Buddhism. A number of Kyoto craftsmen did join Kōetsu at Takagamine, but the nucleus of the group came for religious, not artistic, reasons. It should be noted that Sōtatsu, with whom Kōetsu had worked closely for more than ten years, was not among those who moved to Takagamine.

Kōetsu's attraction to the classical tradition may have derived from his family's association with court nobles and supporters of the classical revival. An acquaintance, Suminokura Soan (1571–1632), one of the three wealthiest businessmen in the capital, was also a great scholar of classical literature and an importer of books and medicines from China. About 1606, Soan initiated an ambitious project, in cooperation with Kōetsu and others, to publish masterpieces of Japanese classical literature and Nō librettos. Kōetsu designed some of the texts, using *kana* script, and these were reproduced for printing with movable type, a technique introduced from Korea only a few years earlier. The books came to be known as the *Sagabon* (Saga Books), after the suburb of Kyoto where they were made.

Although Kōetsu probably worked in 1602 with Sōtatsu to repair the *Heike nōkyō*, a set of twelfth-century sutras at the Itsukushima Shrine, the *Sagabon* project marks the first significant collaboration between Kōetsu as a calligrapher and Sōtatsu as a decorator of paper. Sōtatsu created paper designs for many of the *Saga* books, as well as for Kōetsu's best-known calligraphic pieces. Chief among the latter are the renowned poetry scrolls, such as the *Deer Scroll*, now divided among the Seattle Art Museum and collections in Japan.[5] A seal reading "Inen"— the name associated with Sōtatsu's painting and fan shop, Tawaraya—appears on the Seattle scroll.

Sōtatsu's marriage to a cousin of Kōetsu, the only officially documented connection between the artists, may explain how they came to work together.[6] The two artists collaborated on many beautiful works, but their affiliation gradually came to a close about 1620, perhaps because Sōtatsu was moving beyond the profession of decorator-designer to pursue an independent career as a painter.

The poems chosen for inscription by Kōetsu were taken primarily from literary classics compiled in the Heian and Kamakura periods. His fluid *kana* script and his use of paper decorated with gold and silver for inscribing *waka* poems recall the courtly style of twelfth-century calligraphers (cat. nos. 19, 20). Small motifs from nature and landscapes with exquisite details dominated the repertoire of Heian paper designers, and these motifs continued to be used in Kōetsu's day. Sōtatsu's paper decorations, however, differed dramatically from both traditional and contemporary underdrawings, his innovative genius evident in his selection of a limited number of natural motifs—sometimes only one—enlarged and depicted at close range. On the two album leaves, or *shikishi*, in the Burke Collection, hints of smudged and pooled gold pigment, reminiscent of the *tarashikomi* technique, in which liquid color is applied over a lighter, still-wet color, suggest that he was inspired by his experience in working with stamps to decorate books and scrolls for the *Sagabon* project.

The verses are taken from the *Kokinshū* (A Collection of Poems Ancient and Modern), the anthology of 1,111 poems compiled about 905 at the command of Emperor Daigo (r. 897–930).[7] The ivy-decorated *shikishi* is inscribed with the following verse—number 289 in the anthology—by an unidentified poet:

Aki no tsuki yamabe sayakani
teraseru wa
ochiru momiji no
kazu o miyo toka

The autumn moon shines brilliantly
upon the mountains
illuminating every
fallen colored leaf.

On its companion page, designed with a bold full moon that fills the paper, is verse 293, by the monk Sosei (fl. late 9th–early 10th century), one of the Thirty-six Immortal Poets:

Momijiba no nagarete tomaru
minato niwa
kurenai fukaki
namiya tatsu rane

In the harbor
where the waters converge
the waves are deep red as the
floating autumn leaves swirl and eddy.

Shikishi were usually made in sets of thirty-six, to be pasted on pairs of six-fold screens, three to a panel.[8] These two leaves were originally part of such a set, but comprising now only thirteen sheets. Two more *shikishi* from this group are in the Suntory Museum of Art (poem 286) and in the Nezu Institute of Fine Arts (poem 277), both in Tokyo.[9]

Kōetsu seldom concerned himself with the relationship between the poems he brushed on the sheet and the pictorial motifs over

which he wrote. Here, for example, the autumn-moon poem is inscribed over a design of ivy leaves, and the poem about maple leaves is written over a painting of the full moon. Kōetsu sometimes began a poem with Chinese characters—as, for example, on the ivy-decorated *shikishi*—rendering them in large strokes to create blocklike forms, the brush thickly loaded with black ink. By way of contrast, he sharply reduced the size of the *kana* characters to delicate, thread-thin lines and shapes. At other times, as on the moon-decorated paper, the composition is deliberately off-center. Thus, Kōetsu's *shikishi* are characterized by a remarkable variety of scripts and brushstrokes. Arranged and pasted on screens, they must have formed a visually exciting composition.

The designs on the Burke, Suntory, and Nezu *shikishi* closely resemble underdecorations on a group of thirty-six *shikishi* by Kōetsu in the Museum für Ostasiatische Kunst, Berlin, which were executed about 1610.[10] However, the calligraphic style of these four pieces reveals a less vigorous brush; they are therefore dated to the years just prior to 1615.[11]

1. *Hon'ami gyōjōki to Kōetsu* 1965.
2. *Nihon zuihitsu zenshū* 1929, pp. 89–189.
3. Hayashiya Tatsusaburō et al. 1964; and Masuda Takashi 1980. Many examples are also included in Komatsu Shigemi 1980; and Osaka Municipal Museum of Art 1990.
4. Itō Toshiko 1970, pp. 5–22; and Itō Toshiko 1978, pp. 95–103.
5. Yamane Yūzō 1962b, fig. 1.
6. For a genealogical chart, see Paine and Soper 1975, p. 215.
7. *Kokinshū* 1984.
8. See Komatsu Shigemi 1963, p. 11, fig. 1; and Minamoto Toyomune 1966.
9. *Kōetsu sho Sōtatsu kingindei-e* 1978, fig. 76; and Nezu Institute of Fine Arts 1981, fig. 113.
10. *Kōetsu sho Sōtatsu kingindei-e* 1978, pl. 70.
11. Ibid., pp. 114–15.

CALLIGRAPHY BY HON'AMI KŌETSU (1558–1637)
DESIGNS BY TAWARAYA SŌTATSU (DIED CA. 1640)

84. Two Poems from the "Ogura hyakunin isshu"

Momoyama period (1573–1615), shortly after 1615
Fragment of a handscroll, mounted as a hanging scroll, ink, silver, and gold on paper
32.8 × 60.3 cm (12⁷⁄₈ × 23¾ in.)
Ex coll.: Asada

LITERATURE: Hayashiya Tatsusaburō et al. 1964, p. 21; Mizuo Hiroshi 1966, vol. 2, p. 83; Murase 1975, no. 49; *Kōetsu sho Sōtatsu kingindei-e* 1978, fig. 4-3; Tokyo National Museum 1978, no. 244; Yamane Yūzō 1979, no. 11; Komatsu Shigemi 1981, pl. 13; Kita Haruchiyo 1985, p. 85; Pekarik 1985a, fig. 8; Tokyo National Museum 1985a, no. 76; Kobayashi Tadashi 1990, no. 84; Schirn Kunsthalle Frankfurt 1990, no. 54.

Measuring nearly twenty-five meters (about 82 ft.) in length, the handscroll to which this fragment once belonged originally comprised the one hundred poems from the *Ogura hyakunin isshu* (One Hundred Poems by One Hundred Poets).[1] The anthology is traditionally attributed to the poet Fujiwara Teika (1162–1241; see cat. no. 39), who is said to have compiled the volume at his country villa on Mount Ogura, giving the work its name. The anthology has long been a favorite in Japan, known primarily through a game using one hundred playing cards with the poems written on them that was, until recently, an indispensable part of the New Year's Day celebration. The handscroll was severely damaged during the earthquake of 1923, and fifty-seven poems—numbers 1–20, 27–32, 51–73, 81–85, 93, 94, and 96—were lost. The surviving sections have been divided among several collections.[2]

The scroll was composed of sheets of paper dyed in different colors, with underdecorations in gold and silver by Sōtatsu (died ca. 1640) that described the life cycle of the lotus. Starting with large leaves shown floating on water, the illustrative sequence moved through the plant's nascency, with tight buds supported by upright stems; its florescence, with open blossoms; and finally its decline, with withered leaves and fallen petals. Enigmatically, a few flowers were once again in full bloom at the very end.

The large golden leaf in this fragment stands erect, flanked by a segment of another leaf and a slender stalk. The lotus is in its full maturity, just before it begins to wane. The long stem at the left was part of a large, drooping leaf riddled with wormholes. Soft pools of gold ink create amorphous patterns within the leaves. The two poems over Sōtatsu's design were inscribed by Hon'ami Kōetsu (1558–1637). Poem 79 in the anthology is by Fujiwara Akisuke (1090–1155), whose name is given together with his official title, Sakyō Daibu (Minister of the Office of the East District):

Akikaze ni tanabiku kumo
no taema yori
more izuru tsuki no kage no sayakesa

How bright and clear is the harvest moon
that shines through the cloud,
driven by the autumn wind.[3]

Poem 80 at the left is by a twelfth-century poet of the Fujiwara family who is commonly known as Taikenmon'in Horikawa, as she served as lady-in-waiting at the court of the empress dowager, Taikenmon'in:

Nagakaran kokoro mo shirazu
kurokami no
midarete kesa wa mono o koso omoe

As I wonder this morning how long the love
of my beloved will endure,
my thoughts wander in disarray
like my long black hair.[4]

Stylistic analysis of Kōetsu's calligraphy suggests that the scroll may be dated slightly later than the two album leaves with poems from the *Kokinshū* inscribed and decorated by the same artists (cat. no. 83). Such a date is corroborated by the fact that at the end of the scroll are Kōetsu's signature and the name of his studio, Taikyoan (Studio of Great Emptiness), which he built in the village of Takagamine, northwest of Kyoto, in 1615. Kōetsu's rounded characters are here slightly less bold and supple than in the earlier works; the brushstrokes often end in pencil-sharp points (especially noticeable in the small letters at the extreme left). The brush moved slowly, at times hesitantly, and characters are disconnected; the once powerful brushstrokes, which formerly followed briskly from one character to the next, without leaving the paper have lost their strength. In places Kōetsu's hand appears to have trembled, a symptom perhaps of the rheumatism of which he complained in a letter of about 1612.[5] Certainly his calligraphic style altered slightly after the age of fifty. Thus, the scroll may be dated to after 1615, when he was fifty-four. It marks the final collaboration of two great masters.

The presence of the lotus plant, so important in Buddhist iconography, may indicate that Kōetsu intended the scroll as a tribute to his mother, who died in 1618, a suggestion that has a particular poignancy, as it may explain the resurgence of blossoms at the end of the scroll, after the plant's decline.[6] Because the leaves and flowers toward the end are delineated in less fluid lines, they are sometimes believed to be additions made by Kōetsu rather than by Sōtatsu.[7]

1. Yasuda 1948; and Mostow 1996.
2. For the extant sections, see *Kōetsu sho Sōtatsu kingindei-e* 1978, fig. 148.
3. Yasuda 1948, p. 40.
4. Ibid.
5. Hayashiya Tatsusaburō et al. 1964, letter 59.
6. Ibid., p. 80.
7. Ibid., p. 66.

85. Twelve Poems from the "Shin kokinshū"

Edo period (1615–1868)
Handscroll, ink and gold on silk
33.7 × 489.8 cm (1 ft. 1¼ in. × 16 ft. ⅛ in.)
Signature: *Gen'na ninen Kōetsu*
Seals: *Kōetsu* and *Kamishi Sōji* [on the back]
Ex coll.: Marquis Asano, Tokyo

LITERATURE: Murase 1975, no. 50; *Kōetsu sho Sōtatsu kingindei-e* 1978, pp. 82–83, fig. 50; Tokyo National Museum 1985a, no. 77; Schirn Kunsthalle Frankfurt 1990, no. 53.

This elegant silk handscroll includes twelve poems from the *Shin kokinshū* (New Collection of Poems Ancient and Modern), an anthology commissioned by the retired emperor Go-Toba (r. 1183–98). The compilation was completed about 1206 by a committee headed by Fujiwara Teika (1162–1241), the foremost poet of his time (cat. no. 39). It fills twenty volumes and includes 2,008 poems.

The poems in the *Shin kokinshū* were often a source for the calligrapher Hon'ami Kōetsu (1558–1637). The twelve included on this scroll—numbers 515 through 526—are from the chapter on autumn, Kōetsu's favorite season:

515
*No one comes
along this path,
now that it is buried
under the fallen leaves.*

516
*Iridescent tears
wet my sleeve.
Cold and lonely
are the autumn fields.*

517
*Desolate fields
beneath a chill moon.
Crickets chirp
in the frost of late autumn.*

518
*Crickets chirp
in the night of winter.
I lie alone
on my cold mat.*

519
*Cold wakens me
this September dawn.
Chill winds
have beckoned forth the frost.*

520
*The color of autumn deepens
on the Isle of Awaji.
The salty breeze over the ocean fans away
the fading glow of the morning moon.*

521
*The crescent moon
of dying September
illuminates the fields.*

522
*The magpie's bridge of heaven
is a fluffy cloud.
As the color of autumn deepens,
the frost sparkles in the frigid night sky.*

523
*When did the mountain cherries
change their colors?
Only yesterday I wept
to see the flowers fall.*

524
*Crimson leaves
barely visible
punctuate the
rising mist.*

525
*Showers on the mountains
of these autumn days.
How are the trees at Mount Mimuro,
where the ancient gods have so long resided.*

526
*Fallen leaves crowd the waters
of Suzuka River.
I count the days and listen to the sleet
as it falls on the fields of Yamada.*

Kōetsu's calligraphy shows sensitivity and restraint; individual characters are less robust and less tightly organized than in the two *shikishi* in the Burke Collection (cat. no. 84). The scroll is dated by inscription to the second year of the Gen'na era, which corresponds

<div style="text-align: center">520 519 518</div>

<div style="text-align: center">526 525 5</div>

to 1616. There is, however, some doubt about the authenticity of the inscription: its calligraphic style and ink tone do not match the text, which resembles that of Kōetsu's inscribed *tanzaku* (narrow strips of decorated paper used for writing poems) in the Yamatane Museum of Art, Tokyo, dated to shortly before the Kan'ei era (1624–44).[1] Thus, the Burke and the Yamatane examples may both be dated to about 1620, when silk began to supercede paper for handscrolls.

This scroll is decorated with plant motifs imprinted by stamping. As the scroll is un-rolled from right to left, the flowering plants are gradually replaced by other species. Tips of cypress appear at the top, ivy vines hang from above, and delicate ferns fill the field below. At the end is a rising hill lined with small pine trees. The signature and date and the large "Kōetsu" seal follow at the very end. Across the entire scroll, at top and bottom, tiny flecks of gold are scattered in drifts, as in *maki-e* lacquer (cat. nos. 45, 46), a technique not seen in the earlier *shikishi* associated with Kōetsu and his frequent collaborator Sōtatsu. Two hues of gold dust can be discerned, the more luminous perhaps a later addition. The use of stamps or carved blocks, probably made of wood, was a departure from the tra-ditional method of blockprinting. Some stamps were employed repeatedly through-out the scroll, in different combinations and in different positions, thus allowing for a variety of designs with a limited number of blocks. The paper backing is printed with a design in gold of butterflies and pine needles.

The scroll begins and ends with two rect-angular seals, both reading "Kamishi Sōji," stamped on the backing sheet. "Kamishi" (paper master) traditionally meant a supplier of paper and a mounter of scrolls; in addi-tion, it probably denoted a printer who used

517 516 515

523 522 521

mica for decorative designs such as those favored during the Heian and Kamakura periods (cat. nos. 19, 20). We know that this particular supplier, whose name was Sōji, lived across the street from Kōetsu in Taka-gamine.[2] He is also mentioned in three of Kōetsu's letters, in connection with paper supplies.[3] Nearly one third of all the hand-scrolls with Kōetsu's calligraphy and with decorations attributed to Sōtatsu have Sōji seals,[4] as well as printed designs of flowers, butterflies, pine needles, and other motifs, on their backing sheets. Some of these designs are found even on the front of the scroll proper. It is conceivable that Sōji may have contributed more to the creation of these beautiful and innovative paper decorations than was previously thought. His seal disappears from Kōetsu's handscrolls after 1626. While it is not yet possible to differentiate designs made by Sōtatsu from those perhaps made by Sōji, the prospect of doing so is intriguing. No doubt there were close ties between the two artists, who shared significant professional and aesthetic interests, as well as part of their names, "Sō."

On the back of the scroll is an inscription which implies that it was once owned by Akiba Kōan, a noted seventeenth-century calligrapher who worked in the Kōetsu style.[5] The scroll was sold at auction in 1934, along with other objects belonging to the Asano family, descendants of the governor of Aki Province.

1. Minamoto Toyomune 1967, p. 5.
2. Nakabe Yoshitaka 1989, pp. 30–42; and Tsuzuki Etsuko 1991, pp. 9–28.
3. Hayashiya Tatsusaburō et al. 1964, p. 141.
4. Tsuzuki Etsuko 1991, p. 11.
5. I am grateful to Gen Sakamoto, Ph.D. candidate, Columbia University, New York, for his assistance in deciphering this inscription.

86. Ise monogatari: "Utsu no yama"

Edo period (1615–1868)
Album leaf, mounted as a hanging scroll, ink,
color, and gold on paper
24.4 × 20.8 cm (9⅝ × 8¼ in.)
Ex coll.: Masuda Takashi

LITERATURE: Tanaka Shinbi 1932, pl. 10; Tanaka
Kisaku 1941, pl. 23; Tokyo National Museum 1952,
no. 59; Yamane Yūzō 1962b, pl. 174; Tokyo National
Museum 1972, pl. 99; Yamane Yūzō 1974, fig. 14;
Murase 1975, no. 52; Shirahata Yoshi 1975, vol. 1,
pl. 28; Yamane Yūzō 1975, p. 19; Murase 1977, p. 91;
Yamane Yūzō 1977–80, vol. 1 (1977), pl. 56;
Yamane Yūzō 1979, no. 1; Kita Haruchiyo 1985,
p. 81; Murase 1985, pl. v; Tokyo National Museum
1985a, no. 42; Kobayashi Tadashi, Murashige
Yasushi, and Haino Akio 1990, p. 152, fig. 14; Schirn
Kunsthalle Frankfurt 1990, no. 55; Murashige Yasushi
1991, pl. 1-4; Murashige Yasushi 1993, pl. 63.

Despite the renown of the Rinpa artist Sōtatsu (died ca. 1640), to whom a large number of stunningly beautiful paintings are attributed, he remains an elusive figure. Nothing is known of his background—except that his family name may have been Nonomura—or his early training. One letter written by him and occasional references to him or to his paintings by court nobles, essayists, artists, a tea master, and a novelist are the only documents that tell us anything about his life.[1]

According to a genealogical chart in the possession of the Kataoka family, Sōtatsu married a cousin of Hon'ami Kōetsu (cat. nos. 83–85).[2] He became the proprietor of a shop in Kyoto called Tawaraya, probably one of the many specialty shops mentioned in Momoyama literature that made and sold a variety of painted objects—fans, lantern paper, seashells for games, *shikishi*, and *tanzaku*. They also made screens and dolls, designed patterns for kimonos, and took commissions for decorating residential interiors.

The earliest paintings attributed to Sōtatsu are the frontispieces and covers he made in 1602 as replacements for three scrolls of the *Heike nōkyō*, a set of twelfth-century sutras at the Itsukushima Shrine on Miyajima in the Inland Sea.[3] These six modest works reveal features characteristic of Sōtatsu's later paintings. They are without human figures and are limited to five landscapes and a design with a single deer. The landscape motifs are dramatically stylized abstract patterns, which later became a hallmark of the Rinpa school. And there is an emphasis on surface decoration, created by limiting the palette to gold and silver.

The famous collaboration between Sōtatsu and the calligrapher Kōetsu seems to have begun a few years later. About 1606, Suminokura Soan (1571–1632) launched the *Sagabon* (Saga Books), an ambitious project to publish handsome editions of classical literature. Sōtatsu decorated the paper to be used for the book covers and the texts with stamped designs, and Kōetsu and other calligraphers transcribed the text to be carved on wood stamps and then printed. After the *Sagabon* project, the two men collaborated on many other works (cat. nos. 83, 84). Sōtatsu had an important but secondary role in these projects, for paper designs were then viewed primarily as backgrounds for the calligraphy. With the exception of the well-known *Deer Scroll*, the motifs are limited to flowers and birds, usually seen at close range. Gold and silver predominate, with occasional touches of color, and some of the designs are stamped. None of the papers includes Sōtatsu's signature, but a few show a seal reading "Inen," a name that has come to be associated with the artist and his shop, Tawaraya.

During the early years of the seventeenth century, the shop established a reputation for artistic excellence among cultivated and wealthy connoisseurs in Kyoto, and soon Sōtatsu was moving in such elevated circles that he was able to invite a leading tea master, Sen Shōan (1546–1614), to his own *chanoyu*.[4] Kōetsu moved to Takagamine, on the outskirts of Kyoto, in 1615, but the collaboration between the two artists seems to have continued until about 1620, when Sōtatsu was recognized in his own right as a major painter. Sōtatsu was given the honorary title *hokkyō*, awarded to the master of a school or shop, probably after he had decorated the doors and screens for Yōgen'in, a temple in Kyoto rebuilt in 1621 by order of the wife of Tokugawa Hidetada (r. 1605–23), the second Tokugawa shogun.[5] On the large door panels at the temple, he painted pine trees and exotic animals—elephants, lions, and mythical beasts. Human figures do not appear in his oeuvre until much later.

The earliest known reference to a narrative painting associated with Sōtatsu occurs in the *Chikusai* (1621–23), a humorous tale about a country doctor who visits Kyoto and Edo as a tourist.[6] Isoda Michiharu, to whom the novel is attributed, mentions a Tawaraya fan painted in brilliant colors with episodes from the *Genji monogatari*. Sōtatsu relied exclusively on narrative themes drawn from classical literature as sources for his figure

paintings, and the most innovative aspect of his work is the reuse, in a totally new context, of pictorial elements borrowed from ancient handscrolls.[7] Sōtatsu's interest in classical themes and in the native *yamato-e* style may have been stimulated by his association with Karasumaru Mitsuhiro (1579–1638), an eccentric and highly cultivated court noble well known for his interest in classical literature, who is said to have studied calligraphy with Kōetsu. That Sōtatsu and Mitsuhiro worked together is documented in a colophon of 1630 attached to a set of scrolls with a painting of the priest Saigyō (1118–1190; see cat. no. 79). The set is now dispersed among the Idemitsu Museum of Arts, Tokyo, and other collections. In the colophon Mitsuhiro attests that he wrote the text for the handscrolls, that Sōtatsu painted the pictures, and that their model was a set of Saigyō scrolls in the Imperial Collection.[8]

Sōtatsu's reputation reached its height about 1630, after he had painted screens for Emperor Go-Mizunoo (r. 1611–29). The artist's death is not recorded, but he probably died about 1640; the title *hōkkyō* was traditionally passed on to a successor when the master died, and sometime between 1639 and 1642 it was inherited by an artist named Sōsetsu (fl. 1639–50).

This small polychrome album leaf illustrates an episode from the tenth-century *Ise monogatari* (Tales of Ise), which ranks with the *Genji monogatari* as one of Japan's great literary classics.[9] The tale is composed of poems interspersed with narrative vignettes in prose that describe the travels in Japan of a gentleman identified only as "a man." Most of the verses are love poems exchanged between the anonymous hero and various ladies whom he encounters. The scene represented here illustrates an episode in chapter 9 that recounts a journey to eastern Japan. The passage, known as "Utsu no yama" (Mount Utsu), includes the poem that is inscribed on the painting:

Utsu no yamabe no
utsutsu nimo yume nimo
hito ni awanu narikeri

Beside Mount Utsu
in Suruga,
I can see you
neither waking
nor, alas, even in my dreams.[10]

The painting still preserves almost all the original pigments—red, brown, gold, and brilliant greens and blues. Rocks and hills, painted without ink outlines, are soft, round forms characteristic of Sōtatsu. A zigzag path, the defining element in the composition, is emphasized by the placement of a figure at each of three sharp bends. A triangular area of plain gold overwritten with fluid calligraphic lines at the upper right serves to counterbalance the massive horse and the attendant at the lower left. Carrying a wood box on his back, the wandering ascetic is seen walking away from the courtier after their encounter.

Forty-seven *shikishi* illustrating episodes from the *Ise monogatari* and attributed to Sōtatsu and members of his studio are known today.[11] All but five include a short poem. Most likely, they were originally pasted in an album. They may, however, have belonged to two different sets of illustrations, as two of them have identical compositions, though only one is accompanied by text. When some of the *shikishi* were remounted and the paper backing was removed, seventeen names of calligraphers were discovered, including that of Takeuchi Toshiharu (1611–1647), the name on the leaf in the Burke Collection.[12] The biographical records of the calligraphers indicate that the *shikishi* were worked on in 1634 and again sometime between 1648 and 1651.

The *Ise monogatari* was a popular subject for the artists of the later Rinpa school (see pages 308–9). Illustrations were already common in the eleventh century, and they are mentioned in the "E-awase" (Picture Competition) chapter of the *Genji monogatari*, though none from the Heian period has survived. The earliest extant examples are a few fragments from the Kamakura period. The printed editions of the *Ise monogatari* published in the seventeenth century as part of the *Sagabon* project (see cat. no. 83)

include the earliest complete sets; we know, however, that a late Kamakura handscroll was still complete in 1838, when seven Kano artists collaborated in copying it. The copy, now in the Tokyo National Museum, preserves the complete text and all the pictures of the lost original, as well as the colophon added to the scroll in 1636 by Karasumaru Mitsuhiro, the court noble who frequently collaborated with Sōtatsu.[13] Mitsuhiro states in the colophon that he examined the original in 1636, and he dates the scroll to the late Kamakura period. In view of the fact that the illustrations in the *Sagabon* edition are distinctly different from those in the nineteenth-century copy of the Kamakura scroll, it is clear that there were at least two traditions for the *Ise* pictures.

It is possible that when Mitsuhiro examined the Kamakura scroll, Sōtatsu copied the pictures and later adapted them for his own *Ise* compositions. Some leaves from the group of forty-seven clearly derive from the Kamakura compositions; others are related to the *Sagabon* illustrations. The episode illustrated in the Burke *shikishi* is modeled after the *Sagabon* version, with slight changes in the poses of the three figures inspired by earlier *emaki*.[14] Sōtatsu's composition became very popular with many later Rinpa artists—among them Ogata Kōrin (cat. nos. 132, 133), Fukae Roshū (1699–1757), and Sakai Hōitsu (cat. no. 134).

The "Utsu no yama" *shikishi* in the Burke Collection is regarded as one of the finest of the forty-seven *Ise* leaves. It is therefore most likely by the master himself.

1. See Yamane Yūzō 1962b, pp. 238–50; Murase 1973, pp. 52–54; and Link and Shinbo Tōru 1980, pp. 22–30.
2. Yamane Yūzō 1962b, p. 248; and Paine and Soper 1975, p. 215.
3. Kyoto National Museum 1974a, pls. 19, 20, 63, 64, and 89.
4. Yamane Yūzō 1962b, p. 241.
5. Kobayashi Tadashi 1991, nos. 83, 200.
6. "Chikusai monogatari" 1960.
7. See Murase 1973.
8. Yamane Yūzō 1962b, fig. 32.
9. *Tales of Ise* 1968.
10. Ibid., p. 75.
11. Five of these are in American collections: in addition to the present *shikishi*, the Nelson-Atkins

Museum of Art, Kansas City; the Cleveland Museum of Art; the Minneapolis Institute of Arts; and a private collection in New York have one each. Twelve *shikishi* that differ distinctly in style are also known. See Murashige Yasushi 1991, pl. 2; and Nakamachi Keiko 1992b, pp. 11–28.

12. Itō Toshiko 1984, pp. 128–30. Unfortunately, the inscription is no longer visible, as the backing sheet was replaced when the Burke piece was again remounted.

13. Ibid., pp. 30–45. Mitsuhiro's colophon is on pp. 44–45.

14. Yamane Yūzō 1975, p. 19.

STUDIO OF TAWARAYA SŌTATSU

87. From the "Genji monogatari"

Edo period (1615–1868)
Eight-panel folding screen, ink and color on gilded paper
81 × 327 cm (2 ft. 7⅞ in. × 10 ft. 8¾ in.)
Signature: *Sōtatsu hokkyō*
Seal: *Taisei-ken*
Ex coll.: Yoshioka Tajūrō, Kanazawa Prefecture

LITERATURE: Tanaka Kisaku 1933, pp. 366–67, 369–70; Yamane Yūzō 1962b, pls. 42, 43; Murase 1971, no. 1; Murase 1975, no. 51; Yamane Yūzō 1975, fig. 71; Akiyama Terukazu 1976, figs. 14, 141; Yamane Yūzō 1977–80, vol. 1 (1977), pls. 17–19; Akiyama Ken et al. 1978, no. 129; Yamane Yūzō 1979, no. 51; Yamane Yūzō et al. 1979, pl. 12; Murase 1985, figs. 4, 5, and 7; Akiyama Ken and Taguchi Eiichi 1988, pp. 160–68.

Murasaki Shikibu's *Genji monogatari* had been a rich source of themes for artists since the eleventh century (the novel is discussed on pages 204–5).[1] The work illustrated here, a rather small eight-fold screen showing episodes from the novel, relies on a number of pictorial conventions developed during the twelfth century. Fingerlike cloud patterns in gold, a common device, are used to divide the remaining picture surface into a series of compartments. To afford a direct view of building interiors, roofs are eliminated in a *yamato-e* convention known as *fukinuki yatai*. The faces of the youthful noblemen and long-haired court ladies who inhabit the houses are represented simply: as in Late Heian and Kamakura-period paintings of courtly romances, eyes are drawn as a single line, and noses with a hooked stroke, a technique called *hikime kagihana* (dash for eyes, hook for nose). Along the bottom, a wide band of gold occupies nearly one-third of the screen's height. Pines with twisted trunks and branches grow out of its golden expanse.

Nine episodes from seven chapters are illustrated, one to a panel with the exception of the eighth (at the far left), in which two are shown. The scenes—from chapters 19 through 26—are shown consecutively, suggesting that many additional screens accompanied this one, probably illustrating the other forty-seven chapters. Two or three other screens that may have been part of the set are documented, but most of them are now cut up and mounted as hanging scrolls.[2]

The scene on the first panel illustrates an episode from chapter 19, "Usugumo" (A Rack of Cloud). The consort of the former emperor Fujitsubo died at the age of thirty-seven. Genji, who had secretly loved her, is overcome with grief and retires to his chapel. At sundown he sees the flaming sun about to sink beneath the horizon. The scene on the second panel represents an episode from chapter 20, "Asagao" (The Morning Glory). A full moon shines on a cold winter night. Looking out into the garden, Genji and his favorite consort, Murasaki, watch children make a great snowball near a frozen pond. The third panel illustrates an episode from chapter 21, "Otome" (The Maiden). Yūgiri, Genji's young son, tries to talk to his childhood love, Kumoi no kari, who is being sent away to live at her father's palace. Yūgiri lingers on the threshold. In the fourth panel, an episode from chapter 22, "Tamakazura" (The Jeweled Chaplet), Tō no Chūjō's daughter, Tamakazura, who had been raised in secrecy on Kyūshū, makes the long journey back to the capital in search of her father. The fifth panel illustrates a scene from chapter 23, "Hatsune" (The First Warbler). Murasaki, celebrating the third day of the New Year in her quarters, is surprised by Genji's unexpected arrival. The sixth panel describes a festival from chapter 24, "Kochō" (Butterflies; see cat. no. 81). A colorful pageant is staged on Genji's estate. Small girls in bird or butterfly costumes arrive from Murasaki's garden in a Chinese boat. They bring cherry blossoms and *yamabuki* flowers as offerings to the Buddha. In the seventh panel, from chapter 25, "Hotaru" (Fireflies), Genji tries to persuade his ward, Tamakazura, to talk to his brother, Prince Sochi, who wishes to court her. The prince is shown standing in the corridor. The two scenes in the eighth panel illustrate Genji's frustrated attempts to seduce Tamakazura, described in chapter 26, "Tokonat su" (Wild Carnations).

Most of the scenes vary little from standard compositional types used by different schools. The notable exception is the scene at the top of the fourth panel from the right,

showing the episode from chapter 22 in which Tamakazura returns to the capital. Usually, the young woman and her party are shown traveling by boat from Kyūshū across the Inland Sea and the scene is placed at the bottom of the panel. Here, Tamakazura and her attendants are on foot in a scene set at the top of the screen, probably to preserve the continuity of the background setting.

Fewer figures than usual are shown in this screen, and the architectural settings are less obtrusive than in most *Genji* illustrations. Each scene is compact and self-contained, and the total effect is that of *shikishi* scattered across a screen of painted pines. Indeed, some screens attributed to the Sōtatsu studio are actually decorated with *shikishi* that illustrate *Genji* scenes.

At the lower right corner of the screen is the signature, "Sōtatsu Hokkyō," and a large round seal that reads "Taisei-ken." The same seal appears on a number of scrolls and screens, together with one of Sōtatsu's two signatures, "*Hokkyō* Sōtatsu" or "Sōtatsu *hokkyō*."[3]

Particularly characteristic of the Sōtatsu style are the bending pine trees and the use of *tarashikomi*, the application of dark ink or colors over wash to create a blurred effect. The colorful brilliance and charm of the paintings give credence to a remark in the *Chikusai* that Tawaraya fans with scenes from the *Genji monogatari* were the best souvenirs from the capital. However, as the figures are more delicate than those found in other paintings generally accepted as by Sōtatsu, the screen is perhaps more correctly attributed to the Sōtatsu studio.

1. Murasaki Shikibu 1976.
2. Yamane Yūzō 1962b, p. 210.
3. "Sōtatsu *hokkyō*" is less formal and carries the meaning "studio of Sōtatsu granted the title *hokkyō*." However, although most artists with this title placed it before their personal names in a signature, Karasumaru Mitsuhiro refers to "Sōtatsu *hokkyō*" in the colophon he wrote for the Saigyō scrolls of 1630, so it was perhaps simply an alternate signature. See Yamane Yūzō 1962b, pp. 228–37.

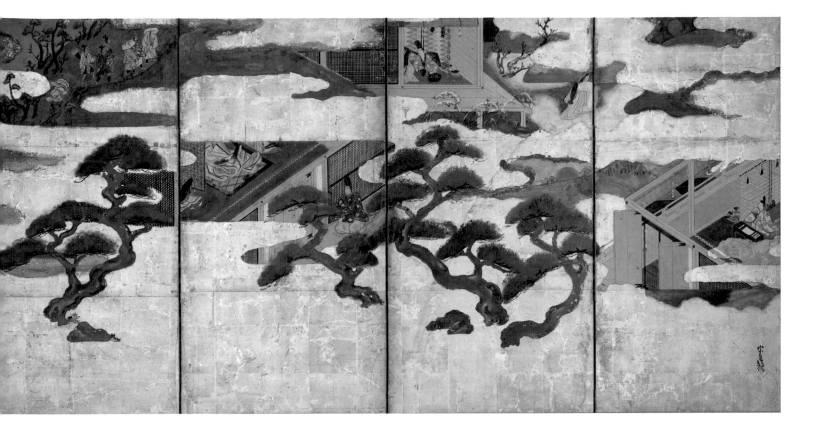

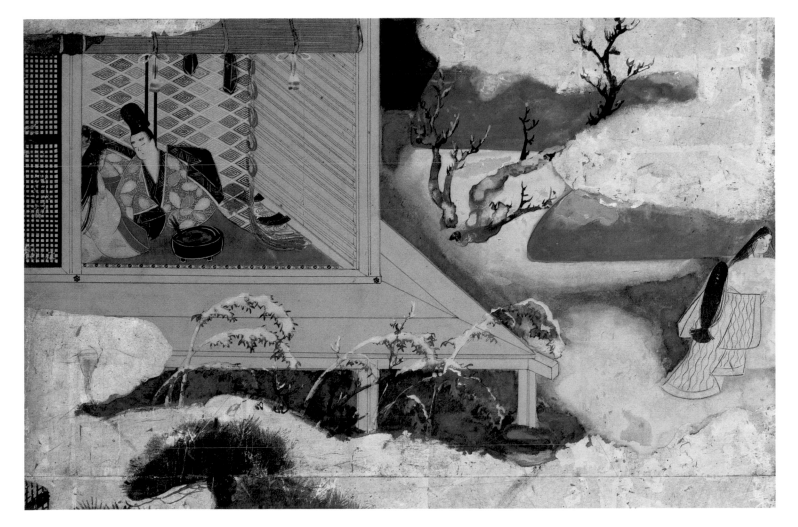

Kōdaiji maki-e

CATALOGUE NOS. 88-94

The term *maki-e* means "sprinkled picture."[1] The technique was probably brought from China to Japan by Buddhist monks in the ninth century, and Japanese craftsmen subsequently raised it to a new level of artistry. In an exacting and laborious procedure, several coats of black lacquer would be brushed over areas that had been dusted with silver or gold and then partially scraped away to reveal a picture in *maki-e*. A final coat of clear, shiny lacquer would then be applied over the entire surface as a sealant. A method of scattering gold flakes across the surface of a lacquered object was also developed, giving the background a granular texture and sparkling effect. Two boxes in the Burke Collection are decorated in this technique, called *nashiji* (pear skin; cat. nos. 45, 46).

In the fifteenth century a family of *maki-e* specialists, the Kōami of Kyoto, became preeminent in the field of lacquer manufacture. Like the Kano family of painters, they enjoyed the patronage of the Ashikaga shoguns and the imperial court, and though they made both simple and elaborate lacquerware, their specialty was a sumptuous type of *maki-e* with inlays of metal foil and mother-of-pearl.

The use of *maki-e* to decorate building interiors dates back to the Heian period, after which the custom apparently languished until it was revived in the sixteenth century. Large structures of the Momoyama period, such as General Oda Nobunaga's Azuchi Castle on Lake Biwa, were decorated extensively with lacquer, much of which probably involved the application of *maki-e*.[2] The name "Kōami" and a date corresponding to the year 1596 appear on a lacquered door of a shrine at Kōdaiji, Kyoto, created by order of the widow of Toyotomi Hideyoshi (1536–1598) as a mausoleum for her husband and herself.[3] The interior of the shrine, known as the Mitamaya (Spirit House; fig. 41), was ornamented in gold *maki-e* on black-lacquered wood. The Mitamaya is believed to have been constructed in 1606 from materials removed from Hideyoshi's castle at Fushimi, built from 1594 to 1597 and demolished in 1622. Lacquer objects decorated in a similar manner can be found in several Kyoto temples traditionally associated with Hideyoshi. The term "Kōdaiji *maki-e*" is applied to all of it.

Apart from favoring larger decorative motifs, such as close-up views of autumn grasses, Kōdaiji *maki-e* differs from traditional gold-decorated lacquerware in that much simpler methods were used to produce it. The design was drawn on the lacquer base freehand, thus eliminating the laborious preliminary-drawing stage. In place of elaborate inlay and raised decoration, flat designs (*hiramaki-e*) were created in thick applications of metallic dust on a plain black background. The gold or silver dust was often left exposed, without a protective coating of shiny, clear lacquer; this technique, called *maki hanashi* (left as sprinkled), resulted in a soft, subtle surface. In traditional *maki-e*, delicate details like the veins of leaves are carefully delineated by fine lines of lacquer; in Kōdaiji pieces, they are simply incised by *harigaki* (needle drawing) on lacquered areas. In a variation on the *nashiji* technique called *e-nashiji* (pictorial *nashiji*), small motifs in the design are filled in with a light powdering of gold speckles, giving them a subtly different color and placing them in dramatic contrast with the plain, black-lacquered background.

The influx of European visitors to Japan in the sixteenth century increased the demand for lacquerware, large quantities of which were purchased by the foreigners to decorate their homes. In 1610, a "lacquer company" was established in Amsterdam for the purpose of acquiring more pieces.[4] Letters from visiting European merchants to their friends and colleagues frequently refer to the progress of orders placed with local craftsmen.[5] All this suggests that by the end of the sixteenth century large workshops in Kyoto, employing as many as fifty artisans, were laboring to meet a vastly enlarged demand for decorated lacquerware.[6] Such shops may have increased their output by using simpler, less time-consuming techniques, and this perhaps led, albeit unintentionally, to the creation of the

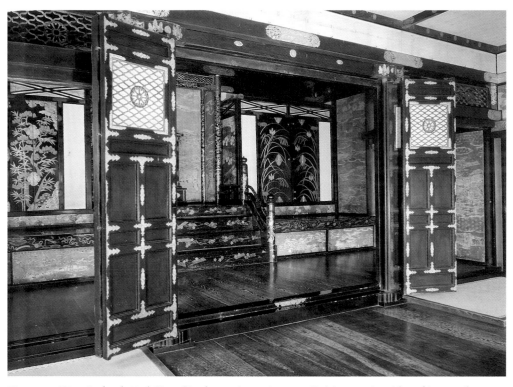

Figure 41. Kōami school, Kōdaiji *maki-e* decoration, Mitamaya (Spirit House), Hideyoshi Mausoleum, Kōdaiji, Kyoto. Momoyama period, 1606

direct, vivid, and sensuous style of Kōdaiji *maki-e*. The elimination of one important step in the preparation of traditional lacquerware, the use of preliminary drawings, further contributed to the freshness of Kōdaiji *maki-e* imagery. It has also been speculated that to complete large commissions from Hideyoshi, the Kōami may have hired craftsmen from outside the family whose different skills and outlook infused the traditional style with fresh vitality and encouraged the development of new methods.

Kōdaiji *maki-e* remained the most popular type of lacquerware decoration in the sixteenth and seventeenth centuries. It was applied not only to architectural interiors but to personal furnishings such as boxes for toiletries and writing implements, tableware, game sets, *chanoyu* utensils, and even arms and armor. The dominant decorative motifs of Kōdaiji *maki-e* are flowers and autumn grasses; in contrast to Muromachi-period lacquer decoration, literary themes and allusions are absent. Not surprisingly, the warrior patrons of the Momoyama era preferred dramatic images of the natural world to arcane visual references to the poetry and prose of classical times.

1. For a detailed discussion of *maki-e*, see Watt and Ford 1991, pp. 154–60. See also "Kōdaiji" 1995.
2. For a description of the interior of this destroyed castle, see *Shinchō-kō ki*, a biography of Oda Nobunaga by Ōta Gyūichi, in *Shiseki shūran* 1967–68, vol. 22, pp. 125–27.
3. Kyoto National Museum 1971; Namiki Seiji 1989, pp. 1–10; and "Kōdaiji" 1995.
4. Tsuji Nobuo, Kōno Motoaki, and Yabe Yoshiaki 1991, p. 188.
5. Arakawa Hirokazu 1971, pp. 124–28.
6. *Dai Nihon shiryō* 1928, pp. 48–49.

88. Sumiaka tebako with Chrysanthemums and Autumn Grasses

Momoyama period (1573–1615), 16th century
Black lacquer with gold *maki-e*; red lacquer over coarse cloth
19 × 33 × 29 cm (7½ × 13 × 11⅛ in.)

LITERATURE: Kyoto Furitsu Sōgō Shiryōkan 1967, pl. 34; Yoshimura Motoo 1976, pl. 2; Murase 1993, no. 65.

The gently curving top and slightly swelling sides of the overlapping lid on this box suggest a late-sixteenth-century date. This relatively early date is also indicated by the freedom of the drawings of chrysanthemums and autumn grasses gently swaying in the wind. The large, round floral forms are depicted either in flat gold *maki-e* (*hiramaki-e*), with details scratched out by needles (*harigaki*), or in gold outlines that contrast with the black-lacquered background. Tiny dots of gold depicting the autumn dew appear along the delicate stems of the eulalia.

The box, a *tebako*, was used to store personal accessories. It once contained a tray and smaller boxes for such objects as combs, mirrors, and the utensils used for *haguro* (teeth-blackening; see cat. nos. 45, 46). Many *tebako* have survived, including some dating to the twelfth century. Such boxes were usually displayed on shelves like the one in the Burke Collection (cat. no. 94). A box of this type, possibly a prototype for a *sumiaka* (red-cornered) *tebako*, but without *maki-e* designs, appears in a depiction of a monk's quarters in the *Boki ekotoba* (Illustrated Biography of the Monk Kakunyo) of 1351, where it is shown on a shelf next to a folding screen.[1]

Red-cornered *tebako*, commonly made in sets of different sizes to hold cosmetics and other personal effects, became part of the bridal trousseau, the contents of which were standardized toward the beginning of the Edo period. Sumptuous sets made for the daughters of the shoguns are still preserved.[2] A complete trousseau would have filled three sets of shelves. A 1793 manual on their contents lists, illustrates, and gives the dimensions of each of the three hundred items to be included in such a set.[3]

The present box is one of the earliest known *sumiaka tebako*. An ample lid overlaps the base. Red lacquer, applied to coarse cloth, is visible between the lid and the base and also through two small heart-shaped cutouts in each corner of the lid. On the long sides of the base are metal knobs in the shape of flowering paulownia, whose loop attachments once held a silk cord. The paulownia, a symbol of royal power, was long associated with the emperor, who had bestowed upon the shoguns the privilege of using the symbol in the early fourteenth century. Hideyoshi had a particular fondness for the motif, and it appears regularly on the Kōdaiji lacquerwares associated with his building projects.[4]

The origin of the *sumiaka* box is not known. Scholars at one time thought that the red cutout areas imitated metal fittings,[5] but it is more likely that the idea of contrasting elegantly lacquered with undecorated areas covered in a coarser material was inspired by containers with lacquered panels made in China or the Ryūkyū Islands, some of which have cutout areas similar to those found on *sumiaka* boxes.[6] Although the Chinese and Ryūkyū pieces are finely woven bamboo baskets and the *sumiaka tebako* cloth-covered wood, in each case it is the contrast between the two different materials and colors that gives the objects their strong stylistic character.

1. Scroll 11 of this *emaki*, in the collection of Nishi Honganji, Kyoto, is published in Komatsu Shigemi 1985a, p. 16.
2. Y. Shimizu 1988, nos. 227, 228.
3. Saitō Gyokuzan 1937, pp. 346–47. See also Yoshimura Motoo 1976, p. 147.
4. Watt and Ford 1991, p. 159.
5. Ragué 1976, pl. 142; Yoshimura Motoo 1976, p. 146; and Watt and Ford 1991, no. 103.
6. Watt 1985.

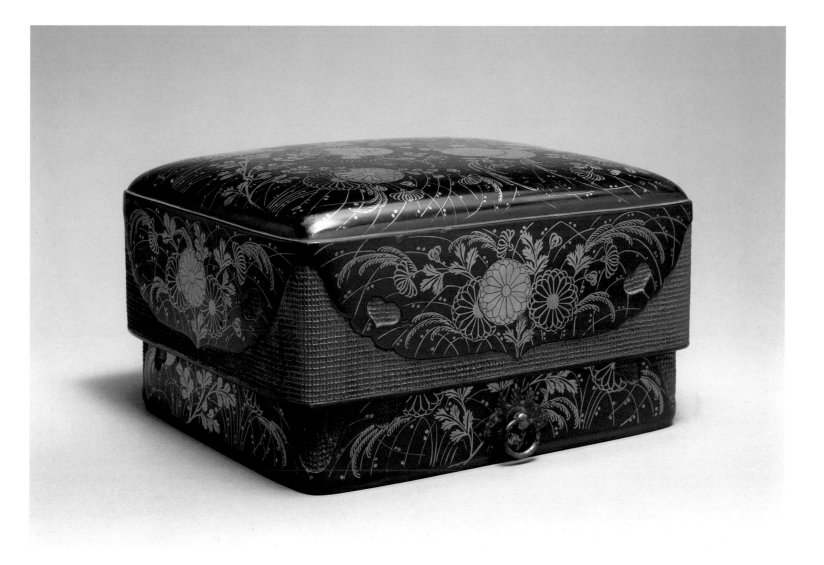

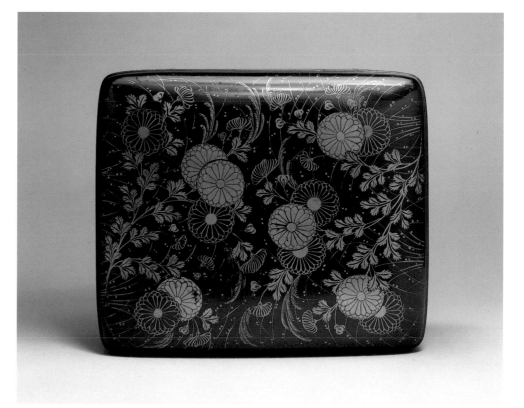

89. Ōtsuzumi with Grapevines and Squirrels

Momoyama period (1573–1615), late 16th century
Black lacquer with gold *maki-e*
Height 28 cm (11 in.); diameter 11.5 cm (4½ in.)

LITERATURE: Minamoto Toyomune et al. 1973,
no. 57; Murase 1975, no. 103; Pekarik 1985b, fig. 2;
Tokyo National Museum 1985a, no. 107; Schirn
Kunsthalle Frankfurt 1990, no. 110.

90. Ōtsuzumi with Tigers and Pines

Momoyama period (1573–1615), late 16th century
Black lacquer with gold *maki-e*
Height 27.8 cm (11 in.); diameter 11.2 cm (4⅜ in.)

LITERATURE: Murase 1993, no. 66.

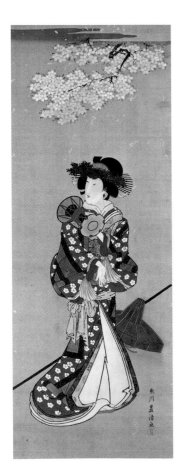

Figure 42. Utagawa Toyokiyo
(1799–1820), *Kabuki Dancer*.
Hanging scroll, color on silk,
95.2 × 35.8 cm (37½ × 14⅛ in.).
Tokyo National Museum

The earliest examples of hourglass-shaped hand drums with wood cores decorated in *maki-e* date from the fourteenth century. *Ōtsuzumi*, or large drums like the pieces shown here, and slightly smaller ones (*kotsuzumi*) about twenty-five centimeters (10 in.) in height, were originally played during ceremonies at temple dedications, but both types later became an important part of the secular performances of Nō and Kabuki (fig. 42). The body is generally made of cherry or Zelkova wood, with the cup-shaped drumhead at either end covered with a sheet of horsehide lashed to the richly ornamented core. With the instrument held against the left shoulder, the player would strike the drum end with the right hand. One distinguishing mark of the *ōtsuzumi* is the carved ring in the middle of the shaft; the shaft of the smaller *kotsuzumi* is smooth and straight.

In the lacquer decoration of the drum core, animals and plants are arranged so that the pictorial motifs can be understood regardless of the way in which the drum is held. One drum (cat. no. 89) is decorated with grapevines—a motif popular in the decorative arts of the late sixteenth and early seventeenth centuries—and squirrels, one at either end. Often seen on Kōdaiji *maki-e* lacquers, the grapevine motif was part of the standard repertory of decorative designs in Buddhist arts of the Nara period, with roots in Tang China.[1] After a decline during the late eighth century, the motif reappeared as the subject of ink painting more than six hundred years later (cat. no. 57), echoing its popularity in China and, especially in the Chosŏn dynasty (1392–1910), in Korea. The resurgence of the motif in Momoyama arts is therefore not

solely the result of European influence, as has often been maintained. Grapevines alone are represented on export ware made for use in the Christian church; the grapevine-and-squirrel motif is found only on traditional Japanese objects.

A golden squirrel boldly displaying its furry tail appears on either side. Several large vine leaves, filled with speckles in the *e-nashiji* technique, provide a contrast of colors. Although the drum was made for use in Nō performances, the design does not have a Nō theme, but is embellished in the Kōdaiji style, which was generally limited to plants and animals. Inside each drumhead (opposite) are two signatures—one reading "Itoku," the other "Yazaemon"—and a *kaō*, or hand-written seal, which may have belonged to the musician.

Two tigers are seen on the other *ōtsuzumi* (cat. no. 90). One stalks around the drumhead with its legs splayed wide, while on the opposite end the other tiger pauses to scratch itself. Three techniques were used to produce this example of fully evolved Kōdaiji *maki-e*: plain gold *maki-e*, *nashiji* (for the ring on the shaft), and *e-nashiji* (for the rounded hillocks, the cavities in the tree trunks—seen upside down in the illustration—and the wheel-like forms representing clusters of pine needles). The areas decorated with *e-nashiji*, which received only a sparse application of gold powder, have a soft, reddish glow. The bold designs of animals and plants, while they cover the surface of a small object, create the illusion of a monumental composition.

1. Minamoto Toyomune et al. 1973.

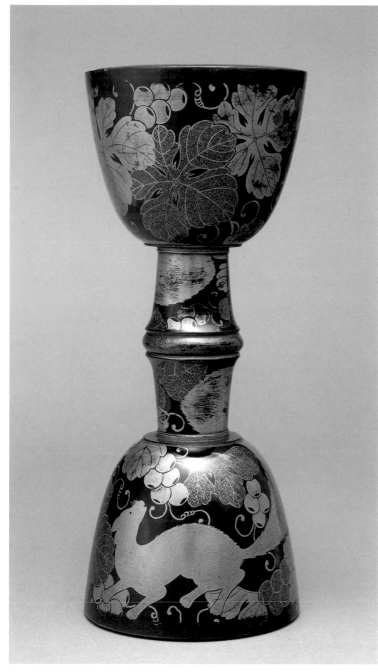

Cat. no. 89

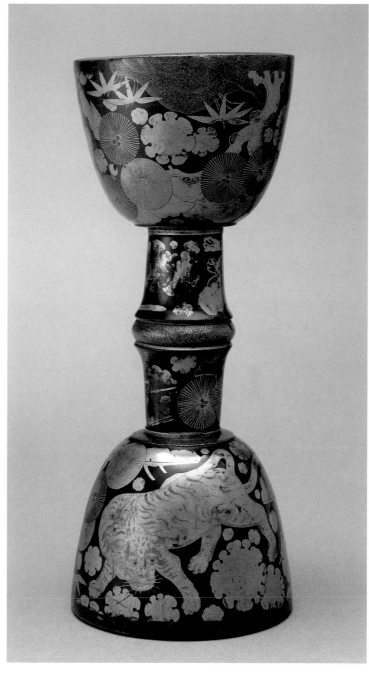

Cat. no. 90

Drumhead interiors, cat. no. 89

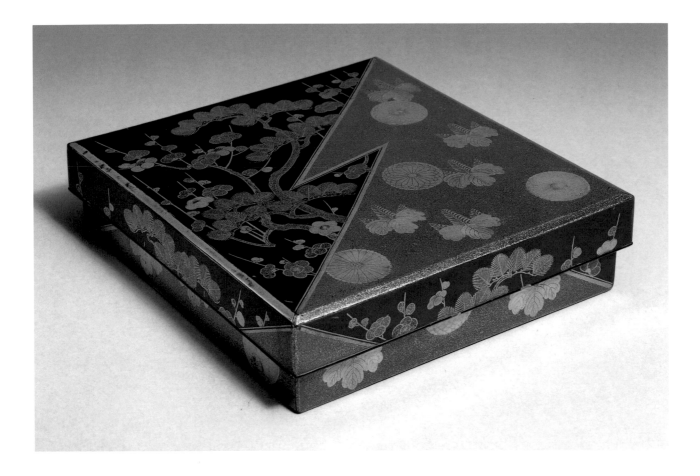

91. Suzuribako with Pines, Plum, Crysanthemums, and Paulownia

Momoyama period (1573–1615), 16th century
Black lacquer with gold *maki-e*
6 × 23.2 × 24.8 cm (2⅜ × 9⅛ × 9¼ in.)

LITERATURE: Pekarik 1985b, figs. 4, 5; Tokyo National Museum 1985a, no. 110; Schirn Kunsthalle Frankfurt 1990, no. 112.

This handsome *suzuribako*, or writing box, was made to hold an inkstone and other writing implements. The underside of the bevel-edged lid and the interior of the box are covered with plain black lacquer; the top is decorated with designs in *maki-e*.

One of the distinctive features of Kōdaiji lacquerwares is the division of a design area into contrasting fields by a zigzag, lightning-like line. The origin of this dramatic device, known as *katami-gawari* (alternating sides), is not known, but similar patterns are found on textiles as early as the late Kamakura period. On the lid of this *suzuribako*, a jagged bolt divides the black ground from one covered with red-gold flecks applied in the *nashiji* technique. Different motifs fill the two areas: pines and plum on the black lacquer, and chrysanthemums and paulownia on the gold ground. The floral motifs, which later become closely identified with two powerful families—the chrysanthemum with the imperial house and the paulownia with the Toyotomi clan—have not yet been standardized as crests. The paulownia motifs are nearly identical to those on a set of lacquer articles made for Hideyoshi's castle at Fushimi and later brought to the general's mausoleum at Kōdaiji.

92. *Table with Autumn Flowers*

Momoyama period (1573–1615), 16th century
Black lacquer with gold *maki-e*
45.8 × 25.6 × 24 cm (18 × 10⅛ × 9½ in.)

LITERATURE: Murase 1993, no. 67.

This elegant table with slender frame, originally placed in front of Buddhist icons to hold incense burners and other small objects, may have been converted later for use in *chanoyu*. The bottom shelf is covered in plain black lacquer, while the top and middle shelves are embellished with gold *maki-e* with similar designs of autumn grasses, chrysanthemums, Chinese bellflowers, and eulalia; also present on the top and middle shelves are, respectively, designs of bush clover and wild pinks. The delicate plants sway gently in an autumn breeze that scatters pearls of dew, and pine seedlings cover the edges of the shelves and posts.

The variety of *maki-e* techniques compensates for the limited design vocabulary. As in the large *sumiaka tebako* (cat. no. 88), the black ground is left undecorated, drawing the eye to the gold-filled leaves and flowers executed in the *e-nashiji* (pictorial *nashiji*) technique. The slender stems and leaf veins, threadlike eulalia leaves, and tiny beads of dew are rendered in fine gold powder sprinkled directly over the carefully applied wet lacquer, producing a sharp contrast of colors and textures within the small flowers and leaves. Negative outlines are created by the *kakiwari* (divided drawing) technique, in which areas of the black ground are kept in reserve during the sprinkling of gold flakes. In a timesaving and daring innovation in

the production of export (*nanban*) lacquer (cat. nos. 95, 96), extremely thin lines were made by scratching out gold-filled areas with a needle, a method known as *harigaki* (needle drawing), also used to delineate such fine details as the contours of petals and the veins of leaves.

On the back of the bottom shelf is a handwritten seal (below, left), probably that of a previous owner, who remains unidentified.

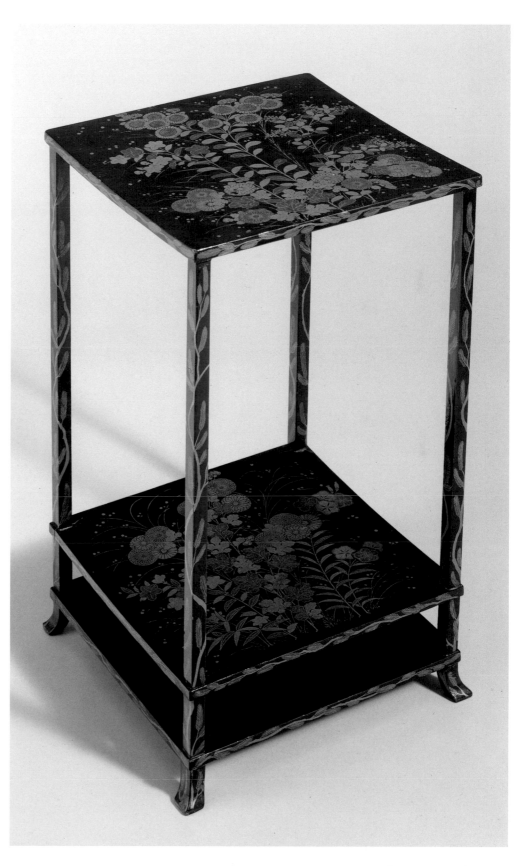

93. *Sutra Box with Lotus*

Momoyama period (1573–1615), early 17th century
Black lacquer with gold *maki-e*
15 × 36.5 × 20.5 cm (5⅞ × 14⅜ × 8⅛ in.)

LITERATURE: Tokyo National Museum 1985a, no. 108; Pal and Meech-Pekarik 1988, pl. 87; Schirn Kunsthalle Frankfurt 1990, no. 111.

This box made to hold sutras is decorated with a motif of lotus in a pond—an apt theme, as the lotus is the most sacred plant in Buddhist iconography. The depiction of leaves at various stages of the plant's growth and decay is reminiscent of early-seventeenth-century handscroll designs painted by Sōtatsu and bearing poems inscribed by Hon'ami Kōetsu (cat. no. 84).

Except for the bottom and the interior of the close-fitting lid, both of undecorated lacquer, the design covers the entire surface of the box. A shallow drawer with a metal handle is set into the box just above the base. Gilded metal fittings with incised designs of foliage protect the four corners and the center of each long side of the lid and base.

Dewdrops filled with various shades of sprinkled gold are scattered across the black-lacquered background and on the lotus plants. The blossoms, leaves, and stems are filled in with gold dust, and patches of granular gold create a dark and light ground and the impression of subtle shading. Stylistically, the sutra box belongs to the Kōdaiji *maki-e* type of lacquerware (cat. nos. 88–92), but technically the decoration is far more complex and accomplished than that found on other works of the Kōdaiji type. It may therefore be dated to the end of the Momoyama period, in the early seventeenth century.

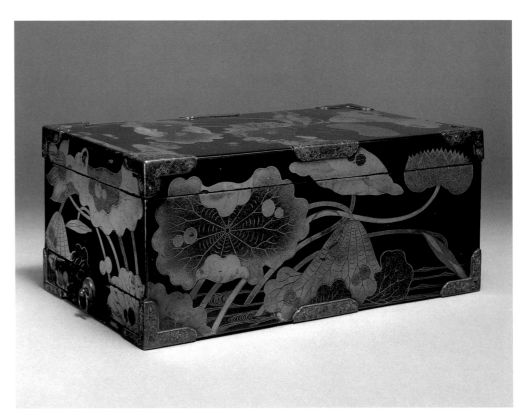

94. Kurodana with Grapevines and Crests

Edo period (1615–1868), early 17th century
Black lacquer with gold *maki-e*
68 × 76.2 × 36.9 cm (26¾ × 30 × 14½ in.)

LITERATURE: Murase 1975, no. 103; Tokyo
National Museum 1985a, no. 115.

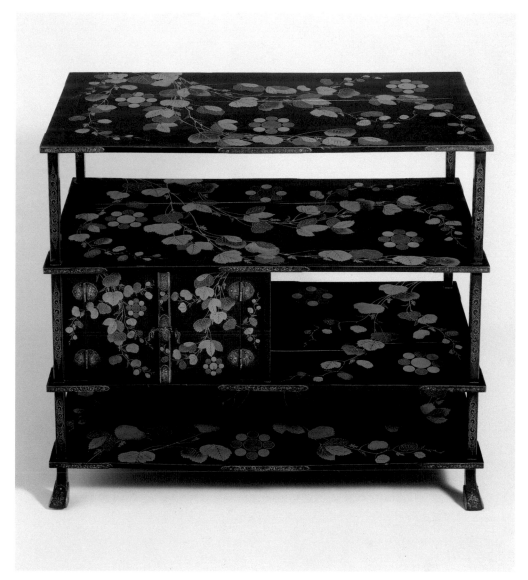

The four-shelved *kurodana* was an important item in the wedding trousseau of a bride in a daimyo family of the Edo period. Made as part of a set of cabinets called the *santana* (three shelves), which also included a *zushidana* (for toilet articles) and a *shodana* (for writing materials), the *kurodana* was used to store and display cosmetic boxes and toilet articles, especially those used to blacken the teeth (*haguro*; see cat. nos. 45, 46). The set was the centerpiece of the functional and decorative furnishings in the living quarters of upper-class women. The *kurodana* is distinguished from the two other types of trousseau cabinets by its open sides, single compartment with hinged double doors on the second shelf from the bottom, level top shelf, and slightly smaller size. A prototype is shown in the fourteenth-century *Zenkyōbō emaki* (Illustrated Teachings of the Monk Zenkyōbō) in the Suntory Museum of Art, Tokyo,[1] but the form was not standardized much before the sixteenth century.

On this *kurodana* grapevines sway gracefully from shelf to shelf. They are punctuated by a family crest, of the type known as *kuyō* (nine stars), which signified protection from evil spirits in Buddhist cosmology. Because it was used by many families as early as the twelfth century, the crest does not identify the patron who commissioned the piece. The decorative scheme, common at that time, is found on many of the prototypical lacquerware objects in the Kōdaiji style made for Toyotomi Hideyoshi (1536–1598) and installed in his mausoleum in Kyoto. The combination of motifs executed in granular and plain gold is also found in lacquer decoration of Kōdaiji. On the back of the compartment doors are a pair of leonine creatures. Common motifs on golden screens of the Momoyama and early Edo periods, these beasts are executed partially in the flat *hiramaki-e* technique and partially in low relief (*takamaki-e*). The combination of two techniques in the decoration of one object is found on some Kōdaiji lacquer associated with the Kōami artists, but practically never on the lacquer pieces made during the same period for the European market and known as *nanban* (cat. nos. 95, 96). The influence of the export style is evident in such features as the scroll patterns on the vertical posts supporting the shelves. These patterns, known as *nanban* palmettes to distinguish them from traditional Japanese palmette designs, appear frequently on objects made for Christian use and also occasionally on traditional Japanese furnishings.

1. Suntory Museum of Art 1968, no. 4.

Nanban Lacquerware

CATALOGUE NOS. 95, 96

Japan's first encounter with the West sparked a brilliant phase in lacquerware design and production. Christian missionaries to Japan, accompanied by merchants, began arriving in great numbers in the 1550s and 1560s, and by the 1580s there were as many as two hundred churches throughout the country, serving about one hundred thousand converts. The missionaries admired the rich yet restrained character of the lacquer objects they saw in Japanese homes and soon began placing orders with local craftsmen for church furnishings in the exotic medium. These included ciboria, shrines for religious paintings, lecterns for missals and Bibles, and many other items (fig. 43). Equally impressed by the beauty of Japanese lacquer objects were the foreign merchants, who recognized their potential as export items. Soon ships filled with the novel goods were sailing toward the marketplaces of Europe. Lacquer was the first Japanese decorative art introduced in the West, where it inspired many imitative crafts, all known as "japanning."

The brisk trade in lacquerware continued even after Tokugawa Iemitsu (r. 1623–51) banned Christianity and expelled the missionaries from Japan during the early decades of the seventeenth century. Japanese artisans responded to the extraordinary demand by making quantities of lacquered boxes, chests, tankards, screens, and many other pieces in short order. A letter written in 1617 from a Will Adams then stationed at Sakai, south of Osaka, informed a Richard Wickham in Hirado, on Kyūshū, that a lacquer workshop in Kyoto employed fifty artisans who were working day and night to meet the production schedule.[1] Lacquer objects topped the list of export items from Japan until the mid-seventeenth century, when they were supplanted in importance by Arita porcelains (cat. nos. 128, 129).

Japanese consumers, in turn, became enamored of the foreign novelties that the lacquer shops were producing for export. Such merchandise included folding chairs, gaming pieces, gunpowder flasks, and saddles. Some of the pieces were crafted in the traditional Japanese manner but decorated with Western motifs; others were new to the Japanese market. All these commodities, whether made for export or for domestic consumption, were called *nanban* (foreign or export) lacquer.[2]

As mentioned above (see pages 220–21), the Kyoto shops in which traditional lacquerware was made simplified their production methods late in the sixteenth century, probably in response to the surge in demand for their wares at home and abroad. The elimination of two steps in particular—one at the beginning and one at the end of the manufacturing process—contributed, perhaps unintentionally, to the freshness and sensuousness of the new lacquer styles that appeared at the time: Kōdaiji *maki-e* lacquer (cat. nos. 88–94) and *nanban* decorated lacquer (cat. nos. 95, 96). The first of these two steps was the preparation of preliminary drawings; the second, the application of a protective coat of clear lacquer over the *maki-e* pattern in gold or silver dust.

The makers of *nanban* lacquers may have belonged to the same workshops that produced Kōdaiji lacquers; if so, it is interesting that the two lines differed so sharply in their decoration. Only in *nanban* lacquerware were shells of various kinds used extensively for inlay—probably to satisfy the taste of the intended European owners; such materials were largely absent in Kōdaiji-style lacquer. Mother-of-pearl, for example—used frequently for inlay in Nara-period lacquers and for the decoration of building interiors during the Heian period—had declined in popularity at the end of the Kamakura era, only to be revived for the ornamentation of *nanban* lacquers.[3] Europeans may have come to appreciate the technique through exposure to Chinese inlayed lacquer. As for specific motifs, autumn grasses and family crests were reserved for Kōdaiji-style works, whereas windowlike cartouches, stripes, and abstract

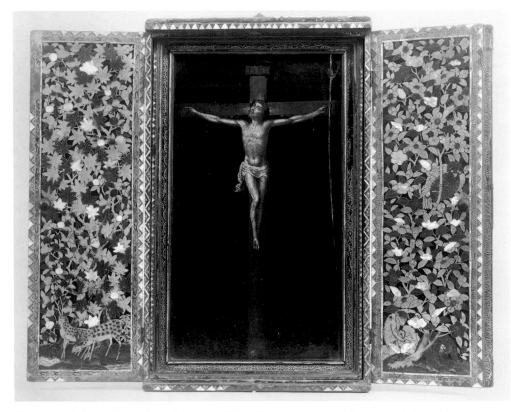

Figure 43. Shrine with painting of the Crucifixion. Momoyama period (1573–1615), late 16th century. Black lacquer with gold and silver *maki-e* and mother-of-pearl inlay, 49.5 × 30 × 4.8 cm (19½ × 11⅞ × 1⅞ in.), closed. Tokyo National Museum

decorative patterns densely covered the surfaces of *nanban* articles. The lacquer artists must have shifted gears, so to speak, as they moved between these two groups of luxury items, only occasionally producing an object in which restrained and simple Kōdaiji motifs mingled with bold, novel *nanban* elements.

1. *Dai Nihon shiryō* 1928, pp. 48–49.
2. *Nanban*, meaning "barbarians from the south," was a Chinese word for people from south of China. During the sixteenth century, the Japanese used the term to denote European visitors to their shores, most of whom were Portuguese or Spanish. On *nanban* lacquerware, see Watt and Ford 1991, pp. 163ff.; and Kyoto National Museum 1995.
3. A few pieces from the late sixteenth and early seventeenth centuries, notably those attributed to Hon'ami Kōetsu (see cat. no. 83), do feature inlay applied in the sixteenth-century manner of Chosŏn Korea. See Hayashiya Tatsusaburō et al. 1964, pls. 57, 58.

95. Cabinet with Deer, Birds, Fish, and Plants

Momoyama period (1573–1615)
Black lacquer with gold and silver *maki-e* and mother-of-pearl inlay
31.5 × 43.6 × 30.5 cm (12⅜ × 17⅛ × 12 in.)

LITERATURE: Tokyo National Museum 1985a, no. 111.

This cabinet or escritoire has a drop front, hinged at the bottom, that encloses eight drawers of different sizes. Like most Japanese *nanban* ware, lacquered articles made for export, it was first painted in black lacquer and then decorated in *maki-e* and inlays. Nearly all the design motifs commonly found on *nanban* lacquerwares, both abstract and from nature, are present here. The panels on the front and top are decorated with window-like cartouches bordered with inlaid mother-of-pearl; the front cartouche frames two deer and trees; the top cartouche encloses a hut among trees. The side panels have brass handles and are embellished with orange and

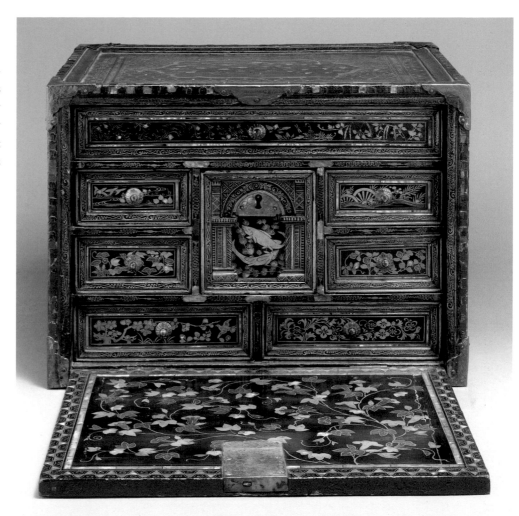

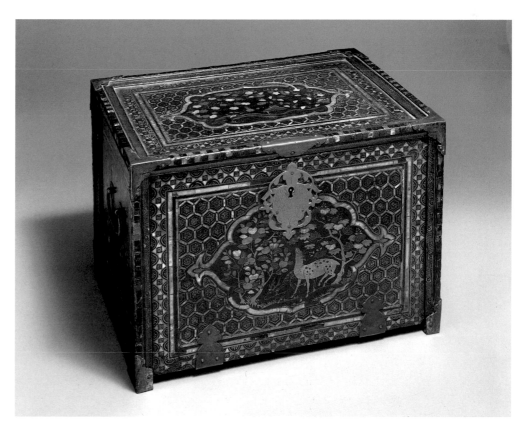

maple trees. The metal fitting with engraved floral designs on the front panel seems to be of Japanese manufacture. Both the back of the drop leaf and the rear panel are decorated with a design of morning glories.

Every inch of the cabinet's surface is covered with designs. The small drawers within are embellished with traditional Japanese motifs, such as wheels in a flowing stream and plants and fish. The background is covered with a hexagonal pattern, and the borders are marked with the undulating scroll pattern of the ubiquitous *nanban karakusa*.

Such cabinets are rare in Japan but quite common in European homes and museums.

96. Striped Jūbako

Momoyama period (1573–1615), early 17th century
Black lacquer with powdered gold and mother-of-pearl and lead inlays
22 × 23.8 × 21.3 cm (8⅝ × 9⅜ × 8⅜ in.)

LITERATURE: Tokyo National Museum 1985a, no. 112; Schirn Kunsthalle Frankfurt 1990, no. 116.

This beautiful piece of *nanban* lacquer was probably made for a Japanese patron, in whose household it would have been not only decorative but practical. The stacked trays were commonly used to store delicacies for New Year's Day celebrations or for outings such as cherry-blossom viewing. Although it served a familiar household purpose,

this *jūbako*, with three tiers of food trays, displays an almost startling aura of modernity, produced by the restrained handling of the *nanban* design vocabulary, the usual inlays (of mother-of-pearl and lead), and bands of *maki-e* motifs marshaled in a strict allover pattern of stripes. While the same techniques and some of the same patterns—the *nanban karakusa*, for example—are employed on the *nanban* lacquerware cabinet (cat. no. 95), the austerity of the ornamentation here produces a completely different effect.

Popular during the Heian period, stripes and checks returned to favor in Momoyama Japan, thanks to European traders, who brought cloth with similar designs from Southeast Asia. Applied here on a lacquered box, these motifs are both elegant and exotic.

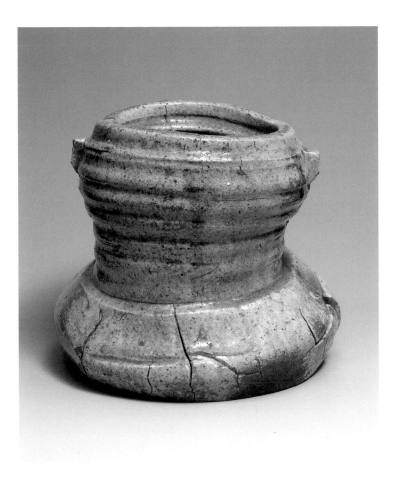
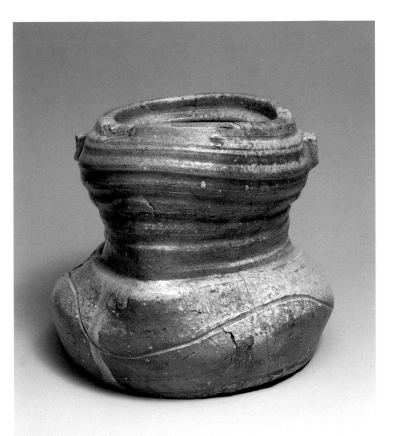

97. Mizusashi

Momoyama period (1573–1615), late 16th–early
17th century
Iga ware; stoneware with natural-ash glaze
Height 20.6 cm (8⅛ in.)
Ex coll.: Count Matsu'ura

LITERATURE: Rhodes 1970, fig. 10; Hayashiya
Seizō 1972b, pl. 352; Hayashiya Seizō 1972a,
pp. 93–94; Murase 1975, no. 97; Hayashiya Seizō
1981, no. 15; Tokyo National Museum 1985a, no. 94;
Schirn Kunsthalle Frankfurt 1990, no. 136.

The peculiar, distorted beauty of this *mizu-sashi*, or water jar, epitomizes the aesthetic spirit of Momoyama *chanoyu* (see page 126). In its vibrant presence and tactile surface the jar resembles modern abstract sculpture, but it was meant for use in the preparation of tea. Like many other products of the kilns of Iga Province (northern Mie Prefecture), most of which were flower vases or *mizusashi*, it is misshapen and cracked, and has an uneven transparent green glaze produced during the firing process as a result of the accidental scattering of natural ash. Many Iga pots also have deep incisions deliberately made by a sharp spatula or a knife. One is visible here between the jar's bulbous neck and squashed body. As the potter turned the soft clay on the wheel, he marked the piece with his fingers, leaving an intimate imprint of his activity.

The Iga pottery was situated near the Shigaraki kiln district in Ōmi Province (Shiga Prefecture). These two famous sites were centers for ceramics production from the very beginning of the industry in Japan. At the end of the fifth century they produced

Sueki (cat. no. 4), and in the medieval period (1185–1573) they turned out utilitarian vessels so similar in body and glaze that they are barely distinguishable. During the Momoyama period, however, the Iga kilns began to produce *chanoyu* vessels that were fired at a much higher temperature than Shigaraki wares. The deformity of Iga wares is partly the result of eruptions caused by the extremely high firing. The firing process usually lasted four hundred hours, or about seventeen days, but sometimes as long as seventy days. Extreme heat also caused red or black scorch marks, which dramatically contrast with the vitreous green glaze. The shape of the jar and the run of the glaze were usually accidental, but after tea cognoscenti began to praise the ware for its beauty, such "damage" was artificially induced.

The first recorded use of Iga ware in *chanoyu* was a tea gathering of 1581 described by Tsuda Sōkyū (d. 1591), a merchant based in Sakai and a prominent tea aficionado.[1] It is then mentioned regularly and frequently in the diaries of tea connoisseurs. The extraordinary quality of the ware is thought to be a

reflection of the aesthetic principles of the tea master Furuta Oribe (1544–1615), who was himself a potter. And indeed, descriptions of Oribe's tea gatherings frequently refer to his use of Iga flower vases and *mizusashi*.[2] Oribe's approach to the ceremony echoed the extroverted, dynamic spirit of the samurai class to which he belonged, in contrast to the refined, subdued approach of his teacher Sen Rikyū (1522–1591), the great tastemaker of the Momoyama period, who perfected the aesthetic of *chanoyu*.

Tsutsui Sadatsugu (1562–1615), the cultivated warrior-ruler of Iga Province from 1585 to 1608, was instructed in *chanoyu* by Oribe. Pottery making flourished under his regime, and large kilns were operated within his castle compound at Ueno. Although shards and even complete vessels similar to this *mizusashi* were excavated from the castle compound,[3] similar shards were also found at kiln sites outside the area; the Burke *mizusashi* thus cannot be dated to the reign of Sadatsugu. It is likely, however, that both this

highly original water jar and a celebrated and very similar *mizusashi* in the Gotoh Museum, Tokyo, were produced when Iga wares attained their greatest popularity, in the late sixteenth or early seventeenth century.[4]

1. In the entry for the twenty-seventh day of the tenth month of the ninth year of the Tenshō era (1581); see *Sadō koten zenshū* 1967, vol. 8.
2. Mitsuoka Tadanari 1966, pp. 12–15; and Katsura Matasaburō 1968, pp. 148–53.
3. Kikuyama Toneo 1936, pp. 10–15; and Hayashiya Seizō 1972b, pp. 101–2.
4. Hayashiya Seizō 1977, pl. 56.

98. Teabowl

Momoyama period (1573–1615), ca. 1580–90
Mino ware, Seto Guro type; stoneware with black glaze
Height 9 cm (3½ in.); diameter 12 cm (4¾ in.)

LITERATURE: Cort 1985, fig. 3; Tokyo National Museum 1985a, no. 94; Schirn Kunsthalle Frankfurt 1990, no. 129.

The Mino kilns are situated in Gifu Prefecture, some twenty-four kilometers (15 miles) north of Seto, the great center of pottery manufacture in Japan during the medieval period (1185–1573). The kilns produced some of the finest wares of the Momoyama period, including Shino (cat. nos. 100, 101), Oribe (cat. no. 104), Ki Seto (Yellow Seto), and Seto Guro (Black Seto). After the eighteenth century, however, they were no longer in use and the wares that had been produced there in the Momoyama period were misattributed to the nearby Seto kilns. Errors about the origin of Mino ceramics—particularly wares like Ki Seto and Seto Guro—were perpetuated until 1930, when old kiln sites were discovered at Mino by the renowned potter Arakawa Toyozō (1894–1985). Recent excavations at the site have made it possible to reconstruct the chronology of kiln activity.

Mino has a long, continuous history as an important center of ceramics production. Beginning in the late seventh century, the kilns there turned out fine Sueki pieces (cat. no. 4); during the Heian and Kamakura periods, they produced glazed wares for use in temples and aristocratic homes. Their activities were probably conducted under the partial control of persons designated by the emperor, and their wares had the unique distinction of bearing the stamped "Mino" seal.[1] Mino kilns are also sometimes credited with having inaugurated production of a superior

type of fine, glazed white Sueki.[2] During the Kamakura, Nanbokuchō, and early Muromachi periods, Mino production was overshadowed by that of the more successful Seto kilns. In the mid-fifteenth century, however, when potters from Seto, across the mountains, brought the technique of controlled glazing to the Mino area the local potters achieved a brilliant reversal in their fortunes. By the end of the century, to keep pace with the great quantities of imports from China, large, more efficient kilns had been constructed at both Mino and Seto.

During the Momoyama period, changes in the leadership of tea circles also contributed to the spectacular revival of the Mino kilns. A leading tea master of the Muromachi period, Murata Shukō (Jukō, 1423–1502), had preferred Chinese imports or Japanese copies of them for *chanoyu*. But Takeno Jōō (d. 1555/58) displayed a taste for native ceramics, and his disciple Sen Rikyū (1522–1591), the great Momoyama tea master and arbiter of the aesthetics of tea, firmly rejected the symmetrical perfection of Chinese ceramics in favor of more spontaneously potted and casual-looking, if imperfect, indigenous wares. New shapes and new types of glazes made their appearance in the late sixteenth century, as potters were guided by the spirit of *wabicha*, the simple and austere style established by Rikyū. As a result, the fortunes of the two neighboring and rival kilns

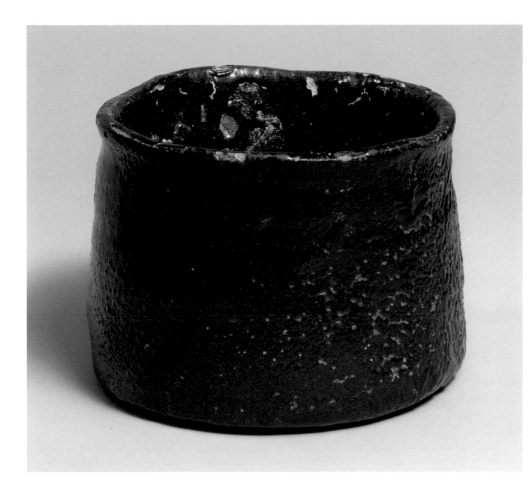

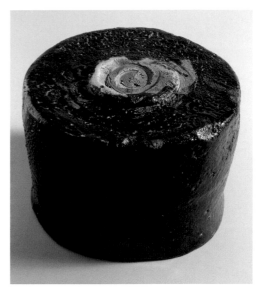

were reversed. Blessed with high-quality clay and an abundant source of firewood, Mino superseded Seto.

The main products of the Mino kilns were tea-related vessels: tea bowls, *mizusashi* (water jars), and *kaiseki* wares—plates and containers used to serve *kaiseki*, the small meal that precedes *chanoyu*. These dinner wares, which constitute the majority of Shino and Oribe ceramics, signified a new era in the industry, as well as in the eating habits of the Japanese people. Before the Momoyama period, the Japanese used dinner wares of wood, lacquered wood, unglazed pottery, or, on special occasions, prized, imported Chinese ceramics. If only for this reason, Mino kilns occupy an important place in the cultural history of Japan.

This cylindrical teabowl of the Seto Guro type reflects Rikyū's strong preference for simple, black teabowls. Seto Guro bowls were the first tea wares to reflect the Rikyū aesthetic of imperfection. Understated yet robust, they closely resemble Raku ware, the famous, similarly glazed pieces first made at Mino about 1570, at the close of the Muromachi period. Except for the outer rim, which flares slightly, the profile of this bowl is relatively straight, rising from a low, broad base. The almost nonexistent foot is formed by a shallow carved spiral. At Mino it was customary to use the potter's wheel to make teabowls and other small vessels. The strength of this bowl, however, derives from the hand-sculpting, done with a spatula, that followed the initial shaping on the wheel.[3] The shape, reminiscent of a mallet, is associated with the Mutabora kiln, which was active during the Tenshō era (1573–91).[4]

In keeping with the vessel's sturdy vigor is the heavy black glaze, apparently developed specifically for use on cylindrical Mino bowls. Its pitch-black, lacquerlike luster was created by removing the bowl from the kiln at the peak of the firing process. This allowed the piece to cool much faster than it would have within the confines of the kiln. The bowl was also slightly underfired, which produced a mottled, pitted texture. The signs of age and of wear on the inside of the rim would also have been admired. All these features combine to form a harmonious work of calculated simplicity—a quintessential example of *wabi* taste.

1. Osaka Municipal Museum of Art, Tokugawa Art Museum, and Nezu Institute of Fine Arts 1971, p. 99.
2. Ibid., p. 101.
3. Cort 1985, p. 122.
4. Ibid.

99. Chaire

Momoyama period (1573–1615), late 16th century
Mino ware; stoneware with iron-rich glaze
Height 9.5 cm (3¾ in.); diameter of mouth 4 cm
(1⅝ in.)

LITERATURE: Tokyo National Museum 1985a,
no. 96; Schirn Kunsthalle Frankfurt 1990, no. 130.

The *chaire*, or tea caddy, is a small ceramic vessel used to hold powdered tea for *chanoyu*; the lid is made of ivory or animal bone. *Chaire* must have been in fairly common use by the mid-fourteenth century. An early-four-teenth-century encyclopedic record, the *Isei teikin ōrai*, classifies *chaire* according to shape,[1] and *chaire* are illustrated in the 1351 pictorial biography of the monk Kakunyo (fl. late 13th century).[2] Furthermore, recent excavations at late-thirteenth-century Seto kiln sites have yielded a number of *chaire* that are clearly of local manufacture.[3] These pieces are copies of Chinese wares, suggesting that the first tea caddies used in Japan were Chinese imports originally made as containers for oil, medi-cine, or condiments.

This *chaire*, traditionally classified as Seto, is now thought to be a product of the Mino kilns (see cat. no. 98).[4] Small yet solid in appearance, it was thrown on a potter's wheel; traces of the cord used to separate it from the wheel are visible on the footless base. The body bulges toward the base and flares slightly just below the shoulder, which was leveled sharply to form the special shape known as *katatsuki* (straight shoulder). Casual application of the thick brown glaze resulted in accidental, uneven shifts in color tonality and flow. At the base, where the glaze is heavily pooled, the dark brown glis-tens with highlights of shiny black and dark green. The interior is glazed lightly in brown. Both this form and the glazing technique were much admired by connoisseurs of *chanoyu* during the Momoyama period.

1. Nezu Institute of Fine Arts and Tokugawa Art Museum 1997, p. 107.
2. The *Boki ekotoba* handscroll is in the collection of the Nishi Honganji, Kyoto. See Komatsu Shigemi 1985a, p. 46.
3. Kanzaki Kazuko 1991, pp. 36–44.
4. Tokyo National Museum 1985a, no. 96.

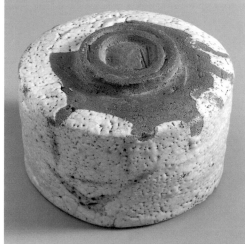

100. *Teabowl with Bridge and House*

Momoyama period (1573–1615), late 16th century
Mino ware, Shino type; glazed stoneware with
design painted in iron oxide
Height 10.5 cm (4⅛ in.); diameter 14 cm (5½ in.)

LITERATURE: Murase 1975, no. 98; Pekarik 1978,
no. 80; Hayashiya Seizō 1981, no. 22; Tokyo
National Museum 1985a, no. 98; Schirn Kunsthalle
Frankfurt 1990, no. 131.

First produced at the Mino kilns during the
Momoyama period (see cat. no. 98), Shino
ware is regarded as a quintessentially Japa-
nese ceramic. It is characterized by a heavy
body and coarse, crackled, uneven white
feldspathic glaze. The intimacy, informality
of shape, and "softness" of glaze were com-
patible with the ideal of simplicity and art-
lessness treasured by the tea master Sen
Rikyū (1522–1591). Although production of
Shino seems to have begun in the 1580s, it
was not clearly distinguished from the wares

of other kilns until the beginning of the eigh-
teenth century.[1] Because some of the wares
are identified in *chanoyu* records as "Shino
Ten'moku,"[2] some scholars believe that the
name "Shino" may have been that of the
owner of a particular vessel, most likely the
tea master Shino Sōshin (1441–1522),[3] and
that the vessel may have been a Ten'moku
(Chinese-style glazed teabowl) that was
white rather than the usual black brown. In
the first half of the sixteenth century, white
Ten'moku teabowls were manufactured

Figure 44. *Noborigama*.
Mino kiln, Gifu Prefecture

either at the Seto or the Mino kilns in an attempt to reproduce the prized Korean bowls known in Japan as Ido bowls. This was the first successful attempt by the Japanese to produce white-glazed wares, and it is generally believed that Shino wares evolved from white Ten'moku.[4]

Many Shino pieces have decorations in iron brown or cobalt blue (the latter perhaps an attempt to emulate Chinese blue-and-white) that were painted directly on the wet clay body. This marks a distinct innovation in Japanese ceramics; earlier designs had been incised, stamped, appliquéd, or executed in relief. Shino ware was fired in single-chambered, partly subterranean kilns in which it took at least five days to achieve the high temperature needed for vitrification. The resulting glaze was a thick, warm, uneven white; the iron glaze below the surface was unstable and showed through in different colors, depending on kiln conditions. The introduction in the early seventeenth century of the more efficient multichambered climbing kiln known as the *noborigama* signaled the end of Shino production at Mino (fig. 44, page 239); the glazes matured quickly (enabling more complex painted designs) and ran smooth and thin. By then, potters at Mino had shifted their efforts—presumably under the guidance of Furuta Oribe (1544–1615)—to making another, equally renowned ware, Oribe, which is distinguished by its daring and complex painted decorations (cat. no. 104).

This teabowl is typical of the Shino bowls produced before the introduction of the improved kilns. Like many examples from the late sixteenth century, it is decorated with a simple design of a bridge and a house, painted in iron oxide under the white glaze. This subject, repeated on many teabowls from the Mino kilns, is sometimes interpreted as a highly simplified rendition of the Sumiyoshi Shrine, Osaka, an especially popular motif for lacquerware.

The tactile quality of teabowls was as important as their visual appeal. Pieces such as this one, after preliminary shaping on the potter's wheel, were subtly altered by pressing them gently with the hands while the clay was still soft. Here, the rim undulates slightly as it flares outward, and the finished object feels comfortable in the hands. It has the standard, late-sixteenth-century double-ringed low foot under a wide, flat base, so that it would sit securely on the woven-straw tatami mat when in use. Because the potter held the foot of the vessel in his hand as he dipped it into the liquid glaze, that area was left unglazed. On this bowl, the potter's small thumb mark can be seen under the image of the bridge. As on a number of vessels, two lines are incised on the wet clay inside the foot ring. These may have been made to distinguish one group of objects from others fired together in the same kiln.

1. Fujioka Ryōichi 1970, p. 22.
2. See, for example, *Sōjinboku* (Grasses, People, and Trees; 1626), in *Sadō koten zenshū* 1967, vol. 3, p. 248.
3. Hayashiya Seizō 1967, p. 39.
4. Fujioka Ryōichi 1970, pp. 22–25.

101. Oval Plate with Grapevines and Trellis

Momoyama period (1573–1615), 16th century
Mino ware, Nezumi Shino type; stoneware with iron-slip underglaze
7.3 × 28.5 × 27 cm (2⅞ × 11¼ × 10⅝ in.)
Ex coll.: Okabe Kan

LITERATURE: *Encyclopedia of World Art* 1960, pl. 171; Arakawa Toyozō 1962, pl. 49; Tokyo National Museum 1971, no. 52; Arakawa Toyozō 1972, pl. 87; Minamoto Toyomune et al. 1973, no. 32; Hayashiya Seizō 1974, no. 42; Murase 1975, add. no. 112; Tokyo National Museum 1985a, no. 99; Hayashiya Seizō and Enjōji Jirō 1990, no. 41; Schirn Kunsthalle Frankfurt 1990, no. 132.

An overall design of grapevines and a trellis, executed in white against a rich gray background, ornaments this large oval plate with rounded corners. The decoration of the outer rim—bands of fiddleheads alternating with bands of short bars—resembles inlay in the glazed surface. This effect was created by first applying an iron-rich red-clay slip to the body and then scratching out the designs with a sharp instrument; the entire piece was then covered with a feldspathic glaze. In the kiln the slip usually turned mouse gray (the name of the ware, Nezumi, is Japanese for "mouse"); on occasion, it became a brilliant red. Here, the plate was treated almost like a surface for painting—unprecedented in Japan's ceramics industry. A small indentation was made in the center of the plate by the potter, who placed his hand there as he rotated the piece on the wheel. The sides of the plate curve gently upward, and three short legs are attached to the rounded underside. The thick, mottled glaze, which pooled near the bottom of the exterior, has a strongly tactile quality.

This platter is one of the two finest extant examples of Gray Shino ware.[1] The other, a nearly identical piece, is in the collection of the Museum of Fine Arts, Boston.[2]

1. Hayashiya Seizō 1974, no. 42.
2. Hayashiya Seizō 1981, no. 26.

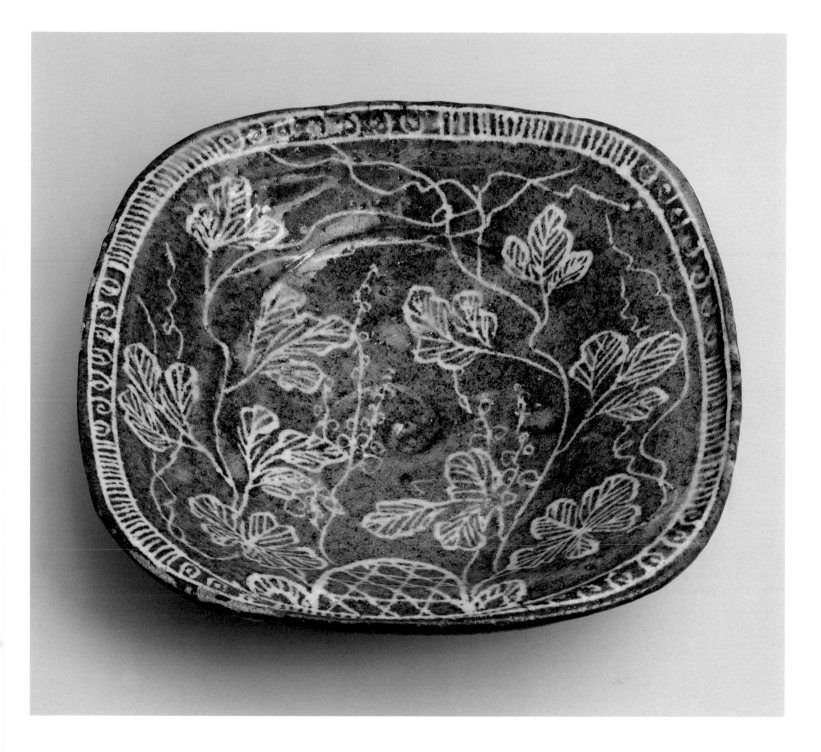

to learn about the step kiln at that time. At a later date he may also have helped Katō Kagenobu (d. 1632), the leading potter at Mino, to establish the kiln in that area. The new kiln permitted earlier maturity of glazes under controlled conditions, as well as the implementation of complex designs and a range of colors to decorate the wares.

The introduction of the step kiln coincided with a shift in the hierarchy of tea masters that occurred in 1591, when Hideyoshi ordered Sen Rikyū to commit *seppuku*. After Rikyū's death, Oribe assumed his mantle as the foremost tea master of Japan. As the scion of a warrior family and the product of the swiftly changing political landscape of the Momoyama period, Oribe had an aesthetic that was diametrically opposed to that of Rikyū. Whereas the older master had prescribed subdued simplicity and refined artlessness, Oribe called for forceful, extroverted beauty. The Oribe wares produced at the Mino kilns vividly reflect this change.

Beginning in the last few years of the sixteenth century, "new" and "misshapen" wares are noted in *chanoyu* records.[1] These descriptions evoke features characteristically associated with Oribe wares, but the name "Oribe" does not begin to appear in the literature of tea before 1724.[2] Many Oribe pieces are decorated with sensuous, brilliant glazes

in black, iridescent green, and brown, further enriched by underglaze drawings in iron oxide. The distinctive copper-green glaze was new in Japanese pottery. But innovation was not limited to new glazes. Oribe *kaiseki* wares in particular show an unprecented diversity of shape, design, and size, and they are often intentionally distorted.

This ewer is typical of Oribe wares dating to the beginning of the seventeenth century, when production was at its height. Although originally intended for pouring soup during the *kaiseki*, such vessels were also used as *mizusashi* (water jars) for *chanoyu*, as the wide opening and tall handle were ideally suited to this function. The vessel belongs to a special category known as Narumi Oribe, for which two types of clay—different in color but equal in strength—are used. The decorated lower body was made of red clay; the handle and upper body, both covered in green glaze, were made separately in white clay. The latter material is best suited to bring out the brilliance of the green glaze, while the former shows through the clear glaze in a subtle shade of salmon pink, creating a striking color contrast previously unknown in Japanese pottery. The designs were executed with great freedom, painted in white slip and then outlined in iron oxide.

As in many other Oribe wares, the decora-

tion of this ewer combines naturalistic and geometric designs: plum flowers and a triangular, curtainlike motif. Oribe potters freely adopted shapes and designs from other art forms. Designs on Oribe vessels bear a striking affinity to those on contemporary Japanese textiles, and a relationship between them is not unlikely.[3] The most active Mino kilns, those which produced the finest Shino and Oribe wares, were located in areas once inhabited by textile designers and dyers; moreover, the name "Narumi" may refer to a village in the nearby Nagoya area, which was famous for its high-quality tie-dyed textiles. Conceivably, artisans who supplied designs for textile makers may also have worked as decorators of pottery. The shape of this ewer, new in Japanese ceramics, was modeled after that of a wood or lacquered-wood vessel. The small, round protrusions at the base of the handle, while not functional, imitate the nailheads on the wood model.

1. Katō Hajime 1961, p. 2.
2. The name "Oribe" first appears in the *Kaiki*, a chronicle of the life of Konoe Iehiro (1667–1736). See *Sadō koten zenshū* 1967, vol. 5, entry for the eighteenth day, tenth month, ninth year of the Kyōhō era (1724).
3. Fujioka Ryōichi 1970, p. 81; and Kakudo 1972, p. 74.

105. Platter with Pine Tree

Momoyama period (1573–1615), early 17th century
Hizen ware, Karatsu type; stoneware with applied glaze and design painted in iron oxide
Diameter 32 cm (12⅝ in.)

LITERATURE: Tokyo National Museum 1985a, no. 101; Schirn Kunsthalle Frankfurt 1990, no. 142.

Karatsu mono, or Karatsu wares, were objects of everyday use in western Japan, much as *Seto mono* were the utilitarian ceramics of eastern Japan. Karatsu pottery was produced in the region known as Hizen (Saga and Nagasaki Prefectures), in northern Kyūshū, an area that produced Sueki (cat. no. 4) between the sixth and the tenth century. The term "Karatsu," in its broadest definition, refers to all pottery shipped from the port city of that name, that is, the many wares produced at the Hizen kilns, including Agano, Takatori, Shōdai, and Yatsushiro. Karatsu thus incorporates a variety of styles. What they have in common is the unmistakable influence of Korean ceramics.[1]

This influence is usually traced to the late 1590s, following Hideyoshi's invasions of

the Korean Peninsula in 1592 and 1593, when Korean potters were forcibly relocated to the Karatsu region. However, earlier wares from the area—made during the 1570s and 1580s—also reflect strong Korean influence. Considering the proximity of Karatsu to the southern tip of Korea, it is reasonable to assume that Korean artisans had settled in the region and practiced their craft in the closing years of the Muromachi period—even before Hideyoshi's raids—thus marking the inception of glazed-pottery manufacture in the area.

The simple, unpretentious beauty of everyday wares produced at the Karatsu kilns attracted tea masters such as Furuta Oribe (1544–1615). The first reference to the use of Karatsu ware for *chanoyu* was in connection

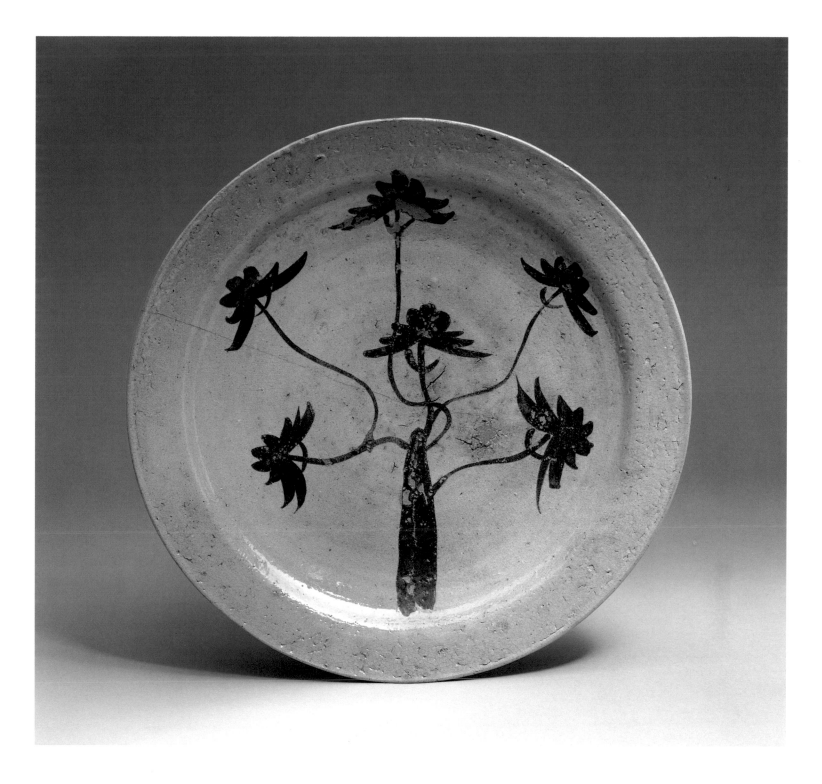

with a tea gathering held at Oribe's house in 1603,[2] and his influence is vividly demonstrated by the deliberately misshapen teabowls and the asymmetrical designs on many of the painted wares produced at the Karatsu kilns. Karatsu craftsmen, however, used simpler glazing techniques than did the potters who made Oribe wares at the Mino kilns (cat. no. 104). The popularity of Karatsu ceramics declined after 1616, when another group of Korean potters, led by Ri Sanpei (1579–1655), began production of porcelain wares (cat. nos. 128, 129).

This platter, like all Karatsu wares, was thrown on a potter's wheel. It retains the marks made as the wheel rotated around the small, low foot. The broad, raised rim serves as a frame for the simple but charming drawing of a pine tree with six branches, brushed onto the plate with iron oxide. Except for the area around the foot, the platter is covered with a light grayish brown glaze, a mixture of feldspar and ash.

A slightly larger platter, in the Idemitsu Museum of Arts, Tokyo, bears a pine-tree design that is nearly identical to this one.[3]

A number of shards that hint at objects with identical shapes and similar designs were excavated at the site of the Kameya no Tani kiln, to which both the Burke and the Idemitsu platters are attributed.[4]

1. Becker 1974.
2. *Matsuya kaiki* (Records of Three Generations of Lacquerers and Tea Masters), compiled by Matsuya Genzaburō and edited by Matsuya Hisashige (1566–1652). See *Sadō koten zenshū* 1967, vol. 9, entry for the twelfth day, tenth month, eighth year of the Keichō era (1603).
3. Kawahara Masahiko 1977, fig. 1.
4. Ibid., figs. 123, 124.

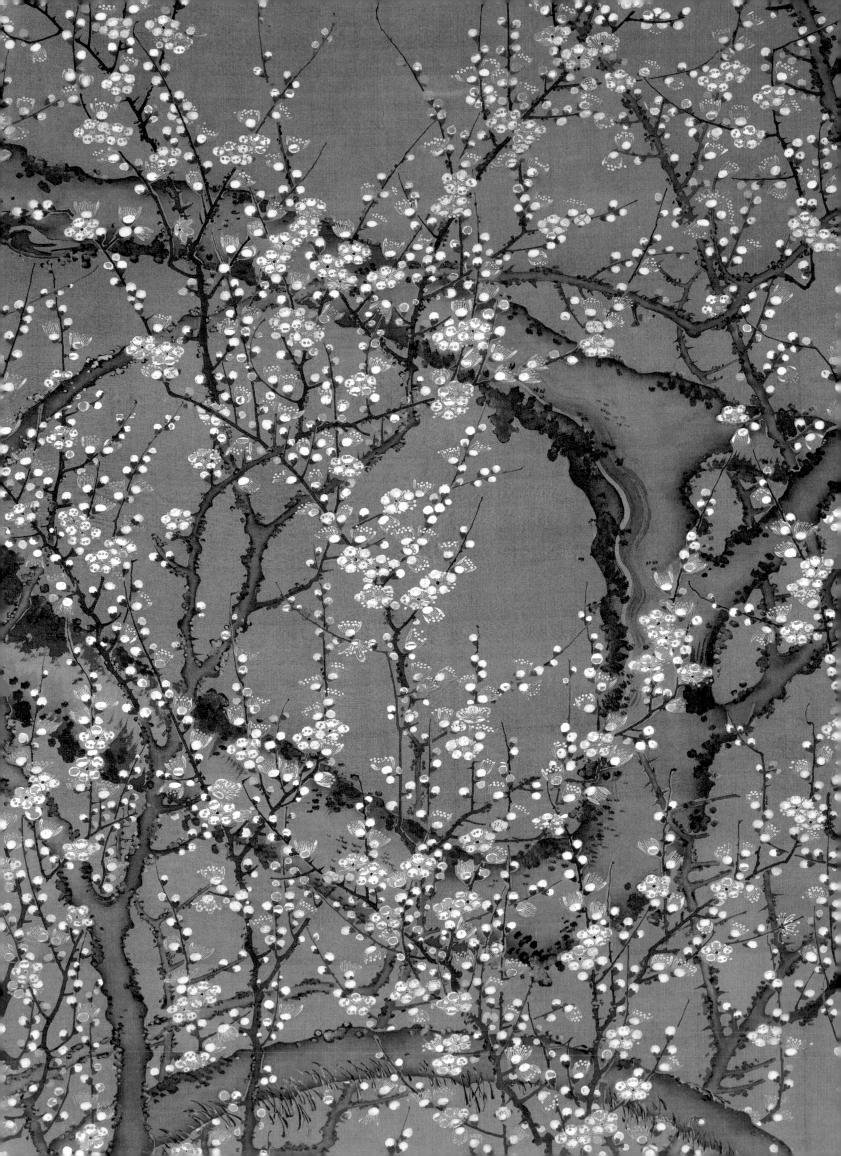

VI. Edo Period (1615–1868)

CATALOGUE NOS. 106–168

In 1600, Tokugawa Ieyasu (r. 1603–5) emerged from the battle of Sekigahara as the uncontested victor in a struggle that had involved nearly all the samurai of Japan during the second half of the sixteenth century. Three years later, the royal court granted him the title of shogun. In 1615, Ieyasu's army encircled and destroyed Osaka Castle, the last Toyotomi stronghold. Relative peace reigned for the next two hundred fifty years, until the restoration of imperial rule in 1868, which ushered in the modern era.

This long-enduring regime is called either the Tokugawa period, after the name of the ruling family, or the Edo period, after the city (modern Tokyo) where Ieyasu established the seat of the military regime. Situated on low-lying marshlands skirting what is now named Tokyo Bay, Edo was the small fishing village from which Ieyasu had ruled his fiefdom before he became shogun. After choosing it as the seat of the *bakufu* (military government), he promptly launched a full-scale project to remodel and enlarge Edo Castle, today familiar as the Imperial Palace. In the early days of the regime, few subjects were willing to settle in the primitive, undeveloped town, but a shrewd ordinance, issued in 1635, served to enhance Edo's position. Every feudal baron, or daimyo, was required to maintain a household in Edo and another in his hometown, as well as to spend several months of the year in Edo. Highways were rapidly laid out between Edo and the provincial cities to accommodate the daimyos and their retinues on the obligatory journeys. Edo expanded rapidly and haphazardly, unlike Nara and Kyoto centuries before, whose founders had used careful planning. Thus Edo was a city of natural growth and hasty construction, which led to dangerous overcrowding. By the end of the seventeenth century the sprawling, free-spending metropolis comprised a population of one million people. It was a city not of producers but of consumers, supplied by goods shipped from many parts of the country. The political nerve center of the nation, Edo was nevertheless slow to acquire a culture of its own and in this respect lagged far behind the former capital, Kyoto.

Nowhere was the contrast between these two cities, new and old, more clearly evident than in two seventeenth-century buildings, the Tōshōgū mausoleum at Nikkō, north of Edo, and Katsura Imperial Villa, south of Kyoto (figs. 45, 46). The Tokugawa shoguns were serious but intellectually and aesthetically undeveloped men, lacking in artistic vision.

Opposite: Detail of cat. no. 119

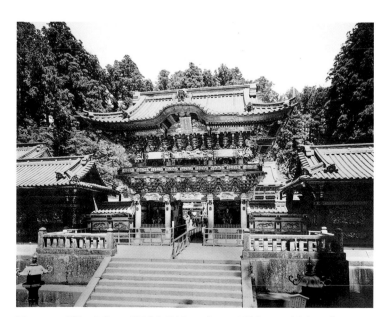

Figure 45. Yōmei Gate, Tōshōgū Mausoleum, Nikkō, Tochigi Prefecture. Edo period (1615–1868), 1634–36

Figure 46. Chū Shoin, Katsura Imperial Villa, Kyoto. Edo period (1615–1868), ca. 1641

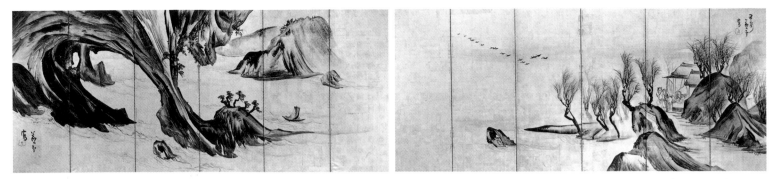

Figure 47. Nagasawa Rosetsu (1754–1799), *Landscape*. Pair of six-panel folding screens, ink and gold on paper, each screen 154.8 × 355.8 cm (5 ft. 1 in. × 11 ft. 8 in.). The Metropolitan Museum of Art, New York. The Harry G. C. Packard Collection of Asian Art, Gift of Harry G. C. Packard and Purchase, Fletcher, Rogers, Harris Brisbane Dick and Louis V. Bell Funds, Joseph Pulitzer Bequest and The Annenberg Fund Inc. Gift, 1975 (75.268.75, 76)

They had little taste for architecture, whether secular or religious. Notable exceptions to this indifference were the mausoleums they built for themselves and for the daimyos, on whose loyalty the feudal system was based. Tōshōgū, built to house the remains of Ieyasu and completed about 1619, is the most opulent of the mausoleums, a symbol of military might and newly acquired wealth.

In contrast, the Japanese predilection for architectural simplicity and open space was realized in Katsura Imperial Villa, on which construction began in 1620. Situated along the Katsura River, southwest of Kyoto, it is regarded as one of the finest architectural monuments of Japan. Devoid of ornament and integrated into the environment, it achieves a harmonious balance between man and nature.

The Edo period is especially notable for the Tokugawa shoguns' tenacious hold over the daimyos; for the extraordinary expansion of the national economy, which led to the rise of an affluent urban middle class; and for the flowering of several divergent schools of painting. To clarify the artistic developments that took place, the Edo period may be divided into two phases.

During the seventeenth century, artistic and cultural activities were dominated by the ancient and cultivated city of Kyoto, where the shogun and the daimyos maintained their secondary residences and which served as the seat of the imperial court. Kyoto was the center of finance and commerce, and of communications, scholarship, and cultural activities. It was the source from which new knowledge was disseminated to the provinces. In Kyoto books were published and men were trained to become scholars, teachers of Nō theater,

masters of *chanoyu*, and arbiters in the art of flower arranging. And it was from Kyoto that painters were sent to Edo and other cities to execute commissions and to instruct aspiring local artists.

The major painting styles of the seventeenth century were still imbued with the spirit of the Momoyama period. The Kano school flourished under the leadership of the last great masters of the Kano family, Tan'yū (cat. nos. 107, 108) and Sansetsu (1589–1651), the former active in the new city of Edo and the latter in the old capital. While the art of the Kano school represented a forward-looking continuum with the previous era, the Tosa (cat. no. 109) and Sumiyoshi schools preserved the traditions of *yamato-e*. Rinpa, a style of vivid colors and decorative patterning established by Hon'ami Kōetsu and Tawaraya Sōtatsu (cat. nos. 83–87), was embraced by a large group of artists working mainly in Edo (cat. nos. 132–138). And genre paintings of life in the capital (cat. no. 139), which had proliferated in the Momoyama period, paved the way for *ukiyo-e* (pictures of the floating world; cat. nos. 146–151).

The second phase of artistic activity in the Edo period extended through the eighteenth century and into the first half of the nineteenth. While the Rinpa tradition was carried forward by its many followers, *ukiyo-e* achieved world fame through the work of such master printmakers as Suzuki Harunobu (1725–1770), Kitagawa Utamaro (1753–1806), Katsushika Hokusai (1760–1849), and Utagawa Hiroshige (cat. no. 152). Insatiably curious and undaunted by strictures against contact with foreigners and foreign ideas, artists made bold efforts to learn about the arts of China and Europe. The *bakufu*'s decision

in 1639 to close Japan's doors to the world—a policy known as Sakoku—was one component of the anti-Christianity instituted and stringently implemented earlier in the seventeenth century. A thriving trade with the Portuguese, Spanish, and English was banned—ostensibly to curtail missionary activity—and Japanese subjects were forbidden to travel abroad. And although limited commercial exchange continued with the Dutch and the Chinese, they were admitted only to the port of Nagasaki, at Kyūshū. It was through these contacts with foreigners in Nagasaki that eighteenth-century Japanese artists learned of Western art theories and practices and had their admiration for the arts of China revived.

Nanga, the literary man's painting, was the last of many efforts to emulate the Chinese tradition before Western styles swept the cultural landscape in the second half of the nineteenth century. The movement produced a wealth of poetry, as well as exquisite calligraphy, painted landscapes, and nature studies in the Chinese literati style (cat. nos. 153–168). The principles and techniques of Western realism were absorbed by the artists of the Maruyama and Shijō schools (cat. nos. 115–117), and despite the repressive climate of the feudal regime, several independent-minded artists unexpectedly emerged. Perhaps the most radical were Nagasawa Rosetsu, Itō Jakuchū, and Soga Shōhaku, who are often grouped together as the Three Eccentrics (cat. nos. 118–121; fig. 47).

While these many schools of painters and printmakers wove a rich tapestry in the pictorial arts, technical advances in the ceramics and lacquer industries laid the foundations for arts that continue to thrive in our own time.

106. Ancient, and Hawk on an Oak Tree

Edo period (1615–1868), mid-seventeenth century
Pair of fan-shaped paintings, mounted on a two-panel folding screen, ink on paper
Each screen 98.9 × 76 cm (39 × 29⅞ in.)
Signature: *Soga Chokuan Ni* [on the painting at left]
Seals: *Hōin* and *Nichokuan* [on painting at right]; *Hōin* [on painting at left]

LITERATURE: Tokyo National Museum 1985a, no. 35; Lillehoj 1989, fig. 5; Schirn Kunsthalle Frankfurt 1990, no. 79.

On the right panel of this two-fold screen an elderly, emaciated man is shown seated in the shade of two trees, a walking stick in one hand. His bald head, scrawny limbs, and bare feet are delineated with smooth brushlines in light ink; dark spots mark his eyes and the corners of his downturned mouth.

No particular physical characteristics or attributes identify this stubborn-looking old gentleman, and as he lacks any of the bizarre features that frequently characterize Daoist immortals, he perhaps represents a scholarly recluse. The painting was cut down to its present irregular shape from a larger, rectangular work, which may have held clues to the identity of the seated figure.

The companion piece, on the left panel, depicts a hawk perched on the branch of an oak tree whose leaves turn and twist as if expressing the fierce tension of the bird of prey. This painting is signed "Soga Chokuan Ni" (Soga Nichokuan) and bears a seal reading "Hōin." The seal also appears on the

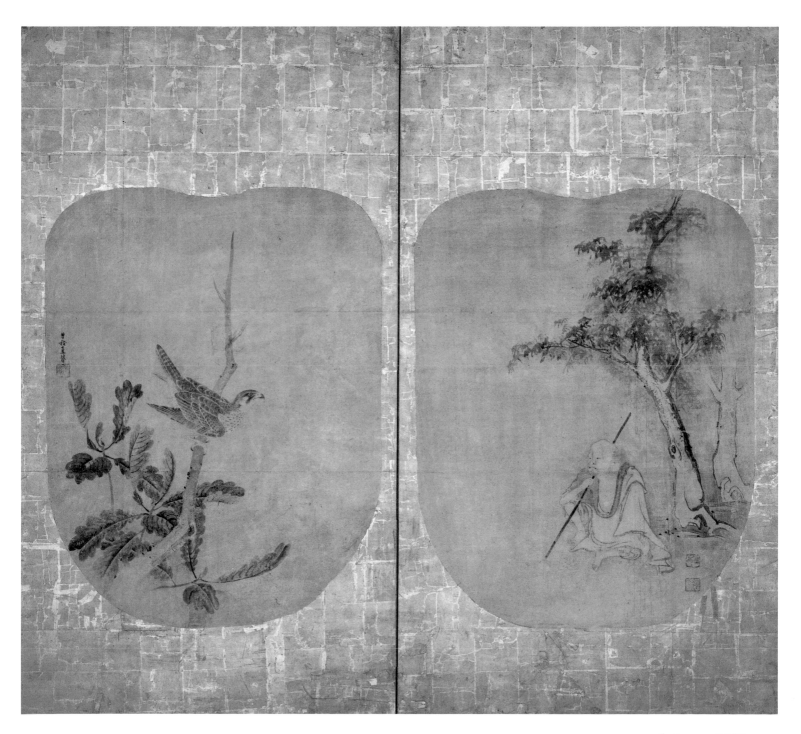

painting of the old man, where another seal, "Nichokuan," can be seen above it.

Soga Nichokuan (fl. mid-17th century), well known as a painter of hawks, is generally regarded as the successor to, and perhaps the son of, Soga Chokuan (fl. 1596–1610), who was similarly known for his hawk paintings. They may also have been connected to a number of Muromachi ink painters who used the name "Soga," as well as to one of the great eccentric masters of the Edo period, Soga Shōhaku (cat. no. 121). The biographies of both Chokuan and Nichokuan present a tantalizing, if frustrating, picture of artists who worked outside the mainstream Kano school. Some of the confusing and plainly fabricated claims they made about their lineage reflect opportunistic attempts to succeed in a fiercely competitive art market. Nichokuan sometimes signed his name "the Sixth Generation from Shūbun" (see cat. no. 61). What is certain, however, is that Nichokuan succeeded Chokuan as the leader of the Soga school and that he most likely worked in the vicinity of the port city of Sakai, south of Osaka. Several screen paintings by Nichokuan found at temples on Mount Kōya and at Taimadera, Nara, testify to his activity in the Osaka–Nara region. Colophons inscribed on his paintings by two monks who are known to have died in 1643 and 1649, respectively, suggest that he was active in the middle of the seventeenth century.

Nichokuan's mature works are distinguished by an eccentric, almost surreal treatment, with serrated rocks, agitated water patterns, and contorted, knobby trees silhouetted against dark ink backgrounds that stand in harsh contrast against highlighted areas.[1] These features are generally regarded as characteristics of his later career. The dark shadow and eyelike knot on the tree in the painting at the right offer only a hint of this later boldness and eccentricity. It may thus be dated to the earlier part of Nichokuan's career. The signature is written in a calm, controlled script. In later years, the artist's hand was looser and more elongated; an example appears on a triptych of White-Robed Kannon and two birds at Chōenji (Aichi Prefecture), which is dated to about 1649.[2]

1. See, for example, the six-fold screens *Flowers and Birds*, in Nara Prefectural Museum of Art 1989, no. 22; and *Egrets and Hawks*, in Tokyo National University of Fine Arts and Music 1977, no. 10. Both these screens are considered to be by Nichokuan, though each bears a signature reading "Soga Chokuan."

2. Nara Prefectural Museum of Art 1989, no. 32.

107. *Landscapes of the Four Seasons*

Edo period (1615–1868), 1630s
Pair of six-panel folding screens, ink and light
color on paper
Each screen 153.5 × 352.6 cm (5 ft. ⅜ in. × 11 ft. 6⅞ in.)
Signature: *Kano Uneme no shō Morinobu hitsu* [on
the left screen]; *Kano Uneme no shō Morinobu koreo
egaku* [on the right screen]
Seals: *Uneme* and [unidentified]
Ex coll.: Myōkakuji, Kyoto; Matsukata Iwao, Tokyo

LITERATURE: "Sansui zu byōbu" 1910, pp. 385–
86; Kihara Toshie 1995, fig. 6; Kihara Toshie 1998,
pp. 97, 132, fig. 11.

Kano Tan'yū (1602–1674) is a pivotal figure in the history of Japanese painting. His domination of the art world extended beyond his lifetime to the close of the Edo period, perpetuated by the patronage system that he helped to create. Enormously talented, politically savvy, and born when the center of shogunal power was shifting to Edo, Tan'yū learned at an early age to take full advantage of any opportunities that came his way.

A grandson of Kano Eitoku (1543–1590), the great master of Momoyama painting, Tan'yū began to paint when he was quite young; one work executed when he was eleven is still extant.[1] Stories of his precocity abound. When he was only ten his father, Takanobu (1571–1618), the second son of Eitoku, took him to Edo for an audience with the shogun Tokugawa Hidetada (r. 1605–23), and on the way Tan'yū was interviewed by none other than Tokugawa Ieyasu (r. 1603–5), the founder of the shogunate.[2] Two years later, the boy demonstrated his painting skill in front of Hidetada, who praised him as "Eitoku Reincarnate."

In 1617, the fifteen-year-old Tan'yū was appointed official painter to the shogun, and not long thereafter established the power base of the Kano school in the new city of Edo. Tan'yū's astute political moves helped to assure the family's fortunes for the next two hundred fifty years. In 1621, he was granted a large tract of land for a house and studio, just outside the Kajibashi gate of Edo Castle, paving the way for his younger brothers Naonobu (1607–1650) and Yasunobu (1613–1685) to receive the same honor. The three brothers eventually established the *bakufu*'s stable of painters, drawn from Tan'yū's Kajibashi Kano studio and from Naonobu and Yasunobu's Kobikichō and Nakabashi studios, respectively. Thus, in addition to training students and serving as advisers to the shogunal collections, they also monopolized shogunal commissions. The positions they held were part of the hierarchical system established at this time, one that endured for the entire Edo period. The brothers were *oku eshi* (Painters of the Inner Court), a hereditary title, and, like samurai,

they were allowed to wear swords. Lesser clan members and prominent pupils filled the ranks of the *omote eshi* (Painters of the Outer Court). The third rank of Kano artists, those employed by the daimyos, or feudal lords, were known as *kakae eshi* (Painters for Hire). Given the inflexibility and exclusivity of the system, it is no wonder that many artists railed against it, and during the eighteenth century other schools were established. Criticism of the Kano school—and of Tan'yū in particular—focused on its reliance on traditional models and its distrust of originality and individualism.

A large number of paintings by Tan'yū have survived, and we can date many of those he produced as screens to decorate important monuments in Edo and Kyoto (often in collaboration with other members of the school).[3] It is customary to divide the artist's career into three phases. The first extends from his late teens through the period during which he used the youthful name "Uneme" in both his signature and his seal. It is not known exactly how long he continued to use this name, but he may have done so until about 1635, when he adopted the name "Tan'yūsai." The paintings from this second phase are often referred to as *saigaki* (studio cited). Signatures on most of the paintings produced in the third phase include the title *hōgen* (eye of the law), granted in 1638, or *hōin* (seal of the law), which he received in 1665. In this final phase, and especially after he turned sixty, Tan'yū often included his age in his signatures; works signed in this manner are generally known as *gyōnengaki* (age cited).

Both Burke screens bear "Uneme" seals and signatures, and thus belong to Tan'yū's youthful period, from which merely a few examples survive. The landscapes convey many hints of seasonal change: on the right screen, the cascading water and melting snow in the foreground, with hazy summer mountains in the distance; on the left screen, the geese in flight and a full moon—signs of autumn—and snow-covered scenery. The formula for screen compositions of the four seasons, which was firmly established in the Muromachi period, is simplified and trans-

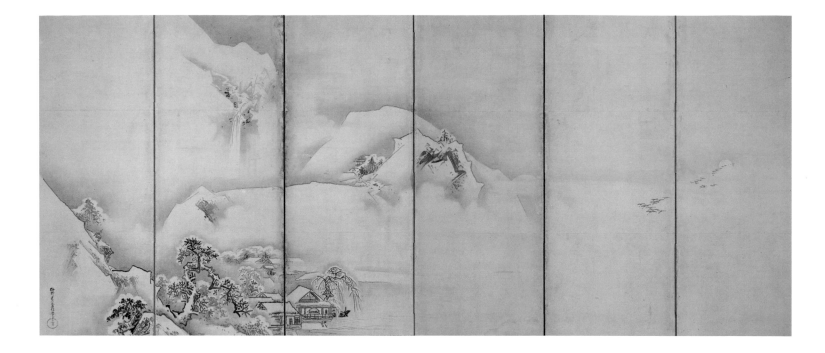

formed in Tan'yū's work. The composition of the right screen, which by tradition ought to have featured tall mountains at the extreme right, has been opened up; apart from the waterfall, only a few trees and partial views of houses define the low, modestly scaled foreground. There, without moving through a middle ground, the scene suddenly shifts to distant mountains and water, gently defined in soft ink wash.

The Edo-period critic and *nanga* artist Nakabayashi Chikutō (1776–1853) complained in his *Chikutō garon* (Chikutō's Treatise on Painting) that Tan'yū's paintings lacked visual rationality because the pictorial elements were abbreviated in too drastic a manner.[4] In our own time, Kihara Toshie has offered an opposing interpretation of Tan'yū's rejection of the traditional formula, arguing that in fact unfilled space is of greater significance in his landscapes than in Muromachi works.[5] Indeed, as can be seen in the screen at the right, empty space actually invades the filled areas, blurring firm demarcations. This disregard for rational structure in landscape became even more pronounced in the Nagoya Castle paintings of 1634, and evolved into the minimalism of the sliding-door panels at Shōjū Raigōji of 1643, in which unfilled space dominates, allowing only

glimpses of mountains, houses, and trees to emerge, as from a dense fog.

While exhibiting the first signs of Tan'yū's dissolution of rational space, the Burke screens still adhere to traditional formulas governing composition and brushwork. This is particularly evident in the left screen, in the area of the snow-covered mountains and in the strong brushlines in the foreground. The so-called Sesshū elements detected by many critics also make their appearance here: the dark surface textures of the rocks, the strong outlines of the pine tree at the right, and the solidly constructed buildings.

Given these stylistic features, the Burke screens may be dated to the 1630s, the final years of Tan'yū's "Uneme" period, shortly before he became involved in the Nagoya Castle project. They are major works, reflecting an early yet transitional stage in the development of his mature landscape style.

1. Takeda Tsuneo and Matsunaga Goichi 1994, pl. 7.
2. Yasumura Toshinobu 1978, pp. 17–36.
3. These include commissions for Nijō Castle in Kyoto (1626), Nagoya Castle (1634), the Tōshōgū Mausoleum at Nikkō (1636), and the Kyoto temples of Daitokuji (1641, 1669), Shōjū Raigōji (1643), Shūon'an (1650), Myōshinji (1654), and Nishi Honganji (1657).
4. See Sakazaki Shizuka 1917, p. 148.
5. Kihara Toshie 1995, pp. 95–115.

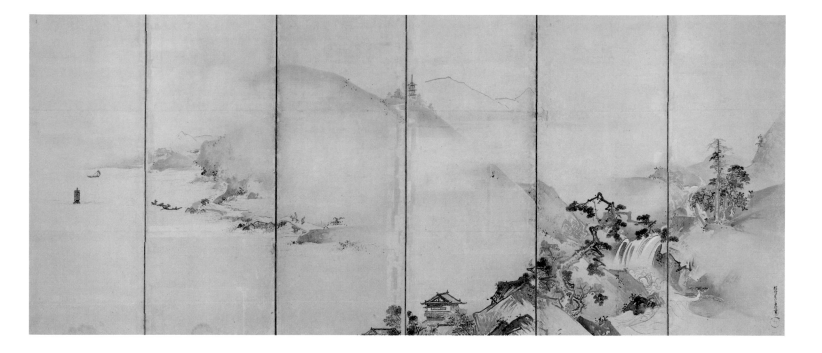

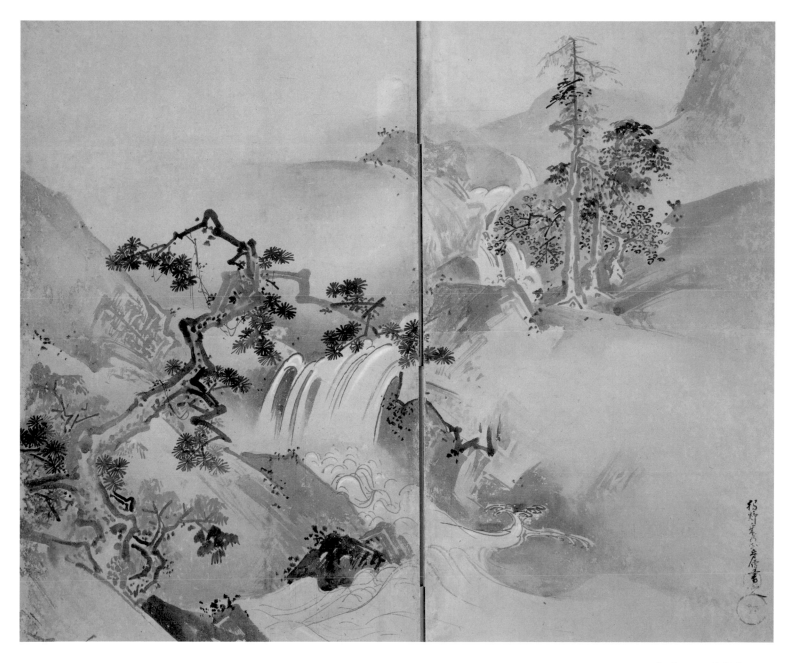

108. *Jizō Bosatsu Playing a Flute*

Edo period (1615–1868), ca. 1638–65
Hanging scroll, ink and light color on paper
99 × 38.9 cm (39 × 15⅜ in.)
Signature: *Tan'yū hōgen hitsu*
Seal: *Morinobu*
Ex coll.: Matsukata Iwao

LITERATURE: Iizuka Beiu 1932a, pl. 58; Takeda Tsuneo 1978b, no. 21; Kōno Motoaki 1982b, fig. 72; Burke 1985, fig. 7; Tokyo National Museum 1985a, no. 33; Nakahashi 1990, fig. 1; Schirn Kunsthalle Frankfurt 1990, no. 75; Kobayashi Tadashi and Kano Hiroyuki 1992, no. 9; Kōno Motoaki 1993, no. 24; Yasumura Toshinobu 1998, no. 24.

In this charming but curious depiction of Jizō Bosatsu (Skt: Bodhisattva Kshitigarbha), the youthful savior of souls condemned to the Buddhist hells, he is shown riding on a swiftly descending cloud. As if to announce his coming, Jizō plays a flute. His robes flutter in the wind and his shaved head is well protected by a large lotus-leaf hat. The entire drawing is executed in ink, except for the pale green of his garment. While the plump, youthful face is delineated in fine, delicate brushlines, the garments are executed in swift, almost sketchlike strokes. Romantic and lyrical, the painting is a departure from Tan'yū's other works, which were mainly auspicious subjects and Chinese-style landscapes (cat. no. 107) popular with his upperclass warrior clientele.

While Tan'yū made few paintings of Buddhist figures, he did make numerous *shukuzu* (reduced sketches) of paintings of religious themes by earlier Chinese and Japanese masters. The flute-playing Jizō, known affectionately as Fuefuki Jizō, resembles to some extent an enlarged and refined *shukuzu*.

Tan'yū included the honorary title *hōgen* in his signature. The work may thus be placed between 1638, when he was granted the title, and 1665, when he was promoted to *hōin*. It may be compared to another Buddhist painting by Tan'yū, which depicts Fugen Bosatsu (Skt: Bodhisattva Samantabhadra) seated on an elephant. This work, in the collection of Manpukuji, Uji, forms part of a triptych with Shakyamuni and Monju Bosatsu.[1] All three paintings—like the present work—are signed "Tan'yū hōgen hitsu" and bear the seal "Morinobu" (Tan'yū's given name). The triptych also bears undated colophons by the monk Ingen Ryūki (Ch: Yinyuan Longqi, 1592–1673), who had immigrated to Japan after the fall of the Ming dynasty in 1644 and established Rinzai temples, first in Nagasaki and then at Manpukuji in 1661. The monks chose to call their sect Ōbaku, after Mount Huangbo in Fujian Province, where their temple, Wanfusi (transliterated as Manpukuji), was situated. The Fugen in the triptych and the Burke Jizō have youthful countenances and comparable facial features.

Another Shaka triad in the Manpukuji collection, by the monk-painter Itsunen Shōyu (Ch: Yiran Xiangrong, 1601–1668), is nearly identical to the Tan'yū triptych.[2] Itsunen

signed each painting and added a cyclical date corresponding to the year 1660 to the image of Shaka. The colophons (also by Ingen) on the Monju and Fugen paintings have cyclical dates that correspond to the year 1665.[3] The strong affinity between the two triptychs suggests that the paintings may have been executed between 1656, when Tan'yū possibly had his first contact with the Ōbaku community,[4] and 1660, the date of Itsunen's Shaka painting.

The iconography of the Burke Jizō is its most puzzling feature. Since the Late Heian period the Jizō Raigō (Descent of Jizō) had been a popular iconic image associated with Pure Land Buddhism. In such compositions, Jizō is depicted standing on a lotus pedestal amid billowing clouds. The imagery of the present work seems to derive, in part, from the *raigō* theme, since the figure is represented with cloud formations. However, Jizō's customary attributes, a monk's staff and the wish-granting jewel, have been replaced by a flute and a lotus hat. Equally plausible as an iconographic source is the Amida Raigō (Descent of Amida), in which the Buddha, surrounded by a host of bodhisattvas, descends to earth. One of the bodhisattvas in Amida's retinue is Hōzō Bosatsu, who plays a transverse flute in a pose which resembles that of the Burke Jizō.

The lotus hat, while it seems to be without a textual source, appears relatively early in Japanese painting. Frogs wearing such hats are pictured in the celebrated twelfth-century handscrolls the *Chōjū giga* (Frolicking Animals and Birds), in Kōzanji, Kyoto.[5] That Tan'yū knew these scrolls, which include parodies of animals imitating monks and courtiers, is attested by his *shukuzu*; they may well have been a source for this motif.[6]

GWN

1. Nakahashi 1990, fig. 3.
2. Ibid., fig. 4.
3. Ibid., p. 38.
4. Yasumura Toshinobu 1978, p. 30. Yasumura's observation is based on an entry in the *Ingen Oshō unto nishū*, one of a series of poetry compilations by Ingen; see Ingen 1979, vol. 6, p. 2877. See also Fuji Masaharu and Abe Zenryō 1977, p. 137.
5. Tanaka Ichimatsu 1959, pl. 3.
6. Kyoto National Museum 1980–81, vol. 1, p. 63.

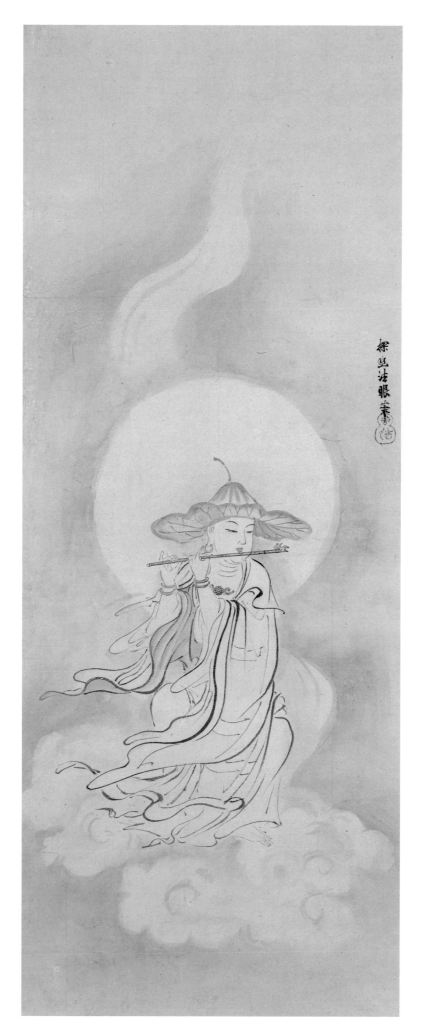

109. *Two Albums with Scenes from the "Genji monogatari"*

Edo period (1615–1868), early 17th century
Two albums of thirty leaves each, ink, red pigment, and gold on paper
Each album leaf 13.4 × 12.9 cm (5¼ × 5⅛ in.)
Seal: *Tosa Mitsunori*

LITERATURE: Murase 1975, no. 59; Mayuyama Junkichi 1976, no. 427, illus. (four leaves); Murase 1983b, illus. (forty-one leaves); Murase 1985, fig. 11 (one leaf); Tokyo National Museum 1985a, no. 39, illus. (four leaves); Akiyama Ken and Taguchi Eiichi 1988, illus. pp. 256–63 (all sixty leaves); Schirn Kunsthalle Frankfurt 1990, no. 68, illus. (one leaf); Guth 1996, fig. 36 (one leaf).

Written in the eleventh century by Murasaki Shikibu, an aristocratic lady of the late Heian court, the *Genji monogatari* (The Tale of Genji) is considered one of the world's great literary works. It became a source not only for poets but also for artists, who illustrated scenes from the story in many mediums—including books, handscrolls, and screens—from the twelfth century into modern times (cat. nos. 81, 82, 87, 110; and pages 204–5).

The five paintings shown here are selected from two small albums by Tosa Mitsunori (1583–1638) dating from the early seventeenth century. Sixty leaves illustrating all fifty-four chapters of the *Genji monogatari* are evenly distributed between the albums. There is no text, and as the usual practice of representing each chapter with one illustration has been ignored in several instances, identification of individual scenes is sometimes problematic. This difficulty is compounded by the fact that a recent remounting disturbed the original sequence in which the leaves were pasted into the albums. Moreover, because the images often deviate from the standard *Genji* formula, identification must often rely on minor motifs, such as flowers or birds that relate to a specific season or to an incident in the narrative.

A large seal in black ink reading "Tosa Mitsunori" was recently exposed when a flap was cut in the backing paper of the last leaf. It is likely that the same seal is impressed on the back of each leaf, as was the custom of the artist who was either Mitsunori's father or his teacher, Tosa Mitsuyoshi (cat. no. 81). Mitsunori's fine, detailed drawing style clearly derives from the manner of Mitsuyoshi. The compositions in the Burke albums are even smaller than Mitsuyoshi's, reflecting a trend among illustrators of courtly tales after the late Muromachi period.

Another set of *Genji* drawings by Mitsunori is in the collection of the Freer Gallery of Art, Washington, D.C.[1] Both the Burke and the Freer albums are executed in the exquisite ink-painting style known as *hakubyō* (white drawing), which distinguishes it from the dynamic, Chinese-inspired ink brushwork that had flourished in Japan since the Muromachi period. When *hakubyō* was first

developed, in the Late Heian period, it was admired for possessing a subtlety not possible in polychrome *yamato-e*.[2] No Heian examples of *hakubyō* have survived; the earliest extant works of this type date to the Kamakura period. From the second half of the thirteenth century, the technique was often chosen to illustrate romantic novels of the Late Heian period, such as the *Ise monogatari* (Tales of Ise) and the *Genji monogatari*. *Hakubyō* is characterized by thread-thin, unmodulated ink lines that outline figures as well as architectural and landscape elements. The monochromatic presentation is highlighted by tiny, barely perceptible dots in red, on such details as lips or flames. The effect of fragile delicacy is dramatically interrupted by isolated areas of heavy black ink, used for tall court hats or for the undulating cascades of jet black hair. Set against the pale delicacy of the background and figures, these solid black shapes form abstract patterns of unexpected beauty.

Mitsunori—whose career took him from Sakai to Kyoto, the old capital city—may have been attempting to revive the classical *hakubyō* style in these album leaves, though his drawings are less dramatic than the Kamakura-period works. He embellished the garments of both male and female figures with minuscule designs, softening the effect of the stark, black elements against the spidery ink lines. He drew even the smallest objects in minute detail, rendering them barely visible to the naked eye. It has been suggested that Mitsunori used a magnifying glass to execute his work;[3] lenses had become quite popular in Japan soon after they were introduced from the West, in the mid-sixteenth century.

Sakai, when Mitsunori was in residence there, was a busy port city, one that often set the latest fashion trends. In 1633, however, the government's ban on foreign trade dealt a severe blow to the local economy, which may have prompted Mitsunori's return to Kyoto the following year. The decision was a wise one, as Mitsunori's son, Mitsuoki (1617–1691), eventually regained the position which in the past had belonged to the head of the Tosa school, that of official artist to the imperial court.

An episode from "Kiritsubo" (The Paulownia Court), the first chapter in the novel explains why Genji, a son of the reigning emperor, is not chosen to succeed to the throne: a visiting Korean physiognomist, who is moved by the boy's intelligence and beauty, believes it would be wise to keep Genji out of the line of succession, as misfortune would certainly befall him.[4] In the image shown here (a), the meeting between the Korean sage and the young prince takes place in a walled courtyard beneath a canopy of softly glowing golden clouds (suyari). Genji's carriage and retinue wait outside the wall. The composition is nearly identical to that of a painting by Mitsuyoshi in another Genji album, now in the Kyoto National Museum.[5]

One of the few outdoor scenes in the entire album, the second drawing (b) depicts an episode from chapter 16, "Sekiya" (The Gatehouse), in which Genji and his former lover, Utsusemi, the Lady of the Locust Shell, are shown at a chance meeting.[6] The two had had a brief affair, but the lady subsequently moved to a faraway province to be with her husband. Now, returning to enter a nunnery, she pauses at the Osaka barrier, outside the city. Genji arrives at the same barrier while on a pilgrimage to the nearby temple of Ishiyamadera. Because of the difference in their social postions, the former lovers can exchange only poems. As if to suggest the disparate paths the two must follow, most paintings of this episode depict two groups of travelers separated by a mountain barrier.

Chapter 38, "Suzumushi" (The Bell Cricket), describes the aftermath of Genji's betrayal by his wife, the tragic Third Princess. The young woman has decided to become a nun, as penance for her sad love affair with Kashiwagi, the son of Genji's best friend. In the third illustration (c), the princess offers prayers to the Buddha. It is a warm summer day, lotus flowers are in full bloom in the garden pond. Ladies-in-waiting crowd the room, incense burners have been placed on the floor, and small boys walk about. Genji peeks through a curtain to watch the princess, who is seated on a sumptuous dais partially concealed by curtains.[7]

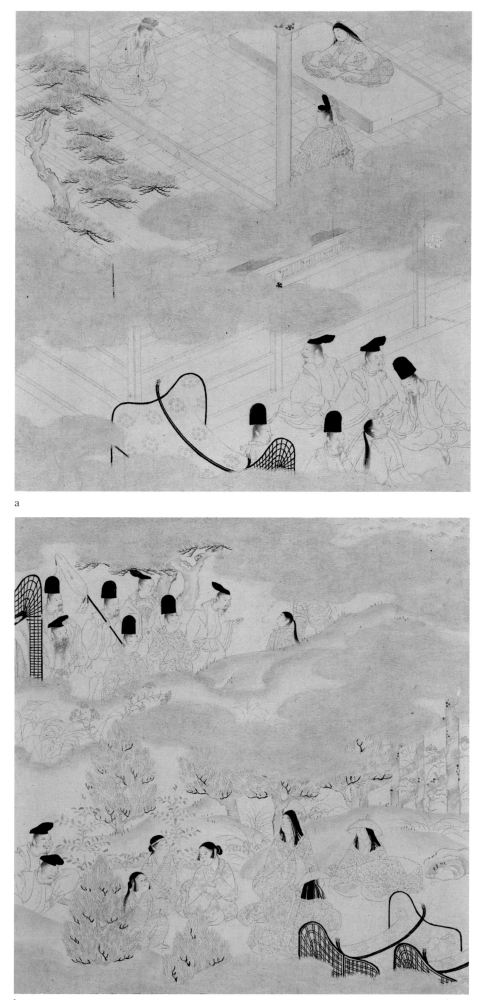

a

b

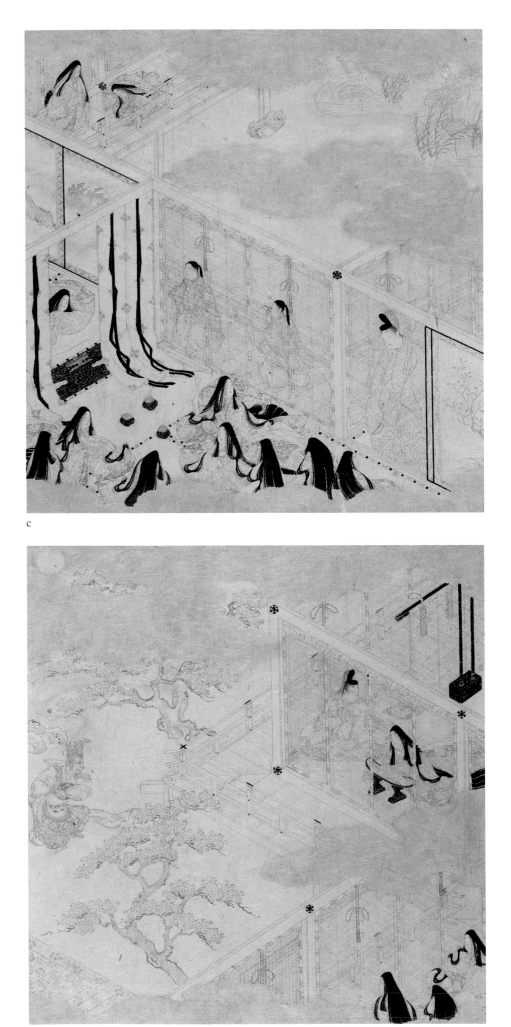

c

d

As the narrative proceeds, Murasaki, Genji's favorite consort, has been ill for some time. In this scene from chapter 40 (*d*), "Minori" (The Rites), a *Lotus Sutra* is dedicated to the Buddha in anticipation of her death. The chanting continues through the night, and a dancer performs to the intricate beat of the drum.[8]

Genji never recovers from the loss of his beloved Murasaki, and the death of Genji himself, at age fifty-two, is hinted at in chapter 41, "Maboroshi" (The Wizard). From chapter 42, "Nioumiya" (His Perfumed Highness), the principal heroes of the tale are Niou, Genji's grandson and third son of the reigning emperor, and Kaoru, born of the illicit affair between the Third Princess and Kashiwagi. The pursuit of women takes these two highly sought after and handsome young men to Uji, outside Kyoto. The final ten chapters are often distinguished from the rest of the narrative as the "Uji jūjō" (The Ten Chapters at Uji).

Episodes from the "Uji" chapters center around Kaoru's futile efforts to capture the heart of Ōigimi, the eldest daughter of Genji's half brother. Constantly in doubt about his own identity, Kaoru is unsuccessful in his search for love. In the fifth illustration (*e*), a scene from chapter 47, "Agemaki" (The Trefoil Knots), Kaoru makes an autumn visit to Uji, in a doomed attempt to win Ōigimi's hand. Uji Bridge (see cat. no. 80) is visible in the distance, and the late autumn moon hangs in the sky.[9]

1. The Freer album comprises only thirty leaves of drawings, with an equal number of text pages. Each page measures 13.7 × 14.9 centimeters (5⅜ × 5⅞ in.). See Murase 1983b; and Akiyama Ken and Taguchi Eiichi 1988.
2. For other examples of *hakubyō*, see Shinbo Tōru 1970.
3. Kobayashi Tadashi 1972b, p. 21.
4. Murasaki Shikibu 1976, pp. 14–15.
5. For a color reproduction, see Akiyama Ken and Taguchi Eiichi 1988, p. 30.
6. Murasaki Shikibu 1976, pp. 303–4.
7. Ibid., pp. 668–69.
8. Ibid., pp. 713–15.
9. Ibid., p. 834.

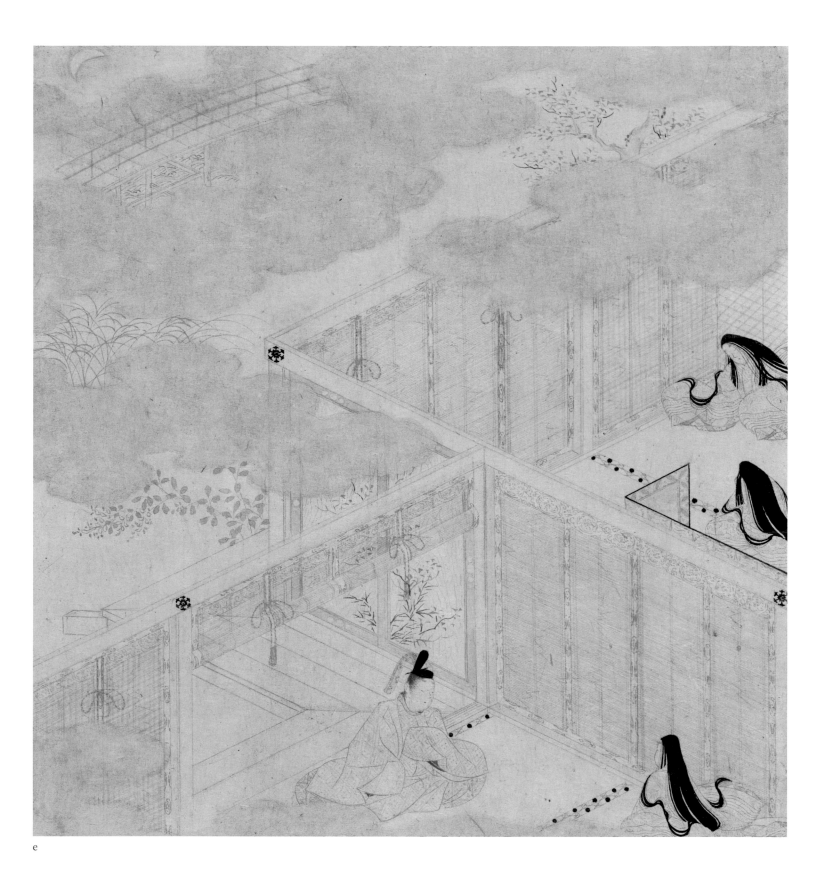

e

110. *Genji monogatari hakkei*

Edo period (1615–1868)
Handscroll, ink, color, and gold on silk
33 × 768 cm (13 in. × 25 ft. 2 in.)
Signature: *Sahyōe no Kami Mototada*
Seal: *Mototada*

Soon after the Chinese theme of the Eight Views of the Xiao and Xiang Rivers (cat. nos. 64, 77) was introduced to Japan in the mid-thirteenth century,[1] it was assimilated into Japanese literature and painting, gradually losing its original association with Zen Buddhism and assuming a connection to Japanese secular life. By the early fourteenth century, this thoroughly Chinese theme had become especially popular with poets who specialized in *waka*, the ultimate expression of Japanese culture. It is not surprising that the *Genji monogatari*, with its rich, poetic allusions to the seasons and to beautiful and evocative sites, was used as a source of inspiration for depictions of the Eight Views.

The earliest known text in which the Eight Views are combined with scenes from the *Genji* is one that was copied by Emperor Higashiyama (r. 1687–1709) and is now in the Museum of the Imperial Collections, Tokyo; a later copy, of 1768, is in the collection of Kyoto University. The present handscroll, with text and titles inscribed by eight unidentified calligraphers and paintings by Ishiyama Moroka (1669–1734)[2] may be the earliest known example of *Genji monogatari hakkei* (The Eight Views from the Tale of Genji).

Chinese artists did not observe a specific sequence of the Eight Views. Once the theme was introduced to Japan, however, it became customary to interpret *Mountain Market, Clearing Mist* as a scene of spring, thus to be placed at the beginning, and for *River and Sky in Evening Snow*, a winter scene, to be placed at the end.

The artist of the Burke scroll here signed with his youthful name, "Sahyōe no Kami Mototada." A high-ranking courtier and a pupil of Kano Einō (1631–1697), at that time the leading Kano artist in Kyoto, Moroka was known also for his *waka* poetry and for his carvings. Despite their lack of sophistication, these paintings from his youthful period are charming in their directness and sweet, high-key coloration. Moroka seems to be working here without the benefit of an earlier model and to be struggling, often without much success, to incorporate the scenes of the Eight Views into the *Genji* episodes. Invariably, the

eight scenes depict Genji (and in one case his son, Yūgiri) seated or standing in a room at the right side of the composition, with the remaining space filled with a cursory description of settings that distinguish one scene from another.

a. "Hahakigi" (chapter 2, The Broom Tree); Eight Views: *Night Rain on the Xiao and Xiang Rivers*.

The sixteen-year-old Genji is seen at home on a rainy summer evening. Guests will arrive shortly. The lively discussion that ensues about the merits—and the failings—of women, known as the "Critique of Women on a Rainy Night," became quite well known.[3]

b. "Matsukaze" (chapter 18, The Wind in the Pines); Eight Views: *Sails Returning from a Distant Shore*.

Genji is seen standing on a sandspit watching a small boat being poled across the Inland Sea. The lady from Akashi is about to arrive in Kyoto.[4]

c. "Yūgiri Seikishō" (chapter 39, Evening Mist); Eight Views: *Sunset over a Fishing Village*.

Genji's son, Yūgiri, comes to visit his new love at Ono, outside the capital. Although the text states that the setting sun is so bright that Yūgiri shields his eyes with his fan, the sun is not represented in the painting and this gesture is not included. The deer on the hillocks at the left are an allusion to autumn.[5]

d. "Tamakazura" (chapter 22, The Jeweled Chaplet); Eight Views: *Mountain Market, Clearing Mist*.

Genji is shown in his apartments, thinking of Tamakazura, the daughter of his lost love Yūgao and his best friend, who is on her way to Kyoto from the provinces.[6]

e. "Akashi Banshō" (chapter 13); Eight Views: *Evening Bell from a Mist-Shrouded Temple*.

Genji, exiled to Akashi and filled with sadness, is seen looking out toward the bell tower on

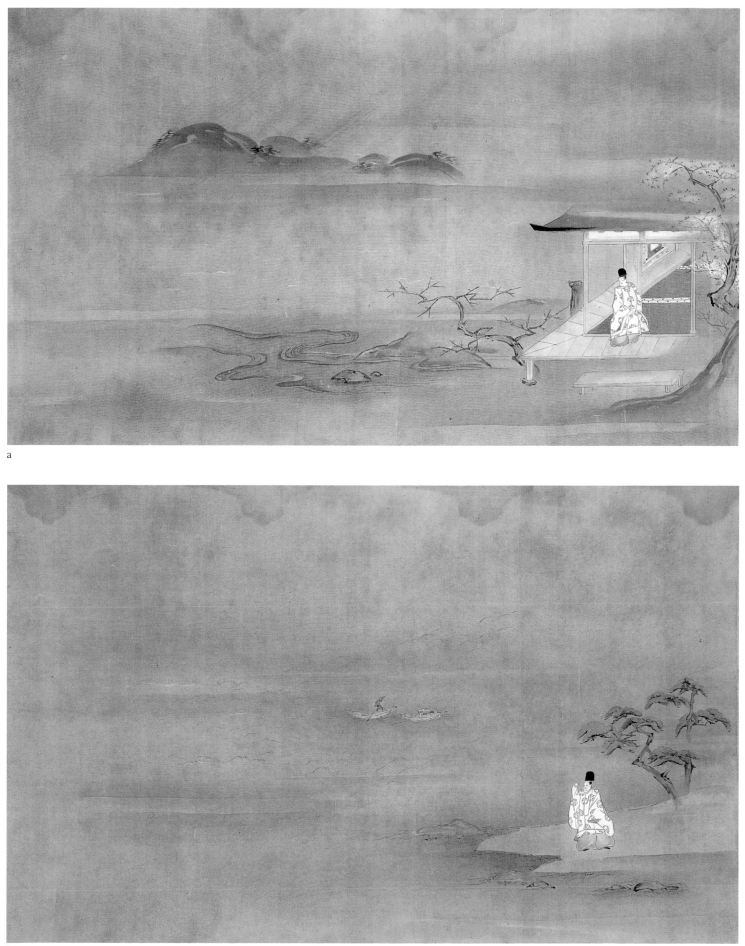

a

b

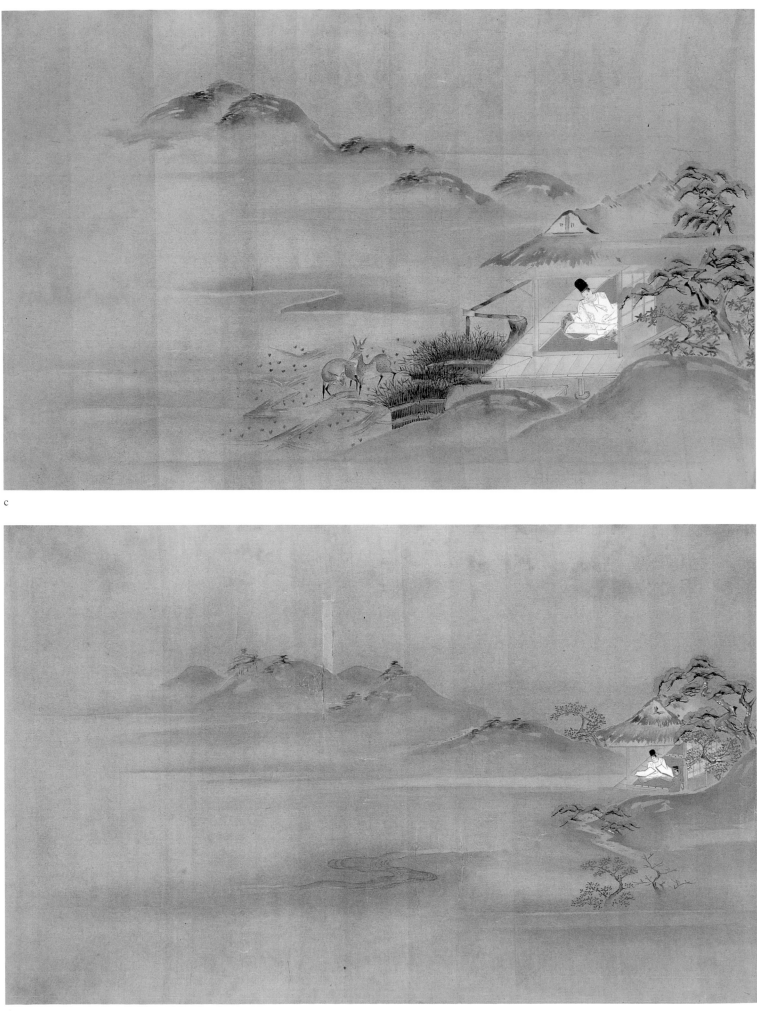

c

d

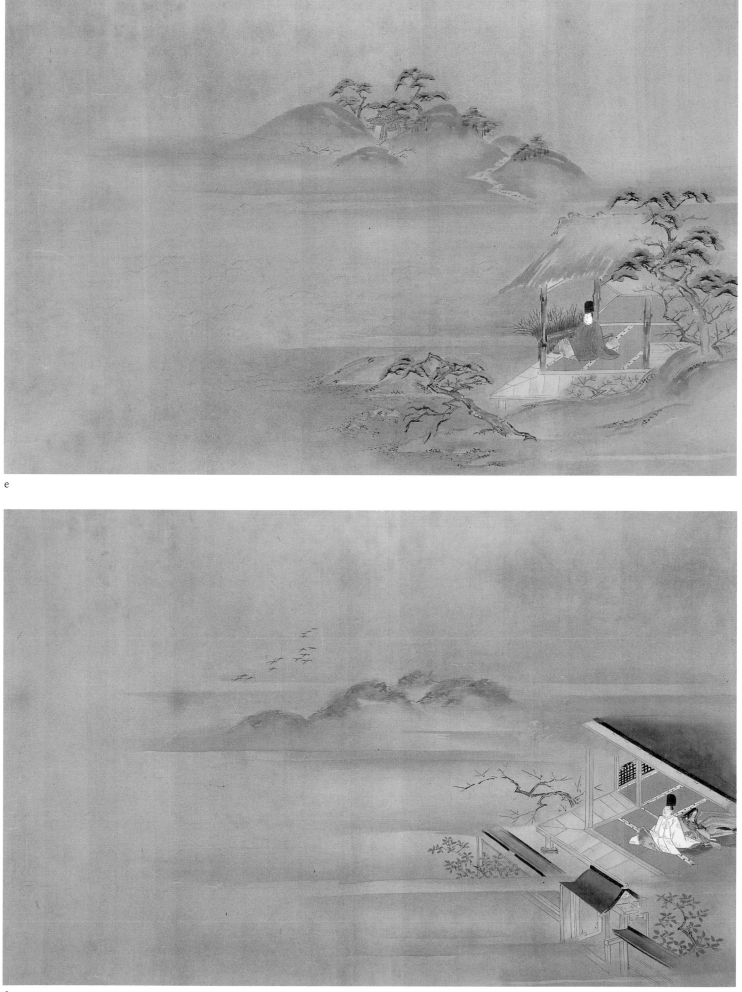

e

f

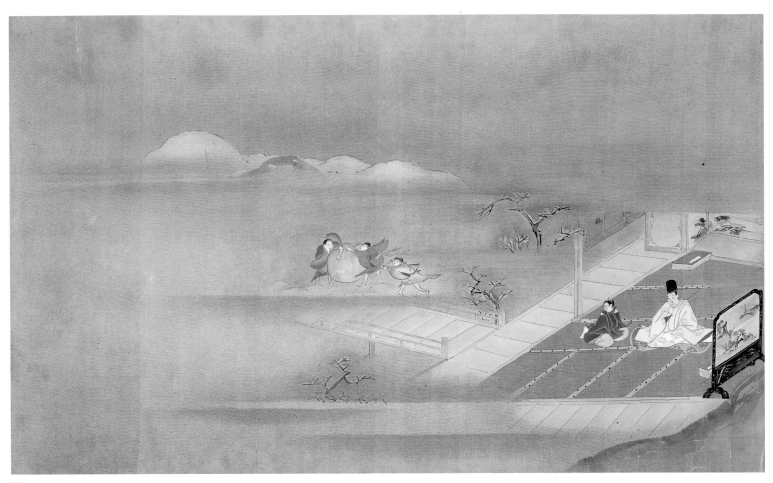

g

h

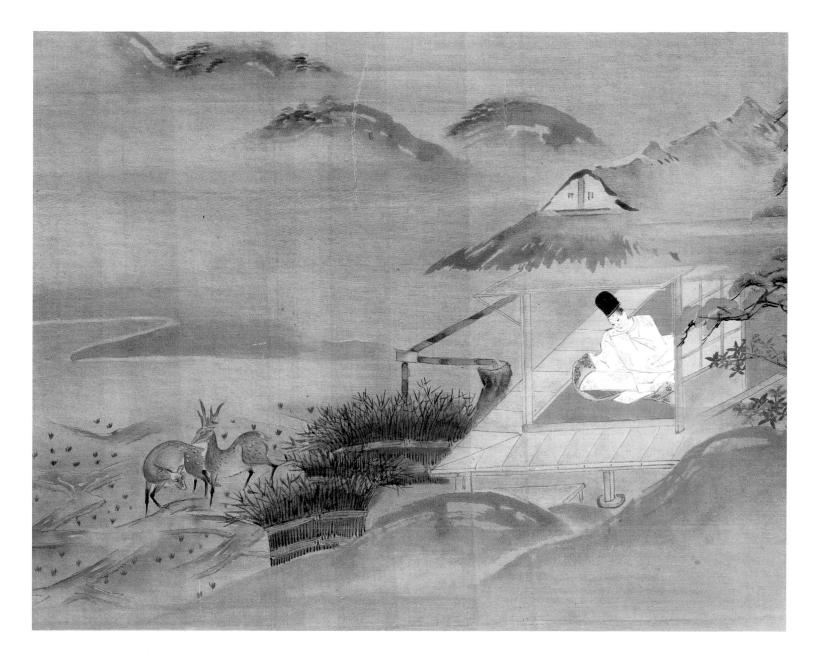

the mountain across the water; it is one of the artist's most faithful depictions of the text.[7]

f. "Otome Hatsukari" (chapter 21, The Maiden); Eight Views: *Wild Geese Descending on a Sandbank.*

Yūgiri is shown gazing pensively at the sky. Visiting his grandmother, he attempts without success to see his sweetheart, Kumoinokari. "The wind rustled sadly through the bamboo thickets and from far away came the call of a wild goose."[8]

g. "Asagao Bosetsu" (chapter 20, The Morning Glory); Eight Views: *River and Sky in Evening Snow.*

In this scene, one of the most popular and frequently illustrated, Genji and his favorite

lady, Murasaki, are seated indoors watching their servants build a snowman in the wintry garden.[9] Moroka apparently misunderstood the passage he was illustrating, for the servants are boisterous young boys, not the little maidservants described in the text. This scene displays the artist's Kano-school training to best advantage. Both the sumptuous *tsuitate* (small, freestanding screen) in Genji's room and the walls of the *tokonoma* (alcove) are decorated with ink landscape paintings executed in *mokkotsu*, the boneless technique. They appear to represent scenes from the Eight Views—perhaps, on the *tsuitate*, *Evening Bell from a Mist-Shrouded Temple*, suggested by the tall pagoda.

h. "Suma Shūgetsu" (chapter 12); Eight Views: *Autumn Moon over Lake Dongting.*

In exile in the area of Suma–Akashi, Genji looks out across Osaka Bay at the radiant harvest moon and is reminded of happier days in the capital.[10]

1. Horikawa Takashi (1989, p. 101) believes that the theme was introduced in 1269 by the monk Daikyū Shōnen (Ch: Daxiu Zhengnian, 1211–1285).
2. The life dates for this artist are given in the *Koga bikō* as 1672 to 1734. See Asaoka Okisada 1905 (1912 ed.), p. 79.
3. Murasaki Shikibu 1976, pp. 21–38.
4. Ibid., p. 322.
5. Ibid., p. 695.
6. Ibid., p. 400.
7. Ibid., p. 262.
8. Ibid., p. 371.
9. Ibid., p. 357.
10. Ibid., p. 238.

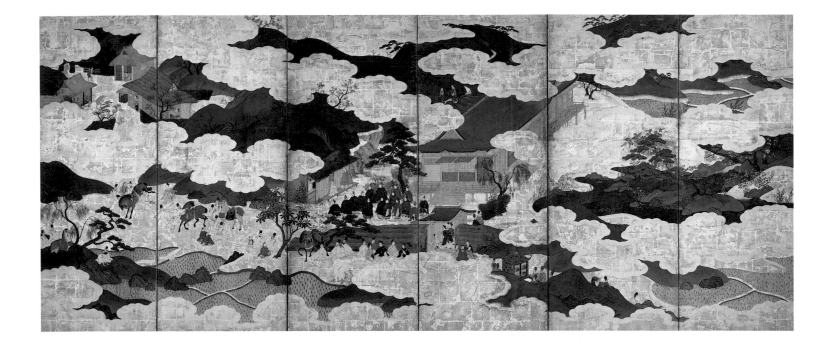

111. From the "Heike monogatari"

Edo period (1615–1868), first half of 17th century
Pair of six-panel folding screens, ink, color, and
gold on gilded paper
Each screen 154.7 × 360.4 cm (5 ft. ⅞ in. ×
11 ft. 9⅞ in.)

LITERATURE: Nagazumi Yasuaki et al. 1979,
fig. 237 (detail of the right screen); Takeda Tsuneo
1980b, nos. 84, 85 (left screen); Tokyo National
Museum 1985a, no. 29; Miyajima Shin'ichi 1986,
figs. 86, 87 (details of the left screen); Ford 1997,
pp. 41–45.

The sound of the Gion Shōja bells echoes
the impermanence of all things; the color
of the *sala* flowers reveals the truth that
the prosperous must decline. The proud
do not endure, they are like a dream on a
spring night; the mighty fall at last, they
are as dust before the wind.[1]

With these elegiac lines—among the most
widely quoted in Japanese literature—begins
the *Heike monogatari* (The Tale of the Heike),
the dramatic account of the changing fortunes
and final collapse of the mighty Heike clan.

The brief period in which the Heike clan
exerted control over the imperial court began
and ended during Go-Shirakawa's reign of
influence as retired emperor (1158–92). Their
rise to power was the culmination of a series
of skirmishes among three contending fami-
lies—the Fujiwara, the Heike (Taira), and
the Minamoto (Genji)—during the Hōgen
(1156–58) and Heiji (1159–60) eras. Taira
Kiyomori (1118–1181), patriarch of the
Heike, emerged victorious, and by 1168 he
had all but attained a position that no mem-
ber of a military family had held before, that
of de facto ruler of the court. In 1180, he
managed to install his grandson, aged three,
as Emperor Antoku (r. 1180–85). But
Kiyomori's triumph was short-lived. That
same year the Minamoto clan, led by Yori-
tomo, rallied to defeat him. In early 1185 at
Dan'noura, at the mouth of the Inland Sea,

Yoritomo's army routed the Heike forces,
and the entire clan—including the child-
emperor Antoku—perished in the sea. Not
long after, in 1192, Yoritomo became the first
shogun of Japan (r. 1192–99).

Stories of the Heike's meteoric rise and
calamitous fall were first transmitted orally,
by blind minstrels, and many years passed
before they were written down. The final
version took shape about the middle of the
thirteenth century, after many revisions by a
number of writers, nobles as well as monks.
The *Heike monogatari* ranks as Japan's finest
epic, on the same level as the *Genji mono-
gatari*, the pinnacle of classical romantic
narrative.

The tale of the Heike differs from the
fictional story of Prince Genji in that it is a
historical chronicle, a record of battles,
accounts of brave deeds and occasional acts
of cowardice, interspersed with tragic tales
of love. Its twelve chapters and epilogue are
written in crisp, rhythmic phrases, and it is
easy to understand why recitation of the text
became so popular at social gatherings. The
Heike narrative also served as a model for
later military tales and inspired many the-
atrical works.

Because the tale includes an enormous
number of characters and incidents and has
no protagonist, early attempts to illustrate
the entire narrative were probably unsuccess-
ful. The earliest known reference to a *Heike*

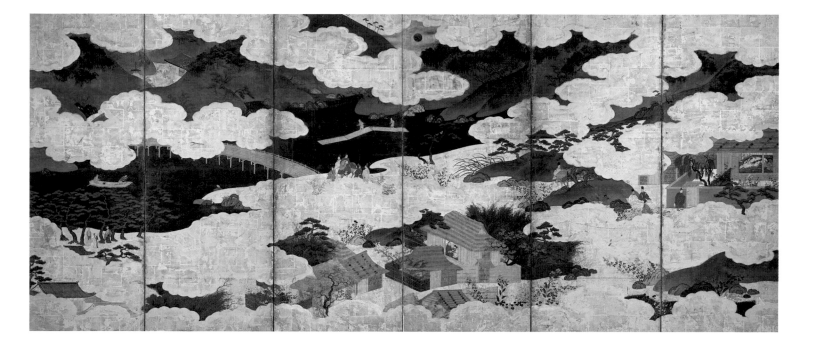

painting dates to 1438.[2] A series of forty books of *Heike* paintings is described as having been in the Imperial Collection.[3] And three handscrolls of what is believed to have been an eight-scroll set attributed to Tosa Mitsunobu (fl. 1469–1523) are extant.[4] The largest surviving complete set, in the Hayashibara Museum of Art, Okayama, dates to the eighteenth century and consists of thirty-six scrolls.[5] Other extensive groups of *Heike* pictures, also dating to the eighteenth century, are painted on small fans.[6]

A different type of Heike-related illustrated handscroll dates to a much earlier period and focuses on individual characters from the narrative. One example from the late thirteenth century recounts the story of Lord Takafusa's unrequited love for Lady Kogō, the subject of the right screen in the Burke Collection.[7] More commonly chosen for depiction on Heike screens are scenes of combat and the episode shown on the left screen in the present pair—the meeting at Ōhara between Go-Shirakawa and Kenreimon'in, Kiyomori's daughter and the mother of Antoku, after the debacle at Dan'noura.[8]

The story of Lady Kogō, recounted in chapter 6, is one of the many tragedies caused by Kiyomori's overriding ambition to marry his daughters into the imperial family so that one of their offspring would become emperor, giving him—as grandfather of the ruler—even more political power. Kogō, a renowned

beauty and an accomplished *koto* player, became lady-in-waiting to Kenreimon'in, married to Emperor Takakura (r. 1168–80). Kogō soon attracted the attention of Lord Takafusa, who was married to another daughter of Kiyomori. Takafusa was forced to renounce his love when the emperor became infatuated with Kogō. The love triangle involving both his sons-in-law infuriated Kiyomori, and Kogō was banished from the court. One autumn evening when the full moon was out, the despondent Takakura sent his retainer Nakakuni to search for the young woman. His attention drawn by the sound of Kogō's music, Nakakuni found her at last, in the area of Saga, northwest of Kyoto. Kogō finally agreed to return to the capital, where for a time she lived in secret and gave birth to a baby girl. Her whereabouts were eventually discovered by the vindictive Kiyomori, who forced her to become a nun. She died not long after, at the age of twenty-three.

The right screen contrasts with its companion in many respects. The season is autumn and the day is drawing to a close. The composition, which opens out toward the Ōi River and is pervaded by a melancholy lyricism, is relatively empty of human figures. While the left screen closely follows details given in the *Heike* text for the natural setting, the right screen relies on the artist's own invention. The text of this episode says little about the setting, referring only to the full

moon and a pair of stags. The image in the third panel from the right, of women fulling cloth, also alludes to autumn. In the sixth panel, two cormorant fishermen are seen, as are two monks and an acolyte, who must be from Hōrinji, across the river; both groups provide visual references to place-names given in the text.

Nakakuni appears twice with his retinue in this screen. Thinking that Kogō may be found near Hōrinji, he stops (in the fourth panel) at the foot of the bridge, and (at the extreme right) he arrives at Kogō's hiding place and tries to persuade her attendant to admit him. Kogō is seen within, playing the *koto*.

The left screen depicts events from the "Kanjō no maki" (The Initiate's Chapter), actually an epilogue that describes Go-Shirakawa's unannounced visit to Ōhara. The bereaved mother, Kenreimon'in, has retired to a nunnery there after having been rescued by Minamoto soldiers when she threw herself into the Inland Sea with the other members of her family. Summer is just beginning in the quiet mountain retreat: "Young grasses burgeoned in the courtyard, green willow branches tangled in the wind. . . . The wisteria clinging to the islet pines had put forth purple flowers."[9]

In the third panel from the right, the ex-empress and her attendant, dressed in the gray-and-black habit of Buddhist nuns, may

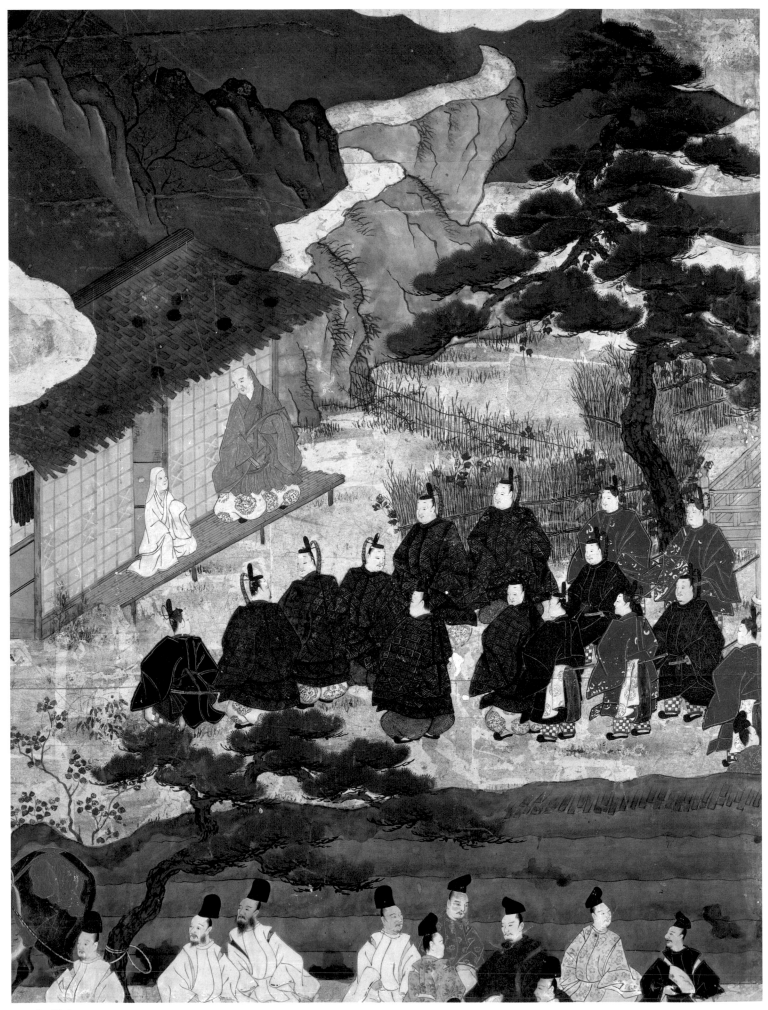

Detail of left screen, cat. no. 111

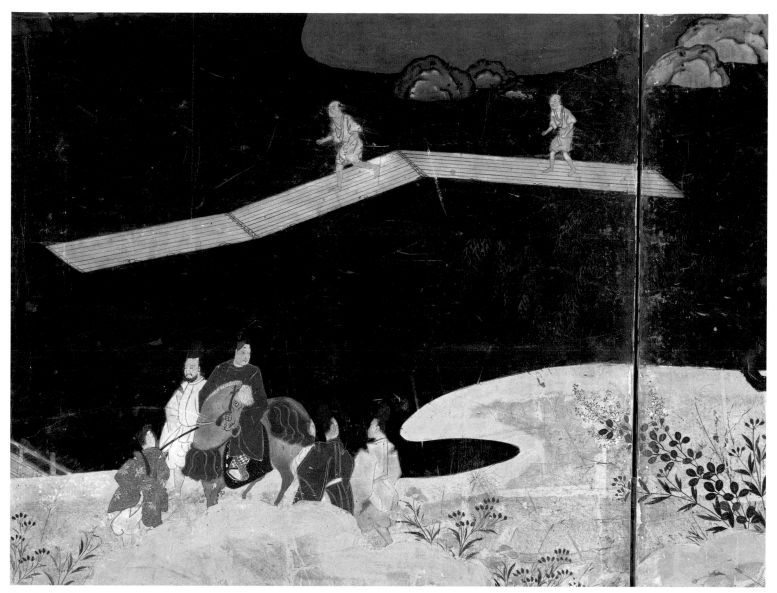

Detail of right screen, cat. no. 111

be seen walking in the hills, where they gather flowers. A steep mountain path descends to the nunnery. There, the retired emperor stands on the veranda of a run-down hut and a crowd of followers fills the narrow courtyard. In keeping with the text—"By way of visitors, there were only the cries of monkeys . . . and the sounds of woodcutters' axes"[10]— the painting includes a pair of monkeys (at the top of the fourth panel) and an old man cutting wood (at the top of the sixth).

The Ōhara and Kogō episodes were rarely paired on folding screens. The only other known example of this combination has been tentatively identified as the work of Hasegawa Kyūzō (1568–1593), eldest son of the famous Tōhaku (1539–1610).[11] The arrangement of pictorial elements in the Burke Kogō screen

closely resembles the image painted by Kyūzō. Stylistically, however, the work can be attributed to a Tosa artist. Characteristic of that school are the mountains and hills with gentle, rounded profiles, the ink outlines on rocks, the delineation of human figures with thin, gentle brushlines, and the large trees silhouetted against the background as two-dimensional forms. Moreover, the delicacy and elegance of autumn grasses and flowers are reminiscent of the miniature plant motifs in many *Genji* paintings by Tosa masters (cat. nos. 81, 82).[12] Such stylistic features also suggest that this pair of screens were painted at the beginning of the Edo period, during the first half of the seventeenth century.

1. *Tale of the Heike* 1988, p. 23.

2. *Kanmon gyoki*, entries for the eighth, tenth, thirteenth, and sixteenth days, sixth month, tenth year of the Eikyō era (1438). See *Kanmon gyoki* 1944.
3. Ibid., entry for the sixth month, twenty-sixth day, of the same year.
4. Kurokawa Harumura 1885–1901, vol. 10, pp. 27–28; and Miyajima Shin'ichi 1986, fig. 54.
5. Komatsu Shigemi 1994–95.
6. These sets, of sixty fans each and painted in the eighteenth century, are in the Nezu Institute of Fine Arts, Tokyo, and the Gene Zema collection, Seattle. Thirty fans of a similar group of sixty are in the Museum für Ostasiatische Kunst, Berlin.
7. Murase 1983a, no. 11.
8. Murakami Genzō 1975, p. 12.
9. *Tale of the Heike* 1988, p. 430.
10. Ibid., p. 431.
11. Sale catalogue, Yamanaka and Company 1939, no. 174.
12. Miyajima Shin'ichi (1986, pp. 76–77) believes that Tosa Mitsuyoshi was the first artist to pair the Ōhara and Kogō episodes, but this cannot be verified.

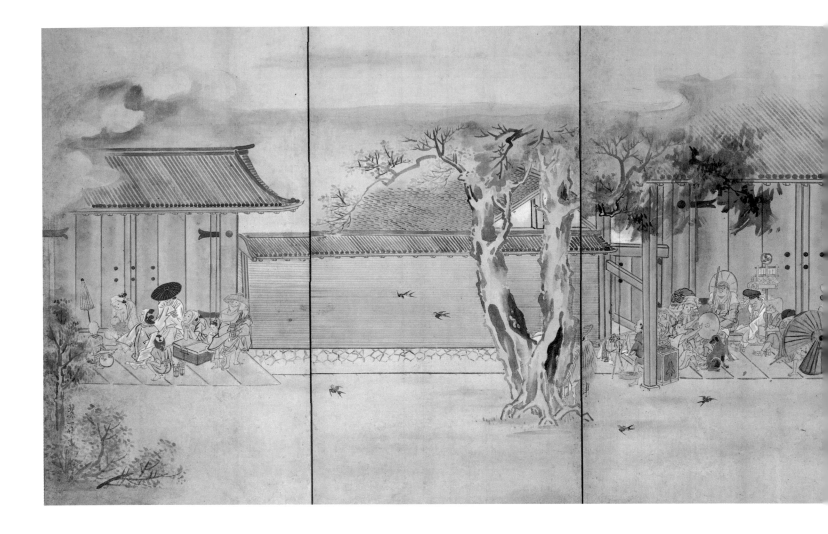

HANABUSA ITCHŌ (1652–1724)

112. *Taking Shelter from the Rain*

Edo period (1615–1868), after 1709
Six-panel folding screen, ink and color on paper
121.3 × 316.2 cm (3 ft. 11¾ in. × 10 ft. 4½ in.)
Signature: *Hanabusa Itchō egaku*
Seals: *Shuzai San'un Senseki kan* and *Ai Moko*

LITERATURE: Kobayashi Tadashi 1968, pp. 28, 29, and 31; Tsuji Nobuo 1968, p. 35; Murase 1971, no.8926; Takeda Tsuneo 1977b, no. 98; Kobayashi Tadashi and Sakakibara Satoru 1978, no. 48; Tsuji Nobuo 1980, no. 105; Kobayashi Tadashi 1988, fig. 10; Murase 1990, no. 27; Kobayashi Tadashi and Kano Hiroyuki 1992, no. 39; Meech-Pekarik 1993, no. 15; Screech 1995, fig. 1.

A diverse group of travelers takes shelter from a sudden downpour. Heavy rain clouds envelop the rooftops, while the leaves of nearby trees rustle in the wind. A creek, already flooded, is visible at the right, and wild grasses heavy with moisture bend toward the ground. Four men preceded by a bamboo vendor rush to seek shelter under the wide-eaved gate of a large estate, where men and women from different walks of life—a warrior, assorted pilgrims, a lion-dance performer, a flower vendor, a bookseller with a stack of books—are huddled under the roof. A restless child, blissfully untroubled by the rainstorm, hangs upside down from a beam. At the smaller gate to the left, a young mother nurses her baby among a group of women, and swallows flutter about a tree, agitated by the storm. Light washes of color and fluid brushstrokes in soft ink convey an impression of wetness and sudden chill.

The subject of the painting—a moment in the day-to-day life of common people—is true genre, apparently chosen by the artist, Hanabusa Itchō (1652–1724), to represent the summer season. A handscroll by Itchō in the Honolulu Academy of Arts depicts activities of the calendar year and includes a nearly identical scene to mark the month of June.[1] Itchō may have been particularly fond of this subject, as he used it again on a very similar but slightly smaller screen now in the collection of the Tokyo National Museum.[2]

Born in Kyoto, the son of a physician, Itchō was taken to Edo by his parents at the age of eight (or fifteen, according to some scholars). There he entered the studio of Kano Yasunobu (1613–1685), a younger brother of Kano Tan'yū (cat. nos. 107, 108) and one of the leading painters of his time. It is generally believed that he was expelled from the Kano studio, but no evidence exists to support this claim. On the contrary, Itchō

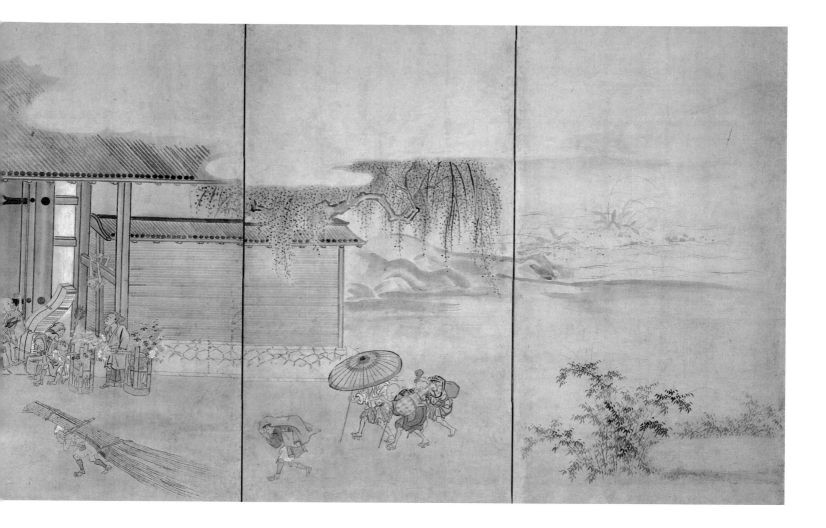

apparently maintained a close relationship with Kano masters until late in his life. Working under the name "Taga Chōko," he also studied *haikai*, a type of chain poetry from which the seventeen-syllable *haiku* developed, with Matsuo Bashō (1644–1694), the master of the genre. As Chōko, he published a collection of his own poetry. He also came to admire *ukiyo-e* (see cat. nos. 146–151), which was rapidly gaining popularity in Edo. In the *Shiki-e batsu* (Commentary on Paintings of the Four Seasons), an autobiographical essay written in 1718, when he was sixty-six,[3] he explains that he had studied *ukiyo-e* with the goal of surpassing Iwasa Matabei (1578–1650) and Hishikawa Moronobu (ca. 1618–1694), the two giants of *ukiyo-e* art. Itchō's own youthful activities in the pleasure district of Yoshiwara are well documented. In 1698, he was implicated in a scandal involving Yoshiwara and its clientele. Arrested and sent into exile on Miyakejima, a remote

island south of Edo, he spent eleven years as a convict before being pardoned in 1709.

During his years on the island, Itchō eked out a living selling food and occasionally executing paintings for the island's residents.[4] Most of these were simple, casual pictures that exhibit a noticeable decline in quality. But his work after his return to Edo in 1709, when he adopted the name "Hanabusa Itchō," regained its former authority. This new phase—particularly the first half of the remaining fifteen years of his life—was remarkably productive, and it is to this period that the Burke screen is assigned. The screen also recalls Itchō's youthful involvement with *haikai*, in which the "sudden shower" motif was extremely popular.

During his final years, Itchō returned to the classical themes of China and Japan, which he had explored in his youth at the Kano studio. His own school flourished and produced a number of able pupils, and he

had as well many later admirers, some of whom, like Kō Sūkoku (1730–1804) and Teisai Hokuba (1771–1844), painted copies of this screen, thereby contributing to the revival of interest in Itchō's work.

1. Narazaki Muneshige 1969, p. 45.
2. Kobayashi Tadashi 1988, fig. 9. Kobayashi believes that the Tokyo version was painted after the Burke screen.
3. Reprinted in Kobayashi Tadashi and Sakakibara Satoru 1978, p. 119.
4. For Itchō's activities on the island, see Kobayashi Tadashi 1968, pp. 5–20; and Tsuji Nobuo, Kobayashi Tadashi, and Kōno Motoaki 1968, pp. 36–46.

KATŌ NOBUKIYO (1734–1810)

113. *Ten Rakan Examining a Painting of White-Robed Kannon*

Edo period (1615–1868), 1792
Hanging scroll, ink, color, and gold on paper
130.3 × 57.7 cm (55¼ × 22¾ in.)
Signature: *Hokekyō ichibu yokan o motte kinsho Enjinsai Nobukiyo*
Seals: *Nobukiyo*; *Nobukiyo In*; and *Kudoku Muhen*

LITERATURE: Kaufman 1985, figs. 13, 14; Pal and Meech-Pekarik 1988, figs. 130, 131; Schirn Kunsthalle Frankfurt 1990, no. 104; Murase 1993, no. 7; A. N. Morse and S. C. Morse 1995, no. 50.

The artist Katō Nobukiyo (1734–1810), once all but forgotten, is today enjoying a modest revival. A minor official in the Tokugawa government who lived in Edo, he left his family in his early fifties and took vows of abstinence. In 1788, he began a project to produce a group of fifty rakan paintings, each with ten figures.[1] To this set Nobukiyo added a painting of a Shaka Triad.[2] The fifty-one scrolls were completed in 1792 and dedicated to Ryūkōji, Edo.[3] A seal reading "Kōfu Ryūkō Zenji Jyūbutsu" (A Treasure of the Edo Zen Temple Ryūkō) is impressed at the left. The Burke scroll is one of this set.

The rakan in the composition are shown examining a painting of White-Robed Kannon (Skt: Pandaravasini), the bodhisattva of compassion (see cat. no. 49). Closely scrutinized, the work reveals an extraordinary technical feat: all the pictorial elements—the figures, the architecture, the tree, the painted scroll—are delineated in Chinese characters. Even facial details and areas that appear to be shaded with color and white pigment are, in fact, clusters of thinly drawn Chinese characters. The characters spell out a section of the *Lotus Sutra*. While most of them are difficult to read because they are necessarily compressed or distorted to conform to the shapes they constitute, the title of chapter 4, "Shingehon dai yon" (Belief and Understanding), is legible in the upper left corner among the boughs of the tree. In this chapter the disciples of Shaka Buddha recite a parable about the son of a rich man who returns home after a long absence.[4]

The technique that Nobukiyo used has a long tradition that reaches back at least to Tang China. Individual characters and scripts were often considered sacred and endowed with special meaning. Thus, the early Buddhist practice of "writing" a sacred image (usually a pagoda) with lines of a sacred text had a special potency. Many examples survive from the Late Heian period.[5] During the Muromachi period, the practice continued but the pagoda was supplanted in popularity by images of the Guardian King Fudō Myōō (Achala) and Monju (Manjusri), the bodhisattva of wisdom.

Before Nobukiyo the technique had been limited to the outlining of images, using gold pigment or black ink. By employing colors Nobukiyo was able to fill most of the painting surface with words, using them to represent folds of clothing, exposed skin, rough tree bark, even the darkened background in the painting-within-a-painting of Kannon. It is a tour de force of patient but obsessive piety and technical skill.[6]

According to the *Koga bikō* (Notes on Old Painters), most of the scrolls were dispersed from Ryūkōji in 1892.[7] Today, only two, including the Shaka Triad, remain at the temple.

GWN

1. Pal and Meech-Pekarik 1988, p. 323.
2. Shōtō Art Museum of Shibuya Ward 1995, pls. 56, 57.
3. Suzuki Hiroyuki 1989, p. 40.
4. For this text, see *Daizōkyō* 1914–32, vol. 9, no. 262, pp. 16–19.
5. Miya Tsugio 1976.
6. For other paintings by Nobukiyo in this technique, see Shōtō Art Museum of Shibuya Ward 1995, pp. 53–59; and Shōtō Art Museum of Shibuya Ward 1996, pp. 56–58.
7. Asaoka Okisada 1905 (1912 ed.), p. 1174.

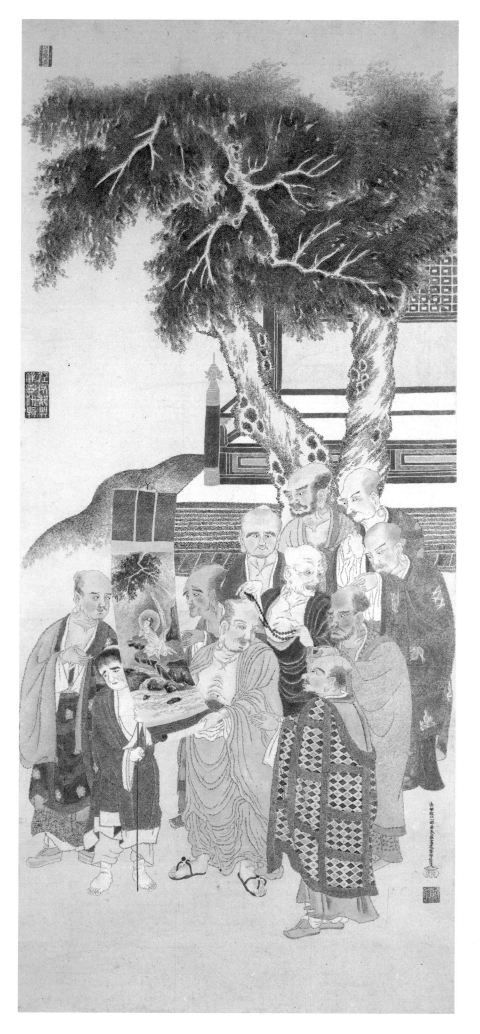

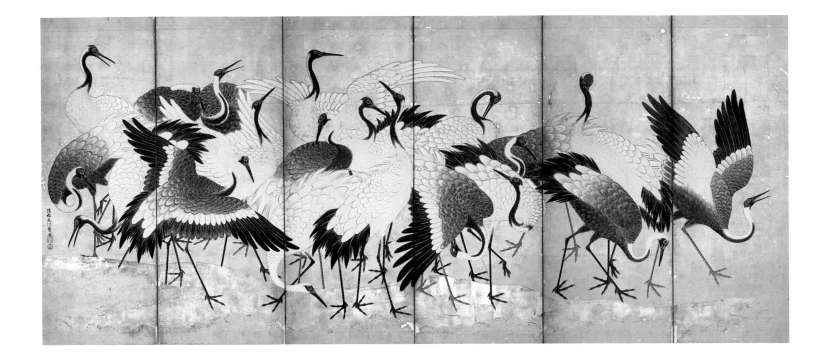

ISHIDA YŪTEI (1721–1786)

114. *Flock of Cranes*

Edo period (1615–1868)
Pair of six-panel folding screens, ink, gold, and color on gilded paper
Each screen 156.5 × 355 cm (5 ft. 1⅝ in. × 11 ft. 7⅞ in.)
Signature: *Hokkyō Yūtei-sai egaku* [on each screen]
Seals: *Gishūdō* and *Morinao* [on each screen]

LITERATURE: Sasaki Jōhei 1996, no. 3; Sasaki Jōhei 1996a, fig. 4.

As many as thirty-six cranes are shown on a gold ground, forming a powerful, restive group. Most of them are *tanchō*, distinguished by their red crests, white plumage, and black cheeks, throats, and wing feathers. Long regarded in East Asia as virtually sacred, these noble, elegant creatures, symbols of longevity—they were said to live for a thousand years—were for centuries a common sight in northeastern China, Korea, and Japan, and a favored subject for the artist's brush. Their dwindling numbers in recent years have made them an endangered species.

On this pair of screens several cranes are shown with wings spread wide, about to launch skyward; others preen, search the sand for tidbits, or sound their trumpeting call. The artist, Ishida Yūtei (1721–1786), painted an even larger and more tightly packed flock of cranes on a pair of six-panel screens now in the Shizuoka Prefectural Museum of Art.[1]

Yūtei was the teacher of Maruyama Ōkyo (cat. no. 115), the highly influential master of the Maruyama school. He has been long neglected by art historians, and a brief essay by Doi Tsugiyoshi published in 1970 remains the only serious study on the artist to date.[2] Born in Harima, near Kyoto, Yūtei took the name "Ishida," after the Kyoto merchant who had adopted him. Yūtei studied painting under Tsuruzawa Tangei (1688–1769), a son of the Kyoto-born artist Tsuruzawa Tanzan (1655–1729). Tanzan, who had studied in

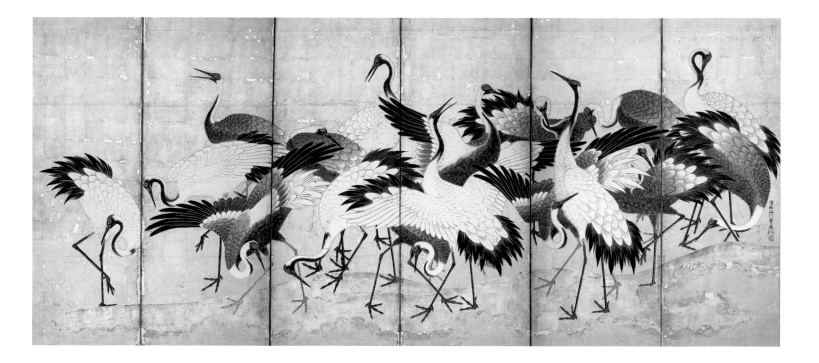

Edo with Kano Tan'yū (cat. nos. 107, 108), was invited to Kyoto to help decorate the Imperial Palace. Having done so, he remained there in the service of the imperial family, infusing the so-called Tan'yū style of the Kano atelier with new influences, most notably the strongly decorative, polychromatic style of Kano Sanraku (1559–1635) and his successor Kano Sansetsu (1589–1651), who had maintained the Kano school in Kyoto. Yūtei in turn further expanded the school's artistic parameters by incorporating aspects of *yamato-e*, which dominated the style of Tsuruzawa painting toward the end of the Edo period.[3] He must have been an open-minded and liberal teacher, for he numbered among his students both Ōkyo, a champion of Western-influenced naturalism, and Tanaka Totsugen (1767–1823), a leader of the *yamato-e* revival movement.

In the Burke screens, such features as the legs partially obscured by the gold rise in the foreground reflect the artist's interest in the more innovative ideas of the day. Here he has combined naturalism with a strong sense of pattern to produce, with a simple palette of black and white on gold with touches of red, a powerful image that is strikingly different from the "polite" art of Yūtei's more famous pupil, Ōkyo.

1. Hosono Masanobu 1988, pp. 56–57.
2. Doi Tsugiyoshi 1970, pp. 401–3.
3. For Yūtei's *yamato-e* works, see Sasaki Jōhei 1996, pp. 20–21.

115. *Sweetfish in Summer and Autumn*

Edo period (1615–1868), 1785
Pair of hanging scrolls, ink, gold, and color on silk
Each scroll 104.3 × 37 cm (41⅛ × 14⅝ in.)
Signatures: *Ōkyo utsusu* [on the scroll at right] and *Tenmei otsushi chūshun utsusu Ōkyo* [on the scroll at left]
Seals: *Ōkyo no in* and *Chūsen* [on each scroll]

LITERATURE: Yamakawa Takeshi 1977a, pp. 17, 19; Tokyo National Museum 1985a, no. 60; Schirn Kunsthalle Frankfurt 1990, no. 103; Sasaki Jōhei and Sasaki Masako 1996, fig. 313.

The paintings of Maruyama Ōkyo (1733–1795) were in such demand that long lines of carriages formed in front of his house.[1] He is said to have taught nearly a thousand pupils—some through correspondence. Ōkyo combined a virtuoso technique in the depiction of the natural world with a sensitive apprehension of the decorative, making his art easy to grasp and appreciate and laying the foundation of his own Maruyama school and the Shijō school, founded by one of his students, Matsumura Goshun (cat. no. 117).

Ōkyo's life is fairly well documented in a number of sources, two of which were written by his students.[2] According to these accounts, Ōkyo was born in Harima, not far from Kyoto, in Tanba Province (Kyoto Prefecture), the son of a farmer. He moved to Kyoto probably while still in his early teens and found employment at a shop that sold toys and novelties. One of these was a stereoscopic device, the *nozoki karakuri*, that heightened the illusion of three-dimensional space and perspective in the pictures seen through its lenses. Most of these *megane-e* (peep show pictures) were Chinese imports. Ōkyo copied them, but he also created his own. During this period, from about 1759 to 1767, Ōkyo also received formal training in painting from Ishida Yūtei (cat. no. 114), a prominent artist who had come to Kyoto from Ōkyo's hometown. It has been noted that Ōkyo's early paintings do not resemble Yūtei's brightly polychromatic compositions; rather, they are stylistically closer to the work of Yūtei's teacher, Tsuruzawa Tangei (1688–1769), a Kano artist.[3]

Ōkyo's artistic production was enormous. Many of his paintings bear dated inscriptions or are datable through letters or contracts, making it possible to reconstruct the evolution of his style, which is generally divided into four phases.

Before 1765, Ōkyo acquired the basics of the Kano-school style, the techniques of Chinese Song and Yuan painting, and the manner of Shen Nanpin (Shen Quan, fl. 1725–80). He also became well versed in many styles of traditional Japanese painting, most notably that of the Rinpa school. But it was Western realism—specifically, the techniques of linear perspective and chiaroscuro—that had the strongest influence on the formation of his personal style.

In 1765, Ōkyo met Yūjō (d. 1773), the abbot of Enman'in, Ōtsu, not far from Kyoto, who recorded the encounter in his diary, the *Manshi* (Records of Ten Thousand Things).[4] While Ōkyo worked for the temple, he also instructed Yūjō in painting. Yūjō in turn instilled in Ōkyo a fascination with many of the European sciences, including anatomy and natural history. During the late eighteenth century, European books on a variety of scientific subjects, often containing illustrations, were entering Japan for the first time since the policy of expelling foreigners and excluding foreign artifacts and ideas had been mandated by the *bakufu* in 1639. They immediately became the focus of intense interest among Japanese intellectuals. Ōkyo's commentaries on the realistic portrayal of human figures, which Yūjō recorded in his *Manshi*, reflect this excitement.

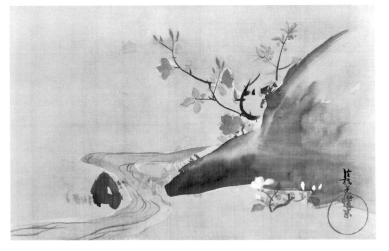

Figure 48. Ogata Kōrin (1658–1716), *Azaleas*. Hanging scroll, ink and color on paper, 39.6 × 60.5 cm (15⅝ × 23⅞ in.). Hatakeyama Memorial Museum of Fine Art, Tokyo

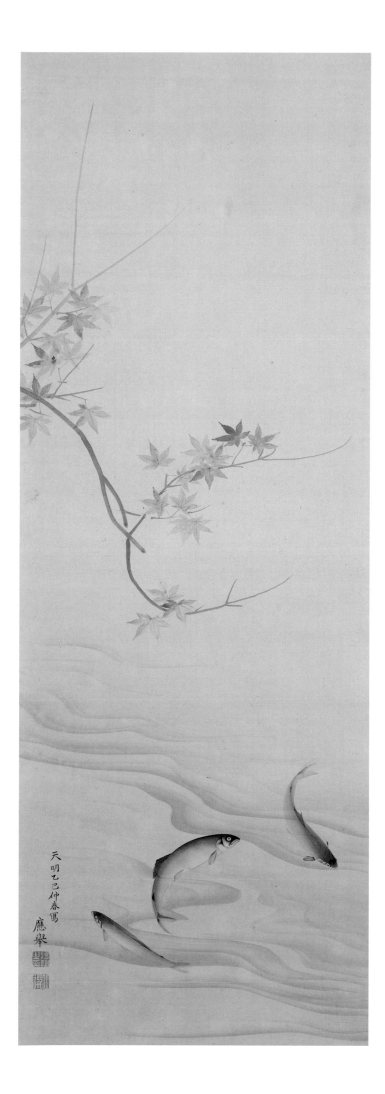
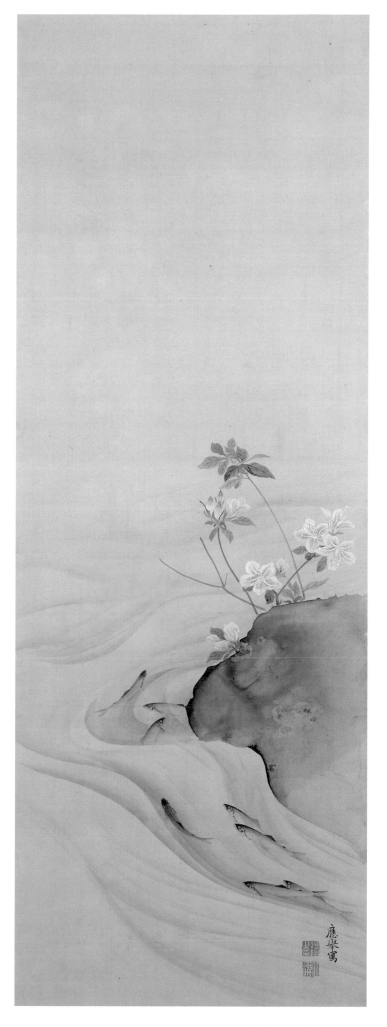

Until 1766 the artist had used many names, but in the winter of that year he chose, and retained, "Ōkyo." With Yūjō 's help, he also obtained patronage at court. By 1775, Ōkyo was a well-established figure in Kyoto's artistic circles, and during the last ten years of his life he received many commissions for important, large-scale projects, including several at Buddhist shrines. In 1790, he was engaged in the renovation of the Imperial Palace in Kyoto, and in 1794 he completed a set of ninety screens for the Kotohiragū Shinto shrine, in northern Shikoku Island. He worked on a commission for Daijōji, northwest of Kyoto, until 1795, the year of his death.

On the left scroll of the elegant Burke diptych, Ōkyo's signature reads "Tenmei otsushi chūshun utsusu Ōkyo" (Ōkyo painted [this] in February, the Year of the Snake, the Tenmei era [1785]). The paintings thus signal the beginning of the ten-year period during which the artist was constantly busy with major commissions. In the scroll at the right, eight small sweetfish streak up a narrow stream. Their almost translucent bodies, defined by chiaroscuro, while highly realistic, are submerged in the decorative, pale blue lines of the current. Pink azaleas signal early summer. In the scroll at the left, the crimson leaves of a maple tree are indicative of autumn. Here, the fish are fewer but larger, for it is in autumn that fingerlings are spawned and mature fish return to the sea.

The paintings reveal many features of Ōkyo's style, as well as his artistic lineage. The obvious reference to the passage of time—the behavior of fish in different seasons—and the decorative landscape settings reflect his considerable debt to the aesthetics of *yamato-e*. The expanses of unfilled space reveal a mastery of the Kano-school handling of solid and void, and the subtle blending of still-wet colors—pale gold with ink wash—a command of the Rinpa technique of *tarashikomi* (pouring of ink).

The composition is startlingly reminiscent of a painting by Ogata Kōrin (cat. nos. 132, 133) in the Hatakeyama Memorial Museum of Fine Art, Tokyo, of red and white azaleas growing on the banks of a stream (fig. 48).

1. Mori Senzō 1934, pp. 584–93.
2. Oku Bunmei, *Sensai Maruyama Sensei den* (Biography of the Teacher Maruyama Sensai), and Okamura Hōsui, *Maruyama Ōkyo den* (Biography of Maruyama Ōkyo), in, respectively, Mori Senzō 1934, pp. 591–93; and Umezu Jirō 1934, pp. 441–42. See also Rathbun and Sasaki Jōhei 1980, pp. 29ff.
3. Hashimoto Ayako 1969, p. 12.
4. Sasaki Jōhei and Sasaki Masako 1996, pp. 447–60; see also Oku Bunmei, *Sensai Maruyama Sensei den*, in Mori Senzō 1934, pp. 591–93.

GENKI (1747–1797)

116. *Two Chinese Beauties*

Edo period (1615–1868), 1785
Pair of hanging scrolls, ink and color on silk
Each scroll 109.8 × 55.8 cm (43¼ × 22 in.)
Signatures: *Genki utsusu* [on the right scroll];
Tenmei otsushi chūshū Genki utsusu [on the left scroll]
Seals: *Genki no in* and *Shiun* [on each scroll]

Having claimed descent from the ancient Minamoto (Genji) family, the artist Komai Ki (1747–1797) was more commonly known as Genki. He has been stigmatized as the "dutiful pupil" of Maruyama Ōkyo (cat. no. 115), the mere perpetuator of the latter's painting style. Certainly, Genki often collaborated with Ōkyo, and for the last two years of his life—following the death of his master in 1795—he was administrator of the Maruyama school. Ill health and a relatively early death at the age of forty-nine are often cited as the reasons for his failure to emerge from his teacher's shadow or develop as distinctive a career as that of his volatile younger colleague, Nagasawa Rosetsu (cat. no. 118), who established a highly idiosyncratic style from his early days as a student in Ōkyo's studio.

Genki's own self-effacing personality is reflected in one of the artistic names he chose for himself, "Shiun." In this name, which appears in seal form on each of the Burke scrolls, *un* means "to veil or cover," implying that he is a man who conceals. Ōkyo, too, must have recognized this aspect of his pupil's character, for he frequently delegated his own commissions in the distant provinces to Rosetsu, whereas Genki was given no such honor. However, as noted in 1769 by Yūjō, the abbot of Enman'in, Ōtsu, the great chronicler of Ōkyo's career, Genki seems to have been his master's constant companion.[1] Negative assessments of Genki's work notwithstanding, he is still regarded as one of the two finest practitioners—with Goshun (cat. no. 117)—of Ōkyo's style to emerge from the Maruyama circle.

While Ōkyo's reputation lies in his realistic portraits from life, his imaginary depictions of men and women from ancient China are in fact more numerous than his portraits of contemporary Japanese figures. The student followed the master's example. Genki's Chinese beauties are lavishly dressed and fashionably coiffed in the manner of aristocratic ladies of the Tang dynasty.

A porcelain-delicate Chinese beauty graces each of these paintings. The pensive figure in the left scroll reflects upon a peony plant, symbol of wealth and beauty, here shown somewhat past its peak. The absence of specific attributes makes it difficult to identify the woman as someone from Chinese history or legend. In addition to the artist's signature

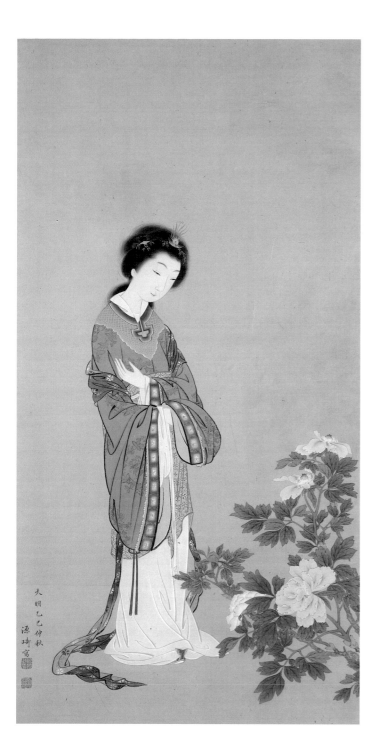

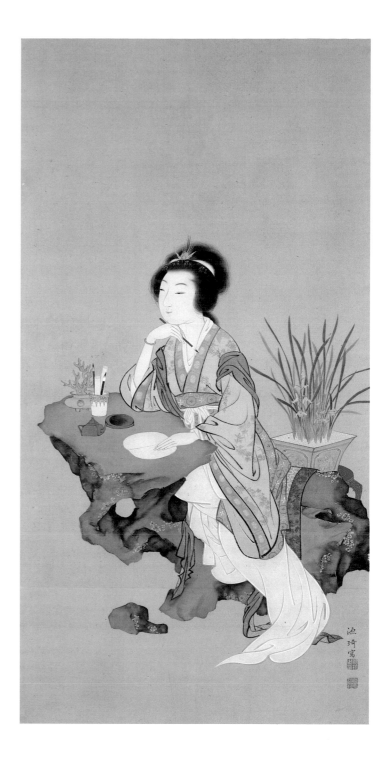

and two seals, the scroll bears the date "Tenmei kinoto-mi chūshū," which corresponds to mid-August 1785.

While the peony makes clear reference to summer, the narcissus, symbol of pure beauty seen in the right scroll, is a flower of early spring. Here, a seated woman about to write or paint on the fan before her holds a brush wistfully to her chin. On the stone table are the usual paraphernalia of the scholar-painter.

A painting by Rosetsu in a private collection in Japan depicts a similarly posed Chinese lady, a painting of bamboo spread before her.[2] It is perhaps a portrait of Guan

Daoshen (1262–1325), the wife of the Yuan literati painter Zhao Mengfu, who distinguished herself as a painter of bamboo. Rosetsu's work has been dated, from the style of his signature, to about 1795, ten years after Genki made the Burke scrolls. Similarities between the paintings suggest the existence of a common model by their master, Ōkyo.

Ōkyo often made full-size preparatory drawings, and he frequently used the same drawings over and over as a basis for his paintings.[3] His pupils would make copies of these drawings to serve as models for their own work; hence the existence of many simi-

lar compositions by both Ōkyo and his followers. Another diptych by Genki, in the Furitsu Sōgō Shiryōkan, Kyoto, is almost identical to the Burke scrolls, but lacks a dated inscription.[4]

Although Ōkyo's influence is undeniable, the gossamer ladies created by Genki are in fact more ethereal, more dreamlike, and more elegant than those of his teacher.

1. Miyajima Shin'ichi 1984, p. 23.
2. Ibid., fig. 87.
3. Sasaki Jōhei and Sasaki Masako 1996, pp. 212ff.
4. Museum of Kyoto 1993, no. 43.

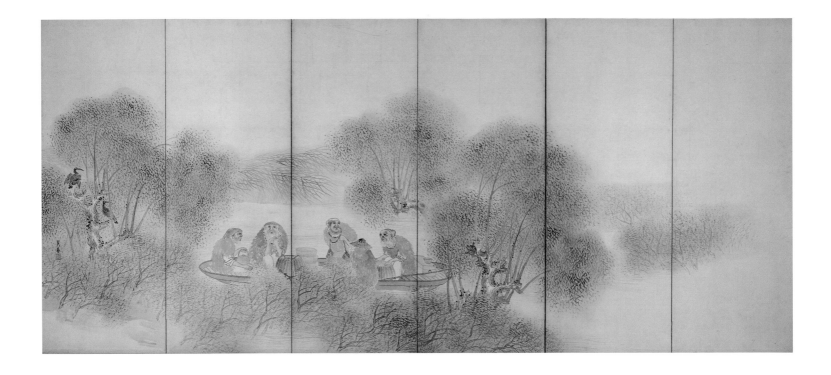

MATSUMURA GOSHUN (1752–1811)

117. *Woodcutters and Fishermen*

Edo period (1615–1868), ca. 1790–95
Pair of six-panel folding screens, ink and light
color on paper
Each screen 170.8 × 347.6 cm (5 ft. 7¼ in. ×
11 ft. 4⅞ in.)
Signatures: *Goshun utsusu* [on the right screen]
and *Goshun* [on the left screen]
Seals: *Goshun* and *Hakubō* [on each screen]

LITERATURE: Shimada Shūjirō 1969, vol. 2, no. 89
(erroneously as in the collection of the M. H. de Young
Memorial Museum, San Francisco); Murase 1971,
no. 13; Hillier 1974, pl. 19 (*Fishermen*); Takeda
Tsuneo, Takio Kimiko, and Minamidani Kei 1982,
pp. 83, 171; Murase 1993, no. 32.

Set against rolling hills and an enclosed
lagoon, woodcutters trudge among the pines
and fishermen relax on a small boat. The
hazy atmosphere and delicate flush of the
willows suggest the warmth of spring. Satu-
rated black ink, limited to a few dots and
details, accents the mellow shades of ocher,
palest blue, and tawny bisque.

Most of the workmen are old; their gar-
ments indicate that they are Chinese. The
woodcutters, heavily laden with bundles of
kindling, are shown emerging from the woods
into a clearing, and the fishermen—some
with expressions of bemused animation—
enjoy a tea break. Perhaps one of them has
just told a good story, catching the attention
of the two cormorants on a nearby tree. In
this idyllic depiction, the artist has chosen
the fisherman to symbolize the lofty purity of
the life of the recluse scholar, following in
the tradition of the Chinese literati painters.

Matumura Goshun (1752–1811), was born
to a family that for four generations had
served as officials at the government mint.[1]
His father, Kyōtei, lived on Shijō Street, in
central Kyoto, and it was here that Goshun
was probably born and raised. In his later
years he arranged for nearly all his pupils to
live close by on this same street, and his stu-
dio came to be known as the Shijō school.
The mint where Goshun was employed as
foreman, following the family tradition, was
established by the Edo *bakufu* to purchase
gold bullion and to mint coins. Exactly when
Goshun left this much-respected position to
start a career as a painter is unknown, though
as a young man from a wealthy upper-class
family, he would have studied painting as a
matter of course.

Goshun's first teacher was Ōnishi Suigetsu
(fl. ca. 1780), but he soon became a pupil of
Yosa Buson (cat. nos. 155, 156), a much more
influential artist. Goshun—who at the start
of his career used the name "Gekkei"—
studied both painting and *haikai* verse under
Buson. He proved to be an outstanding pupil,
and Buson generously recommended him to
his own patrons. Their association must have
begun when Goshun was in his early twenties,
as a painting that is quite similar to the style of
Buson is dated 1774 by inscription.[2] Paintings
from this early period usually derive from
known works by Buson and can easily be
mistaken for those by the master.[3] Professionally
and personally, Goshun remained close to
Buson until the latter's death, in 1783.

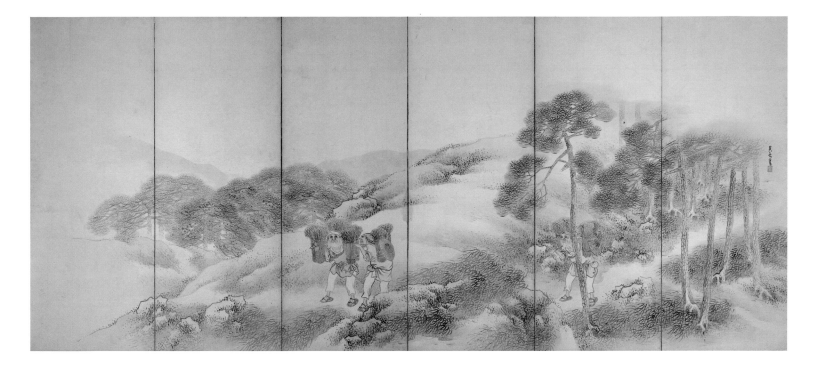

After the loss of both his wife and his father in 1781, Goshun left Kyoto to live in Ikeda (part of modern Osaka). There he took the tonsure and, in 1782, adopted the name "Goshun." He remained in Ikeda until 1789, a brief but productive period. In 1787, Goshun joined a group of six artists headed by the realist master Maruyama Ōkyo (cat. no. 115), on a project to paint sliding-door panels at Daijōji, northwest of Kyoto. The contract refers to Goshun as "Buson's star pupil," indicating that although he was working under Ōkyo, he was still regarded as Buson's disciple.[4]

It is generally agreed that Goshun shifted his artistic allegiance to the Maruyama school after becoming closely acquainted with Ōkyo at Kiun'in, Kyoto, where the two men took refuge after the great fire that devastated Kyoto on New Year's Day 1788, for Goshun's work shows a noticeable stylistic shift toward the Maruyama aesthetics about that year. The artist's absorption of Ōkyo's techniques is reflected in his naturalistic landscape details, in his implementation of linear perspective, and in the plasticity of his forms. These gains are offset, however, by the loss of the shimmering luminosity and elegant lyricism that distinguish his earlier, Buson-influenced works—exemplified by the Burke screens.

The signature on the screen at the right is inscribed in rich, dark ink, in the soft *gyōsho* (running) style, as are the signatures on most of the paintings Goshun made under the influence of Buson. The signature on the left screen is written in clearly articulated *kaisho* (standard) script, which is how it appears on his Ōkyo-influenced works. It is believed that Goshun first used *gyōsho* for his signature, then combined it with *kaisho* for the second character, *shun*, switching finally to the exclusive use of *kaisho* sometime before 1795.[5] Here, the signature in *kaisho* is still tentative, without the leftward slant that became increasingly pronounced in later works. The screens may therefore be dated to the first half of the 1790s.

1. Okada Rihei 1960, pp. 2–8. See also Inazuka Takeshi 1919, pts. 1, 2; and Inazuka Takeshi 1920, pp. 392–96.
2. Mochizuki Shinjō 1940, pl. 2.
3. Suntory Museum of Art 1981.
4. Yamakawa Takeshi 1977b, p. 116.
5. For Goshun's seals and signatures, see Ozaki Yoshiyuki 1989, pp. 24–34.

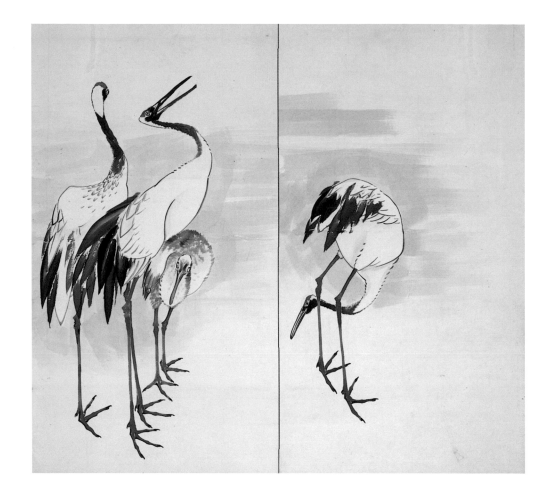

NAGASAWA ROSETSU (1754–1799)

118. *Family of Cranes*

Edo period (1615–1868), ca. 1787
Pair of two-panel folding screens, ink and light
color on paper
Each screen 156.5 × 172.4 cm (61⅝ × 67⅞ in.)
Signature: *Rosetsu shai* [on the right screen]
Seal: *Gyo* [on the right screen]

The so-called Three Eccentrics of the Edo
period, Rosetsu, Jakuchū (cat. nos. 119, 120),
and Shōhaku (cat. no. 121), owe their sobri-
quet both to the nature of their art and to
stories—some probably apocryphal—about
their personalities and behavior. The fame of
Nagasawa Rosetsu (1754–1799) seems to
derive more from his painting, which is filled
with humor and with the unexpected, than
from his undeniably lively personality.[1] An
element of mystery surrounds his premature
death, at the age of forty-five, which is some-
times attributed to suicide, sometimes to poi-
soning at the hand of a jealous rival.

Of the Three Eccentrics, it was Nagasawa
Rosetsu (1754–1799) who most often violated
aesthetic traditions. In his dynamic ink paint-
ings, he presents nature in a highly unorthodox
way, often baffling—and delighting—the
viewer. In some works he rejects completely
the use of Chinese-style linear brushwork in
favor of broad strokes in coal black rendered
with explosive energy.

Rosetsu was reportedly born to a provin-
cial upper-class warrior family near Kyoto.

By the time he was in his mid-twenties, he
had entered the studio of Maruyama Ōkyo
(cat. no. 115), the premier realist painter of
the era. It has been suggested that he studied
first with Tsuruzawa Tansaku (d. 1797) and
then moved on to the atelier of Ōkyo, who
had also trained with a member of Tansaku's
school.[2] Numerous anecdotes describe the
irreconcilable differences between these two
men of contrasting personalities—the well-
adjusted, mild-mannered teacher and the
imaginative but often abrasive pupil. Rosetsu
is said to have been expelled from Ōkyo's stu-
dio, but it is apparent that his teacher regarded
him as a talented artist. Indeed, Ōkyo depu-
tized Rosetsu to complete commissions that
he himself could not fit into his schedule and
collaborated with him on important projects.

Many of Rosetsu's major works can be
found in the provincial regions where he had
completed Ōkyo's commissions. The first
such journey occurred in the winter of 1786.
Rosetsu went to Nanki, in the southern part
of the Kii Peninsula (Wakayama Prefecture),
to work at the sites of three important Zen

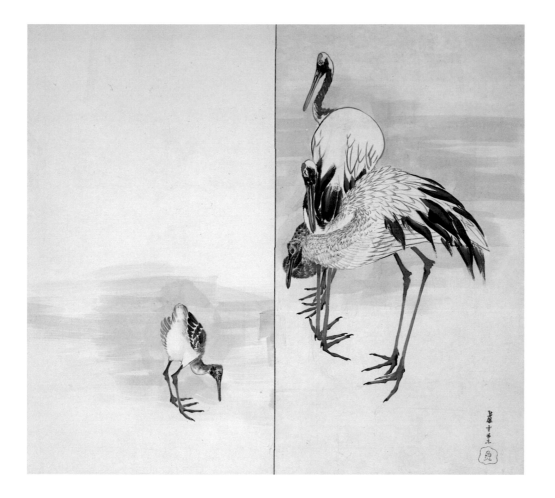

Buddhist temples that had been destroyed by the disastrous tsunami of 1707. Rosetsu remained in Nanki until early 1787.[3] While there, he also produced paintings for other local temples and for wealthy residents of the region. A large number of Rosetsu's paintings remain in Nanki, evidence of a period during which Rosetsu established the idiosyncratic character of his art.

Through the study of Rosetsu's seals and signatures, scholars have been able to trace to some extent the evolution of his turbulent style, one that differs so radically from Ōkyo's academic and decorous mode. His career falls into three phases. During the earliest period, when he was in his twenties, Rosetsu painted realistic, minutely detailed, colorful images of birds, as well as strangely erotic pictures of Chinese women in elegant costumes. His signature from this period is written in careful *kaisho* (standard) script rendered in sharp, thin, rigid strokes. This tight, textbook style begins to loosen about 1786, gradually becoming bolder and more individualistic. The paintings in Nanki date from

this period, and they are almost exclusively in ink monochrome. He made efforts to vary them in subject matter, brush style, and composition. They were dramatically different from his earlier work—fresh, powerful, and innovative. Further differences are observable in the paintings Rosetsu made during the last several years of his life. The brushstrokes are softer, done in the light, watery, less self-conscious *mokkotsu* (boneless) technique. His signature is more loosely brushed, usually in the abbreviated, spontaneous *sōsho* (grass writing) manner.[4]

The artist's signature, "Rosetsu shai" (Painted by Rosetsu), appears on the right screen of the present pair. Written with an extra vertical extension at the bottom of the second character, *setsu*, the brushstrokes are thin and prickly, the style differing slightly from the rigid *kaisho* of the artist's earlier works. A similar signature may be seen on the paintings in Nanki.[5]

Rosetsu turned to the subject of cranes several times during his career, painting them on folding and sliding screens as well as on

hanging scrolls. Here, the same family may be shown on the two screens. At the right, the parent cranes watch protectively over their offspring, while on the left they preen over the ability of their older chick to contort its body and twist its neck. A crane on a six-fold screen by Rosetsu, painted late in the artist's career (1789–99) and now in a Japanese private collection, bends over in a nearly identical manner.[6] The Burke screens, however, are closer in style to a painting of a crane family on sliding panels at Sodoji, Nanki, where the brushstrokes are broader and less linear.[7] Stylistic evidence points to a date around the year 1787 for the Burke screens, which may have been painted for a patron in Nanki.

1. Yamakawa Takeshi 1963, pp. 59, 63 n. 6.
2. Kōno Motoaki 1995, p. 112.
3. Miyajima Shin'ichi 1984, pp. 17–18.
4. Ibid., p. 24.
5. The large seal reading "gyo" (fish) is enclosed in the intact six-lobed frame; the frame lost its upper right section sometime between May 1792 and the winter of 1794; see Yamakawa Takeshi 1977b, p. 73.
6. Yamakawa Takeshi 1981, pp. 26–27.
7. Yamakawa Takeshi 1963, n.p.

119. *White Plum Blossoms and Moon*

Edo period (1615–1868), 1755
Hanging scroll, ink and color on silk
140.8 × 79.4 cm (55⅜ × 31¼ in.)
Signature: *Hōreki otsugai haru nigatsu Heian koji
Jakuchū Kin sei*
Seals: *Jokin*; *Tōshi Keiwa*; and *Shutsu shin'i oite
hattō no uchi*

LITERATURE: Mizuo Hiroshi 1968, p. 35; Tsuji
Nobuo 1974, pl. 63; Murase 1975, no. 60; Tsuji
Nobuo, Hickman, and Kōno Motoaki 1981, pl. 25;
Tokyo National Museum 1985a, no. 61; Satō Yasu-
hiro 1987, fig. 36; Hickman and Satō Yasuhiro 1989,
fig. 26; Schirn Kunsthalle Frankfurt 1990, no. 85;
Kano Hiroyuki 1993, pl. 40; Burke 1996a, fig. 1.

*One patch of white resembles snow.
Plum blossoms are alone,
Unknown even to spring.*

*Spring, second month, Year of the Boar,
fifth year of the Hōreki era* [1755]
—*Jakuchū Kin*

In the stillness of a moonlit night stands an old plum tree in bloom; white flowers fill the dark sky. Except for the unpainted full moon, the entire background is dark gray. The tree branches are a darker gray, with occasional touches of green for the clinging moss and dabs of brown for the knobby hollows. Petals are white, pistils and stamens yellow.

Itō Jakuchū (1716–1800), who painted this extraordinary, dreamlike scroll, was the eldest of the Three Eccentrics of the Edo period, the others being Rosetsu and Shōhaku (cat. nos. 118, 121). Jakuchū was less outrageous in his behavior and in the expression of his talent than the other two artists, and his reputation as an eccentric seems to have been based on his tendency to combine incompatible elements in his paintings—realism, for example, with brilliant color and decorative abstraction.

Jakuchū was the eldest son of a wholesale grocer at Nishikikōji, Kyoto, the bustling section of the old city where vegetable and fish markets still operate.[1] Much of what we know about his life is found in the *Tō Keiwa gaki* (Notes on Paintings by Tō Keiwa), written by his religious mentor, the monk-poet Daiten Kenjō (1719–1801) of Shōkokuji.[2] According to Daiten's account, Tō Keiwa (a name Jakuchū often used) as a young man disliked studying and was not a good callig-

rapher. He did, however, have a talent for painting. Jakuchū inherited the family business and ran it for more than fifteen years after the death of his father in 1738. During this period he seems to have developed an interest in Buddhism, becoming a disciple and friend of Daiten, whose artist friends included the painter Taiga (cat. nos. 157–159). The name by which he is best known, Jakuchū (Like the Void), was given to him by Daiten; he combined it with the lay title *koji*.

Jakuchū is believed to have studied painting initially with a minor master of the Kano school, Ōoka Shunboku (1680–1763), who is known primarily for his books with woodblock reproductions of Chinese and Japanese paintings, including many in the Shōkokuji collection.[3] Much has been made of the fact that the early works of Jakuchū are in the Kano-school tradition, which valued the study of early masters above individual expression. His originality, according to this argument, was the result of his rebellion against this discipline.[4] Nevertheless, he appears to have benefitted enormously from the old masters, both Chinese and Japanese.[5] Indeed, Jakuchū's bird-and-flower paintings, often densely packed, two-dimensional, and bursting with brilliantly contrasting colors, are reminiscent of this genre as painted by artists of Ming China, or even as they were mass-produced for a broader market.

The earliest date inscribed on a painting by Jakuchū is 1752. Two years later, he persuaded his younger brother Hakusai to take over the family business so that he could devote himself to painting. Focusing his attention on the natural world, Jakuchū began his career by painting birds, wildflowers, and shellfish—humble subjects that had never been considered important enough for the painter's brush. No doubt the time he spent as a youth in the lively markets of Kyoto contributed in part to his aesthetic, but as was the case for many artists of the eighteenth century, exposure to Chinese and European books on botany, zoology, and mineralogy—only recently made available in Japan—was even more significant. The effect in Jakuchū's paintings of the juxtaposition of realistic detail and two-dimensional,

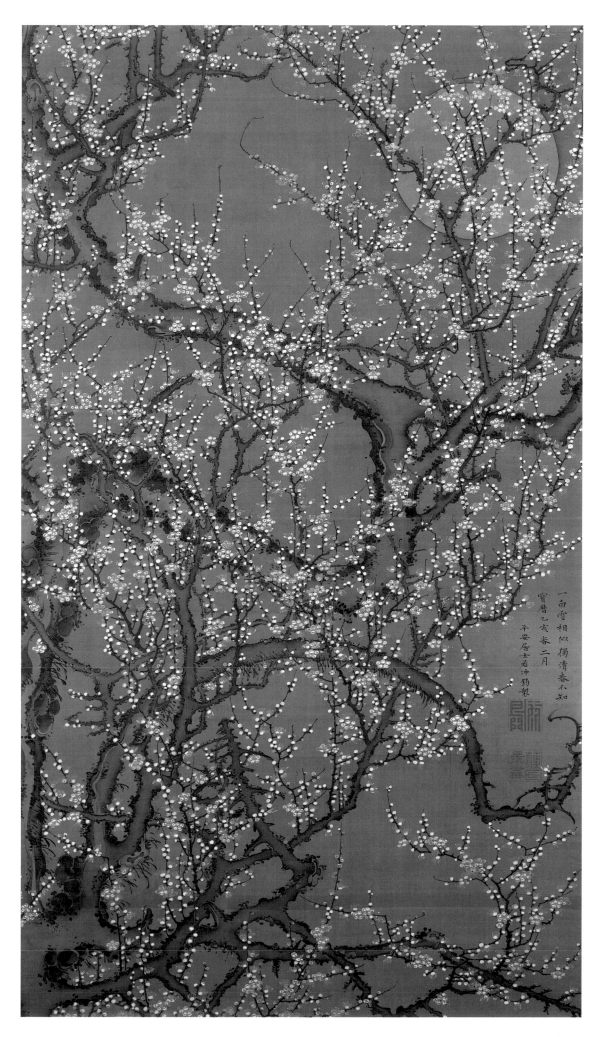

一白雪相似獨清春不知

寶暦乙亥春二月

平安居士若冲鈞製

strongly decorative pattern is somewhat like that of the paintings of Kōrin (cat. nos. 132, 133). At the same time, his work is livelier, with an emotional power not found in the more straightforward style of the realist painter Maruyama Ōkyo (cat. no. 115).

About 1757, Jakuchū launched an ambitious project to paint a set of large hanging scrolls—thirty paintings of flowers, birds, and fish, and three more on Buddhist themes. The paintings were donated to Shōkokuji, which in 1889 presented all but the Buddhist triad to the imperial family. Twenty years after that project he undertook a large sculpture commission for Sekihōji, south of Kyoto. Following the great fire of 1788 in Kyoto, which left him penniless, Jakuchū opened a studio. There, with the help of assistants, he

produced many paintings—mostly in ink monochrome—in an attempt to recover his financial losses.[6] Jakuchū worked with great energy until his death, at the age of eighty-four, in 1800.

Jakuchū's own inscription dates *White Plum Blossoms and Moon* to 1755, less than a year after he left the family business. In the painting he combines a fairly naturalistic description of the blossoming flowers with decorative distortions, such as the odd knots on the trunk and the exaggerated curves of the branches. Jakuchū depicts the blossoms at their most exuberant moment, concentrating on the energy of nature itself. Earlier Muromachi ink painters, by contrast, had attempted to convey the symbolic purity traditionally associated with the flower.

At least two more, nearly identical paintings of plum blossoms by Jakuchū are known, including one in the Museum of the Imperial Collections, Tokyo.[7] The Burke painting is the earliest example, and it must have served as the model for later versions.

1. On the life of Jakuchū, see Hickman and Satō Yasuhiro 1989, pp. 16–32. The present entry is indebted to this study.
2. Reprinted in Tsuji Nobuo 1974, p. 241.
3. Hickman and Satō Yasuhiro 1989, p. 35.
4. See, for example, Kano Hiroyuki 1984, pp. 116–20.
5. Tsuji Nobuo 1974; Satō Yasuhiro 1981, pp. 18–34; and Hickman and Satō Yasuhiro 1989, pp. 33–81.
6. Kobayashi Tadashi 1972a, pp. 3–19. Jakuchū may have had at least four assistants. See Kano Hiroyuki 1993, p. 313.
7. Mizuo Hiroshi 1968, p. 35.

ITŌ JAKUCHŪ (1716–1800)

120. *Two Cranes*

Edo period (1615–1868), 1795
Hanging scroll, ink on silk
140.8 × 79.4 cm (55½ × 31¼ in.)
Signature: *Beito-ō gyōnen hachijussai ga*
Seals: *Tō Chūgin in* and *Jakuchū koji*

Two humorously depicted standing cranes are the subject of this painting signed "Beito-ō gyōnen hachijussai ga" (Painted by the Eighty-Year-Old Four-Gallon Rice Man). The signature indicates that the work belongs to the final phase in Itō Jakuchū's long career, when he kept a studio in front of Sekihōji, south of Kyoto. There he sold quickly executed ink paintings to support himself after the disastrous Kyoto fire of 1788 had left him in financial ruin. Because he would exchange a drawing for a *to* (about four gallons) of rice, he began to call himself Beito-ō (Four-Gallon Rice Man). While thus engaged, he was also trying to finance a project begun about 1776 to design five hundred stone rakan statuettes for Sekihōji.[1] Most of the hastily brushed ink-monochrome images from this period are characterized by an exaggerated style. They appear, for the most part, to have been made by Jakuchū's assistants, of whom he evidently had at least four.[2]

This painting on silk shows a pair of cranes in quiet repose, resting contentedly on three sticklike legs. Like the roosters often depicted in late ink paintings attributed to Jakuchū, these birds are highly stylized and abstracted in form, showing none of the obsession with minute detail that characterized his earlier, polychrome works, such as *White Plum Blossoms and Moon* (cat. no. 119). This work differs, however, from many of his late ink-monochrome paintings on paper in that it is done simply, without the overwrought hyperbole that points to execution by pupils rather than by the master himself. It is therefore likely that *Two Cranes* is the product of Jakuchū's own brush.

1. A number of these statuettes still remain at the temple; see Umehara Takeshi 1968, pls. 58–66.
2. *Myōhōin Shin'nin Shin'nō gochoku nikki*, which is unpublished. See Kano Hiroyuki 1993, p. 313.

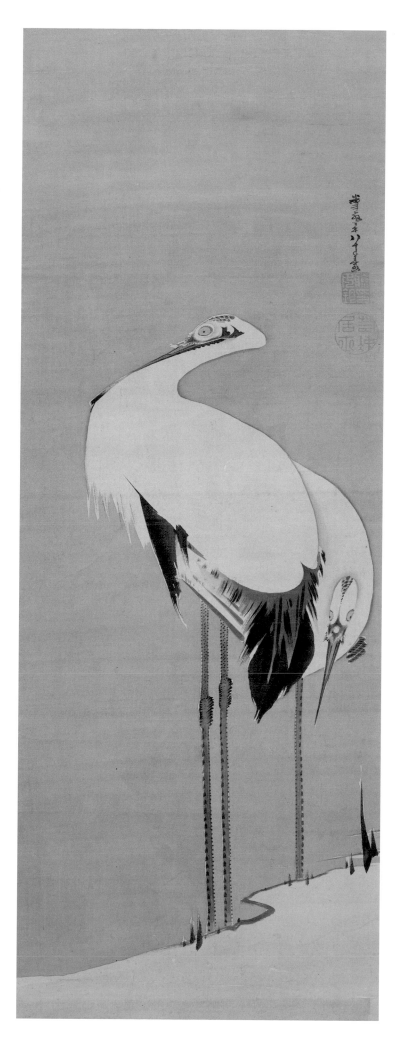

121. Lions at the Stone Bridge of Tendaisan

Edo period (1615–1868), 1779
Hanging scroll, ink on silk
113.9 × 50.8 cm (44⅞ × 20 in.)
Signature: *Soga Shōhaku*
Inscription by Gazan Nansō (1727–1797)
Seal: *Jasoku-ken Shōhaku*

LITERATURE: "Shōhaku hitsu Shakkyō zu" 1899, p. 193; Iizuka Beiu 1932c, pl. 57; Tsuji Nobuo 1970, fig. 25; Kobayashi Tadashi et al. 1973, pl. 84; Murase 1975, no. 61; Mayuyama Junkichi 1976, no. 461; Tsuji Nobuo, Hickman, and Kōno Motoaki 1981, pl. 71; Tokyo National Museum 1985a, no. 62; Kano Hiroyuki 1987, fig. 56; Schirn Kunsthalle Frankfurt 1990, no. 86; Satō Yasuhiro 1991, pl. 66; Tanaka Yūko 1998, fig. 1; Tsuji Nobuo and Itō Shiori 1998, no. 35.

Tiantaishan (J: Tendaisan), the holy mountain of the Tientai sect of Buddhism in Zhejiang Province, Southeast China, was the legendary abode of three famous Chan eccentrics, Fengkan, Hanshan, and Shide (J: Bukan, Kanzan, and Jittoku; cat. no. 54). The mountain was a favorite pilgrimage site for generations of Chinese and Japanese monks and literary men, who extolled its beauty in a number of memorable accounts.[1] One of the most impressive sights on the mountain was an extraordinary natural stone bridge, which is described in Chinese literature as rising to a height of eighteen thousand feet, its curve likened to the arc of a rainbow or the back of a giant turtle. Watered by the mist rising from nearby falls, its stone surface was covered with a slippery layer of ancient moss.

The fame of the bridge spread beyond China, and became the subject of legend. Perhaps the best known in Japan is the Nō play *Shakkyō* (The Stone Bridge), by Kanze Motokiyo (1363–1443).[2] A second popular legend, of uncertain origin, is illustrated here. To test the endurance of her newborn cubs, a lioness pushes them off a promontory near the stone bridge. She will care only for those that manage to climb back to her by scaling the steep cliffs. The subject is rare in the Chinese and Japanese repertory, and its depiction in this painting is even more bizarre than the story. Hundreds of lion cubs leap from rock to rock, trying to claw their way to the top of the cliff. Those that fail are shown falling to the churning waters thousands of feet below; the lioness, bewildered, observes the scene.

The artist would be expected to be a man of odd vision, and Soga Shōhaku (1730–1781) was indeed eccentric. Stories of his outlandish antics have entered the realm of folklore, and we can imagine him as a rebellious individual who knowingly violated the rules of social decorum. Interestingly, his behavior did not alienate him from his patrons, but was accepted—even applauded—no doubt because it held a refreshing appeal in the highly structured society. By the twentieth century, Shōhaku was virtually unknown in Japan. His reputation has recently revived, however, thanks in large measure to American scholars' and collectors' appreciation of his individuality and modernity. Many of his paintings are in American collections, and through the efforts in the 1880s of Ernest F. Fenollosa (1853–1908) and William S. Bigelow (1850–1926), the Museum of Fine Arts, Boston, today houses the largest collection of Shōhaku's work.

The facts of Shōhaku's life have undoubtedly been distorted by fictitious embellishments. It is generally believed that he was born in Kyoto to a merchant family named Miura. He made several trips to the Ise region when he was in his late twenties and early thirties, and Buddhist temples in that area still preserve a number of his paintings. As a young man, Shōhaku studied painting with a minor Kano artist, Takada Keiho (1673–1755), who was a student of Kano Eikei (1662–1702), a grandson of Kano Sansetsu (1589–1651). Shōhaku proclaimed himself the tenth-generation heir of an ink painter named Soga Jasoku (Dasoku), who lived at Daitokuji, Kyoto, in the fifteenth century and painted several screens in Shinjuan, a subtemple of Daitokuji. Shōhaku is thought to have used this painter's name as his own (he signed as both Soga Jasoku and Jasoku-ken), probably in an attempt to revive the earlier artist's reputation. Apparently, he was quite popular in the seventeenth century, but his identity is only now emerging.[3] Kano Sansetsu had also occasionally used the name Jasoku-ken. Interestingly, the mid-seventeenth-century painter Soga Nichokuan (cat. no. 106) claimed to be the sixth-generation descendant of the same artist. Nichokuan's paintings often include fantastic rocks that resemble those of Shōhaku.

Shōhaku's self-proclaimed heritage is certainly justified on stylistic grounds. While his subject matter is often bizarre—demons and skulls, for example, that are grotesque and repulsive—the basic vocabulary of his art remained largely within the tradition of Muromachi ink painting. His compositions, especially those of his large screen paintings, also rely on formulas used by artists of the Muromachi period. Pictorial elements are concentrated at either end of a screen, with the center left open, giving his landscape paintings structural stability.

The eccentricity of Shōhaku's work is sometimes criticized as a deliberate, aggressive attempt to draw attention to himself and away from his more successful contemporaries, such as Taiga (cat. nos. 157–159) and Ōkyo (cat. no. 115).

The colophon that appears at the top of the scroll was composed and inscribed by the monk Gazan Nansō (1727–1797) of Tenryūji, Kyoto:

Tendaisan towers upward forty-eight thousand feet,
Fantastic cliffs, steep and sheer, lofty scarps that reach the sky.
At the top a stone bridge, whereon Perfected Beings tread
And winged magicians with cranes linger and wheel.
Those who have not transmigrated cannot take a step to cross it.
Oh, how wondrous! Such an immortal is Master Soga.
A hundred, hundred thousand lions appear at the tip of his brush,
Chasing and racing top to bottom, ferociously growling and snarling.
Scaling peaks, fording streams, the cubs strive for first place

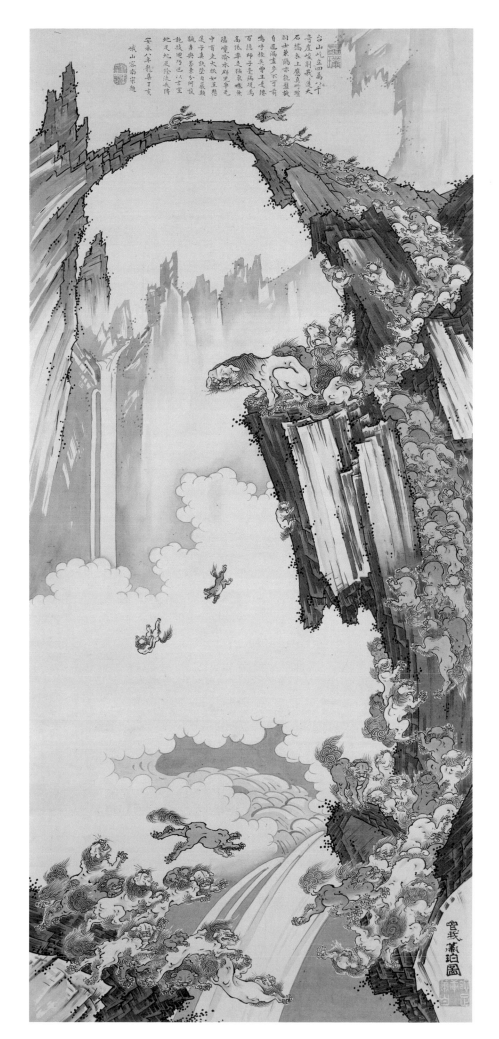

While one among them, old and huge, sits with
eyes like falling stars.
Those that have followed the wrong path
Fall from the craggy brink.
They can reverse their course if they repent their
basic nature.
The artistry and skill shown here cannot be
expressed in words.
Though mine are unworthy, this painting will be
handed down forever.[4]
 —*An'ei hachinen ryushū teigai*
 Gazan yō nansō dai

The date inscribed at the end of the colophon translates as "eighth year of the An'ei era, the end of the Year of the Boar." The eighth year of the An'ei era corresponds to 1779, but the cyclical sign, Teigai (second Year of the Boar), falls in 1767, which was not in the An'ei era. The cyclical sign for the eighth year of An'ei should in fact read "Kigai" (third Year of the Boar). Gazan refers to the peaks of Tendaisan as reaching a height of forty-eight thousand feet rather than eighteen thousand, the more commonly cited figure and the one used by the Chinese poet Li Bo (701–762); the figure given by Gazan reflects the enormous popularity of Chinese poetry and of Li Bo in particular among the Japanese literati at this time.

Lions at the Stone Bridge is one of a handful of dated works from Shōhaku's last period. His less restrained paintings were for the most part made early in his career. Evidently the excesses of his youth were later tamed by an element of humor. The crystalline quality of the rocks here recalls the work of Kano Sansetsu, whose landscapes are also oddly surrealistic. Shōhaku may have learned this effect from his teacher, Takada Keiho.

1. Many Chinese records of visits to this mountain are included in the *Tiantaishan Quanzhi*, 6 vols., edited in 1717 by *Zhang Lianyuan*. The earliest Japanese account is by the monk Jōjin, who visited the site in 1072; see *San Tendai Godaisan ki* (Record of a Visit to the Five Great Mountains of Tendai), in *Dai Nihon Bukkyō zensho* 1959, p. 336.
2. Sanari Kentarō 1930, vol. 2, pp. 1373–81.
3. Tanaka Ichimatsu 1971, pp. 15–35; and Minamoto Toyomune 1972, pp. 29–39.
4. Translation after Stephen D. Allee.

122. Ibaraki

Meiji period (1868–1912), 1882
Pair of two-panel folding screens, ink, color, and
gold on paper
Each screen 168.6 × 166 cm (66⅜ × 65⅜ in.)
Signature: *Nanajūgo-ō Zeshin* [on the right screen];
Zeshin [on the left screen]
Seal: *Tairyūkyo* [on each screen]
Ex coll.: Roger and Kathleen Weston, Chicago

LITERATURE: Gōke Tadaomi 1974, fig. 78; Gōke
Tadaomi 1981, vol. 1, nos. 209, 210; Murase 1990,
no. 33; Murase 1993, no. 54.

Shibata Zeshin (1807–1891) is one of the few artists of pre-twentieth-century Japan to become known in the West during his lifetime. His lacquer pieces were included in the Vienna World's Fair of 1873,[1] and his work today, particularly his lacquerware (cat. no. 127) and *urushi-e* (lacquer painting), is much admired.

Zeshin was born in Edo to a shop owner and a former geisha. His father worked also as a carver and studied *ukiyo-e* with Katsukawa Shunshō (cat. no. 149). At age eleven Zeshin began an apprenticeship with the leading lacquer artist, Koma Kan'ya (Kansai II, 1767–1835), and at sixteen he became a student of Suzuki Nanrei (1795–1844), a painter of the Shijō school. A few years later he traveled to Kyoto to improve his painting skills under Okamoto Toyohiko (1773–1845), a prominent pupil of Matsumura Goshun (cat. no. 117). Zeshin's later reputation as a

Shijō-school painter had its genesis in this four-year sojourn in Kyoto.

Already successful in his teens, Zeshin was catapulted to fame in 1840, when he was commissioned by an association of sugar wholesalers to paint an *ema*, or votive tablet, to be dedicated to Ōji Inari, a Shinto shrine in Edo. Perhaps at the suggestion of his sponsors, he painted a startling image of the ghostly demon Ibaraki, which is nearly identical to the figure depicted on the Burke screen.[2] The subject is drawn from the legendary exploits of the warrior Watanabe Tsuna (953–1024). The Rashōmon Gate, which once marked the southern entrance to the old capital of Kyoto, was said to be inhabited by a demon who assaulted innocent passersby and hapless domestic animals. Tsuna, charged by his master, Minamoto Raikō, with the task of slaying the evil

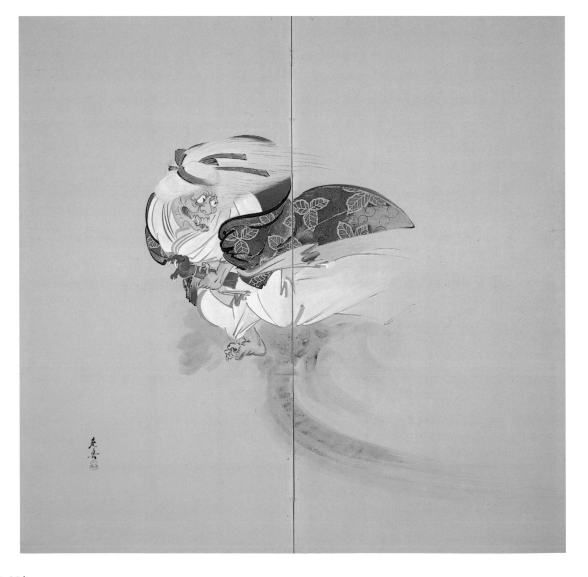

creature, was able only to cut off its hairy, claw-handed arm. Vowing that he would return to claim the severed limb, the demon escaped. Tsuna presented Ibaraki's arm to his master, who locked it in a casket and recited Buddhist sutras for seven days. On the sixth day, Raikō's aunt came to visit and begged to see the arm. Against his better judgment, Raikō consented. The aunt, who was actually the demon in disguise, seized the arm and departed.

The story of Ibaraki was widely popularized in the Nō play *Rashōmon*, which was based on the *Taiheiki*, a classic of the fourteenth century.[3] More than thirty years after Zeshin made the *ema*, Kikugorō, a leading Kabuki actor, saw the image and commissioned the dramatist Mokuami (1816–1893) to write a play based on the theme for the Kabuki stage. The play, also titled *Ibaraki*,

was first performed in May 1883. Zeshin himself painted the billboard depicting the hideous demon. When the play closed, the billboard was donated to Sensōji, a temple not far from the theater, where it remains to this day.

Zeshin returned to the subject more than once, painting the demon on hanging scrolls and *tsuitate* (small freestanding screens).[4] The Burke *Ibaraki* is the only known example to have been executed in the folding-screen format. As stated in the inscription on the right screen, Zeshin painted the screens as "an old man of seventy-five."

The work is also unique in that it depicts the setting of the narrative—the casket encircled by purifying ropes, as well as the oil lamp, whose flickering flame enhances the eerie atmosphere. Zeshin's use of the *tarashi-komi* (poured-in colors) technique further

distinguishes this version from the others. Soft, blurred effects were produced by the application of darker ink on a still-wet lighter wash to create the black cloud conjured up by the fleeing demon. A prolific and versatile artist, Zeshin had a keen appetite for new techniques. He copied Chinese paintings, Kano-school works, and Muromachi ink paintings. His debt to the Rinpa school is reflected here in his masterly use of *tarashikomi*.

A painting of gingko leaves caught in a spider web appears on the back of the Burke screens. Its date of execution and the identity of the artist, whose seals are indecipherable, remain unknown. A possible connection to Ibaraki, if any, may be found in the story of another of Tsuna's heroic exploits, which is known by the title "Tsuchigumo" (Earth Spider). In this story, a popular subject for *emaki* and various performing arts of the

fourteenth century and later,[5] Tsuna and Raikō again assail an evil creature, this time a giant earth spider. The web on the back of the screens is perhaps a reference to this legend. It is intriguing in this connection that Zeshin once painted a screen depicting butterflies and other insects caught in a spider web;[6] stylistic similarities between the two images suggest that the painting on the back of the Burke screens may also be the work of Zeshin. The seal that accompanies it, however, is not known to have been used by the artist.

1. For the life of Zeshin, see Gōke Tadaomi 1974; and Gōke Tadaomi 1981. For documentary material, see Earle 1996, pp. 36–63.
2. A preparatory ink drawing for the *ema* is in the Cleveland Museum of Art; see Gōke Tadaomi 1974, fig. 31; and Gōke Tadaomi 1981, p. 164.
3. Gotō Taniji and Okami Masao 1988, pp. 227–28.
4. Gōke Tadaomi 1974, figs. 1, 30; and Gōke Tadaomi 1981, pls. 206–10.
5. An early-fourteenth-century *emaki* of this tale in the Tokyo National Museum is reproduced in Komatsu Shigemi 1984b.
6. Gōke Tadaomi 1981, pl. 141.

123. *Yuoke with Wisteria*

Momoyama or early Edo period, late 16th–early 17th century
Black lacquer with traces of red lacquer and silver and gold *maki-e*
Height, without handle, 19 cm (7½ in.)

LITERATURE: Wheelwright 1989, fig. 61; Schirn Kunsthalle Frankfurt 1990, no. 117; Murase 1993, no. 72.

Antecedents for this type of *yuoke* (hot-water ewer) can be found among the lacquer food vessels, such as Negoro-ware utensils, that were used by Buddhist monks. During the Momoyama period, the nobility added lacquer *yuoke* to their elegant tableware, and production of the vessels increased accordingly.[1] In later years this type of ewer may have been used during the *kaiseki*, the light meal that precedes *chanoyu*.

The design of wisteria blossoms and leaves was first executed freehand in red lacquer (traces of which are still visible) on the already hardened black lacquer ground. Silver and gold powders were then dusted over the wet lacquer drawings using the *hiramaki-e* (flat sprinkled picture) technique. The manner in which the metallic powders were blended produced subtle tonal contrasts in the design, which is predominantly silver.

The wisteria plant, a recurrent decorative motif, has many poetic and historical connotations in Japanese culture. Countless verses included in early imperial anthologies describe the beauty of the plant growing amid the branches of the pine tree.[2] The Japanese word for wisteria, *fuji*, forms part of the surname of the Fujiwara, the most powerful family of the Late Heian period, who adopted the flower as the family emblem. The graceful articulation of this ewer echoes the refined sensibilities embodied in the wisteria design. GWN

1. I am indebted to Haino Akio, Nara University, for providing information used in this entry.
2. Yoshioka Yukio 1985, p. 158. For another *yuoke* with a similar design, see ibid., pl. 72.

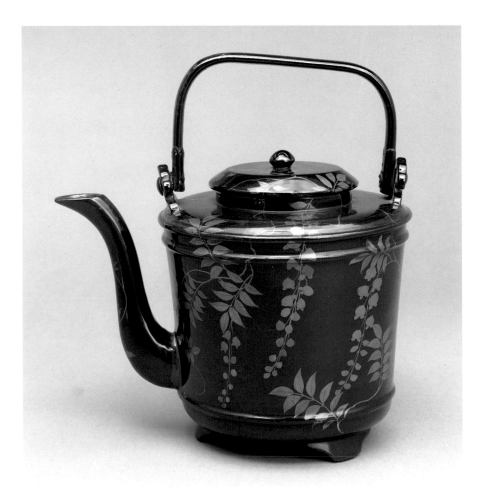

124. Mirror with Copper Pheasant in a Chestnut Oak Tree

Edo period (1615–1878), 1661–72
Bronze with silver *maki-e* and red lacquer
Diameter 13.6 cm (5⅜ in.)
Signature: *Tenka ichi Inbe no kami*

LITERATURE: Murase 1993, no. 68.

Mirrors were believed in ancient times to possess magical powers that could ward off evil and were thus regarded as potent talismans. Mirrors were introduced to Japan from China during the Yayoi period (ca. 4th century B.C.–3rd century A.D.). In Buddhist practice, mirrors were placed in front of icons or buried with other objects beneath pagodas. Over time the mirror became an emblem of power and was chosen, together with the sword and the *magatama* (curved jewel), to symbolize the legitimacy and authority of the emperor.

Japanese mirrors made prior to the Late Heian period were modeled closely after Chinese prototypes, which had a knob set into the center of the reverse side through which a silk cord, for hanging the mirror, was threaded. A new type of mirror popular in Southern Song China supplanted this traditional shape after it was introduced to Japan in the late Muromachi period. The new type had a short handle attached to the circular plate, rendering the knob obsolete and enabling a more unified design. Handled mirrors were small at first, with a narrow shaft that was generally longer than the mirror's diameter. In the late seventeenth century, the diameter of the plate increased as the handle, in inverse proportion, became shorter (fig. 49).[1]

This example is one of the new type. A copper pheasant perches on the branch of a chestnut oak tree, which bends to follow the contour of the mirror. Tiny silver particles enliven the leaves of the tree, as well as the bird's red-lacquer feathers and tail. The bold simplicity of the design echoes the brilliant decorative style that was the hallmark of the earlier Momoyama period. At the left is a signature in relief that reads "Tenka ichi Inbe no kami" (Number One under the Sky, Lord of Inbe Province). The brazen "Tenka ichi" was a title devised by the general Oda Nobunaga (1534–1582) to encourage indigenous crafts. Accordingly, the finest practitioner in each of the various crafts—lacquerware, ceramics, Nō mask carving, metalwork— was allowed to bestow the honorific upon himself. Its indiscriminate use, however, soon made it meaningless, and in 1682 it was banned.

Bronze mirrors with *maki-e* decoration are extremely rare. Only one other example, in a Japanese collection, is known.[2] Almost identical in design, it too bears the "Tenka ichi Inbe no kami" signature, known to have been used only on mirrors that date from the Kanbun era (1661–72).[3]

1. On Japanese mirrors, see Nakano Masaki 1969; and Tanaka Migaku 1981, pp. 60–62.
2. Narukami Yoshio 1968, no. 1.
3. Nakano Masaki 1969, p. 110. Inbe (or Inaba) is part of modern Tottori Prefecture. Its use, however, does not imply that the artist lived there, because such names were often chosen at random.

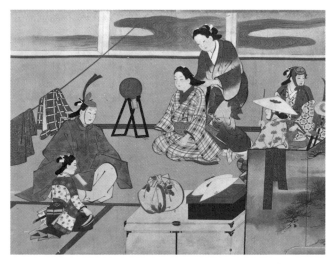

Figure 49. Miyagawa Chōshun (1683–1753), *Dance Performance at the Residence of a Daimyo*. Detail of a handscroll, ink and color on silk, overall 39.6 × 387.8 cm (15⅝ in. × 12 ft. 8¾ in.). Tokyo National Museum

125. Suzuribako with "Dream in Naniwa"

Edo period (1615–1868), 18th century
Black lacquer with gold *maki-e* and lead inlay
5.5 × 24 × 23.5 cm (2⅛ × 9½ × 9¼ in.)

LITERATURE: Tokyo National Museum 1985a, no. 120; Schirn Kunsthalle Frankfurt 1990, no. 123.

This *suzuribako* (inkstone box) was made to hold an inkstone, a water dropper, and writing brushes. The exterior of the beveled lid is covered in gold *maki-e*, with a design of water and sand under golden *suyari* (stylized cloud formations). The small water reeds were created with *takamaki-e* (raised *maki-e*, or sprinkled gold applied in high relief), and the three rocks are made of lead inlay. What might seem to be an anonymous design is in fact connected to a literary theme, revealed on the inside of the lid (below, right), where the words "Naniwa no yume nareya"—from a poem by the twelfth-century monk Saigyō (see cat. no. 79)—are inscribed. The poem, number 625 in the *Shin kokinshū* (New Collection of Poems Ancient and Modern, ca. 1206), reads in its entirety:

*Tsu no kuni no Naniwa no haruwa yume nareya
Ashi no kareha ni kaze wataru nari*

*Was the spring a dream I dreamed in Naniwa?
Only the withered reeds now rustle in the wind.*

Writing implements and *suzuribako* were essential items in the daily lives of cultivated Japanese men and women, and more than any other type of lacquerware, these objects featured decorative motifs related to classical literature. Scenes from famous works such as the *Genji monogatari* or the *Ise monogatari*, were often represented on the lids of writing boxes, and designs often included quotations from classical poems. The device of inscribing words from a poem in such a manner that the characters become part of the image is known as *ashide*, or *ashide-e* (pictures with reed script), a term originally used to describe a fluid calligraphic style that was appropriate to images of flowing water.[1] It later came to refer to the integration of letters with the representational scheme. There are no surviving examples of *ashide* from the tenth or eleventh century, when, judging from literary references, they were extremely popular. Examples from the twelfth century, of which many are extant, include the frontispieces of the *Heike nōkyō* (Sutras Donated by the Heike

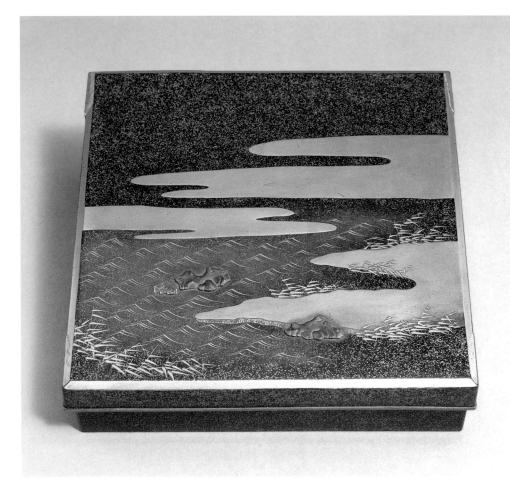

Interior of lid

296

Clan, ca. 1167) in the Itsukushima Shrine (Hiroshima Prefecture).[2] While letters in the twelfth-century paintings are closely integrated with pictorial elements, they became increasingly independent of them during and after the Kamakura period.[3]

Naniwa, one of the *meisho* (scenic spots) of ancient Japan, was closely associated with reed imagery in poetry;[4] in the *Genji monogatari*, reeds on Naniwa beach are compared to *ashide*.[5] The popularity of literary themes as subjects for the decorative arts declined during the Momoyama period. Warrior-class patrons preferred less tradition-bound images, as can be seen from Kōdaiji-style lacquerware, which was tailored to their taste (cat. nos. 88–94). Literary themes enjoyed a revival during the Edo period, although poetic allusions were generally limited to *meisho*.[6] This *suzuribako* is a fine example of the continuing tradition of *meisho* representation in lacquer design of the Edo period.

1. Shirahata Yoshi 1980, p. 291.
2. Meech-Pekarik 1977–78, pp. 52–78.
3. Haino Akio 1980, p. 298.
4. See Ienaga Saburō 1966a, poems 903, 936, and 1083 from the mid-tenth century.
5. Murasaki Shikibu 1976, p. 518.
6. Haino Akio 1980, p. 301.

126. Jūbako with "Tagasode"

Edo period (1615–1868), 18th century
Black lacquer with gold *maki-e* and inlay of lead and mother-of-pearl
26.9 × 22.5 × 21 cm (10⅝ × 8⅞ × 8¼ in.)

This set of four nearly square *jūbako*, or stacked food boxes, is decorated in the *nashiji* (pear skin) technique. The pictorial design, which begins on the lid and continues down two sides, depicts a kimono draped over a clothes rack whose lower panel illustrates a scene from the *Genji monogatari*. A narrow sash, women's amulets, and perfume bags are also suspended from the rack; on the floor is a *tamoto otoshi* (drop-into-sleeves), a small purse kept inside the sleeves. A second rack holds additional garments and amulets, and a small screen depicting a landscape with a waterfall—with yet another draped kimono—completes the design.

The literary and pictorial theme known as *tagasode* was popular as a subject for screen painting during the Momoyama and Edo periods (see cat. no. 143). The term—which translates as "Whose sleeves?"—refers to the beautiful, though absent, owner of the kimonos and other feminine accessories that are represented. It was a word frequently used in *waka* poetry as early as the Heian

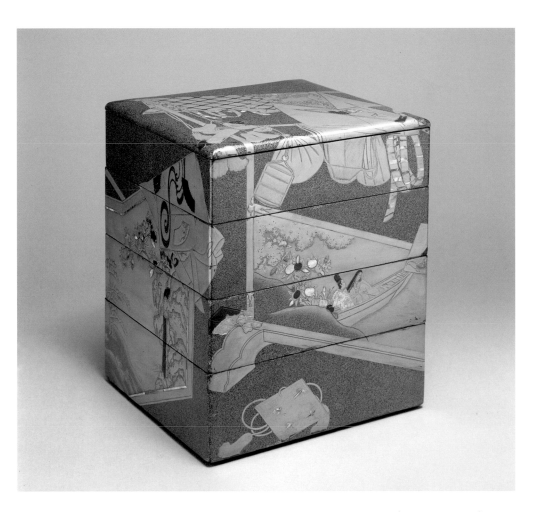

period; verses mentioning *tagasode* are included in the *Kokinshū* (A Collection of Poems Ancient and Modern; ca. 905). On this set of lacquer boxes, the theme is combined with the *Genji* episode.

The image on the lower panel of the clothes rack, which shows a young man and woman in a boat, is one of the most frequently rendered from the narrative. In chapter 51, "Ukifune" (A Boat upon the Waters), a young girl of the same name is abducted on a cold February day by the amorous Prince Niou and taken by boat to the Isle of Orange Trees.[1] Despondent over the incident—for she is also romantically involved with Niou's handsome kinsman, Kaoru—she later attempts to drown herself.[2] The oranges in this picture-within-a-picture are inlaid in dark lead and shimmering mother-of-pearl, seen also on the kimonos and accessories. The craggy hill and waterfall depicted on the small screen reflect the painting style of the Kano school, which suggests that a Kano-trained artist perhaps supplied the preliminary design.

Lacquered containers for food became increasingly lavish during the Edo period.[3] *Jūbako* sets, sumptuously decorated with motifs rich in literary allusions, were used at gatherings of the well-to-do, both at home and at festive outdoor picnics.

1. Murasaki Shikibu 1976, pp. 991–92.
2. Chapter 53, "Tenarai" (At Writing Practice), in ibid., pp. 1043ff.
3. Haino Akio 1985, p. 37.

SHIBATA ZESHIN (1807–1891)

127. *Jūbako with Taro Plants and Chrysanthemums*

Late Edo or early Meiji period, 19th century
Colored lacquer with gold and silver *maki-e*
42 × 23 × 24.5 cm (16½ × 9 × 9⅝ in.)
Signature: *Zeshin* [on the inside of each lid]

LITERATURE: Gōke Tadaomi 1981, vol. 1, no. 8; Schirn Kunsthalle Frankfurt 1990, no. 126; Murase 1993, no. 73.

This elegant set of *jūbako* (stacked food boxes) was made by Shibata Zeshin (1807–1891), a lacquer master and painter celebrated for the originality of his designs (cat. no. 122). Zeshin began his study of the art of lacquer at the age of eleven in Edo. His teacher was Koma Kan'ya (Kansai II, 1767–1835), a member of the Koma school, which served the Tokugawa shogunate and had a long tradition of lacquer-making. Zeshin also received training in the naturalistic style of painting developed by artists of the Shijō school (cat. no. 117); that background and his own interest in sketching from nature are reflected in the detailed depictions of flowers and plants that appear in much of his work.[1] Zeshin was innovative in his use of the lacquer medium for painting as well as for the production of functional and decorative objects. He added the unusual and difficult *urushi-e* (lacquer painting) technique to his repertory during the 1870s and 1880s.

Alternate lid

Zeshin's career spanned the closing years of the Tokugawa regime and the beginning of the era initiated by the restoration of imperial rule in 1868, after which there was increased cultural and economic exchange with the West. Zeshin benefited from this climate of openness and was encouraged to exhibit abroad. A prolific artist, he earned international recognition with the lacquer plaques that were exhibited at expositions in Vienna (1873), Philadelphia (1876), and Paris (1899).[2]

Jūbako were used to store delicacies specially prepared for celebratory occasions. This example is equipped with two lids, so that when necessary the boxes could be separated into two groups. The design on one (opposite) continues the motif of taro leaves seen on the boxes, and that on the other (below) shows a full moon and leaves. The artist's name is engraved on the inside of both lids. In pleasing contrast to the broad, heart-shaped taro leaves, small flowers and scalloped foliage of chrysanthemum plants embellish the lower tiers. Zeshin's dramatic juxtaposition of bold forms against a neutral background reflects his study of techniques used for lacquerwares of the Rinpa school.[3]

GWN

1. Gōke Tadaomi 1981, vol. 1, pp. 164–65.
2. Watt and Ford 1991, p. 291.
3. Ibid., p. 285.

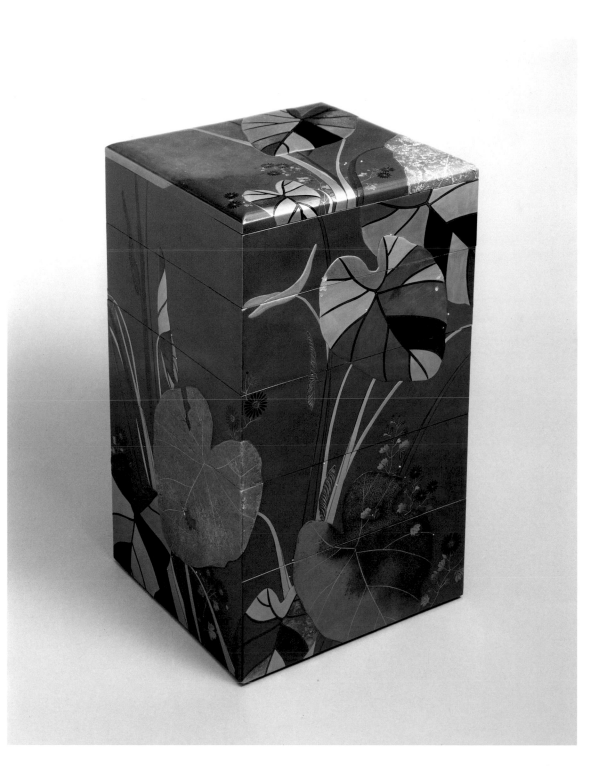

Japanese Porcelains

CATALOGUE NOS. 128–131

The many excavations of kiln sites in northern Kyūshū since the 1960s, as well as the chance discoveries of wares from Arita and other kilns in the homes of wealthy consumers, have led scholars to make new interpretations of the development of Japanese ceramics. Those that relate to works included in this catalogue are summarized below.[1] It should be noted that scholars now prefer to use the term "Hizen" for all the wares produced in the kilns of Hizen Province (which included parts of modern Saga and Nagasaki Prefectures), in addition specifying individual kilns for clarity.

Beginning in the late sixteenth century, the Japanese ceramics industry entered a period of creative productivity that has continued until the present day. Although pottery making had flourished in Japan since the Protoliterate era (see cat. nos. 1–4), innovations in the potter's art evolved over thousands of years. During the early historic era Sue ware, produced in the Nara–Osaka region, served as the principal type of ceramics; about the thirteenth century, it was supplanted by the first high-fired stonewares, which introduced deliberately applied glazes (cat. no. 47). The most important sites for pottery making from the twelfth through the seventeenth century were the so-called Six Old Kilns—Seto, Tokoname, Echizen, Shigaraki, Tanba, and Bizen. This term is no longer in use, as many additional medieval kiln sites have since been discovered. Nevertheless, these six kilns were undeniably significant in the development of Japanese ceramics, particularly during the sixteenth century, with the arrival of Korean potters and the rise of the great masters of *chanoyu*.

The dramatic evolution of ceramic tea utensils is one of the most important developments in the history of Japanese art. While the finest tea wares were created at the Six Old Kilns, new kilns—such as those at Mino, near Nagoya (cat. nos. 99–101, 104)—were at the same time opened for the explicit purpose of turning out tea wares. The Karatsu kilns also merit special mention, as they can be credited with establishing northern Kyūshū as one of the most important locations for later ceram-

ics manufacture (cat. no. 105). It was in this region, in the beginning of the seventeenth century, that the industry made another leap forward, this time in the area of porcelain production.

Japanese potters had made some half-hearted attempts in the ninth century to imitate Chinese and Korean porcelain wares, but their first serious efforts date to the early 1600s and are traditionally thought to have been inspired by Korean potters resettled by the lord of Nabeshima in his domain in 1616. These craftsmen were led by Ri Sanpei (1579–1655), who had been extradited from his homeland after Toyotomi Hideyoshi's infamous second invasion of Korea, in 1597. Ri Sanpei was long thought to have been the first to discover kaolin, a fine clay used for making porcelain, in the Arita area. It has been pointed out, however, that Arita was already involved in producing ceramics and that Korean craftsmen had helped to construct kilns in the nearby Karatsu area during the Momoyama period. Porcelain manufacture in northern Kyūshū may in fact predate 1616.

Nevertheless, the Arita kilns were certainly the first in Japan to manufacture true porcelains. Initially, production was limited to white wares underglazed with cobalt blue (*sometsuke*) or celadon green, but in the 1640s Arita potters succeeded in producing brilliant overglaze enamel colors that glowed against the smooth, milky white surface of the new wares. With red predominant over greens, blues, yellows, purples, and later even gold, these enamels were applied to fired vessels, which were then refired at a lower temperature. Tradition associates this important innovation with Sakaida Kakiemon (1596–1666), whose family documents date the event to 1647. Arita soon became one of the largest porcelain manufacturing centers in the world, turning out everyday wares used throughout the country. It also made highly profitable export items, sold in Asia and Europe with the help of Chinese and Dutch traders. Trade with Europe was facilitated by the activities of the Dutch East India Company, founded in 1602, which

established its headquarters in Batavia (modern Jakarta), Indonesia, in 1622. Arita continues today to produce ceramics for international as well as domestic consumption.

Numerous factors contributed to the meteoric rise of the Hizen kilns, and the great variety of their porcelain wares was clearly one of them. Porcelains of different shapes, color schemes, and quality have been staples of Hizen ware since the early seventeenth century, and their nomenclature can be highly confusing. The appellation "Imari," widely used for the products of the Arita kilns, derives from the name of the port from which porcelains were shipped to Southeast Asia, Europe, and other parts of Japan. Europeans in particular use the name "Imari" for enameled porcelains imported from Japan during the seventeenth and eighteenth centuries. The category does not, however, include Kakiemon, generally believed to have been created by the potter of that name and his descendants. Another regional ware, Nabeshima, was not made for export but was reserved exclusively for the lords of Nabeshima. The ware known traditionally as Ko Kutani (Old Kutani; cat. no. 128) was also produced at the Hizen kilns.

A variety of factors contributed to the invention of enameled ware. Many contemporary nonporcelain Kyoto wares were decorated with bright colors (cat. no. 130). There were also attempts to imitate the enameled porcelains of Ming China. The *Kakumeiki*, a diary kept by Hōrin Shōhō (1592–1668), abbot of Rokuonji, Kyoto, is an often quoted source on the subject of early colored porcelains. The diary refers to a blue-and-white Imari piece that Hōrin came across in 1636, and it records a gift in 1652 of a *nishiki-e* (enameled or, literally, brocade picture) bowl from Imari.[2] It is thus likely that enameled wares were being produced before they caught the attention of this Kyoto connoisseur.

The importance of the Dutch East India Company's presence in Asia at this time cannot be overemphasized. The Dutch had made handsome profits from the export of large quantities of Chinese porcelains to Japan in the 1630s. These pieces included both blue-and-white and enameled wares. In 1644, however, the political turmoil that accompanied the end of the Ming dynasty brought an end to this phase of the company's trading activities, and the Dutch shifted their attention to the Hizen kilns. Company records show that they placed their first large order in 1653,[3] but it is probable that there were private deals for even greater quantities than officially recorded orders.[4] In a few decades Japanese porcelains, like Japanese lacquer cabinets, would become common decorative elements in the great houses of Europe.[5] Thus began the golden age of the porcelain industry at Arita. The prosperity enjoyed by the Japanese during this era also boosted the sale of Hizen products as domestic demand for porcelains increased, due in part to the cessation of the ceramics trade with China.

At some point during the Kanbun era (1661–72), eleven kilns were assembled in Arita to produce enameled wares; the site soon became known as *Aka e machi* (red painting village, i.e., enamelers' quarters).[6] Dutch sales of Arita wares to Europe, which reached their height in the 1680s, continued into the mid-eighteenth century. The last official order for Arita wares—only three hundred pieces—was issued in 1759. The rising prices of Japanese products and the resumption in the 1670s of operations at the large Jingdezhen kilns in China (where production had almost entirely ceased in 1644) contributed to the decline in Dutch-Japanese trade. The Dutch East India Company, too, was in its final days; it was dissolved in 1799. By that date the Dutch had bought more than ten million Arita pieces,[7] the majority of which were exported to Europe, though a large number were also sold in Southeast Asia. In addition, an unrecorded number of pieces were traded by the Chinese. Today, these Imari wares—sometimes called Ko Imari (Old Imari) to distinguish them from later products—are proof of the unprecedented activity in pottery making that catapulted Arita and its products to world attention and gave rise to Europe's longstanding fascination with Japanese ceramics. It was this passion for Japanese wares that subsequently served as a catalyst to the production of imitation Imari porcelain in Europe.[8]

1. See, for example, Singer et al. 1998.
2. *Kakumeiki* 1958–67. The entry for the thirteenth day, intercalary month, thirteenth year of the Kan'ei era (1636); the entry for the second day, first month, fifth year of the Keian era (1652).
3. Volker 1954.
4. Oliver Impey in Ayers et al. 1990, p. 17.
5. Ibid., p. 24.
6. Excavations suggest that other kilns also produced enameled wares. See Saga Prefectural Museum of Kyūshū Ceramics 1991, p. 173.
7. Nishida Hiroko 1976, p. 54.
8. For examples of European copies, see Jorg 1980.

128. Plate with Pumpkins

Edo period (1615–1868), ca. 1660s
Hizen ware, Aode Ko Kutani style
Porcelain with overglaze enamels
Diameter 37.8 cm (14⅞ in.)

LITERATURE: Murase 1993, no. 59.

This large, impressive platter bears a striking design of pumpkins in deep aubergine and leaves of luminescent green. Set against a grain-patterned background in a warm yellow earth color, the plant elements extend across the entire plate and appear almost to overflow its borders; the serpentine tendrils of the vines are vibrant with life. While in its simplicity and boldness the design has a modern look, it is strongly reminiscent of the dramatic, decorative screen paintings of the Momoyama period.[1]

Controversy surrounds the attribution of this and similar wares to the Kutani kilns in Kaga, northeast of Kyoto. These pieces, traditionally labeled Ko Kutani (Old Kutani) to distinguish them from nineteenth-century works, are unique among the enameled wares of the early Edo period. Most are large plates that feature bold, sensuous designs rendered in a limited palette of blue, green, yellow, and aubergine, with touches of red. The pigments are so thickly applied that they often form deep pools of glossy color. Decorative elements deviate from the Chinese-influenced bird-and-flower motifs typical of enameled

Hizen porcelains; their bold execution also differs from the restrained treatment of line and color that characterizes, for example, the official wares of the Nabeshima kilns. In addition, no two Ko Kutani pieces bear identical designs.

Documentation on the manufacture of Ko Kutani wares is scarce, and when the Kutani region was designated as a dam site, the excavation of the kiln became a matter of urgency. Three controlled excavations were carried out—in 1970, 1971, and 1974.[2] Contrary to expectations, the investigations yielded material that appeared unrelated to Ko Kutani porcelains. Nevertheless, because the excavated objects corroborate some of the claims made in the literature, the most common of these assumptions are summarized below.[3]

The earliest reference to ceramics manufacture at Kutani connects porcelain production to the lord of the Maeda clan, from Kaga fief. In a family document of the potter Sakaida Kakiemon (1596–1666) of Arita, we read that he sold enameled wares to an official from Kaga who was visiting nearby Nagasaki to purchase rare objects for his

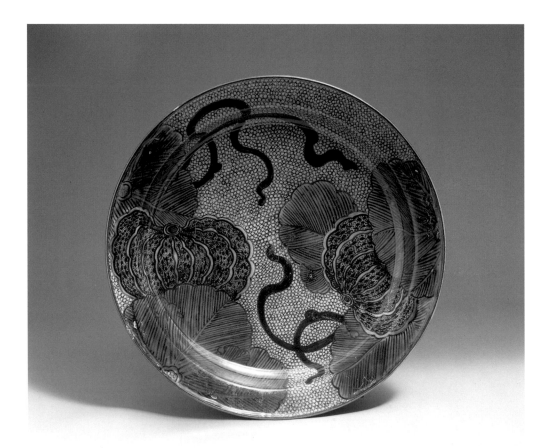

master. The sale apparently took place in 1646 or 1647. The founding of the Kutani kilns is attributed in other documents to Maeda Toshiharu (1618–1660), who established the subfief of Daishōji. Toshiharu was a cultivated man with a keen interest in the welfare of his tiny domain. At some time during the Meireki era (1655–57), after having learned of the discovery of kaolin (clay for making porcelain), he purportedly instructed a craftsman named Gotō Saijirō to travel to Arita for the purpose of learning the techniques of porcelain production. A somewhat later date for the inception of the Kutani kilns is given in the *Hiyō zasshu*, an essay written in 1784, which attributes their opening to the second lord of Maeda, Toshiaki (1637–1693). To complicate the issue, the *Bakkei kibun* (1803) claims that the first Kutani potter to study porcelain making in Arita was Tamura Gonzaemon, not Gotō Saijirō.[4]

All these records assert that it was the lord of Kaga who established the kilns and that, from the beginning, the Kutani kilns were closely tied to the kilns in Arita. Excavations at Kutani have yielded evidence to suggest that the oldest kiln in the area—Kiln Number One—began operations about 1656; the oldest shards found at the site are quite similar to those found at early Arita kilns. Moreover, Kiln Number One was identical in its construction to the earliest *noborigama*, or climbing kilns, at Arita, the Tengudani kilns.

The excavations also revealed that Kiln Number One ceased operations about 1670, although other Kutani kilns continued to function. Their products evidently caught the attention of connoisseurs, for Kaga records such as the *Kaga ōrai* (1672) and the *Sanshū meibutsu ōrai* (1688–1740) refer to the teabowls known as Daishoji ware as specialties of the Kaga region.[5]

Neither the shards found at kiln sites nor these documentary references give evidence of characteristics that would distinguish Ko Kutani porcelains from other ceramics. However, unenameled porcelains used as base vessels for Ko Kutani wares have been discovered at Hizen kiln sites, and fragments of enameled Ko Kutani have also been found. The current, generally accepted hypothesis is that Ko Kutani was produced in Hizen and that it was probably among the first enameled wares to be made there.[6] The production of Ko Kutani porcelain came to an end in the 1660s, when it was superseded by the more delicate wares of Kakiemon and Nabeshima. Moreover, the demand for large platters, used primarily at great social gatherings, diminished considerably in the late seventeenth century as a result of economic decline.[7]

The deep plate shown here belongs to a subgroup known as Aode Ko Kutani (Blue Ko Kutani). Unlike most Ko Kutani vessels, on which a portion of the surface is left uncolored to serve as background for a design, Aode Ko Kutani are completely glazed, usually in two or three colors: deep green, yellow, blue, or aubergine. Aode porcelains were once thought to be a later development in the history of Ko Kutani, but it is now believed that they were made from the earliest days of Ko Kutani production and that they flourished alongside other types of Ko Kutani wares. Aode seem to have been particularly popular in Indonesia,[8] where they were imported by Dutch and Chinese traders. (Notably, they were not sold in Europe in the seventeenth century.) And with their warm, earthy colors and dramatic designs derived from common garden vegetables, Aode vessels do indeed bring to mind the lush tropical landscapes of Indonesia.

1. Arakawa Masaaki (1992, pp. 50–63) compares Aode Ko Kutani designs to Momoyama gold screens and kimono patterns of the early seventeenth century.
2. Ishikawa ken Kyōiku Iinkai 1971–72.
3. Nakagawa Chisaku 1974, p. 18.
4. Ibid.
5. Nishida Hiroko 1990, pp. 95–96.
6. Included in this group of porcelains is a plate with a paulownia design—previously designated as Ko Kutani—which bears a dated inscription corresponding to 1653. Saga Prefectural Museum of Kyūshū Ceramics 1991, pl. 22.
7. Arakawa Masaaki 1996, p. 100.
8. Nishida Hiroko 1990, p. 115.

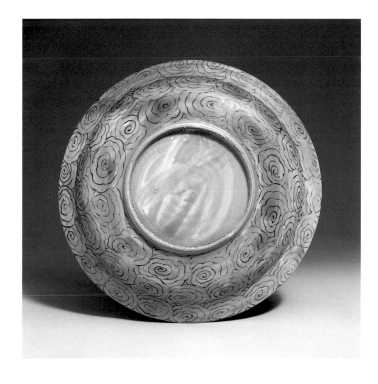

129. Bottle with Peonies and a Chinese Lion

Edo period (1615–1868), ca. 1660s
Hizen ware, Ko Imari style
Porcelain with overglaze enamels
Height 28.3 cm (11⅛ in.)

LITERATURE: Murase 1993, no. 60.

The peony—king of flowers—and the lion—king of beasts—were a popular combination in Chinese design. Here, they are seen together on an elegant bottle with pear-shaped body and long, tapering neck. Brilliantly colored enameled wares of this type have been variously labeled Ko Kutani, Imari, Early Enameled Ware, and Kakiemon, indicative of the fact that it is extremely difficult to distinguish the products of the various kilns that operated in the Arita area. Indeed, designations have even changed periodically. The legend of the potter Sakaida Kakiemon (1596–1666) and the claims made for his part in the development of enameled wares are today seriously questioned, and many pieces like this bottle—decorated with yellow, green, blue, and matte red outlined in black—are now given the name Ko Imari, while the term "Kakiemon" or "Kakiemon-style" is reserved for wares with bodies covered in a colorless "white" glaze, perfected sometime after 1660.[1]

1. Kakiemon is defined (in Ayers et al. 1990, no. 139) as finely potted porcelain with a refined white body covered in a colorless "white" glaze over which a sparse, painterly decoration is applied in translucent overglaze enamels, without the use of underglaze blue.

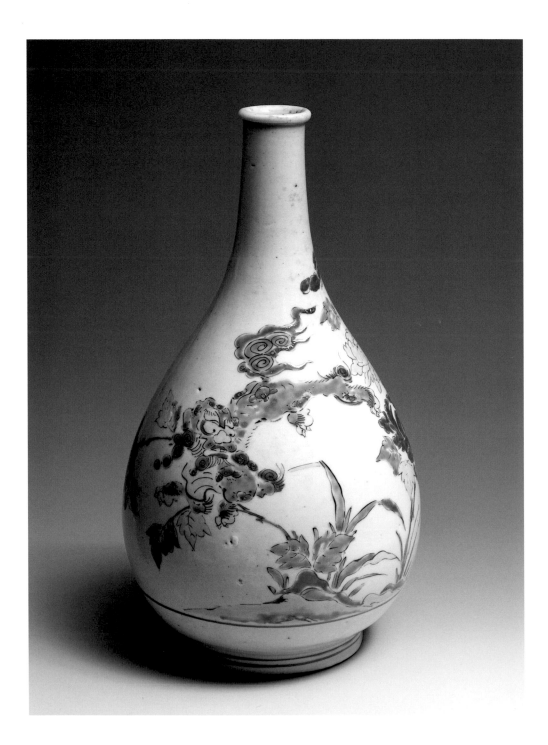

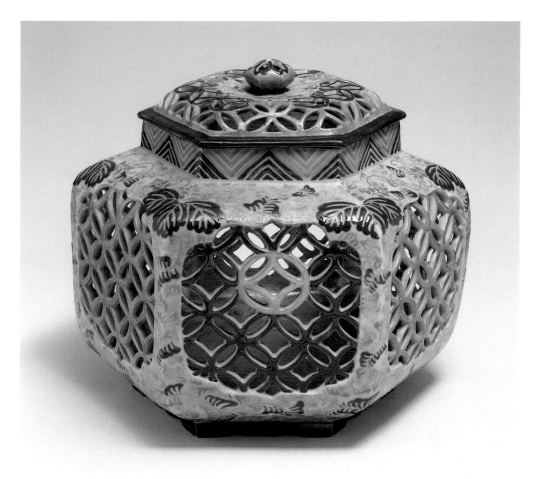

130. Brazier

Edo period (1615–1868), late 17th century
Kyōyaki; Ko Kiyomizu style
Stoneware with overglaze enamels
Height 21.1 cm (8¼ in.); diameter of mouth
13.1 cm (5⅛ in.); diameter of foot 14.2 cm
(5⅝ in.)

LITERATURE: Hayashiya Seizō 1975, no. 49.

The term "Kyōyaki" (capital ware) covers a variety of ceramics, including Ko Kiyomizu, produced in and around Kyoto. In Heian times the Kyoto kilns manufactured ash-glazed wares, but their activity came to an end between the Kamakura and the late Muromachi period. Why they ceased operations is not known. One can speculate that the shift of political power to Edo created conditions unfavorable to Kyoto potters. And perhaps the spectacular success of nearby kilns such as Shigaraki, Seto, and Tanba during this time discouraged Kyoto artisans. Moreover, the vogue for Chinese imports among the rich may have contributed to a decline of interest in indigenous products.

In the late sixteenth century, attempts were made to revive the Kyoto ceramics industry. Renewal of activity was perhaps initiated by the arrival of potters from the Mino area.[1] The Kyoto kilns were certainly in operation by 1605, when their wares attracted the attention of the Sakai merchant Kamiya Sōtan (1551–1635). In a diary entry for that year, Sōtan refers to a tea caddy made at a Kyoto kiln.[2] The polychrome enameled wares produced

at Kyoto evolved quickly and differed radically from the tea ceramics made at sites such as Mino, Bizen, and Karatsu (cat. nos. 98–105), and they soon rivaled the products of the new Nabeshima and Arita kilns on northern Kyūshū (cat. nos. 128, 129). The Kyūshū wares were also enameled but had porcelain bodies, whereas seventeenth-century Kyōyaki were stonewares.

Although the various ceramics today classified as Kyōyaki include wares from many different kilns, they share one outstanding feature: the potters usually did not use red glaze. The blues, greens, purples, and gold glaze or gold leaf that they applied to the light brown body were covered with a finely crackled clear glaze. The production of Kyōyaki peaked in the mid-seventeenth century; by the 1700s its popularity had been eclipsed by the growing appeal of porcelains.

In the late eighteenth century, Kiyomizu, one of the Kyoto kilns, began to keep pace with the new trend by producing enameled porcelain wares. The works of this kiln, situated at the foot of the Kiyomizu temple, achieved great popularity, especially among

tourists. The term "Ko Kiyomizu" (Old Ki-yomizu) is used to distinguish the earlier stoneware pieces from the later, porcelain pieces produced at the kiln.

This elegant example of Ko Kiyomizu was used as a brazier—or perhaps as an incense burner, in which case it would originally have included an ash container. Its fine-quality clay enabled the potter to create a complex, multifaceted form. The shape may have been inspired by Chinese porcelains or by a metal object, such as a bronze lantern. The lid, neck, body, and base are a series of hexagons, each embellished with geometric designs and floral motifs; six large paulownia leaves ornament the shoulder area.

Especially noteworthy among Ko Kiyomizu is the use of intricately modeled open-work, such as that seen here on the side panels and lid, which allows views into the gilded interior. The elegantly subdued colors are quite different from the brilliant hues found on the more lavishly decorated Hizen ceramics (cat. nos. 128, 129). Design, color, and shape here fuse to create an object of sophistication and refinement, one that embodies the aristocratic taste of Kyoto's courtly patrons of the arts.

1. Hayashiya Seizō 1985, p. 57.
2. *Kamiya Sōtan nikki*, the entry for the fifteenth day, sixth month, tenth year of the Keichō era (1605). See *Sadō koten zenshū* 1967, vol. 6.

NONOMURA NINSEI (FL. CA. 1646–CA. 1694)

131. *Chaire*

Edo period (1615–1868), after 1657
Stoneware
Height 17 cm (6¾ in.)
Seal: *Ninsei*

LITERATURE: Tokyo National Museum 1985a, no. 102; Schirn Kunsthalle Frankfurt 1990, no. 144.

Nonomura Ninsei's was the only significant name to emerge from the large community of mainly unidentified potters working at the Kyoto kilns during the Edo period. The most reliable sources for his biography are two essays by Ogata Kenzan (1663–1743), the *Tōkō hitsuyō* (Essentials for Potters) and the *Tōji seihō* (Manuals for Making Pottery and Porcelain).[1] A younger brother of the painter Ogata Kōrin (cat. nos. 132, 133) and a leading figure in the art of Rinpa, Kenzan was a much younger contemporary of Ninsei, with whom he studied in 1689, a few years before the latter's death.

According to Kenzan, Ninsei (the name he adopted in 1657) was born Nonomura Seiemon, suggesting that he was a native of Nonomura, in nearby Tanba Province (Kyoto Prefecture), which had a long tradition of pottery making and was known particularly for its large storage jars; he is sometimes referred to as the Tanba Potter. Ninsei apprenticed at the Awataguchi kilns in Kyoto before moving to Seto, where he studied the production of *chaire* (tea caddies) for several years. At some point he relocated to western Kyoto, and by 1647 he had built kilns in front of Nin'naji, also known as Omuro, a highly prestigious Mikkyō temple traditionally headed by a member of the imperial family. Ninsei's products, initially called Nin'naji or Omuro wares, are mentioned in 1648 in the diary of Hōrin Shōshō (1592–1668), chief abbot of Rokuonji, Kyoto.[2]

We also know that Ninsei was acquainted with the leading tea master of the day, Kanamori Sōwa (1584–1656). Kenzan refers to Ninsei's wares as "satisfying to Sōwa's taste," and indeed they reflect the taste of the new generation of tea masters and of the Kyoto elite. Departing from the rustic aesthetic of *wabicha*, which had governed tea circles since the late sixteenth century (cat. nos. 97–105), they are elegant, sophisticated, and highly refined. The Nin'naji kilns became, to all intents and purposes, the unofficially designated "official" kilns, producing wares for the emperors, the Tokugawa shoguns, high-ranking priests, and cultivated samurai.[3]

As noted, in 1657 the artist took the name "Ninsei," which combined the "Nin" of Nin'naji with the "Sei" of Seiemon. Prior to this time, potters had not impressed their seals on their work, but Ninsei was part of a new tradition. Like Raku craftsmen at about the same time, he began to stamp his name on many of his pieces. He was also the first to apply lavish, painterly decorations to large tea-leaf storage jars. His enameled wares differ from other Kyōyaki wares (cat. no. 130) in that they are applied with red and gold leaf. Ninsei used the exteriors of his jars almost as though they were silk or paper for painting; and indeed the leading painters of the Kano school, Tan'yū (cat. nos. 107, 108) and his younger brother Yasunobu (1613–1685), are known to have supplied preparatory drawings for his pottery.[4]

Ninsei also created a variety of new shapes for sculpted wares, such as braziers and incense burners, which he modeled in the form of birds and animals. The rich diversity of glazes and shapes created by this artist mark a brilliant phase in the development of postmedieval ceramics. It is believed that Ninsei died about 1694, for in that year comments began to circulate to the effect that the son (Ninsei II) was not as talented as the father.[5] Ninsei's mantle was assumed by Kenzan, who perpetuated the extraordinary style of Kyōyaki that Ninsei had established.

Ninsei produced many *chaire*. This thinly and perfectly made example, in the *katatsuki* (straight shoulder) shape, is based on a Chinese prototype. The Chinese influence is evident in the shallow, outward-curving mouth and in the incised lines that circle the slightly swelling body. A streak of dark brown glaze descends from the neck over the lighter brown glaze that covers the upper part of the vessel. The natural buff color of the unglazed clay is visible above the base. The piece bears a "Ninsei" stamp on the bottom, and is therefore datable to after 1657.

1. Wilson and Ogasawara Saeko 1992, vol. 3, pp. 101–6.
2. *Kakumeiki*, entry for the ninth day, first month, fifth year of the Shōhō era (1648). On that day, Shōshō received the gift of a *chaire* made at the Omuro kilns. See *Kakumeiki* 1958–67.
3. *Omuro kankei nenpyō* (Chronology of the Omuro Kilns and Related Matters), in Ishikawa Prefectural Art Museum and MOA Museum of Art 1992, pp. 154–57.
4. *Yōshūfu shi* of 1684 (first year of the Teikyō era), in *Gunsho ruijū* 1906–9, vol. 8, p. 203.
5. Ishikawa Prefectural Art Museum and MOA Museum of Art 1992, p. 157.

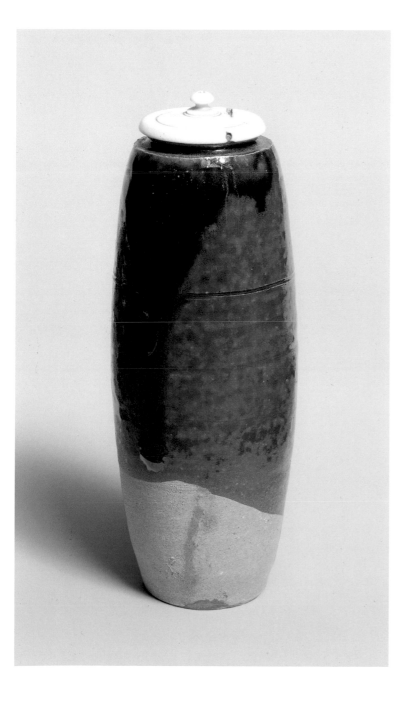

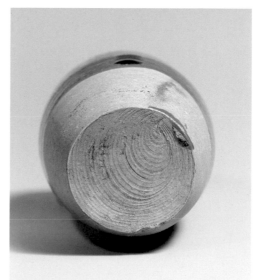

The Art of Rinpa

The Rinpa artists did not, strictly speaking, constitute a school. Although family ties existed among some members of the group, inclusion was determined neither by birthright nor by teacher-pupil relationships; rather, it was based on common artistic aspirations. Nevertheless, the name "Rinpa" derives from the character for "school" (*pa*) and the second syllable of the name "Kōrin," after Ogata Kōrin (1658–1716). Kōrin was not in fact the originator of the tradition; he was a follower and later a rejuvenator of the ideals of Hon'ami Kōetsu (1558–1637) and Tawaraya Sōtatsu (died ca. 1640), the two artists who forged the Rinpa style.

The Rinpa artists produced paintings, calligraphy, ceramics, and lacquerware, and perpetuated a tradition that endured nearly as long as that of the Kano school. Their art is an expression of an indigenous aesthetic of vivid colors and bold, decorative patterning. Standing apart from the artists who decorated the castles of the feudal barons, they shared instead the artistic ideals cultivated at court by members of the imperial family, who felt a deep nostalgia for Japan's native traditions. Unburdened by the demands of military patronage, they often worked on a small scale, painting handscrolls and *shikishi* (album leaves) intended for personal appreciation. As thematic material they preferred stories drawn from medieval literature to the more banal symbols of wealth and power. Rejecting too the Chinese-inspired art of the Kano school, which valued ink monochrome, they developed a style rooted in the painting of the Late Heian and Kamakura periods.

The origins of the Rinpa aesthetic apparently derive from a small group of learned courtiers close to the emperors Go-Yōzei (r. 1586–1611) and Go-Mizunoo (r. 1611–29), who aspired to revive the arts of the past, in particular the aristocratic ideals of the Late Heian period. During the reign of Emperor Go-Mizunoo, the Tokugawa *bakufu* in Edo was still consolidating its power. Adopting harsh policies, it interfered with the activities of the court, even in matters of a purely ceremonial nature. The shoguns went so far as to force Go-Mizunoo to marry a woman of their

Figure 50. Ogata Kōrin (1658–1716), *Irises*, early 18th century. Pair of six-panel folding screens, color on gilded paper, 150.9 × 338.8 cm (4 ft. 11 in. × 11 ft. 1½ in.). Nezu Institute of Fine Arts, Tokyo

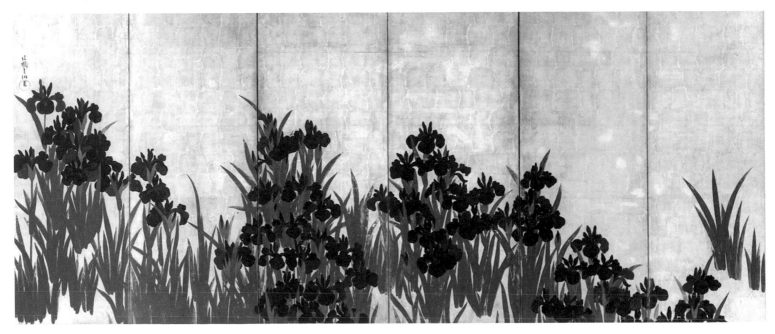

clan. It is not unlikely that the emperor's support for the classical arts was a way of declaring his independence. Wealthy Kyoto merchants drawn to his inner circle set the stage for a brief but brilliant revival of Heian aesthetics in the early seventeenth century. About 1606, Suminokura Soan (1571–1632), an importer of books and medicine from China and himself a scholar of classical literature, initiated the reprinting of favorite classics, including the *Genji monogatari*, the *Ise monogatari*, and various Nō plays, in an ambitious publishing venture known as *Sagabon* (Saga Books).

One of Soan's intimate friends was Kōetsu, whom Soan commissioned to design the texts for the books, which were then reproduced for printing in movable type. Another artist who worked on the project was Sōtatsu, who was to make small stamps with designs of flowers, grasses, butterflies, and similar motifs, for printing in mica. Together they produced a large number of handscrolls and *shikishi*, Sōtatsu creating designs over which Kōetsu wrote poems selected from anthologies of

the Late Heian and Kamakura periods (cat. nos. 83, 84).

This collaboration ended after 1615, when Kōetsu moved to Takagamine, a suburb of Kyoto. Sōtatsu's career as an independent painter began at the same time. Not only did he paint subjects taken from classical literature (cat. no. 86), he also combined unrelated scenes from different *emaki*, transforming earlier compositions into bold, decorative schemes.

The artists who upheld the aesthetic principles formulated by Kōetsu and Sōtatsu were Kōrin (cat. nos. 132, 133; fig. 50) and his younger brother Kenzan (1663–1743). Although they had never met or worked with either of the earlier masters, who died decades before they were born, there was a distant family connection. Sons of a wealthy businessman, Kōrin and Kenzan received a thorough education in the arts, as was customary for young gentlemen of their class. A prolific and versatile painter, Kōrin employed many styles and formats, frequently taking his themes from classical literature and working

them into vivid abstract patterns with radiant colors. And Kenzan established a kiln outside Kyoto that produced fine ceramics. Decorated with classical themes, sometimes painted by Kōrin, these too exemplify the Rinpa aesthetic.

The Rinpa tradition continued through the Edo period, and it continues to be practiced today, with moderate success. Kōrin's followers settled in Edo, where many wealthy art patrons lived. One important result of this change in patronage was that later Rinpa artists—Sakai Hōitsu, Suzuki Kiitsu, and Ikeda Koson, for example—usually chose as subjects straightforward depictions of nature, frequently flowers of the four seasons (cat. nos. 134–136), and the subtle allusions to classical themes, the aesthetic basis of the art of Sōtatsu and Kōetsu, were largely forgotten.

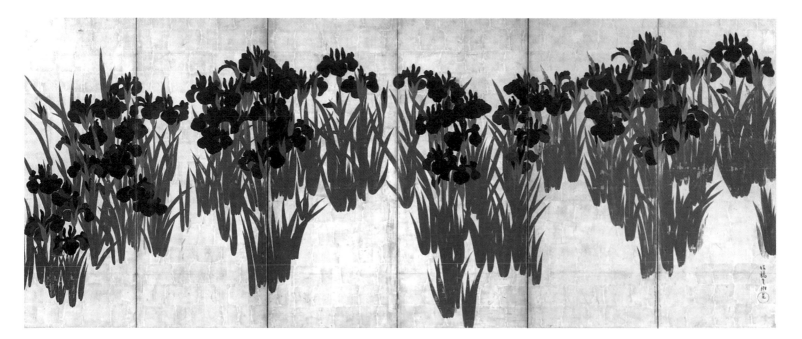

132. Flowers of Spring and Autumn

Edo period (1615−1868), shortly after 1701
Pair of panels, ink and color on cryptomeria wood
Each panel 137.2 × 19.9 cm (54 × 7⅞ in.)
Signature: *Hokkyō Kōrin* [on the panel at right]
Seal: *Koresuke* [on each panel]
Ex coll.: Hosomi Ryō, Osaka; Inoue Tatsukurō

LITERATURE: Yamauchi Naosaburō 1918, illus.;
Tanaka Ichimatsu 1965b, fig. 1; Mizuo Hiroshi 1966,
vol. 3, pl. 68; Stern 1971, no. 18; Murase 1975, no. 54;
Tokyo National Museum 1985a, no. 43; Schirn
Kunsthalle Frankfurt 1990, no. 57.

Other than the artists of woodblock prints, Ogata Kōrin (1658−1716) is perhaps the Japanese artist best known in the West as well as in Japan, and his work reflects a truly indigenous taste. Prolific and versatile, Kōrin painted in many different styles and formats, frequently taking as his subject themes derived from classical literature. His compositions are characterized by bold, brilliantly colored abstract patterns, and his work epitomizes what came to be known as the Rinpa school. While other artists working in this style preceded him, it was his name (specifically, the last part) that was adopted to denote the entire group; "Rinpa" means "school of Rin." Kōrin's popularity was so great that only a century after his death, Tani Bunchō (cat. no. 168) warned against forgeries of his work.[1] In the nineteenth century two of his followers, Saikai Hōitsu (cat. no. 134) and Ikeda Koson (cat. nos. 136, 137), attempted to establish an authenticated oeuvre.[2] A group of materials known as the Konishi Documents, which includes family papers, personal correspondence, diaries, sketches from life, and copies of old paintings, provides insights into the artist's personal life.[3] Preserved by the Konishi family, whose ancestors had adopted Kōrin's son, they are now divided between the Osaka Municipal Museum of Art and a private collection in Tokyo.

The successive heads of the Ogata family—active patrons of the arts and themselves trained in painting and the classics—

made and sold kimonos in their shop Kariganeya and typified the cultivated businessmen-gentlemen of the capital. Kōrin's father, Ogata Sōken (1621−1687), was an accomplished painter and calligrapher as well as a wealthy, well-connected businessman,[4] and his influence on Kōrin's early artistic career may have been greater than is generally acknowledged.

Kōrin is widely believed to have studied painting with the minor Kano artist Yamamoto Sōken (d. 1706). His happy, if somewhat irresponsible, youth ended abruptly with his father's death, in 1687. Even before this, the family business had suffered severe losses in patronage as wealth shifted from the old aristocracy to the emerging middle-class merchants, and Kōrin, now in serious financial difficulty, was forced to find a new means of supporting himself.

About 1692, perhaps as an attempt to improve his situation, Kōrin changed the written form of his name, preserving the old pronunciation but adopting a new set of Chinese characters that may be interpreted to mean "shining gems." He kept this form for the rest of his life, and it appears as his signature on many paintings. Kōrin began his professional career as a painter by decorating pottery made by his younger brother Kenzan (1663−1743), who established a kiln in 1699 at Narutaki, northwest of Kyoto. Together they created some of the most beautiful pottery of the Edo period. Soon afterward, Kōrin's paintings

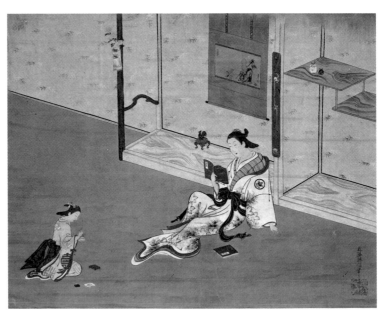

Figure 51. Kondō Katsunobu (fl. ca. 1716−36), *Courtesan Reading in Front of a Tokonoma*. Hanging scroll, color on paper, 48.8 × 61.6 cm (19¼ × 24¼ in.). Museum of Fine Arts, Boston

began to gain recognition, and in 1701 he was granted the title *hokkyo*, an honor reserved for artists of unusual distinction. Attracted by the more affluent clientele in the bustling city of Edo, Kōrin went there at least twice, in 1704–5 and again in 1707–9. He spent his last years in the congenial company of the waning court aristocracy of Kyoto.

Very few of Kōrin's works are known from before 1701, the year he received the honorific *hokkyo*. What is most characteristic of his extant work is its urbane sophistication and charm. His dramatic compositions also reveal a knowledge of textile designs and techniques. At the basis of Kōrin's art is a deep admiration for the aesthetic ideals of the early Rinpa masters Kōetsu and Sōtatsu (cat. nos. 83–87), to whom he was distantly related. He once owned a lacquer box by Kōetsu and a screen painting by Sōtatsu, and he made copies after Sōtatsu's designs. One

could say that the aesthetic aspirations of the two earlier masters culminate in the classical narrative paintings of Kōrin.

Flowers of Spring and Autumn combines two aspects of Kōrin's art—decorative paintings of flowers and ink paintings after Chinese subjects. On the panel at the right is the single motif of white plum blossoms, harbinger of spring. The small flowers stand out against the fine-grained wood and stark branches of the leafless tree. In the lower right corner are Kōrin's signature, "*Hokkyo Kōrin*," and his round seal, "Koresuke." The same seal without the signature appears on the companion panel, which depicts flowers and grasses of late summer and early autumn: morning glories, pampas grasses, white and blue bellflowers, and exuberant white, pink, and red chrysanthemums.

Both panels are slightly bowed. Contemporary paintings of room interiors (fig. 51,

page 310) sometimes include similar panels that are shown hanging against the curved posts that often served to set off *tokonoma* (alcoves). Although the Burke panels are too wide to have been displayed side by side against a single pillar, they may have been displayed on adjoining sides.

The handling of the brush and the sharp brushline in the signature resemble the signature on his pre-*hokkyo* works. Furthermore, the "Koresuke" seal was used on works dating to shortly after he was granted the title in 1701. The panels may therefore be dated to just after 1701.

1. *Buncho gadan*, in Sakazaki Shizuka 1917, p. 799.
2. Sakai Hōitsu 1815; and Ikeda Koson 1864.
3. On Kōrin's life, see Yamane Yūzō 1962a.
4. The second-generation head of the Ogata family, Dōhaku, was married to Kōetsu's sister; Kōrin's grandfather, Sōhaku, lived near Kōetsu at Takagamine.

OGATA KŌRIN (1658–1716)

133. *Hotei*

Edo period (1615–1868), after 1704
Hanging scroll, ink on paper
28.5 × 36.9 cm (11¼ × 14½ in.)
Signature: *Jakumei Kōrin*
Seal: *Dōsū*
Ex coll.: Hara Tomitarō, Kanagawa Prefecture

LITERATURE: Yamauchi Naosaburō 1918, illus.; Uemura Masurō 1940, fig. 110; Tanaka Ichimatsu 1965b, fig. 42; Shimada Shūjirō 1969, vol. 2, p. 81; Murase 1975, no. 55; Tokyo National Museum 1985a, no. 44; Schirn Kunsthalle Frankfurt 1990, no. 58; Murashige Yasushi 1991, fig. 162.

Believed to be an avatar of Maitreya, the Buddha of the Future, Hotei (Ch: Budai) is one of the most beloved characters of Zen Buddhism.[1] Potbellied and bald, this cheerful, blissful man roamed the countryside in the late ninth–early tenth century in the area of Mount Si-ming, in southern China, carrying his few belongings in a patched cloth bag. Hotei was probably portrayed in painting soon after his death, and later entered the folklore of China and Japan as one of the Shichifukujin (Seven Gods of Good Fortune). Beginning in the Muromachi period, the deity was depicted by innumerable artists, regardless of their religious inclination.

Kōrin's paintings of Chinese mythological and historical personages usually differ from conventional interpretations in that he often transforms them into humorous characters. He made many ink drawings of Hotei in unorthodox poses—bouncing on his bag while kicking a ball skyward or riding a wild horse,

for example, activities that perhaps express his divesting himself of wordly attachments.[2] Here, Hotei is shown leaning against the bag, his constant companion. Merging with Hotei, it can easily be mistaken for the deity's potbelly. Grinning, Hotei seems amused by this cunning deception of the unsuspecting viewer. The bag, drawn in light ink, contrasts with the four patches of pitch-black ink that denote Hotei's two sleeves and the tip and base of the pole on which he carries his bag. Kōrin here loaded the brush with dark ink and, turning it on its side to form two broad strokes, "wrote" the sleeves.

The square "Dōsū" seal is impressed below Kōrin's signature. Adopted in 1704, the name can be used to date the drawing to the last dozen years of his life.[3]

1. Chapin 1933, pp. 47–52.
2. Murashige Yasushi 1991, figs. 157–62.
3. Tanaka Ichimatsu 1965b, p. 27.

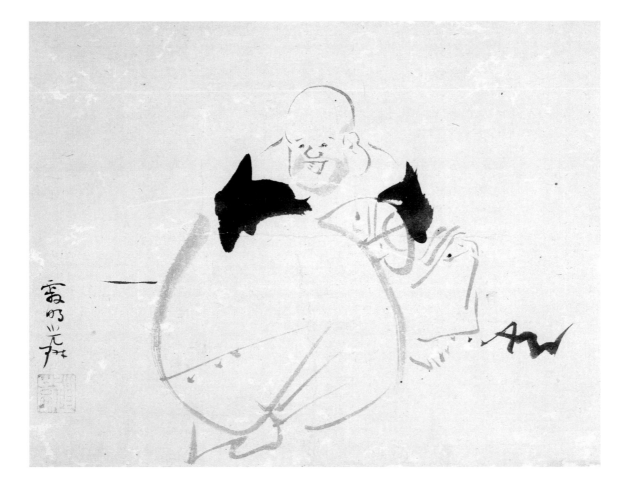

SAKAI HŌITSU (1761–1828)

134. *Blossoming Cherry Trees*

Edo period (1615–1868), ca. 1805
Pair of six-panel folding screens, ink, color, and
gold on gilded paper
Each screen 96.5 × 208.8 cm (38 × 82¼ in.)
Signature: *Kishin hitsu* [on each screen]
Seal: *Hōitsu* [on each screen]
Ex coll.: Iwasaki, Tokyo

LITERATURE: Honma Art Museum 1969, no. 18;
Yamane Yūzō 1977–80, vol. 5 (1978), pls. 10, 23,
24; Chizawa Teiji 1981, fig. 40; Tokyo National
Museum 1985a, no. 45; Kobayashi Tadashi 1990,
pl. 57; Schirn Kunsthalle Frankfurt 1990, no. 59;
Nakamachi Keiko 1992a, pp. 1032–33.

Sakai Hōitsu (1761–1828), who painted this
simple and elegant pair of screens, was an
ardent admirer of the art of Ogata Kōrin (cat.
nos. 132, 133), and eventually he succeeded
where Kōrin had failed—in transplanting the
Kyoto art of Rinpa to Edo. Hōitsu was born
in this new center of power, the second son of
Sakai Tadamochi, lord of Harima Province
and Himeji Castle. He was thus part of the
elite of Edo society. He was trained not only
in the martial arts—as befitting a member of
the samurai class—but in the literary arts
of *haikai* and *kyōka* (satirical poetry), and in
painting. Through his family's patronage,
Hōitsu came to know such eminent painters of
Edo as Sō Shiseki, Kameda Bōsai, who fre-
quently wrote colophons on Hōitsu's paint-
ings, and Tani Bunchō (cat. nos. 166–168).
No doubt reflecting the styles of these older
contemporaries, Hōitsu's work reveals many
influences, but his earliest interest seems to
have been in *ukiyo-e*, the paintings and prints
of city life, especially as observed in the
pleasure quarters of the capital. Hōitsu based
several paintings on the work of the leading
ukiyo-e painter and printmaker Utagawa

Toyoharu (1735–1814). One of these, dated to
1785, also reveals the influences of Nagasaki-
school realism and of the Kano manner, sug-
gesting that Hōitsu was already well versed in
several styles while still in his early twenties.[1]

In 1797, Hōitsu took the tonsure under the
guidance of a monk from Nishi Honganji,
Kyoto, who was visiting Edo at the time. He
nevertheless continued to lead a secular life;
indeed, he later lived with a former courtesan
of the Yoshiwara district of Edo. Ostensibly,
he had taken the tonsure for reasons of health,
but so doing enabled him to remove himself
from official duties, which must have increased
after the death of his older brother. As a
monk, Hōitsu immersed himself in the artistic
life. In 1798, he traveled to Nishi Honganji to
visit the monk who had officiated at his investi-
ture. The temple owned the *Irises*, a famous
pair of screens by Kōrin now in the Nezu
Institute of Fine Arts, Tokyo (fig. 50, pages
308–9), and Hōitsu most likely had the oppor-
tunity to study them during his visit. His paint-
ings dating to 1801, one of which is the *Irises*
formerly in the Aschwin Lippe collection, cer-
tainly reflect the influence of the Kōrin work.[2]

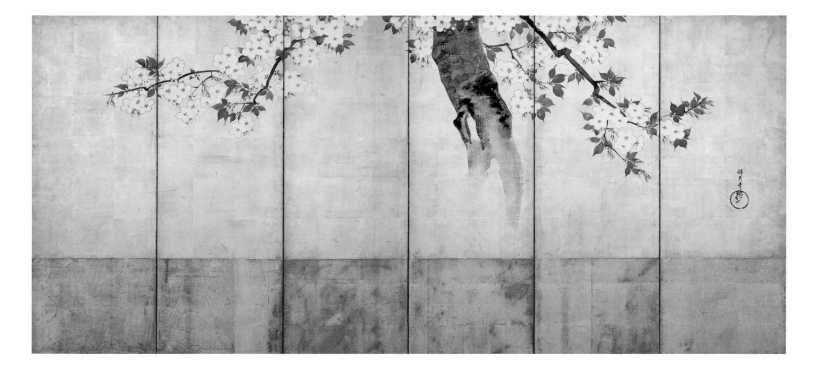

Hōitsu seems to have regarded the revival of Kōrin's art in Edo as a lifelong personal mission. In 1815, he published the *Ogata ryū ryaku inpu* (A Selection of Seals from the Kōrin School). The same year, he organized the commemoration of the centennial of Kōrin's death, which involved a retrospective exhibition and the publication of a catalogue of Kōrin's work the *Kōrinhyakuzu* (A Selection of One Hundred Paintings by Kōrin). In 1817, Hōitsu's own oeuvre was published as the *Ōson Gafu* (Collected Paintings of Hōitsu). His publishing activities also included a catalogue of the work of Kōrin's brother Kenzan (1663–1743), which appeared in 1823. But despite his involvement with many different schools, most of his own work, even the ink-monochrome paintings, reflect the Rinpa style.

Paintings of cherry trees—the premier symbol of Japan—in isolation are surprisingly rare. An emblem of spring in literature and painting or an allusion to a famous site (*meisho*; cat. nos. 140, 141), cherry trees had rarely, if ever, been treated alone as a subject for painting. Here, three cherry trees—one

large and venerable, at the right, and two young and slender, at the left—seem to reach beyond the painting frame to entwine their branches. Originally without the wide silver band at the bottom, the composition illustrates Hōitsu's unerring sense of space, created by an expanse of gold leaf. The screens have the sophistication that characterizes the art of Hōitsu and the art of Rinpa after it was freed from the literary allusions with which it had been associated since its beginnings in Kyoto.

The signature name, "Kishin," was one of three priestly names that Hōitsu adopted in 1797. "Hōitsu," which appears in the seal, is the name he began to use about 1798. Judging from the calligraphic style of the signature, the screens would date to about 1805, when Hōitsu was in his mid-forties.[3]

1. The painting, which depicts two sisters, is in the Hosomi Museum, Kyoto; see Chiba Municipal Museum 1996, no. 156.
2. Kōno Motoaki 1978, fig. 6; Nakamachi Keiko 1990, p. 87.
3. Kobayashi Tadashi 1990, p. 301.

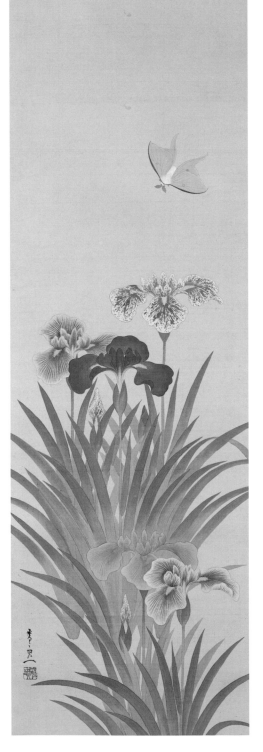

135. Irises and Moth

Edo period (1615–1868), ca. 1850s
Hanging scroll, ink and color on silk
101.6 × 33 cm (40 × 13 in.)
Signature: *Seisei Kiitsu*
Seal: *Shukurin*

LITERATURE: Murase 1975, add. no. 109; Shira-hata Yoshi 1975, vol. 3, pl. 54; Yamane Yūzō 1977–80, vol. 5 (1978), pls. 156, 182; Hosono Masanobu 1979, pl. 53; Nakamura Tanio 1979, pl. 73; Kōno Motoaki 1982a, fig. 25; Tokyo National Museum 1985a, no. 46; Kobayashi Tadashi 1990, pl. 132; Schirn Kunsthalle Frankfurt 1990, no. 60.

Sharp blades of iris here grow in a vacuum, with tight buds and flowers in full bloom— the petals striped and spotted—receding to the back of the picture plane. The wings of a lone moth echo the large petals and green blades. The impression created from combining two seemingly irreconcilable elements— Western realism and the decorativeness of the Rinpa style—is that of a conflicting vision of nature, at once realistic and surreal.

Suzuki Kiitsu (1796–1858), who painted this scroll, left a large body of work, some of which emulates the style of his teacher, Sakai Hōitsu (cat. no. 134). Others, which are at times tinged with a jolting modernity, display a more individualistic style. Only one painting is inscribed with a date—1857, the year before the artist's death.[1]

The son of a cloth dyer, Kiitsu entered Hōitsu's studio in 1813, at the age of seventeen. Hōitsu is said to have arranged for Kiitsu to marry the older sister of a fellow student, Suzuki Reitan, a samurai retainer of Lord Sakai; a few years later, the young artist was permitted to adopt the name "Suzuki" and to assume Reitan's position in the Sakai family. By then an accomplished follower of Hōitsu, Kiitsu assisted the master in the 1815 publication *Kōrin hyakuzu* (A Selection of One Hundred Paintings by Kōrin) and served as his companion on many occasions. Together they visited Yoshiwara and attended *chanoyu*

and *haikai* gatherings and performances of Nō plays. Kiitsu's friendship with Hōitsu thus extended to many of Hōitsu's other acquaintances—the *nanga* artist Kameda Bōsai (cat. no. 167), for example, and the poet and essayist Ōta Nanpo (1749–1823). Kiitsu's responsibilities as Hōitsu's assistant continued to increase, especially after the early death of Hōitsu's adopted son, Ōho, in 1841 (cat. no. 138). Kiitsu became so adept at working in Hōitsu's style that he was given the task of executing paintings on his master's behalf.[2]

A chronology of Kiitsu's work based on the calligraphic style of his signatures was compiled by Tsuji Nobuo in 1978.[3] The signature on the Burke painting is executed in two styles: "Seisei" is written with a flourish, while "Kiitsu" is written in the simpler *gyōsho* script. The one dated work, painted in 1857, is signed in an identical manner. *Irises and Moth* can thus be dated to the last phase of the artist's career.

1. The painting, entitled *Setsubun*, which illustrates the celebration of the first day of spring, is also in the Burke Collection. See Yamane Yūzō 1977–80, vol. 5, no. 203. For a detailed discussion of Kiitsu's life, see Yokoyama Kumiko 1994, pp. 193–216.
2. Archives at the University of Michigan include letters from Hōitsu asking Kiitsu to complete commissions for his patrons. See also Kōno Motoaki 1983, pp. 9–25.
3. Tsuji Nobuo 1978, pp. 57–72.

IKEDA KOSON (1802–1867)

136. Cypress Trees

Edo period (1615–1868)
Two-panel folding screen, ink on paper
150.6 × 160.2 cm (59¼ × 63⅛ in.)
Signature: *Koson Sanshin utsusu oite Renshinkutsu*
Seals: *Chaga ẓanmai-an shu* and *Sanshin*

LITERATURE: Murase 1971, no. 7; Yamane Yūzō
1977–80, vol. 5 (1978), pl. 213; Tokyo National
Museum 1985a, no. 47; Murase 1990, no. 9; Schirn
Kunsthalle Frankfurt 1990, no. 61; Kobayashi
Tadashi 1991, pl. 92.

Little is known about Ikeda Koson (1802–
1867), who painted this exquisite screen, other
than that he was one of the leading students—
with his older colleague Kiitsu (cat. no. 135)—
of Sakai Hōitsu (cat. no. 134). His signature,
"Koson Sanshin utsusu oite Renshinkutsu"
(Drawn by Koson Sanshin at the Cavern for
Refining the Mind) hints at a leaning toward
the spiritual life, and the larger of his two
seals, "Chaga zanmai-an shu" (Master of the
Hut for Tea, Painting, and Spiritual Concen-
tration), suggests an involvement with *chanoyu*.
Stylistically, Koson's work emulates that of
his teacher. Also like Hōitsu, he published a
book on Ogata Kōrin (cat. nos. 132, 133),
Shinsen Kōrin hyakuzu (A New Selection of
One Hundred Paintings by Kōrin).[1]

Koson's oeuvre is composed mainly of
brilliantly colored, sharply delineated, semi-
realistic works that show traces of Western
influence. This exceptionally beautiful screen
in ink monochrome veers sharply from the
artist's standard style and is widely praised as
one of the finest ink paintings by an artist of
the Rinpa school.

The cypress was a favorite Rinpa subject.
Using only ink, Koson achieves a subtly dec-
orative effect in a spectrum of tones from
black to pearl gray. The uniformity of the
leaves in both shape and size may indicate that
Koson copied them from preexisting patterns,
as did Kōrin on occasion. The application of
wet over partially dried ink, in the *tarashiko-
mi* technique, lends a blurred effect, creating
an impression of damp woods in early morn-
ing, with soft, intermittent rays of sun.

1. Ikeda Koson 1864.

IKEDA KOSON (1802–1867)

137. *The Thirty-six Immortal Poets*

Edo period (1615–1868)
Two-panel folding screen, ink and color on silk
172.8 × 174.6 cm (68 × 68¾ in.)
Signature: *Koson Fujiwara Sanshin utsusu*
Seals: *Renshinkutsu* and *Sanshin*

LITERATURE: Yamane Yūzō 1977–80, vol. 5
(1978), pl. 214; Takeda Tsuneo, Takio Kimiko, and
Minamidani Kei 1982, p. 47; Murashige Yasushi
1991, pl. 74; Yamane Yūzō et al. 1994, no. 13.

As far as we know from extant examples, the
theme of the Thirty-six Immortal Poets
(*Sanjūrokkasen*; cat. nos. 39–41) did not appear
on large screens until the early Edo period. At
that time, the Rinpa painter Ogata Kōrin (cat.
nos. 132, 133) made a group portrait on a two-
fold screen, with the poets depicted in semi-
caricature.[1] The composition became one of
the most frequently copied of Kōrin's paint-
ings. At least ten versions—by such Rinpa
artists as Hōitsu, Kiitsu, and Ōho—are known
today. Six of the copies, all of which are close-
ly modeled on the original, are on two-fold
screens; the other four are on hanging scrolls.

This version, by Ikeda Koson (1802–1867),
also maintains the general appearance of the

original. Seventeen poets are depicted on the
right panel and eighteen on the left (Princess
Saigū no Nyōgo, behind the curtain at the
top, is not visible). Koson's version has
more breathing space than does the original,
created by the presence of a kind of path
that weaves through the composition. The
arrangement of the figures in three parallel
diagonals brings to Kōrin's powerful—though
crowded—composition a sense not only of
ordered space but of a certain intimacy among
the poets, who appear to be engaged in highly
absorbing conversation.

1. Murashige Yasushi 1991, pl. 68.

138. Mu Tamagawa (Six Jewel Rivers)

Edo period (1615–1868), ca. 1839
Six handscrolls, ink, color, and gold on silk
Average dimensions 9 × 119.6 cm (3½ × 47⅛ in.)
Signature: *Ōho hitsu* [on each scroll]
Seal: *Hansei* [on each scroll]

LITERATURE: Kobayashi Tadashi and Murashige Yasushi 1992, suppl. 3; Murase 1993, no. 39; Yasumura Toshinobu 1993, nos. 94–101; Murase 1995, pp. 94–97.

These six handscrolls are so tiny that when rolled up each fits comfortably in the palm of the hand. The paintings, which are in pristine condition, shimmer with vibrant color. There is no text. The subject is identified by the title of each scroll, which is inscribed on a small piece of paper affixed to the scroll's cover. The titles refer to six rivers in various parts of Japan that are named Tamagawa, or Jewel River: Noda no Tamagawa, Tetsukuri no Tamagawa, Noji no Tamagawa, Ide no Tamagawa, Kinuta no Tamagawa, and Kōya no Tamagawa. The labels were most likely executed by Nakano Kigyoku, a student of Suzuki Kiitsu (cat. no. 135) who also wrote the two inscriptions on the lid of the two-tiered box in which the paintings are kept. On the outside of the lid the scrolls are identified as *Mu Tamagawa rokkan* (Six Scrolls of the Six Jewel Rivers); on the underside are the inscriptions "Ōho hitsu" (Painted by Ōho) and "Seisei Kigyoku shi" (Recorded by Seisei Kigyoku). Ōho himself signed "Ōho hitsu" at the end of each scroll, which is also impressed with his *hansei* seal.

Each scroll shows a horizontal expanse of landscape in which the main elements of the composition are gradually introduced and then slowly fade out in almost cinematic fashion. The tradition of miniature handscrolls—which offered the singular challenge of working within a format that allowed little room for vertical expansion while providing a broad horizontal space—had been established long before Ōho's time; *ko-e* (little pictures), of which many examples are extant, are mentioned in the literature of the Muromachi period.[1]

Hills and shorelines are here rendered in soft gray ink, and a light shade of robin's-egg blue leads the eye to the middle section of each scroll, where breathtaking views of the river in midcurrent unfold in vivid hues of aquamarine. Ōho made no attempt to organize the scenes according to the four seasons or any other sequence. An arbitrary system is therefore adopted here, though the northernmost river, Noda no Tamagawa, is placed first and the southernmost, at Kōya, south of Nara, is placed last.

Noda no Tamagawa is located at Noda, near Sendai, in the province of Mutsu (Miyagi Prefecture). An aristocratic lady, elegantly dressed, is shown with a male servant. Their attention is diverted by a flight of beach plovers; the lady turns her head toward the birds, partially shielding her face with a raised sleeve in a gesture reminiscent of a dance pose. A boat with a white sail appears on the far horizon, and a cluster of houses at the foot of the hills across the water suggests the great distance they have yet to cover. The vast space serves to evoke both the mood of the travelers and the lonely isolation of the far north.

Tetsukuri no Tamagawa is on the Musashino plain, west of Tokyo. In this scene, two women beat clothes in a tub; strips of white fabric have been hung up to dry near the farmhouses behind them. The riverbanks are protected by a weir. At the end of a sandbar, the bent figure of a woman can be seen as she rinses her clothes in the stream. Across the water is Mount Fuji, its majestic snow-covered peak rising high above a range of hills.

In the next scene, a courtier and his two attendants stand on the bank of Noji no Tamagawa, in Ōmi Province (Shiga Prefecture), contemplating a grove of bush clover resplendent with autumn color. (The river is also known as Hagi no Tamagawa, or Jewel River of Bush Clover.)

Ide no Tamagawa lies south of Kyoto. In this scene a courtier on horseback, accompanied by two attendants on foot, crosses the river in the spring. Yellow *yamabuki* are in bloom, and cherry trees blossom on the distant hills.

Kinuta no Tamagawa is in Osaka. The shadows cast by eulalia plants that ring the base of low-lying hills are a harbinger of evening. Plumes of eulalia in the foreground are tinged with gold, while the hills and trees in the distance are submerged in shadowy gray. Two women are hard at work fulling cloth, their night repast close at hand. Spots of gold wash applied to the teapot, cups, and fulling block reflect the radiance of the full moon, hanging high above the river at the left, and a flock of geese traverses the shining circle, their cries shattering the stillness of the evening.

The final handscroll shows the Tamagawa located deep in the sacred mountains at Kōya, south of Nara. Dark ink tones dominate, in combination with a deep green that enhances the shadowy depths of the mountain range. The current is rough, broken by stones and rocks, and no flowering plants are visible. The figure taking in this wild, barren scene is, appropriately, an aged Buddhist monk accompanied by a young acolyte. The atmosphere is somber, befitting the holy character of the site.

The name "Tamagawa" may originally have been used to refer to any beautiful river, as the word *tama* (jewel) was often employed

by itself as an adjective to describe any splendid or elegant object. The theme of six beautiful rivers enjoyed great popularity in the nineteenth century, especially among *ukiyo-e* printmakers. Nevertheless, these six tiny handscrolls remain, so far, one of only two extant examples of paintings on the theme, the other being a single handscroll by Sumiyoshi Gukei (1631–1705).[2] We do not know when these particular rivers were singled out or when the six were grouped together to form a set.

A poem about a Tamagawa appears in Japan's earliest anthology of poetry, the late-

Noda no Tamagawa

eighth-century *Man'yōshū* (Collection of Ten Thousand Leaves). This verse, from the section "Azuma uta" (Eastern Poems), refers to the bleaching of cloth, an occupation later selected for inclusion in images of Tetsukuri no Tamagawa. The name "Tamagawa" was eventually included in a large compendium of place names used as *utamakura* (pillow words), phrases that served to inspire poets; subsequently, many verses were composed about rivers called Tamagawa.[3] Although the majority of such poems mention "beautiful rivers" without reference to sites, a small number describe objects, activities, or attributes that later became associated with six specific rivers:[4]

Noda no Tamagawa: Beach plover, new green leaves

Tetsukuri no Tamagawa: Bleaching and drying of cloth

Noji no Tamagawa: Bush clover, moon

Ide no Tamagawa: *Yamabuki* flowers, *unohana* flowers, horseback riding, frogs

Kinuta no Tamagawa: Fulling of cloth, pines

Kōya no Tamagawa: Travelers

While many *meisho* (famous scenic places) served as subjects for paintings (*meisho-e*) during the Heian and Kamakura periods, apparently none of the six Tamagawa was among them. Only one poem about a Tamagawa painting is recorded in the Heian period.[5] Interestingly, among the many *meisho* on sliding screens at the palace complex of the Saishō Shiten'nōin, which was built for retired emperor Go-Toba in 1207, there was not a single one that represented a Tamagawa.[6]

There are few references to *meisho-e* from subsequent eras,[7] but it is possible that the iconographic standard for the representation of the theme was established shortly before the production of a set of six Tamagawa prints by the woodblock-print master Suzuki Harunobu (1725–1770). These can be dated to between 1765 and the year of Harunobu's death. In 1765, Harunobu perfected the technique of *nishiki-e* (brocade pictures, or colored prints) by using multiple blocks for a single image. The prints bear the title *Mu Tamagawa*; each scene depicts a river and includes a quotation from a Heian-period poem. It is not unlikely that these prints provided a prototype for other *ukiyo-e* artists,

Tetsukuri no Tamagawa

whose works include the same poems and
some of the same sites:

1. *Noda no Tamagawa*
 When evening approaches,
 plovers cry in the briny air
 over Tamagawa's stream
 at Noda of Michinoku.

 —*Nōin Hōshi*[8]

2. *Tetsukuri no Tamagawa*
 The cloth that is hung
 over the fence for bleaching
 catches the morning dew
 at the village of Tamagawa.

 —*Fujiwara Nagakiyo*[9]

3. *Noji no Tamagawa*
 I shall come back again tomorrow
 to the Tamagawa of Noji.
 The moon shines over the bush clovers
 and rests upon the
 river's colored waves.

 —*Minamoto Toshiyori*[10]

4. *Ide no Tamagawa*
 As I stop my horse
 to give him water,
 dew from the yamabuki flowers
 is lost in the stream
 of Tamagawa at Ide.

 —*Fujiwara Shunzei*[11]

5. *Kinuta no Tamagawa*
 The autumn wind over the pines
 sounds forlorn.
 In the loneliness,
 the sound of fulling cloth
 at Tamagawa.

 —*Minamoto Toshiyori*[12]

6. *Kōya no Tamagawa*
 Forgetting the warning
 not to do so,
 a traveler to Kōya's Tamagawa
 dips his hand in the water.

 —*Kōbō Daishi*[13]

If, as seems to be the case, the iconographic tradition for *Mu Tamagawa* was established sometime before Harunobu's prints, it can be traced clearly only in printmaking, literature, and music. About 1700, a number of essays by *haikai* poets were published that included the name *Mu Tamagawa* in their titles.[14] And nearly contemporaneous with Harunobu's prints, a musical composition written for the *koto* by Mitsuhashi Kengyō (d. 1760) was also titled *Mu Tamagawa*. The composition apparently inspired a series of song and dance pieces that were used until the mid-nineteenth century by such major schools

Noji no Tamagawa

of music as the Tomimoto, Jōruri, Nagauta, and Kiyomoto.

Documentation on the room decorations of Edo Castle may provide an important clue to the origins of the theme in painting. Now used as the residence of the imperial family in Tokyo, Edo Castle was the seat of the Tokugawa administration and the residence of the shoguns. First constructed in 1456, it was chosen as the Tokugawa power base by Ieyasu (r. 1603–5) in 1600. The castle underwent a succession of constructions and renovations throughout the Edo period, while the city of Edo, a small fishing village before

Ieyasu's day, expanded by leaps and bounds. Edo's mushrooming population suffered from a chronic water shortage, particularly disastrous in the wake of the fires that frequently ravaged the city.

Nothing of the splendor of the castle's Edo-period interior decoration remains, but the plan of the sliding screens can be determined from the sketches made in preparation for the reconstruction of the *nishi no maru* (the residence of the retired shoguns and heirs-apparent) and the *hon maru* (the living quarters of the reigning shoguns), carried out in 1839 and 1845, respectively. The drawings,

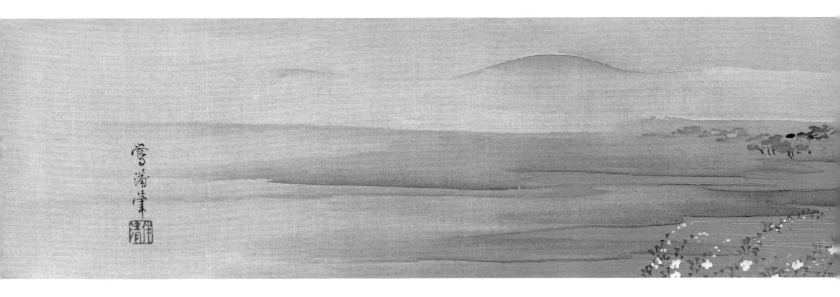

now mounted on 264 handscrolls, are preserved in the Tokyo National Museum, along with the many volumes of the *Kōyō nikki* (Chronicles of Official Projects), which were kept by Kano Osanobu (1796–1846), the leader of the Kano school, to whom responsibility for both reconstruction projects had been given.[15]

Osanobu's orders from the shogun were to copy the screen paintings that remained in the *hon maru*. These panels had been executed by the most revered of the Kano-school masters, Kano Tan'yū (cat. nos. 107, 108) for a much earlier reconstruction, of 1659, and were

still in situ. Sadly, they were destroyed by fire in 1844, and it is thus impossible to determine whether Tan'yū's panels were used as models for all the paintings made for Osanobu's restoration. It seems safe to assume, however, that most of them were based closely on the mid-seventeenth-century works.[16]

In both the *nishi no maru* and the *hon maru*, the *kyūsoku no ma* (rooms for relaxation) were decorated with numerous *meisho-e*. Understandably, these included famous sites recently selected from the eastern and northern provinces, which were closer to Edo, rather than the western and southern sites favored

Ide no Tamagawa

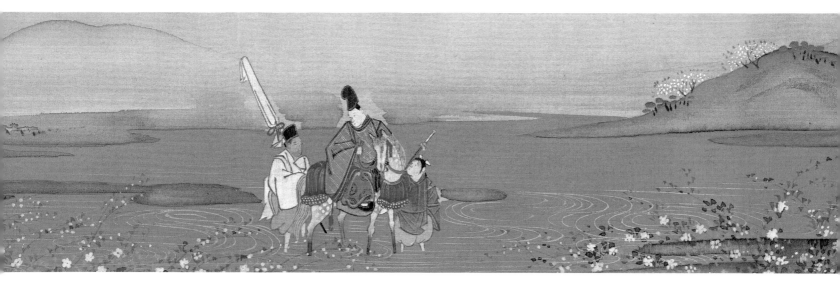

during the Heian and Kamakura periods.[17] Scenes of the Tamagawa were among these pictures (fig. 52), and it is possible that their inclusion marked their debut in the genre of *meisho* painting. Most significantly, the scenes are identifiable even without inscriptions, as the principal pictorial elements are identical to those that appear in Harunobu's woodblock prints and in the present paintings by Ōho. Also notable is the fact that most of the scenes were placed in the bottom areas on small screens, while Tetsukuri no Tamagawa occupied the entire length of a full screen.

Figure 52. Kano Osanobu (1796–1846), *Preparatory Drawing for "Tetsukuri no Tamagawa."* Handscroll, ink and color on paper, 42.7 × 239.7 cm (16⅞ × 94⅜ in.). Tokyo National Museum

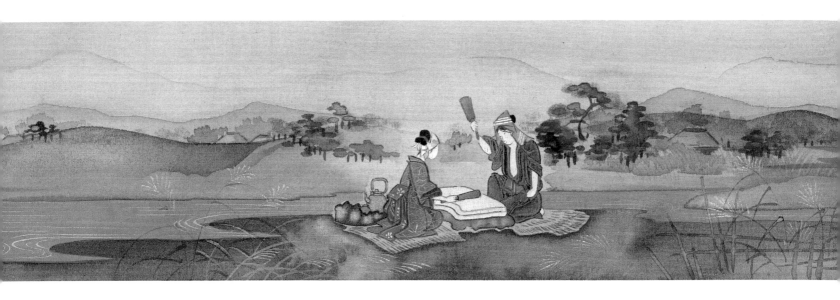

What prompted Tan'yū, in 1659, to accord such a prominent position to Tetsukuri no Tamagawa? The answer to this question may be found in the records of the city construction projects commissioned by the Edo *bakufu*. In 1652, to alleviate the chronic water shortage, the *bakufu* launched an ambitious project to construct an aqueduct that would bring water to the city from the river of Musashino. This aqueduct, known as the Tamagawa Jōsui, is still partially preserved in the western section of Tokyo.[18] Its completion in 1654 was enthusiastically welcomed by both the citizens of the city and the residents of Edo Castle.[19]

It may thus be posited that the theme of the six Tamagawa was devised to commemorate the government's successful undertaking. The grouping together of six rivers was clearly inspired by the tradition of assembling objects, themes, or persons into groups of six. The many examples would include, most prominently, the Rokudō (Six Realms of Reincarnation) and the Rokkasen (The Six Immortal Poets).

Ōho, one of the last Rinpa artists of the Edo period, died when he was quite young, leaving only a small body of work. Many of his paintings are based on, or inspired by, the

Kinuta no Tamagawa

work of Sakai Hōitsu (cat. no. 134), his adoptive father and teacher. The second son of a monk at Honganji, Edo, Ōho was adopted at age twelve and later assumed Hōitsu's artistic mantle. His paintings reflect not only the influence of Hōitsu but also that of Suzuki Kiitsu (cat. no. 135), Hōitsu's star pupil. Hōitsu was a noted *haikai* poet, with a number of poetry anthologies to his credit, and Kiitsu pursued similar interests. Ōho was perhaps inspired to use the Tamagawa theme because of its popularity with the circle of *haikai* poetry enthusiasts who gathered around his teacher and his older colleague.

Other factors may also have encouraged Ōho to turn to this subject. It is well known, for instance, that early in his career Hōitsu experimented with *ukiyo-e*, and it was among the *ukiyo-e* printmakers at Edo that the theme was first established. It is entirely possible that Ōho himself may have had a close working relationship with such master printmakers as Hiroshige (cat. no. 152), who produced a large number of woodcuts on this subject, including a set of six that is identical to Ōho's but which appears to postdate Ōho's death in, 1841.

The Mu Tamagawa theme might well have disappeared as a subject for painting after

Tan'yū used it in 1659. Fortunately, it was revived in 1839, when Osanobu copied Tan'yū's wall paintings; Ōho's handscrolls may be dated to about the same time. Although no connection has been established, it is also possible that Ōho was first introduced to the imagery of the Jewel Rivers by artists of the Kano school.

1. Umezu Jirō 1961, pp. 103–4.
2. This scroll, in a private collection in the United States, dates to between 1691 and 1705. Poems are inscribed on the scroll, and its painted scenes are quite different from those on the Burke set; one of the six rivers, moreover, is located in a different place. See Murase 1995, pp. 98–99 and fig. 10.

3. Katagiri Yōichi 1972, pp. 418–19.
4. Takahashi Yoshio 1974, pp. 2–21.
5. The preface of poem 899 (listed again as poem 935), by Mibu no Tadami, dated 958, states that it was "composed about a painting on a *byōbu* which depicts a man leaning over a fence as he attempts to entice a young girl at Ide, where *yamabuki* flowers are in bloom." See Ienaga Saburō 1966a.
6. These screens, depicting forty-six *meisho*, are lost, but a diary kept by the courtier-poet Fujiwara Teika (1162–1241) preserves the *Meigetsuki*, a day-to-day account of the progress of the project and provides information about the artists, the places chosen as subjects, and the layout of the scenes. The appearance of the lost paintings can be reconstructed from the 460 poems by ten poets (one poem per *meisho* for each) that were written to accompany the paintings. The poems can be found

Kōya no Tamagawa

in *Gunsho ruijū* 1928–37, vol. 8, pp. 398–410. See also *Meigetsuki* 1977, vol. 2, p. 297.

7. Inoue Ken'ichirō 1977, pp. 150–55.

8. Nōin (b. 988), *Shin kokinshū* (New Collection of Poems Ancient and Modern, ca. 1206), poem 643.

9. Fujiwara Nagakiyo, *Fuboku wakashō*, poem 14647.

10. Toshiyori (ca. 1055–ca. 1129), *Senzaishū* (ca. 1188), poem 280.

11. Toshinari (Shunzei, 1114–1204), *Shin kokinshū*, poem 159.

12. *Senzaishū*, poem 339.

13. Kūkai (Kōbō Daishi, 774–835), *Fūgashū* (1344–46), poem 1788.

14. Takahashi Yoshio 1974, p. 9.

15. For excerpts from this chronicle, see Tokyo National Museum 1989a, vol. 1, pp. 167–461.

16. Ibid., pp. 22–23.

17. For the *hon maru* wall paintings, see ibid., vol. 2,

p. 58; for the *nishi no maru* paintings, see ibid., p. 129 (these are reproduced in color, in a larger plate, in Tokyo National Museum 1988, p. 18); see also Murase 1995, fig. 9.

18. It originally extended for 85 kilometers (53 miles) through the open field of Musashino, first as an open canal and then, inside the city proper, as a series of pipes made of wood and bamboo.

19. For a summary of this project, see Hamurochō Kyōiku Iinkai 1980.

Genre and Ukiyo-e

Much admired by the French Impressionists, the prints and paintings known as *ukiyo-e* (pictures of the floating world) continue to be the Japanese art form most familiar in the West. In its earliest written form, the word *ukiyo* reflected the Buddhist belief that life (*yo*) on earth is wearisome (*uki*) and transitory. This attitude mellowed considerably through the centuries. By the Edo period the word *uki* was indicated by a Chinese ideogram that means "to float." In its modified connotation *ukiyo* was an injunction to make the most of this ephemeral life by plunging into its "floating" current. *Ukiyo-e* are thus pictures that show the pursuit of all the pleasing things the world offers, with an emphasis on the transitory indulgences available for purchase in the theater and pleasure districts of the great cities.

Ukiyo-e represents the final phase in the long evolution of Japanese genre painting (*fūzokuga*). Although its ultimate origins lie in Heian painting of the tenth century, it may be more directly traced to the sixteenth-century panoramic compositions known as *rakuchū-rakugai zu* (scenes in and around the capital; cat. no. 139). The emphasis in these paintings was not so much on human figures as on landscapes and symbols of seasonal change. (Gradually *rakuchū-rakugai* screens would go out of fashion, when Kyoto was supplanted by Edo as the nation's political and economic center.) During the Momoyama period, human figures began to dominate. As though in a bid for independence, the myriad small scenes that had filled the Kyoto screens began to acquire a life of their own, as it were, in a new vogue that showed one subject, much enlarged, per screen. At the same time, far greater attention was given to the figures participating in the activities, now portrayed in close-ups, by artists delighted to record contemporary affairs and fashions.

Scenes of Kyoto's suburbs—outdoor picnics under cherry or maple trees—were among the first to be treated independently in this new style (cat. nos. 140, 141). Also popular were the horse races at the Kamikamo Shrine and the floats and processions at the Gion Festival in Kyoto. But the subject that exerted the most direct influence on the evolution of *ukiyo-e* was the colorful life of the urban Kabuki theaters and brothel districts in Edo (fig. 53).

Kabuki, a fusion of dance and drama derived from the ancient Nō theater, was introduced in Kyoto at the beginning of the seventeenth century by a woman performer named Okuni. Before it became an all-male theater, as it is today, Kabuki underwent a series of somewhat amusing transformations. In 1604, the highly

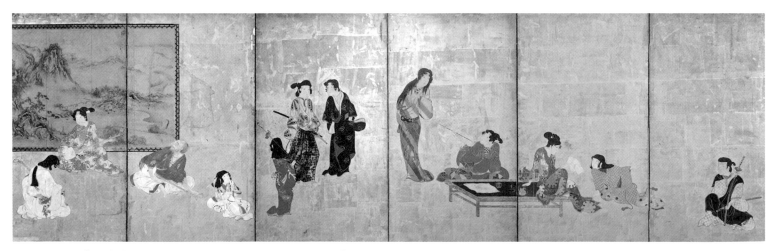

Figure 53. Unidentified artist (17th century), *Pleasure District*. Pair of six-panel folding screens, ink and color on gilded paper, each screen 61 × 198 cm (24 × 78 in.). Hosomi Museum of Art, Kyoto

successful Okuni was granted a permanent stage near the Kitano Shrine, in the northwestern section of the capital, and women's Kabuki was performed before audiences for the next quarter of a century (such a performance is depicted in cat. no. 139). But many of the performers engaged in highly remunerative after-hours pursuits, and government disapproval led to a series of prohibitions against female performers beginning in 1629 and their replacement by young boys. This solution also proved unsatisfactory when the youthful thespians attracted too much attention from homosexuals. In 1652, they too were cashiered and older men took their place.

As the artists' choice of subject focused increasingly on the participants in these delights of city life, their interest shifted to indoor activities. The most favored subjects for painting at this stage were scenes of merrymaking at houses of pleasure, especially in the notorious Yoshiwara quarter of Edo. Originally situated within the city limits, this "red-lantern" district was relocated after the great fire of 1657 to the northeastern outskirts, which came to be known as the "reed-covered field" (*yoshiwara*). Visitors reached it first by riverboat, and later by land. About this time, during the Kanbun era (1661–72), actresses and the alluring courtesans of Yoshiwara were singled out for individual portrayal, on a scale larger than usual and garbed in opulent costumes. Such paintings as the *Kanbun Beauty* (cat. no. 144) were only a step away from authentic *ukiyo-e*, which describe the hedonistic enticements of life in Edo.

The birth of *ukiyo-e* reflects the growing wealth of the urban middle class during the Genroku era (1688–1704). Sudden affluence brought with it a series of adjustments in the nation's social structure, among the most significant of which was the rise of the merchant class. In accordance with ancient Confucian philosophy, commoners were divided into four categories—in descending order, warriors (samurai), farmers, artisans, and merchants. The Tokugawa *bakufu* demanded strict adherence to this system, requiring every man and woman, at least in principle, to remain forever in the class into which he or she was born. But because of an antiquated system of taxation—based on rice production and aggravated by inflation—farmers and warriors, whose revenues were paid in quantities of rice, became ever poorer, while the merchants' assets, relatively lightly taxed, multiplied rapidly.

By the beginning of the eighteenth century the samurai were impoverished, while for the first time the merchants were in the ascendent, both economically and socially. Financially well off they lived luxuriously and sought, in playhouses and bordellos, distraction and liberation from society's stern moral codes.

Portraits of famous courtesans and actors were made more accessible to a mass audience in the form of inexpensive woodblock prints. The method of reproducing artwork or texts by woodblock printing was known in Japan as early as the eighth century, and many Buddhist texts were reproduced by this method (cat. no. 7). The designer and painter Tawaraya Sōtatsu used wood stamps in the early seventeenth century to print designs on paper and silk. Until the eighteenth century, however, woodblock printing remained primarily a convenient method of reproducing written texts. What *ukiyo-e* printmakers of the Edo period achieved was an innovative use for a centuries-old technique.

In the late seventeenth and early eighteenth century, woodblock prints depicting courtesans and actors were much sought after by tourists to Edo and came to be known as "Edo pictures." In 1765, new technology made it possible to produce single-sheet prints in a whole range of colors. Each color was printed, with remarkable precision, from a separate block. Printmakers who had heretofore worked in monochrome and painted the colors in by hand, or had printed only a few colors, gradually came to use full polychrome printing to spectacular effect.

The first polychrome prints, or *nishiki-e*, were calendars made on commission for a group of wealthy patrons in Edo, where it was the custom to exchange beautifully designed calendars at the beginning of the year. These household items, which still command a prominent place in every Japanese home, were even more indispensable at that time, when the nation adhered to a complicated lunar system for reckoning the months. In 1765, Suzuki Harunobu (1725–1770) designed a polychrome calendar. It was an instant success, and Horunobu went on to market polychrome prints without calendrical notations.

Great print masters like Harunobu and Utagawa Hiroshige (cat. no. 152) are today recognized as artists of rare vision. We must remember, however, that each print required the collaboration of four experts: the designer, the engraver, the printer, and the publisher. A print was usually conceived and issued as a commercial venture by the publisher, who was often also a bookseller. It was he who chose the theme and determined the quality of the work. Designers were dependent on the skill and cooperation of their engravers and of the printers charged with executing their ideas in finished form.

The last quarter of the eighteenth century was the golden age of printmaking. At this time, the popularity of women and actors as subjects began to decline. During the early nineteenth century, Hiroshige and Katsushika Hokusai (1760–1849) brought the art of *ukiyo-e* full circle, back to landscape views, often with a seasonal theme, that are among the masterpieces of world printmaking.

In the decade following the death of Hiroshige, in 1858, the major printmakers disappeared in the brutal sociopolitical upheavals that brought down the Tokugawa shogunate in 1867. Edo's society, the mainstay of *ukiyo-e* art, underwent a drastic transformation as the country was drawn into a campaign to modernize along Western lines. Like many other elements of Japanese culture, *ukiyo-e* was swept away in the maelstrom that heralded the coming of a new age.

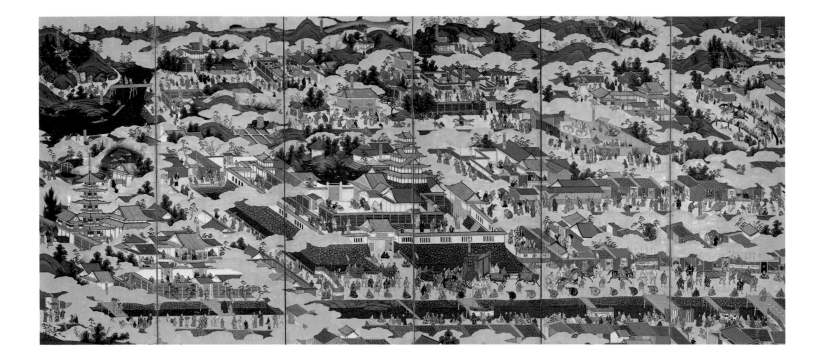

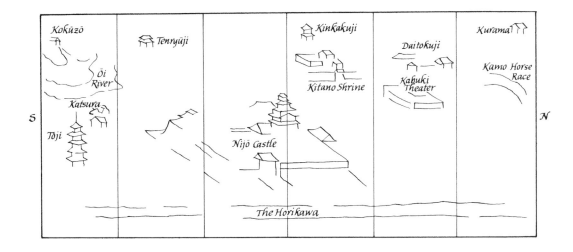

139. Rakuchū-rakugai zu (Scenes in and around the Capital)

Edo period (1615–1868), ca. 1629
Pair of six-panel folding screens, ink and color on gilded paper
Each screen 156.1 × 352.2 cm (5 ft. 1½ in. × 11 ft. 6¾ in.)

LITERATURE: Narazaki Muneshige 1964, pp. 11–17; Tani Shin'ichi 1964, illus.; Shimada Shūjirō 1969, vol. 2, no. 22; Murase 1975, no. 45; Tsuji Nobuo 1976, fig. 70 (detail); Takeda Tsuneo 1978a, nos. 88, 89; Schirn Kunsthalle Frankfurt 1990, no. 49; McKelway 1997, pp. 48–57.

Paintings with views of Kyoto and its suburbs are known as *rakuchū-rakugai zu*, a term referring to "inside" the capital city (*rakuchū*) and "outside" (*rakugai*). Usually executed on screens, these pictures illustrate the famous scenic spots and important monuments that served as settings for seasonal festivals and entertainments. Such screens, more than seventy of which are still extant, were much admired and in great demand in Kyoto. They were also popular with visitors from out of town, who purchased them as souvenirs of their trips to the capital. In 1582, when a group of Japanese Christian converts traveled to Rome, they took with them a set of *rakuchū-rakugai zu* by Kano Eitoku (1543–1590) as a gift to the pope from the warlord Oda Nobunaga (1534–1582). One of the two earliest extant pairs was a gift from Nobunaga

to Lord Uesugi, whose descendants are still in possession of the set.

The origin of *rakuchū-rakugai* imagery can be traced to an important genre of *yamato-e*, the distinctly native style of Japanese painting whose basic concept and techniques were perfected in the Late Heian and Kamakura periods.[1] Few examples of these early genre paintings remain, but there are literary and documentary references to two specific types of *yamato-e*: *meisho-e*, paintings that depict activities taking place in famous scenic spots around the country, and *tsukinami-e*, pictures of seasonal events.[2] Because most famous scenic locations came to be associated with special seasonal festivals, the two themes were often combined in a single work. Even during the Muromachi period, when the influence of Chinese culture was profound,

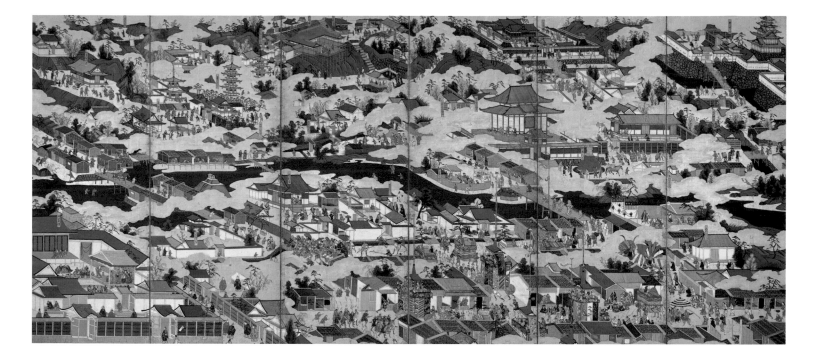

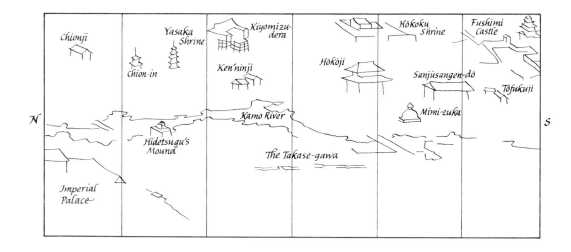

interest in *meisho-e* and *tsukinami-e* persisted. Zen monks, the champions of Chinese learning and aesthetics, actually composed poems in praise of paintings that depicted these purely Japanese themes.[3] While no screen paintings of this subject have survived from the Muromachi period, many folding fans decorated with *meisho-e* and *tsukinami-e* are still extant. Their compositions, and the detailed manner in which they were rendered, eventually served as models for panoramic screen paintings. *Rakuchū-rakugai ẓu* thus represent a final synthesis of *meisho-e* and *tsukinami-e*.

The formula for such screens was established in the early sixteenth century. In 1506, Tosa Mitsunobu (fl. 1469–1523) painted a single screen showing only views of the inner city. This work was hailed as a novelty.[4] The more common format for *rakuchū-rakugai ẓu*, which includes the suburbs as well, was established shortly afterward. The oldest extant screens of this type are a pair dating to the 1520s formerly in the Machida collection and now in the National Museum of Japanese History, Sakura.[5] A pair in the Uesugi collection attributed to Kano Eitoku have been dated to between 1550 and 1570. While Tosa artists undoubtedly followed the example set in 1506 by their ancestor Mitsunobu, most of the later versions were produced by anonymous artists, generally known as *machi-eshi* (town painters). The screens are encyclopedic visualizations of Kyoto and the lives of its citizens. They depict customs and costumes, performing arts, modes of transportation, commercial activities, and men and women from all walks of life. *Rakuchū-rakugai ẓu* also generated many types of smaller genre paintings, which flourished during the Edo period. The decline in popularity of *rakuchū-rakugai* screens in the late seventeenth and eighteenth century coincided with Kyoto's loss of prestige as the center of the nation's cultural, political, and commercial life.

The sixteenth-century screens in the National Museum of Japanese History and the Uesugi collection represent the first stage in the development of the *rakuchū-rakugai* genre. In both pairs, the city of Kyoto is divided into two sections. The left screen shows views of the uptown district, while the right one depicts the downtown section. To create for the viewer the impression of being in the midst of the city, the screens when unfolded for viewing were placed facing each other,

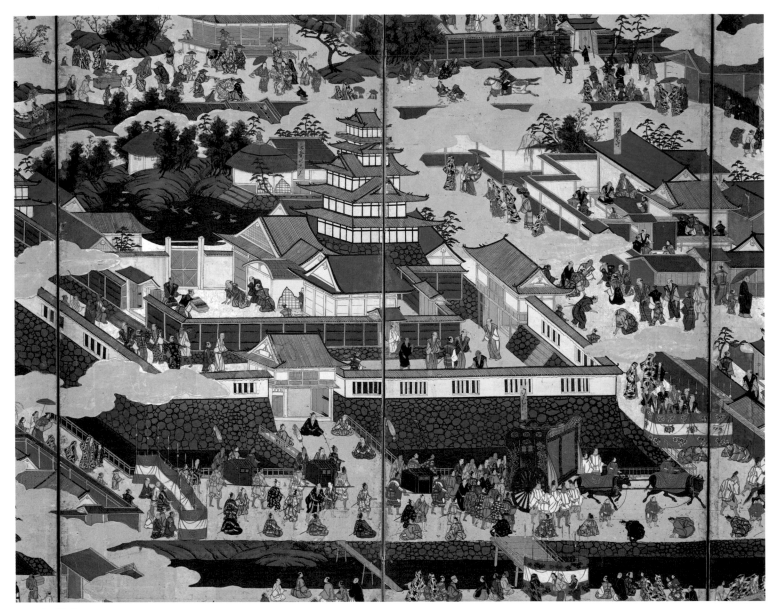

Detail of left screen, cat. no. 139

flanking the viewer, rather than side by side. References to the four seasons are also included. In other types of landscape screens, winter is usually represented at the extreme left panel of the left-hand screen. Here, however, winter is seen at the top left of the right screen continuing to the top right-hand corner of the left screen. Because this portion of the composition depicts the northern hills, it is an appropriate place for winter.

The Burke screens and the majority of extant Kyoto screen paintings belong to a second type of *rakuchū-rakugai* screens. In these the city is separated into east and west, with Abura-kōji Street (running north and south, east of Nijō Castle) as the dividing line. On the right screen, Higashiyama (the eastern hills) is shown at the top and the Gion Festival dominates the street activity.

On the left screen are Nijō Castle and the western half of the city, with Kitayama (the northern hills) and Nishiyama (the western hills) in the background.[6]

Brilliant green hills and mountains, colorful houses, temples and shrines, palaces, streets, and human figures emerge from the golden clouds that partially envelop the capital. Avenues and houses are laid out in an orderly pattern. Running horizontally across the right screen—almost at its center—is the broad Kamo River, which divides the city into the metropolitan and suburban districts. In the foreground, to the west of the river and nearly parallel to it, runs a narrow canal, the Takasegawa, which was constructed in 1611. Structures of major importance and famous scenic locations are identified by small labels. Most of the major monuments

on the screen at the right were constructed by Toyotomi Hideyoshi (1536–1598), who united the country after a lengthy period of civil strife among various feudal lords. Fushimi Castle, in the top right corner, was demolished in 1622; the Hōkoku mausoleum, built for Hideyoshi in 1599, is to the left; directly below the mausoleum is the Great Buddha Hall of Hōkōji, dedicated by Hideyoshi in 1591.

At the northern end (the viewer's left) is the Imperial Palace, where the *Ise odori*—a popular dance that originated at Ise—is being performed. In the downtown section, the mid-July Gion Festival, the most important summer event in Kyoto, is in progress. A major tourist attraction to this day, the festival originated in the mid-ninth century and has been observed annually since the year 970. Here, merchants and other citizens have deserted

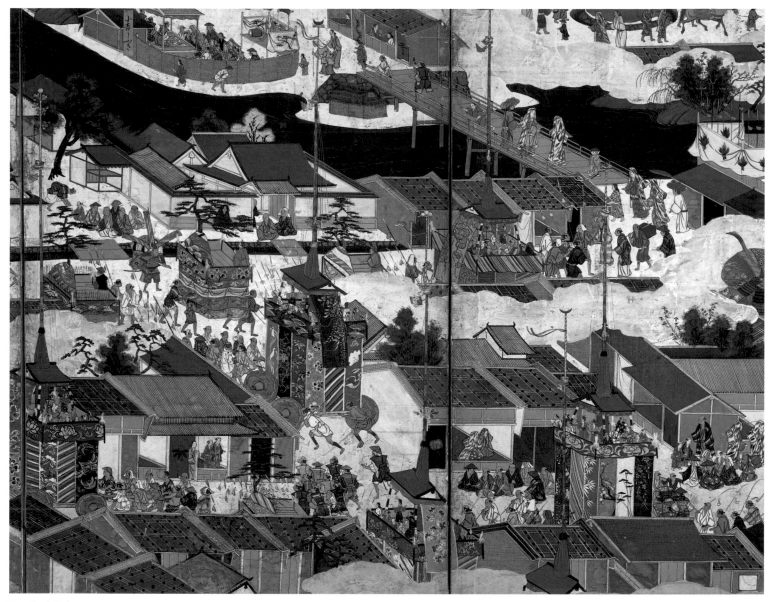

Detail of right screen, cat. no. 139

their shops and homes to watch the procession, with its colorful floats and theatrical performances, as it meanders through the streets and avenues.

Among the better-known Buddhist monuments in the suburbs on the eastern hills are three temples. In the south (at the right) are Tōfukuji, Sanjūsangendō, and the Great Buddha Hall of Hōkōji. In front of Hōkōji stands an unusual monument, also related to Hideyoshi: an earthen mound surmounted by a stone stupa, identified by its label as the Mimizuka (Ear Burial Mound). This structure was built for the interment of the ears and noses of enemy soldiers, which were brought back to Japan from Korea by Hideyoshi's troops. The stepped pyramid to the left, on the western (near) bank of the Kamo River, contained the remains of some thirty concu-

bines, kept by the amorous Hidetsugu, the adopted son of Hideyoshi. To pay for his life of dissipation, Hidetsugu was ordered by Hideyoshi to commit suicide in 1595; the members of his household followed suit.

In the eastern hills (at the top of the screen), pinkish white cherry blossoms dot the hilltops and valleys: spring is depicted in the suburbs, though a summer festival is in progress in the city proper. Major structures here include Kiyomizudera, a temple easily identified by its halls raised on stilts, the Yasaka Shrine with its beautiful pagoda, and Chion'in, another famous temple. On the eastern bank of the Kamo River, in the Gojō area, Okichi Kabuki, performed by young male dancers attracts a crowd of spectators. (Begun in 1629, it was banned in 1652 as the young males were thought to encourage prostitution; they

were replaced by older men.) Facing this, in the Shijō district, is a Nō theater.

The left screen is dominated by the imposing structure of Nijō Castle, completed in 1603 to serve as the temporary residence of the shogun Tokugawa Ieyasu (r. 1603–5). The street in front of the castle is the site of some unusual security measures: roadblocks made of cloth curtains have been set up at intervals around the moat. An ox-drawn carriage moving toward the viewer's right has just emerged from the main gate of the castle. The label pasted above the carriage identifies the procession as that of a visiting member of the Tokugawa clan, on its way to the Imperial Palace. The vehicle probably carries Hidetada (r. 1605–23), the second Tokugawa shogun, who made an official visit to the Imperial Palace shortly after the ascension of Emperor

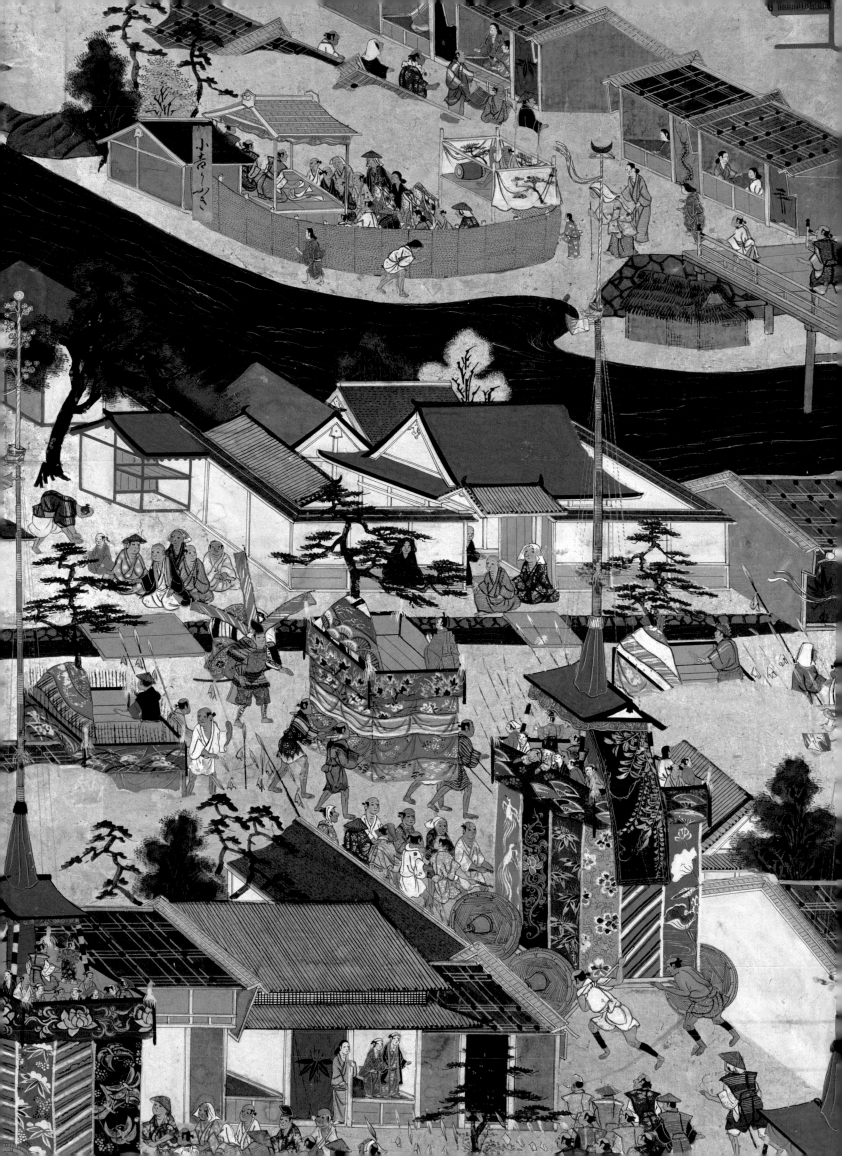

Go-Mizunoo in 1611. Hidetada was accompanied on this occasion by three younger brothers, who followed in three palanquins behind him.[7] Nijō Castle is depicted as it looked prior to the extensive renovation of 1626. (A good example of a post-1626 representation of the castle can be found on a screen in the Brooklyn Museum of Art.)[8] Across from the castle, to the right, is the residence of Itakura Katsushige, who served as Kyoto's first governor, from 1601 to 1619.[9]

In the suburbs, beginning in the south (to the viewer's left) and moving northward, we come to the slender five-storied pagoda of Tōji, which marks the southern boundary of the city. The group of farmhouse-like structures with thatched roofs immediately above may reflect the original appearance of the famous Katsura Villa, before it was rebuilt in the 1620s as the elegant estate that still stands today. Across the Ōi River, in the mountainous area, is Kokūzō temple. At the foot of the steep approach to the compound an *e-toki*

(picture explainer) is in the middle of delivering a lecture for which she has set up a large hanging scroll to illustrate a Buddhist story.

Other famous monuments in the western hills include the temples of Tenryūji, Kinkakuji, and Daitokuji. A major attraction in the western suburbs is a large Kabuki theater adjacent to the Kitano Shrine. A crowd has gathered in front of the building, and within the walled enclosure a play, accompanied by a small orchestra, is being performed. The inscribed cartouche identifies this as the Okuni Kabuki—forerunner of the modern Kabuki drama—which made its first appearance near the Kitano Shrine in or before 1603. In the western and northern hills, blazing red maple leaves signal the arrival of autumn. Incongruously, the famous horse race at the Kamikamo Shrine is shown at the extreme right of the first panel. Introduced in 678, this festival is customarily held in May.

The presence of the Okichi Kabuki allows us to date the screens to about 1629. They

were probably painted in a shop that produced ready-made pictures. Stylistically, several landscape details suggest that the artist may have been trained in the Kano school. Prominent *shun* (wrinkles), for example, were used to delineate the surface texture of rocks, and strong ink outlines form sharp angles to give the impression of roughness.

1. On the evolution of this theme, see Kyoto National Museum 1966; Tsuji Nobuo 1976; and McKelway 1997.
2. Soper 1942, pp. 351–79; K. Toda 1959, pp. 153–66; and Akiyama Terukazu 1964.
3. See, for example, *Kanrin koroshū*, a collection of poems and essays by Keijo Shūrin (1440–1518), in Kamimura Kankō 1936, vol. 4.
4. Sanjōnishi Sanetaka 1979, in the entry for the twenty-second day, twelfth month, third year of the Eishō era (1506).
5. Takeda Tsuneo 1978a, pp. 13–18.
6. For a detailed description, see McKelway 1997, pp. 48–57.
7. Ibid., p. 53.
8. Murase 1971, p. 117.
9. McKelway 1997, p. 55.

140. *Cherry-Blossom Viewing at Yoshino and Itsukushima*

Edo period (1615–1868), 1st half of 17th century
Pair of six-panel folding screens, ink and color on gilded paper
Each screen 153.6 × 348.6 cm (5 ft. ½ in. × 11 ft. 4¼ in.)

LITERATURE: Murase 1990, no. 22; Murase 1993, no. 50.

The image of the blossoming cherry has for centuries been nearly synonymous with the aesthetic values of Japan. Often used as a metaphor for the evanescence of life and of beauty, it has long been a common subject for poetry and a popular image in the visual arts. Interestingly, the plum blossom, not the cherry, was the favorite flower of the classical era, although cherry-blossom viewing was certainly practiced during Heian times. It was Saigyō (1118–1190; see cat. no. 79), the great *waka* poet, who helped initiate the cherry's rise to its venerated status.[1] Many of Saigyō's verses on the beauty of cherry blossoms were inspired by the region of the Yoshino Mountains, in central Nara Prefecture.

Dramatic panoramas of blossoming cherry trees at two famous scenic locations are spread across this pair of six-fold screens.

The rolling mountains of Yoshino (at right), with their fabled groves of *yamazakura* (mountain cherries), and the elegant architectural structures of the Itsukushima Shrine, on Miyajima Island in the Inland Sea (at left), appear through a framework of golden clouds. The clouds themselves are ornamented with floral motifs raised above the surface of the screen with *gofun*, a gessolike substance made from powdered seashells, and covered with gold leaf. Both landscapes abound in colorful figures—pilgrims, picnickers, merrymakers, and dancers. Details of nature and architecture are carefully rendered, as are textile patterns. While these impressive vistas can clearly be classified as *meisho-e* (pictures of famous places), they also include elements of *fūzokuga* (genre painting) in their careful depiction of contemporary activities and customs.

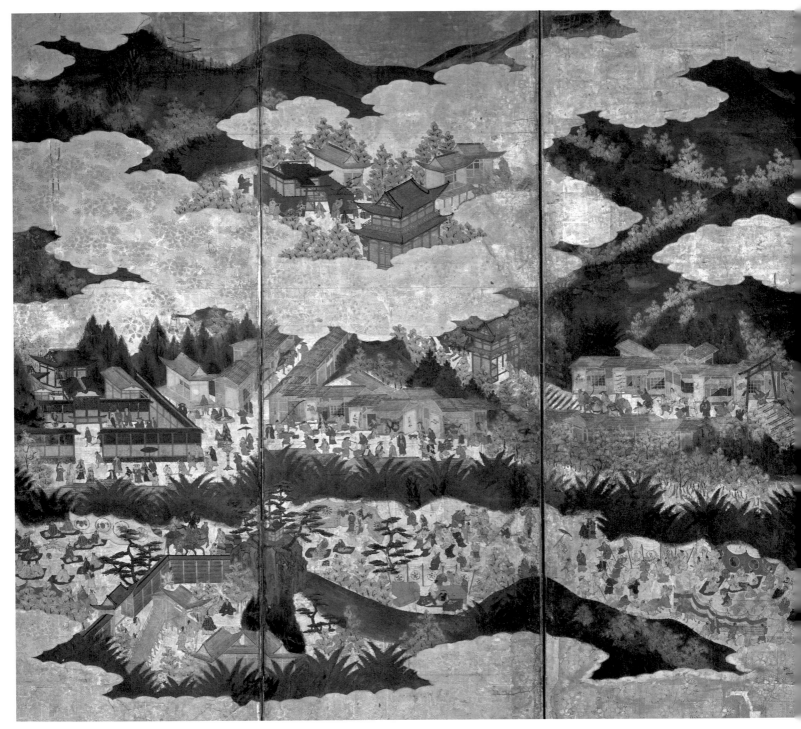

Yoshino (right screen), cat. no. 140

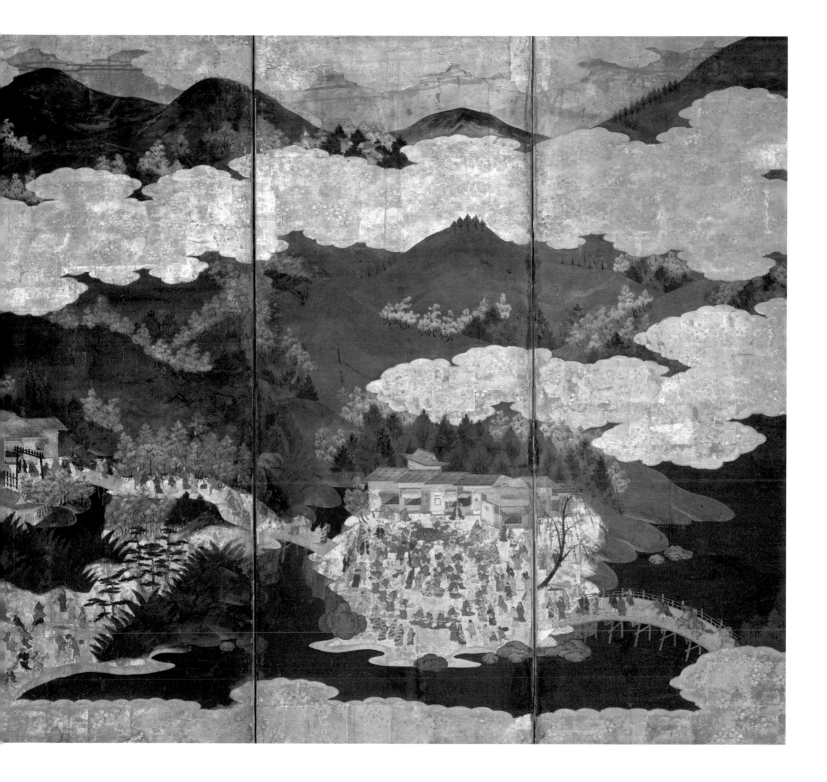

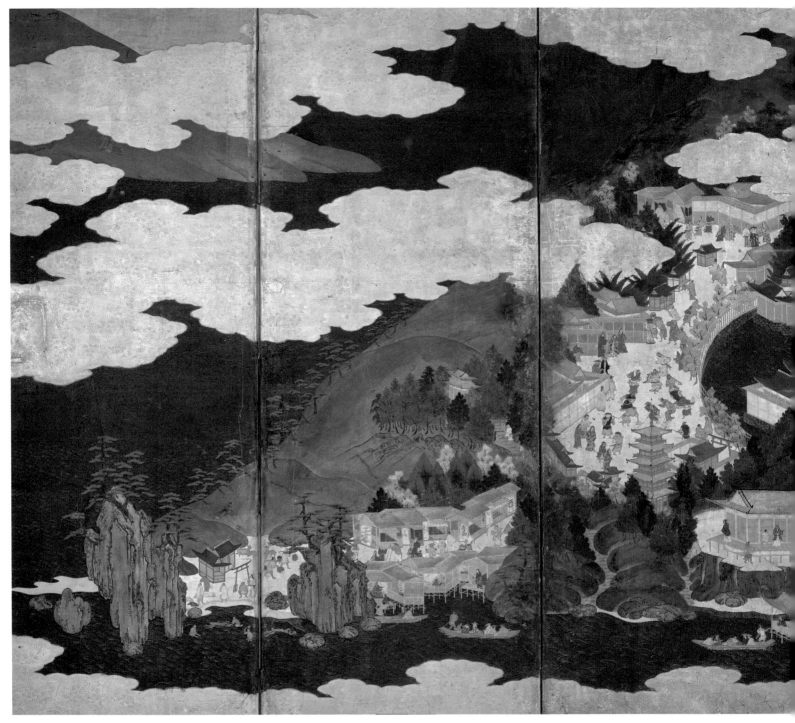

Itsukushima (left screen), cat. no. 140

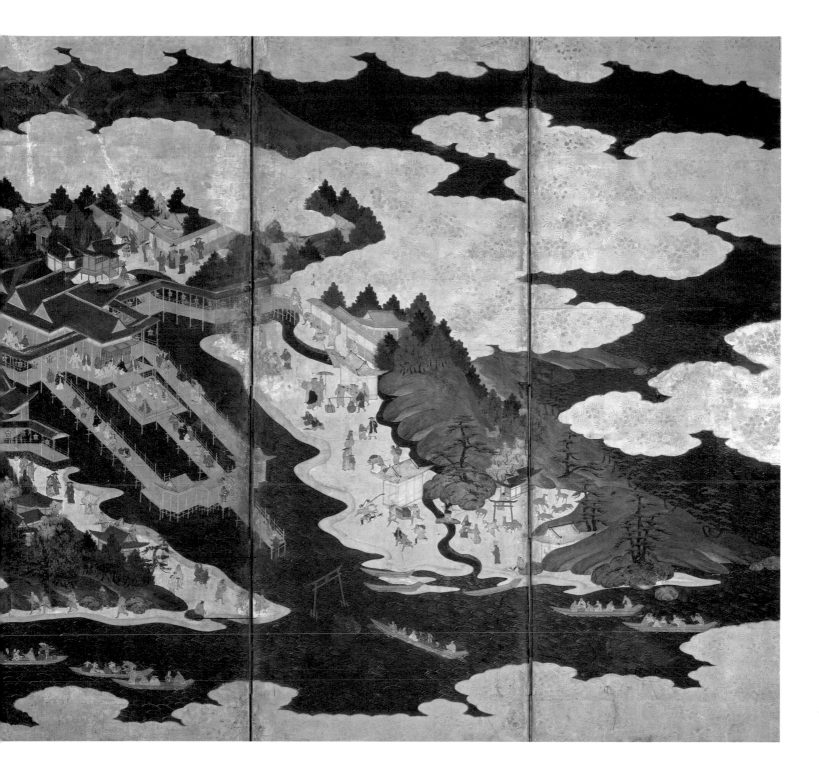

The concept of *meisho* as subject matter for art and literature evolved in Japan during the Heian period. *Meisho-e* may have begun to appear as early as the ninth century,[2] and they soon became an important category within the indigenous *yamato-e* tradition. However, the majority of extant *meisho-e* date from the Momoyama and Edo periods. These later works frequently blend characteristics of classical *meisho-e*, which emphasize literary content and seasonal associations, with aspects of *fūzokuga* drawn from folk and popular culture as well as ancient traditions. Because many *meisho* are closely identified with certain human activities—usually seasonal in nature—the two modes of painting complemented each other and, when combined, produced animated, richly decorative images such as the Burke screens.

The Yoshino and Itsukushima screens are connected thematically and compositionally by the profusion of pale pink and white blossoming cherry trees. Yoshino had been praised for its blossoms from the time of the *Man'yōshū* (Collection of Ten Thousand Leaves), the earliest extant anthology of native poetry, compiled during the late eighth century. Although the mountains were also famed for their appearance in winter under snow,[3] by the sixteenth century images of Yoshino were devoted almost exclusively to the spring season. In addition to its poetic associations, the name "Yoshino" conjured up references to such important historical events as the attempt by Emperor Go-Daigo (r. 1318–39) to wrest power from the shogunate and reinstate imperial rule.

The earliest known screens to depict Yoshino date from the late Muromachi period; they represent the landscape in cherry-blossom season, with only some consideration for the real topography of the region. Momoyama artists, including Hasegawa Sōtaku (fl. mid-17th century), son of the great master Hasegawa Tōhaku (1539–1610), transformed the older prototype into a bolder, more striking composition, eliminating all but the gently rising green hills as background for the explosion of pink and white blossoms.[4] The ultimate expression of this format is the magnificent example by the much later Rinpa artist Watanabe Shikō (1683–1755), now in a private collection in Kyoto.[5]

The Yoshino image in the Burke Collection retains the basic compositional scheme of Muromachi-period screens, extending from the Yoshino River, in the first panel at the right, to the Yoshimizu temple and the Katsute (Katte) Shrine in the fifth and sixth panels. But there the similarity to earlier works ends. The primary focus is now the activities of the men and women who have gathered to enjoy the beauty of the flowers at their peak. In this, the screens hark back to the ancient tradition of *meisho-e*, in which the human element is inseparable from the natural world.

Various activities are in progress. In the second panel from the right, spectators from different classes ring a circle of dancers cavorting to the beat of drums. Garbed in crimson and gold and wearing headcloths, the dancers, tapping sticks together in time to the drumbeats, engage in *fūryū odori*—"fashionable" or "new" dances—which were in vogue during the late sixteenth and early seventeenth century. Others enjoy outdoor meals screened from the view of passersby by fabric barriers raised on poles. The merrymakers in the fourth panel unpack picnics from tiered boxes similar in shape and design to the Ryūkyū Islands lacquers popular in Japan during the early seventeenth century.[6] The aristocratic figures seated on the ground at the far left are most likely engaged in composing poetry, an occupation ideally conducted under blossoming cherry trees.[7]

The Itsukushima screen presents an even more striking vista, with an undulating shoreline rendered in gold edged with white and the dramatic depiction of the Itsukushima Shrine at the center. The graceful complex, first built in the twelfth century by order of Kiyomori (1118–1181), the powerful head of the Heike clan, was reconstructed in the thirteenth century and renovated in the mid-1400s. Constructed in the palace style of the Late Heian period, the buildings feature symmetrical wings, lantern-hung galleries, and connecting walkways. A Nō stage is built out over the water. Access to the compound was by sea from Hiroshima Bay; pilgrims would arrive by boat, passing under the great red *torii* (Shinto gate) standing in the waves before the shrine.

Masked dancers engage in a street performance to the left of the shrine compound, and naked pilgrims purify themselves in the sea just beyond the village. To the left of the shrine proper stands the Daikyōdō, the sutra repository. The small village of Ari no Ura is farther to the left. The great rock capped by pine trees is Hōrai-iwa, named for the mythical island in the China Sea where, according to Chinese legend, immortal beings made their home.

Screens of famous places often depict two sites, one per screen. This is the only known instance in which Yoshino and Itsukushima are paired in this way. Itsukushima was commonly shown with Matsushima, in northern Japan, or with Ama no Hashidate, north of Kyoto. Yoshino, on the other hand, was usually depicted by itself, covering two screens. One reason for the pairing here may have been their significance as major pilgrimage sites. Another may be related to patronage and to the political environment of the early years of the seventeenth century. Both sites house monuments commissioned by members of the Toyotomi clan, and both are connected with events in the life of Toyotomi Hideyoshi (1536–1598), who united the country after more than a century of civil unrest. Hideyoshi's lavish excursion to Yoshino in 1594 was much celebrated in contemporary literature and painting. His connection with Itsukushima is less well known. In 1587, he ordered that the Senjōkaku (Thousand Mat Pavilion) be constructed next to the shrine as an offering. It appears in the lower central portion of the Burke screen. Attention is also drawn to this part of the composition by the passenger-laden boats that have congregated along the shore. It is quite possible that the screens were painted for a Toyotomi follower in western Japan, where "many . . . remained secretly loyal [to the memory of Hideyoshi]."[8]

Compositionally, the Burke screens provide a contrast between the rolling hills and mountains of Yoshino and the seacoast view of Itsukushima. Most sixteenth- and seventeenth-century screens depicting famous places feature panoramic views from a high vantage point, with attention devoted to topographical details and to the layout of architectural structures and their accurate placement within the landscape. The popularity of *byōbu* of this type may have resulted in part from the publication of *meisho ki* (illustrated guidebooks and travelogues) and in part from the increasing

interest in recording everyday customs and colorful festivals against the backdrop of familiar scenic settings.

The Burke screens bear certain similarities to other works more or less firmly dated to the first years of the Edo period. The costumes of the revelers, pilgrims, and townsfolk are in keeping with the styles of the early 1600s.[9] While the unknown artist was most likely a *machi-eshi* (a town-based painter with no formal affiliation to any particular school), the linear brushwork of the rocks and boulders on the Itsukushima screen indicates that the artist had some experience with the methods of ink painting practiced by the Kano school. SW

1. Miner, Odagiri, and Morrell 1985, p. 223.
2. Chino Kaori 1980, pp. 115–21.
3. K. Toda 1959, pp. 153–66; and Y. Shimizu 1981, pp. 1–14.
4. For Muromachi and Momoyama examples, see Tokyo National Museum 1989b, no. 40; Murase 1990, no. 11; and Suntory Museum of Art 1997, pls. 4, 5, and 13.
5. Yamane Yūzō et al. 1994, pl. 31.
6. Watt and Ford 1991, pp. 334–35.
7. Plutschow 1973, p. 100.
8. McKelway 1997, p. 51.
9. See, for example, the pair of screens depicting cherry-blossom viewing and falconry attributed to Unkoku Tōgan (1547–1618) and now in the MOA Museum of Art, Atami; Murase 1990, p. 129.

141. Cherry-Blossom and Maple-Leaf Viewing

Edo period (1615–1868), ca. 1630s
Pair of six-panel folding screens, ink, color, and gold on gilded paper
Each screen 125.8 × 362.2 cm (4 ft. 1½ in. × 11 ft. 9⅝ in.)

Outings to enjoy blossoming cherry trees and the turning colors of maple leaves have been two of the most cherished seasonal activities in Japan since ancient times. On the screen at the right, where cherry blossoms are at their peak, aristocratic women have arrived by carriage. They look almost anachronistic, with long, trailing hair and voluminous silk garments, while the men, other women, and children who have joined them are dressed in contemporary fashion. The courtesans at the scene have shorter hair and are dressed in stylish kimonos with bold designs. Seated with a writing box, a lady composes a poem, while her attendants relax, some enjoying the sake being served. At the left, women and children gather herbs and edible plants of spring.

The central figures in the screen at the left, which depicts an autumn scene, are court noblemen, warriors, and merchants; even Buddhist monks have joined in the merrymaking. As in the spring scene, the most prominent courtier is shown composing a poem, hinting at some narrative connection to the right screen; others are engaged in cooking or drinking. Long pipes such as the one being smoked by the seated gentleman in the second panel from the right began to appear prominently in genre paintings after tobacco was introduced to Japan, in 1601.

Although only spring and autumn activities are shown in this pair of screens, the tradition of depicting the progression of the seasons in four stages is not totally forgotten. Spring here advances from right to left. At the point where the two screens meet is a stand of hibiscus—symbol of summer.[1] And on the screen at the left, autumn leaves serve as the setting for another picnic.

It is difficult to trace the genesis and evolution of such genre scenes because so few early examples are extant. Three small fans dating from the second quarter of the twelfth century and a few other scattered works suggest that in early times seasonal excursions were usually made to sacred places.[2] Scenic spots were often consecrated by sacred monuments dedicated either to Shinto or to Buddhist deities. Seasonal outings were therefore occasions to enrich the spirit as well as the senses.

As the close connection that had traditionally been made between the seasons and specific scenic sites faded, the thematic focus shifted to human activities. Close scrutiny marks the depiction of costume design in these screens, and a great variety of textile designs can be seen, almost as though the artist had used a textile pattern book. While the court ladies have only dashes for eyes, in the traditional *hikime-kagihana* technique, other figures, though small, are depicted with lively gestures and facial expressions with wide-open eyes. The latter begin to resemble the figures that would become independent

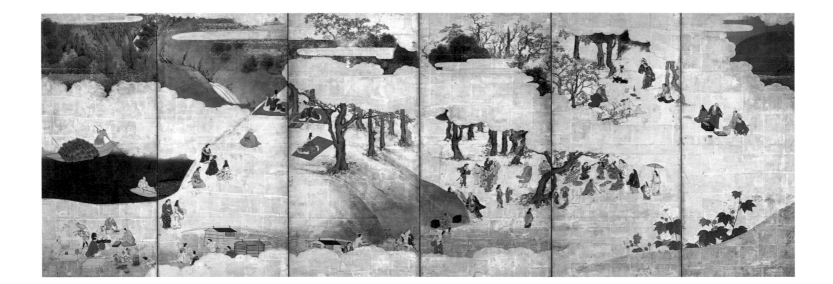

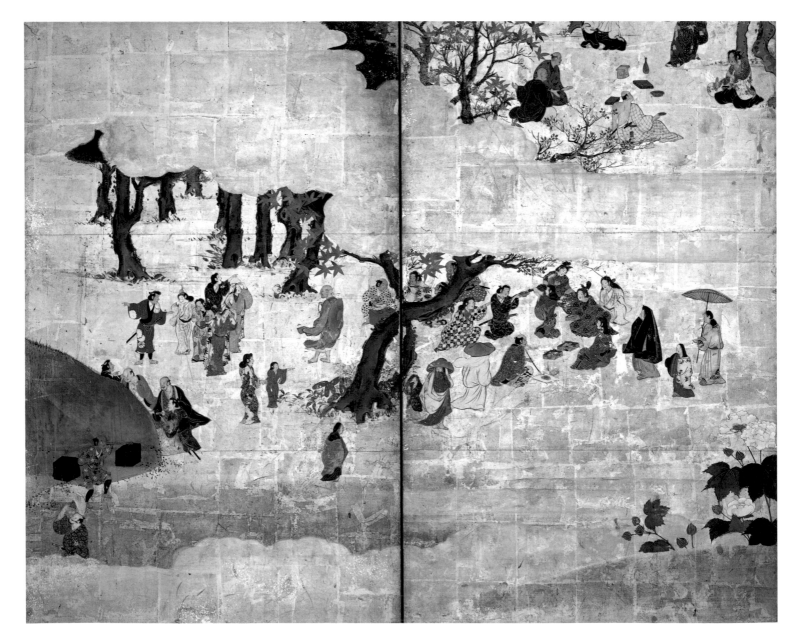

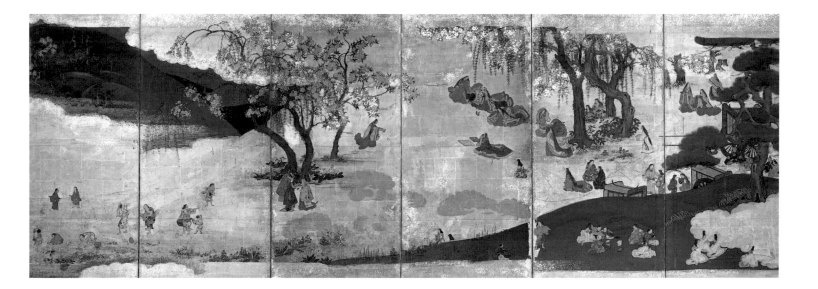

subjects of screens and hanging scrolls, depicted against neutral backgrounds, in such paintings as the Kanbun Beauties (cat. no. 144). By depicting people from all walks of life, the artist of these screens seems to have wanted to represent a true genre scene.

The painter of these screens seems to have been trained in the orthodox Kano-school manner. Trees are carefully delineated with heavy ink lines, used also to define the rocks and distant mountains on the screen at the left. The courtesan seated between trees in the screen at the right wears a dress with the same coin design as that of one of the performers on a screen formerly in the Kanda collection known as the Dancers Screen, which dates to the 1630s; their faces too are nearly identical.[3] The resemblance between these two figures is so close that it would be safe to attribute the Burke screens to the same artist, or at least to the same workshop.

1. A single screen in the collection of the Honolulu Academy of Arts depicts cherry-blossom viewing and fishing together. See Narazaki Muneshige 1971, pp. 20–25.
2. For the fans, in the Itsukushima Shrine, see Akiyama Terukazu 1964, pp. 343–62; and Egami Yasushi 1992, pls. 3–5, 38–40. On outings to sacred places, see Takeda Tsuneo 1977c, pp. 115–21.
3. Takeda Tsuneo et al. 1977, pls. 32, 81.

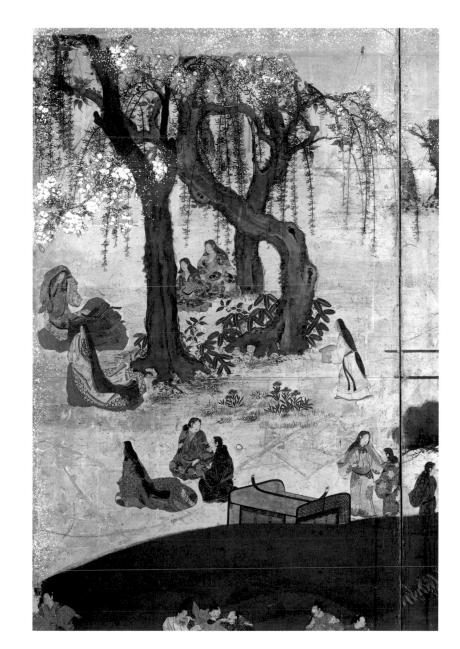

142. Women Contemplating Floating Fans

Edo period (1615–1868), early 17th century
Six-panel folding screen, ink, color, and gold on
gilded paper
157 × 354.4 cm (5 ft. 1⅞ in. × 11 ft. 7⅝ in.)

Surrounded by billowing gold clouds, a golden bridge sweeps across an expanse of dark blue water. Unlike the earlier *Willows and Bridge* (cat. no. 80), this screen has as its primary focus a group of eighteen stately women and their four young attendants. The figures stand or sit by the railings of the bridge; some watch the painted fans that float on the current below, while others appear about to cast their fans into the water. Two gilded bamboo baskets filled with stones, which protect the shoreline from soil erosion, can be seen at the edge of the river.

The subject of this dramatic composition could perhaps have been identified by the scene depicted on the companion screen, now missing.[1] The absent screen most likely depicted a house of pleasure. If this is the case, the women on the bridge would be professional courtesans, and the golden bridge would signify a path to "paradise on earth." Here, on what was originally the left screen, we are presented with three groups of women: five figures at the extreme right viewing the fans on the water and two groups of women clustered along the railings in the center. Two of the women look across the bridge, creating a visual link with the other figures. Two attendants approach from the extreme left. One carries a long pipe, the other a tray laden with a box and two bottles. The attendant jauntily balancing the pipe over his shoulder may be a boy, as the red jacket appears to be a *jinbaori* (a jacket worn in military camps), a strictly male accoutrement.

All the fans—both those held and those floating on the river—have painted scenes and designs. Among the images is a famous episode from chapter 34, "Wakana jō" (New Herbs: Part One), of the *Genji monogatari*, which tells of the game that led to the tragic love affair between Genji's young wife and the son of his best friend. The fans also depict flowers of different seasons, painted in bright colors on gold, and three feature subjects frequently chosen by Kano-school artists: a kingfisher on a tree branch and a family of musk cats among carnations (see also cat. no. 60). A fan painting of a large moon rising out of autumn grasses presents the popular *yamato-e* theme of Musashino, the plain west of Edo. Another, showing Mount Fuji and the beach of Miho lined with pines, typifies the traditional genre of *meisho-e* (pictures of famous places).

Ōgi (folding fans) are thought to have evolved from the round Chinese fan during the Early Heian period. They served a variety of functions. Their primary use was, of course, to cool the owner in the heat of summer. Open, they could serve as trays. One type of fan had iron ribs that could be used by warriors as impromptu weapons.[2] Fans were employed in games, and they were important props in the performing arts. While the earliest extant examples of painted fans date to the mid-twelfth century, the earliest surviving illustrations of fans—from the *Genji monogatari*—date to the first quarter of the century.

One of the important duties of painters in the service of the emperor or shogun was to make presentations of their fans at the beginning of each year. *Ōgi eshi*, painters of fans intended for the general public, and *ōgiya*, shops that produced and sold fans, became staples of city life. Records of *ōgiya* began to appear in the second half of the fourteenth century, and the shops were included in paintings of cities, such as *rakuchū-rakugai* screens (cat. no. 139).

While used fans were generally discarded at the end of the summer, they were often kept for their sentimental value and pasted into albums or on folding screens. A screen ornamented with fans served as a kind of miniature museum, where many paintings could be viewed at the same time. The earliest pictorial evidence for the practice of arranging fans on screens is a scene from the *Boki ekotoba*, an illustrated biography of the monk Kakunyo dating to 1482 in the collection of Nishi Honganji, Kyoto.[3] Many screens with painted fans—some of which are not actually fans but fan-shaped paintings—have background designs of autumn grasses. It was also popular to paste (or paint) fans over a background of flowing water, a type of imagery that may have evolved from the medieval pastime of casting fans into the water to float on the surface. References to such screens first appear in literature of the fifteenth century.[4]

Screens painted with the fans-and-stream motif were often installed in shogunal residences. A story that appears in the *Ansai zuihitsu* (Essays by Ansai), a collection of essays on miscellaneous subjects by the antiquarian Ise Sadatake (1717–1784), suggests one explanation for this fashion.[5] According to the tale,

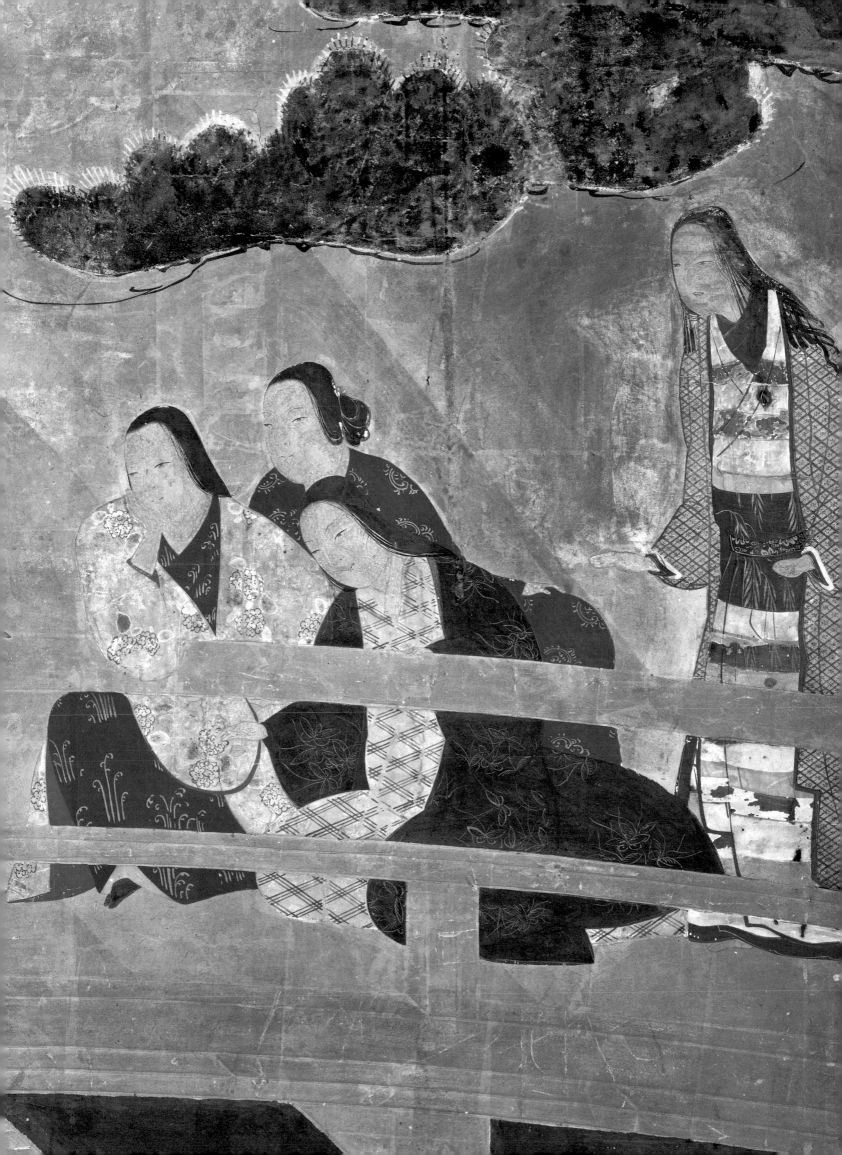

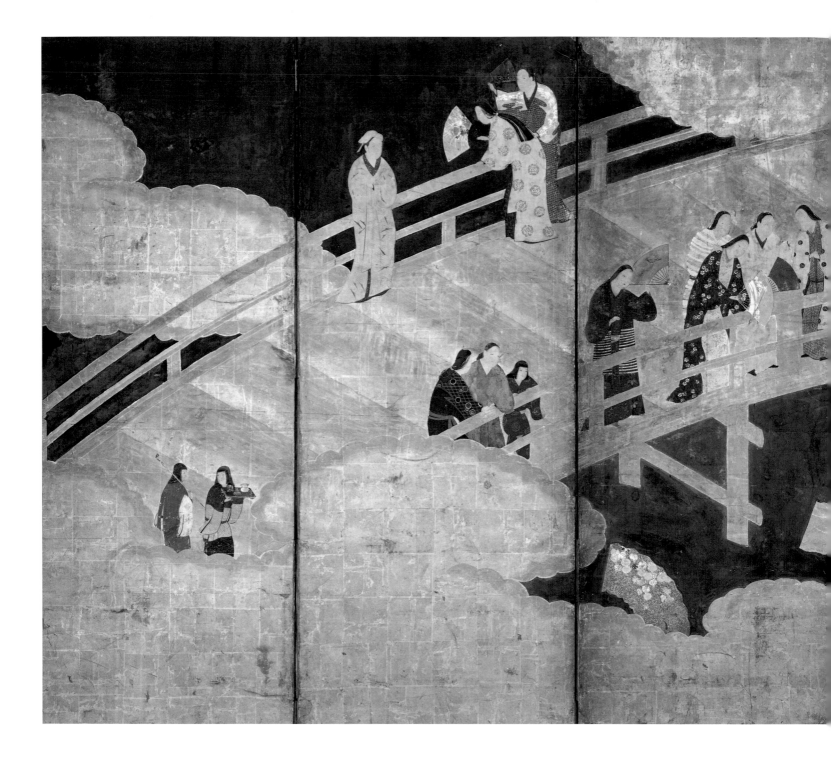

an Ashikaga shogun of the Muromachi peri-
od was on his way to the Kyoto temple of
Tenryūji when one of his pages accidentally
dropped his master's fan into the Ōi River
from the bridge, Togetsukyō. Taking their
cue from the page, all the other members of
the shogun's retinue followed suit and tossed
their fans into the water. It is not unlikely
that the story derives from a painting. On the
other hand, the tale itself may have inspired
the creation of a type of screen composition
known as *senmen nagashi* (fans afloat).[6]

 As noted above, several of the floating

fans reveal the artist's Kano-school training.
Most early examples of genre painting are
associated with Kano artists, and the school's
contributions to the development of genre
imagery are widely recognized. The full,
oblong faces and clearly delineated features
of the women in the Burke screen also sup-
port an attribution to a Kano artist.

 The figures on the bridge wear their hair
flowing loosely or tied simply at the nape of
the neck. Both styles, prevalent among young
women during the Momoyama period, pre-
date the more elaborate coiffures that appear in

the genre paintings of a slightly later period.[7]
The presence of the long smoking pipes tells
us that the screen could not have been painted
before 1605, when smoking first became pop-
ular following its introduction by a Spanish
missionary visiting Japan in 1601.[8]

 The designs on the women's clothing are
dominated by stripes, small patterns, and
overall tie-dyed motifs. The sharply contrast-
ing patterns, segregated from other motifs in
large areas at the top and bottom, were known
as *kata suso* (shoulders and hems); these pre-
date the more ostentatious, eye-catching

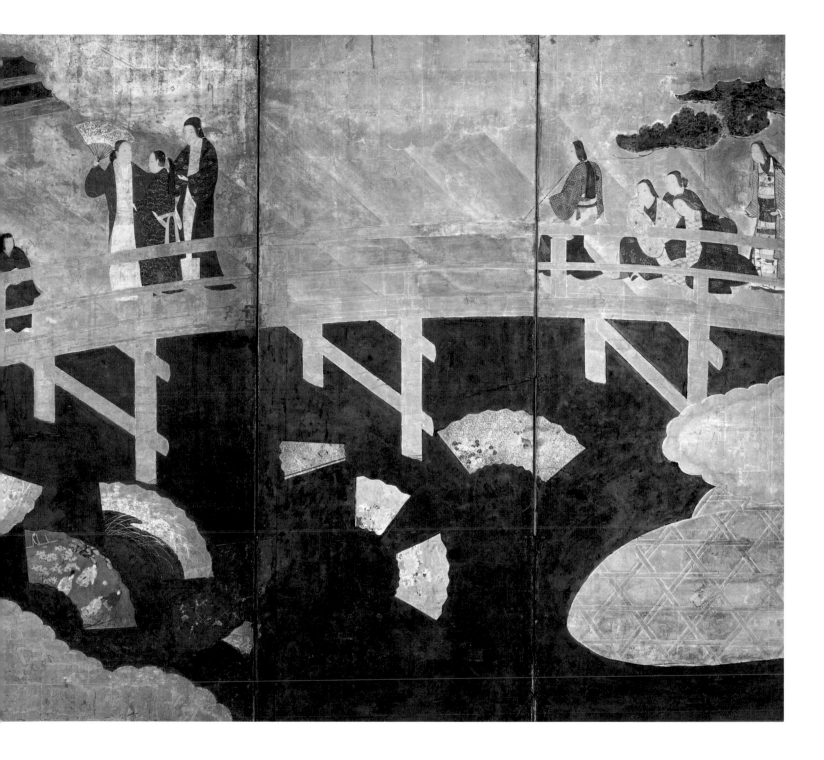

designs that appear in paintings beginning in the early seventeenth century. This change in fashion is documented by records of orders kept by the ancestors of Ogata Kōrin (cat. nos. 132, 133), who owned a highly successful textile shop, Kariganeya, which produced material for kimonos and catered to the shoguns and members of the royal family. An account of the shop's commissions from 1602 and 1603 reflects the popular demand for *kata suso* patterns.[9] Kariganeya's record book includes notes on the most fashionable colors for garments at the time: white and light blue are the

most frequently mentioned. The browns, dark reds, and other somber colors that also appear in the Burke screen forecast the change in textile design that took place during the second decade of the 1600s.[10]

In summation, this screen, one of a small number of genre paintings dating to the early Edo period, may be attributed to an anonymous Kano artist active at the beginning of the seventeenth century.

1. Curiously, two other screens with similar compositions are also missing their companion screens. See

Kobayashi Tadashi 1994, no. 8; and Takeda Tsuneo 1997, no. 157.
2. For documentary materials on fans, see Miyajima Shin'ichi 1993.
3. Komatsu Shigemi 1985a, p. 13.
4. Miyajima Shin'ichi 1993, p. 46.
5. *Zōtei kojitsu sōsho* 1929, p. 258.
6. See Miyajima Shin'ichi 1993, p. 41.
7. See, for example, Singer et al. 1998, no. 233.
8. Tobacco and Salt Museum 1985, p. 18.
9. I am indebted to Joyce Denny, Senior Research Assistant in the Department of Asian Art at the Metropolitan Museum, for reminding me of the Kariganeya records; see Yamane Yūzō 1962a, pp. 10–19.
10. Nagasaki Iwao 1993, p. 89.

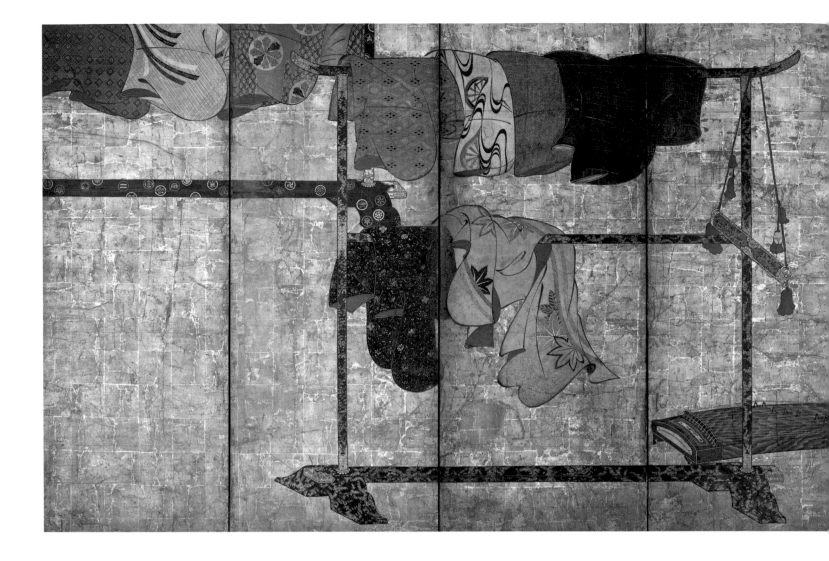

143. Tagasode (Whose Sleeves?)

Edo period (1615–1868), early 17th century
Six-panel folding screen, ink, color, and gold on
gilded paper
170.7 × 380.8 cm (5 ft. 7¼ in. × 12 ft. 6⅜ in.)

LITERATURE: Takeda Tsuneo 1967, pl. 13; Murase
1971, no. 19; Murase 1975, no. 47; Murase 1977,
pp. 88–89; Takeda Tsuneo et al. 1977, no. 104;
Burke 1985, pl. II (detail); Murase 1990, no. 21.

Two lacquered clothing racks draped with
kimonos are shown on this six-fold screen.
One rack appears in full view, while the
other is only partially seen. A tube contain-
ing an amulet hangs on a silk cord from the
rack in the foreground, and a *koto* rests on
the floor to the right. Both the furniture and
the musical instrument are decorated with
exquisite patterns in gold, and the rack in the
background bears family emblems. Many of
the kimonos display small tie-dyed motifs
that may have been stenciled onto the screen,
as they are uniform in size and regular in
placement. The extensive use of tie-dyed
decorations—one kimono is covered entirely
with tiny patterns of this type—reflects the
fashion in textiles that was prevalent during
the early seventeenth century. This screen
originally formed the right half of a pair; the
whereabouts of the companion screen is
unknown. As on other similar screens, the
left screen probably depicted additional items

of clothing, perhaps including men's gar-
ments, with some hanging on racks and oth-
ers folded on the floor.

Many screens of this type are extant, and
they are grouped under the general designa-
tion *tagasode*, meaning "Whose sleeves?"
The term was often used in Heian poetry as a
"pillow word," a word on which a poem might
be based.[1] *Sode* (sleeves) signify an extension
of the hands; thus, *tagasode* refers to a beauti-
ful woman, now absent, whose elegant kimono
sleeves and the fragrance arising from them
evoke the image of their owner.[2] As a literary
device in poetry, a kimono was interchange-
able with its wearer; by the same token, per-
fume bags, amulets, musical instruments, and
letter boxes would also have been understood
as references to a beautiful woman.

Paintings on this rather melancholy theme
were probably inspired by *tagasode* poems,
but it is unlikely that either the woman or her
kimono would have been shown. In accor-

dance with court taste of the Heian period, the paintings would have included even more subtly allusive motifs. Although no paintings on this theme survive from the Heian or Kamakura period, some late-fifteenth-century lacquerwares provide a hint of what they may have been like, as *tagasode* was a popular subject for lacquer artists of the Muromachi period. Inspired by classical literature, they often decorated their wares with motifs of plum flowers and incense burners, references to the fragrances that would recall a beautiful but absent woman. Screen paintings on the theme from the Momoyama and Edo periods may in turn have been inspired by such lacquerware compositions.

The *tagasode* theme can also be traced to the everyday activities of ladies of fashion. It was a traditional practice to drape elegant kimonos over clothes racks, which could then function as temporary interior partitions or be displayed as decorative objects—much

as folding screens and curtains were used.[3] Kimonos so draped became such a fixture of interior decoration that rules were eventually established to codify the manner in which they were shown.[4] At picnics, colorful kimonos were draped over ropes to create temporary enclosures. The custom of hanging up kimonos also afforded owners the opportunity to display their treasured possessions or their most recently acquired articles of clothing. *Tagasode* screens thus could have evolved as a kind of enlargement of details within screen paintings that depicted interiors or outdoor scenes in which draped kimonos were displayed.

A pair of six-fold screens in the Nezu Institute of Fine Arts, Tokyo, which depict an interior scene with a veranda opening onto a garden, exemplify a transitional work.[5] Three clothing racks are shown draped with the kimonos of both men and women. Two tall beauties in animated conversation stand

against the sumptuous backdrop. *Tagasode* screens such as the one in the Burke Collection may represent the final step in the evolution of the theme in painting, as the figures are eliminated altogether.

Tagasode screen paintings became popular in the late sixteenth century and are contemporary with genre paintings of women dressed in brilliantly colorful clothing (cat. no. 144). The women in these pictures, known as *Kanbun bijin* (Kanbun Beauties), most of whom were from the licensed pleasure district, eventually became the sole subject of hanging-scroll paintings; their stylish garments perhaps became the subject of screens sans figures.

1. See Nakamura Tanio 1959b, pp. 89–90.
2. Tsukamoto Mizuyo 1989, p. 57.
3. For literary references to this practice, see ibid., p. 60.
4. *Masasuke shōzoku shō*, in *Gunsho ruijū* 1928–37, vol. 5, pp. 542–604.
5. Takeda Tsuneo et al. 1977, pls. 34, 35.

144. Kanbun Beauty

Edo period (1615–1868), late 17th century
Hanging scroll, ink, color, and gold on paper
61.2 × 24.4 cm (24⅛ × 9⅝ in.)

LITERATURE: *Ukiyo-e meisaku senshū* 1967, illus.;
Narazaki Muneshige 1969, pl. 18; Jenkins 1971,
no. 1; Murase 1975, no. 87; Kobayashi Tadashi and
Kitamura Tetsurō 1982, pl. 90; Tokyo National
Museum 1985a, no. 63; Schirn Kunsthalle Frankfurt
1990, no. 81.

Kanbun bijin (Kanbun Beauties) refers to paintings of women standing alone against a neutral background. This painting is typical of the genre. The tall, slender woman, her hair dressed in an elaborate style called *gosho mage* (palace chignon), covers her face in a coy gesture resembling a dance pose. Three layers of brilliantly designed robes contrast with and serve to accentuate her delicate beauty.

The term "Kanbun Beauty" was not limited to paintings executed during the Kanbun era (1661–72); this scroll probably dates to a slightly later period. The designs on the outer garment include areas of tie-dyed pattern interspersed with painted designs, perhaps reflecting the new fashion that became popular after a sumptuary law of 1683 banned the use of overall tie-dyed fabrics.[1]

Kanbun bijin evolved from earlier group portraits of women of the pleasure quarters, as part of a general trend in genre painting. Sprawling compositions, such as *rakuchū-rakugai* screens in which the entire city of Kyoto and its environs are shown (cat. no. 139), were gradually replaced by less elaborate compositions that focused on indoor scenes within the brothel districts or theaters, subjects popular with the affluent merchant patrons of the arts.

Single-figure studies of women may have been painted and mounted on hanging scrolls to be sold to patrons as mementos of their visits. Prints of courtesans and actors were mass-produced by artists of the Torii and Kaigetsudō schools (cat. nos. 146, 147), who must have been inspired by paintings like this one.

1. Narazaki Muneshige 1969, p. 26.

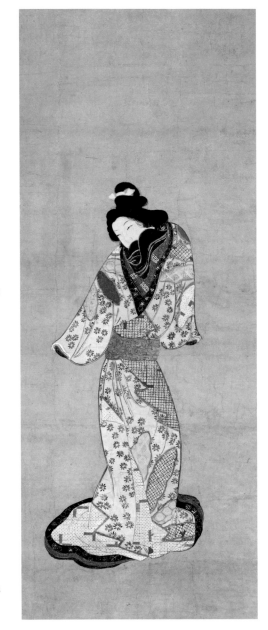

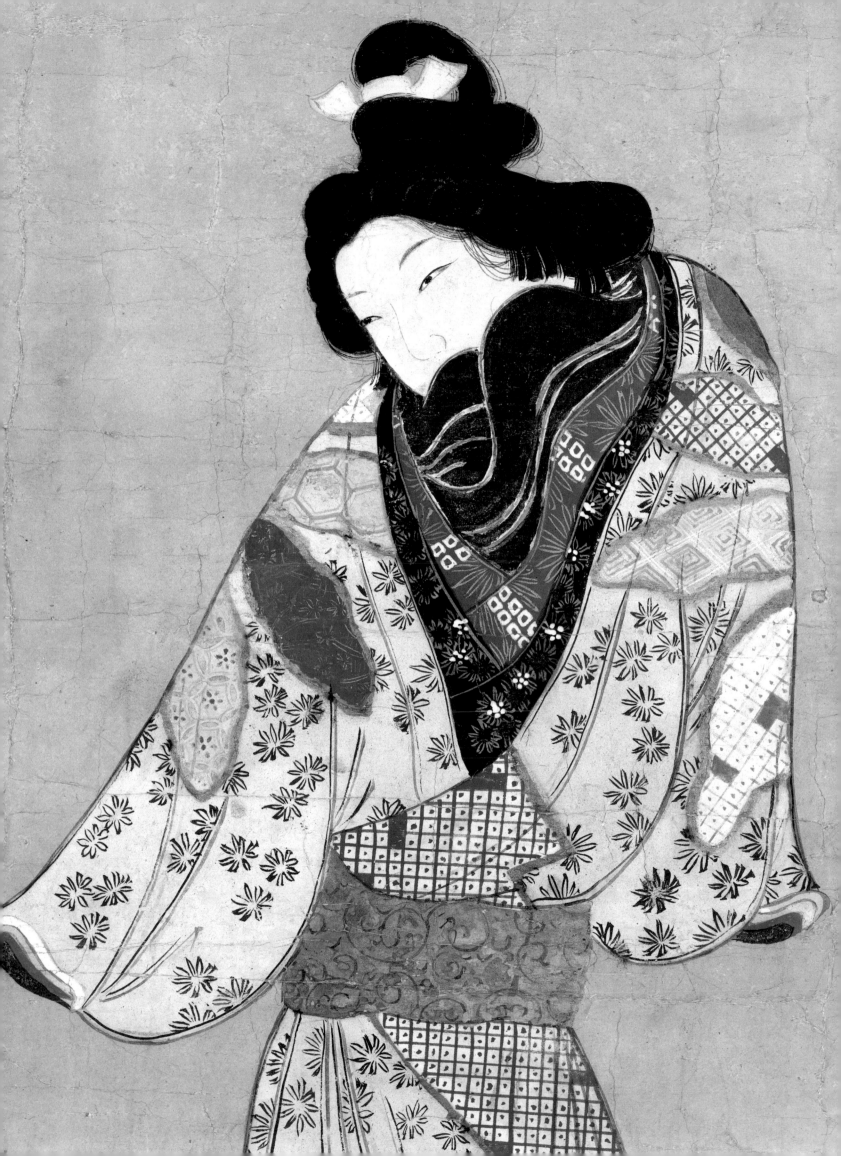

145. Lady from the "Ise monogatari"

Edo period (1615–1868), 2nd half of 17th century
Hanging scroll, ink and color on paper
63.6 × 25.6 cm (25 × 10⅛ in.)

LITERATURE: Jenkins 1971, no. 2; Murase 1980b, no. 1; Murase 1993, no. 44.

At first glance, this painting is a typical *kanbun bijin*, a painting depicting a beautiful woman of the Kanbun era (1661–1672; cat. no. 144). A woman stands against a blank background, her left arm drawn within her sleeve, while with her right hand she holds the outer gown close to her body. Her gesture and slightly bent head suggest a pensive mood. The design motifs on the garments, one in crimson and the other in white, allude to the autumn season. The red kimono bears stylized designs of large chrysanthemums, linked diamond patterns, and crests of waves tie-dyed in white. The white outer gown has a painterly design of eulalia, chrysanthemums, and bush clover surrounding two gamboling deer. Large maple leaves, also with white tie-dyed spots, seem to be blown by the wind.

The pose, long flowing hair, and rather incongruous cresting-wave motif on the kimono reveal that this lady is neither a dancer nor an actress—nor is she a courtesan—of the Kanbun era. Okudaira Shunroku has identified a group of images of similarly dressed women in identical poses as depictions of the mistreated heroine of a well-known episode from the tenth-century *Ise monogatari* (Tales of Ise).[1] In the story, the woman's husband frequently travels to Takayasu to visit his new mistress. The wife knows of his infidelity, yet she never complains. The husband, suspecting from his wife's silence that she herself may be having an affair, one evening hides behind some bushes after pretending to go off on his usual escapade. Unaware of his presence, the woman recites a poem:

When the winds blow,
White waves rise higher at Tatsutayama.
Shall you be crossing the river
Quite alone by night?[2]

Impressed by his wife's loyalty, the husband ceases to visit his mistress. Illustrations of this episode usually depict the wife, either seated or standing on the veranda, staring into the night and reciting a poem while her husband conceals himself behind a garden hedge (fig. 54).

The autumnal motifs that adorn the lady's garments refer to Tatsutayama, where the Tatsuta River flows. The site, often mentioned in early *waka*, is inevitably associated with the image of maple leaves in autumn. The tall crests on the red kimono allude to the "white waves [that] rise higher" in the poem. The painting is a kind of visual pun (*mitate*); although removed from the narrative context, the figures nevertheless represents the heroine of the tale.

Many other paintings identified as Kanbun Beauties may eventually prove to be similarly conflated images of figures that derive from classical literature but are attired as fashionable women of contemporary Edo society.

1. Okudaira Shunroku 1989, pp. 646–90.
2. *Tales of Ise* 1968, p. 88.

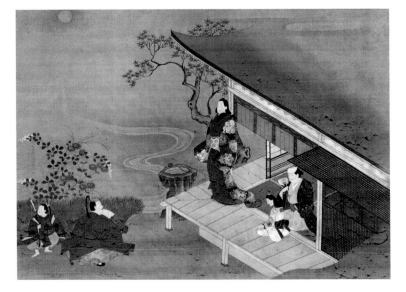

Figure 54. Unidentified artist (18th century), *Beauty on a Veranda, from the "Ise monogatari."* Detail of a hanging scroll, color and gold on silk, overall 50.4 × 690.4 cm (19⅞ in. × 22 ft. 8 in.). Mary and Jackson Burke Foundation, New York

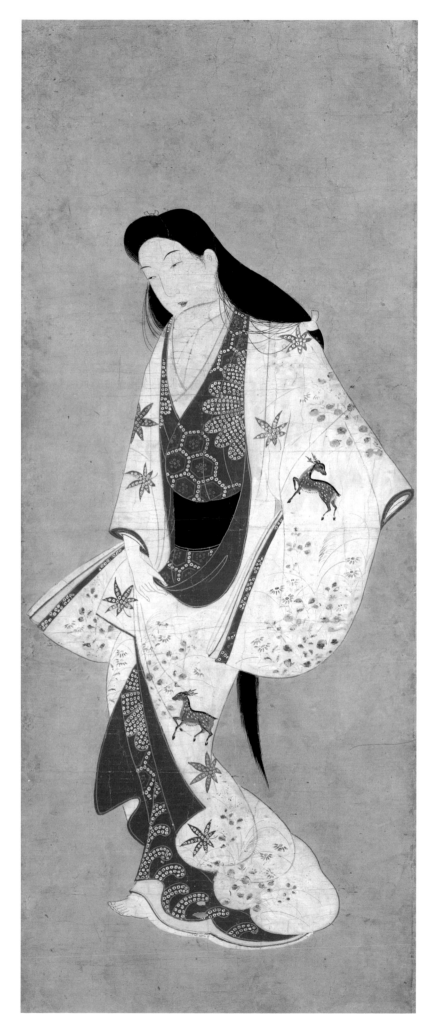

146. Standing Beauty

Edo period (1615–1868)
Hanging scroll, ink and color on paper
100.4 × 42.3 cm (39½ × 16⅝ in.)
Signature: *Nihon giga Kaigetsudō*
Seals: *Kan'unshi* [?] and *Ando*
Ex coll.: Frank E. Hart, Palm Beach, Florida

LITERATURE: Society of the Four Arts 1963, no. 16; Jenkins 1971, no. 102; Murase 1975, no. 88; Burke 1985, pl. III; Kita Haruchiyo 1985, p. 80; Tokyo National Museum 1985a, no. 64; Schirn Kunsthalle Frankfurt 1990, no. 82.

The imposing figure of a courtesan here fills the picture plane, her body arched in an S-curve as she lifts the hem of her kimono and glances over her shoulder, showing her costume and her full, white face to best advantage. The painting has the quality of a fashion plate, and its appeal is frankly sensuous.

The colophon at the upper right corner, brushed by an anonymous calligrapher on a *shikishi* (poem sheet), is a familiar classical poem attributed to Sarumaru Dayū, a monk of the Early Heian period and one of the Thirty-six Immortal Poets (see cat. nos. 39–41). The poem is included in the *Kokinshū* and other anthologies.

*Okuyama ni momiji
fumiwake naku shika no
koe kiku toki zo
aki wa kanashiki*

*Treading through the
autumn leaves in the deepest
mountains, I hear the
belling of the lonely deer—
then it is that autumn is sad.*[1]

The scroll bears the signature "Nihon giga Kaigetsudō"(Playfully Painted by Japan's Kaigetsudo). Because the numerous paintings and woodblock prints with this signature usually include an additional name or seal as well, "Kaigetsudō" is believed to have been a studio name. Tall, majestic women were the favorite subject of this studio, and all Kaigetsudō courtesans are remarkably similar. A woman is shown standing alone adjusting her hair or looking back over her shoulder. The faces are stereotypes, seldom revealing individuality or emotion. The costumes reflect popular fashions in textile designs and are strongly outlined in rhythmic curves that set off the large, clearly defined patterns and lively color contrasts. The basic costume design—the position of the sleeves, the shape of the obi, and the flare of the lower hem—is often repeated in many works, varied only by different textile patterns. Such paintings were mass-produced, and the same shop would make cheaper woodcut versions of them in monochrome.

Various signatures and seals on the paintings and prints differentiate six Kaigetsudō artists: Ando, Anchi, Dohan, Doshin (cat. no. 147), Doshu, and Doshū. Ando is generally credited with founding the studio. This painting includes, in addition to the "Kaigetsudō" signature, a seal reading "Ando" and another seal frequently found with it, which can be deciphered as "Kan'unshi." Ando's successors made woodblock prints of these women, but no print is associated with Ando himself.

Kaigetsudō Ando is known to have used another name, "Kaigetsudō Jōsen," and to have sold his pictures to visitors to the Yoshiwara pleasure district in Edo.[2] His real name was Okazaki (or Okazawa) Genshichi, and he was acquainted with the inner circle of women who served members of the Tokugawa shogunate. Implicated in a scandal involving a love affair between one of the women and a Kabuki actor—a serious criminal offense—he was ordered into exile in 1714. Paintings by Ando found on the remote islands south of Tokyo indicate that he was sent either to Niijima or to Ōshima. He remained there until 1722.[3] It is generally assumed that this incident ended Ando's painting career and that his shop was continued by his pupils, who signed their names "Kaigetsudō matsuyō" (the last leaf of Kaigetsudō).

The few paintings by Ando that survive suggest that he was trained in a fairly orthodox school. A handscroll in the Museum of Fine Arts, Boston, exhibits his familiarity with the Kano style and an interest in *nanga* (see pages 373–74), which was then emerging as a new painting style.[4] Ando's images of solitary courtesans mark the height of a style of figure painting that began in the early seventeenth century and would subsequently be refined by Hishikawa Moronobu (ca. 1618–1694).

1. *Kokinshū* 1984, poem 215, identified as the work of an anonymous poet.
2. Narazaki Muneshige 1987, p. 42; and Asano Shūgo 1994, p. 24.
3. Tsuji Nobuo, Kobayashi Tadashi, and Kōno Motoaki 1968, p. 46.
4. Narazaki Muneshige 1969, pls. 28, 29.

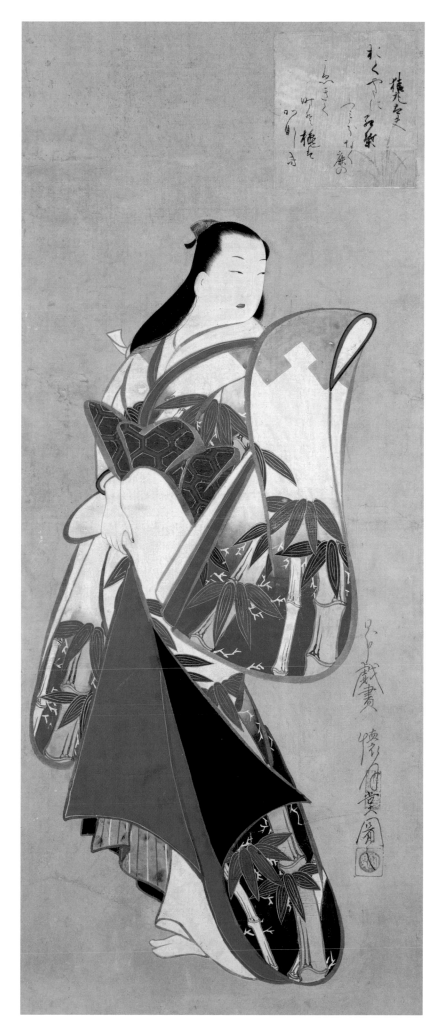

147. Beauty Writing a Letter

Edo period (1615–1868)
Hanging scroll, ink and color on paper
49.4 × 60 cm (19½ × 23⅝ in.)
Signature: *Nihon giga Kaigetsu matsuyō Doshin koreo ƶusu*
Seal: *Ando*
Ex coll.: Frank E. Hart, Palm Beach, Florida

LITERATURE: Society of the Four Arts 1963, no. 17; Jenkins 1971, no. 108; Murase 1980b, no. 3; Murase 1993, no. 45.

Departing from the standard Kaigetsudō formula (see cat. no. 146), Doshin depicts a woman not standing unoccupied but seated and writing a letter, probably to her lover. This was a popular subject for *ukiyo-e* painters of the seventeenth and early eighteenth century, and its origins may perhaps be found in scenes depicting figures within the pleasure district of Edo. The brilliantly colored pattern of the woman's clothes highlights the chalk-white expanses of the letter paper and of her delicate hands and plump face. Indeed, the striking camellias on her outer garment almost threaten to overwhelm her. The garments are outlined in heavy strokes of dark ink, a feature common to the Kaigetsudō studio. As did all other successors of Kaigetsudō Ando, Doshin signed his name on this painting "Matsuyō" (last leaf) of Kaigetsudō. The seal appears to read "Ando," and indeed many Kaigetsudō artists continued to use the seal of the studio's founder.

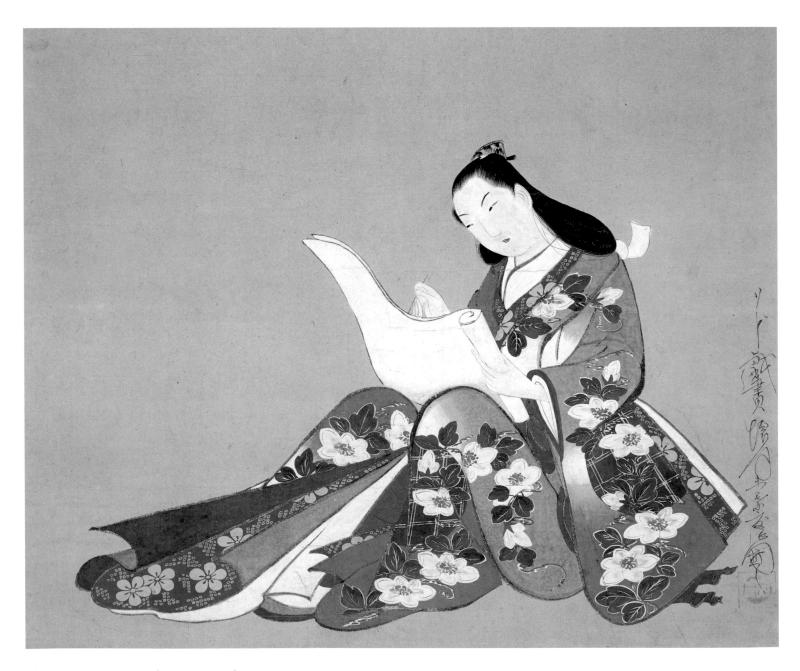

148. The Nō Dance-Drama "Okina"

Edo period (1615–1868), 1781
Triptych of hanging scrolls, ink, color, and gold on paper
Each scroll 87.3 × 27.2 cm (34⅛ × 10¾ in.)
Signature: *Gyōnen nanajussai Sekien ga* [on each scroll]
Seal: *Sekisō Tsukioka no in* [on each scroll]
Ex coll.: Frank E. Hart, Palm Beach, Florida

LITERATURE: Society of the Four Arts 1963, no. 46; Young and Smith 1966, no. 46; Narazaki Muneshige 1969, pls. 50–52; Murase 1975, no. 91.

The three dancers shown in this triptych are performers in the Nō dance-drama called *Okina*, sometimes also known as *Shiki sanba*.[1] *Okina*, which means "old man," is performed before the formal program begins. A dance without specific narrative content, it is reserved for special occasions, such as New Year's festivities, prayers for the peace and prosperity of the nation, and ceremonies to purify the site of a Shinto shrine.

Okina, the protagonist, is the figure shown in the center scroll, wearing the white mask of an old man. His light brown overblouse, or *kariginu*, is decorated with a tortoiseshell pattern, symbol of longevity and happiness.

The cranes and tortoises that adorn the costumes of the other two dancers are also emblems of longevity. The black mask and the bells held by the dancer on the right scroll identify him as Sambasō, "the third old man." The figure without a mask on the left scroll is a young man, though his name is Senzai, meaning "a thousand years of age"; his role is that of companion to Okina. The strong ink outlines that define the costumes, with their neatly organized folds, are reminiscent of those used in printmaking, and indeed Toriyama Sekien (1712–1788), who painted these scrolls, made many woodblock prints as book illustrations.

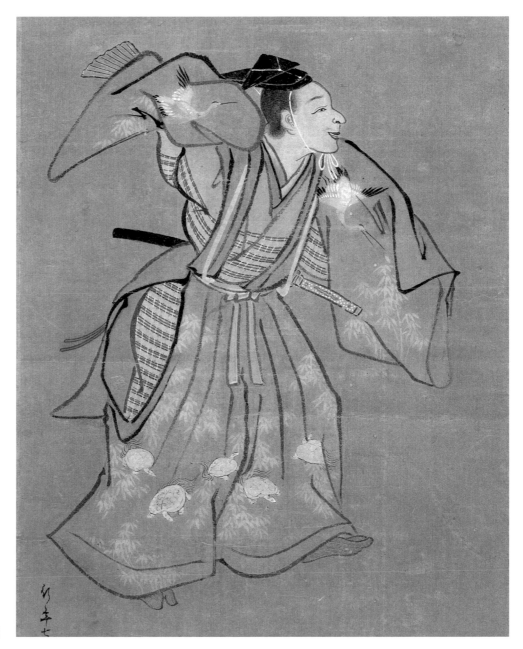

Detail of left scroll

As a young man, Sekien studied painting with Kano Shūshin (1660–1728) and Kano Gyokuen (1683–1743). Like many artists of the time, he was interested in Chinese realism of the Ming and Qing dynasties—a manner that is also reflected in the work of contemporary *nanga* artists (see cat. nos. 153–168). Sekien's training in the Kano school greatly enriched the art of printmaking, and his most significant contribution perhaps lies in his role as the teacher of such promising young artists as Kitagawa Utamaro (1753–1806) and Eishōsai Chōki (fl. late 18th century).

1. Sanari Kentarō 1930, vol. 1, pp. 1–12.

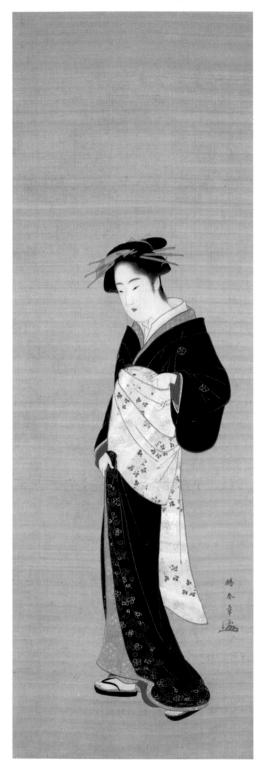

149. Woman in a Black Kimono

Edo Period (1615–1868), 1783–89
Hanging scroll, ink, color, and gold on silk
85.1 × 28.5 cm (33½ × 11¼ in.)
Signature: *Katsu Shunshō ga*
Seal: [*kaō*]

LITERATURE: Murase 1980b, no. 15; Murase 1993, no. 47.

This pensive woman, her head tilted slightly and her left hand tucked into her obi, is dressed in kimonos of subdued gray and black decorated with delicate designs of white spring flowers. The red cuffs and hems of her undergarment provide the only bright spots of color in an otherwise restrained composition. Mature and understated, the woman—most likely the wife of a merchant—seems the antithesis of the younger, more ebullient courtesans who usually inhabit pictures of the pleasure district.

The painting bears the signature of Katsukawa Shunshō (1726–1792), followed by the artist's *kaō*, or handwritten seal, a practice that was popular among contemporary novelists and *ukiyo-e* artists.

Shunshō is known today primarily for his dramatic prints of actors, which he began making about 1765.[1] Other than the fact that he studied painting with Kō Sūkoku (1730–1804) and Miyagawa Shunsui (fl. 1744–64), little is known about his life before that time. Shunshō is also remembered as the printmaking teacher of Katsushika Hokusai (1760–1849), one of the great artists of this genre.

His other pupils were Shunkō (1743–1812) and Shunchō (fl. late 18th century), who inherited the school name "Katsukawa."

Shunshō's oeuvre is clearly divided into two categories: prints of actors and paintings of women, the latter which he began producing quite late in life, about 1780. Shunshō seems to have used his personal seal exclusively on his paintings. Because very few of his paintings are dated by inscription, the handwritten seals have been useful in establishing a chronological framework.[2] About 1783, Shunshō began adding an upward stroke (as seen here) to his *kaō*, a flourish he used until about 1789, when he abandoned the *kaō* altogether in favor of carved seals. About the same time, he also changed the style of his signature, modeling it after the manner of the renowned Heian poet Fujiwara Teika (1162–1241),[3] whose calligraphic style had an impact not only in the area of high art but also on the more prosaic level of Edo shop signs.[4] These changes in Shunshō's seal and signature coincided with the evolution of his paintings of women. The figures in his earlier portrayals tend to be somewhat squat; those in his later works, such as the woman in this painting, are more slender and more refined.

All factors considered, this painting can be dated to the period between 1783 and 1789.

1. On the paintings and prints of Shunshō, see Hayashi Yoshikazu 1963; Gotō Shigeki 1974; and Narazaki Muneshige 1982.
2. Naitō Masato 1989, pp. 57–81.
3. Tanaka Tatsuya 1984, nos. 16, 17.
4. Gotoh Museum 1987.

150. A Courtesan and Her Attendants under a Willow Tree

Edo period (1615–1868), 1796
Hanging scroll, ink, color, and gold on silk
92.7 × 34 cm (36½ × 13⅜ in.)
Signatures: *Kansei hachi tatsu shotō Unchō ga*; *Santō Kyōden san*; and *Kyokutei Bakin gigō*
Inscriptions by Santō Kyōden (1761–1816) and Takizawa Bakin (1767–1848), each with a signature and seal
Seals: [*kaō*] and *Bakin*

LITERATURE: Narazaki Muneshige 1966, p. 34; Narazaki Muneshige 1969, pl. 64; Murase 1975, no. 93.

An *oiran*, or high-class courtesan, and her two attendants saunter past a willow tree at Ōmon, the main gate to Yoshiwara, the pleasure district of Edo. The coiffures and hair ornaments and the intricate patterns on their kimonos are described with unusual care. While the overall scheme is one of subtle hues, the eye is attracted to the bright red obi worn by the young girl attendant and the flicker of color on the linings of undergarments. The effect is complemented by touches of thick, shiny ink on black hair, clothing, and wooden clogs.

In spite of the unusually high quality of this scroll, we know nothing about the artist, who signed the work "Unchō, early winter, Year of the Dragon, eighth year of the Kansei era [1796]." No document supporting the existence of Unchō has yet been found. Nor has any other painting with his name come to light since this scroll was first published, in 1966. The name "Unchō," composed of characters meaning "cloud" (*un*) and "tide" (*chō*), suggests that the artist may have been associated with the painter Katsukawa Shunchō (fl. late 18th century), whose name means "spring tide." Shunchō was a pupil of Katsukawa Shunshō (cat. no. 149). Another possible link between Unchō and Shunshō is the fact that both artists used as a seal a *kaō*, a stylized cipher, that was employed only by a small number of *ukiyo-e* artists and novelists.

There is, however, no apparent stylistic connection between this painting and the work of Shunshō. The short stature of these women

and their plump faces and full hairstyles, in which the swell of the side locks is exaggerated, point instead to the print artist Kitao Shigemasa (1739–1820). Santō Kyōden, one of the two colophon writers, is known to have been friendly with Shigemasa, and Unchō also may have known him.

In contrast to the anonymity of the painter, the lives of the two colophon writers, both of whom were popular novelists, are well documented. Santō Kyōden (1761–1816), the elder of the two, was a printmaker before 1790, when he turned to writing full time.[1] Kyōden made prints under the pseudonym Kitao Masanobu. His works reflect the style of his teacher, Shigemasa, and there are certain similarities between the prints he produced as a young man and this painting by Unchō. Kyōden's career exemplifies the kind of collaboration that existed between writers and book illustrators in the Edo period. Because his own novels were illustrated with woodblock prints, Kyōden maintained close ties with printmakers even after he had become a writer.

Kyōden's pupil Takizawa Bakin (1767–1848) is the writer of the second colophon.[2] A prolific novelist, Bakin is often regarded as the first professional writer of Japan, and like Kyōden he was closely associated with *ukiyo-e* artists. It is possible that Unchō designed illustrations for books by both these authors.

Each inscription consists of a short preface, a satirical poem, a signature, and a seal. Kyōden's poem reads:

*Anyone can break off the branch of a willow by
 the roadside or pick a flower from a fence.
Even Saigyō has not yet seen Yoshiwara
 in the season of flowers.*

The twelfth-century monk Saigyō (see cat. no. 79) as a youth renounced his military career to become a wandering poet. An episode in the Nō play *Eguchi*, written in 1424, dramatizes the exchange of poems between Saigyō, after he became a mendicant, and the courtesan Eguchi no Kimi (the Princess of Eguchi).[3] The theme of the play is the acknowledgment of the sacred nature of all human activity—even the most profane, that of prostitution. Eguchi no Kimi later came

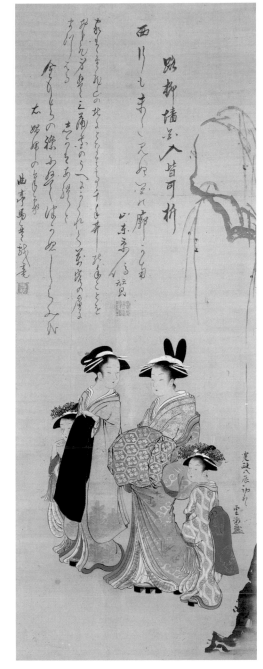

to be regarded as an incarnation of Fugen (Skt: Samantabhadra), and Saigyō a symbol of the religious sanction of Yoshiwara and its women.

Bakin's poem reads:

*The house of Yoshiwara is north of Kinryūzan;
The courtesan thinks often of Thousand-Armed
 Kannon.
She lies on three layers of quilts
And touches the bodies of ten thousand men.*

Yet lice never cling to the collars of her wealthy customers;
Such is the disposition of the women of Yoshiwara.

Kinryūzan, mentioned in Bakin's poem, is another name for Sensōji, popularly known as the Asakusa Kannon temple. Asakusa is a section of Edo near the Yoshiwara district, and the principal deity of the temple is Kannon (Skt: Avalokiteshvara). The number of quilts given to a customer at Yoshiwara depended on his wealth; three quilts would have been reserved for an affluent and frequent customer.[4]

1. On the life of Kyōden, see Schamoni 1970.
2. On the life of Bakin, see Zolbrod 1967.
3. For an English translation of this play, see *Japanese Noh Drama* 1955, pp. 109–24.
4. Mitani Kazuma 1973.

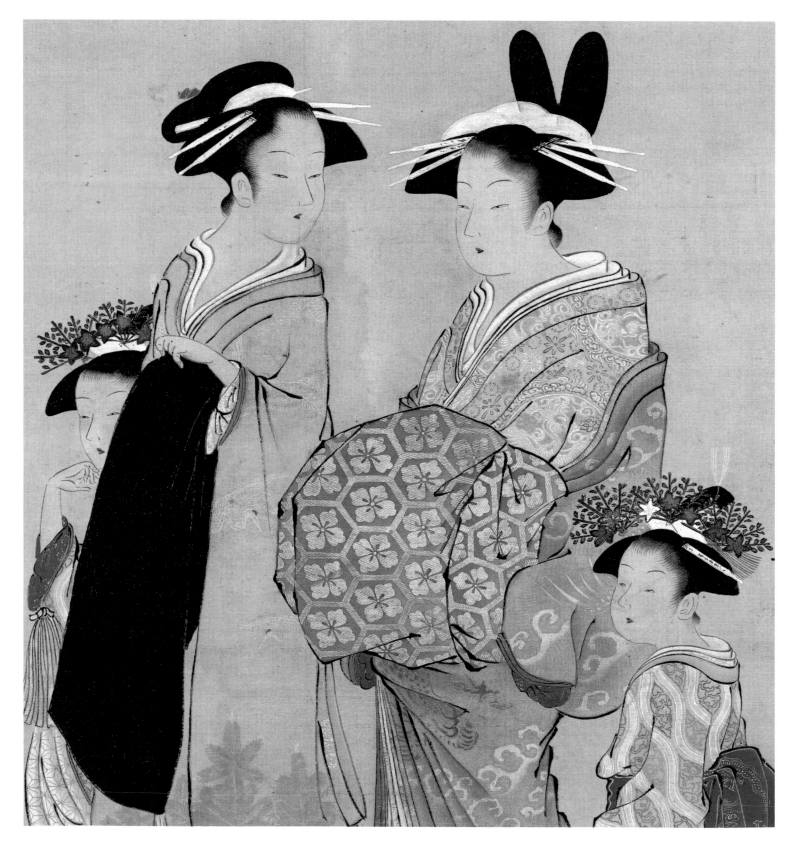

151. Snow, Moon, and Cherry Blossoms

Edo period (1615–1868), 1804–15
Triptych of hanging scrolls, ink, color, and gold on silk
Each scroll 82.4 × 30.2 cm (32½ × 11⅞ in.)
Signature: *Chōbunsai Eishi hitsu* [on each scroll]
Inscriptions by Ōta Nanpo (1749–1823) with his signature, *Shokusanjin* [on each scroll]
Seal: *Eishi* [on each scroll]
Ex coll.: Frank E. Hart, Palm Beach, Florida

LITERATURE: Society of the Four Arts 1963, nos. 53–55; Murase 1975, no. 92.

This triptych represents Yoshiwara, the brothel district of Edo, and its neighboring areas, in three seasons of the year, each with its most appealing feature—snow in winter, the moon in autumn, and cherry flowers in spring. In the center scroll, a courtesan proudly displays her beauty before her only rival—cherry blossoms, symbol of spring. The inscriptions on the scrolls are seasonal poems by Ōta Nanpo (Shokusan-jin, 1749–1823), the most popular satirical poet of his time.[1] The poem on the center scroll reads:

*Nakano-chō uetaru hana no katawara ni
miyamagi nado wa hitomoto mo nashi.*

*Beside the flowering cherries of Nakanochō
Not a single tree from the deep mountain valleys.*[2]

Nakanochō was the center of the Yoshiwara district. After cherry trees were planted there in 1749, they were often used as a metaphor for Yoshiwara. The poem here alludes to the unsurpassed beauty of the district's women.

On the left scroll, the route to Yoshiwara appears at its most enchanting, illuminated by the clear moon of autumn. After the district was relocated in 1657, away from the center of the city, the river Ōkawa was the most commonly used route.[3] A large pine tree called Shubi no Matsu (Pine of Fate), which stood on the riverbank, became a landmark for customers:

*Yūshio ni tsuki no katsura no sao sashite
Sate yoi shubi no matsu o miru kana.*

*On the evening tide,
Rowing the boat with oars made of the
Katsura branch growing on the moon,
Now I look at the Pine of Fate,
Wishing for luck.*

On the right scroll, the adventure of a hazardous journey through winter snow heightens the anticipation of pleasure at the end of the road:

*Mimeguri no torii no kasagi omokereba
Chikaku te tōki yuki no Yoshiwara.*

*Heavy snow is piled on the lintel of the
gate to the Mimeguri Shrine.*

*Yoshiwara is near,
But it seems distant in this snow.*

Hosoda Eishi (1756–1815), who painted this triptych, was born into a respected samurai family that included a number of high-ranking government officials. This was unusual, as most *ukiyo-e* artists were from the middle class. Eishi is believed to have studied painting with a leading Kano master, Michinobu (1730–1790). Sometime during the 1780s, after Eishi had given three years of service to the tenth shogun, Ieharu (r. 1760–86), he switched his artistic affiliation from the academic style to *ukiyo-e*, specializing in paintings and woodblock prints of courtesans.

Nearly monochromatic depictions of courtesans such as this one—perhaps a reflection of Eishi's early training in the Kano school—rely on subtle gradations of ink tonality as the major vehicle of expression. Known as *beni girai* (red avoiding), this technique differs from traditional ink monochrome in that it may include some gold, purple, yellow, and a touch of red. Many of Eishi's contemporaries used this technique for painting and printmaking in the 1780s and perhaps also in the early 1790s. It is well known that Sakai Hōitsu (cat. no. 134), a leading Rinpa artist who studied *ukiyo-e* painting, employed it for a painting that is dated by inscription to 1785.

The origin and practice of *beni girai* have long been attributed to a series of government restrictions that banned the use of red pigments and other rich colors in prints. This legislation was part of the Kansei Reforms, a puritanical policy implemented by the regent Matsudaira Sadanobu (1758–1829) from 1787 to 1793.[4] One study, however, states that Sadanobu referred to *beni girai* prints in his memoir of 1787 as "a recent development" and regarded them as no less sumptuously decorative than other types of prints.[5] Thus it would appear that monochromatic prints and paintings had already made their appearance prior to the Kansei Reforms, at least as early as 1785, the date of Hōitsu's painting.

Shokusanjin, the signature that appears in the inscriptions on the present scrolls, was the pen name of Ōta Nanpo. Born to an impoverished samurai family in Edo, Nanpo was a

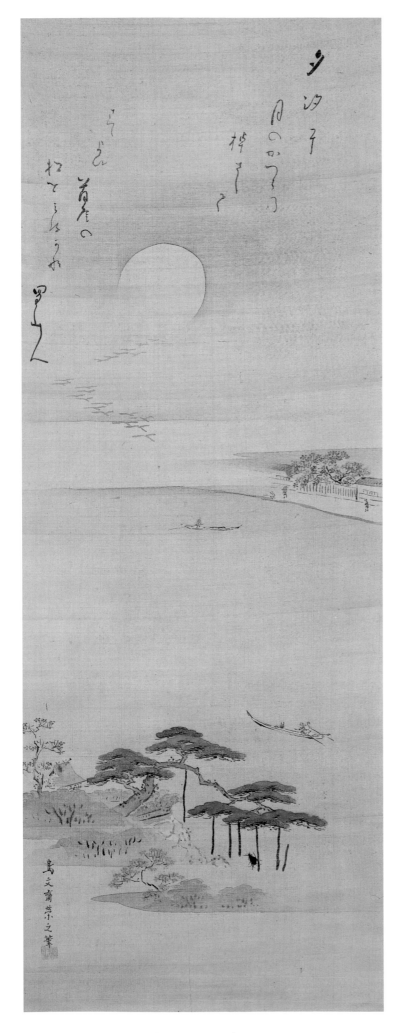

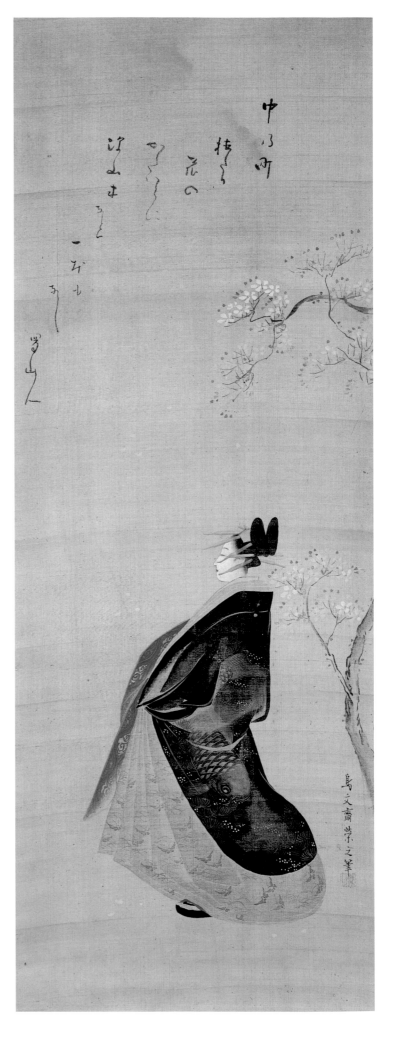

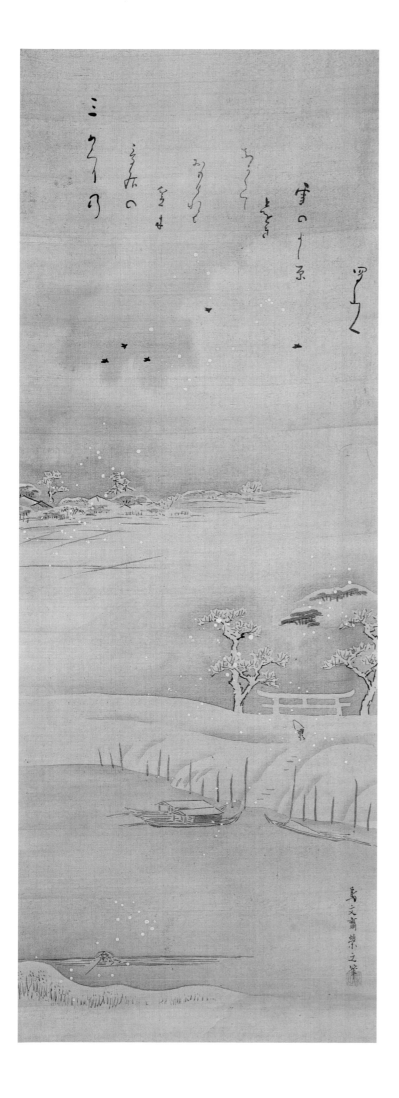

child prodigy in literature. At eighteen, he published books of Chinese-style poetry and while still in his teens a collection of *kyōka* (satirical poems), many of which parodied classical poetry. These biting, often vulgar verses quickly caught the attention of the townsfolk, and Nanpo is frequently credited with starting a *kyōka* craze in Edo.

Nanpo developed a strong interest in *ukiyo-e*, and at least some portions of the first essay on this new type of painting, the *Ukiyo-e ruikō*, are attributed to him.[6] Nanpo wrote inscriptions on several paintings by Eishi; a portrait of Nanpo by Eishi, painted in 1814, is in the collection of the Tokyo National Museum.

The Burke triptych may be dated to late in Eishi's career. His earlier depictions of beauties were more ethereal in treatment. This courtesan, by contrast, impresses us with her physical presence, felt beneath the voluminous layers of heavy silk. Such a change in Eishi's style may be partially attributable to the influence of Katsushika Hokusai (1760–1849), Eishi's enormously popular contemporary. Although throughout his career Eishi appears to have used a fluid *gyōsho* (running script) signature on his prints, the signature on each of these scrolls is written in a careful *kaisho* (standard script), a feature of his later paintings. Nanpo is also believed to have adopted the name Shokusanjin only at the beginning of the nineteenth century, about 1802. Finally, the calligraphic style of the inscriptions points to Nanpo's late style. The triptych may thus be dated to the last dozen years of Eishi's life.[7]

1. On the life of Ōta Nanpo, see Hamada Giichirō 1963; and Tamabayashi Haruo 1996.
2. Translation in Rosenfield and Shimada Shūjirō 1970, no. 149; see also Ōta Nanpo 1985–90, vol. 1, p. 40.
3. For a description of the customs of Yoshiwara, see Mitani Kazuma 1973; Jenkins 1993; and Seigle 1993.
4. For a detailed discussion of this ordinance, see Asano Shūgō and Clark 1995, p. 41.
5. Matsubara Shigeru 1981, pp. 27–33; see also Matsubara Shigeru 1985, pp. 4–15.
6. Sakazaki Shizuka 1917, pp. 1376–1437.
7. For a pair of paintings similar to two of the scrolls in the Burke triptych, also with colophons by Nanpo, see Rosenfield and Shimada Shūjirō 1970, no. 149.

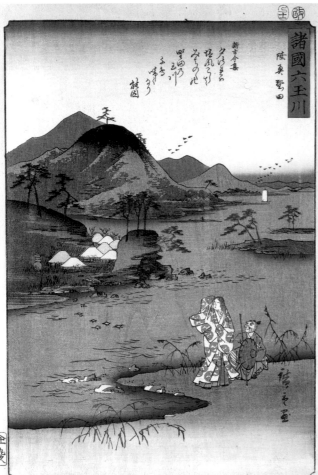

Noda no Tamagawa

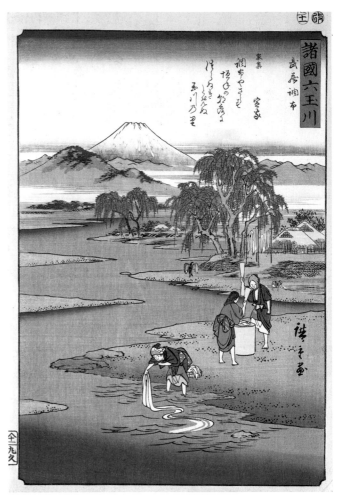

Tetsukuri no Tamagawa

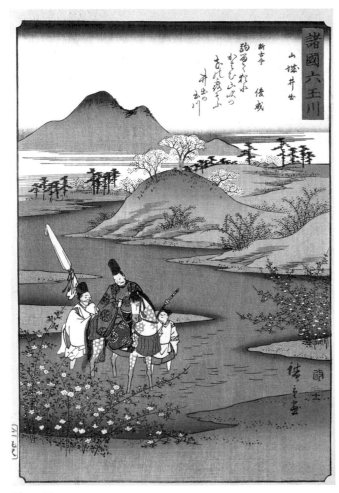

Ide no Tamagawa

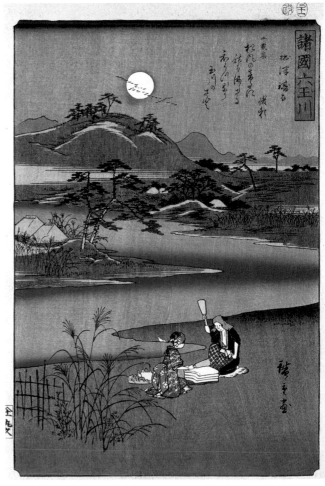

Kinuta no Tamagawa

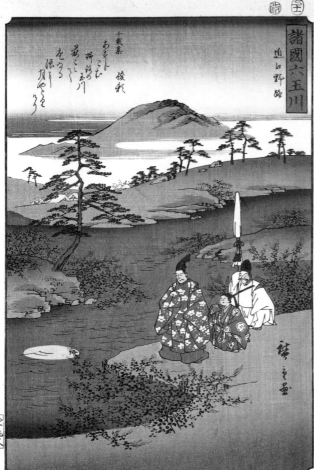

Noji no Tamagawa

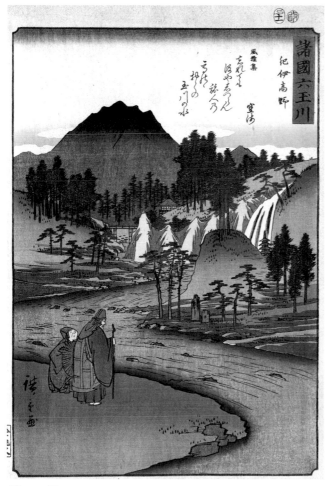

Kōya no Tamagawa

152. *Mu Tamagawa (Six Jewel Rivers)*

Edo period (1615–1868), 1857
Six woodblock prints
Each print 36.2 × 24.5 cm (14¼ × 9⅝ in.)
Signature: *Hiroshige ga* [on each print]
Publisher: Maruya Kyūshirō

He is known affectionately as an "artist of rain, snow, and moon," and a "painter of blue," and his name, Hiroshige, is as familiar in the West as it is in Japan. The details of his life are here briefly recapitulated. Utagawa Hiroshige (1797–1858) was born in the downtown section of Edo, the son of Andō Gen'emon, a low-ranking samurai who held a hereditary position in Edo's Fire Brigade. As a member of the samurai class, Hiroshige received early training in painting from a minor Kano-school artist named Okajima Rinsai (1791–1865). His parents died when he was twelve, and he inherited his father's position. About the same time, he attempted, unsuccessfully, to enter the atelier of the printmaker Utagawa Toyokuni (1769–1825); he was accepted instead by Toyokuni's younger brother Toyohiro (1773–1828). He was given the artistic name Utagawa Hiroshige in 1812. Following in his teacher's footsteps, he first produced prints of women and actors.

Hiroshige's career as a printmaker can be traced fairly accurately through the changes he made in the style of his signature and in his artistic names, which he changed periodically; also useful as documentation are censors' seals, dates of publication, and publishers' names, often included in the margins of his prints.[1] During the first years of his career, from 1818 to 1830, Hiroshige's signature sometimes includes the name "Ichiyūsai." He wrote "Hiroshige" during this period in *kaisho* (standard script), with all the strokes rendered evenly, in equal width. In 1823, he resigned from the Fire Brigade to concentrate on his artistic activities; his son inherited his position. About 1830, he changed the "yū" in "Ichiyūsai" from the character meaning "to wander" to the character meaning "hushed." Also during this time, he began to write the first letter of "Hiroshige" in a modified *gyōsho* (running script).

The *Tōto meisho* (Famous Views of Edo), a series of prints published about 1831, established Hiroshige as a major landscape artist. Shortly thereafter, in early 1832, he changed his acronym to "Ichiryūsai," perhaps to celebrate his success; the new name can be understood as "standing alone." He also used the name "Ryūsai" beginning about 1841. In 1833–34, he published his most successful landscape series, the *Tōkaidō gojūsantsugi* (Fifty-three Stations of Tōkaidō Road), surpassing in popularity his older rival Katsushika Hokusai (1760–1849). Toward the end of the 1830s, he began to use a large character for "hiro" and a much smaller one for "shige," which was increasingly abbreviated into *sōsho* (grass writing), as on the prints seen here. The last phase of Hiroshige's career extends from 1848 to 1858, when he continued to publish landscape series and also collaborated with Utagawa Kunisada (Toyokuni III, 1786–1864), who supplied the figures in Hiroshige's landscapes.

Beginning in the 1830s, Hiroshige executed a number of series on the *Mu Tamagawa* (Six Jewel Rivers) theme, using different formats: narrow and vertical, horizontal, fan-shaped, or circular. The present set, made the year before his death, is in a vertical *ōban* (large print) format. Each sheet, except the fourth, has a small round stamp in the upper margin. In the fourth sheet the seal is included within the picture, alongside the signature; it reads "tsuchinoto jūichi," meaning the eleventh month of the year that corresponds to 1833, 1845, or 1857. Another stamp, a round censor's seal, reads "Aratame." Also in the lower left margin of all six prints is the rectangular seal of the publisher Maruya Kyūshirō. All this points to the date 1857 for the print.[2] Hiroshige's signature is written in the style of his late period.

Each of the six scenes bears the title of the set, *Shokoku mu tamagawa* (Six Jewel Rivers of Various Provinces), and the name of the individual river depicted. These are followed by a poem, identified by the author and the

anthology in which it appears. The poems are identical to those quoted in Hiroshige's other *Mu Tamagawa* series, suggesting that in the poetic inscriptions Hiroshige followed the standard formula established by Harunobu.

This is not true of the compositions, which differ from set to set. In this 1857 version, Hiroshige crystallized the theme, reducing the number of figures and having them stand out from the landscapes, which seem almost like stage settings. Notably, the figure groupings as well as the postures of individuals are identical to those in the renditions of Sakai Ōho (cat. no. 138). The landscape settings are more compact, but essentially they are vertical, narrow versions of Ōho's compositions. While Ōho's renditions may have been inspired by Hiroshige's earlier versions of the Mu Tamagawa, this set seems to have been modeled on Ōho's scrolls.

1. For the life of Hiroshige, see Izzard 1983; and Link and Kobayashi Tadashi 1991.
2. I am grateful to Joan Mirviss for her help in interpreting this data.

Detail of *Tetsukuri no Tamagawa*, cat. no. 152

Nanga: The Literary Man's Painting

The two prevailing art movements in Japan during the eighteenth and the first half of the nineteenth century were *ukiyo-e* (pictures of the floating world) and *nanga* (southern painting), also called *bunjinga* (literati painting). In many ways, *ukiyo-e* and *nanga* mirrored two social strata within the Japanese culture, and their life-styles fostered two separate concepts of painting. Each style had its own patrons, and each was centered in a different city.

Unabashedly hedonistic, *ukiyo-e* depicted the pleasures and pastimes of the rising middle class, whose members resided for the most part in Edo and the big commercial cities (for a discussion of *ukiyo-e*, see pages 332–33). *Nanga*, by contrast, was practiced by artists from the more cultivated upper strata of Japanese society, whose aesthetic convictions derived from Chinese teachings and traditional artistic conventions. Like the Chinese literati on the Asian mainland, *nanga* artists discovered in the pursuit of landscape painting—which they executed primarily in ink monochrome—a refuge from the world of commerce and politics. Rejecting the enticements of Edo, they were drawn to the spiritual solace and tranquillity of Kyoto.

During the war-torn sixteenth century, artists in Japan had been out of touch with new art movements in China. This alienation continued through the seventeenth century as a result of the official policy of sealing off the nation from the outside world—ostensibly to thwart the dissemination of Christianity. Exceptions were made for the Dutch and the Chinese, who traded on a limited scale in Nagasaki, and from that port ideas and goods filtered into the country from abroad.

Although the Tokugawa *bakufu* maintained the principle of insularity, it ventured to take a few tentative steps toward modifying it in the eighteenth century. The eighth shogun, Yoshimune (r. 1716–45), the most enlightened administrator of the Edo period, launched a series of reform measures in the Kyōhō era (1716–36). Vigorously enforcing the principles of Confucianism, the moral basis for his reforms, he demanded unwavering loyalty to its precepts in both official and private life. The warrior clans in particular were required to observe strict rules of behavior. They were constrained to live frugally and to hold learning in high esteem. Because Chinese books were indispensable to the success of Yoshimune's crusade, in 1720 the *bakufu* relaxed the ban on foreign publications, on the condition that their purpose was not to propagate Christian dogma.

The study of Chinese culture was also spurred by Zen monks of the Ōbaku (Ch: Huangbo) sect, who had sought refuge in Japan when the Manchus invaded China and assumed power in 1616. The main Ōbaku temple, Manpukuji, was established in 1622 on the outskirts of Kyoto. The influence of the Ōbaku clerics is often cited in the development of the *nanga* aesthetic.

Nanga was introduced to this generally auspicious environment during the first half of the eighteenth century. The concept originated in China, where from ancient times it was believed that an individual of learning and refinement should cultivate his capacity to reveal the inner nature of the universe through music, poetry, calligraphy, and painting. Because the literati did not pursue the arts as a means of earning their livelihood, they were exempt from official dictates on aesthetic matters and could follow a more individualistic path than artists bound by patronage.

In its strict interpretation, the term *nanga* does not refer to a particular style of painting but to the attributes of the literati painter—education, social position, and nobility of mind. The term derives from the Southern school of Zen Buddhism, which advocated the instantaneous and intuitive grasp of truth. Thus, paintings that were spontaneous in execution and inspired by the intrinsic values of life were classified as *nanga*. Because *nanga* could not be codified and taught as a set of precepts, those who were trained as professional painters were deemed inferior to scholarly amateur artists, who painted as an avocation.

Figure 55. Okada Beisanjin (1744–1820), *Visiting a Friend in Autumn.* Hanging scroll, ink on paper, 136.4 × 29.4 cm (53¾ × 11⅝ in.). The Metropolitan Museum of Art, New York. The Harry G. C. Packard Collection of Asian Art, Gift of Harry G. C. Packard and Purchase, Fletcher, Rogers, Harris Brisbane Dick and Louis V. Bell Funds, Joseph Pulitzer Bequest and The Annenberg Fund Inc. Gift, 1975 (1975.268.102)

The introduction of this approach to artistic expression coincided with the cultural vacuum that existed in Kyoto in the early eighteenth century. After the death of the Rinpa painter Ogata Kōrin in 1716 and before the rise of the Maruyama and Shijō schools in the mid-eighteenth century, no painting school of any real consequence existed in Kyoto. In Edo the official taste in painting was satisfied by the Kano school, while more plebeian tastes were met by *ukiyo-e* artists. But neither was pleasing to the intelligentsia, who turned instead to Confucian teachings and *nanga* theory.

The *nanga* artists, many of whom received early training in Confucian studies, were well versed in Chinese literary theory and Confucian philosophy. They transcribed their poetry into fine calligraphy, and in their work honored the ancient Chinese credo "Painting is silent poetry." Nevertheless, few *nanga* painters could be called true literati; most were professionals forced to earn their living by their art, often in the service of feudal lords.

While the Japanese were not able to fully absorb the teachings of *bunjinga*, the new concept nevertheless helped to focus their attention on the world outside Japan. Some *nanga* practitioners, denied permission to travel abroad, made the journey to Nagasaki to establish contact with foreign traders. They were also exposed to non-Confucian books— painting manuals and texts on painting theory with woodcut illustrations. Among the most influential were an eight-album collection of woodcuts published in Suzhou about 1620, which appeared in Japan in 1671 as the *Hasshu gafu* (The Eight Albums of Painting), and the *Kaishien gaden* (The Mustard-Seed Garden Manual), a painting manual published at the beginning of the eighteenth century.

The *nanga* movement remained rooted in Kyoto, the center of Confucian learning. Not until the nineteenth century was well advanced did it spread to Edo, largely through the efforts of Tani Bunchō (cat. no. 168) and a few other artists.

Following the precepts of the Chinese literati, the Japanese *bunjin* regarded communion with nature as requisite to the ideal life, and *nanga* artists, like their Chinese counterparts, traveled constantly, some of them spending a good part of their lives on the road. Traveling afforded them the opportunity not only to meet other artists and to exchange theories and ideas but also to collaborate on works of art.

The Chinese advocated the close observation of nature in the service of re-creating what they had seen. The early *nanga* artists, on the other hand, while they aspired to emulate the Chinese masters, painted not from nature but from Chinese renditions of landscapes (fig. 55). Because they had never set foot on the Chinese mainland, they were obliged either to paint from their imagination or to copy Chinese paintings and woodcut illustrations from manuals. Soon, however, such *nanga* masters as Buson and Taiga struck out on their own, making paintings that depicted native scenes (cat. nos. 156, 158).

Gradually, other painting styles were incorporated into the *nanga* aesthetic. Some of them—Rinpa and Tosa, for example—had no connection to China. At the same time, the commitment of many *nanga* artists to the Chinese aesthetic was so fixed that they went so far as to drop parts of their family names or to pronounce their names so that they sounded more Chinese.

The *nanga* movement came to fruition in the work of Taiga and Buson. These two painters essentially transformed *nanga* by adapting it to the Japanese sensibility. Incorporating indigenous styles with Chinese idioms, they forged a style that was markedly different from the foreign prototype, expanding the rather narrow framework of *nanga* art to encompass new styles and poetic visions.

In the first half of the nineteenth century, the principles of *nanga* spread to the provinces, from the region north of Edo to Shikoku Island in the south. The painting styles adopted by the provincial artists were as varied as their backgrounds. Some softened the Chinese idiom in shimmering, lyrical landscapes. Others found ways to combine Chinese conventions with European naturalism. *Nanga* would continue to attract artists through the first half of the twentieth century, when the nation made a concerted effort to Westernize the culture.

153. *Bamboo Window on a Rainy Day*

Edo period (1615–1868)
Hanging scroll, ink on paper
131.8 × 58 cm (51⅞ × 22⅞ in.)
Signature: *Nankai Gyofu utsusu*
Seals: *Kikai Kasai* [?]; *Senso* [?]; and *Tenran*

LITERATURE: Murase 1975, no. 64.

Gion Nankai (1677–1751), an innovator
among *nanga* artists in Japan, enjoyed a lin-
eage, education, and temperament that con-
formed to the Chinese concept of the literatus
(J: *bunjin*), a connoisseur and man of letters.[1]
He was born in Edo to a physician who served
the lord of Kii (Wakayama Prefecture) and
studied medicine under Kinoshita Jun'an
(1621–1698), a Confucian scholar and pio-
neering doctor of pre-Meiji Japan. He also
studied Chinese philosophy and literature. As
a painter Nankai was probably self-taught,
learning from such manuals as the *Hasshu
gafu* (The Eight Albums of Painting; 1671)
and the *Kaishien gaden* (The Mustard-Seed
Garden Manual), which had been introduced
to Japan from China.

As was customary among young men of
good family and education in the late seven-
teenth century, Nankai started his profes-
sional career as a Confucian scholar, serving
the same family that employed his father.
Perhaps because his artistic pursuits inter-
fered with his duties, Nankai was released
from his post about 1700. He led the impov-
erished life of an unemployed retainer until
1710, when he was pardoned and reinstated.
Eventually, he became a professor in the fami-
ly school. We know nothing of his painting
during his ten years of unemployment, but his
activities as a poet during the same period are

well documented; he continued to write poems and essays on poetry throughout his life.

All the dated paintings are from the period after 1710. The earliest is a painting of bamboo executed in 1719, now in the Wanaka Kin'nosuke collection. Nankai's paintings were by-products of his intellectual pursuits, and his studies of bamboo reflect the ideals of the Chinese literati. In the Chinese tradition, the strength and flexibility of bamboo are likened to the spirit of the gentleman-scholar, who bends but does not break under adversity. The bamboo—together with the plum, harbinger of spring, and the pine, green throughout the winter—symbolized moral steadfastness and friendship. During the twelfth century in China, the three were thematically associated as the Three Worthies. Because the tall, graceful bamboo is best rep-

resented in painting by the use of calligraphic brushwork, the depiction of bamboo in ink monochrome came to be regarded as indicative of a painter's skill.

Bamboo as a subject for ink painting was introduced to Japan in the early fourteenth century and became popular with Zen monk-painters of the late Kamakura and early Muromachi periods.[2] Replaced in popularity by landscape painting in the fifteenth century,[3] the subject was rediscovered and revitalized by *nanga* artists of the Edo period.

The title of Nankai's painting of rain-drenched bamboo, *Chikusō ujitsu* (Bamboo Window on a Rainy Day), is inscribed by the artist, and the painting is executed in the kind of clear, direct brushwork advocated in Chinese painting manuals. The oddly shaped rock at the foot of the bamboo looks

strangely alive, as though it were growing along with the young shoots. Ink tones vary from rich black to pale gray in a subtle combination of boldness and restraint, and light ink washes applied to the background suggest the moist atmosphere of a rainy day.

At the upper left corner of the painting is a seal that reads "Tenran" (Viewed by the Emperor), and around the emperor's seal are carvings that testify to the presence at that occasion of the finance minister, Matsukata Masayoshi (1835–1924). We thus know that the viewing took place sometime between 1880 and 1885, when Matsukata held that position.

1. Uetani Hajime 1959, pp. 388–92; and Wakayama Prefectural Museum 1986.
2. See *Butsunichian kumotsu mokuroku*, in Kamakura-shi Shi Hensan Iinkai 1956.
3. Tani Shin'ichi 1936, pp. 439–47.

SAKAKI HYAKUSEN (1697–1752)

154. *Snowy Landscape*

Edo period (1615–1868), 1744
Hanging scroll, ink and light color on paper
121.4 × 50.3 cm (47¾ × 19¾ in.)
Signatures: *Kōshi kajitsu Bō Shin'en sha*
Seal: *Bō Shin'en in*

Along with Gion Nankai (cat. no. 153) and Yanagisawa Kien (1706–1758), Sakaki Hyakusen (1697–1752) is regarded as one of the pioneers of the *nanga* movement.[1] Hyakusen's birthplace is still unknown, but it is generally believed that his father was a wealthy pharmacist in Nagoya. He appears to have studied literature, specializing in *haikai*, or *haiku*, a distinctly Japanese verse form of seventeen syllables, which gave him an entrée to literary circles. Hyakusen is said to have received training in the Kano school of painting, but it is a style he soon rejected. Even his earliest dated work, executed in 1720, reveals few traces of Kano influence. Rather, it reflects the principles and techniques of the Chinese tradition. Sometime before 1728, Hyakusen moved to Kyoto, where he quickly acquired a reputation as a painter. Gion Nankai is credited with indirectly encouraging Hyakusen to shift from the aesthetics of the Kano school to those of *nanga*, having supposedly given him a copy of the *Kaishien gaden* (The Mustard-Seed Garden Manual), which inspired the young artist. Nevertheless, it is questionable that a single book could have

determined Hyakusen's course as a painter.

Hyakusen is among the most difficult of the *nanga* painters to appreciate. He experimented with a variety of techniques, seldom pursuing one for any length of time, and stylistic diversity characterizes his oeuvre. Hyakusen painted everything from *haiga*, spontaneous cartoonlike sketches made to accompany *haikai*, to monumental compositions executed in the Chinese manner. Perhaps because of his accomplishments in *haiga*, and in other styles more traditionally Japanese, he was awarded the title *hokkyō*. A similar eclecticism marks the work of other *nanga* artists, perhaps because their knowledge of literati subjects and brushwork, rather than deriving from the work of the Chinese literati, was based on anything Chinese that they happened upon. Chinese influences on *nanga* also included the fifteenth- and sixteenth-century Zhe school of professional painters, whose approach to painting was more or less the antithesis of literati painting. The stylistic diversity of the early *nanga* practitioners thus in many ways reflects the school's restless, searching spirit.

Hyakusen was crucial to the development of *nanga*, less perhaps through his work than through his artistic activities. He encouraged aspiring young painters such as Yosa Buson (cat. nos. 155, 156) and published books on the Chinese tradition, including a catalogue of paintings and calligraphy from the Yuan, Ming, and Qing dynasties and an anthology of biographies of Yuan and Ming painters.[2]

James Cahill, in his 1983 study, discerns in Hyakusen's work the strong and persistent influence of late Ming painting, particularly styles prevalent in Suzhou, in southern China. He also suggests that a technical breakthrough in Hyakusen's landscape painting occurred in the 1740s. Until the early years of that decade, Hyakusen was concerned primarily with surface details, relying mainly on hemp-fiber strokes and repetitive, lively dotting. In the mid-1740s, the *shun* become broader and are often used for shading, to distinguish one surface area from another; dabs of ink adhere more firmly to contour lines, and dotting is less frequently employed. Shading in pale ink, applied to broader areas, marks works from Hyakusen's final period, the late 1740s until his death, in 1752. Some of the paintings from this period are strongly reminiscent of the vibrant, contorted rocks and mountains of such Suzhou artists as Xie Shichen (1487–ca. 1567).[3]

Snowy Landscape is dated by inscription to "Kōshi kajitsu" (a summer's day, the Year of the Rat), which corresponds to 1744. Hyakusen has painted a Chinese winter landscape, the mountains and trees blanketed with snow beneath a menacing sky. A hillock at bottom center, from which tall trees rise upward to the foot of the massive mountains, serves to connect foreground and background. The earlier hemp-fiber strokes have given way to dots of black and gray ink applied over light washes, creating a sense of mass and volume. The painting is among the earliest works from the 1740s to display Hyakusen's new technique.

1. For studies on the life of Hyakusen, see "Hyakusen" 1939; Uetani Hajime 1960, pp. 483–90; and Nagoya City Museum 1984.
2. See, respectively, Sakaki Hyakusen 1777 and Sakkai Hyakusen 1751.
3. Cahill 1983.

YOSA BUSON (1716–1783)

155. *Two Birds on Willow and Peach Trees*

Edo period (1615–1868), 1774
Hanging scroll, ink and color on silk
128.9 × 70.5 cm (50¼ × 27¾ in.)
Signature: *An'ei kōgo natsu utsusu oite Yahantei Sha Shunsei*
Seals: *Sha Chōkō* and *Sha Shunsei*

LITERATURE: "Yosa Buson hitsu Kachō zu kai" 1930, pl. III; Tsuji Nobuo 1980, no. 27; Murase 1993, no. 24; Haga Tōru and Hayakawa Monta 1994, pls. 50, 71.

Yosa Buson (1716–1783) is regarded as one of the two greatest painters of the *nanga* school, the other being his contemporary Ike Taiga (cat. nos. 157–159). He was also one of the most important poets of the Edo period.[1] Buson's literary accomplishments were not in Chinese poetry, the primary interest of *nanga* artists, but in *haikai* (or *haiku*), a Japanese verse form of seventeen syllables. It is generally agreed that Buson was born in Osaka to the Taniguchi, a modest family of farmers. About 1735, he moved to Edo. There, his initial pursuit was not painting but *haikai*, which he first studied with Uchida Senzan (d. 1758) and then from 1737 with Hayano Hajin (1677–1742). Beginning in 1738 his poems were published regularly in anthologies. Early in his career as a poet Buson admired Matsuo Bashō (1644–1694), the greatest poet of *haikai*, and he later came to be regarded as the poet who restored the genre to the level of excellence it had known under Bashō. In 1744, he adopted "Buson" as the name he used as a poet; it is also the name for which he is best known as a painter. Buson signed this name only on *haiga*, the illustrations that accompany his *haikai*, while he used many other names on the paintings that are unrelated to this form of poetry.

Buson apparently learned to paint while working as a young poet in Edo. He may have believed this was necessary to further his career, as it was the fashion to have one's poems illustrated. But while most poets had others perform this task, Buson, in a book published in 1738, illustrated his own poems. Buson's early paintings, all of which include figures, reflect some knowledge of the Kano and Tosa schools,[2] but nothing of *nanga*.

The death in 1742 of Hajin seems to have prompted Buson to leave Edo on a journey to the north, retracing the route that Bashō had made famous through his travel diary, the *Oku no hosomichi* (The Narrow Road to the Deep North; 1694). Buson's wanderings continued for nearly ten years. He settled eventually in Kyoto, in 1751, and began to devote his energies to painting. The surname "Yosa," or "Yosano," by which Buson is generally known, was taken from the village of Yosa, northwest of Kyoto, where he lived briefly during this time, and which may have been the birthplace of his mother. Buson's screen paintings from his stay in Yosa show the influence of *yamato-e*, *nanga*, and the ink-painting styles of Sesson Shūkei (cat. nos. 67–69) and the Unkoku school (cat. no. 78).

為歌甲申晚景寫於蘿峰寫

謝春星

At the same time, his work increasingly reflects the manner of *nanga*, a shift that is generally considered the influence of his mentor Sakaki Hyakusen (cat. no. 154). Buson returned in 1757 to Kyoto, where he lived until his death. In Kyoto he is believed to have made a careful study of the bird-and-flower paintings of the Chinese master Shen Nanpin (Shen Quan, fl. 1725–80), who lived in Nagasaki from 1731 to 1733. Some of his paintings, like this one in the bird-and-flower genre, are obviously inspired by Chinese models.

Throughout his life Buson maintained close contact with other *haikai* poets. Indeed, contemporary accounts, both by Buson himself and by his fellow artists, do not refer to him as a painter; he was considered, during his lifetime, a poet exclusively.

In this painting, two exotic birds are depicted, one perched on the branch of a willow tree, its mate on a peach tree that has sprouted pink blossoms. The date given in the artist's inscription is "An'ei kōgo natsu" (summer, Year of the Rat, An'ei era), which corresponds to 1774. The painting reflects Buson's debt to the work of Nanpin and his followers, known as the Nagasaki school, a group of artists who adopted the Western techniques of realism and linear perspective. Here, however, the spatial relationship of the trees to the rocks is too ambiguous to give the illusion of real space, and the rocks seem flattened, without volume. The subject of the painting and the short brushstrokes in wet ink of varying tonalities are Chinese derived, and are seen in the work of many of Nanping's followers.[3] Buson's paintings are, however,

more lyrical than typical Nagasaki-school works, such as those by his near contemporary in Edo Sō Shiseki (cat. no. 166). Here, a misty sky is brushed with pale blue bands. The painting was made in Yahantei, Buson's studio—named in the inscription.

A painting by Buson in The Metropolitan Museum appears to have been modeled after this work.[4]

1. On the life of Buson, see French 1974.
2. For these works, see Hayakawa Monta and Yamamoto Kenkichi 1984.
3. Koshinaka Tetsuya, Tokuyama Mitsuru, and Kimura Shigekazu 1981. On Buson's landscape paintings, see Cahill 1996b, pp. 151ff.
4. The painting is signed "Heian Sha Shunsei" (Sha Shunsei of Kyoto) and bears two seals, "Sha Chōkō" and "Sha Shunsei." It is incorrectly identified as part of the Burke Collection in Hayakama Monta and Yamamoto Kenkichi 1984, no. 15. For a reproduction, see Shimada Shūjirō 1969, vol. 2, no. 86.

YOSA BUSON (1716–1783)

156. From Bashō's "Oku no hosomichi"

Edo period (1615–1868), ca. 1780
Folding fan, mounted as a hanging scroll, ink and color on paper
18 × 48.4 cm (7⅛ × 19 in.)
Signature: *Buson*
Seals: *Chōko* and *Shunsei*

LITERATURE: Murase 1975, no. 74; Gitter and Fister 1985, no. 17; Schirn Kunsthalle Frankfurt 1990, no. 93.

A man sits in a hut, enclosed by a wooden fence and a thatched gate, his only companion an enormous chestnut tree. The text inscribed at the right by the artist, Yosa Buson (1716–1783), is also contained within the compound, while another block of text frames the scene at the left. Beneath the tree are the title of the painting, *Shōo Oku nikki* (Diary of the Deep North by Old Man Bashō); Buson's signature; and two seals, "Chōkō" and "Shunsei," carved half in intaglio and half in cameo, a form the artist used in the later years of his life.

The painting illustrates an episode from the *Oku no hosomichi* (The Narrow Road to the Deep North, 1694), a diary by Matsuo Bashō that became one of the most popular literary works of Japan. Bashō wrote it during a journey of more than two and a half years that he took beginning in 1689 to northern Japan and the coastal regions along the Sea of Japan. About a month after he left Edo, Bashō arrived at Sukagawa, a small village north of Edo. There he visited a monk

named Kashin, who reminded him of the Late Heian monk-poet Saigyō (see cat. no. 79).

The text of Bashō's diary, a part of which was copied by Buson on this fan, reads:

There was a great chestnut tree on the outskirts of a post town, and a monk in seclusion lived in its shade. When I stood in front of the tree, I felt as though I was surrounded by the deep mountains where the poet Saigyō had once picked nuts. I took a piece of paper from my bag, and wrote the following: "The chestnut is a holy tree. The Chinese ideograph for the chestnut is a tree placed directly below the west, the direction of the holy land. The monk Gyōki [668–749] is said to have used [the branch of] a chestnut for his walking stick and as the chief support of his house.

People hardly note its flowers,
The chestnut near the eaves.[1]

From 1777 to 1780, Buson painted scenes from the *Oku no hosomichi* at least five

times—on scrolls, screens, and fans. This fan is nearly identical in composition to the scene in a scroll version now in the Itsuō Museum, Osaka.[2] The soft, resilient strokes that Buson used in all his illustrations for the *Oku no hosomichi* have the distinct charm peculiar to his work. Quick splashes of dark ink over broad washes of blue for the foliage and the pale pink on the thatch lend warmth and intimacy, reflecting the affection that both Bashō and Buson must have felt for the solitary country monk. Here, Buson returns to memories of his own youthful wanderings (see cat. no. 155) and captures the essence of *haiga*, an abbreviated and poignant pictorial expression that corresponds to *haikai*.

The painting probably dates to the end of Buson's life, possibly about 1780, when he also painted other versions of the story.

1. Translation after Matsuo Bashō 1996, p. 63.
2. Okada Rihei 1978, pl. 18.

IKE TAIGA (1723–1776)

157. Two Poems from the "Kokin wakashū"

Edo period (1615–1868), 1734
Hanging scroll, ink on paper
33.3 × 26.7 cm (13⅛ × 10½ in.)
Signature: *Shisei jūissai*
Seal: *Ikeno Shisei*
Ex coll.: Okamoto Kōhei, Kanagawa Prefecture; Mizuta Chikuho

LITERATURE: Kyoto National Museum 1933, pl. 79; Hitomi Shōka 1940, p. 3; Tanaka Ichimatsu et al. 1957–59, no. 1; Matsushita Hidemaro 1970, fig. 8; Murase 1975, no. 68; Y. Shimizu and Rosenfield 1984, no. 116.

Most *nanga* painters were not true *bunjin* (literati) in that they had to sell their work to support themselves, but as scholar-artists they were given *bunjin* status in intellectual circles. Curiously, two of the most prominent masters of *nanga*, Ike Taiga (1723–1776) and Buson (cat. nos. 155, 156), failed to fit even this adjusted definition of the term. Although both were well educated, they lacked formal instruction in Chinese literature and, as professional artists, they supported themselves solely through painting. Taiga was extremely prolific; more than one thousand of his works are believed to be extant.[1] Much of his oeuvre, including the folding screens in the Burke Collection (cat. no. 159), is Chinese derived, both in subject matter and style, but he also produced paintings on indigenous themes, using brushwork and compositions not generally associated with *nanga*. These works show both the influence of Japanese traditions celebrated by such schools as Rinpa and a knowledge of linear perspective and chiaroscuro, techniques developed in the West.

Taiga attained fame quite early in life. The standard accounts cite Kyoto as his birthplace. The family name was Ikeno, but Taiga later dropped the character "no" to make it sound more Chinese, following a trend among *nanga* artists. His father is said to have worked for Nakamura Kuranosuke, an official of the Ginza (the government mint) and a patron of Ogata Kōrin (cat. nos. 132, 133). However, because two officials with the name Nakamura worked at the Ginza at that time, it is impossible to identify Ikeno senior's employer with certainty.[2] Taiga's formal training in calligraphy began when he was about seven, under the tutelage of the monk Seikōin Issei (1672–1740).

Taiga began working as a professional painter by the age of fifteen, when he opened a fan shop in Kyoto to support his widowed mother. His earliest extant painting, *Willows at Weicheng*, painted when he was twenty-two, is already in the *nanga* mode. Taiga may have acquired his knowledge of *nanga* from the *Hasshu gafu* (The Eight Albums of Painting), a collection of Chinese woodcuts that was printed in Japan in 1671. While still in his teens, he became a close friend of Kō Fuyō (1722–1784), an artist of wide interests and learning who was an examplar for many *nanga* artists. He also attracted the attention of Yanagisawa Kien (1706–1758), a leader of the early *nanga* movement, who encouraged Taiga and wrote inscriptions on his compositions.

Poets and scholars gravitated toward Taiga. Among the many artists who were inspired or influenced by him was his wife, Tokuyama Gyokuran (cat. no. 160), also a *nanga* painter. He was a frequent traveler, and his oeuvre includes a number of paintings that document his journeys.

This piece of calligraphy, signed "Shisei jūissai" (Shisei at the age of eleven), is the second earliest known example of Taiga's work.[3] It is composed of two poems taken

from the tenth-century *Kokinshū* (A Collection of Poems Ancient and Modern). The first, number 24 in the anthology, is by Minamoto Muneyuki (d. 939):

Tokiwa naru matsu no
midori mo
haru kureba
ima hitoshio no iro masarikeri

Now that spring has come
even the unchanging pine
is dressed in
fresh new foliage that is
dyed a brighter shade of green.

The second poem, number 53, is by Ariwara no Narihira (825–880):

Yo no naka ni taete

sakura no nakariseba
haru no kokoro wa
nodoke karamashi

If this world had never
known the ephemeral charms
of cherry blossoms
our hearts in spring might match
nature's deep tranquillity.

The second syllable of "Shisei," Taiga's signature on this scroll, is taken from the name of his calligraphy teacher, Issei; "Shisei" means "a child's well," while "Issei" means "a well." Rather than use a carved seal, Taiga wrote the difficult seal characters by hand on this work, demonstrating his precocious ability. For the calligraphy itself, he was probably following a model provided by Issei. Instead

of using the standard *kana* script, Taiga wrote in *man'yōgana*, which uses mostly Chinese characters. While Taiga's calligraphy is hesitant and accurate, in the manner of a boy attempting to copy his model to perfection, his skill nevertheless remains impressive.

1. Suzuki Susumu and Sasaki Jōhei 1979, p. 98.
2. Yoshizawa Chū 1959, p. 360.
3. One example of his writing believed to have been executed when he was only two years old is in the Ike Taiga Museum of Art, Kyoto; see Matsushita Hidemaro 1970, p. 9.

158. Four Paintings and Five Calligraphies

Edo period (1615–1868)
Nine sheets from an album, each mounted as a
hanging scroll, ink on paper
Each scroll 23 × 37 cm (9 × 14⅝ in.)
Seals: *Mumei*; *Taisei*; and *Sekitei*
Ex coll.: Nozoe Heibei, Kyoto; Wakamura
Genzaemon, Shiga Prefecture

LITERATURE: Tanaka Ichimatsu et al. 1957–59,
no. 197; Murase 1975, no. 69; Suzuki Susumu and
Sasaki Jōhei 1979, pl. 61; Tsuji Nobuo 1980, nos.
13–16; Tokyo National Museum 1985a, no. 51;
Schirn Kunsthalle Frankfurt 1990, no. 90.

Ike Taiga probably composed these four small
paintings as a set. The title of each is inscribed
on the sheet. Abbreviated, soft strokes are
rapidly, almost casually brushed, capturing
the essence of the scene—the tranquillity of
the two men who gaze silently toward the
mountains across the valley (*Discussion under
a Pine Tree about the Vicissitudes of Time*) or
the bustle of activity in the village (*Evening
Glow in a Mountain Village*), where figures
are merely a few smears of ink.

Each painting is now accompanied by a
separate sheet of calligraphy, with the excep-
tion of *Summer Mountains in the Rain*, which
has two. The poems were composed and
added to the paintings long after Taiga's
death by a group of famous scholars, poets,
and calligraphers: Minagawa Kien (1734–
1807), Ōkubo Shibutsu (1766–1837), Shi-
nozaki Shōchiku (1781–1851), Kameda Bōsai
(cat. no. 167), and Rokunyo (1737–1801), a
Buddhist monk.

Discussion under a Pine Tree about the Vicissitudes of Time

Summer Mountains in the Rain

Fishing Boat at the Reed-Covered Bank

Evening Glow in a Mountain Village

*Discussion under a Pine Tree about the
Vicissitudes of Time (Shōka ronko)*

Together we discuss a thousand ancient matters,
Until the setting sun shifts across the hill.
No one can say what is true and what is false.
Only the towering pine tree knows.

> I write this colophon on Ike Mumei's
> "Shōka ronko"
> —Minagawa Kien

Summer Mountains in the Rain (Kazan yoku'u)

Still with the fragrance of dripping wet ink,
Deep mountains in the rain painted in the
 manner of Mi Fei.
How can one know if an artist is good or bad?
It all resides in the tip of the artist's brush.

> I write this colophon on Kashō Sanjin's
> "Kazan yoku'u"
> —Ōkubo Shibutsu

In the hot, humid days of summer,
I look at the rain-drenched hills.
The bright sun glistens over the shower-
 washed foliage
And fresh air cools the world of men.

> Twentieth day of the seventh month of
> the Year of the Dragon. For over a month
> it has not rained. The heat is unbearable.
> Unrolling this scroll I am refreshed, and
> write this poem with a glad heart.
> —Shinozaki Shōchiku

a

b

c

Fishing Boat at the Reed-Covered Bank (Katei kinshū)

A lone fishing boat on a cold river.
Withered reeds rustle in the wind.
A fisherman pulls in his rods.
By which route is he heading home?
He must be off to a meeting of the Night
Tide Society.[1]

I write this colophon on Kashō's "Katei kinshū"
—Kameda Bōsai

Evening Glow in a Mountain Village (Koson henshō)

Smoke in the trees and a slanting bridge by
a cove at sunset.
Villagers come and go in the caps and robes
of yore,
Unaware that their garb evokes bygone times.
Outsiders see them as figures in a painting.[2]

Composed after seeing the painting
—Rokunyo

Although now mounted as hanging scrolls, these nine sheets were formerly pasted in a book, together with eight other calligraphies. They were in this format at least until 1957, when the *Ike Taiga sakuhinshū* (The Works of Ike Taiga) was published.[3] Shortly thereafter, the nine leaves were mounted separately, leaving the eight remaining colophons in the book. The scrolls were acquired by the Burke Collection from different sources. The album, a gift from the late Yabumoto Sōshirō, of Tokyo, makes it possible to view the entire set as it appeared in its former, though not original, state. Among the eight colophons still remaining in the album, one dated to 1799 is by Taya Kei of Shimotsuke Province (Tochigi Prefecture), who explains how he came into possession of the four paintings. He states that he found them mounted on small sliding screens at the home of a certain Yuzawa in Nikkō; and indeed, the faint marks on each of the paintings suggest that they were once pasted on sliding doors. Impressed by their beauty, he succeeded in exchanging them for his own paintings. He then began to assemble appropriate colophons by famous calligraphers to complement the paintings, and gradually the album took shape.

The seven other colophons that remained in the album were written by Ōkubo Tadanari

d

e

Five Calligraphies for Four Paintings by Ike Taiga. Five sheets from an album, each mounted as a hanging scroll, ink on paper, 23 × 37 cm (9 × 14⅝ in.). Mary and Jackson Burke Foundation, New York

a. Minagawa Kien (1734–1807). Calligraphy for *Discussion under a Pine Tree about the Vicissitudes of Time.* Signature: *Minagawa Gen sho.* Seals: *Kien* [?]; *Minagawa Gen in*; and *Sho* [?]

b. Ōkubo Shibutsu (1766–1837). Calligraphy for *Summer Mountains in the Rain.* Signature: *Shibutsu gyō.* Seals: *Shisei Seido* and *Shibutsu*

c. Shinozaki Shōchiku (1781–1851). Calligraphy for *Summer Mountains in the Rain.* Signature: *Shōchiku Sanjin hitsu.* Seals: *Shinozaki hiten*; *Shōchikusai saku*; and [unidentified seal]

d. Kameda Bōsai (1752–1826). Calligraphy for *Fishing Boat at the Reed-Covered Bank.* Signature: *Bōsai Rōjin.* Seals: *Bunkyo Monjin* [?]; *Chōko Shiin*; and *Bōsai Dōjin*

e. Rokunyo (1737–1801). Calligraphy for *Evening Glow in a Mountain Village.* Signature: *Rokunyo dai.* Seals: *Shujō Genpōsai* [?]; *Shakuin Jishū*; and *Rokunyo*

(1766–1851), the daimyo of Karasuyama fief in Shimotsuke Province, who gave the album its title, *Sansui sei'in* (The Pure Sound of Mountains and Waters); Tachihara Suiken (1744–1823), of Mito Province (Ibaraki Prefecture), a Confucian scholar whose colophon is dated to 1818; Hayashi Seiu (1793–1846), a Confucian scholar serving the government in Edo; Ikeda Kanzan (1767–1833), the daimyo of Wakazakura fief, who wrote his colophon in 1821; Suiken's son Tachihara Kyōsho (1785–1840), a *nanga* painter whose colophon is a faithful copy of Kanzan's; Shokatsu Kentai (1748–1810), a Confucian scholar employed by the daimyo of Himeji, whose colophon is dated 1800; and Hōzan, a monk from Awatani, Shimotsuke Province.

If Taya Kei's colophon is to be trusted, Taiga's four paintings were probably made for the Yuzawa family in Nikkō. Taiga visited the Nikkō area in 1748, while on a trip that included a visit to Mount Fuji and Matsushima, though on stylistic grounds the four paintings are dated slightly later. Two of the seals on the paintings—"Mumei" and "Taisei"—are known to have been used only after 1749. The calligraphy for the titles also suggests that Taiga was in his thirties when he inscribed them.[4] In 1760, at the age of thirty-seven, Taiga returned to the Nikkō area with two of his closest friends, Kan Tenju (1727–1795) and Kō Fuyō (1722–1784). The three artists spent nearly two and a half months traversing the mountainous regions of Shinshū and Nikkō, eventually climbing Mount Fuji. Very possibly, Taiga painted these four landscapes on this journey.

1. The Night Tide Society was an informal group of writers led by the Song loyalist Xie Ao (1249–1295) in Hangzhou after the Mongol conquest.
2. Translations after Stephen D. Allee.
3. Tanaka Ichimatsu et al. 1957–59, no. 197.
4. Ibid.

IKE TAIGA (1723–1776)

159. The Gathering at the Orchid Pavilion and Autumn Festival

Edo period (1615–1868), ca. 1763
Pair of six-panel folding screens, ink and light color on paper
Each screen 159.5 × 354.6 cm (5 ft. 2¾ in. × 11 ft. 7⅝ in.)
Signatures: *Kyūka Sanshō utsusu* [on the right screen]; *Kyūka Sanshō shai* [on the left screen]
Seals: *Kashō* and *Ike Mumei in* [on the right screen]; *Ike Mumei in* and *Gyokkō Kōanri* [on the left screen]
Ex coll.: Kuribayashi Shigeru, Tokyo

LITERATURE: Tanaka Ichimatsu 1957, pp. 91–96; Tanaka Ichimatsu et al. 1957–59, no. 241; Takashimaya Department Store 1965, no. 22; Cahill 1972, no. 10 (right screen); Suzuki Susumu 1972, p. 52 (detail of the right screen); Murase 1975, no. 70; Suzuki Susumu 1975, no. 10; Mayuyama Junkichi 1976, no. 476; Burke 1985, pl. 1 (right screen); Tokyo National Museum 1985a, no. 50 (right screen); Yoshizawa Chū 1986, pp. 29, 30; Murase 1990, no. 15; Schirn Kunsthalle Frankfurt 1990, no. 89 (right screen); Guth 1996, figs. 43, 44 (right screen).

These two screens are a study in contrasts of composition, mood, and narrative content. The screen on the right depicts a poetry gathering at Lanting, the Orchid Pavilion, on the third day of the third lunar month in the year 353 at Huiqi, Chekiang Province, southern China. The screen on the left shows a rustic country scene, the autumn festival after the harvest at the foot of Mount Ohu in Kiangsi Province.

The poetry contest at the Orchard Pavilion was immortalized for future generations of literati, both Chinese and Japanese, by the preface to the poems, which was written by the host of the gathering, Wang Xizhi (ca. 303–ca. 361). Wang, regarded as the greatest calligrapher of China, invited forty-one of his scholarly friends to an outing on the orchid-filled banks of a winding stream. The group composed poetry and drank wine from cups that had been set floating on the stream. Wang's preface to the forty-one poems is a sophisticated discourse on the meaning of life and death, past and present.[1] According to tradition, the original text was the favorite possession of the Tang emperor Taizong and was interred with him when he died, in 649. The many copies that survived insured that the preface would be known and revered in years to come.

To the *nanga* artists of the Edo period, the gathering at the Orchid Pavilion was the epitome of a literati pastime. Of the many Japanese artists who painted the theme, Ike Taiga (1723–1776) is the most prominent, depicting it repeatedly on scrolls and screens, each time with a similar compositional scheme. A broad, winding stream dips low into the foreground at the lower right, boldly dividing the composition into near and far. Wang and his friends are shown seated inside the pavilion. (The man with a scroll spread before him on the table is most likely Wang himself.) Scholars and servants appear throughout the landscape, along the stream and in the great cavities of the rocks. Two children on the bridge at the left use long poles to try to catch the wine cups as they float on the water.[2]

Taiga may have devised this composition originally for the small *ema* (votive plaque) at the Yasaka Shrine in Kyoto. His inscription on the *ema* states that he painted it in 1754, at the request of ten citizens. The plaque is now badly damaged, but the painting can be studied from a preliminary drawing and an early-nineteenth-century woodcut copy.[3]

The Burke screen, dated to about 1763, is the earliest known example in screen format to follow the composition of the *ema*.[4] In the

painting, verdant leaves heighten the freshness of rose-colored plum and peach blossoms on a day in early spring. The variety of brushstrokes used for the foliage—loops, stubby lines, and dots against the hemp-fiber texture strokes of rock surfaces—produces a vibrant, brocade effect. The screen, with its rich texture and color and complex composition, contrasts sharply with the screen at the left, which is executed with spare restraint.

The subject of *Autumn Festival* is a popular Chinese poem generally attributed to Wang Jia (b. 851) but sometimes to another Tang poet, Zhang Yan. The poem is inscribed by Taiga on the screen:

At the foot of Mount Ohu, the rice and millet
 are fat.
Pigs are in their pens, chickens in their coops;
The door to the house has been left ajar.
The Autumn Festival is over, and in the evening
Mulberry leaves cast long shadows.
To every house tipsy men return, holding each
 other up.[5]

The landscape of *Autumn Festival* is viewed from a farther distance than in the *Orchid Pavilion*. A mountain peak towers above a village in the center foreground, contrasting sharply with the lake on the right and the low-lying fields and hills beyond. Crisp autumn air permeates the scene. Pale ink dominates, punctuated by touches of dark ink for foliage and patches of red and green, hidden among the trees.

The Autumn Festival was another of Taiga's favorite subjects, but he did not usually include the poem. Like the Orchid Pavilion paintings, the Autumn Festival paintings are compositionally close. No doubt the theme was a popular one, as the poem appealed to many *nanga* artists.

The two screens are so different in style that scholars question whether they were originally intended as a pair.[6] But Taiga may not have followed any particular formula when he matched two subjects on pairs of screens. He seldom repeated the same combination of themes, and he seems to have been more interested in creating contrasts than in adhering to stylistic or thematic coherence. Indeed, he may have been searching for a way to depart from the traditional formula for paired screens in an attempt to create a new scheme—a spacious scene complemented by a more compressed view.

Taiga is believed to have used as many as 115 seals, perhaps more.[7] Three seals are impressed on these two screens. "Kashō" and "Ike Mumei in" on the Lanting screen, and "Taiga," "Ike Mumei in," and "Gyokkō Kōanri" on the Festival screen. "Kashō" and "Ike Mumei in" are the two seals most frequently used by Taiga. The latter calls for some explanation, as "Mumei" is sometimes read as "Arina."[8] Taiga adopted this name in 1749 at the suggestion of his teacher, Gion Nankai (cat. no. 153). When Taiga met Nankai, he was still using his personal name "Tsutomu." Asked about his artistic name, Taiga replied that he had "no name" (*mumei*), upon which Nankai suggested that he use "Mumei." Taiga gave a humorous twist to the new name, pronouncing it "Arina" (Have Name).

The seal "Gyokkō Kōanri" comes from a verse by the Tang poet and official Yuan Zhen (779–831) and means "Official in Charge of the Jade Emperor's Incense Burner."[9] Taiga's choice of this title for a seal reflects aspirations typical of sinophile artists of the *nanga* movement.

The years during which these seals were used can be roughly determined from the paintings on which they are impressed. "Kashō," "Ike Mumei in," and "Gyokkō Kōanri" are found on works dated, respectively, from 1763 to 1771, from 1759 to 1765, and from 1755 to 1766. These are consistent with the date of about 1763 for the Burke screens, arrived at independently through stylistic analysis.

1. Ch'en Chih-mai 1966, p. 62.
2. A six-fold screen almost identical to this work is in a private collection and is reproduced in Tōkyū Department Store 1972, p. 20; and Yoshizawa Chū 1986, pp. 33–35.
3. Yabumoto Kōzō 1974, p. 53.
4. Tanaka Ichimatsu et al. 1957–59, no. 241.
5. Translation after Stephen D. Allee. In the commonly used texts of this poem, the word *pan*, meaning "half," is given for the fourth character from the top on the second line from the right. Taiga, however, gives the word *tui*, which means "to oppose" or "to confront," suggesting that he may have used a corrupt text.
6. See, for example, Tanaka Ichimatsu 1957, p. 90.
7. Suzuki Susumu 1975, pp. 105–6; see also M. Takeuchi 1992, pp. 159–65, where thirty-seven seals are reproduced.
8. M. Takeuchi 1992, seal no. 16.
9. Ibid., seal no. 23.

TOKUYAMA GYOKURAN
(CA. 1728–1784)

160. *Peony and Bamboo by a Rock*

Edo period (1615–1868), ca. 1768
Hanging scroll, ink and light color on paper
92.8 × 41.7 cm (36½ × 16⅜ in.)
Signature: *Gyokuran*
Seal: *Gyokuran*

LITERATURE: Murase 1980b, no. 28; Fister 1988, no. 31; Murase 1993, no. 28.

Gyokuran, the most well known woman artist of the Edo period, was the wife of the painter Ike Taiga (cat. nos. 157–159). Her parents owned a tea shop in Kyoto. Gyokuran's mother, Yuri (1694–1764), and Yuri's adoptive mother, Kaji, both had reputations as published *waka* poets.[1] Gyokuran, née Machi, was thus exposed to the world of the literati early in her life. Her mother was a friend of Yanagisawa Kien (1706–1758), a *nanga* artist and Taiga's early mentor. Kien may have instructed Machi in painting; he gave her part of his artistic name, "Gyoku," which she used to form "Gyokuran." Her marriage to Taiga is believed to have taken place about 1751. In their devotion both to each other and to their art, they are often compared to the painters Zhao Mengfu (1254–1322) and his wife, Guan Daoshen. It is notable, however, that contemporary

records, including the 1768 edition of the *Heian jinbutsushi* (the Who's Who of the Kyoto art world) lists Gyokuran under "Tokuyama" and not by her husband's name, Ike or Ikeno.[2]

Although Gyokuran seems to have painted before her marriage, Taiga's influence on her work is apparent. Taiga's idiosyncrasies are muted and softened in her paintings; here, the use of an angled brush in the broad strokes of the bamboo leaves and rock recalls his favorite technique. Gyokuran's tranquil depiction of nature is imbued with purity and freshness. Pale blue washes enhance the rich coloristic effects created by the varying tonalities of ink.

Only one work by Gyokuran with a dated inscription is known, a painting of plum on which her mother wrote a poem.[3] Gyokuran's signature on the painting is brushed in a vigorous, youthful calligraphy. The painting is nearly identical to a work by Taiga, which he is thought to have completed when he was about thirty and Gyokuran about twenty-five.[4] Some of Gyokuran's works reflect Taiga's early style, others his late manner. Although comparing Gyokuran's paintings with those of her husband is an unsatisfactory method by which to deduce the chronological framework of her oeuvre, it is at present the only viable one.[5] The style of the signature on the present work suggests that she was about forty years old when she painted it. The character for *gyoku* (jewel) in Gyokuran's name is written with a distinct loop in the middle, giving it a round, open appearance. In some, perhaps later, works, this character no longer has the loop and has acquired a narrower, leaner profile.

1. Their poems were anthologized in *Kaji no ha* (Kaji's Leaves, 1707) and *Sayuriba* (Leaves of Little Yuri, 1727), respectively; see Fister 1988, no. 30.
2. It has been noted that Gyokuran's address is listed in this book as different from that of Taiga and that she was interred with her mother and grandmother rather than with her husband; see Hoshino Rei 1977, p. 36.
3. Ibid.
4. Tanaka Ichimatsu et al. 1960, no. 93.
5. Suzuki Susumu 1974, pp. 37–50.

161. Crossing a Mountain Bridge with a Zither

Edo period (1615–1868), 1814
Hanging scroll, ink on paper
127.4 × 54.4 cm (50⅛ × 21⅜ in.)
Signature: *Gyokudō Kinshi toshi shichijū nari*
Inscriptions: *Bunka kōjutsu no shunjitsu* and *Shatoku Yakyō hōkin ᵹu*
Seal: *Takeuchi Daijin no mago*
Ex coll.: Idegawa Shigeru, Kumamoto

LITERATURE: Miyake Kyūnosuke 1955, pl. 25; Narazaki Muneshige 1955, p. 85; Honma Art Museum 1961, illus.; Tokyo National Museum 1965, no. 181; Murase 1975, no. 76; Suzuki Susumu 1978, fig. 26; Guth 1996, fig. 45.

Uragami Gyokudō (1745–1820) is one of the most compelling of the *nanga* artists, both for the unusual emotional quality of his art and for his independence.[1] Gyokudō was born to a family of high-ranking warrior-retainers in the service of their relative the daimyo Ikeda in Okayama. When his father died, in 1751, the six-year-old Gyokudō inherited the post in the Ikeda administration traditionally held by the Uragami family. He was educated in Chinese literature, painting, and possibly in Western studies, which were then in vogue. He also learned to play the *qin* (a Chinese zither). He gave instructions in the *qin* when he was in his early twenties, and also composed music for it. He took his artistic name after he acquired a *qin* called Gyokudō Sei'in (Pure Tone of the Jade Hall) in 1779.

The death in 1768 of his master, Ikeda Masaka, with whom Gyokudō had been associated since childhood, seems to have marked a turning point in his life. The Ikeda family records mention, in slightly scornful tones, that Gyokudō, who had been a diligent and loyal retainer until Masaka's death, began to neglect his duties and to spend time with his gentlemen friends, playing the *qin* and painting. Nevertheless, Gyokudō remained in service for another twenty-five years. On a trip in 1794 with his two sons, Shunkin and Shūkin (Spring Zither and Autumn Zither), Gyokudō sent a letter of resignation to Okayama. He was then forty-nine. Resignation was considered a serious act of disloyalty, a moral lapse regarded almost as a crime. Nevertheless, Gyokudō was permitted to travel, which indicates that his actions were viewed with a certain degree of tolerance.

Following his resignation Gyokudō traveled extensively, earning his livelihood primarily as an instructor of the *qin*. He later settled in Kyoto with his son Shunkin. Most of Gyokudō's paintings with dated inscriptions were made in the last decade of his life.

Gyokudō was already acquainted with a number of *nanga* painters by the time he was in his thirties. His work is included, together with paintings by the leading *nanga* artists of the late eighteenth century, in an album now in the Idemitsu Museum of Arts, Tokyo, which was executed in 1792–93 for the art dealer Nyoi Dōjin of Ise.[2]

Gyokudō painted landscapes exclusively. His early work is hesitant and uncertain, depending chiefly on the use of the short, horizontal strokes known as Mi dots, after the brush technique favored by the Northern Song Chinese painter Mi Fu (1052–1108). Most of his works dating from the time of his resignation share distinctive traits: spiky, needlelike twigs on old trees, large areas of unpainted white, and the figure of a stooped old man—perhaps Gyokudō himself—crossing a bridge in the depths of a forest.

Gyokudō's decision to live as a wandering *rōnin* (retainer without master) conforms to the idealized life of the Chinese literatus. His personality, however, did not correspond to the ideal of calm detachment. Gyokudō's landscapes are emotionally charged, and the ever-present figure of the old man is expressive of the artist's deep loneliness. Perhaps to reach a better understanding of Gyokudō it is necessary also to study his music.[3]

Gyokudō painted the scene depicted on this hanging scroll many times. An old man, accompanied by a servant carrying a *qin* on his

back, is seen crossing a bridge on his way to a gentleman who waits on the other side to greet him. A fourth figure is seated inside a steep-roofed pavilion. The presence of additional figures mitigates somewhat the forlorn solitude characteristic of most of Gyokudō's work.

At first glance, the painting seems uncontrolled; short twigs explode from trees like firecrackers, and dry willow leaves burst forth in scratchy lines. Gaping areas of unpainted white appear on the ground and mountains. On closer inspection, however, the painting reveals a careful structure, the mountains, hills, and rocks roughly laid out in light washes of ink and then further defined by darker strokes applied in clear, rhythmic movements that impart life and vitality to the forms.

The colophon, inscribed by Gyokudō himself, is written in a deliberate, antiquated style. It includes the date of the painting (a spring day, the Year of the Dog, Bunka era [1814]); the artist's age as sixty-nine; and the title of the painting. The seal reads "a grandson of Minister Takeuchi." Takeuchi no Sukune was a semilegendary warrior-statesman of ancient Japan, from whom the Uragami family claimed its descent.

1. On the life of Gyokudō, see Addiss 1987.
2. Yoshizawa Chū 1974, pp. 9–12.
3. Attempts were made along this line in Addiss 1987; and Fukushima Prefectural Museum 1994.

URAGAMI GYOKUDŌ (1745–1820)

162. *Lingering Rain in a Mountain Hamlet*

Edo period (1615–1868), ca. 1815–20
Folding fan, mounted as a hanging scroll, ink on
paper
16.6 × 47.9 cm (6½ × 18⅞ in.)
Signature: *Gyokudō*
Inscription: *Zan'u hanson*
Seals: *Hakuzen Kinshi* and *Kinsen*

LITERATURE: Miyake Kyūnosuke 1955, pl. 28;
Tokyo National Museum 1965, no. 200; Okayama
Art Museum 1970, illus.; Suzuki Susumu 1970,
p. 127; Murase 1975, no. 77; Suzuki Susumu 1978,
fig. 141; Gitter and Fister 1985, no. 30; Tokyo
National Museum 1985a, no. 54; Addiss 1987, figs. 5,
22; Schirn Kunsthalle Frankfurt 1990, no. 95.

This small composition evokes a country
landscape in changing weather. As the artist,
Uragami Gyokudō (1745–1820), notes in his
inscription, rain still lingers over half the
hamlet. Mountain peaks reemerge through
the mist while the area below remains envel-
oped in vapor. A pagoda and two roofs, barely
visible at the far right, are the only signs of a
village; the tiny figure of a solitary man in the
center foreground is almost indecipherable.

Using a fine brush and dry ink, Gyokudō
here paints with greater restraint than in
Crossing a Mountain Bridge (cat. no. 161),
employing short, carefully executed strokes.
Although his dated paintings are very few, it
would appear that the works from the last
years of his life are less exuberant in their
display of dark, wet ink. Heavy sizing on
the paper has given it a silvery sheen. The
scratchy lines in varying shades of gray on
the shiny paper lend a pearl-like, translucent
quality. As a true *bunjin*, Gyokudō seldom
painted screens; only one, dating to 1815, is
known. Of the many fans that he painted,

two which closely resemble this one also date
to the last period in his career, when the artist
was in his seventies.[1]

1. Sugimoto Hidetarō and Hoshino Suzu 1994, p. 104.

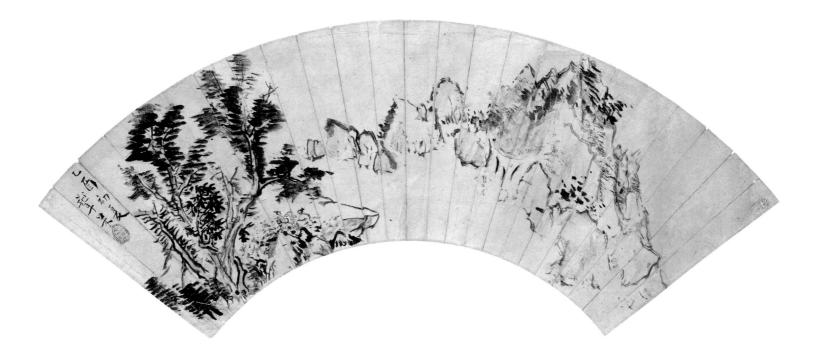

AOKI MOKUBEI (1767–1833)

163. *Preparing Tea by a Mountain Gorge*

Edo period (1615–1868), 1825
Folding fan, mounted as a hanging scroll, ink and
light color on paper
14.8 × 49.4 cm (5⅞ × 19½ in.)
Signatures: *Otsuyū shoka Rōbei*
Seals: *Aoki* and *Mokubei*
Ex coll.: Kuraishi

LITERATURE: Murase 1975, no. 80; Tokyo National
Museum 1985a, no. 55; Schirn Kunsthalle Frankfurt
1990, no. 96.

Aoki Mokubei (1767–1833) was the youngest
son of a restaurateur and brothel keeper in
the Gion district of Kyoto, which is still
known today for its many restaurants. The
name of the family business was "Kiya."
The first Chinese character of this name is
also pronounced "moku" in Japanese.
Mokubei's childhood name was Yasohachi,
which is written in three characters—
"eight," "ten," and "eight"—Japanese for
the numeral eighty-eight. When written
together, the three characters form one Chi-
nese character that means "rice" and is pro-
nounced "kome" or "bei." Thus, "Mokubei"
is an acronym that combines the family's
trade name with Mokubei's childhood name.
Mokubei had a penchant for playing with
names, and in his later years he invented
another name for himself, "Rōbei." Mokubei
is believed to have lost his hearing while work-
ing at pottery kilns, and "Rō" means deaf.

When he was about fifteen, Mokubei was
introduced to the art world through the anti-
quarian, seal carver, and painter Kō Fuyō

(1722–1784), and it was perhaps through this
association that he became adept at making
copies of antique objects. He was also a pot-
ter, and though today his reputation is based
on his work as a painter, in his own day he
was known primarily for his pottery. Mokubei
began making pottery under the guidance of
Okuda Eisen (1753–1811), and he was soon
celebrated for his copies of Chinese ceram-
ics.[1] These in turn inspired the young potters
of Kyoto, where the art of pottery making
had been in decline since the death of Ogata
Kenzan, in 1743. Together with Eisen and a
colleague Nin'ami Dōhachi (1783–1855),
Mokubei is credited with reviving the ceram-
ics industry in Kyoto (on this revival, see
cat. no. 130).

Mokubei made many ceramic vessels for a
special kind of tea drinking called *sencha*, in
which leaf tea is used rather than *matcha*
(powdered tea), which is required in *chanoyu*.
Sencha is less formal than *chanoyu*, and it was
the only kind of tea drinking that the Japa-
nese practiced before the introduction of

matcha in the early Kamakura period. *Sencha* was then virtually replaced by *matcha* until it was reintroduced by a Chan monk, Yin Yuan (1591–1673), who arrived in Japan in 1654. Japanese sinophiles, dissatisfied with the highly institutionalized *chanoyu*, promptly returned to *sencha* drinking.

The preparation or drinking of *sencha* was a frequent subject for the Chinese painters most admired by the Japanese—Qian Xuan (ca. 1235–1300), for example, and Qian Gu (1508–ca. 1574). Mokubei followed in this tradition and made a number of paintings that depict figures drinking tea.

Here, a man—perhaps Mokubei himself—is shown assisted by a servant preparing the *sencha* over a tall ceramic stove on a hilltop next to a mountain gorge. The rock on which the two men are seated hangs precariously over a ravine, left undefined as an ambiguous void. Mountains, hills, and outcrops rise on the far side. The height of the

mountain and the depth of the ravine would have appeared greater when the painting was properly pasted on the frame of a folding fan, as was originally intended. The almost lacquerlike black ink concentrated on the foliage at the left shimmers against the silver luster of the sizing agent applied to the paper. Contour lines are discontinuous, breaking in quick, agitated strokes. The hills in the center are rendered with a scratchy brush and dry, light ink, which creates the effect of crumbling rock. Red ochre on the rocks hints at the warm, dry air of early summer. The influence of pottery decoration is especially apparent in the abrupt division of the landscape into two distinct areas, as though they were painted on opposite sides of a large bowl.

Mokubei's painting techniques suggest that he learned to paint while working as a potter. It is often assumed that he began painting only late in life. However, his accomplishments as a painter by the time he

was twenty-nine led to his participation in an exhibition organized by Minagawa Kien (1734–1807) in 1796, the "Higashiyama shin Shoga Tenkan" (Exhibition of New Calligraphy and Painting in Kyoto).[2]

The majority of Mokubei's paintings with dated inscriptions were done in the last twenty years of his life. This one is dated by his own inscription "early summer, the Year of the Bird," which corresponds to 1825, one of the most productive years of the artist's life. His seal, "Mokubei," is impressed at the top right corner of the fan. Another seal, "Aoki," appears below the signature, but it is impressed upside down. It is believed that Mokubei was losing his sight—as he had earlier lost his hearing—toward the end of his life and was often unable to determine the correct way to impress his seals.

1. On the life of Mokubei, see "Mokubei" 1967, p. 46.
2. Sasaki Kōzō 1977, p. 103.

TANOMURA CHIKUDEN (1777–1835)

164. Rainstorm over a River Village

Edo period (1615–1868)
Hanging scroll, ink and light color on paper
132.3 × 42.2 cm (52⅛ × 16⅝ in.)
Signature: *Chikuden-sei*
Inscription by Tanomura Chikuden
Seals: *Denshaji*; *Jinsei Kōrakuji*; and [an unidentified collector's seal]

LITERATURE: Suzuki Susumu 1963, fig. 136; Murase 1975, no. 84.

Under a threatening sky, trees sway in the wind and a boatman navigates a ferry on choppy waters; a passenger huddles inside. In the distance a small village is buffeted by the storm. With his brush held at an angle Tanomura Chikuden (1777–1835), who painted this scroll, applied dark, wet ink in a staccato rhythm over watery gray ink, creating patches of dense foliage. The painting is almost completely covered with blue-gray and coal-black washes; areas left unpainted suggest the heavy moisture of rising mist. Chikuden also composed and inscribed the short colophon:

A small boat—a leaf on the water—
 returns home.
Like mountains, fierce waves rise up.
Who would think life's hardships
Could be more defeating than a rainstorm
Over a river village.[1]

Chikuden was one of the great *nanga*

painters and the most scholarly of his generation. His artistic name, "Chikuden," is another reading of "Takeda" (bamboo field), the name of his birthplace in Bungo Province (Ōita Prefecture). Chikuden's life and career exemplify the spread of the concept of the *bunjin* (literatus) to small provincial towns far from Edo or Kyoto. As the son of a clan physician, Chikuden was trained in his father's profession, but his artistic talent and a predilection for scholarship led him in another direction. He first studied painting with minor local artists. In 1798, he left his post as physician to serve as a professor in the clan school. The same year he was commissioned to compile a history of Bungo, an assignment that allowed him to travel extensively and to examine art collections within the province.

In 1811 and 1812, the farmers of Bungo revolted against the harsh taxation system. On both occasions Chikuden advised that

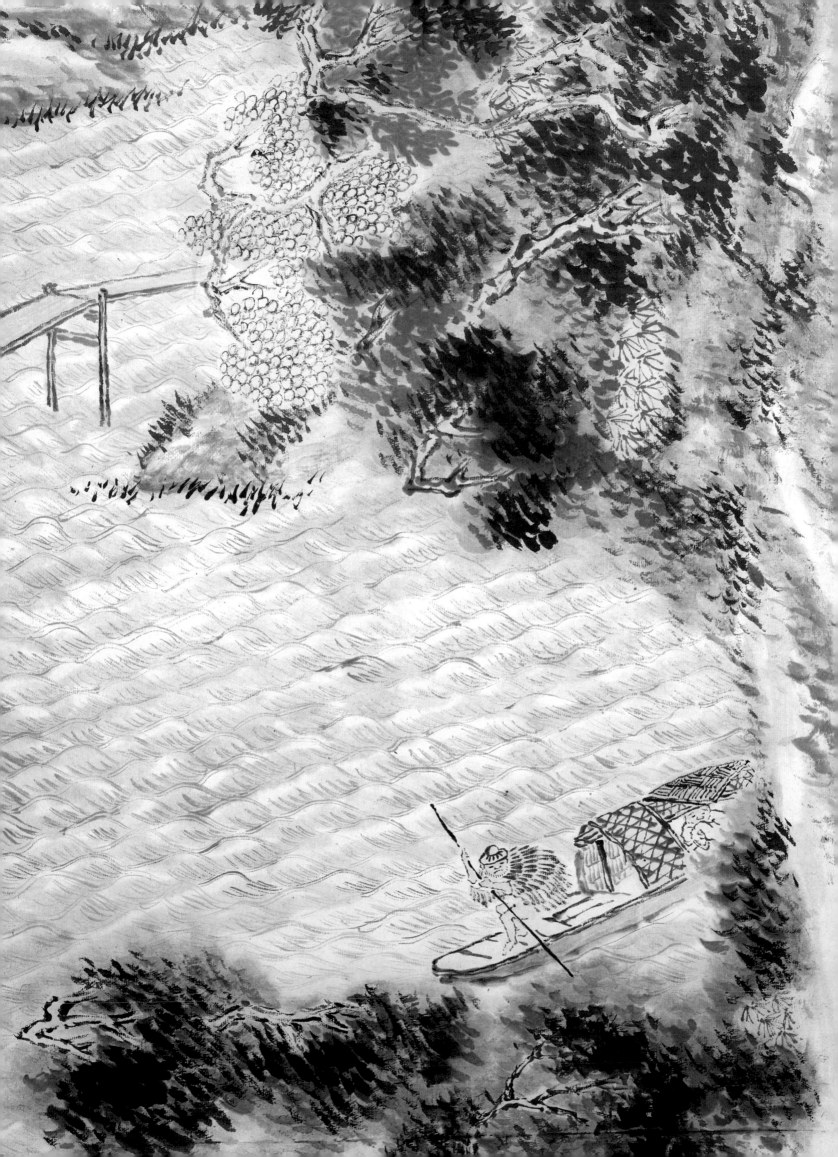

the clan government adopt drastic policy reforms. When his recommendations were rejected, he resigned on the pretext of ill health, as he had suffered from chronic ear and eye ailments from his late teens.

After his resignation, travel became a way of life. Chikuden's many trips across the Inland Sea to meet with *nanga* artists in Kyoto and Osaka were a source of artistic inspiration, and journeys over turbulent rivers and bays became a frequent theme. In 1827, the year he spent nearly ten months in Nagasaki, he paint-ed several scenes of rainstorms.[2] In this he set himself apart from other *nanga* artists, who created imaginary landscapes or copied pic-tures of a China they had never seen.

Chikuden's career has been divided into three phases.[3] Until 1812, when he resigned his post as professor, he focused on bird-and-flower paintings in polychrome. After 1820, hemp-fiber texture strokes, indicative of the *nanga* manner, begin to appear in his work.[4] In Nagasaki and thereafter, he produced many paintings that describe stormy journeys and wind-whipped trees. The Burke *Rainstorm* closely resembles some of his Nagasaki-period works both in composition and in painting and calligraphy styles. A portion of the poem is also identical to one that Chikuden com-posed during the Nagasaki period.[5]

Chikuden wrote a treatise on painting, the *Sanchūjin jōzetsu* (Superfluous Words by a Mountain Hermit).[6] He also wrote commen-taries on a number of *nanga* artists and *bun-jin* whom he met in Kyoto and Osaka. The *Chikuden-sō shiyū garoku* (Records of Paintings by Chikuden's Teachers and Friends) includes accounts of the lives of 104 artist-friends and comments on their work. Chikuden's portraits of his friends are full of warmth, reflecting not only an intimate acquaintance but also a deep affection.

1. Translation after Stephen D. Allee.
2. Suzuki Susumu 1963, figs. 34, 36.
3. Sasaki Kōzō 1983, pp. 27–39.
4. Yoshizawa Chū 1978.
5. Ibid., fig. 37.
6. See Tanomura Chikuden 1916, pp. 139–59; and Taketani Chōjirō 1975.

165. Landscapes of the Four Seasons

Edo period (1615–1868), 1848
Four hanging scrolls, ink and light color on silk
Average height 102.6 cm (40⅜ in.); average width 35.2 cm (13⅞ in.)
Signatures: *Boshin mōshun utsusu Baiitsu Ryō* [*Spring*]; *Baiitsu saku* [*Summer*]; *Baiitsu ga* [*Autumn*]; *Baiitsu sei oite Gyokuzen-shitsu* [*Winter*]
Seals: *Yamamoto Ryō* [on each scroll] and *Meikyō* [on *Winter* scroll]

LITERATURE: Iizuka Beiu 1932b, pls. 68–71; Suzuki Susumu 1973, pp. 75–82; Murase 1980b, no. 41; Graham 1986, fig. 18 (*Summer*); Murase 1993, no. 30.

Yamamoto Baiitsu (1783–1856), who is best known for his elegant polychrome paintings in the bird-and-flower genre, was born to a carver's family in Nagoya, a city between Edo and Kyoto. The painting teacher of young Baiitsu is believed to have been Chō Gesshō (1770–1832), a minor artist of the realist Shijō school. Yamamoto Rantei, a now almost forgotten Kano-school artist, might also have given Baiitsu instruction, as well as the use of his family name.[1] While Baiitsu was still in his teens, he met Nakabayashi Chikutō (1776–1853), a painter from his hometown, and in 1802 they left Nagoya together for Kyoto to pursue their studies. Always in search of new ideas, new models for painting, and new friends, Baiitsu traveled continually throughout the Kyoto–Osaka area, painting, composing poetry, and playing the flute—leading a life that followed the ideals of the Chinese literati. In about 1815, the sphere of his travels widened to include Edo, where he met many other like-minded literati. His peripatetic life continued until about 1854, when he returned to Nagoya. He remained there until his death two years later.

Each of these four hanging scrolls depicting the four seasons of the year is signed and impressed with a seal. The first one (*Spring*) gives the date as "the Year of the Dog," the first month of spring," which corresponds to January 1848. The last scroll (*Winter*) identifies the place where Baiitsu painted the set as the Studio of Jade Contemplation.

Each painting depicts the solitary figure of a scholar, except for *Summer*, in which two gentlemen and a servant are shown. All the men are engaged in quiet contemplation or in music-making. The flute player under the full autumn moon—indeed, any of the figures in these scrolls—may surely be understood as a self-portrait.

The scrolls are a virtuoso display of brush techniques. Dark, wet, and unusually short strokes are employed to convey the feel of lush vegetation in the warm spring and summer seasons, and dark inks combined with pale, soft washes fade into the shimmering, unpainted silk, evoking a vaporous mist. The *Autumn* scroll has a greater sense of open space, and the trees have shed their leaves. Deftly brushed reeds accent the otherwise muted scene. In *Winter*, broken strokes in light ink mark the distant hills, and traces of the dry brush cover the entire landscape. The barren, flat-topped peaks recall the landscape paintings of Chikutō. A scholar contemplates the frozen world.

The Burke scrolls represent Baiitsu, sixty-five years of age, at the pinnacle of his technical and expressive powers.

1. On Baiitsu's life, see Graham 1983, pp. 21–79.

Summer

Winter *Spring*

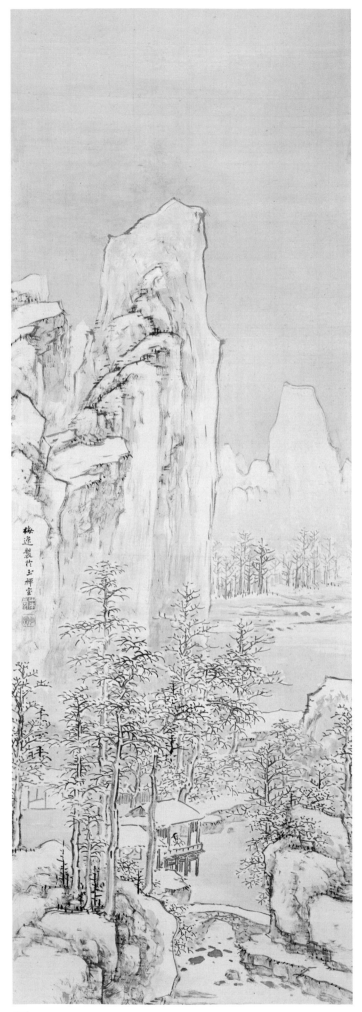

Winter

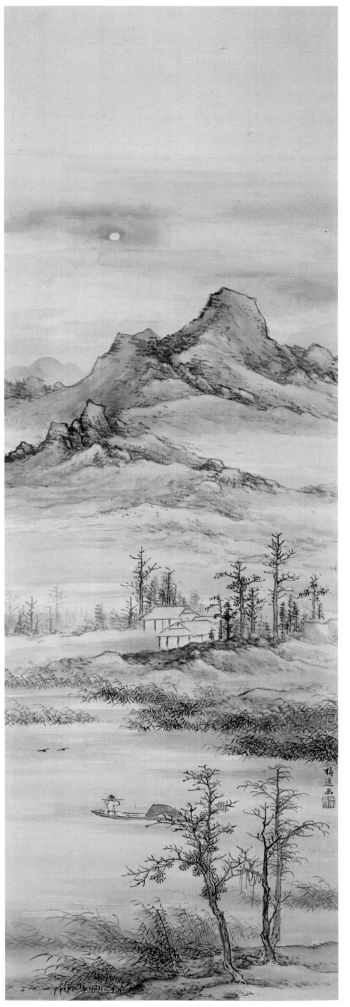

Autumn

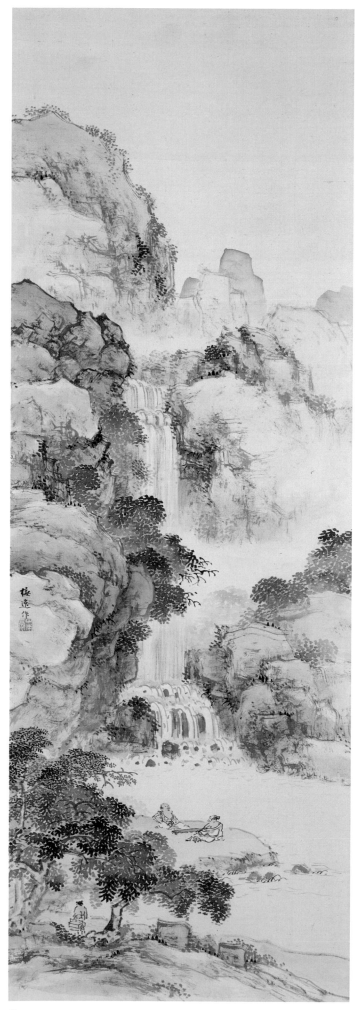

Summer

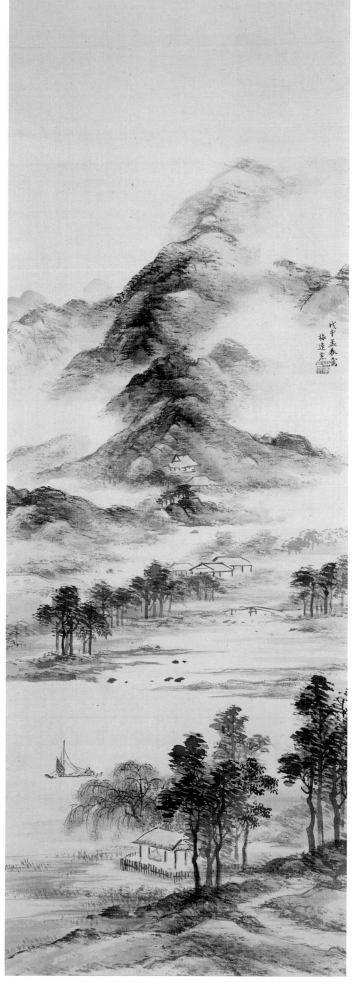

Spring

166. *Parakeets among Flowers*

Edo period (1615–1868), after 1770
Hanging scroll, ink and color on silk
34.8 × 57.8 cm (13¾ × 22¾ in.)
Signature: *Shiseki*
Seals: *Sō Shiseki in* and *Kunkaku*

LITERATURE: Murase 1980b, no. 29; Murase 1993, no. 23.

Sō Shiseki (1715–1786), the painter of these colorful parakeets perched on a branch of hydrangea, was from Edo, and his family name was Kusumoto.[1] Sometime before 1759 he was in Nagasaki and studied painting with Kumashiro Yūhi (1713–1772), a pupil of the Chinese painter Shen Nanpin (Shen Quan, fl. 1725–80), who had lived in the port city from 1731 to 1733. Dissatisfied with Nanpin's art, Kusumoto decided to study instead with Song Ziyuan, who had arrived in Nagasaki from China in 1758 and who would die only two years later. Despite the short period of their association, Kusumoto's devotion to Song was apparently so deep that he changed his name to Sō Shiseki (Song Purple Stone), an obvious reference to the Japanese pronunciation of the teacher's name, Sō Shigan (Song Purple Cliff).[2]

In contrast to the obscurity of his youth, the life of Sō Shiseki after his return to Edo sometime before March 1759 is well known.[3] He settled in the Nihonbashi section of the city, the center of the downtown area, and was a next-door neighbor of the surgeon Sugita Genpaku (1733–1817), the leading proponent of Western medicine.

It is possible that Sō Shiseki had received some training in the Nanpin style even before his journey to Nagasaki, as this blend of Chinese and Western realism was admired and practiced in Edo by such artists as Kurokawa Kigyoku (1732–1756) and Tatebe Ryōtai (1719–1774). His activities in Edo included teaching as well as painting and illustrating. Among his pupils was Shiba Kōkan (1738–1818), who went on to become the most famous Western-style painter in Japan, and Sakai Hōitsu (cat. no. 134). Sō Shiseki was also active as a publisher. Among his more important publications is the *Sō Shiseki gafu* (Paintings of Sō Shiseki), which appeared in 1765. The three volumes include reproductions not only of his own work but woodcuts of paintings by Nanpin and other Chinese artists working in Nagasaki.

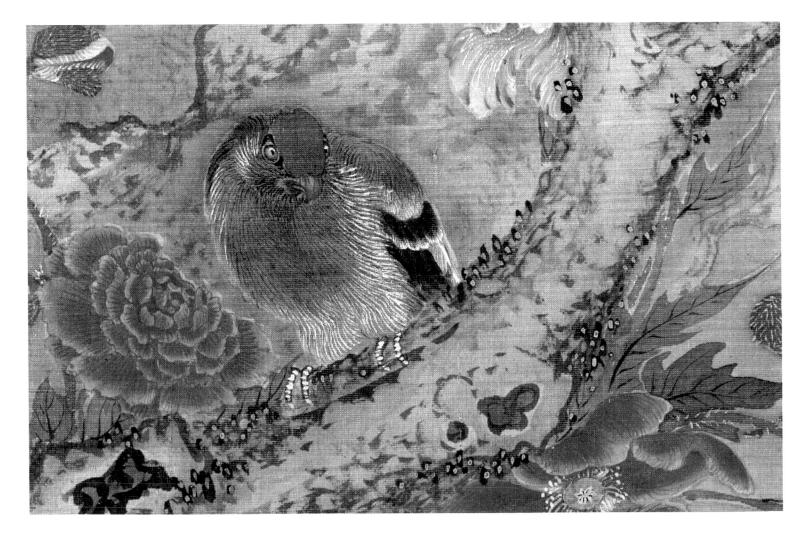

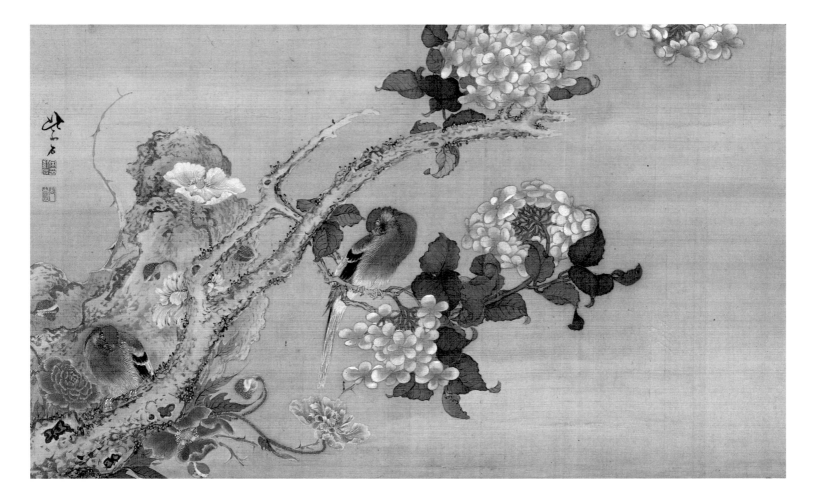

The majority of paintings by Sō Shiseki belong to the bird-and-flower genre, in which the major pictorial elements are meticulously detailed in brilliant polychrome and the backgrounds are neutral, consisting of a lightly brushed-in wash.[4] In composition they reflect a Chinese convention established centuries before, in which asymmetry is of great importance. Sō Shiseki varied this formula very little throughout his career, adhering to a tradition established by followers of Nanpin in Edo, the so-called Nagasaki school.[5]

The calligraphic style of Sō Shiseki's signature also varied little, which makes it doubly difficult to establish a chronology for his oeuvre. In works dating from 1770 and later,

however, he sometimes signed his name in the looser *gyōsho* style. It is in this manner that the Burke painting is signed, and may thus be dated to a period late in his life.

1. On the life of Sō Shiseki, see Yamakawa Takeshi and Nakajima Ryōichi 1986; Yamakawa Takeshi et al. 1986; and Tsuruta Takeyoshi 1993.
2. On Sō Shigan, see Tsuruta Takeyoshi 1979, pp. 35–39.
3. The date of Sō Shiseki's return to Edo is based on a diptych of carps, in Tokuhonji, Tokyo, which he dated March 1759 and signed with this new name; Yamakawa Takeshi and Nakajima Ryōichi 1986, pl. 1.
4. Takeda Kōichi 1986, pp. 94–97.
5. On the Nagasaki school, see Koshinaka Tetsuya, Tokuyama Mitsuru, and Kimura Shigekazu 1981.

167. Landscape with Waterfall

Edo period (1615–1868), ca. 1817
Hanging scroll, ink and light color on silk
107.2 × 48.6 cm (42¼ × 19⅛ in.)
Signature: *Bōsai Rōjin kyō suisha*
Seals: *Chōkō no ki*; *Kaitō rōnin*; and *Kikubu shōsho*

LITERATURE: Addiss 1984, no. 22; Murase 1993, no. 31.

Born in Edo, the son of a middle-class merchant of tortoiseshell products, Kameda Bōsai (1752–1826) followed the scholarly path of a *bunjin*. Beginning at about the age of thirteen and for approximately ten years thereafter, he studied under Inoue Kinga (1732–1784), a Confucian scholar, at a private academy in his neighborhood.[1] Kinga's calligraphy and painting would remain an important influence on Bōsai throughout his life.

At the age of twenty-two, in 1774, Bōsai opened his own school of Confucian studies. Takizawa Bakin (1767–1848), one of the most popular novelists of the nineteenth century, was among the students at the academy. Bōsai was forced to close the school in 1797 when a repressive shogunal policy placed restrictions on Confucian teachings.

Bōsai's life as an independent—albeit impoverished—scholar began at this time. He not only wrote commentaries on Confucian texts but published essays on such esoterica as the food production and eating habits of the ancient Chinese. To earn a living, he made calligraphic works and wrote colophons on paintings by such artists as Ike Taiga (cat. nos. 157–159), Sakai Hōitsu (cat. no. 134), and Suzuki Kiitsu (cat. no. 135). Bōsai was invited by Hōitsu to write the preface to the book of woodcut reproductions of paintings by Ogata Kōrin that was published in 1815 to commemorate the centennial of Kōrin's death.[2] The following year he designed a woodblock-printed book of his own landscapes, *Kyōchūzan* (Mountain in My Heart).[3]

Primarily a scholar and calligrapher, Bōsai is believed to have begun painting only at the age of about fifty. For the most part his paintings are imaginary landscapes, with little variation in the compositional scheme.

Bōsai frequently included with his signature the word "suiga," or "suisha," meaning that he painted while in a state of intoxication. The Burke *Landscape with Waterfall* is a rare exception in Bōsai's oeuvre. Although he signed it "Drunkenly Painted for Pleasure by Old Man Bōsai Kō," the painting is more carefully constructed than many other works thus signed. Extensive use of ink washes and deliberately applied tints of blue and buff colors bring into question his self-proclaimed drunkenness. The painting is a much larger version of two other landscapes, now in the Gitter collection, New Orleans, that are dated by inscription to 1807.[4] Human figures are here eliminated altogether, their presence merely suggested by the solid houses. The foreground is firmly established by trees with thick foliage and by the row of houses nearby. Mottled effects of dark ink applied on the tall, craggy hills are reminiscent of the *tarashikomi* (poured ink) technique, a hallmark of the Rinpa style and perhaps indicative of Bōsai's association with Hōitsu and Kiitsu.

Bōsai's signature is written in an expressive yet controlled running script. The two seals in the upper left corner translate as "Record of Chōkō" and "Masterless Man from the Eastern Sea," which are believed to have been used from 1817 to 1824 and from 1807 to 1817, respectively. At the bottom right a large seal reads "Malt Section, Reverence for Books," a possible reference to Bōsai's fondness for sake; he used this seal on works dated from 1808 to 1823.[5] These three seals, the painting style, and the calligraphy of the signature help to date this scroll to the artist's late period, about 1817.

1. On the life of Bōsai, see Addiss 1984; and Sugimura Eiji 1985.
2. For the English translation of this preface, see Addiss 1984, p. 116.
3. Ibid., nos. 28a–h.
4. Ibid., nos. 14, 15.
5. Ibid., pp. 123–24.

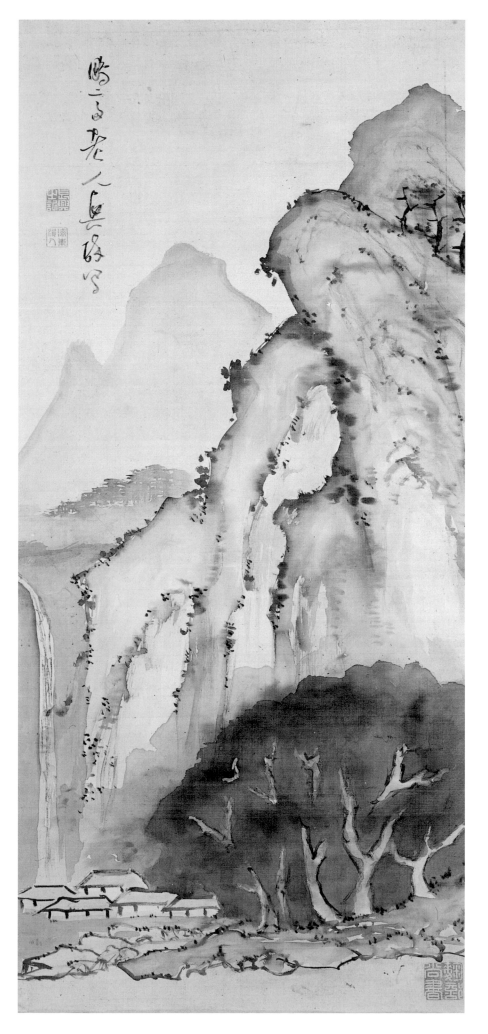

168. *Landscape with Waterfall*

Edo period (1615–1868), 1828
Hanging scroll, ink on silk
126.2 × 59.2 cm (49⅝ × 23¼ in.)
Signature: *Bunchō*
Seal: *Bunsei boshi Bunchō ga in*

LITERATURE: Kōno Motoaki 1971, p. 35; Murase 1975, no. 81; Ueno Kenji 1976, p. 43; Nakajima Ryōichi 1982, fig. 11-A; Tokyo National Museum 1985a, no. 56; Schirn Kunsthalle Frankfurt 1990, no. 98.

Aside from the outlines used to define trees and waves, this painting is built up with broad ink washes in various hues applied almost in the manner of Western watercolor and distinguished by touches of rich black ink. Several other paintings by the artist, Tani Bunchō (1763–1840), closely resemble this work. The model for the composition is one of the best-known Chinese paintings in a Japanese collection, part of a thirteenth-century diptych long attributed to the Chinese master Li Tang (ca. 1070s–ca. 1150s) and now in Kōtōin, a subtemple of Daitokuji, Kyoto.[1] In his reworking Bunchō retained the general compositional scheme of the original, but the ax-cut strokes that delineate the rocks and mountains are less structured, meshing with the dark, wet ink washes. By introducing vaporous clouds above the waterfall, Bunchō creates a mist-filled, mysterious landscape, with strong contrasts of dark and light that resemble Western chiaroscuro.

Born the son of Tani Rokkoku, a well-known poet in the Chinese style, Bunchō received his early training in painting from two Kano artists, Kantō Bunrei (1706–1782) and Watanabe Gentai (1749–1822). In his early twenties, he became interested in Western-style painting and in 1788 made the long journey from Edo to the southern port city of Nagasaki in search of a teacher who could instruct him in Western techniques. En route he stopped in Osaka to visit Kimura Kōkyō (Kenkadō, 1736–1802), the spiritual and artistic mentor of a group of artists in the Kansai area. At Kenkadō's home, Bunchō met the painter Kushiro Unzen (1759–1811) and was introduced by him to *nanga*. He then continued on to Nagasaki, where he studied briefly with the Chinese painter Zhang Xin, who lived in Japan from 1781 to 1788.

After returning to Edo, by 1792, Bunchō earned distinction among his contemporaries for his familiarity with Western painting techniques. His knowledge of linear perspective was especially useful when he was in the service of the regent Matsudaira Sadanobu (1758–1829). In 1793, when invasion was being threatened from the West, Bunchō accompanied Sadanobu on an inspection tour of the Sagami and Izu coasts, south of Edo, to make sketches of the coastline for purposes of defense. He worked for Sadanobu again in 1800 as the illustrator of Sadanobu's catalogue of ancient objects, the *Shūko jusshu*.[2] A visit to Kyoto to study the city's collections of ancient art in 1796 may have provided Bunchō with the opportunity to see the "Li Tang" on which the present painting is based. (It was then attributed to Xia Gui, fl. ca. 1195–1230.)

Eclectic in his interests and enormously prolific, Bunchō was versed in Rinpa and *yamato-e*. He made portraits and Buddhist icons, and kept copious notes on his many commissions.[3] Bunchō was considered in his day to be one of the two greatest painters in Edo (the other was Kameda Bōsai; cat. no. 167). His reputation was such that "silks and gilded screens to be painted by Bunchō were piled mountain-high [in his studio]."[4] He also had a large following, which included Sakai Hōitsu (cat. no. 133), before the latter switched his allegiance to Rinpa. Bunchō's sons assisted him in filling the never-ending orders for his work. Many women in Bunchō's family also painted—his wife, Kankan (1770–1799), his younger sisters Shūkō and Kōran, and his daughters Shun'ei and Kitsukitsu.

The unusual seal impressed on this scroll includes the name of the era, Bunsei, and the cyclical year, Boshi (Year of the Rat), which corresponds to 1828.

1. The attribution to Li Tang is now discredited and the painting is dated to the thirteenth century. See Cahill 1996a, p. 194 and fig. 71.
2. For their collaborations, see Fukushima Prefectural Museum 1992.
3. Ueno Kenji 1976, pp. 37–78.
4. In *Ariya nashiya* by Shimizu Seijun. See Mori Senzō 1980, p. 396.

Glossary

COMPILED BY STEPHANIE WADA

Amida (Skt: Amitabha) The Buddha of Boundless Light, who presides over the Western Paradise, or Pure Land.

Amida Raigō The depiction of Amida Buddha as he descends to earth to welcome his devotees to the Western Paradise. In some versions, Amida is accompanied by a host of bodhisattvas; in others, he appears with only Kannon and Seishi.

anagama A tunnel, or "through-draft," kiln, used in the production of high-fired ceramics.

apsara See *hiten*.

arhat See rakan.

ashide (picture writing) Characters of Japanese script combined with outlines or patterns in a painting in such a way that they appear to be part of the image. The semidisguised words served as references to secular and religious literature; the paintings are referred to as *ashide-e*.

bakufu (government from the tent) Military governments controlled by military dictators, or shoguns, that in effect ruled Japan from the Kamakura period until the Meiji Restoration of 1868.

besson **mandala** A mandala that depicts a small number of deities from the pantheon of gods in Esoteric Buddhism. *Besson* mandalas served in rituals whose purpose was to obtain the benefits promised by these deities.

bodhisattva See Bosatsu.

Bosatsu (Skt: bodhisattva) Compassionate enlightened beings who have delayed their entrance into *nirvana* in order to assist others in finding salvation. In the visual arts, they are most often depicted as radiant, princely figures; some carry specific symbolic objects.

Bugaku A form of dance and music based on continental prototypes introduced to the Japanese court during the Nara period. Bugaku was performed for Shinto shrine rituals as well as during court ceremonies.

bunjinga See *nanga*.

Bunraku A form of puppet theater introduced in the seventeenth century and performed by a narrator, musicians, and puppeteers.

busshi: A sculptor of Buddhist images.

byobu (protection from the wind) Folding screens, used as room dividers or as backdrops for ritual ceremonies. The most common format is a pair of six-panel screens; the painting surface may be either paper or silk.

chaire A tea caddy made specifically to hold the powdered green tea used in *chanoyu*.

Chan See Zen.

chanoyu (hot water for tea) The tea ceremony, a ritual form of preparing, serving, and drinking tea, often within a space designed to reflect a tea master's aesthetic. Masters who helped shape *chanoyu* include Murata Shukō (Jukō, 1423–1502), Sen Rikyū (1522–1591), and Furuta Oribe (1544–1615).

Chikurin Shichiken See Seven Sages of the Bamboo Grove.

chinsō A portrait of a Zen Buddhist master, executed according to a standard format. Such a portrait was given to a student monk as evidence that he had received transmission of the Buddha-mind from his master.

daimyo A feudal baron who served as overlord to an army of samurai. From the Kamakura through the Edo period, many daimyos wielded considerable political as well as military power.

Dainichi (Skt: Mahavairochana) The Cosmic Buddha of Boundless Light, supreme deity of Esoteric Buddhism. He is the central figure of many mandalas, and the *Dainichikyō* (Skt: *Mahavairochana Sutra*) served as one of the basic texts of the Shingon sect of Esoteric Buddhism.

darani (Skt: *dharani*) Buddhist incantations believed to have magical properties.

deva See Ten.

dharma One of the Three Jewels of Buddhism, the teachings of the historical Buddha.

dhyana See Zen.

Diamond World mandala (J: *Kongōkai mandara*) One of the Ryōkai mandalas, the major paired mandalas in Esoteric Buddhism, the Kongōkai mandala is a diagrammatic painting composed of nine rectangles that represent Buddha worlds. A guide to enlightenment through spiritual practice, it also represents the transcendental Buddha, Dainichi, in relation to his various physical manifestations.

dogū A low-fired clay figurine of the Jōmon period.

dōtaku Ritual bronze bells of the Yayoi period.

e-busshi Artists who specialize in Buddhist painting.

Edokoro An official painting bureau composed of professional artists. Edokoro were attached to major institutions such as the imperial court and the shogunal government, as well as to important temples and shrines.

Eiga monogatari (Tale of Flowering Fortunes) The life of the courtier-statesman Fujiwara Michinaga (966–1028). Written after 1092, the account includes a wealth of detail on customs and court etiquette.

Eightfold Path The Buddhist path to enlightenment, comprising right understanding, right intent, right speech, right behavior, right livelihood, right effort, right awareness, and right concentration.

ema Small paintings, usually executed on wood, used as votive offerings in shrines and temples.

emaki (or *emakimono*, "rolled-up pictures") Illustrated narrative handscrolls.

e-nashiji See *nashiji*.

Esoteric Buddhism (J: Mikkyō) First developed in India around the seventh or eighth century, the dogma of Esoteric Buddhism is believed to have been revealed by Vairochana (J: Dainichi) to those prepared by special initiation. It was practiced in China during the Tang dynasty, then brought to Japan in the ninth century by monastic leaders such as Kūkai (Kōbō Daishi, 774–835) and Saichō (Dengyō Daishi, 767–822).

etoki Individuals who explain the meaning and content of religious and secular paintings. The term also refers to the stories and explanations themselves. *Etoki* commonly provided commentary or narration for Buddhist pictures.

Fudō Myōō (Skt: Achala or Achalanatha; The Immovable One) One of the fierce-visaged divinities known as Myōō, or Guardian Kings, who represent the Buddha's power against evil.

Fujiwara Michinaga (966-1028) The most powerful official of the late tenth–early eleventh century, Fujiwara Michinaga exercised control over the throne through the judicious marriage of Fujiwara daughters to members of the royal family. A cultivated and charismatic figure, Michinaga is believed to have been the model for the protagonist of Murasaki Shikibu's *Genji monogatari*.

fukinuki yatai (room with roof blown away) A pictorial device that first appeared in narrative paintings of the Heian period as a means of revealing figures in interiors. While walls and pillars are left intact the roof is eliminated, allowing the viewer to look into the exposed room from above.

fūzokuga Genre painting, depicting the activities and customs of people from contemporary society.

Genji monogatari (The Tale of Genji) The fifty-four-chapter narrative by Lady Murasaki Shikibu (ca. 973–ca. 1015) recounting the life and loves of the fictional Hikaru Genji (Shining Genji) and his descendants. Prince Genji, the epitome of beauty, elegance, and courtly virtue, is believed to have been modeled after the statesman Fujiwara Michinaga, a contemporary of Murasaki. Perhaps the greatest work of Japanese literature, the novel provides a wealth of information on the taste, practices, fashions, and beliefs of the eleventh-century aristocracy.

Go Dai Myōō The Five Guardian Kings (Skt: Vidyarajas) of Esoteric Buddhism, symbols of the Buddha's ability to vanquish evil.

gongen An avatar, or form assumed by a deity for the purpose of manifesting itself in the physical world. In syncretic Buddhism, Shinto gods are viewed as avatars of Buddhist divinities.

Go shūi wakashū (Later Collection of Gleanings) A collection of *waka* poetry commissioned by Emperor Shirakawa (r. 1073–87) and completed in 1086. The compiler, Fujiwara Michitoshi, modeled the anthology after the tenth-century *Kokin wakashū*.

gyōsho Semicursive, or running, script.

haboku (splashed ink) A style of ink painting characterized by spontaneously applied, abbreviated brushstrokes; used in *haboku sansui* (splashed-ink landscapes) to imply rather than to define landscape elements.

Hachiman The Shinto protector of warriors and patron god of the Minamoto clan.

haguro The practice of tooth-blackening, using a solution made from iron filings soaked in tea, vinegar, or sake. In the Heian period, *haguro* was an indication of a girl's coming of age; it was later used as a sign of marriage.

haikai An indigenous form of poetry that originated in the chain verses known as *haikai no renga* (linked *haikai*), verses usually of three lines of five, seven, and five syllables, respectively. The term is often used interchangeably with *haiku*, independent poems of seventeen syllables that are no longer part of a "chain."

hajiki (Haji ware) Unglazed earthenware produced from the late Yayoi period through the tenth century.

hakubyō (white drawing) A form of *yamato-e* painting in which fine ink brushlines define the pictorial elements. Areas of solid black used for women's hair and courtiers' caps contrast with the delicate ink outlines. The only areas of color are touches of red on lips or of gold on cloud patterns and on furnishing designs.

haniwa Low-fired, reddish pottery sculptures made for funerary purposes during the Kofun period. *Haniwa* of human figures, animals, and various objects were attached to the tops of hollow clay cylinders and then placed on the surface of large tomb mounds.

harigaki (needle drawing) The technique of creating designs on lacquerware by scratching through the outer layers of still damp lacquer to reveal the hardened layers underneath.

Heiankyō (capital of peace and tranquillity) The capital of Japan from 794 to 1868. By the Late Heian period the city was also called Kyoto, the name by which it is known today.

Heiji Insurrection A military confrontation between the Heike (Taira) and the Minamoto (Genji) clans that took place in 1159; it left the Heike in control of the imperial court.

Heiji monogatari (The Tale of the Heiji Insurrection) A war tale of unknown authorship composed during the Kamakura period. The three-part narrative recounts the rivalry and military conflict between the Heike (Taira) and Minamoto (Genji) clans.

Heike monogatari (The Tale of the Heike) The most famous of the war tales written during the Kamakura period. The story follows the fortunes of the Heike clan from about 1131 to 1191, focusing on the struggle between the Heike and the eventually victorious Minamoto (Genji) forces.

heishi A type of sake vessel with a slender spout and a shape based on that of the Chinese *meiping* vase.

hihaku (flying white) A brushstroke that allows the white paper to show through the lines created by the separated hairs of the brush.

hikime-kagihana (a dash for the eyes, a hook for the nose) A stylized rendering of faces in traditional *yamato-e* courtly narrative illustration.

hiramaki-e (level-sprinkled picture) A technique of decorating lacquerware by sprinkling powdered metal over a design drawn in wet lacquer.

hiten (Skt: *apsara*) Bodhisattvas shown seated or standing on flying clouds, usually as attendants of a buddha figure. They are often represented playing a musical instrument, such as a *biwa* (a lutelike instrument) or pipes.

hōgen (Eye of the Law) An honorary priestly title conferred on both Buddhist and secular artists, second in rank to the title *hōin*.

Hōgen Insurrection A military conflict of 1156 involving political struggles between the Fujiwara family, the Heike (Taira) and Minamoto (Genji) clans, and the imperial house. It was the first such event in which members of the increasingly powerful samurai class served to resolve a political dispute by force.

hōin (Seal of the Law) The highest honorary priestly title conferred on Buddhist and secular artists.

hōjō The temple quarters of an abbot, or chief monk, usually comprising six rooms, including an altar chamber.

Hōjō clan A warrior clan of the Kamakura period, whose leaders served as hereditary regents to the Minamoto shogunate. The virtual rulers of Japan from the thirteenth through the early fourteenth century, their power came to an end in 1333 with the Kenmu Restoration.

hokkyō (Bridge of the Law) The third of the three honorary priestly titles bestowed on Buddhist and secular artists.

honji suijaku (manifestations of deities in their original form) The syncretic system of beliefs formed by the integration of Shinto and Buddhism.

honpa (rolling waves) Garment folds carved with alternating sharp and rounded ridges characteristic of sculptures of the Early Heian period.

ichiboku zukuri The technique of carving sculpture from a single block of wood. Separate pieces of wood were sometimes used for hands, arms, and feet.

Ise monogatari (Tales of Ise) Composed about the tenth century, this *uta monogatari*, or "stories centered around poems," is a precursor of the *monogatari* prose narrative. In its most commonly known recension, it comprises 125 brief lyrical episodes, most of which concern incidents in the life of an unnamed courtier. This figure is often associated with the *waka* poet Ariwara Narihira (825–880), a number of whose verses are included in the stories.

Issaikyō See *Tripitaka*.

Jidai Fudō uta-awase (Competition of Poets of Different Periods) An imaginary grouping together of great poets from different eras into competing "teams," with each individual represented by three poems. The selection of poets for this imaginary competition is attributed to the retired emperor Go-Toba (r. 1183–98).

Jizō (Skt: Kshitigarbha) A compassionate bodhisattva often depicted in the robes of a monk and holding a staff in his right hand.

The guardian of children and travelers, he is also capable of saving those who have been condemned to suffer in hell.

Jōdo sect (J: Jōdoshū) A school of Pure Land Buddhism founded by the monk Hōnen (1133–1212). Its practice centers around Amida Buddha and the belief that the invocation of his name at the moment of death enables the worshiper to be reborn in the Western Paradise.

jūbako Stacked food boxes generally made of lacquered wood.

Kabuki A form of popular theater combining song and dance that originated in the seventeenth century. Originally performed by an all-female troupe in Kyoto, Kabuki was from 1629 on restricted by government decree to male performers.

kaiseki ryōri A light meal served prior to *chanoyu*.

kaisho The standard form of Japanese script, with each character stroke clearly delineated, in contrast to the semicursive (*gyōsho*) and cursive (*sōsho*) forms.

kami Shinto gods and spirits, manifestations of the divine force that inhabits all aspects of nature. Historical figures and venerated ancestors can also be given *kami* status.

kana The native form of Japanese script, developed around the ninth century. The syllabic letters, or symbols, about fifty in number, derive from the cursive form of Chinese characters.

Kannon (Skt: Avalokiteshvara; One Who Observes the Sound of the World) A bodhisattva revered for his mercy and compassion, Kannon is central to Mahayana Buddhism, particularly the Pure Land sects. He often appears as one of the two principal attendants of Amida Buddha and is depicted with an image of Amida in his crown.

Kano school The school of painting founded by Kano Masanobu (1434–1530), its greatest influence was during the Momoyama and Edo periods. Kano artists combined a Chinese academic style of ink painting with decorative elements and the use of polychrome derived from Japanese *yamato-e*. Official artists to the Tokugawa shogunate during the Edo period, Kano masters dominated Japanese painting from the seventeenth through the nineteenth century.

Kanze school The tradition of Nō theater founded by the actor-playwrights Kan'ami (Kan'ami Kiyotsugu, 1333–1384) and his son Zeami (Kanze Motokiyo, 1364–1443).

kaō Personal signs or symbols derived from Japanese characters and inscribed by authors

or artists on their works in lieu of, or in conjunction with, a signature.

kara-e (Tang-style painting) A term that originated during the Heian period to distinguish paintings based on Chinese techniques and having Chinese themes from *yamato-e*, works representing indigenous scenes and taste.

kasen Immortal poets. Great poets of different ages were sometimes organized into groups or categories, such as the Rokkasen (The Six Immortal Poets) and the Sanjūrokkasen (The Thirty-six Immortal Poets).

kasen-e Paintings of *kasen*, or immortal poets, often including representative poems.

kata-suso (shoulders and hem) Kimono decoration with three horizontal bands of different colors and designs.

Kei school A sculpture studio that flourished during the Kamakura period and produced Buddhist works characterized by naturalistic representation. The school, whose major masters included Kaikei (fl. 1185–1223) and Unkei (1151–1223), was active in rebuilding campaigns at Tōdaiji and Kōfukuji.

Kenmu Restoration Emperor Go-Daigo's attempt, from 1333 to 1336, to restore imperial sovereignty. Go-Daigo hoped to take advantage of the fall of the Kamakura shogunate in 1333, but this short-lived era was supplanted by the Ashikaga shogunate about 1338.

Kinkakuji (Golden Pavilion Temple, known formally as Rokuonji) A three-story Zen temple in northern Kyoto. Famous for its gilded exterior, it was built in 1397 as a retreat for the third Ashikaga shogun, Yoshimitsu (r. 1369–95).

kirikane The application of finely cut pieces of gold or silver leaf to the surface of paintings, sculpture, or lacquerware.

ko-e (little pictures) Miniature illustrated handscrolls, the earliest of which date to the Muromachi period.

kōgō An incense box, usually made of lacquered wood.

koji A Buddhist layman. Also, a deceased person's Buddhist name.

Kokin wakashū (*Kokinshū*; A Collection of Poems Ancient and Modern) The first imperially commissioned anthology of Japanese poetry. It was commissioned by Emperor Daigo (r. 897–930), compiled by the poet Ki no Tsurayuki (ca. 868–945) and others, and completed about 905.

komainu (Korean dog or lion dog) Sculptures of mythical leonine beasts, customarily placed in pairs at the entrance of a Shinto shrine to serve as guardians.

kondō (golden hall) The structure in a temple compound that houses images of the primary deities.

koto A zitherlike instrument with thirteen strings, known in China as a *qin*.

kotsuzumi A small hand-held drum.

kumogami (cloud paper) Decorated writing paper in which filaments of colored pulp create the impression of clouds.

kurodana (black shelf) Lacquered shelves to hold toiletry articles.

kyōka A *waka* poem with a humorous message or wordplay.

Kyo-Kano A branch of the Kano school of painters that remained in Kyoto after Kano Tanyū settled in Edo.

Lotus Sutra (Skt: *Saddharmapundarikasutra;* J: *Hokekyō* or *Myōhō Rengekyō*) The primary sacred text of the Tendai sect of Buddhism and one of the most influential sutras in East Asian Buddhism.

machi-eshi (town painter) Anonymous urban-based artists without specific studio affiliation who often worked for shops that produced ready-made pictures.

Mahayana Buddhism (Greater Vehicle) One of the two main traditions, together with Hinayana (Lesser Vehicle), of the Buddhist faith. Mahayana stipulates that the release from the cycle of life, death, and rebirth can be achieved by all sentient beings. It also regards the historical Buddha, Shakyamuni, as a transcendent being rather than as a mortal teacher and reveres the figure of the bodhisattva as the embodiment of compassion.

maki-e (sprinkled picture) The decoration of lacquer by sprinkling gold or silver powder on the lacquered surface.

Makura no sōshi (The Pillow Book) A prose work with passages of poetry by Lady Sei Shōnagon (late 10th–early 11th century). It includes personal observations, reflections on various subjects, diary-like entries, and miscellaneous jottings.

mandala (Sanskrit term for "that which possesses essence and totality"; J: *mandara*) In Esoteric Buddhism, a diagrammatic image illustrating the relationships of various deities to one another, as well as the relationship between the spiritual and the phenomenal world. It is regarded as a symbol of the universe.

mantra (Sanskrit term for "true words") A series of words or sounds chanted repeatedly in Buddhist worship or ritual.

man'yōgana An early system of writing the Japanese language using Chinese characters.

Man'yōshū (Collection of Ten Thousand Leaves) The earliest extant collection of Japanese poetry, compiled in the eighth century, written in *man'yōgana*.

mappō The era foretold in Buddhist literature during which the world would enter a period of decadence and the decline of Buddhist law.

Maruyama–Shijō school Two schools often linked together because of their historical connection and stylistic similarities. The Maruyama school, founded by Maruyama Ōkyo (1733–1795), specialized in a style of painting that combined aspects of traditional ink painting with the more decorative manner of Chinese professional painters and with Western-style realism. The Shijō school was founded by Matsumura Goshun (1752–1811), as an offshoot of the Maruyama studio.

meisho (famous place) A location or site renowned for its natural beauty, its association with a specific season, and/or its connection to a literary theme.

meisho-e Pictures of famous places.

meisho-ki Illustrated guidebooks.

Mikkyō (The Secret Teachings) *See* Esoteric Buddhism.

Miroku (Skt: Maitreya) The Buddha of the Future, sometimes portrayed as a bodhisattva.

mizusashi A freshwater container used in *chanoyu*.

mokkotsu The "boneless" manner of painting, employing supple brushstrokes and wash without ink outlines.

mon Symbols or designs adopted as family crests or personal insignia.

Monju (Skt: Manjushri) The bodhisattva of wisdom, often depicted riding a lion and holding a sword and a sutra.

mudra Symbolic hand positions and gestures displayed by buddhas and bodhisattvas.

nanban (barbarians from the south) A term derived from the Chinese and used by the Japanese to designate European merchants, missionaries, and sailors who arrived in Japan during the sixteenth and seventeenth centuries.

nanga (Southern painting) Known also as *bunjinga*, "painting of the literati," a school of the eighteenth and nineteenth centuries that followed in the tradition established by Chinese scholar-painters, adopting aspects of Ming- and Qing-dynasty painting and modifying them according to native taste. Unlike the Chinese literati painters, the practitioners of *nanga* were not themselves scholar-officials, but came from a variety of backgrounds.

nashiji (pear skin) A speckled lacquerware effect created by sprinkling fine metal powder or flakes (usually gold) over a surface covered with partially hardened lacquer. The term *e-nashiji* refers to pictorial images produced in this technique.

nenbutsu The invocation of the names of buddhas, in particular that of Amida Buddha; used in Pure Land Buddhist sects.

nirvana (Sanskit term for "extinction"; J: *nehan*) The state of enlightenment that is achieved when one has eliminated all desire and all illusion; release from the cycle of birth, death, and rebirth.

nise-e (likeness picture) A style of portraiture characterized by sketchlike depictions that capture individual facial features and expressions.

nishiki-e (brocade pictures) Single-sheet polychrome woodblock prints, first produced in the eighteenth century.

Nō The classical theater of Japan. A form of drama combining song, dance, mime, and music, Nō was first standardized in the late Nanbokuchō–early Muromachi period by the actor-playwrights Kan'ami (1333–1384) and his son Zeami (1364–1443), founders of the Kanze school.

noborigama A type of climbing kiln used to produce high-fired ceramics.

ōgi-eshi Painters of folding fans.

ōgiya Fan shops.

oku eshi (Painters of the Inner Court) Painters who held this hereditary title were members of one of the four Kano subschools in Edo. They received an annual stipend from the Shogunate.

omote eshi (Painters of the Outer Court) Family members or pupils of the four *oku eshi* families who served as their assistants.

ōtsuzumi (large drum) A type of handheld drum used in the performance of religious music as well as in Nō and Kabuki theater.

Pure Land (J: *Jōdo*) The Western Paradise of Amida Buddha.

raigō *See* Amida Raigō.

rakan (Skt: *arhat*) Legendary disciples of Shakyamuni who have chosen to remain in the world to protect the Buddhist law rather than to pass into *nirvana*. In paintings and sculpture, rakan are usually depicted as monks and sometimes as aged, almost grotesque-looking recluses.

renga Linked poetry. A courtly pastime in the Late Heian period, *renga* evolved into a literary art form with specific sequences, topics, and language usage.

Rinpa (school of [Kō]rin) The artistic tradition founded in the Momoyama period by the calligrapher Hon'ami Kōetsu (1558–1637) and the designer-painter Tawaraya Sōtatsu (died ca. 1640) and perpetuated in the Edo period by Ogata Kōrin (1658–1716), his brother Kenzan (1663–1743), and various followers. Inspired by classical literature and painting, Rinpa artists produced dramatic reinterpretations of Heian- and Kamakura-period motifs and themes. They worked in a variety of media, including lacquer and ceramic, for clients drawn from both the court and the wealthy merchant class.

Rinzai sect One of the two major sects of Zen Buddhism practiced in Japan. Its introduction from China, in the twelfth century, is attributed to the monk Eisai (1141–1215).

Ritsu sect One of the six sects of Nara Buddhism, introduced to Japan in the eighth century by the Chinese monk Jianzhen (J: Ganjin). Ritsu emphasized the importance of monastic discipline.

Rokkasen (The Six Immortal Poets) The six poets selected by Ki no Tsurayuki (ca. 868–945) for inclusion in the preface of the *Kokin wakashū*.

Rokudō In Buddhism, the Six Realms of Rebirth: heavenly beings, humans fighting spirits, animals, hungry ghosts, and souls in hell.

Rokuonji See Kinkakuji.

Sagabon (Saga Books) Printed books published under the auspices of Suminokura Soan (1571–1632), a wealthy merchant, connoisseur, and patron of the arts.

sangha Sanskrit term for the Buddhist community, including lay practitioners as well as monks and nuns.

Sanjūrokkasen (The Thirty-six Immortal Poets) A listing of outstanding Japanese poets from the *Man'yōshū* era to the mid-Heian period, selected by Fujiwara Kintō (966–1041). The *Sanjūrokuninshū* (1112) is a collection of representative works by these poets.

senmen nagashi (floating fans) A painting motif of folding fans floating on water.

Senzaishū (*Senzai wakashū*; Collection of a Thousand Years) A poetry anthology commissioned in 1183 by Emperor Go-Shirakawa (r. 1155–58), compiled by Fujiwara Shunzei (1114–1204), and completed about 1188.

setsubun Traditionally, the eve of New Year's Day (the first day of spring, according to the ancient Chinese solar calendar). The term also designates the ceremony practiced on that day of scattering beans to ward off demons.

Seven Sages of the Bamboo Grove (J: Chikurin Shichiken) Legendary scholar-recluses of third-century China who periodically fled their official responsibilities in order to pursue the Daoist practice of "pure conversation" in a bamboo grove.

Shakyamuni (J: Shaka Nyorai, ca. 563 B.C.–ca. 483 B.C.) The historical Buddha, known also as Gautama Buddha. Born to the ruler of the Shakya kingdom, situated between India and Nepal, he renounced his princely status and became a spiritual leader. His teachings constitute the matrix for the many branches of Buddhism.

shakyō A term that refers to the practice of copying sutra texts and to the copied sutras themselves.

shigajiku A hanging scroll with a painted image, usually landscape, and, at the top, poetic inscriptions.

Shijō school See Maruyama–Shijō school.

Shika wakashū (*Shikashū*; Collection of Verbal Flowers) An anthology of *waka* poetry commissioned in 1144 by the retired emperor Sutoku (r. 1123–42), compiled by Fujiwara Akisuke (1090–1155), and completed about 1151.

shiki-e (pictures of the four seasons) A popular type of *yamato-e* painting.

shikishi Album leaves or poem sheets used for calligraphy and/or paintings.

shinden zukuri (mansion construction) A style of architecture developed in the Heian period for the palaces of the aristocracy. It featured a principal hall (*shinden*), or living quarters, a courtyard, and a garden with a decorative pond and bridges. Walkways (some covered, others open-air) extended from the main building to the smaller residences of family members, guests, and servants. Other walkways led to pavilions overlooking the pond.

Shingon (True Word) A form of Esoteric Buddhism introduced to Japan by Kūkai (Kōbō Daishi, 774–835). Shingon claims to have received its teachings directly from the Cosmic Buddha, Dainichi (Skt: Mahavairochana), of whom the historical Buddha is a manifestation. It views the physical and the transcendental realms as different manifestations of the same absolute principle and places importance on secret rites, the use of images as aids to meditation, and the possibility of attaining enlightenment in one's present life.

Shin kokin wakashū (*Shin kokinshū*; New Collection of Poems Ancient and Modern) The eighth of the imperially commissioned poetry anthologies, ordered in 1201 by the retired emperor Go-Toba (r. 1183–98), compiled by Fujiwara Teika (1162–1241) and others, and completed about 1206. Along with the *Kokinshū*, this twenty-book work is regarded as one of the greatest collections of native classical verse.

Shinto (The Way of the Gods) The indigenous religion of Japan, based on the customs and folklore of Japan's ancient agrarian culture. Shinto comprises legends, myths, and practices centered around the presence of *kami*, divine entities that inhabit all aspects of nature and control natural forces. Specific *kami* are worshiped at sites associated with their visitations.

shoin A style of domestic architecture developed during the Muromachi and Momoyama periods. Its principal features are the *tokonoma* (alcove), the use of *tatami* mats, and *fusuma* screens.

Shugendō A syncretic Buddhist order whose members subject themselves to vigorous ascetic practices in the mountains in order to obtain beneficial magical powers, including the power to heal.

Shūi wakashū (*Shūishū*; Collection of Gleanings) The third of the imperially commissioned poetic anthologies. It was ordered by the retired emperor Kazan (r. 984–86) and is believed to have been compiled by the poet Fujiwara Kintō (966–1041).

shukuzu Reduced pictures, or sketches, of paintings, intended to serve as records.

sometsuke White ceramic wares decorated with cobalt blue.

sōsho (grass writing) Cursive script, the most fluid and spontaneous form of calligraphy, in contrast to *kaisho* (standard script) and *gyōsho* (running, or semicursive).

suminagashi (ink flow) A method of creating marbled effects on handmade paper by using drops of ink on the surface of water.

Sumiyoshi monogatari (The Tale of Sumiyoshi) A romantic narrative of the Heian period about a beautiful girl, her evil stepmother, and her faithful lover, the son of an important court official, the *Sumiyoshi monogatari* is the subject of a thirteenth-century illustrated handscroll, the *Sumiyoshi monogatari emaki*.

suyari A painting motif of stylized cloud formations.

suyari gasumi A painting technique for depicting mist and clouds.

suzuribako Boxes containing implements for writing, usually made of lacquer.

tagasode (Whose Sleeves?) A literary and pictorial theme in which a kimono or other personal items refer to a beautiful woman who is absent.

Taiheiki (Chronicle of the Great Peace) A forty-part war tale composed during the Nanbokuchō era that concerns the Ashikaga *bakufu*. The story covers the roughly fifty-year period of civil strife following the Kenmu Restoration (1333–36), Emperor Go-Daigo's attempt to restore imperial sovereignty.

takamaki-e Low-relief designs on lacquer, created through the use of sprinkled metal powder.

Taketori monogatari (The Tale of the Bamboo Cutter) A romantic narrative of the Early Heian period that tells of a girl child found in a bamboo stalk who grows up to be a woman desired by all who see her, including the emperor; she is, however, a heavenly being, and eventually returns to her celestial home.

Takuma school A hereditary school of artists that flourished in Kyoto and Kamakura during the Late Heian, Kamakura, and Nanbokuchō periods. Specializing in Buddhist images, the artists were particularly known for incorporating stylistic elements of Chinese Song- and Yuan-dynasty painting into their work.

Tansei jakubokushū The first known book of biographies of Japanese painters, written by Kano Ikkei (1599–1662), an artist to the Tokugawa shogunate.

tarai A washbasin.

tarashikomi A method of pooling pigments and/or ink to produce a mottled or marbled effect; a signature technique of the Rinpa school.

Ten (Skt: *deva*) A deity drawn from the Brahmanic beliefs of ancient India and incorporated into Buddhism.

Tendai sect A form of Esoteric Buddhism brought to Japan from China by Saichō (Dengyō Daishi, 767–822), Tendai focuses on the concept that all humans possess Buddha-nature and can attain enlightenment in this life. Its primary text is the *Lotus Sutra*. Tendai and Shingon, introduced to Japan about the same time, were the dominant sects of the Heian period.

tokonoma A shallow alcove built into a room in such a way that its floor is slightly higher than the floor of the main chamber. *Tokonoma*

were used for the display of art or flower arrangements.

torii Two upright posts topped by two beams that serve as the gateway to the precincts of a Shinto shrine.

Tosa school A school of painting that specialized in traditional *yamato-e* styles and subject matter. From the seventeenth century on, Tosa artists often worked in a detailed, miniaturist manner, which they used to illustrate classical narratives.

Tripitaka (J: Issaikyō) The complete compendium of Buddhist scriptures.

tsuitate A single-panel freestanding screen.

tsukinami-e Pictures of activities associated with the twelve months; popular in the *yamato-e* tradition.

urna The circular protuberance on the forehead of the Buddha signifying supernatural wisdom.

urushi-e (lacquer picture) A painting in which lacquer serves as a binding agent for the pigments. When used in relation to painting, the term applies to various techniques of painting with lacquer.

ushnisha The protuberance on top of the Buddha's head, sometimes depicted as a topknot. It signifies supernatural wisdom.

uta awase (poetry contest) A courtly pastime in the Heian period in which participants, who composed verses on assigned topics, were divided into two competing groups.

utamakura (pillow words) Words, names (usually of famous places), and phrases used in classical Japanese poetry for their traditional associations.

uta monogatari Stories centered around poems.

wabicha A style of *chanoyu* characterized by an austere and tranquil simplicity; promoted by Sen Rikyū (1522–1591).

waka Classical thirty-one syllable Japanese poetry.

Womb World mandala (J: *Taizōkai mandara*) One of the Ryōkai mandalas, the major paired mandalas in Esoteric Buddhism, the Taizōkai mandala is a diagrammatic painting composed of twelve concentric "precincts" in which various aspects of Buddha-nature are given phys-

ical properties (e.g., compassion takes the form of multilimbed bodhisattvas and the ability to defeat evil is represented by fierce-looking, wrathful deities). Dainichi is depicted at the center of the composition.

Xiao and Xiang Rivers The misty, luxuriant landscape at the confluence of these two rivers in southern China was a subject for both poetry and painting in the Song dynasty. During the Northern Song, a selection of "Eight Views" of the region was codified by artists. In Japan, the theme became popular among ink painters during the Muromachi period.

yamabushi (one who lives in the mountains) Peripatetic monks of the syncretic Shugendō order of Esoteric Buddhism.

yamato-e (Japanese pictures) A term first used in the Heian period to distinguish works painted in a Japanese style from those executed in the Chinese manner, or *kara-e*. Traditional *yamato-e* is characterized by native subject matter, often taken from literature, and themes associated with famous places or the four seasons. Stylistically it features striking compositions, the frequent use of flat planes of rich color, and a number of codified pictorial devices such as *fukinuki yatai* (room with roof blown away).

yokobe A barrel-shaped, recumbent ceramic vessel with the neck on the side rather than on the top. *Yokobe* are typical of Sue ware.

Yoshiwara (reed plain) The government-regulated district for licensed prostitution in the city of Edo. Its inhabitants and entertainments became the subjects of new, popular genres of art, music, and literature that flourished from the seventeenth through the early twentieth century.

Zen (from the Sanskrit *dhyana*, meaning "meditation"; Ch: Chan) A form of Buddhism that emphasizes seated meditation and the enigmatic riddles known as *kōan*. Brought to Japan from China during the Heian period, it gained popularity in the Kamakura era and during the Muromachi period exercised a powerful influence over Japanese arts and culture.

zushidana A lacquered stand with shelves for toilet articles.

zuzō Buddhist iconographic drawings made either as records or as models and instructional tools for artists.

Bibliography

Adachi Keiko

1990 "Nishu no ryūkyō zu byōbu" (Two Screen Paintings of "Bridge and Willows"). *Kokka*, no. 1135 (June 1990), pp. 7–22.

Addiss, Stephen

1984 *The World of Kameda Bōsai: The Calligraphy, Poetry, Painting, and Artistic Circle of a Japanese Literatus*. Exh. cat. New Orleans: New Orleans Museum of Art; Lawrence: University Press of Kansas, 1984.

1987 *Tall Mountains and Flowing Waters: The Arts of Uragami Gyokudō*. Honolulu: University of Hawaii Press, 1987.

Akamatsu Shunshū

1951 "Kami Daigo no Kiyotaki Myōjin zō" (The Statue of Kiyotaki Myōjin in the Upper Temple of Daigo). *Bijutsushi* 1, no. 3 (March 1951), pp. 1–26.

Akazawa Eiji

1980 Editor. *Muromachi no suibokuga: Sesshū, Sesson, Motonobu* (Ink Painting of the Muromachi Period: Sesshū, Sesson, and Motonobu). Nihon bijutsu zenshū (Survey of Japanese Art), 16. Tokyo: Gakken, 1980.

1995 *Nihon chūsei kaiga no shinshiryō to sono kenkyū* (Research on Recently Discovered Japanese Medieval Paintings). Tokyo: Chūōkōron Bijutsu Shuppan, 1995.

Akiyama Ken and Taguchi Eiichi

1988 *Gōka "Genji-e" no sekai: Genji monogatari* (Splendor in the World of Genji Illustrations: The Tale of Genji). Tokyo: Gakken, 1988.

Akiyama Ken et al.

1978 *Genji monogatari* (The Tale of Genji). Zusetsu Nihon no koten (Illustrated Japanese Classics), 7. Tokyo: Shūeisha, 1978.

Akiyama Terukazu

1952 "Heiji monogatari-e Rokuhara kassen no maki ni tsuite" (Fragments of a Hitherto Unknown Scroll of *Heiji monogatari*). *Yamato bunka*, no. 7 (July 1952), pp. 1–11.

1964 *Heian jidai sezokuga no kenkyū* (Secular Painting in Early Medieval Japan). Tokyo: Yoshikawa Kōbunkan, 1964.

1976 *Genji-e* (Genji Pictures). Nihon no bijutsu (Arts of Japan), 119. Tokyo: Shibundō, 1976.

1978 "Genji monogatari emaki Wakamurasaki zu dankan no genkei kakunin" (A New Attribution for a Painting Fragment of the Twelfth-Century Tale of Genji Scrolls). *Kokka*, no. 1011 (1978), pp. 9–26.

1980a Editor. *Emakimono* (Narrative Scroll Painting). Zaigai Nihon no shihō (Japanese Art: Selections from Western Collections), 2. Tokyo: Mainichi Shinbunsha, 1980.

1980b "Jin'ōji engi emaki no fukugen to kōsatsu: Iwayuru Kōnin Shōnin Eden o megutte" (The Reconstruction and Study of the Illustrated History of the Jin'ōji Temple: On the Illustrated Biography of the Monk Kōnin). In Akiyama Terukazu 1980a, pp. 98–113.

Amino Yoshihiko, Ōnishi Hiroshi, and Satake Akihiro

1993 Editors. *Chōjū giga* (Frolicking Animals and Birds). Ima wa mukashi, mukashi wa ima (Present Is Past, Past Is Present), 3. Tokyo: Fukuinkan Shoten, 1993.

Andrews, Allan A.

1973 *The Teachings Essential for Rebirth: A Study of Genshin's Ōjōyōshū*. A Monumenta Nipponica Monograph. Tokyo: Sophia University, 1973.

Aoki Jun

1992 "Kū Amida Butsu Myōhen no kenkyū: Tokuni busshi Kaikei tono kankei o megutte" (A Study of Kū Amida Butsu Myōhen and His Relationship with the Buddhist Sculptor Kaikei). *Indogaku Bukkyōgaku kenkyū* 80 (March 1992), pp. 654–56.

Arakawa Hirokazu

1958 "Kinenmei Negoro nuri ni tsuite" (Dated Specimens of Negoro Lacquerware). *Museum*, no. 92 (November 1958), pp. 25–30.

1969 *Maki-e*. Nihon no bijutsu (Arts of Japan), 35. Tokyo: Shibundō, 1969.

1971 *Nanban shitsugei* (*Nanban* Lacquerware). Tokyo: Bijutsu Shuppansha, 1971.

Arakawa Masaaki

1992 "Kan'ei Baroque bunka to Ko Kutani ishō" (Baroque Culture of the Kan'ei Era and Designs on Ko Kutani Ware). *Kobijutsu rokushō* 6 (1992), pp. 50–63.

1996 "Ōzara no jidai: Kinsei shoki ni okeru ōzara juyō" (The Era of the Large Platter: Demand for Large Platters in the Early Modern Period). *Idemitsu Bijutsukan kiyō* 2 (1996), pp. 71–103.

Arakawa Toyozō

1962 *Shino*. Tōki zenshū (Collection of Ceramics), 4. Tokyo: Heibonsha, 1962.

1972 *Shino, Ki Seto, Seto Guro.* Tōji taikei (Survey of Ceramics), 11. Edited by Koyama Fujio et al. Tokyo: Heibonsha, 1972.

Ariga Yoshitaka
1983 *Heian kaiga* (Paintings of the Heian Period). Nihon no bijutsu (Arts of Japan), 205. Tokyo: Shibundō, 1983.

"Art of Asia"
1966– "Art of Asia Recently Acquired by
1967 American Museums, 1965." *Archives of Asian Art* 20 (1966–67), pp. 84–106.

Asahi Misako
1984 "Ryūkyō suisha zu byōbu no seiritsu" (The Formation of Pictures of Willows and Waterwheels). *Bigaku bijutsushi kenkyū ronshū,* no. 3 (1984), pp. 35–78.

Asano Shūgo
1994 "Kaigetsudō Ando tachi bijin zu" ("Standing Beauty," Painted by Kaigetsudō Ando). *Kokka,* no. 1183 (1994), pp. 24–28.

Asano Shūgo and Timothy Clark
1995 *The Passionate Art of Kitagawa Utamaro.* Exh. cat. London: Trustees of the British Museum, 1995.

Asaoka Okisada
1905 *Koga bikō* (Notes on Old Painters). Tokyo: Yoshikawa Kōbunkan, 1905. 1912 ed.: *Zōtei Koga bikō* (Notes on Old Painters, with Supplement). Revised and enlarged by Ōta Kin. 5 vols. Tokyo: Yoshikawa Kōbunkan, 1912.

Asia Society
1970 *Masterpieces of Asian Art in American Collections II: An Offering of Treasures Celebrating the Tenth Anniversary of Asia House Gallery.* Exh. cat. New York: Asia Society, 1970.

Ayers, John, et al.
1990 *Porcelain for Palaces: The Fashion for Japan in Europe, 1650–1750.* Exh. cat., British Museum. London: Oriental Ceramic Society, 1990.

Barnet, Sylvan, and William Burto
1982 *Zen Ink Paintings.* Great Japanese Art. Tokyo and New York: Kōdansha International, 1982.

Becker, Johanna Lucille
1974 "The Karatsu Ceramics of Japan: Origins, Fabrications, and Types." Ph.D. diss., University of Michigan, 1974.

Bhattacharyya, Benoytosh
1924 *The Indian Buddhist Iconography: Mainly Based on the Sadhanamala and Other Cognate Tantric Texts of Rituals.* London and New York: Oxford University Press, 1924.

"Bokudō zu"
1894 "Bokudō zu" ("Herdboy"). *Kokka,* no. 58 (July 1894), p. 187.

"Bokushō hitsu Sansui zu"
1942 "Bokushō hitsu Sansui zu" ("Landscape," by Bokushō). *Kokka,* no. 618 (May 1942).

Brinker, Helmut, and Kanazawa Hiroshi
1996 *Zen: Masters of Meditation in Images and Writings.* Translated by Andreas Leisinger. Artibus Asiae, Supplementum, 40. Zurich: Artibus Asiae, 1996.

Brown, Kendall H.
1997 *The Politics of Reclusion: Painting and Power in Momoyama Japan.* Honolulu: University of Hawaii Press, 1997.

Burke, Mary Griggs
1985 "Twisted Pine Branches: Recollections of a Collector." *Apollo* 121 (February 1985), pp. 77–83.
1996a "The Delights of Nature in Japanese Art." *Orientations* 27, no. 2 (February 1996), pp. 54–61.
1996b "Miyeko Murase: Friend, Scholar and Mentor." *Orientations* 27, no. 8 (September 1996), pp. 44–45.

Cahill, James
1972 *Scholar Painters of Japan: The Nanga School.* Exh. cat. New York: Asia Society, 1972.
1983 *Sakaki Hyakusen and Early Nanga Painting.* Japan Research Monograph, 3. Berkeley: Institute of East Asian Studies, University of California, 1983.
1996a "The Imperial Painting Academy." In Fong and Watt 1996, pp. 159–99.
1996b *The Lyric Journey: Poetic Painting in China and Japan.* Cambridge, Mass.: Harvard University Press, 1996.

Chapin, Helen B.
1933 "The Ch'an Master Pu-tai." *Journal of the American Oriental Society* 53 (1933), pp. 47–52.

Ch'en Chih-mai
1966 *Chinese Calligraphers and Their Art.* Melbourne: Melbourne University Press; London and New York: Cambridge University Press, 1966.

Chiba Municipal Museum
1996 *Shugyoku no Nihon bijutsu: Hosomi Collection no zenbō to Boston, Cleveland, Sackler no wadaisaku. Kaikan isshūnen kinen* (The Legacy of Japanese Art: An Overview of the Hosomi Collection, with Highlights from the Boston, Cleveland, and Sackler Collections. First Anniversary of the Chiba Museum). Exh. cat. Chiba: Chiba Municipal Museum, 1996.

Chibbett, David G.
1977 *The History of Japanese Printing and Book Illustration.* Tokyo and New York: Kōdansha International, 1977.

"Chikusai monogatari"
1960 Edward Putzar, translator. "Chikusai monogatari." *Monumenta Nipponica* 16, nos. 1–2 (April–July 1960), pp. 161–95.

Chino Kaori
1980 "Meisho-e no seiritsu to tenkai" (The Evolution and Development of Pictures of Famous Places). In Takeda Tsuneo et al., *Keibutsuga: Meisho keibutsu* (Landscape: Famous Sceneries). Nihon byōbu-e shūsei (Collection of Japanese Screen Paintings), 10. Tokyo: Kōdansha, 1980.

Chizawa Teiji
1981 *Sakai Hōitsu.* Nihon no bijutsu (Arts of Japan), 186. Tokyo: Shibundō, 1981.

Chōkoku
1972 *Chōkoku* (Sculpture). Vol. 1. Jūyō bunkazai (Important Cultural Properties), 1. Tokyo: Mainichi Shinbunsha, 1972.

Chōshūki
1965 *Chōshūki.* Vol. 1. Zōho shiryō taisei (Compendium of Historical Material: Supplement), 16. Kyoto: Rinsen Shoten, 1965.

Chosŏn wangjo sillok
1955– Kuksa P'yŏnch'an Wiwŏnhoe, editor.
1958 *Chosŏn wangjo sillok* (Chronicle of the Yi Dynasty). 48 vols. Seoul: Kuksa P'yŏnch'an Wiwŏnhoe, 1955–58.

Cort, Louise Allison
1985 "Ceramics and the Tea Ceremony." *Apollo* 121 (February 1985), pp. 120–23.

Cunningham, Louisa
1984 *The Spirit of Place: Japanese Paintings and Prints of the Sixteenth through Nineteenth Centuries.* Exh. cat. New Haven, Conn.: Yale University Art Gallery, 1984.

Cunningham, Michael R., et al.
1991 *The Triumph of Japanese Style: Sixteenth-Century Art in Japan.* Exh. cat. Cleveland: Cleveland Museum of Art, 1991.

Dai Nihon Bukkyō zensho
1959 Bussho Kankōkai, editor. *Dai Nihon Bukkyō zensho: Yūhōden sōsho* (The Collected Works of Japanese Buddhism: Books on Travels). Vol. 3. Tokyo: Bussho Kankōkai, 1959.
1970– Suzuki Research Foundation, editor. *Dai
1973 Nihon Bukkyō zensho* (The Collected Works of Japanese Buddhism). 100 vols. Tokyo: Kōdansha, 1970–73.

Dai Nihon shiryō
1928 *Dai Nihon shiryō* (Archival Materials on Japan). Vol. 12, pt. 28. Tokyo: Tokyo University, 1928.

Daizōkyō
1914– Takakusu Junjirō and Watanabe
1932 Kaigyoku, editors. *Taishō shinshū Daizōkyō* (The Taishō Edition of the Tripitaka). 100 vols. Tokyo: Taishō Issaikyō Kankōkai, 1914–32.

Daizōkyō zuzō
1932– Ono Genmyō, editor. *Taishō shinshū
1934 Daizōkyō zuzō* (The Taishō Edition of the Tripitaka: Iconographic Drawings). 12 vols. Tokyo: Taishō Issaikyō Kankōkai, 1932–34.

Dallas Museum of Fine Arts

1969 *Masterpieces of Japanese Art.* Exh. cat. Dallas: Dallas Museum of Fine Arts, 1969.

Dien, Albert E., et al.

1987 *The Quest for Eternity: Chinese Ceramic Sculptures from the People's Republic of China.* Exh. cat. Los Angeles: Los Angeles County Museum of Art; San Francisco: Chronicle Books, 1987.

Doi Tsugiyoshi

1970 *Kinsei Nihon kaiga no kenkyū* (Study of the Painting of Recent Times in Japan). Tokyo: Bijutsu Shuppansha, 1970.

1978 *Kano Eitoku, Mitsunobu.* Nihon bijutsu kaiga zenshū (Survey of Japanese Painting), 9. Tokyo: Shūeisha, 1978.

Donohashi Akiho

1977 "Tōdaiji Shaka sanzon jūroku rakan ni tsuite" (The Tōdaiji Shaka Triad with Sixteen Rakan). *Bukkyō geijutsu,* no. 112 (April 1977), pp. 58–80.

Dunhuang Research Institute

1981 Editor. *Tonkō Bakkōkutsu* (Magao Caves at Dunhuang). Vol. 2. Chūgoku sekkutsu (Chinese Caves). Tokyo: Heibonsha, 1981.

Earle, Joe

1996 Editor. *Meiji no takara: Shibata Zeshin meihinshū/Treasures of Imperial Japan: Masterpieces by Shibata Zeshin.* The Nasser D. Khalili Collection of Japanese Art. London: Kibō Foundation, 1996.

Early Japanese Literature

1951 Edwin O. Reischauer and Joseph K. Yamagiwa, editors and translators. *Translations from Early Japanese Literature.* Cambridge, Mass.: Harvard-Yenching Institute, 1951.

Ebine Toshio

1994 *Suibokuga: Mokuan kara Minchō e* (Ink Painting: From Mokuan to Minchō). Nihon no bijutsu (Arts of Japan), 333. Tokyo: Shibundō, 1994.

Egami Yasushi

1972 "Sanjūrokunin shū ryōshi sōshoku ni okeru taiihō teki hibikiai" (The Counterpoint Intensity in the Decorative Patterns on the Ryōshi of the Anthology of the Thirty-six Poets). *Kokka,* no. 946 (June 1972), pp. 11–18.

1992 *Senmenga: Kodai hen* (Fan Paintings: Ancient Period). Nihon no bijutsu (Arts of Japan), 319. Tokyo: Shibundō, 1992.

Encyclopedia of World Art

1960 *Encyclopedia of World Art.* Vol. 3. New York: McGraw-Hill, 1960.

Engishiki

1929 Masamune Atsuo, editor. *Engishiki.* Nihon koten zenshū (Collection of Japanese Classics), 6. Tokyo: Nihon Koten Zenshū Kankōkai, 1929.

Etō Shun

1961 "Motonobu ni kansuru Min no Teitaku shakudoku" (A Letter by Teitaku Addressed to Kano Motonobu). *Yamato bunka,* no. 35 (July 1961), pp. 72–74.

1969a "Rogan zu: Renmon rōsen bokuga" ("Geese and Reeds"). *Kobijutsu,* no. 28 (December 1969), pp. 83–84.

1969b "Sansui zu: Sesson hitsu" ("Landscape," by Sesson). *Kobijutsu,* no. 25 (March 1969), pp. 67–70.

1979 *Sōami, Shōkei.* Nihon bijutsu kaiga zenshū (Survey of Japanese Painting), 6. Tokyo: Shūeisha, 1979.

1982 Editor. *Sesson Shūkei zen gashū* (The Complete Works of Sesson Shūkei). Tokyo: Kōdansha, 1982.

Fister, Pat

1988 *Japanese Women Artists, 1600–1900.* Exh. cat. Lawrence: Spencer Museum of Art, University of Kansas, 1988.

Fong, Wen C.

1958 *The Lohans and a Bridge to Heaven.* Freer Gallery of Art Occasional Papers, vol. 3, no. 1. Washington, D.C., 1958.

1992 *Beyond Representation: Chinese Painting and Calligraphy, 8th–14th Century.* Princeton Monographs in Art and Archaeology, 48. New York: The Metropolitan Museum of Art; New Haven, Conn.: Yale University Press, 1992.

Fong, Wen C., and James C. Y. Watt

1996 *Possessing the Past: Treasures from the National Palace Museum, Taipei.* Exh. cat. New York: The Metropolitan Museum of Art, 1996.

Fong, Wen C., et al.

1984 *Images of the Mind: Selections from the Edward L. Elliott Family and John B. Elliott Collections of Chinese Calligraphy and Painting at The Art Museum, Princeton University.* Exh. cat. Princeton: The Art Museum, Princeton University, 1984.

Fontein, Jan

1967 *The Pilgrimage of Sudhana: A Study of Gandavyuha Illustrations in China, Japan and Java.* The Hague: Mouton, 1967.

Fontein, Jan, and Money L. Hickman

1970 *Zen Painting and Calligraphy.* Exh. cat. Boston: Museum of Fine Arts, 1970.

Ford, Barbara Brennan

1980 "A Study of the Painting of Sesson Shūkei." Ph.D. diss., Columbia University, 1980.

1985 "Muromachi Ink Painting." *Apollo* 121 (February 1985), pp. 114–19.

1997 "Tragic Heroines of the *Heike monogatari* and Their Representation in Japanese Screen Painting." *Orientations* 28, no. 2 (February 1997), pp. 40–47.

French, Calvin L.

1974 *The Poet-Painters: Buson and His Followers.* Exh. cat. Ann Arbor: University of Michigan Museum of Art, 1974.

Fuji Masaharu and Abe Zenryō

1977 *Manpukuji.* Koji junrei Kyoto (Pilgrimage to the Old Temples in Kyoto), 9. Kyoto: Tankōsha, 1977.

Fujioka Ryōichi

1968 *Cha dōgu* (Tea Utensils). Nihon no bijutsu (Arts of Japan), 22. Tokyo: Shibundō, 1968.

1970 *Shino to Oribe* (Shino and Oribe). Nihon no bijutsu (Arts of Japan), 51. Tokyo: Shibundō, 1970.

Fujisawa Yoshisuke

1982 "Ko Seto chūki yōshiki no seiritsu katei" (The Formation of the Middle-Period Style of Ko Seto Ware). *Tōyō tōji* 8 (1982), pp. 29–56.

Fujiwara Munetada

1965 *Chūyūki.* 7 vols. Zōho shiryō taisei (Compendium of Historical Material: Supplement), 9–15. Kyoto: Rinsen Shoten, 1965.

Fujiwara Tadachika

1965 *Sankaiki.* Zōho shiryō taisei (Compendium of Historical Material: Supplement), 26. Kyoto: Rinsen Shoten, 1965.

Fukui Rikichirō

1935 "Sesson shōki" (Brief Notes on Sesson). *Bunka* 2 (November 1935), pp. 131–34.

1944 "Shinshutsu no Heiji monogatari emaki zanketsu" (Newly Discovered Fragments of the *Heiji monogatari emaki*). *Bunka* 11, nos. 8–9 (September 1944).

1999 *Fukui Rikichirō bijutsushi ronshū* (Collected Essays on Art History by Fukui Rikichirō). Vol. 2. Tokyo: Chūōkōron Bijutsu Shuppan, 1999.

Fukushima Prefectural Museum

1992 *Sadanobu to Bunchō: Matsudaira Sadanobu to shūhen no gajin tachi* (Sadanobu and Bunchō: Matsudaira Sadanobu and Painters in His Circle). Exh. cat. Aizu Wakamatsu, Fukushima Prefecture: Fukushima Prefectural Museum, 1992.

1994 *Gyokudō to Shunkin, Shūkin: Uragami Gyokudō fushi no geijutsu* (Gyokudō, and Shunkin and Shūkin: The Arts of Uragami Gyokudō and His Sons). Exh. cat. Aizu Wakamatsu, Fukushima Prefecture: Fukushima Prefectural Museum, 1994.

Fukushima Tsunenori

1993 *Muromachi jidai no Sesshū ryū* (The Followers of Sesshū in the Muromachi Period). Exh. cat. Yamaguchi: Yamaguchi Prefectural Museum of Art, 1993.

Furuta Shōkin

1988 "Geirin okudan 9—Ryūkyo zu: Sono Ujibashi zu o megutte sono igi o tou" (An Artistic Assumption 9: On the "River Uji and Its Banks"). *Idemitsu Bijutsukan kanpō* 61 (1988), pp. 18–23.

Genji no ishō

1998 *Genji no ishō* (Genji Design). Tokyo: Shōgakkan, 1998.

Gitter, Kurt A., and Pat Fister

1985 *Japanese Fan Paintings from Western Collections.* Exh. cat. New Orleans: New Orleans Museum of Art, 1985.

Goepper, Roger

1993 *Aizen-Myōō: The Esoteric King of Lust. An Iconological Study.* Artibus Asiae, Supplementum, 39. Zurich: Artibus Asiae, 1993.

Gōke Tadaomi

1974 *Shibata Zeshin.* Nihon no bijutsu (Arts of Japan), 93. Tokyo: Shibundō, 1974.

1981 *Shibata Zeshin meihinshū: Bakumatsu kaikaki no shikkō kaiga* (Masterpieces by Shibata Zeshin: Painting and Lacquerware from the Late Edo Period). 2 vols. Tokyo: Gakken, 1981.

Gotō Shigeki

1974 Editor. *Shunshō.* Ukiyo-e taikei (Compendium of *ukiyo-e*), 3. Tokyo: Shūeisha, 1974.

Gotō Taniji and Okami Masao

1988 Editors. *Taiheiki; Soga monogatari; Gikeiki.* 5th ed. Kanshō Nihon koten bungaku (Japanese Classical Literature), 21. Tokyo: Kadokawa Shoten, 1988.

The Gotoh Museum

1964 *Daitōkyū Kinenbunko sōritsu jūgonen shūnen tokubetsu ten* (Special Exhibition Commemorating the Fifteenth Anniversary of the Daitōkyū Memorial Library). Exh. cat. Tokyo: The Gotoh Museum, 1964.

1987 *Teika-yō* (Teika: The Stylistic Legacy of a Master Calligrapher). The Gotoh Museum Exhibition Catalogue, 107. Tokyo: The Gotoh Museum, 1987.

1996 *Mokkei: Dōkei no suibokuga* (Ink Mists: Zen Paintings by Muqi). Exh. cat. The Gotoh Museum Exhibition Catalogue, 118. Tokyo: The Gotoh Museum, 1996.

Graham, Patricia Jane

1983 "Yamamoto Baiitsu: His Life, Literati Pursuits, and Related Paintings." 2 vols. Ph.D. diss., University of Kansas, 1983.

1986 "Yamamoto Baiitsu no Chūgokuga kenkyū" (Yamamoto Baiitsu's Approach to the Study of Chinese Painting). *Kobijutsu*, no. 80 (October 1986), pp. 62–75.

1998 *Tea of the Sages: The Art of Sencha.* Honolulu: University of Hawaii Press, 1998.

Grotenhuis, Elizabeth ten

1999 *Japanese Mandalas: Representations of Sacred Geography.* Honolulu: University of Hawaii Press, 1999.

Gulik, Robert Hans van

1969 *Hsi K'ang and His Poetical Essay on the Lute.* A Monumenta Nipponica

Monograph. Rev. ed. Tokyo: Sophia University, 1969.

Gunsho ruijū

1906– Ichishima Kenkichi, editor. *Zoku zoku*
1909 *Gunsho ruijū* (Collection of Old Literary Sources: Second Supplement). 16 vols. Tokyo: Kokusho Kankōkai, 1906–9.

1928– Kawamoto Kōichi, editor. *Shinkō Gunsho*
1937 *ruijū* (Collection of Old Literary Sources: Revised Edition). 29 vols. Tokyo: Naigai Shoseki Kankōkai, 1928–37.

Guoan

1969 *The Ox and His Herdsman: A Chinese Zen Text.* Translated by M. H. Trevor. Tokyo: Hokuseidō Press, 1969.

Guth, Christine

1996 *Art of Edo Japan: The Artist and the City, 1615–1868.* Perspectives. New York: Harry N. Abrams, 1996.

Gyōtoku Shin'ichirō

1993 "Yōgō to shizen to: Yōmei Bunko zō Kasuga shika mandara zu" (Sacred Manifestation and Nature: The *Kasuga shika mandara* in the Yōmei Bunko). *Kokka*, no. 1173 (1993), pp. 3–17.

1994 "Suijakuga no kenkyū: Miya mandara o chūshin ni" (A Study of Shinto Paintings and Shrine Mandalas). *Kajima bijutsu zaidan nenpō* 11 (1994), pp. 240–57.

1996 "Kasuga Miya mandara zu no fūkei hyōgen: Busshō to shinsei no katachi" (Landscape in the Kasuga Shrine Mandala, Symbol of Buddha-dhatu and Shinto). *Museum*, no. 541 (April 1996), pp. 13–42.

Haga Kōshirō

1979 Editor. *Takuan.* Bunjin shofū (Types of Literati), 5. Kyoto: Tankōsha, 1979.

1981 *Chūsei zenrin no gakumon oyobi bungaku ni kansuru kenkyū* (Studies of Scholarly and Literary Works by Medieval Zen Monks). Haga Kōshirō rekishi ronshū (Historical Studies by Haga Kōshirō), 3. Kyoto: Shibunkaku Shuppan, 1981.

Haga Kōshirō and Nishiyama Matsunosuke

1962 Editors. *Cha no bunka shi* (Cultural History of Tea). Zusetsu sadō taikei (Tea in Pictures), 2. Tokyo: Kadokawa Shoten, 1962.

Haga Tōru and Hayakawa Monta

1994 *Buson.* Suibokuga no kyoshō (Great Masters of Ink Painting), 12. Tokyo: Kōdansha, 1994.

Haino Akio

1980 "Shitsugeihin ni miru bungaku ishō" (Lacquer Designs Derived from Literature). In Kyoto National Museum 1980.

1985 *Shikkō* (Lacquerware). Nihon no bijutsu (Arts of Japan), 231. Tokyo: Shibundō, 1985.

Hamada Giichirō

1963 *Ōta Nanpo.* Jinbutsu sōsho (Biographical

Series), 102. Edited by Nihon Rekishi Gakkai. Tokyo: Yoshikawa Kōbunkan, 1963.

Hamada Takashi

1980 *Mandara* (Mandalas). Nihon no bijutsu (Arts of Japan), 173. Tokyo: Shibundō, 1980.

Hamada Takashi et al.

1989 *Hiten.* Asuka Shiryōkan Catalogue, 22. Nara: Asuka Shiryōkan, 1989.

Hamurochō Kyōiku Iinkai

1980 Editor. *Kōza Tamagawa Jōsui* (Lectures on the Tamagawa Aqueduct). Hamurochō shi shiryōshū (Historical Materials on Hamurochō), 6. Tokyo: Hamurochō Kyōiku Iinkai, 1980.

Hanshan

1970 *Cold Mountain: One Hundred Poems by the T'ang Poet Han-shan.* Translated by Burton Watson. New York: Columbia University Press, 1970.

Hanshin Department Store

1971 *Sekai no gasei Sesshū ten* (The World's Great Master: Sesshū). Exh. cat. Osaka: Hanshin Department Store, 1971.

Harunari Hideji

1990 *Yayoi jidai no hajimari* (The Beginning of the Yayoi Period). Kōkogaku sensho (Selected Works of Archeology), 11. Tokyo: Tōdai Shuppankai, 1990.

Hasegawa Nobuyoshi

1979 "Sanjūrokkasen no seiritsu" (A Selection of the Thirty-six Immortal Poets). In Mori Tōru 1979.

Hashimoto Ayako

1969 "Maruyama Ōkyo no sakufū ni tsuite: Ōkyo kenkyū josetsu" (On the Style of Maruyama Ōkyo: An Introduction to the Study of Ōkyo). *Bigaku*, no. 78 (fall 1969), pp. 10–39.

Hashimoto Fumio

1970 Editor. *Kunaichō Shoryōbu zō Goshobon Sanjūrokuninshū* (Deluxe Version of the *Sanjūrokuninshū* in the Collection of the Imperial Library). Tokyo: Rinsen Shoten, 1970.

Hashimoto Shinji

1997 "Muromachi jidai no itsuden gajin I: 'Rikō' in no sakuhin ni tsuite" (Lesser-Known Painters of the Muromachi Period I: On the Paintings Bearing "Rikō" Seals). *Tochigi Kenritsu Hakubutsukan kiyō* 14 (March 1997), pp. 108–16.

Hasumi Shigeyasu

1935 "Nara Hōgen Kantei." *Nihon bijutsu kyōkai hōkoku* 38 (October 1935), pp. 1–7.

Hayakawa Monta and Yamamoto Kenkichi

1984 *Buson gafu* (Paintings by Yosa Buson). Tokyo: Mainichi Shinbunsha, 1984.

Hayashi On

1988 "Han'nya Shingyōhō no mandara" (The

Buddhist Ritual Han'nya Shingyōhō). *Bukkyō geijutsu*, no. 381 (November 1988), pp. 75−95.

Hayashi Susumu

1982 "Sesson hitsu Chikurin Shikiken zu byōbu (Hatakeyama Kinenkan zō) ni tsuite" (Screen Painting of "The Seven Sages of the Bamboo Grove," by Sesson, in the Collection of the Hatakeyama Kinenkan Museum). In *Jinbutsuga: Kanga kei jinbutsu* (Figure Painting: Figures in Chinese-Inspired Paintings). Nihon byōbu-e shūsei (Collection of Japanese Screen Paintings), 4. Tokyo: Kōdansha, 1982.

1984 "Sesson Shūkei no kenkyū" (Study of Sesson Shūkei). *Kajima bijutsu zaidan nenpō* 2 (1984), pp. 68−73.

Hayashi Yoshikazu

1963 *Shunshō*. Enpon kenkyū (Study of Erotic Books), 4. Tokyo: Yūkō Shobō, 1963.

Hayashiya Seizō

1967 *Chawan*. Nihon no bijutsu (Arts of Japan), 14. Tokyo: Shibundō, 1967.

1972a Editor. *Bizen, Tanba, Iga, Shigaraki*. Nihon no tōji (Japanese Ceramics), 2. Tokyo: Chūōkōronsha, 1972.

1972b "Iga mimitsuki mizusashi" (Vase of Iga Ware). *Kobijutsu*, no. 37 (June 1972), pp. 101−2.

1974 Editor. *Shino*. Nihon no tōji (Japanese Ceramics), 2. Deluxe color ed. Tokyo: Chūōkōronsha, 1974.

1975 Editor. *Kyōyaki*. Nihon no tōji (Japanese Ceramics), 13. Tokyo: Chūōkōronsha, 1975.

1977 Editor. *Iga*. Nihon tōji zenshū (Collection of Japanese Ceramics), 13. Tokyo: Chūōkōronsha, 1977.

1981 Editor. *Tōji* (Ceramics). Zaigai Nihon no shihō (Japanese Art: Selections from Western Collections), 9. Tokyo: Mainichi Shinbunsha, 1981.

1985 "Kyōyaki no nagare" (Currents of *kyōyaki*). In *Kyōyaki no sekai: Ninsei kara Hōzen made* (The World of *kyōyaki*: From Ninsei to Hōzen). Exh. cat. Matsue, Shimane Prefecture: Tabe Museum, 1985.

Hayashiya Seizō and Enjōji Jirō

1990 Editors. *Nihon no meitō hyakusen ten* (One Hundred Masterpieces of Japanese Ceramics). Exh. cat., Takashimaya Department Store. Tokyo: Nihon Keizai Shinbunsha, 1990.

Hayashiya Tatsusaburō et al.

1964 *Kōetsu*. Tokyo: Daiichi Hōki, 1964.

"Heian jinbutsushi"

1936 "An'ei yonen-ban Heian jinbutsushi" (Heian *jinbutsushi*: An Address Book of Artists and Scholars in Kyoto, Published in the Fourth Year of An'ei, 1775). *Bijutsu kenkyū*, no. 54 (June 1936), pp. 257−64.

1943 "Tenmei ninen-ban Heian jinbutsushi" (Heian *jinbutsushi*: An Address Book of Artists and Scholars in Kyoto, Published in the Second Year of the Tenmei Era, 1782). *Bijutsu kenkyū*, no. 132 (1943), pp. 227−34.

Hickman, Money L., and Satō Yasuhiro

1989 *The Paintings of Jakuchū*. Exh. cat. New York: Asia Society Galleries, 1989.

Hillier, Jack Ronald

1974 *The Uninhibited Brush: Japanese Art in the Shijō Style*. London: Hugh M. Moss, 1974.

Hirata Yutaka

1985 "Takuma ha ni okeru dentō sei" (The Traditionalism of the Takuma School). *Kokka*, no. 1085 (July 1985), pp. 11−26.

1989 *Nara Bukkyō* (Buddhism in Nara). Zusetsu Nihon no Bukkyō (Illustrated History of Japanese Buddhism), 1. Tokyo: Shinchōsha, 1989.

Hitomi Shōka

1940 "Ike Taiga hyōden" (The Life of Ike Taiga). *Nanga kanshō* 9 (September 1940), pp. 2−5.

Ho, Wai-kam, et al.

1980 *Eight Dynasties of Chinese Painting: The Collections of the Nelson Gallery-Atkins Museum, Kansas City, and the Cleveland Museum of Art*. Exh. cat. Cleveland: Cleveland Museum of Art, 1980.

Hōgen monogatari

1971 William R. Wilson, translator. *Hōgen monogatari, Tale of the Disorder in Hōgen*. Monumenta Nipponica Monographs. Tokyo: Sophia University, 1971.

Holzman, Donald

1957 *La Vie et la pensée de Hi K'ang (223–262 ap. J.-C.)*. Leiden: Harvard-Yenching Institute, 1957.

Hon'ami gyōjōki to Kōetsu

1965 Masaki Tokuzō, editor. *Hon'ami gyōjōki to Kōetsu* (Activities of the Hon'ami Family and Kōetsu). Tokyo: Chūōkōron Bijutsu Shuppan, 1965.

"Honchō gasan"

1939 "Honchō gasan" (Illustrated Biographies of Japanese Painters, Newly Compiled and Reprinted from Various Editions). *Bijutsu kenkyū*, no. 89 (May 1939), pp. 187−206 (pt. 4).

Honma Art Museum

1961 *Dai nikai Nihon nanga ten* (Second Exhibition of Japanese *nanga*). Exh. cat. Sakata, Yamagata Prefecture: Honma Art Museum, 1961.

1968 *Sesson no geijutsu* (The Art of Sesson). Sakata, Yamagata Prefecture: Honma Art Museum, 1968.

1969 *Sakai Hōitsu meisaku ten* (Exhibition of Sakai Hōitsu's Masterpieces). Exh. cat. Sakata, Yamagata Prefecture: Honma Art Museum, 1969.

Horibe Seiji

1943 *Chūko Nihon bungaku no kenkyū* (Medieval Japanese Literature). Kyoto: Kyōiku Tosho, 1943.

Horikawa Takashi

1989 "Shōshō hakkei shi ni tsuite" (On the Poems of the Eight Views of the Xiao and Xiang Rivers). *Chūsei bungaku*, no. 34 (1989), pp. 101−10.

Hōryūji Shōwa Shizaichō Henshū Iinkai

1991 Editor. *Hōryūji no shihō: Shōwa shizaichō* (Treasures of Hōryūji: Shōwa-Era Record of the Temple's Holdings). Vol. 5, *Hyakumantō, Daranikyō*. Tokyo: Shōgakkan, 1991.

Hoshino Rei

1977 "Ike Gyokuran hitsu Bokubai zu: Sansui zu" ("Landscape" by Ikeno Gyokuran and "Plum Tree" by Ikeno Gyokuran). *Kokka*, no. 998 (1977), pp. 36−38.

Hoshiyama Shin'ya

1976 "Gyokuen Bonpō ni tsuite" (On Gyokuen Bonpō). *Geijutsugaku kenkyū* 2 (1976), pp. 33−57.

Hosono Masanobu

1979 *Kindai kaiga no reimei: Bunchō, Kazan to yōfūga* (The Dawn of Modern Painting: Bunchō, Kazan, and Western-Style Painting). Nihon bijutsu zenshū (Survey of Japanese Art), 25. Tokyo: Gakken, 1979.

1988 *Edo no Kano ha* (The Kano School during the Edo Period). Nihon no bijutsu (Arts of Japan), 262. Tokyo: Shibundō, 1988.

"Hyakusen"

1939 "Sakaki Hyakusen tokushū gō" (Special Issue on Hyakusen). *Nanga kanshō* 8, no. 4 (April 1939).

Ibaraki Prefectural Museum of History

1992 *Sesson: Hitachi kara no tabidachi* (Sesson: A Journey Begun in Hitachi Province). Exh. cat. Tokyo: Ibaraki Prefectural Museum of History, 1992.

Ichikawa Hakugen

1978 *Takuan Sōhō*. Nihon no Zen goroku (Collection of Zen Writings of Japan), 13. Tokyo: Kōdansha, 1978.

Ienaga Saburō

1966a *Jōdai yamato-e nenpyō* (Chronology of Ancient Poems Related to Painting). Tokyo: Bokusui Shobō, 1966.

1966b *Jōdai yamato-e zenshi* (History of *yamato-e* of the Ancient Period). Rev. ed. Tokyo: Bokusui Shobō, 1966.

Iizuka Beiu

1931 Editor. *Hokushū ha* (Northern School). Vol. 1. Nihonga taisei (Survey of Japanese Painting), 3. Tokyo: Tōhō Shoin, 1931.

1932a Editor. *Kano ha* (Kano School). Vol. 2. Nihonga taisei (Survey of Japanese Painting), 6. Tokyo: Tōhō Shoin, 1932.

1932b Editor. *Nanshū ha* (Southern School). Vol. 3. Nihonga taisei (Survey of Japanese Painting), 11. Tokyo: Tōhō Shoin, 1932.

1932c Editor. *Shoka* (Miscellaneous Painters). Nihonga taisei (Survey of Japanese Painting), 15. Tokyo: Tōhō Shoin, 1932.

Ikawa Kazuko

1963 "Chiten ni sasae rareta Bishamonten chōzō: Tobatsu Bishamonten zō ni tsuite no ichi kōsatsu" (Statues of Bishamonten Supported by Chiten: Research on the Tobatsu Bishamonten). *Bijutsu kenkyū*, no. 229 (July 1963), pp. 53–73.

Ikeda Koson

1864 *Shinsen Kōrin hyakuzu* (A New Selection of One Hundred Works by Kōrin). 2 vols. [Japan], 1864.

Ikeda Toshiko

1996 "Shōshō hakkei zu no chōsa hōkoku" (Study of Paintings of the Eight Views of the Xiao and Xiang Rivers). *Kajima bijutsu zaidan nenpō* 13 (1996), pp. 521–35.

Inaga Keiji

1964 "Genji higi shō" (Secretly Held Discussions on Genji). *Kokugo to kokubungaku*, no. 483 (June 1964), pp. 22–31.

Inazuka Takeshi

1919 "Goshun ni tsuite" (On Goshun). *Kokka*, no. 348 (May 1919), pp. 417–21 (pt. 1); no. 349 (June 1919), pp. 451–56 (pt. 2).

1920 "Goshun tetsubun" (On the Life of Goshun). *Kokka*, no. 358 (March 1920), pp. 392–96 (pt. 1).

Ingen

1979 *Ingen zenshū* (The Writings of Ingen). Edited by Hirakubo Akira. 12 vols. Tokyo: Kaimei Shoin, 1979.

Inokuma Kanekatsu

1979 *Haniwa*. Nihon no genshi bijutsu (Early Arts of Japan), 6. Tokyo: Kōdansha, 1979.

Inoue Ken'ichirō

1977 "Chūsei no shiki keibutsu: Waka shiryō ni yoru shiron" (Depiction of the Four Seasons in the Medieval Period: Study of *waka* as Historical Documents). In Takeda Tsuneo 1977b.

Inoue Tadashi

1958 "Jōgon'in Amida Nyorai zō ni tsuite" (On a Buddhist Image of Amitabha in the Jōgon'in Temple). *Kokka*, no. 791 (February 1958), pp. 39–51.

1963 "Jōruriji kutai Amida Nyorai zō no zōryū nendai ni tsuite" (On the Date of the Production of the Nine Images of Amitabha in the Jōruriji Temple). *Kokka*, no. 861 (December 1963), pp. 7–20.

Inryōken nichiroku

1978– Takeuchi Rizō, editor. *Inryōken nichiroku*
1979 (Chronicles at Inryōken). 5 vols. Zōho

zoku shiryō taisei (Compendium of Historical Material: Enlarged Supplement), 21–25. Kyoto: Rinsen Shoten, 1978–79.

1989 Kageki Hideo, editor. *Inryōken nichiroku sakuin* (Index to the Chronicles at Inryōken). Kyoto: Rinsen Shoten, 1989.

Ishida Mosaku

1955 *Tōshōdaiji*. Tokyo: Kadokawa Shoten, 1955.

1976 *Shōtoku Taishi sonzō shūsei* (Collection of Images of Shōtoku Taishi). 2 vols. Tokyo: Kōdansha, 1976.

Ishida Mosaku and Okazaki Jōji

1993 *Mikkyō hōgu* (Furnishings for Esoteric Buddhist Temples). Kyoto: Rinsen Shoten, 1993.

Ishikawa ken Kyōiku Iinkai

1971– Editor. *Daiichiji, Niji Kutani koyō chōsa*
1972 *gaihō* (Reports on the First and Second Excavations of the Old Kilns at Kutani). Ishikawa: Ishikawa ken Kyōiku Iinkai, 1971–72.

Ishikawa Prefectural Art Museum and MOA Museum of Art

1992 *Nonomura Ninsei ten: Edo jidai—kyōyaki iroe no taiseisha* (Exhibition of Nonomura Ninsei, Who Perfected Polychrome Glazing Techniques during the Edo Period). Kanazawa: Ishikawa Prefectural Art Museum; Atami: MOA Museum of Art, 1992.

Itō Shirō

1989 *Komainu* (Lion Dogs). Nihon no bijutsu (Arts of Japan), 279. Tokyo Shibundō, 1989.

Itō Toshiko

1970 "Den Kōetsu hitsu Utaibon to Kanze Kokusetsu (A Book of *utai* Ascribed to Kōetsu and Kokusetsu Kanze). *Kokka*, no. 922 (1970), pp. 5–22.

1974 "Den Sōtatsu hitsu Ise monogatari zu shikishi no kotobagaki ni tsuite" (Study of the Texts of the *Ise monogatari shikishi* Attributed to Sōtatsu). *Yamato bunka*, no. 59 (March 1974), pp. 28–55.

1978 "Kōetsu no sho" (The Calligraphy of Kōetsu). In *Kōetsu sho Sōtatsu kingindei-e* 1978, pp. 95–103.

1984 Editor. *Ise monogatari-e* (Illustrated Tales of Ise). Tokyo: Kadokawa Shoten, 1984.

Iwama Kaoru

1986 "Kinsei shoki Tosa ha no kenkyū: Kyoto Shiritsu Geijutsu Daigaku shozō Tosa ha shiryō o chūshin ni" (Study of the Tosa School in the Early Modern Period and Materials of the Tosa School in the Collection of the Kyoto Municipal University of the Arts). *Kajima bijutsu zaidan nenpō* 4 (1986), pp. 164–69.

Izzard, Sebastian

1983 *Hiroshige: An Exhibition of Selected Prints and Illustrated Books*. Exh. cat.,

Pratt Graphics Center. New York: Ukiyo-e Society of America, 1983.

Japanese Noh Drama

1955 Nippon Gakujutsu Shinkōkai, editor. *Japanese Noh Drama*. Vol. 1. Tokyo: Nippon Gakujutsu Shinkōkai, 1955.

Jenkins, Donald

1971 *Ukiyo-e Prints and Paintings: The Primitive Period, 1680–1745*. Exh. cat. Chicago: Art Institute of Chicago, 1971.

1993 *The Floating World Revisited*. Exh. cat. Portland, Oreg.: Portland Art Museum, 1993.

Jikkinshō

1982 Izumi Motohiro, editor. *Jikkinshō*. Kasama sakuin sōkan (Complete Index of Kasama), 78. Tokyo: Kasama Shoin, 1982.

Jishi sōsho

1915 *Jishi sōsho III* (Historical Records of Temples III). In *Dai Nihon Bukkyō zensho* (The Collected Works of Japanese Buddhism), edited by Bussho Kankōkai, vol. 119. Tokyo: Bussho Kankōkai, 1915.

Jorg, C. J. A.

1980 *Pronk porselein: Porselein naar ontwerpen van Cornelis Pronk/Pronk Porcelain: Porcelain after Designs by Cornelis Pronk*. Exh. cat. Groningen: Groninger Museum, 1980.

Kageyama Haruki

1973 *The Arts of Shinto*. Translated by Christine Guth. Arts of Japan, 4. New York: Weatherhill; Tokyo: Shibundō, 1973.

1975 "Kasuga shika mandara: Kodai shinkō no hyōkei to shite" (The Shika Kasuga Mandala). *Kokka*, no. 981 (1975), pp. 7–14.

Kageyama Haruki and Christine Guth Kanda

1976 *Shinto Arts: Nature, Gods, and Man in Japan*. Exh. cat. New York: Japan Society, 1976.

Kageyama Sumio

1984 "Unkoku Tōgan den" (The Life of Unkoku Tōgan). In Yamaguchi Prefectural Museum of Art 1984, pp. 162–67.

Kajihara Masaaki and Julia Meech-Pekarik

1987 Editors. *Hōgen Heiji kassen zu* (Picture of the Battles in the Hōgen and Heiji Eras). Tokyo: Kadokawa Shoten, 1987.

Kajitani Ryōji

1987 "Jūroku rakan zō ni tsuite" (Paintings of the Sixteen Rakan). *Bukkyō geijutsu*, no. 172 (May 1987), pp. 117–33.

"Kakei hitsu Hōgyū zu"

1904 "Kakei hitsu Hōgyū zu" ("A Winter Scene," by Hsia Kuei). *Kokka*, no. 165 (February 1904), p. 182.

Kakudo, Yoshiko

1972 "Some Special Problems of Japanese Ceramics in the Brundage Collection." In Seattle Art Museum, *International Symposium on Japanese Ceramics, Seattle Art Museum, Volunteer Park, Washington,*

U.S.A., September 11–13, 1972, in Conjunction with the Opening of the Exhibition, "Ceramic Art of Japan: One Hundred Masterpieces from Japanese Collections," pp. 72–79. Seattle: Seattle Art Museum, 1972.

Kakumeiki

1958– Akamatsu Shunshū, editor. *Kakumeiki.*
1967 6 vols. Kyoto: Rokuonji, 1958–67.

Kamakura Kokuhōkan

1962 *Kamakura no suibokuga* (Ink Paintings of Kamakura). Kamakura Kokuhōkan zuroku (Catalogue of the Treasure House of Kamakura), 9. Kamakura: Kamakura Kokuhōkan, 1962.

Kamakura-shi Shi Hensan Iinkai

1956 Kamakura-shi Shi Hensan Iinkai. *Kamakura-shi shi: Shiryō hen* (History of the City of Kamakura: Documents). Vol. 2. Tokyo: Yoshikawa Kōbunkan, 1956.

Kameda Tsutomu

1980 *Sesson.* Nihon bijutsu kaiga zenshū (Survey of Japanese Painting), 8. Tokyo: Shūeisha, 1980.

Kamei Masamichi

1995 *Jinbutsu, dōbutsu haniwa* (Haniwa of Humans and Animals). Nihon no bijutsu (Arts of Japan), 346. Tokyo: Shibundō, 1995.

Kamimura Kankō

1936 Editor. *Gozan bungaku zenshū* (Compendium of the Literature of the Five Mountains). 5 vols. Tokyo: Gozan Bungaku Zenshū Kankōkai, 1936.

Kamo no Chōmei

1907 *Hō-jō-ki (Notes from a Ten Foot Square Hut).* Translated by F. Victor Dickens. London: Gowans and Gray, 1907.

Kanagawa Prefectural Museum of Cultural History

1972 *Kamakura no suibokuga: Gasō Shōkei no shūhen* (Ink Painting of the Kamakura Period: The Monk-Painter Shōkei and His Milieu). Exh. cat. Yokohama: Kanagawa Prefectural Museum of Cultural History, 1972.

1989 *Go-Hōjō shi to tōgoku bunka* (The Go-Hōjō Family and Eastern Culture). Exh. cat. Yokohama: Kanagawa Prefectural Museum of Cultural History, 1989.

Kanazawa Hiroshi

1977 *Kaō, Minchō.* Nihon bijutsu kaiga zenshū (Survey of Japanese Painting), 1. Tokyo: Shūeisha, 1977.

1983 *Muromachi kaiga* (Paintings of the Muromachi Period). Nihon no bijutsu (Arts of Japan), 207. Tokyo: Shibundō, 1983.

1994 *Suibokuga: Josetsu, Shūbun, Sōtan* (Ink Painting: Josetsu, Shūbun, and Sōtan). Nihon no bijutsu (Arts of Japan), 334. Tokyo: Shibundō, 1994.

Kanazawa Hiroshi and Kawai Masatomo

1982 *Suiboku no hana to tori: Muromachi no kachō* (Ink Paintings of Birds and Flowers: Birds and Flowers of the Muromachi Period). Kachōga no sekai (The World of Bird-and-Flower Painting), 2. Tokyo: Gakken, 1982.

Kanda, Christine Guth

1985 *Shinzō: Hachiman Imagery and Its Development.* Harvard East Asian Monographs, 119. Cambridge, Mass.: Council on East Asian Studies, Harvard University, 1985.

Kaneko Hiroaki

1991 *Unkei, Kaikei.* Shōgakkan Gallery: Shinpen meihō Nihon no bijutsu (Shōgakkan Gallery: Masterpieces of Japanese Art. New Edition), 13. Tokyo: Shōgakkan, 1991.

1992 *Monju Bosatsu zō* (Images of Monju Bosatsu). Nihon no bijutsu (Arts of Japan), 314. Tokyo: Shibundō, 1992.

Kanmon gyoki

1944 Zoku Gunsho Ruijū Kanseikai, editor. *Kanmon gyoki* (Record of Things Seen and Heard). Tokyo: Kokusho Shuppan Kabushiki Kaisha, 1944.

Kannonkyō emaki

1984 *Kannonkyō emaki* (*Kannonkyō* Painting Scroll). Tokyo: Kadokawa Shoten, 1984.

Kano Einō

1985 *Yakuchū Honchō gashi* (Annotated History of Japanese Painting). Edited by Kasai Masaaki et al. Kyoto: Dōhōsha Shuppan, 1985.

Kano Hiroyuki

1984 "Kinsei itanha gajin no shisōteki kenkyū" (Philosophical Aspects of the Eccentrics of the Edo Period). *Kajima bijutsu zaidan nenpō* 2 (1984), pp. 116–20.

1987 *Soga Shōhaku.* Nihon no bijutsu (Arts of Japan), 258. Tokyo: Shibundō, 1987.

1993 *Jakuchū.* Kyoto: Shikōsha, 1993.

"Kantei hitsu Sansui zu"

1898 "Kantei hitsu Sansui zu" ("Landscape," by Kantei). *Kokka*, no. 105 (June 1898), p. 169.

Kanzaki Kazuko

1991 "Seto chaire no kisoteki kenkyū: Setogama shutsudo no chaire" (Tea Caddies from Seto: Tea Caddies Excavated from Seto Kiln Sites). *Aichi-ken Tōji shiryōkan kenkyū kiyō* 10 (1991), pp. 36–44.

Kasuga

1985 Shinto Taikei Hensankai, editor. *Kasuga.* Shinto taikei: Jinja hen (Compendium on Shinto: Shrines), 13. Tokyo: Shinto Taikei Hensankai, 1985.

Katagiri Yōichi

1972 Editor. *Heian waka utamakura chimei sakuin* (Index of Place Names Used as *utamakura* in Heian-Period *waka*). Kyoto: Daigakudō Shoten, 1972.

Katō Hajime

1961 *Oribe.* Tōki zenshū (Collection of Ceramics), 5. Tokyo: Heibonsha, 1961.

Katsura Matasaburō

1968 *Igayaki tsūshi* (History of Iga Ware). Tokyo: Kawade Shobō, 1968.

Kaufman, Laura

1985 "Practice and Piety: Buddhist Art in Use." *Apollo* 121 (February 1985), pp. 91–99.

Kawada Sadamu

1985 *Negoro.* Kyoto: Shikōsha, 1985.

Kawahara Masahiko

1977 *Karatsu.* Nihon no bijutsu (Arts of Japan), 136. Tokyo: Shibundō, 1977.

Kawai Masatomo

1966 "Yūshō hitsu Shōshō Hakkei zu" (Hsiao-Hsiang Scenery by Kaihō Yūshō). *Bijutsushi*, no. 63 (December 1966), pp. 96–104.

1978 *Yūshō, Tōgan.* Nihon bijutsu kaiga zenshū (Survey of Japanese Painting), 11. Tokyo: Shūeisha, 1978.

1983 *Gohyaku rakan zu* (Paintings of the Five Hundred Rakan). Tokyo: Tokyo to Minato ku Kyōiku Iinkai, 1983.

1986 Editor. *Drucker Collection: Suibokuga meisaku ten/Sansō Collection: Japanese Paintings Collected by Prof. and Mrs. P. F. Drucker.* Exh. cat., Osaka Municipal Museum of Art. Tokyo: Nihon Keizai Shinbunsha, 1986.

1988 "Oguri Sōtan kara Kano Masanobu e" (From Oguri Sōtan to Kano Masanobu). In *International Symposium of the Conservation and Restoration of Cultural Property: Periods of Transition in East Asian Art*, pp. 167–80. Tokyo: Tokyo National Research Institute of Cultural Properties, 1988.

1992 *Muromachi jidai suibokuga no keifu* (Ink Monochrome Painting of the Muromachi Period). Exh. cat. Tokyo: Nezu Institute of Fine Arts, 1992.

Kawamoto Keiko

1991 *Yūshō, Sanraku.* Shōgakkan Gallery, Shinpen meihō Nihon no bijutsu (Shōgakkan Gallery: Masterpieces of Japanese Art. New Edition), 21. Tokyo: Shōgakkan, 1991.

Kawamura Tomoyuki

1981 "Kasuga mandara no seiritsu to girei" (Emergence of the Kasuga Mandala and Its Ritual Background). *Bijutsushi*, no. 110 (March 1981), pp. 86–100.

Kawase Kazuma

1970 *Gozanban no kenkyū* (Study of the Gozan Edition of Medieval Japan). Tokyo: Nihon Kosekisho Kyōkai, 1970.

"Keison hitsu Rokuso"

1927 "Keison hitsu Rokuso oyobi Kachō zu kai" ("Priest Yenō as a Faggot-Seller and

the Birds," by Keison). *Kokka*, no. 436 (March 1927), pp. 73–74.

Kent, Richard K.

1994 "Depictions of the Guardians of the Law: Lohan Painting in China." In *Latter Days of the Law: Images of Chinese Buddhism, 850–1850*, edited by Marsha Weidner, pp. 183–213. Exh. cat. Lawrence: Spencer Museum of Art, University of Kansas, 1994.

1995 "The Sixteen Lohans in the *Pai-miao* Style: From Sung to Early Ch'ing." Ph.D. diss., Princeton University, 1995.

Ki no Tsurayuki

1981 *The Tosa Diary.* Translated by William Ninnis Porter. London, 1912. Reprint. Rutland, Vt.: C. E. Tuttle, 1981.

Kihara Toshie

1995 "Kano Tan'yū no suibokuga ni okeru futatsu no vision" (Two Visions in the Ink Paintings of Kano Tan'yū). *Bijutsushi*, no. 137 (March 1995), pp. 95–115.

1998 *Yūbi no tankyū: Kano Tan'yū ron* (The Search for Profound Delicacy: The Art of Kano Tan'yū). 2 vols. Osaka: Osaka Daigaku Shuppankai, 1998.

Kikuyama Toneo

1936 "Iga no koyō angya" (Pilgrimage to the Old Kilns in Iga). *Chawan* 69 (November 1936), pp. 10–15.

Kim, Hongnam

1991 *The Story of a Painting: A Korean Buddhist Treasure from the Mary and Jackson Burke Foundation.* Exh. cat. New York: Asia Society Galleries, 1991.

Kinoshita Masao

1979 Editor. *Zenshū no bijutsu: Bokuseki to zenshū kaiga* (Arts of Zen Buddhism: Calligraphy and Paintings of Zen). Nihon bijutsu zenshū (Survey of Japanese Art), 14. Tokyo: Gakken, 1979.

1980 *Sanjūrokunin kashū* (Anthologies of Poems by the Thirty-six Immortal Poets). Nihon no bijutsu (Arts of Japan), 168. Tokyo: Shibundō, 1980.

Kinoshita Masashi

1982 *Yayoi jidai* (Yayoi Period). Nihon no bijutsu (Arts of Japan), 192. Tokyo: Shibundō, 1982.

Kinoshita Mitsuun

1975 "Jin'ōji engi" (History of Jin'ōji). *Osaka bunka shi*, no. 1 (May 1975), pp. 154–62.

Kirihata Ken

1983 "Heian, Kamakura, Muromachi no senshoku" (Textiles of the Heian, Kamakura, and Muromachi Periods). *Senshoku no bi*, no. 23 (summer 1983), pp. 9–80.

Kita Haruchiyo

1985 "New York Burke Collection Nihon bijutsu meihin ten" (A Selection of Japanese Art from the Mary and Jackson Burke Collection). *Kobijutsu*, no. 75 (July 1985), pp. 79–85.

"Ko Kano hitsu Hakuga dankin zu kai"

1937 "Ko Kano hitsu Hakuga dankin zu kai" ("Po-ya Playing the Koto," Attributed to Motonobu). *Kokka*, no. 556 (March 1937), pp. 74–78.

Kobayashi Tadashi

1968 "Hanabusa Itchō den: Sono hairu o chūshin to shite" (The Life of Itchō Hanabusa). *Kokka*, no. 920 (November 1968), pp. 5–20.

1972a "Ban'nenki Jakuchū no sakuhin: Suiboku ryakuga o chūshin to shite" (The Work of Jakuchū Itō in His Last Years and the Pictures in *suiboku*). *Kokka*, no. 944 (March 1972), pp. 11–19.

1972b *Tosa Mitsunori e-tekagami* (Tosa Mitsunori Book of Paintings). Kyoto: Fuji Art, 1972.

1988 *Hanabusa Itchō.* Nihon no bijutsu (Arts of Japan), 260. Tokyo: Shibundō, 1988.

1990 Editor. *Rinpa.* Vol. 2, *Kachō* (Seasonal Flowering Plants and Birds). Kyoto: Shikōsha, 1990.

1991 Editor. *Rinpa.* Vol. 3, *Fūgetsu, chōju* (Landscapes, and Animals and Birds). Kyoto: Shikōsha, 1991.

1993 *Senmenga: Kinsei hen* (Fan Paintings: Recent Period). Nihon no bijutsu (Arts of Japan), 321. Tokyo: Shibundō, 1993.

1994 Editor. *Azabu Bijutsu Kōgeikan* (Azabu Museum of Art). Nikuhitsu ukiyo-e taikan (*Ukiyo-e* Paintings), 6. Tokyo: Azabu Museum of Art, 1994.

Kobayashi Tadashi and Kano Hiroyuki

1992 Editors. *Kano ha to fūzokuga: Edo no kaiga I* (The Kano School and Genre Painting: Painting of the Edo Period I). Nihon bijutsu zenshū (Survey of Japanese Art), 17. Tokyo: Kōdansha, 1992.

Kobayashi Tadashi and Kitamura Tetsurō

1982 *Edo no bijinga: Kan'ei, Kanbun-ki no nikuhitsuga* (Paintings of Beautiful Women of the Edo Period: Kan'ei and Kanbun Periods). Tokyo: Gakken, 1982.

Kobayashi Tadashi and Murashige Yasushi

1992 Editors. *Rinpa.* Vol. 5, *Sōgo* (Assorted Themes). Kyoto: Shikōsha, 1992.

Kobayashi Tadashi, Murashige Yasushi, and Haino Akio

1990 *Sōtatsu to Kōrin: Edo no kaiga II, kōgei I* (Sōtatsu and Kōrin: Painting in the Edo Period II, Decorative Art I). Nihon bijutsu zenshū (Survey of Japanese Art), 18. Tokyo: Kōdansha, 1990.

Kobayashi Tadashi and Sakakibara Satoru

1978 *Morikage, Itchō.* Nihon bijutsu kaiga zenshū (Survey of Japanese Painting), 16. Tokyo: Shūeisha, 1978.

Kobayashi Tadashi et al.

1973 *Jakuchū, Shōhaku, Rosetsu.* Suiboku bijutsu taikei (Art of Ink Painting), 14. Tokyo: Kōdansha, 1973.

Kobayashi Taichirō

1947 *Zengetsu Taishi no shōgai to geijutsu* (The Life and Art of Guanxiu). Tokyo: Sōgensha, 1947.

Kobayashi Tatsuo

1979 *Jōmon doki* (Jōmon Earthenware). Nihon no genshi bijutsu (Early Arts of Japan), 1. Tokyo: Kōdansha, 1979.

Kobayashi Yukio

1990 *Haniwa.* Nihon tōji taikei (Survey of Japanese Ceramics), 3. Tokyo: Heibonsha, 1990.

"Kōdaiji"

1995 "Kōdaiji maki-e tokushū" (Special Issue: Kōdaiji). *Kokka*, no. 1192 (1995).

Kōetsu sho Sōtatsu kingindei-e

1978 Kokkasha, editor. *Kōetsu sho Sōtatsu kingindei-e* (Kōetsu's Calligraphy and Sōtatsu's Silver and Gold Underpaintings). Tokyo: Asahi Shinbunsha, 1978.

Koizumi Sakutarō

1926 *Kain Shōja shinkan* (True Mirrors of Kain Shōja). Tokyo: Ōtsuka Kōgeisha, 1926.

Kokinshū

1984 Laurel Rasplica Rodd, with Mary Catherine Henkenius, translators. *Kokinshū: A Collection of Poems Ancient and Modern.* Princeton Library of Asian Translations. Princeton: Princeton University Press, 1984.

Kokon chomonjū

1968 Nagazumi Yasuaki and Shimada Isao, editors. *Kokon chomonjū* (Things Seen and Heard from the Past and Present). Nihon koten bungaku taikei (Compendium of Classical Japanese Literature), 84. Tokyo: Iwanami Shoten, 1968.

Kokuyaku zengaku taisei

1929– *Kokuyaku zengaku taisei* (Collection of
1930 Zen Writings in Japanese Translation). 25 vols. Tokyo: Nishōdō Shoten, 1929–30.

Komatsu Shigemi

1959 "Genji-e ainokami chōshin subeshi: Chōshūki no dokkai o megutte" (A Statement Concerning the Illustrated Genji Scrolls Found in the *Chōshūki*). *Museum*, no. 105 (December 1959), pp. 21–23.

1963 "Kōetsu to Kōetsu-ryū no sho" (The Development of the Calligraphy of Kōetsu and His School). *Yamato bunka*, no. 45 (1963), pp. 10–29.

1977a Editor. *Heiji monogatari ekotoba* (Illustrated Tale of the Heiji). Nihon emaki taisei (Collection of Japanese Handscroll Paintings), 13. Tokyo: Chūōkōronsha, 1977.

1977b Editor. *Shigisan engi* (History of Shigisan). Nihon emaki taisei (Collection of Japanese Handscroll Paintings), 4. Tokyo: Chūōkōronsha, 1977.

1978a Editor. *Ishiyamadera engi* (History of Ishiyamadera). Nihon emaki taisei (Collection of Japanese Handscroll Paintings), 18. Tokyo: Chūōkōronsha, 1978.

1978b Editor. *Obusuma Saburō ekotoba; Ise shin meisho-e uta awase* (Illustrated Tale of Obusuma Saburō; Poetry Competitions about the Famous New Sites in Ise). Nihon emaki taisei (Collection of Japanese Handscroll Paintings), 12. Tokyo: Chūōkōronsha, 1978.

1978c Editor. *Sumiyoshi monogatari emaki; Ono no yukimi gokō emaki* (Illustrated Tale of Sumiyoshi; Illustrated Handscroll of the Royal Snow Viewing). Nihon emaki taisei (Collection of Japanese Handscroll Paintings), 19. Tokyo: Chūōkōronsha, 1978.

1978d Editor. *Mōko shūrai ekotoba* (Paintings of the Mongol Invasions). Nihon emaki taisei (Collection of Japanese Handscroll Paintings), 14. Tokyo: Chūōkōronsha, 1978.

1979 Editor. *Saigyō monogatari emaki* (Illustrated Life of the Monk Saigyō). Nihon emaki taisei (Collection of Japanese Handscroll Paintings), 26. Tokyo: Chūōkōronsha, 1979.

1980 Editor. *Kōetsu shojō I* (The Letters of Kōetsu I). Tokyo: Nigensha, 1980.

1981 Editor. *Kan'ei sanpitsu* (Three Great Calligraphers of the Kan'ei Era). Nihon no sho (Japanese Calligraphy), 10. Tokyo: Chūōkōronsha, 1981.

1983 Editor. *Zen Kunen kassen ekotoba; Heiji monogatari emaki; Yūki kassen ekotoba* (Scroll of the Former Nine Years' War; Illustrated Tale of the Heiji; Scroll of the Battle of Yūki). Zoku Nihon emaki taisei (Collection of Japanese Handscroll Paintings: Supplement), 17. Tokyo: Chūōkōronsha, 1983.

1984a Editor. *San'nō reigenki; Jizō Bosatsu reigenki* (Record of Miracles Performed at the San'nō Shrine; Record of Miracles Performed by Jizō Bosatsu). Zoku Nihon emaki taisei (Collection of Japanese Handscroll Paintings: Supplement), 12. Tokyo: Chūōkōronsha, 1984.

1984b Editor. *Tsuchigumo zōshi; Tengu zōshi; Ōeyama ekotoba* (The Story of Tsuchigumo; The Story of Tengu; The Story of Ōeyama). Zoku Nihon emaki taisei (Collection of Japanese Handscroll Paintings: Supplement), 19. Tokyo: Chūōkōronsha, 1984.

1985a Editor. *Boki ekotoba* (Illustrated Biography of the Monk Kakunyo). Zoku Nihon emaki taisei (Collection of Japanese Handscroll Paintings: Supplement), 4. Tokyo: Chūōkōronsha, 1985.

1985b Editor. *Kohitsu meihin shō* (Selected Masterpieces of Old Calligraphy). 3 vols.

Nihon meiseki sōkan (Collection of Famous Calligraphies of Japan), 95–97. Tokyo: Nigensha, 1985.

1994– Editor. *Heike monogatari emaki* (Illus-
1995 trated Tale of the Heike). 12 vols. Tokyo: Chūōkōronsha, 1994–95.

Kōno Motoaki

1971 "Tani Bunchō hitsu Bakufu zu" ("A Water-Fall," by Bunchō Tani). *Kokka*, no. 930 (February 1971), pp. 32–38.

1976 *Ogata Kōrin*. Nihon bijutsu kaiga zenshū (Survey of Japanese Painting), 17. Tokyo: Shūeisha, 1976.

1978 "Hōitsu no yūnenki sakuhin" (Dated Works by Hōitsu). In Yamane Yūzō 1977–80, vol. 5.

1982a Editor. *Bakumatsu no hyakka-fū: Edo makki no kachō* (One Hundred Flowers from the Late Edo Period: Birds and Flowers from the Late Edo Period). Kachōga no sekai (The World of Bird-and-Flower Painting), 8. Tokyo: Gakken, 1982.

1982b *Kano Tan'yū*. Nihon no bijutsu (Arts of Japan), 194. Tokyo: Shibundō, 1982.

1983 "Suzuki Kiitsu no gagyō" (Works of Suzuki Kiitsu). *Kokka*, no. 1067 (October 1983), pp. 9–25.

1993 Editor. *Kano ha to Rinpa* (The Kano School and Rinpa). Nihon suiboku meihin zufu (Masterpieces of Japanese Ink Painting), 4. Tokyo: Mainichi Shinbunsha, 1993.

1995 "Rosetsu shiron" (A Preliminary Study on Rosetsu). *Bijutsushi ronsō*, no. 11 (1995), pp. 107–50.

Koshinaka Tetsuya, Tokuyama Mitsuru, and Kimura Shigekazu

1981 Editors. *Nagasaki ha no kachōga: Shen Nanpin to sono shūhen* (Bird-and-Flower Painting of the Nagasaki School: Shen Nanpin and His Followers). 2 vols. Kyoto: Fuji Art, 1981.

Kujō Kanezane

1993 *Gyokuyō*. 3 vols. Tokyo: Meicho Kankōkai, 1993.

Kūkai

1972 *Kūkai: Major Works*. Translated by Yoshito S. Hakeda. New York: Columbia University Press, 1972.

Kumagai Nobuo

1933 "Gyokuen Bonpō den" (Bonpō: An Artist and Priest of the Ashikaga Period. A Biographical Study). *Bijutsu kenkyū*, no. 15 (March 1933), pp. 95–113.

Kuno Takeshi

1963 "Shui kontai no Amida Nyorai zō" (A Statue of Golden Amitabha in a Red Robe). *Kobijutsu*, no. 1 (January 1963), pp. 81–83.

1972 "Heian shoki ni okeru Nyorai zō no tenkai II" (The Stylistic Development of Buddha Statues in the Early Heian

Period II). *Bijutsu kenkyū*, no. 283 (September 1972), pp. 93–115.

1976 *Oshidashi butsu to senbutsu* (*Oshidashi butsu* and *senbutsu*). Nihon no bijutsu (Arts of Japan), 118. Tokyo: Shibundō, 1976.

Kuraku Yoshiyuki

1979 *Yayoi doki* (Earthenware of the Yayoi Culture). Nihon no genshi bijutsu (Early Arts of Japan), 3. Tokyo: Kōdansha, 1979.

Kurata Bunsaku

1980 Editor. *Chōkoku* (Sculpture). Zaigai Nihon no shihō (Japanese Art: Selections from Western Collections), 8. Tokyo: Mainichi Shinbunsha, 1980.

1981 *Hōryū-ji: Temple of the Exalted Law. Early Buddhist Art from Japan*. Translated by W. Chie Ishibashi. Exh. cat. New York: Japan Society, 1981.

Kurata Osamu

1967 *Butsugu* (Buddhist Furnishings). Nihon no bijutsu (Arts of Japan), 16. Tokyo: Shibundō, 1967.

Kuroda Taizō, Melinda Takeuchi, and Yamane Yūzō

1995 *Worlds Seen and Imagined: Japanese Screens from the Idemitsu Museum of Arts*. Exh. cat. New York: Asia Society Galleries, 1995.

Kurokawa Harumura

1885– *Zōho Kōko gafu* (Collection of Old
1901 Paintings, with Supplement). Edited by Kurokawa Mayori. 11 vols. Tokyo: Yūrindō, 1885–1901.

Kyoto Furitsu Sōgō Shiryōkan

1967 Editor. *Maki-e*. Kyoto: Kyoto Furitsu Sōgō Shiryōkan, 1967.

Kyoto Municipal University of the Arts Archives

1993 *Hōodō ita-e; Dōshakuga funpon* (Copies of Wood-Panel Paintings at Hōodō; Paintings of Buddhist, Daoist, and Other Religious Figures). Vol. 4 of *Tosa ha kaiga shiryō mokuroku* (Catalogue of Documentary Materials on Tosa-School Paintings). Kyoto: Kyoto Municipal University of the Arts Archives, 1993.

Kyoto National Museum

1933 *Ike Taiga iboku tenrankai mokuroku* (Catalogue of the Exhibition of the Work of Ike Taiga). Exh. cat. Kyoto: Kyoto National Museum, 1933.

1966 *Rakuchū-rakugai zu* (Pictures of Sights in and around Kyoto). Exh. cat. Tokyo: Kadokawa Shoten, 1966.

1971 *Kōdaiji maki-e* (Kōdaiji Lacquerware). Exh. cat. Kyoto: Kyoto National Museum, 1971.

1974 *Kami gami no bijutsu* (The Arts of Japanese Gods). Exh. cat. Kyoto: Kyoto National Museum, 1974.

1974a *Heike nōkyō* (Sutras Donated by the Heike Clan). Exh. cat. Kyoto: Kōrinsha, 1974.

1980 *Kōgei ni miru koten bungaku ishō* (The World of Japanese Classical Literature in Craft Design). Exh. cat. Kyoto: Kyoto National Museum, 1980.

1980– *Tan'yū shukuzu* (Small Sketches by
1981 Kano Tan'yū). 2 vols. Kyoto: Kyoto National Museum, 1980–81.

1981 *Gazō Fudō Myōō* (The Iconography of Fudō Myōō). Exh. cat. Tokyo: Dōhōsha Shuppan, 1981.

1986 *Byakue Kannon zō* (Images of Byakue Kannon). Exh. cat. Kyoto: Kyoto National Museum, 1986.

1990 *Komainu* (Lion Dogs). Exh. cat. Kyoto: Kyoto National Museum, 1990.

1995 *Maki-e: Shikkoku to ōgon no Nihon bi* (*Maki-e*: The Beauty of Black and Gold Japanese Lacquer). Exh. cat. Kyoto: Kyoto National Museum, 1995.

1996 *Muromachi jidai no Kano ha: Gadan seiha e no michi* (The Kano School in the Muromachi Period: On the Road to Artistic Predominance). Exh. cat. Kyoto: Kyoto National Museum, 1996.

1997 *Ōgon no toki, yume no jidai: Momoyama kaiga sanka* (The Age of Gold, the Days of Dreams: In Praise of the Paintings in the Momoyama Period). Exh. cat. Kyoto: Kyoto National Museum, 1997.

Kyūsoshin Noboru

1966 *Nishi Honganjibon Sanjūrokuninshū seisei* (The Nishi Honganji *Sanjūrokuninshū*: Deluxe Version). Tokyo, 1966.

Lee, Sherman E.

1961 *Japanese Decorative Style*. Cleveland: Cleveland Museum of Art, 1961.

Li, Chu-tsing

1962 "The Oberlin *Orchid* and the Problem of P'u-ming." *Archives of the Chinese Art Society of America* 16 (1962), pp. 49–76.

Liezi

1960 A. C. Graham, translator. *The Book of Lieh-tzŭ*. The Wisdom of the East. London: John Murray, 1960.

Lillehoj, Elizabeth Ann

1989 "Soga Chokuan to Nichokuan no zaibei sakuhin ni tsuite" (Paintings by Soga Chokuan and Nichokuan in American Collections). In Nara Prefectural Museum of Art 1989, pp. 46–53.

Link, Howard A., and Kobayashi Tadashi

1991 *Prints by Utagawa Hiroshige in the James A. Michener Collection*. 2 vols. Honolulu: Honolulu Academy of Arts, 1991.

Link, Howard A., and Shinbo Tōru

1980 *Exquisite Visions: Rinpa Paintings from Japan*. Exh. cat. Honolulu: Honolulu Academy of Arts, 1980.

McKelway, Matthew P.

1997 "The Partisan View: *Rakuchū-rakugai* Screens in the Mary and Jackson Burke Collection." *Orientations* 28, no. 2 (February 1997), pp. 48–57.

Makita Tairyō

1955 *Sakugen nyūmin ki no kenkyū* (Study of the Record of Sakugen's Trip to Ming China). Vol. 1. Kyoto: Hōzōkan, 1955.

Man'yōshū

1981 Ian Hideo Levy, translator. *The Ten Thousand Leaves: A Translation of the Man'yōshū, Japan's Premier Anthology of Classical Poetry*. Princeton Library of Asian Translations. Princeton: Princeton University Press, 1981.

Maruo Shōzaburō

1966 Editor. *Nihon chōkokushi kiso shiryō shūsei: Heian jidai, zōzō meiki hen* (Collection of Source Materials for the History of Japanese Sculpture: Heian-Period Buddhist Sculpture and Inscriptions). Vols. 1 and 2. Tokyo: Chūōkōron Bijutsu Shuppan, 1966.

Maruyama Masatake

1963 Editor. *Kanshō bijutsu* (Aesthetic Appreciation). Tokyo: Bijutsu Shuppansha, 1963.

Masuda Takashi

1980 *Kōetsu no tegami* (The Correspondence of Kōetsu). Tokyo: Kawade Shobō Shinsha, 1980.

Matsubara Shigeru

1981 "Beni girai to Kansei no kaikaku" (*Beni girai* and the Renovation of the Kansei Era). *Museum*, no. 358 (January 1981), pp. 27–33.

1985 "Beni girai no hassei to sono haikei" (The Emergence of *beni girai* and Its Background). *Museum*, no. 408 (March 1985), pp. 4–15.

Matsumoto Bunzaburō

1944 *Bukkyōshi zakkō* (Miscellaneous Thoughts on the History of Buddhism). Osaka: Sōgensha, 1944.

Matsumoto Eiichi

1937 *Tonkōga no kenkyū* (Study of Paintings from Dunhuang). Tokyo: Tōhō Bunka Gakuin Tokyo Kenkyūjo, 1937.

Matsunaga, Daigan, and Alicia Matsunaga

1974– *Foundation of Japanese Buddhism*. 2 vols.
1976 Los Angeles and Tokyo: Buddhist Books International, 1974–76.

Matsuo Bashō

1996 *Bashō's Narrow Road: Spring and Autumn Passages. Two Works*. Translated by Hiroaki Sato. Berkeley, Calif.: Stone Bridge Press, 1996.

Matsushima Ken

1985 "Busshi Kaikei no kenkyū" (Study of the Buddhist Sculptor Kaikei). *Kajima bijutsu zaidan nenpō* 3 (1985), pp. 93–99.

Matsushita Hidemaro

1970 *Taiga no sho* (The Calligraphy of Taiga). Tokyo: Chūōkōronsha, 1970.

Matsushita Takaaki

1960 *Muromachi suibokuga* (*Suiboku* Painting of the Muromachi Period). Tokyo: Ōtsuka Kōgeisha, 1960.

1967 *Suibokuga* (Ink Painting). Nihon no bijutsu (Arts of Japan), 13. Tokyo: Shibundō, 1967.

1968 "Hidemori no sūten no sakuhin" (On Several Paintings by Hidemori). *Bukkyō geijutsu*, no. 69 (December 1968), pp. 135–43.

1975 Editor. *Heiji monogatari emaki; Mōko shūrai ekotoba* (Illustrated Tale of the Heiji; Paintings of the Mongol Invasions). Shinshū Nihon emakimono zenshū (Japanese Handscroll Paintings: New Edition), 10. Tokyo: Kadokawa Shoten, 1975.

1977 Editor. *Kawaharadera urayama iseki shutsudohin ni tsuite* (The Relics Excavated from the Site on the Hill behind Kawaharadera). Josei Kenkyūkai hōkokusho, Bukkyō Bijutsu Kenkyū Ueno Kinen Zaidan (Committee on Research, The Ueno Memorial Foundation for Study of Buddhist Art), 4. Kyoto: Kyoto National Museum, 1977.

1979 *Josetsu, Shūbun*. Nihon bijutsu kaiga zenshū (Survey of Japanese Painting), 2. Tokyo: Shūeisha, 1979.

Matsushita Takaaki and Tamamura Takeji

1974 *Josetsu, Shūbun, San Ami*. Suiboku bijutsu taikei (Art of Ink Painting), 6. Tokyo: Kōdansha, 1974.

Matsuura Masaaki

1992 *Bishamonten zō* (Images of Bishamonten). Nihon no bijutsu (Arts of Japan), 315. Tokyo: Shibundō, 1992.

1998 "Bishamonten hō no shōrai to Rajōmon anchi zō" (The Transmission to Japan of the Bishamonten Doctrine and the Bishamonten Statue Enshrined on the Rajōmon Gate). *Bijutsu kenkyū*, no. 370 (March 1998), pp. 285–315.

Mayuyama Junkichi

1966 Editor. *Ōbei shūzō Nihon bijutsu zuroku* (Japanese Art in the West). Tokyo: Mayuyama Ryūsendō, 1966.

1976 *Mayuyama, Seventy Years/Ryūsen shūhō, sōgyo shichijusshūnen kinen*. Vol. 2. Tokyo: Mayuyama Ryūsendō, 1976.

Meech-Pekarik, Julia

1977– "Disguised Scripts and Hidden Poems
1978 in an Illustrated Heian Sutra: *Ashide* and *uta-e* in the *Heike nōgyō*." *Archives of Asian Art* 31 (1977–78), pp. 52–78.

1982 "The Artist's View of Ukifune." In *Ukifune: Love in "The Tale of Genji,"* edited by Andrew Pekarik, pp. 173–215. New York: Columbia University Press, 1982.

1985 "Death of a Samurai." *Apollo* 121 (February 1985), pp. 108–13.

1993	*Rain and Snow: The Umbrella in Japanese Art.* Exh. cat. New York: Japan Society, 1993.

Meigetsuki

1977	Imagawa Fumio, translator. *Kundoku Meigetsuki* (Annotated Text of the Journal of the Full Moon). 6 vols. Tokyo: Kawade Shobō Shinsha, 1977.

Minamoto Toyomune

1930	"Tobatsu Bishamonten zō no kigen" (The Origin of Tobatsu Vaisravana). *Bukkyō bijutsu* 15 (January 1930), pp. 40–55.

1964	Editor. *Tōhaku gasetsu* (Tōhaku's Painting Theory). Tokyo: Wakō Shuppansha, 1964.

1966	*Kōetsu shikishi jō: Germany, Berlin Kokuritsu Hakubutsukan zō* (Kōetsu's *shikishi* in the Collection of the Staatliche Museen Preussischer Kulturbesitz). Kyoto: Kōrinsha Shuppan, 1966.

1967	*Kōetsu tanzaku jō: Yamatane Bijutsukan zō* (Kōetsu's Album of *tanzaku* in the Yamatane Museum of Art). Kyoto: Kōrinsha Shuppan, 1967.

1972	"Soga ha to Asakura bunka" (The Soga School and the Culture of the Asakura Clan). *Kobijutsu*, no. 38 (September 1972), pp. 29–39.

Minamoto Toyomune et al.

1973	Editors. *Budō* (Grapes). Nihon no mon'yō (Decorative Designs of Japan), 13. Kyoto: Kōrinsha Shuppan, 1973.

Minegishi Yoshiaki

1958	*Uta awase no kenkyū* (Study of Poetry Competitions). Tokyo: Sanseidō, 1958.

Miner, Earl Roy, Hiroko Odagiri, and Robert E. Morrell

1985	*The Princeton Companion to Classical Japanese Literature.* Princeton: Princeton University Press, 1985.

Mitani Kazuma

1973	*Edo Yoshiwara zushū* (Pictures of Yoshiwara in Edo). Tokyo: Rippū Shobō, 1973.

Mitsumori Masashi

1985	"Senbutsu zatsu sōkan" (Miscellaneous Views Concerning *senbutsu*). In *Suenaga Sensei beiju kinen kentei ronbunshū* (Studies Dedicated to Dr. Masao Suenaga on the Occasion of His Eighty-eighth Birthday), edited by Suenaga Sensei Beiju Kinenkai, vol. 2, pp. 1531–51. Nara: Nara Meishinsha, 1985.

1986	*Amida Nyorai zō* (Images of Amida Buddha). Nihon no bijutsu (Arts of Japan), 241. Tokyo: Shibundō, 1986.

Mitsuoka Tadanari

1966	*Shigaraki, Iga, Bizen, Tanba.* Tōki zenshū (Collection of Ceramics), 20. Tokyo: Heibonsha, 1966.

Miya Tsugio

1976	*Konji hōtō mandara* (Mandala of Pagodas Written in Golden Scripts). Tokyo: Yoshikawa Kōbunkan, 1976.

Miyajima Shin'ichi

1980	"Shōbyōga ni miru kaiga no hen" (Historical Changes in Japanese Screen Painting). *Bijutsushi*, no. 108 (1980), pp. 119–26.

1984	*Nagasawa Rosetsu.* Nihon no bijutsu (Arts of Japan), 219. Tokyo: Shibundō, 1984.

1986	*Tosa Mitsunobu to Tosa ha no keifu* (Tosa Mitsunobu and the Lineage of the Tosa School). Nihon no bijutsu (Arts of Japan), 247. Tokyo: Shibundō, 1986.

1993	*Senmenga: Chūsei hen* (Fan Paintings: Medieval Period). Nihon no bijutsu (Arts of Japan), 320. Tokyo: Shibundō, 1993.

1994	*Suibokuga: Daitokuji ha to Jasoku* (Ink Painting: The Daitokuji School and Jasoku). Nihon no bijutsu (Arts of Japan), 336. Tokyo: Shibundō, 1994.

Miyake Hisao

1986	"Kamakura jidai no Jōdo shūkyōdan ni okeru zōzō ni kansuru kenkyū" (Study of Sculptural Activities in the Religious Circles of the Jōdo Sect during the Kamakura Period). *Kajima bijutsu zaidan nenpō* 4 (1986), pp. 135–39.

Miyake Kyūnosuke

1955	*Uragami Gyokudō shinsekishū* (The Authentic Works of Uragami Gyokudō). Tokyo: Bijutsu Shuppansha, 1955.

Miyama Susumu

1988	Editor. *Kamakura Bukkyō* (Buddhism in Kamakura). Zusetsu Nihon no Bukkyō (Illustrated History of Japanese Buddhism), 4. Tokyo: Shinchōsha, 1988.

Miyazaki Noriko

1981	"Den Chōnen shōrai jūroku rakan zu kō" (Some Thoughts on the Sixteen Rakan Paintings Brought to Japan by the Monk Chōnen). In *Suzuki Kei Sensei kanreki kinen Chūgoku kaigashi ronshū* (Essays on Chinese Painting in Honor of Professor Suzuki Kei on His Sixtieth Birthday), pp. 153–95. Tokyo: Yoshikawa Kōbunkan, 1981.

Mizoguchi Teijirō et al.

1942	Editors. *Inabadō engi; Ōeyama ekotoba; Kitano honchi* (History of Inabadō; The Story of Ōeyama; The Origins of the Kitano Shrine). Zoku Nihon emakimono shūsei (Japanese Handscroll Paintings: Second Series), 1. Tokyo: Yūzankaku, 1942.

Mizuno Keizaburō, Kon'no Toshifumi, and Suzuki Kakichi

1992	Editors. *Mikkyō jiin to butsuzō: Heian no kenchiku, chōkoku* (Esoteric Buddhist Temples and Sculpture: Architecture and Sculpture of the Heian Period). Nihon bijutsu zenshū (Survey of Japanese Art), 5. Tokyo: Kōdansha, 1992.

Mizuno Keizaburō, Kudō Yoshiaki, and Miyake Hisao

1991	Editors. *Unkei to Kaikei: Kamakura no kenchiku, chōkoku* (Unkei and Kaikei: Architecture and Sculpture of the Kamakura Period). Nihon bijutsu zenshū (Survey of Japanese Art), 10. Tokyo: Kōdansha, 1991.

Mizuo Hiroshi

1966	*Sōtatsu-Kōrin ha gashū* (Paintings of the Sōtatsu-Kōrin School). 4 vols. Kyoto: Kōrinsha Shuppan, 1966.

1968	"Getsuya hakubai zu" ("White Plum Blossoms in the Moonlight"). *Kokka*, no. 910 (January 1968), pp. 32–36.

Mochizuki Shinjō

1940	*Goshun.* Tōyō bijutsu bunko (Library of East Asian Art), 15. Tokyo: Atoriesha, 1940.

"Mokubei"

1967	"Mokubei tokushū" (Special Number Devoted to the Works of Aoki Mokubei). *Yamato bunka*, no. 47 (October 1967).

Mōri Hisashi

1961	*Busshi Kaikei ron* (On the Buddhist Sculptor Kaikei). Tokyo: Yoshikawa Kōbunkan, 1961.

1969	"Kaikei shūi" (Notes on the Sculptor Kaikei). *Bukkyō geijutsu*, no. 71 (July 1969), pp. 22–41.

Mori Senzō

1934	"Maruyama Ōkyo den sakki" (Biographical Notes on Maruyama Ōkyo). *Bijutsu kenkyū*, no. 36 (December 1934), pp. 584–93.

1980	Editor. *Zoku Nihon zuihitsu taisei* (Collection of Japanese Essays: Supplement). Vol. 8. Tokyo: Yoshikawa Kōbunkan, 1980.

Mori Tōru

1958	"Den Fujifusa hitsu no kasen-e ni tsuite" (Portraits of Poets, Attributed to Fujifusa). *Yamato bunka*, no. 26 (June 1958), pp. 37–47.

1965	"Jidai fudō uta awase-e ni tsuite" (Portraits of Poetry Contests of Different Periods)." *Kobijutsu*, no. 8 (March 1965), pp. 25–57.

1978	*Uta awase-e no kenkyū: Kasen-e* (Studies of Paintings of Poetry Competitions: Portraits of the Immortal Poets). Rev. ed. Tokyo: Kadokawa Shoten, 1978.

1979	Editor. *Sanjūrokkasen-e.* (Portraits of the Thirty-six Immortal Poets). Shinshū Nihon emakimono zenshū (Japanese Handscroll Paintings: New Edition), 19. Tokyo: Kadokawa Shoten, 1979.

Morse, Anne Nishimura, and Samuel Crowell Morse

1995	*Object as Insight: Japanese Buddhist Art and Ritual.* Exh. cat. Katonah, N.Y.: Katonah Museum of Art, 1995.

1996 "Object as Insight: Japanese Buddhist Art and Ritual." *Orientations* 27, no. 2 (February 1996), pp. 36–45.

Mostow, Joshua Scott

1996 *Pictures of the Heart: The "Hyakunin isshu" in Word and Image.* Honolulu: University of Hawaii Press, 1996.

Murai Iwao

1971 *Kofun* (Ancient Tombs). Nihon no bijutsu (Arts of Japan), 57. Tokyo: Shibundō, 1971.

Murakami Genzō

1975 "Heike monogatari no sekai" (The World of The Tale of the Heike). In *Heike monogatari emaki* (Illustrated Tale of the Heike). Bessatsu Taiyō, 13. Tokyo: Heibonsha, 1975.

Muraki Chii

1960 "Kusaba Akira shi." *Nihon bijutsu kōgei*, no. 260 (May 1960), pp. 42–48.

Murasaki Shikibu

1955 *Genji monogatari* (The Tale of Genji). Edited by Ikeda Kikan. Tokyo: Asahi Shinbunsha, 1955.

1958 *Murasaki Shikibu nikki.* In Sei Shōnagon and Murasaki Shikibu, *Makura no sōshi; Murasaki Shikibu nikki* (The Pillow Book; The Diary of Murasaki Shikibu). Edited by Ikeda Kikan et al. Nihon koten bungaku taikei (Compendium of Japanese Classical Literature), 19. Tokyo: Iwanami Shoten, 1958.

1976 *The Tale of Genji.* Translated by Edward G. Seidensticker. New York: Alfred A. Knopf, 1976.

1982 *Murasaki Shikibu: Her Diary and Poetic Memoirs. A Translation and Study.* Translated by Richard Bowring. Princeton Library of Asian Translations. Princeton: Princeton University Press, 1982.

Murase, Miyeko

1967 "Japanese Screen Paintings of the Hōgen and Heiji Insurrections." *Artibus Asiae* 29 (spring 1967), pp. 193–228.

1971 *Byōbu: Japanese Screens from New York Collections.* Exh. cat. New York: Asia Society, 1971.

1973 "Fan Paintings Attributed to Sōtatsu: Their Themes and Prototypes." *Ars Orientalis* 9 (1973), pp. 51–77.

1975 *Japanese Art: Selections from the Mary and Jackson Burke Collection.* Exh. cat. New York: The Metropolitan Museum of Art, 1975.

1977 "A Recent Arrival in the Ranks of Great Collectors." *Smithsonian* 8, no. 3 (June 1977), pp. 84–91.

1980a "Sumiyoshi monogatari emaki" (Illustrated Tale of Sumiyoshi). In Akiyama Terukazu 1980a, pp. 114–21.

1980b *Urban Beauties and Rural Charms: Japanese Art from the Mary and Jackson Burke Collection.* Exh. cat. Orlando, Fla.: Lock Haven Art Center, 1980.

1983a *Emaki: Narrative Scrolls from Japan.* Exh. cat. New York: Asia Society, 1983.

1983b *Iconography of The Tale of Genji: Genji monogatari ekotoba.* New York and Tokyo: Weatherhill, 1983.

1985 "Themes from Three Romantic Narratives of the Heian Period." *Apollo* 121 (February 1985), pp. 100–107.

1986 *Tales of Japan: Scrolls and Prints from the New York Public Library.* Exh. cat. Oxford and New York: Oxford University Press, 1986.

1990 *Masterpieces of Japanese Screen Painting: The American Collections.* New York: George Braziller, 1990.

1993 *Jewel Rivers: Japanese Art from the Burke Collection.* Exh. cat. Richmond: Virginia Museum of Fine Arts, 1993.

1995 "The Evolution of *meisho-e* and the Case of *Mu Tamagawa.*" *Orientations* 26, no. 1 (January 1995), pp. 94–100.

1997 "Youthful Manjusri as the Child God of the Wakamiya at the Kasuga Shrine." *The Metropolitan Museum of Art Bulletin* (fall 1997), p. 92.

Murashige Yasushi

1991 Editor. *Rinpa.* Vol. 4, *Jinbutsu* (Scenes from Literature: People). Kyoto: Shikōsha, 1991.

1993 Editor. *Sōtatsu, Kōrin, Hōitsu: Rinpa.* Edo meisaku gajō zenshū (Masterpieces of Painted Albums from the Edo Period), 6. Tokyo: Shinshindō, 1993.

Murata Seiko

1983 "Yamato Bunkakan zō Heian jidai mokuchō joshinzō ni tsuite" (On a Wooden Shinto Goddess of the Heian Period, 794–1184, Owned by the Museum Yamato Bunkakan). *Yamato bunka*, no. 71 (March 1983), pp. 21–31.

Murck, Alfreda

1984 "Eight Views of the Hsiao and Hsiang Rivers by Wang Hung." In Fong et al. 1984, pp. 213–35.

1996 "The Eight Views of Xiao-Xiang and the Northern Song Culture of Exile." *Journal of Sung-Yuan Studies* 26 (1996), pp. 113–44.

Museum of Fine Arts, Boston

1936 *Illustrated Catalogue of a Special Loan Exhibition of Art Treasures from Japan.* Exh. cat. Boston: Museum of Fine Arts, 1936.

Museum of Kyoto

1993 *Kyō no bijinga ten: Koseiha no kyōen— Edo, Meiji, Taishō* (The History of Kyoto's Portraits of Beautiful Women: A Collection of Exceptional Works by Artistic Masters of the Edo Period and the Meiji and Taishō Eras). Kyoto: Museum of Kyoto, 1993.

Nagahiro Toshio

1949 *Hiten no geijutsu* (A Study of *hiten* or Flying Angels). Tokyo: Asahi Shinbunsha, 1949.

1969 *Rikuchō jidai bijutsu no kenkyū* (Representational Art of the Six Dynasties Period). Kyoto Daigaku Jinbun Kagaku Kenkyūjo kenkyū hōkoku (Report of the Research Institute for Humanistic Studies, Kyoto University). Tokyo: Bijutsu Shuppansha, 1969.

Nagasaki Iwao

1993 *Kosode.* Nihon no senshoku, Kyoto Shoin bijutsu sōsho (Kyoto Shoin's Art Library of Japanese Textiles), 4. Kyoto: Kyoto Shoin, 1993.

Nagashima Fukutarō

1944 *Nara bunka no denryū* (Traditions of Nara Culture). Unebi shigaku sōsho (Historical Studies of the Nara Area). Tokyo: Chūōkōronsha, 1944.

Nagazumi Yasuaki et al.

1979 Editors. *Heike monogatari* (The Tale of the Heike). Zusetsu Nihon no koten (Illustrated Japanese Classics), 9. Tokyo: Shūeisha, 1979.

Nagoya City Museum

1984 *Shirarezaru nanga-ka Hyakusen* (The Unappreciated *nanga* Artist Hyakusen). Exh. cat. Nagoya: Nagoya City Museum, 1984.

Naitō Masato

1989 "Katsukawa Shunshō no nikuhitsu bijinga ni tsuite" (On the Paintings of Beauties by Katsukawa Shunshō). *Bijutsushi*, no. 125 (March 1989), pp. 57–81.

Naitō Tōichirō

1932 *Nihon Bukkyō zuzō shi: Yakushi Nyorai, Amida Nyorai* (History of Japanese Buddhist Images: Yakushi Buddha and Amida Buddha). Tokyo: Tōhō Shoin, 1932.

Nakabe Yoshitaka

1989 "Mokuhan kingindei ryōshi sōshoku ni tsuite: Hangi to sono katsuyōhō o chūshin ni" (Concerning the Ornamentation of Papers Imprinted with Gold and Silver Pigment by Blockprinting, with Primary Attention to the Woodblocks and Their Application in the Printing Process). *Yamato bunka*, no. 81 (March 1989), pp. 30–42.

1991 "Den Sōtatsu hitsu Ise monogatari zu shikishi kenkyū josetsu" (A Commentary on the Poem Cards of the "Tales of Ise" Attributed to Sōtatsu). In Murashige Yasushi 1991, pp. 241–45.

Nakagawa Chisaku

1974 *Kutaniyaki* (Kutani Ware). Nihon no bijutsu (Arts of Japan), 104. Tokyo: Shibundō, 1974.

Nakahashi, Gratia Williams

1990 "'The Bodhisattva Jizō Playing a Flute,' by Kano Tan'yū: A New Interpretation."

Orientations 21, no. 12 (December 1990), pp. 36–45.

Nakajima Junji

1968 "Sozai keishiki shugi eno tenraku: Sesshū kei kachōzu byōbu kenkyū II" (Study of Flower-and-Bird Screens by Sesshū and Artists of His School II: Trend for Dominance of Formalistic Units in Compositions). *Museum*, no. 205 (April 1968), pp. 4–21.

1994 *Suibokuga: Shōkei to Sesson* (Ink Painting: Shōkei and Sesson). Nihon no bijutsu (Arts of Japan), 337. Tokyo: Shibundō, 1994.

Nakajima Ryōichi

1982 "Tani Bunchō no Chūgoku sansuiga kenkyū josetsu" (Introduction to the Study of Chinese Landscape Painting by Bunchō Tani). *Kobijutsu*, no. 61 (January 1982), pp. 47–56.

Nakamachi Keiko

1990 "Sakai Hōitsu ni okeru Kōrin ga no keishō to tenkai" (The Preservation and Development of Kōrin's Art in Hōitsu's Oeuvre). *Kajima bijutsu zaidan nenpō* 8 (1990), pp. 87–90.

1992a *Sakai Hōitsu*. Shūkan Artists Japan (Artists Japan Weekly). Tokyo: Shinshūsha, 1992.

1992b "Shinshutsu no Sōtatsu ha Ise monogatari-e shikishi ni tsuite" (Recently Discovered Sōtatsu School *shikishi* Paintings on the *Ise monogatari*). *Kokka*, no. 1154 (1992), pp. 11–28.

Nakamura Kōji

1993 "Jūroku rakan zuzōgaku kotohajime" (The Origin of the Iconography of the Sixteen Arhats). *Bukkyō geijutsu*, no. 206 (January 1993), pp. 15–29.

1996 "Jūroku rakan zuzōgaku kotohajime: Fukuko rakan zu" (The Origin of the Iconography of the Sixteen Arhats: Picture of "Tiger and Arhat"). *Bukkyō geijutsu*, no. 227 (July 1996), pp. 79–97.

Nakamura Tanio

1959a *Sumi-e no bi* (The Beauty of Ink Painting). Tokyo: Meiji Shobō, 1959.

1959b "Tagasode zu byōbu" (A Folding-Screen Picture Called *Tagasode*). *Kokka*, no. 804 (March 1959), pp. 84–91.

1959c "Tesshū Tokusai no gaji" (Paintings by Tesshū Tokusai). *Museum*, no. 98 (May 1959), pp. 20–22.

1966 "Gyokuen Bonpō hitsu Bokuran zu sōfuku" (Pair of "Orchids" by Gyokuen Bonpō). *Kobijutsu*, no. 14 (August 1966), pp. 105–8.

1968 "Sōyū to Gyokuraku: Shinshutsu no Rikka zu o chūshin to shite" (Sōyū and Gyokuraku: On a Recently Discovered Painting of a Flower Arrangement).

Yamato bunka, no. 48 (February 1968), pp. 38–46.

1970 "Bokudō zu, Sekkyakushi hitsu" (Sekkyakushi's Painting of the Ox-Herding Boy). *Nihon bijutsu kōgei*, no. 379 (January 1970), pp. 98–99.

1971 *Sesson to Kantō suibokuga* (Sesson and Ink Painting of the Kantō Region). Nihon no bijutsu (Arts of Japan), 63. Tokyo: Shibundō, 1971.

1972 "Tesshū Tokusai hitsu Rogan zu" ("Geese and Reeds," by Tokusai Tesshū). *Kobijutsu*, no. 38 (September 1972), pp. 79–81.

1973 "Tesshū Tokusai hitsu Ranchikuseki zu" ("Orchids, Bamboos, and Stones," by Tesshū Tokusai). *Kobijutsu*, no. 40 (March 1973), pp. 69–71.

1979 Editor. *Hōitsu ha kachōga fu* (Edo: Rinpa and Artists Surrounding Sakai Hōitsu). Vol. 4. Kyoto: Shikōsha, 1979.

1985 "Koka ni hisui zu: Senka Sōsetsu hitsu" ("Withered Lotus Leaf and a Kingfisher," by Senka Sōsetsu). *Kobijutsu*, no. 76 (October 1985), pp. 129–33.

Nakano Genzō

1986 *Fudō Myōō zō* (Images of Fudō Myōō). Nihon no bijutsu (Arts of Japan), 238. Tokyo: Shibundō, 1986.

Nakano Masaki

1969 *Wakyō* (Japanese Mirrors). Nihon no bijutsu (Arts of Japan), 42. Tokyo: Shibundō, 1969.

Namiki Seiji

1989 "Kōdaiji Mitamaya zushi maki-e kō: Kōdaiji maki-e shiron I" (Study of *maki-e* on the Kōdaiji Mitamaya Shrine: Tentative Thoughts on Kōdaiji *maki-e* I). *Uryū* 12 (1989), pp. 1–10.

Nara National Museum

1964a *Suijaku bijutsu* (Shinto Art). Tokyo: Kadokawa Shoten, 1964.

1964b *Suijaku mandara* (Shinto Mandalas). Tokyo: Kadokawa Shoten, 1964.

1976 *Asuka no senbutsu to sozō* (*Senbutsu* and Clay Sculptures from Asuka). Exh. cat. Nara: Nara National Museum, 1976.

1979 *Shōsōin ten mokuroku* (Exhibition of Shōsōin Treasures). Exh. cat. Nara: Nara National Museum, 1979.

1992 *Tokubetsu ten: Mikkyō kōgei—shinpi no katachi* (Special Exhibition: Applied Art of Japanese Esoteric Buddhism). Exh. cat. Nara: Nara National Museum, 1992.

Nara Prefectural Museum of Art

1989 *Soga Chokuan, Nichokuan no kaiga* (Paintings of Soga Chokuan and Nichokuan). Exh. cat. Nara: Nara Prefectural Museum of Art, 1989.

1994 *Jūsan, jūyonseiki Nihon no suibokuga* (Japanese Ink Painting of the Thirteenth and Fourteenth Centuries). Exh. cat. Nara: Nara Prefectural Museum of Art, 1994.

Narasaki Shōichi

1990 *Hajiki, sueki*. Nihon no tōji: Kodai, chūsei hen (Japanese Ceramics: Ancient and Medieval), 1. Tokyo: Chūōkōron-sha, 1990.

Narazaki Muneshige

1953 "Shinshutsu Tosa Mitsuyoshi hitsu Genji monogatari ejō ni tsuite" (On a Newly-Discovered Picture-Album of the *Genji monogatari*). *Kokka*, no. 736 (July 1953), pp. 191–203.

1955 "Uragami Gyokudō hitsu Yakyō Hōkin zu" ("Landscape," by Gyokudō Uragami). *Kokka*, no. 756 (March 1955), pp. 84–89.

1962 "Sasama-ke zō senmen gajō" (The Album of Fan Paintings in the Sasama Collection). *Kokka*, no. 845 (August 1962), pp. 339–41.

1964 "Kyō meisho fūzoku zu byōbu ni tsuite" (On a Folding-Screen Picture of the Famous Places and the Manners and Customs of Kyoto). *Kokka*, no. 868 (July 1964), pp. 11–17.

1966 "Unchō hitsu Ryūka bijin zu" ("Beautiful Women under a Willow Tree," by Unchō). *Kokka*, no. 894 (September 1966), p. 34.

1969 Editor. *Zaigai hihō: Ōbei shūzō Nihon kaiga shūsei* (Japanese Paintings in Western Collections). Vol. 3, *Nikuhitsu ukiyo-e* (*Ukiyo-e* Paintings). Tokyo: Gakken, 1969.

1971 "Kan'ō gyoraku zu byōbu ("Cherry-Blossom Viewing and Pleasurable Fishing"). *Kokka*, no. 933 (May 1971), pp. 20–25.

1982 Editor. *Shunshō*. Nikuhitsu ukiyo-e (*Ukiyo-e* Paintings), 4. Tokyo: Shūeisha, 1982.

1987 *Nikuhitsu ukiyo-e* (*Ukiyo-e* Paintings). Vol. 1, *Kanbun-Hōreki* (From the Kanbun to the Hōreki Era). Nihon no bijutsu (Arts of Japan), 248. Tokyo: Shibundō, 1987.

Narukami Yoshio

1968 *Ekagami hyakusen* (A Selection of One Hundred Masterpieces of Mirrors with Handles). Tsu, Mie Prefecture: Ekagami Sansō, 1968.

Narusawa Katsutsugu

1985 "Kano Naizen kō" (On Kano Naizen). *Kobe Shiritsu Hakubutsukan kenkyū kiyō* 2 (March 1985), pp. 3–17.

Nedachi Kensuke

1997 *Aizen Myōō zō* (Images of Aizen Myōō). Nihon no bijutsu (Arts of Japan), 376. Tokyo: Shibundō, 1997.

Nezu Institute of Fine Arts

1962 *Shōshō hakkei gashū* (Paintings of the Eight Views of the Xiao and Xiang Rivers). Exh. cat. Tokyo: Nezu Institute of Fine Arts, 1962.

1981 *Kobayashi Collection ten: Muromachi suibokuga o chūshin to shite* (Exhibition of

the Kobayashi Collection: With Emphasis on Muromachi-Period Ink Painting). Tokyo: Nezu Institute of Fine Arts, 1981.

Nezu Institute of Fine Arts and Tokugawa Art Museum

1977　*Chaire* (Tea Caddies). Tokyo: Nezu Institute of Fine Arts; Nagoya: Tokugawa Art Museum, 1977.

Nihon zuihitsu zenshū

1929　Nakatsuka Eijirō, editor. *Nihon ẓuihitsu ẓenshū* (Anthology of Japanese Essays). Vol. 18. Tokyo: Kokumin Tosho Kabushikigaisha, 1929.

Nishida Hiroko

1976　*Ko Imari*. Nihon tōji zenshū (Collection of Japanese Ceramics), 23. Tokyo: Chūōkōronsha, 1976.

1990　*Kutani*. Nihon tōji taikei (Survey of Japanese Ceramics), 22. Tokyo: Heibonsha, 1990.

1998　*Kanan no yakimono: Ki Seto, Oribe, Aode Ko Kutani no genryū o motomete* (The Ceramics of South China: Sources for Ki Seto, Oribe, and Aode Ko Kutani). Exh. cat. Tokyo: Nezu Institute of Fine Arts, 1998.

Nishikawa Kyōtarō

1978　*Bugaku Masks*. Translated by Monica Bethe. Japanese Arts Library, 5. Tokyo: Kōdansha International, 1978.

1983　*Ichiboku ẓukuri to yosegi ẓukuri* (Techniques of One-Block and Assembly-Block Carving). Nihon no bijutsu (Arts of Japan), 202. Tokyo: Shibundō, 1983.

Nishikawa Kyōtarō et al.

1984　Editors. *Kokuhō* (National Treasures). 16 vols. Tokyo: Mainichi Shinbunsha, 1984.

Nishikawa Shinji

1987　Editor. *Byōdōin taikan* (Survey of Byōdōin). 3 vols. Tokyo: Iwanami Shoten, 1987.

Ogisu Jundō

1982　*Takuan oshō nenpu* (Chronology of the Monk Takuan). Kinsei zensō den (Biographies of Zen Monks of Recent Times). Kyoto: Shibunkaku, 1982.

Ogura Hyakunin isshu

1957　Heihachirō Honda, translator. *One Hundred Poems from One Hundred Poets: A Translation of the "Ogura Hyakunin isshu."* Tokyo: Hokuseidō Press, 1957.

Ōhashi Katsuaki

1980　"Kawaradera no zōbutsu to Hakuhō chōkoku no jōgen ni tsuite" (The Production of Buddhist Sculpture at Kawaradera and the Earliest Buddhist Sculpture Made in the Hakuhō Period). *Bukkyō geijutsu*, no. 128 (January 1980), pp. 11–25.

Okada Ken

1998　"Tōji Bishamonten zō: Rajōmon anchi setsu to zōryū nendai ni kansuru kōsatsu" (Tōji's Image of Bishamonten: Thoughts on the Traditional Belief That the Image Was Installed in the Rajōmon Gate and Its Dating). *Bijutsu kenkyū*, no. 370 (March 1998), pp. 259–84.

Okada Rihei

1960　"Matsumura-ke ryakkei to Gekkei (Goshun) den" (Goshun and the History of the Matsumura Family). *Nihon bijutsu kōgei*, no. 266 (November 1960), pp. 2–8.

1978　*Buson*. Haijin no shoga bijutsu (Calligraphy and Painting of the *haikai* Poets), 5. Tokyo: Shūeisha, 1978.

Okamoto Yoshitomo and Takamizawa Tadao

1970　*Nanban byōbu* (*Nanban* Screens). Tokyo: Kajima Shuppankai, 1970.

Okayama Art Museum

1970　*Uragami Gyokudō to sono jidai* (Uragami Gyokudō and His Time). Okayama: Okayama Art Museum, 1970.

Okazaki Jōji

1984　"Mikkyō hōgu" (Sacred Implements of Mikkyō). In *Ten, hōgu, soshi* (*Devas*, Implements, and Patriarchs). Mikkyō bijitsu taikan (Compendium of Esoteric Buddhist Art), 4. Tokyo: Asahi Shinbunsha, 1984.

Okudaira Shunroku

1989　"Ensaki no bijin: Kanbun bijin zu no ichi shikei o megutte" (Beauty on a Veranda: One Form of Kanbun *bijin*, or Beauties of the Kanbun Era). In *Nihon kaigashi no kenkyū* (Studies in the History of Japanese Painting), edited by Yamane Yūzō, pp. 646–90. Yamane Yūzō Sensei Koki Kinenkai. Tokyo: Yoshikawa Kōbunkan, 1989.

"Ōkura Shūkokan"

1934　"Ōkura Shūkokan zō no jūroku rakan zukai" (The Sixteen Rakan Paintings Owned by the Ōkura Shūkokan). *Kokka*, no. 527 (October 1934), pp. 281–82.

Ōmura Seigai

1921　Editor. *Bukkyō ẓuẓō shūko* (Collection of Buddhist Images). Tokyo: Bukkyō Zuzō Shūko Kankōkai, 1921.

Osaka Municipal Museum of Art

1979　*Chūsei byōbu-e* (Folding Screen Paintings of Medieval Japan). Kyoto: Kyoto Shoin, 1979.

1990　*Tokubetsu ten, Kōetsu no sho: Keichō, Gen'na, Kan'ei no meihitsu* (A Special Exhibition, The Calligraphy of Kōetsu: Great Brushes from the Keichō, Gen'na, and Kan'ei Eras). Exh. cat. Osaka: Osaka Municipal Museum of Art, 1990.

Osaka Municipal Museum of Art, Tokugawa Art Museum, and Nezu Institute of Fine Arts

1971　*Mino koto* (Old Potteries from Mino). Osaka: Osaka Municipal Museum of Art; Nagoya: Tokugawa Art Museum; Tokyo: Nezu Institute of Fine Arts, 1971.

Ōta Hirotarō, Yamane Yūzō, and Yonezawa Yoshiho

1990　Editors. *Katsura rikyū* (Katsura Palace). Shōgakkan Gallery: Shinpen meihō Nihon no bijutsu (Shōgakkan Gallery: Masterpieces of Japanese Art. New Edition), 22. Tokyo: Shōgakkan, 1990.

Ōta Hirotarō et al.

1978　Editors. *Kaijūsenji, Gansenji, Jōruriji*. Yamato koji taikan (Ancient *yamato* Temples), 7. Tokyo: Iwanami Shoten, 1978.

Ōta Nanpo

1985–　*Ōta Nanpo ẓenshū* (The Complete Works
1990　of Ōta Nanpo). Edited by Hamada Giichirō. 20 vols. Tokyo: Iwanami Shoten, 1985–90.

Ōtsu City Museum of History

1997　*Ōmi no kyoshō: Kaihō Yūshō* (Kaihō Yūshō: Master Artist of Ōtsu). Exh. cat. Ōtsu, Shiga Prefecture: Ōtsu City Museum of History, 1997.

Ōwaki Kiyoshi

1986　"Senbutsu to oshidashi butsu no dōgenkei shiryō: Natsumehaiji no senbutsu o chūshin to shite" (*Senbutsu* and *oshidashibutsu* Having Common Models: Centering around *senbutsu* from the Temple Ruin of Natsume). *Museum*, no. 418 (January 1986), pp. 4–25.

Ōyama Ninkai

1983　"Tōdaiji zō Konshi ginji Kegongyō zankan (Nigatsudō Yakekyō)" (On the Repair of an Important Cultural Property: Remnants of the *Kegongyō* Sutra Written in Silver on Indigo Paper and Saved from a Fire—"Nigatsudō Yakekyō"). *Gakusō* 5 (March 1983), pp. 143–50.

Ōyama Ninkai and Takasaki Chokudō

1987　*Nihon no shakyō* (Hand-Copied Sutras of Japan). Kyoto: Kyoto Shoin, 1987.

Ozaki Yoshiyuki

1988　"Nishi Honganji no Goshun hitsu Kōsaku zu ni tsuite" ("Farming Scenes" Painted by Goshun at the Nishi Honganji). *Kobijutsu*, no. 85 (1988), pp. 51–69.

1989　"Kansei ki ikō no Goshun ni tsuite" (Goshun in Kansei and Later Periods). *Museum*, no. 455 (February 1989), pp. 24–34.

Paine, Robert Treat, and Alexander C. Soper

1975　*The Art and Architecture of Japan*. Rev. ed. The Pelican History of Art. Harmondsworth, England; Baltimore: Penguin Books, 1975.

Pal, Pratapaditya, and Julia Meech-Pekarik

1988　*Buddhist Book Illuminations*. New York: Ravi Kumar, 1988.

Pal, Pratapaditya, et al.

1984　*Light of Asia: Buddha Sakyamuni in Asian Art*. Exh. cat. Los Angeles: Los Angeles County Museum of Art, 1984.

Pearson, Richard J., et al.

1991 *The Rise of a Great Tradition: Japanese Archaeological Ceramics from the Jōmon through Heian Periods (10,500 B.C.–A.D. 1185)*. Exh. cat., IBM Gallery of Science and Art. [Tokyo]: Agency for Cultural Affairs, Government of Japan; New York: Japan Society, 1991.

1992 *Ancient Japan*. Exh. cat. Washington, D.C.: Arthur M. Sackler Gallery; New York: George Braziller, 1992.

Pekarik, Andrew

1978 *Japanese Ceramics from Prehistoric Times to the Present*. Exh. cat. Southampton, N.Y.: Parrish Art Museum, 1978.

1985a "Japanese Calligraphy and Self-Expression." *Apollo* 121 (February 1985), pp. 84–90.

1985b "Japanese Lacquer: Some Aesthetic Considerations." *Apollo* 121 (February 1985), pp. 124–27.

Plutschow, Herbert Eugen

1973 "Japanese Travel Diaries of the Middle Ages." Ph.D. diss., Columbia University, 1973.

Ragué, Beatrix von

1976 *A History of Japanese Lacquerwork*. Translated by Annie R. de Wasserman. Toronto: University of Toronto Press, 1976.

"Rakan zu"

1918 "Shisei no nenki aru ichi rakan zu ni tsuite" (A Chinese Arhat Painting of the Chih-cheng Era). *Kokka*, no. 337 (June 1918), p. 260.

Rathbun, William J., and Sasaki Jōhei

1980 *Ōkyo and the Maruyama-Shijō School of Japanese Painting*. Exh. cat. Saint Louis: Saint Louis Art Museum, 1980.

Rhodes, Daniel

1970 *Tamba Pottery: The Timeless Art of a Japanese Village*. Tokyo: Kōdansha International, 1970.

Rosenfield, John M.

1967 *Japanese Arts of the Heian Period, 794–1185*. Exh. cat. New York: Asia Society, 1967.

1979 Editor. *Song of the Brush: Japanese Paintings from the Sansō Collection*. Exh. cat. Seattle: Seattle Art Museum, 1979.

Rosenfield, John M., and Fumiko E. Cranston

1999 *Extraordinary Persons: Works by Eccentric, Nonconformist Japanese Artists of the Early Modern Era (1580–1868) in the Collection of Kimiko and John Powers*. Cambridge, Mass.: Harvard University Art Museums, 1999.

Rosenfield, John M., and Elizabeth ten Grotenhuis

1979 *Journey of the Three Jewels: Japanese Buddhist Paintings from Western Collections*. Exh. cat. New York: Asia Society, 1979.

Rosenfield, John M., and Shimada Shūjirō

1970 *Traditions of Japanese Art: Selections from the Kimiko and John Powers Collection*. Exh. cat. Cambridge, Mass.: Fogg Art Museum, Harvard University, 1970.

"Ryūkyō hitsu Kachō zu kai"

1929 "Ryūkyō hitsu Kachō zu kai" ("Birds and Flowers," by Ryūkyō). *Kokka*, no. 461 (April 1929), pp. 100–105.

Sadō koten zenshū

1967 Sen Sōshitsu, editor. *Sadō koten zenshū* (Collection of Classic Writings on the Tea Ceremony). 2nd ed. 12 vols. Kyoto: Tankōsha, 1967.

Saga Prefectural Museum of Kyūshū Ceramics

1991 *Hizen no iro-e "Sono hajimari to hensen" ten* (Polychrome Porcelain in Hizen: Its Early Type and Change of Style. Special Exhibition). Exh. cat. Arita: Saga Prefectural Museum of Kyūshū Ceramics, 1991.

Saigyō

1991 *Saigyō: Poems of a Mountain Home*. Translated by Burton Watson. New York: Columbia University Press, 1991.

Saitō Gyokuzan

1937 *Konrei dōgu zushū* (Illustrated Guide to Trousseaux). Edited by Masamune Atsuo. Nihon koten zenshū (Collection of Japanese Classics). Vol. 2. Tokyo: Nihon Koten Zenshū Kankōkai, 1937.

Sakai Hōitsu

1815 *Kōrin hyakuzu* (A Selection of One Hundred Paintings by Kōrin). 2 vols. [Japan], 1815.

Sakaki Hyakusen

1751 *Gen Min gajin kō* (Biographies of Yuan and Ming Painters). Kyoto: Heian Shorin, 1751.

1777 *Gen Min Shin shoga jinmeiroku* (Catalogue of Paintings and Calligraphy from the Yuan, Ming, and Qing Dynasties). Kyoto: Nakamura Jirōbei; Osaka: Shibukawa Seiemon, 1777.

Sakamoto, Gen

1992 "Painting of Jakō Neko and Problems Concerning the 'Uto Gyoshi' Seal." Unpublished paper, Columbia University, 1992.

1997 "Kano Gyokuraku: Enigmatic Leader of the Odawara Kano School." *Orientations* 28, no. 2 (February 1997), pp. 32–39.

Sakamoto Mitsuru et al.

1982 *Fūzokuga: Nanban fūzoku* (Genre Painting: Genre with *nanban*). Nihon byōbu-e shūsei (Collection of Japanese Screen Paintings), 15. 2nd ed. Tokyo: Kōdansha, 1982.

Sakazaki Shizuka

1917 Editor. *Nihon gadan taikan* (Collection of Essays on Japanese Painting). Tokyo: Mejiro Shoin, 1917.

Sanari Kentarō

1930 Editor. *Yōkyoku taikan* (Collection of Nō Texts). 2 vols. Tokyo: Meiji Shoin, 1930.

Sanjōnishi Sanetaka

1979 *Sanetakakō ki* (The Diary of Lord Sanetaka). Edited by Takahashi Ryūzō. 3rd ed. 13 vols. Tokyo: Zoku Gunsho Ruijū Kanseikai, 1979.

"Sansui zu byōbu"

1910 "Sansui zu byōbu" ("Landscapes," by Tan'yū Kano). *Kokka*, no. 241 (June 1910), pp. 385–86.

Saraswati, Sarasi Kumar

1977 *Tantrayana Art: An Album*. Calcutta: Asiatic Society, 1977.

Sasaki Jōhei

1996 *Edo ki no Kyō gadan: Tsuruzawa ha o chūshin to shite* (Kyoto's Painters during the Edo Period: The Tsuruzawa School). Kyoto: Museum of the School of Humanities, Kyoto University, 1996.

1996a "Ōkyo-ga tōjō no butai: Tsuruzawa ha" (Source for the Emergence of Ōkyo's Painting: Tsuruzawa School Painters). *Nihon bijutsu kōgei*, no. 694 (July 1996), pp. 26–33.

Sasaki Jōhei and Sasaki Masako

1996 *Maruyama Ōkyo kenkyū* (Study of Maruyama Ōkyo). Tokyo: Chūōkōron Bijutsu Shuppan, 1996.

Sasaki Kōzō

1977 *Mokubei, Chikuden*. Nihon bijutsu kaiga zenshū (Survey of Japanese Painting), 21. Tokyo: Shūeisha, 1977.

1983 "Nihon gaka no sakuhin yōshiki no tenkan no keiki ni tsuite: Tanomura Chikuden no baai" (On the Motivations of Stylistic Change of Japanese Painters: The Case of Tanomura Chikuden). *Bijutsushi kenkyū* 20 (1983), pp. 27–39.

Sasaki Kōzō and Okumura Hideo

1979 Editors. *Shintō no bijutsu: Kasuga, Hie, Kumano* (Art of Shinto: Kasuga, Hie, and Kumano). Nihon bijutsu zenshū (Survey of Japanese Art), 11. Tokyo: Gakken, 1979.

Satō Yasuhiro

1981 "Jakuchū ni okeru mosha no igi" (Significance of Copying to Jakuchū). *Museum*, no. 364 (July 1981), pp. 18–34.

1987 *Itō Jakuchū*. Nihon no bijutsu (Arts of Japan), 256. Tokyo: Shibundō, 1987.

1991 *Jakuchū, Shōhaku*. Shōgakkan Gallery: Shinpen meihō Nihon no bijutsu (Shōgakkan Gallery: Masterpieces of Japanese Art. New Edition), 27. Tokyo: Shōgakkan, 1991.

1992 "Un'u no jōkei: Uragami Gyokudō no eroticism" (A Scene of Clouds and Rain: Eroticism Expressed in the Paintings of Uragami Gyokudō). *Museum*, no. 491 (February 1992), pp. 27–38.

Saunders, Ernest Dale

1985 *Mudra: A Study of Symbolic Gestures in Japanese Buddhist Sculpture*. Bollingen Series, 58. New York, 1960. Reprint. Princeton: Princeton University Press, 1985.

Sawa Ryūken

1960 *Mikkyō bijutsu ron* (The Arts of Esoteric Buddhism). Kyoto: Benridō, 1960.

1962 *Butsuzō zuten* (Encyclopedia of the Iconography of Buddhist Icons). Tokyo: Yoshikawa Kōbunkan, 1962.

Schafer, Edward H.

1963 *The Golden Peaches of Samarkand: A Study of Tang Exotics*. Berkeley: University of California Press, 1963.

Schamoni, Wolfgang

1970 *Die Sharebon Santō Kyōden's und ihre literaturgeschichtliche Stellung*. Bonn: Schamoni, 1970.

Schirn Kunsthalle Frankfurt

1990 *Die Kunst des alten Japan: Meisterwerke aus der Mary and Jackson Burke Collection, New York*. Edited by Gunhild Avitabile. Exh. cat. Frankfurt: Schirn Kunsthalle Frankfurt, 1990.

Screech, Timon

1995 *Ō-Edo ijin ōrai* (Foreigner in the Great City of Edo). Translated by Takayama Hiroshi. Tokyo: Maruzen, 1995.

Sei Shōnagon

1958 *Makura no sōshi*. In Sei Shōnagon and Murasaki Shikibu, *Makura no sōshi; Murasaki Shikibu nikki* (The Pillow Book; The Diary of Murasaki Shikibu). Edited by Ikeda Kikan et al. Nihon koten bungaku taikei (Compendium of Japanese Classical Literature), 19. Tokyo: Iwanami Shoten, 1958.

1991 *The Pillow Book of Sei Shōnagon*. Translated by Ivan Morris. New York: Alfred A. Knopf, 1991.

Seigle, Cecilia Segawa

1993 *Yoshiwara: The Glittering World of the Japanese Courtesan*. Honolulu: University of Hawaii Press, 1993.

Sekai bijutsu zenshū

1928 Heibonsha, editor. *Sekai bijutsu zenshū* (Survey of World Art). Vol. 16. Tokyo: Heibonsha, 1928.

Sekine Shun'ichi

1997 *Bonten, Taishakuten zō* (Images of Bonten and Taishakuten). Nihon no bijutsu (Arts of Japan), 375. Tokyo: Shibundō, 1997.

"Sesson hitsu Shichiken suibu zu"

1940 "Sesson hitsu Shichiken suibu zu" ("The Seven Wise Men of the Bamboo Grove in a Drunken Revelry," by Sesson). *Kokka*, no. 591 (February 1940), pp. 40–41.

Shibayama Zenkei

1954 *Jūgyū zu* (Paintings of the Ten Ox-Herding Songs). Tokyo: Kōbundō, 1954.

Shimada Shūjirō

1941 "Sōteki no Shōshō hakkei" (Sung Ti and the Eight Views of the Xiao and Xiang Rivers). *Nanga kanshō* 10, no. 4 (April 1941), pp. 6–13.

1969 Editor. *Zaigai hihō: Ōbei shūzō Nihon kaiga shūsei* (Japanese Paintings in Western Collections). Vol. 1, *Bukkyō kaiga, yamato-e, suibokuga* (Buddhist Painting, yamato-e, and Ink Painting). Vol. 2, *Shōbyōga, Rinpa, bunjinga* (Screen Paintings, Rinpa, and Literati Painting). Tokyo: Gakken, 1969.

1979 Editor. *Suibokuga* (Ink Painting). Zaigai Nihon no shihō (Japanese Art: Selections from Western Collections), 3. Tokyo: Mainichi Shinbunsha, 1979.

1981 Editor. *Tenjin engi emaki; Hachiman engi; Amewakahiko sōshi; Nezumi no sōshi; Bakemono sōshi; Utatane sōshi* (History of the Kitano Tenjin Shrine; History of the Hachiman Shrine; The Story of Amewakahiko; The Story of Mice; The Story of Goblins; The Story of Catnapping). Shinshū Nihon emakimono zenshū, bekkan II, zaigai hen (Japanese Handscroll Paintings: New Edition, Supplement II, Overseas Collections). Tokyo: Kadokawa Shoten, 1981.

1993 "Nikkan to boku-budō" (Jih-kuan and Ink Paintings of Grapes). In *Chūgoku kaigashi kenkyū* (Studies in the History of Chinese Painting), pp. 136–51. Tokyo: Chūōkōron Bijutsu Shuppan, 1993.

Shimada Shūjirō and Iriya Yoshitaka

1987 Editors. *Zenrin gasan: Chūsei suibokuga o yomu* (Inscriptions by Zen Monks on Ink Monochrome Paintings). Tokyo: Mainichi Shinbunsha, 1987.

Shimao Arata

1989 "Jūgo seiki ni okeru Chūgoku kaiga shumi" (The Taste for Chinese Painting in the Fifteenth Century). *Museum*, no. 463 (October 1989), pp. 22–34.

Shimizu, Yoshiaki

1981 "Seasons and Places in *yamato* Landscape and Poetry." *Ars Orientalis* 12 (1981), pp. 1–14.

1988 Editor. *Japan: The Shaping of Daimyo Culture, 1185–1868*. Exh. cat. Washington, D.C.: National Gallery of Art, 1988.

Shimizu, Yoshiaki, and John M. Rosenfield

1984 *Masters of Japanese Calligraphy, 8th–19th Century*. Exh. cat. New York: Asia Society Galleries and Japan House Gallery, 1984.

Shimizu, Yoshiaki, and Carolyn Wheelwright

1976 Editors. *Japanese Ink Paintings from American Collections: The Muromachi Period. An Exhibition in Honor of Shūjiro Shimada*. Exh. cat. Princeton: The Art Museum, Princeton University, 1976.

Shimizu Yoshiko

1960 "Genji monogatari kaiga no ichi hōhō" (Techniques for Illustrating The Tale of Genji). *Kokugo kokubun*, no. 309 (1960), pp. 1–14.

Shin kokinshū

1970 Heihachiro Honda, translator. *The Shin kokinshū: The Thirteenth-Century Anthology Edited by Imperial Edict*. Tokyo: Hokuseidō Press and Eirinsha Press, 1970.

Shinbo Tōru

1970 *Hakubyō emaki* (Handscrolls in the hakubyō Style). Nihon no bijutsu (Arts of Japan), 48. Tokyo: Shibundō, 1970.

1974 "Shinshutsu no Kōanbon Jūgyū zukan: Sorimachi Jūro shi zō" (Recently Discovered Paintings Depicting Zen Enlightenment: The Kōan Scroll of *Jūgyū zu*). *Bukkyō geijutsu*, no. 96 (May 1974), pp. 77–79.

1985 *Besson mandara* (Mandalas of Individual Deities). Tokyo: Mainichi Shinbunsha, 1985.

1990 "Hakubyō Kitano Honji-e" (*Kitano Honji-e* with Ink Drawings). *Bijutsu kenkyū*, no. 347 (March 1990), pp. 1–16.

Shinkai Taketarō and Nakagawa Tadayori

1921 *Rock-Carvings from the Yün-kang Caves*. Tokyo: Bunkyūdō; Peking: Yamamoto Photographic Studio, 1921.

Shinzei kogaku zu

1927 Masamune Atsuo, editor. *Shinzei kogaku zu*. Nihon koten zenshū (Collection of Japanese Classics), 18. 2nd ser. Tokyo: Nihon Koten Zenshū Kankōkai, 1927.

Shirahata Yoshi

1964 "Saigyō monogatari byōbu" (Screens Illustrating the Biography of the Priest Saigyō). *Kobijutsu*, no. 5 (August 1964), pp. 103–4.

1975 *Rinpa kaiga senshū* (Rinpa Paintings). 3 vols. Kyoto: Kyoto Shoin, 1975.

1980 "Heian jidai no kōgei teki mon'yō: Omoni waka tono kanren ni tsuite" (Designs on Decorative Objects in the Heian Period, Especially in Relation to *waka*). In Kyoto National Museum 1980.

Shiseki shūran

1917– Kondō Heijō, editor. *Zoku Shiseki shūran* (Collection of Historical Materials: Supplement). 10 vols. Tokyo: Kondō Shuppanbu, 1917–30.

1967– Shiseki Shūran Kankōkai, editor. *Shintei zoho Shiseki shūran* (New and Expanded Collection of Historical Materials: Supplement). 43 vols. Kyoto: Rinsen Shoten, 1967–68.

Shiten'nōji no Hōmotsu

1992 Executive Committee for the Exhibition "Treasures of the Shiten'nōji Temple and the Worship of Prince Shōtoku." *Shiten'nōji no Hōmotsu to Shōtoku Taishi*

shinkō (Treasures of the Shiten'nōji Temple and the Worship of Prince Shōtoku). Exh. cat., Osaka Municipal Museum of Art and Suntory Museum of Art, Tokyo. Osaka: Executive Committee for the Exhibition "Treasures of the Shiten'nōji Temple and the Worship of Prince Shōtoku," 1992.

"Shōhaku hitsu Shakkyō zu"

1899 "Shōhaku hitsu Shakkyō zu" ("Stone Bridge," by Shōhaku). *Kokka*, no. 118 (October 1899), p. 193.

Shoku Nihongi

1986 Imaizumi Tadayoshi, editor. *Kundoku Shoku Nihongi* (Revised and Expanded History of Japan Continued). Kyoto: Rinsen Shoten, 1986.

Shōsōin Office

1968 *Shōsōin no kaiga* (Paintings in the Shōsōin). Tokyo: Nihon Keizai Shinbunsha, 1968.

Shōtō Art Museum of Shibuya Ward

1995 *Kinsei shūkyō bijutsu no sekai: Hen'yō suru shinbutsu tachi* (The World of Religious Arts in Recent Modern Times: Transformations of Buddhas and Shinto Gods). Exh. cat. Tokyo: Shōtō Art Museum of Shibuya Ward, 1995.

1996 *Moji-e to e-moji no keifu* (Traditions of Writing-Pictures and Picture-Writings). Exh. cat. Tokyo: Shōtō Art Museum of Shibuya Ward, 1996.

Singer, Robert T., et al.

1998 *Edo: Art in Japan, 1615–1868*. Exh. cat. Washington, D.C.: National Gallery of Art, 1998.

Society of the Four Arts

1963 *Japanese Paintings from the Frank E. Hart Collection*. Exh. cat. Palm Beach, Fla.: Society of the Four Arts, 1963.

Songs of the South

1985 David Hawkes, translator. *The Songs of the South: An Ancient Chinese Anthology of Poems by Qu Yuan and Other Poets*. Penguin Classics. Harmondsworth, England; New York: Penguin, 1985.

Soper, Alexander C.

1942 "The Rise of *yamato-e*." *Art Bulletin* 24 (December 1942), pp. 351–79.

1959 *Literary Evidence for Early Buddhist Art in China*. Artibus Asiae, Supplementum, 19. Ascona, Switzerland: Artibus Asiae, 1959.

1961 "A New Chinese Tomb Discovery: The Earliest Representation of a Famous Literary Theme." *Artibus Asiae* 24 (1961), pp. 79–86.

1969 "Some Late Chinese Bronze Images (Eighth to Fourteenth Centuries) in the Avery Brundage Collection, M. H. de Young Museum, San Francisco." *Artibus Asiae* 31 (1969), pp. 32–54.

Spiro, Audrey G.

1990 *Contemplating the Ancients: Aesthetic and Social Issues in Early Chinese Portraiture*. Berkeley: University of California Press, 1990.

Stanley-Baker, Richard

1974 "Gakuō's Eight Views of Hsiao and Hsiang." *Oriental Art*, n.s., 20 (autumn 1974), pp. 284–303.

Stein, Aurel

1921 *Serindia: Detailed Report of Explorations in Central Asia and Westernmost China Carried Out and Described under the Orders of H. M. Indian Government*. 5 vols. Oxford: Clarendon Press, 1921.

Stern, Harold P.

1971 *Rinpa: Masterworks of the Japanese Decorative School*. Exh. cat. New York: Japan Society, 1971.

Su Shi

1991 *Su Dongpo quan ji* (Compilation of Poems by Su Dongpo). Vol. 1. Beijing: Zhongguo Shudian, 1991.

Sugahara Hisao

1967 *Japanese Ink Painting and Calligraphy from the Collection of the Tokiwayama Bunko, Kamakura, Japan*. Translated by Miyeko Murase et al. Exh. cat. Brooklyn: The Brooklyn Museum, 1967.

Sugimoto Hidetarō and Hoshino Suzu

1994 *Gyokudō*. Suibokuga no kyoshō (Great Masters of Ink Painting), 13. Tokyo: Kōdansha, 1994.

Sugimoto Sonoko and Kawai Masatomo

1994 *Yūshō*. Suibokuga no kyoshō (Great Masters of Ink Painting), 4. Tokyo: Kōdansha, 1994.

Sugimura Eiji

1985 *Kameda Bōsai no sekai* (The World of Kameda Bōsai). Tokyo: Miki Shobō, 1985.

"Sumiyoshi monogatari"

1901 Harold Parlett, translator. "The Sumiyoshi monogatari." *Transactions of the Asiatic Society of Japan* 29 (1901), pp. 35–123.

Suntory Museum of Art

1968 *Seikatsu no naka no bi* (Beauty in Life's Accoutrements). Exh. cat. Tokyo: Suntory Museum of Art, 1968.

1981 *Itsuō Bijutsukan meihin ten: Buson to Goshun* (Exhibition of Masterpieces from the Itsuō Art Museum: Buson and Goshun). Exh. cat. Tokyo: Suntory Museum of Art, 1981.

1986 *Sanjūrokkasen-e, Satakebon o chūshin ni* (*Sanjūrokkasen-e*, with Emphasis on the Satake Version). Exh. cat. Tokyo: Suntory Museum of Art, 1986.

1997 *Momoyama hyakusō: Kinsei byōbu-e no sekai* (One Hundred Screens of Momoyama: The World of Screen Painting in the Early Modern Period). Exh. cat. Tokyo: Suntory Museum of Art, 1997.

Suzuki, Daisetz Teitarō

1927 *Essays in Zen Buddhism (First Series)*. London: Luzac and Co., 1927.

1960 *Manual of Zen Buddhism*. New York: Grove Press, 1960.

Suzuki Hiroyuki

1989 "Enjinsai Katō Nobukiyo hitsu Amida sanzon zō" ("Amidtabha Triad," by Nobukiyo Katō). *Bijutsu kenkyū*, no. 343 (February 1989), pp. 37–45.

Suzuki Kei

1964 "Gyokkan Jakufun shiron" (A Study of Yü-chien Jo-fen). *Bijutsu kenkyū*, no. 236 (September 1964), pp. 79–92.

Suzuki Keizō

1952 "Heiji monogatari emaki: Rokuhara kassen no maki" (Paintings in the Scroll of the *Heiji monogatari*: "Battle at Rokuhara"). *Kokka*, no. 727 (October 1952), pp. 309–16.

Suzuki Susumu

1963 *Chikuden*. Tokyo: Nihon Keizai Shinbunsha, 1963.

1970 "Uragami Gyokudō hitsu Zan'u hanson zu" ("Hamlet in Lingering Rain," by Gyokudō Uragami). *Kobijutsu*, no. 30 (June 1970), pp. 143–44.

1972 "Kinsei byōbu-e meisaku ten ni omou koto" (Newly Found Screens). *Kobijutsu*, no. 36 (March 1972), pp. 47–56.

1973 "Yamamoto Baiitsu hitsu Shiki sansui zu" ("Landscape of Four Seasons," by Baiitsu Yamamoto). *Kobijutsu*, no. 40 (March 1973), pp. 79–82.

1974 "Taiga to Gyokuran" (Works of Taiga and Gyokuran). *Kobijutsu*, no. 44 (April 1974), pp. 37–50.

1975 *Ike Taiga*. Nihon no bijutsu (Arts of Japan), 114. Tokyo: Shibundō, 1975.

1978 *Uragami Gyokudō*. Nihon no bijutsu (Arts of Japan), 148. Tokyo: Shibundō, 1978.

Suzuki Susumu and Sasaki Jōhei

1979 *Ike Taiga*. Nihon bijutsu kaiga zenshū (Survey of Japanese Painting), 18. Tokyo: Shūeisha, 1979.

Taishikai zuroku

1912 Hirata Hisashi, editor. *Taishikai zuroku* (Catalogue of the *Taishikai* Tea Ceremony). Tokyo: Hirata Hisashi, 1912.

Tajima Shiichi

1902 Editor. *Shinbi taikan/Selected Relics of Japanese Art*. Vol. 8. Kyoto: Nihon Bukkyō Shinbi Kyōkai, 1902.

1903 *Motonobu gashū* (Paintings by Motonobu). Vol. 2. Tokyo: Shinbi Shoin, 1903.

Takahashi Yoshio

1974 "Utamakura Mu Tamagawa no seiritsu" (Mu Tamagawa as *utamakura*). *Gakuen* 9 (September 1974), pp. 2–21.

Takasaki Fujihiko

1985 *Rakan zu* (Rakan Paintings). Nihon no bijutsu (Arts of Japan), 234. Tokyo: Shibundō, 1985.

Takashimaya Department Store

1965 *Byōbu-e meisaku ten* (Exhibition of Masterpieces of Folding Screens). Exh. cat. Tokyo: Takashimaya Department Store, 1965.

Takeda Kōichi

1986 "Sō Shiseki no kōzu" (Composition in the Paintings of Sō Shiseki). In Yamakawa Takeshi et al. 1986.

Takeda Tsuneo

1967 *Kinsei shoki fūzokuga* (Genre Painting of the Early Modern Period). Nihon no bijutsu (Arts of Japan), 20. Tokyo: Shibundō, 1967.

1974 *Kano Eitoku*. Nihon no bijutsu (Arts of Japan), 94. Tokyo: Shibundō, 1974.

1976 "Tosa Mitsuyoshi to saiga: Kyoto Kokuritsu Hakubutsukan Genji monogatari zujō o megutte" (Tosa Mitsuyoshi and Miniature Painting: On the Album of Scenes from the *Genji monogatari* in the Collection of the Kyoto National Museum). *Kokka*, no. 996 (December 1976), pp. 11–24.

1977a *Kano Eitoku*. Translated and adapted by H. Mack Horton and Catherine Kaputa. Japanese Arts Library, 3. Tokyo and New York: Kōdansha International, 1977.

1977b Editor. *Keibutsuga: Shiki keibutsu* (Landscape: Scenes of Four Seasons). Nihon byōbu-e shūsei (Collection of Japanese Screen Paintings), 9. Tokyo: Kōdansha, 1977.

1977c "Yūraku fūzoku zu no seiritsu to tenkai" (The Formation and Evolution of Paintings of Merry-Making and Genre Scenes). In Takeda Tsuneo et al. 1977.

1978a Editor. *Fūzokuga: Rakuchū-rakugai* (Genre Painting: Scenes in and around the Capital). Nihon byōbu-e shūsei (Collection of Japanese Screen Paintings), 11. Tokyo: Kōdansha, 1978.

1978b *Kano Tan'yū*. Nihon bijutsu kaiga zenshū (Survey of Japanese Painting), 15. Tokyo: Shūeisha, 1978.

1980a Editor. *Fūzokuga: Sairei, kabuki* (Genre Painting: Festivals and Kabuki). Nihon byōbu-e shūsei (Collection of Japanese Screen Paintings), 13. 2nd ed. Tokyo: Kōdansha, 1980.

1980b Editor. *Shōheiga* (Screen Painting). Zaigai Nihon no shihō (Japanese Art: Selections from Western Collections), 4. Tokyo: Mainichi Shinbunsha, 1980.

1997 Editor. *Nihon no bi: Momoyama ten* (The Beauty of Japan: Exhibition of Momoyama-Period Arts). Tokyo: NHK Promotion, 1997.

Takeda Tsuneo and Matsunaga Goichi

1994 *Tan'yū, Morikage*. Suibokuga no kyoshō (Great Masters of Ink Painting), 5. Tokyo: Kōdansha, 1994.

Takeda Tsuneo, Takio Kimiko, and Minami-dani Kei

1982 Editors. *Byōbu-e taikan* (Compendium of Folding Screens). Nihon byōbu-e shūsei (Collection of Japanese Screen Paintings), Supplement. Tokyo: Kōdansha, 1982.

Takeda Tsuneo et al.

1977 Editors. *Fūzokuga: Yūraku, tagasode* (Genre Painting: Pleasures and "Whose Sleeves"). Nihon byōbu-e shūsei (Collection of Japanese Screen Paintings), 14. Tokyo: Kōdansha, 1977.

Taketani Chōjirō

1975 *Chikuden garon: Sanchūjin jōzetsu yakukai* (Chikuden's Treatise on Painting: Commentary on the Superfluous Words by a Mountain Hermit). Tokyo: Kasama Shoin, 1975.

Takeuchi Jun'ichi et al.

1989 *Court and Samurai in an Age of Transition: Medieval Paintings and Blades from The Gotoh Museum, Tokyo*. Exh. cat. New York: Japan Society, 1989.

Takeuchi, Melinda

1992 *Taiga's True Views: The Language of Landscape Painting in Eighteenth-Century Japan*. Stanford, Calif.: Stanford University Press, 1992.

1995 "The Golden Link: Place, Poetry, and Paradise in a Medieval Japanese Design." In Kuroda Taizō, Melinda Takeuchi, and Yamane Yūzō 1995, pp. 30–55.

Takeuchi Misako

1990 "Ryūkyō suisha zu byōbu: Shinshu-tsubon no shōkai o kanete" (On Willow Bridge and Waterwheel Screens: Also Introducing a Newly Discovered Example). *Kokka*, no. 1138 (September 1990), pp. 20–34 (pt. 1); no. 1139 (October 1990), pp. 7–18 (pt. 2).

Takeuchi Shōji

1972 "Kyū Date-ke bon Hakuga dankin zu to Daisen'in Hōjō Ihatsu-kaku shōhekiga" ("Immortal Playing a Harp" Formerly Owned by the Date Family and the Screen Paintings of the Main Hall of the Daisen'in Temple). *Kobijutsu*, no. 39 (December 1972), pp. 87–88.

Tale of Flowering Fortunes

1980 William H. McCullough and Helen Craig McCullough, translators. *A Tale of Flowering Fortunes: Annals of Japanese Aristocratic Life in the Heian Period*. 2 vols. Stanford, Calif.: Stanford University Press, 1980.

"Tale of the Bamboo Cutter"

1956 Donald Keene, translator. "The Tale of the Bamboo Cutter." *Monumenta Nipponica* 11 (January 1956), pp. 329–55.

Tale of the Heike

1988 Helen Craig McCullough, translator. *The Tale of the Heike*. Stanford, Calif.: Stanford University Press, 1988.

Tales of Ise

1968 Helen Craig McCullough, translator. *Tales of Ise: Lyrical Episodes from Tenth-Century Japan*. Stanford, Calif.: Stanford University Press, 1968.

Tamabayashi Haruo

1996 *Shokusanjin no kenkyū* (Study of Shokusanjin). Tokyo: Unebi Shobō, 1944. Reprint. Tokyo: Tokyodō Shuppan, 1996.

Tamagami Takuya

1943 "Byōbu-e to uta to monogatari to" (Screen Paintings, Poetry, and Tales). *Kokugo kokubun*, no. 221 (June 1943), pp. 1–20.

Tamamura Takeji

1983 *Gozan zensō denki shūsei* (Biographies of Zen Priests of Gozan Temples). Tokyo: Kōdansha, 1983.

Tamamushi Satoko

1991 "Muromachi jidai no kingindei-e to Nōami hitsu Shū Hyakku no renga (Gold and Silver Painting in the Muromachi Period and the "Shū Hyakku no renga" by Nōami). *Kokka*, no. 1146 (1991), pp. 21–41.

Tamon'in nikki

1967 *Tamon'in nikki* (Chronicle of Tamon'in). Edited by Tsuji Zen'nosuke. 5 vols. Tokyo: Kadokawa Shoten, 1967.

Tamura Etsuko

1967 "Heiji emaki Rokuhara kassen no maki kotoba-gaki no dankan ni tsuite: Fusete genzon sankan no shoseki ni oyobu" (A Textual Fragment of the Battle of Rokuhara Scroll of the Heiji War Scroll Paintings, with a Detailed Examination of the Calligraphy of the Texts of the Three Existing Scrolls). *Bijutsu kenkyū*, no. 252 (May 1967), pp. 13–31.

Tanabe Saburōsuke

1989 Editor. *Shinbutsu shūgō to shugen* (Shugen and the Syncretism of Buddhism and Shinto). Zusetsu Nihon no Bukkyō (Illustrated History of Japanese Buddhism), 6. Tokyo: Shinchōsha, 1989.

Tanabe Shōzō

1989 *Sue*. Nihon tōji taikei (Survey of Japanese Ceramics), 4. Tokyo: Heibonsha, 1989.

Tanabe, W. J.

1988 *Paintings of the Lotus Sutra*. New York: Weatherhill, 1988.

Tanaka Hisao

1987 Editor. *Meihō seishō* (Treasures from Private Museums of Art in Japan). Tokyo: Mitsui Seimei Hoken Sōgo Kaisha, 1987.

Tanaka Ichimatsu

1953 "Kontai Butsuga-jō to Takuma Tametō" (Buddhist Iconographical MSS of the Twelfth Century and the Buddhist Painter Tametō). *Yamato bunka*, no. 12 (December 1953), pp. 22–27.

1957 "Ike Taiga hitsu Rantei kyokusui, Gako shajitsu zu byōbu" ("Rantei kyokusui" and "Gako shajitsu" by Taiga Ike). *Kokka*, no. 780 (March 1957), pp. 89–97.

1958 "Sesson hitsu Shiki sansui zu byōbu ni tsuite" (The Screen-Painting "Landscapes of Four Seasons" by Sesson). *Bijutsu kenkyū*, no. 198 (May 1958), pp. 1–10.

1959 Editor. *Chōjū giga* (Frolicking Animals and Birds). Nihon emakimono zenshū (Japanese Handscroll Paintings), 3. Tokyo: Kadokawa Shoten, 1959.

1965a "E-Ingakyō dankan gōma zu" (Illustrated Ingakyō Sutra). *Kokka*, no. 881 (August 1965), p. 24.

1965b Editor. *Kōrin* (The Art of Kōrin). Rev. ed. Tokyo: Nihon Keizai Shinbunsha, 1965.

1966 *Nihon kaigashi ronshū* (Collection of Essays on Japanese Painting). Tokyo: Chūōkōron Bijutsu Shuppan, 1966.

1971 "Soga Jasoku to Sōjō o meguru shomondai" (Several Problems on Soga Jasoku and Sōjō)." *Bukkyō geijutsu*, no. 79 (April 1971), pp. 15–35.

1972 *Japanese Ink Painting: Shūbun to Sesshū*. Translated by Bruce Darling. Heibonsha Survey of Japanese Art, 12. Tokyo: Heibonsha, 1972.

1974 *Kaō, Mokuan, Minchō*. Suiboku bijutsu taikei (Art of Ink Painting), 5. Tokyo: Kōdansha, 1974.

Tanaka Ichimatsu and Nakamura Tanio

1973 *Sesshū, Sesson*. Suiboku bijutsu taikei (Art of Ink Painting), 7. Tokyo: Kōdansha, 1973.

Tanaka Ichimatsu and Yonezawa Yoshiho

1970 *Suibokuga* (Ink Painting). Genshoku Nihon no bijutsu (Japanese Art in Color), 11. Tokyo: Shōgakkan, 1970.

1978 *Hakubyōga kara suibokuga e no tenkai* (The Development of Ink Painting from *hakubyō*). Suiboku bijutsu taikei (Art of Ink Painting), 1. Tokyo: Kōdansha, 1978.

Tanaka Ichimatsu et al.

1957– Editors. *Ike Taiga sakuhinshū* (The Works
1959 of Ike Taiga). Tokyo: Chūōkōron Bijutsu Shuppan, 1957–59.

1959 *E-Ingakyō* (Illustrated Sutra of Cause and Effect). Nihon emakimono zenshū (Japanese Handscroll Paintings), 16. Tokyo: Kadokawa Shoten, 1959.

1960 Editors. *Ike Taiga sakuhinshū* (The Works of Ike Taiga). 2 vols. Tokyo: Chūōkōron Bijutsu Shuppan, 1960.

1962 Editors. *Tokugawa Bijutsukan* (Tokugawa Art Museum). Tokyo: Tokyo Chūnichi Shinbun Shuppanbu, 1962.

Tanaka Kaidō

1942 *Koshakyō sōkan* (Collection of Hand-Copied Sutras). Nara: Ikaruga Koshakyō Shuppanbu, 1942.

Tanaka Kisaku

1933 "Sōtatsu zakkō" (Studies on Sōtatsu: A Japanese Painter of the Seventeenth Century). *Bijutsu kenkyū*, no. 20 (August 1933), pp. 362–73.

1936 "Gashi Shūtoku" (Shūtoku: A Priest Painter of the Ashikaga Period). *Bijutsu kenkyū*, no. 54 (June 1936), pp. 236–42.

1941 *Den Sōtatsu hitsu Ise monogatari zu* (Paintings of the "Tales of Ise" Attributed to Sōtatsu). Tokyo: Zōkei Geijutsusha, 1941.

Tanaka Migaku

1981 *Kokyō* (Old Mirrors). Nihon no bijutsu (Arts of Japan), 178. Tokyo: Shibundō, 1981.

Tanaka Shigehisa

1966 "Chōkan o itadaku Jiten Bishamon no nendai" (The Origin of Jiten Bishamon Wearing a Bird-Shaped Crown). *Bukkyō geijutsu*, no. 63 (December 1966), pp. 92–110.

Tanaka Shinbi

1932 *Sōtatsu hitsu Ise monogatari* (Paintings of the "Tales of Ise" by Sōtatsu). Tokyo: Shōkokai, 1932.

1950 *Sanjūrokuninshū* (Anthology of Poems by the Thirty-six Poets). Tokyo: Nihon Keizai Shinbunsha, 1950.

Tanaka Tatsuya

1984 *Nikuhitsu ukiyo-e meihin ten: Saki kaoru Edo no josei bi* (Exhibition of Masterpieces of *ukiyo-e* Paintings: The Beauty of Edo Women, Fragrant and Blossoming). Exh. cat. Nagoya: Asahi Shinbunsha, 1984.

Tanaka Toyozō

1942 "Tansei jakubokushū to Gakō benran" (*Tansei jakubokushū* and *Gakō benran*). *Gasetsu* 69 (September 1942), pp. 601–7 (pt. 1); 70 (October 1942), pp. 665–76 (pt. 2).

Tanaka Yūko

1998 "Watarenai hashi" (Uncrossable Bridge). *Nihon no bigaku* 28 (1998), pp. 36–51.

Tani Shin'ichi

1936 "Gyobutsu gyoga mokuroku" (On the "Gomotsu-Onye mokuroku," or the Catalogue of Chinese Paintings in the Collections of the Ashikaga Shoguns, Compiled by Nōami). *Bijutsu kenkyū*, no. 58 (October 1936), pp. 439–47.

1964 "Rakuchū-rakugai zu byōbu" (Screen Paintings of *rakuchū-rakugai*). *Nihon rekishi*, nos. 191–92 (April–May 1964), pp. 2–4.

Tanomura Chikuden

1916 *Tanomura Chikuden zenshū* (The Collected Writings of Tanomura Chikuden). Edited by Hayakawa Junzaburō. Tokyo: Kokusho Kankōkai, 1916.

Teramoto Naohiko

1964 "Genji-e chinjō kō" (Debates on the Production of Illustrations of The Tale of Genji). *Kokugo to kokubungaku*, no. 486 (September 1964), pp. 26–44 (pt. 1); no. 488 (November 1964), pp. 24–38 (pt. 2).

Tobacco and Salt Museum

1985 *Tabako to Shio no Hakubutsukan* (Tobacco and Salt Museum). Tokyo: Tobacco and Salt Museum, 1985.

Tochigi Prefectural Museum

1994 *Kanzan Jittoku: Egakareta fūkyō no soshi tachi* (Hanshan and Shi-de). Exh. cat. Utsunomiya: Tochigi Prefectural Museum, 1994.

Tochigi Prefectural Museum and Kanagawa Prefectural Museum of Cultural History

1998 *Kantō suibokuga no nihyakunen: Chūsei ni miru kata to image no keifu* (Two Hundred Years of Ink-Painting in the Kantō Region: Lineage of Stylistic Models and Themes in Fifteenth and Sixteenth Century Japan). Exh. cat. Utsunomiya: Tochigi Prefectural Museum; Yokohama: Kanagawa Prefectural Museum of Cultural History, 1998.

Toda, Kenji

1959 "Japanese Screen Paintings of the Ninth and Tenth Centuries." *Ars Orientalis* 3 (1959), pp. 153–66.

Toda Teisuke

1962 "Godai Hokusō no bokuchiku" (Ink Bamboo in the Five Dynasties and Northern Sung). *Bijutsushi*, no. 46 (September 1962), pp. 51–68.

1991 "Ō Ryōshin hitsu Boku-budō zu" ("Grapes in Ink," by Wang Liang-chen). *Kokka*, no. 1143 (1991), p. 23.

Tōdaiji yōroku

1944 Tsutsui Eishun, editor. *Tōdaiji yōroku* (Chronicles of Tōdaiji). Osaka: Zenkoku Shobō, 1944.

Tokiwa Daijō and Sekino Tei

1975 *Chūgoku bunka shiseki* (Monuments of Chinese Culture). Vol. 4. Kyoto: Hōzōkan, 1975.

Tokugawa Art Museum

1983 *The Shogun Age Exhibition from the Tokugawa Art Museum, Japan*. Exh. cat. Tokyo: Shogun Age Exhibition Executive Committee, 1983.

Tokyo Metropolitan Teien Art Museum

1986 *Muromachi bijutsu to Sengoku gadan: Ohta Dōkan kinen bijutsu ten* (Art of the Muromachi and Sengoku Periods: Ohta Dōkan Memorial Art Exhibition). Exh. cat. Tokyo: Tokyo Metropolitan Teien Art Museum, 1986.

Tokyo National Museum

1952 *Sōtatsu-Kōetsu ha zuroku* (The Art of the Sōtatsu-Kōetsu School). Exh. cat. Tokyo: Benridō, 1952.

1965 *Nihon no bunjinga ten* (Exhibition of Japanese Literati Painting). Exh. cat. Tokyo: Tokyo National Museum, 1965.

1971 *Tōyō tōji ten kinen zuroku* (Commemorative Catalogue of the Exhibition of Oriental Ceramics). Exh. cat. Tokyo: Tokyo National Museum, 1971.

1972 *Rinpa.* Exh. cat. Tokyo: Tokyo National Museum, 1972.

1978 *Nihon no sho* (Japanese Calligraphy). Exh. cat. Tokyo: Tokyo National Museum, 1978.

1980 *Cha no bijutsu* (Art of the Tea Ceremony). Exh. cat. Tokyo: Tokyo National Museum, 1980.

1985a *Nihon bijutsu meihin ten: New York Burke Collection/A Selection of Japanese Art from the Mary and Jackson Burke Collection.* Exh. cat. Tokyo: Tokyo National Museum, 1985.

1985b *Nihon no tōji* (Japanese Ceramics). Exh. cat. Tokyo: Tokyo National Museum, 1985.

1988 *Tokubetsu tenkan: Edo-jō shōhekiga no shita-e* (Special Exhibition: Preliminary Paintings for Edo Castle). Exh. cat. Tokyo: Tokyo National Museum, 1988.

1989a *Edo-jō shōhekiga no shita-e* (Preliminary Drawings for the Screen Paintings at Edo Castle). 2 vols. Tokyo: Daiichi Hōki, 1989.

1989b *Muromachi jidai no byōbu-e* (Screen Paintings of the Muromachi Period). Exh. cat. Tokyo: Tokyo National Museum, 1989.

1993 *Yamato-e: Miyabi no keifu* (*Yamato-e*: Japanese Painting in the Tradition of Courtly Elegance). Exh. cat. Tokyo: Tokyo National Museum, 1993.

1998 *Kisshō: Chūgoku bijutsu ni komerareta imi* (*Jixiang*: Auspicious Motifs in Chinese Art). Exh. cat. Tokyo: Tokyo National Museum, 1998.

Tokyo National Museum and Kyoto National Museum

1983 *Boston Bijutsukan shozō Nihon kaiga meihin ten* (Exhibition of Japanese Paintings from the Collection of the Museum of Fine Arts, Boston). Exh. cat. Tokyo: Tokyo National Museum; Kyoto: Kyoto National Museum, 1983.

Tokyo National University of Fine Arts and Music

1977 *Tokyo Geijutsu Daigaku shozō meihin ten: Sōritsu kyūjusshū-nen kinen* (Masterpieces from the Collection of the Tokyo Geijutsu Daigaku: Commemorating Its Ninetieth Anniversary). Exh. cat. Tokyo: Tokyo National Museum and Tokyo National University of Fine Arts and Music, 1977.

Tōkyū Department Store

1972 *Kinsei byōbu-e meisaku ten* (Exhibition of Masterpieces of Folding Screens from Recent Times). Exh. cat. Tokyo: Tōkyū Department Store, 1972.

Tsang, Ka Bo

1996 "The Grapevine as an Allegorical Motif in Chinese Art." *Arts of Asia* 26, no. 2 (1996), pp. 85–94.

Tsuboi Kiyotari

1990 *Yayoi.* Nihon tōji taikei (Survey of Japanese Ceramics), 2. Tokyo: Heibonsha, 1990.

Tsuji Nobuo

1966– "Kano Motonobu (Study of Kano
1970 Motonobu). *Bijutsu kenkyū,* no. 246 (May 1966), pp. 10–29 (pt. 1); no. 249 (November 1966), pp. 129–59 (pt. 2); no. 270 (July 1970), pp. 41–78 (pt. 3); no. 271 (September 1970), pp. 85–126 (pt. 4); no. 272 (November 1970), pp. 150–67 (pt. 5).

1968 "Hanabusa Itchō hitsu Ama yadori zu" (Itchō's "Ama yadori zu"). *Kokka,* no. 920 (November 1968), p. 35.

1969 "Shoki fūzokuga to aibiki zu" (Early Genre Painting and Paintings of Romantic Encounters). *Nihon bijutsu kōgei,* no. 373 (1969), pp. 7–17.

1970 *Kisō no keifu: Matabei—Kuniyoshi* (Lineage of Eccentrics: Matabei—Kuniyoshi) Tokyo: Bijutsu Shuppansha, 1970.

1974 *Jakuchū* (The Life and Works of Jakuchū Itō). Tokyo: Bijutsu Shuppansha, 1974.

1976 *Rakuchū-rakugai zu* (Scenes in and around the Capital). Nihon no bijutsu (Arts of Japan), 121. Tokyo: Shibundō, 1976.

1978 "Suzuki Kiitsu shiron" (The Life and Work of Kiitsu). In Yamane Yūzō 1977–80, vol. 5, pp. 57–72.

1980 Editor. *Bunjinga, shoha* (Literati Painting and Other Schools). Zaigai Nihon no shihō (Japanese Art: Selections from Western Collections), 6. Tokyo: Mainichi Shinbunsha, 1980.

1994 *Sengoku jidai Kano ha no kenkyū: Kano Motonobu o chūshin to shite* (Study on the Early Kano School: Motonobu and His Family of Painters). Tokyo: Yoshikawa Kōbunkan, 1994.

Tsuji Nobuo, Money L. Hickman, and Kōno Motoaki

1981 *Jakuchū, Shōhaku.* Nihon bijutsu kaiga zenshū (Survey of Japanese Painting), 23. Tokyo: Shūeisha, 1981.

Tsuji Nobuo and Itō Shiori

1998 Editors. *Soga Shōhaku ten: Edo no kisai* (Soga Shōhaku Exhibition: Eccentric Artists of the Edo Period). Exh. cat. Chiba: Chiba Municipal Museum, 1998.

Tsuji Nobuo, Kobayashi Tadashi, and Kōno Motoaki

1968 "Hōkokuki: Miyake, Mikura, Niijima santō ni nokoru Hanabusa Itchō no gaseki, Miyagawa Isshō, Kaigetsudō Ando no shiryō nado mo awasete" (Reports: Pictures by Itchō Remaining in Miyake-jima, Mikura-jima, and Niijima Islands). *Kokka,* no. 920 (November 1968), pp. 36–46.

Tsuji Nobuo, Kōno Motoaki, and Yabe Yoshiaki

1991 *Eitoku to shōbyōga: Momoyama no kaiga, kōgei II* (Eitoku and Wall Decorations: Paintings and Crafts of the Momoyama Period II). Nihon bijutsu zenshū (Survey of Japanese Art), 15. Tokyo: Kōdansha, 1991.

Tsukamoto Mizuyo

1989 "Tagasode zu byōbu to ishō" (*Tagasode* Screens and Clothing). *Gunma Kenritsu Joshi Daigaku kiyō* 9 (March 1989), pp. 51–64.

Tsuruta Takeyoshi

1979 "Sō Shigan ni tsuite: Raihaku gajin kenkyū" (Paintings with a Bird on a Pomegranate Branch and a Bird on a Plum Branch by Sung Tzu-yen). *Kokka,* no. 1028 (1979), pp. 35–39.

1993 *Sō Shiseki to Nanpin ha* (Sō Shiseki and the Shen Nanpin School). Nihon no bijutsu (Arts of Japan), 326. Tokyo: Shibundō, 1993.

Tsuzuki Etsuko

1991 "Mokuhan kansubon ryōshi ni okeru Kamishi Sōji no yakuwari" (The Role of Kamishi Sōji in the Ornamentation of Handscroll Papers Printed by Woodblock). *De Arte* 7 (March 1991), pp. 9–28.

Uchida Minoru

1932 *Hiroshige.* Tokyo: Iwanami Shoten, 1932.

Ueda Reijō

1989 *Shingon Mikkyō jisō gaisetsu: Shosonhō to Kanjōbu* (Practices in Shingon Esoteric Buddhism: Individual Icon and Initiation Ceremonies). Vol. 1. Tokyo: Dōhōsha Shuppan, 1989.

Uemura Masurō

1940 *Kōrin.* Tokyo: Takamizawa Mokuhansha, 1940.

Ueno Kenji

1976 "Tani Bunchō shukuzu gasatsu" (Album of Drawings by Tani Bunchō). *Tochigi Prefectural Museum Bulletin,* no. 4 (1976), pp. 37–78.

1986 "Kantō kanryō Uesugi shi to sono shūhen: Kano ha no shutsuji ni furete" (The Uesugi Clan: Governors of the Kantō Region and Their Milieu, Especially in Connection with the Emergence of the Kano School). In Tokyo Metropolitan Teien Art Museum 1986.

Uetani Hajime

1959 "Gion Nankai nenpu" (Chronological Account of the Life of Nankai Gion). *Kokka,* no. 811 (October 1959), pp. 388–92.

1960 "Sakaki Hyakusen nenpu" (Chronological Account of the Life of Hyakusen Sakaki). *Kokka*, no. 825 (December 1960), pp. 483–90.

Ukiyo-e meisaku senshū

1967 Nihon Ukiyo-e Kyōkai, editor. *Ukiyo-e meisaku senshū: Shoki ukiyo-e* (Selected Masterpieces of *ukiyo-e*: Early *ukiyo-e*). Vol. 1. Tokyo: Yamada Shoin, 1967.

Umehara Takeshi

1968 *Rakan: Hotoke to hito tono aida* (Arhats: Between Buddhas and Humans). Kyoto: Tankō Shinsha, 1968.

Umezu Jirō

1934 "Maruyama Ōkyo den" (Biography of Maruyama Ōkyo, a Japanese Painter, 1733–1795. Reprint from the Manuscript Written by Hōsui Okamura, 1770–1845, with an Introduction by Umezu Jirō). *Bijutsu kenkyū*, no. 33 (September 1934), pp. 441–42.

1961 "Suzuriwari emaki sonota: Ko-e no mondai" (On the *Suzuriwari-zōshi* Picture-Scroll). *Kokka*, no. 828 (March 1961), pp. 97–104.

1970 *Emakimono zanketsu no fu* (Thoughts on Fragments of *emakimono*). Tokyo: Kadokawa Shoten, 1970.

Usui Nobuyoshi

1961 "Gyokuen no in" (Seals of Gyokuen Bonpō). *Nihon rekishi*, no. 171 (August 1961), pp. 36–39.

Volker, T.

1954 *Porcelain and the Dutch East India Company, as Recorded in the Dagh-Registers of Batavia Castle, Those of Hirado and Deshima, and Other Contemporary Papers, 1602–1682.* Mededelingen van het Rijksmuseum voor Volkenkunde, Leiden, 11. Leiden: E. J. Brill, 1954.

Wakayama ken Kyōiku Iinkai

1981 *Negoroji bōin ato hakkutsu chōsa gaihō I (1978), II (1979)* (Brief Report on the Excavations of Temple Sites at Negoroji I [1978], II [1979]). Wakayama: Wakayama ken Kyōiku Iinkai, 1981.

Wakayama Prefectural Museum

1986 *Gion Nankai: Zuroku* (The Work of Gion Nankai). Exh. cat. Wakayama: Wakayama Prefectural Museum, 1986.

Watanabe Akiyoshi

1976 *Shōshō hakkei zu* (Paintings of the Eight Views of the Xiao and Xiang Rivers). Nihon no bijutsu (Arts of Japan), 124. Tokyo: Shibundō, 1976.

Watanabe Hajime

1985 *Higashiyama suibokuga no kenkyū* (Study of Ink Painting of the Muromachi Period). Rev. ed. Tokyo: Chūōkōron Bijutsu Shuppan, 1985.

Watsky, Andy

1994 "The Art of the Ensemble: The Tsukubushima Sanctuary, 1570–1615." Ph.D. diss., Princeton University, 1994.

Watt, James C. Y.

1985 *The Sumptuous Basket: Chinese Lacquer with Basketry Panels.* Exh. cat. New York: China House Gallery, 1985.

Watt, James C. Y., and Barbara Brennan Ford

1991 *East Asian Lacquer: The Florence and Herbert Irving Collection.* Exh. cat. New York: The Metropolitan Museum of Art, 1991.

Weigl, Gail Capitol

1980 "The Reception of Chinese Painting Models in Muromachi Japan." *Monumenta Nipponica* 35 (autumn 1980), pp. 257–72.

Weinstein, Lucie Ruth

1978 "The Hōryūji Canopies and Their Continental Antecedents." Ph.D. diss., Yale University, 1978.

Wheelwright, Carolyn

1981 "Kano Shōei." 2 vols. Ph.D. diss., Princeton University, 1981.

1989 *Word in Flower: The Visualization of Classical Literature in Seventeenth-Century Japan.* Exh. cat. New Haven, Conn.: Yale University Art Gallery, 1989.

Wilson, Richard L., and Ogasawara Saeko

1992 *Ogata Kenzan: Zen sakuhin to sono keifu* (Ogata Kenzan: His Life and Complete Work). 4 vols. Tokyo: Yūzankaku, 1992.

Wu Chi-yu

1957 "A Study of Han-shan." *T'oung Pao* 45 (1957), pp. 392–450.

Xuanzang

1958 *Si-yu-ki: Buddhist Records of the Western World. Chinese Accounts of India.* Translated by Samuel Beal. New ed. Calcutta, 1958.

Yabe Yoshiaki

1989 *Kakiemon.* Nihon tōji taikei (Survey of Japanese Ceramics), 20. Tokyo: Heibonsha, 1989.

1990 *Bizen.* Nihon no bijutsu (Arts of Japan), 291. Tokyo: Shibundō, 1990.

Yabumoto Kōzō

1974 "Taiga hitsu Rantei zu hengaku to sōkō" (Plaque with Painting of "Poetry Party at Lan-t'ing" by Taiga and Its Draft). *Kobijutsu*, no. 44 (April 1974), pp. 52–55.

Yamaguchi Keizaburō et al.

1983 *Kiyonaga, Shigemasa.* Nikuhitsu ukiyo-e (*Ukiyo-e* Paintings), 5. Tokyo: Shūeisha, 1983.

Yamaguchi Prefectural Museum of Art

1984 *Unkoku Tōgan to Momoyama jidai* (Unkoku Tōgan and the Momoyama Era). Exh. cat. Yamaguchi: Yamaguchi Prefectural Museum of Art, 1984.

1998 *Zen-dera no eshi tachi* (Painters of Zen Temples). Exh. cat. Yamaguchi: Yamaguchi Prefectural Museum of Art, 1998.

Yamakawa Takeshi

1963 "Nagasawa Rosetsu to sono Nanki ni okeru sakuhin" (Rosetsu Nagasawa and His Works Remaining in Southern Kishū Province). *Kokka*, no. 860 (November 1963), pp. 5–57.

1977a "Maruyama Ōkyo hitsu Shunjū ayu zu" ("Ayu in Spring and Autumn," by Maruyama Ōkyo). *Kokka*, no. 1002 (July 1977), p. 21.

1977b *Ōkyo, Goshun.* Nihon bijutsu kaiga zenshū (Survey of Japanese Painting), 22. Tokyo: Shūeisha, 1977.

1981 "Nagasawa Rosetsu hitsu Taki ni tsuru kame zu byōbu: Dō Sekiheki zu byōbu" ("Landscape with Waterfall, Cranes and Tortoises" and "Red Cliff" by Rosetsu). *Kokka*, no. 1047 (December 1981), p. 22.

Yamakawa Takeshi and Nakajima Ryōichi

1986 Editors. *Sō Shiseki gashū* (The Paintings of Sō Shiseki). Tokyo: Nigensha, 1986.

Yamakawa Takeshi et al.

1986 *Sō Shiseki to sono jidai: Chūgoku tōrai no shaseijutsu gahō* (Sō Shiseki and His Time: Realism Imported from China). Exh. cat. Tokyo: Itabashi Ward Art Museum, 1986.

Yamamoto Hideo

1988 "Unkoku Tōgan no sakufū tenkai ni tsuite" (Stylistic Development in the Art of Unkoku Tōgan). *Bijutsushi*, no. 124 (1988), pp. 148–65.

1994 "Kano Motonobu oyobi sono shūhen gaka no kenkyū: In'ei ni yoru sakuhin no bunrui to seiri" (A Study of Kano Motonobu and His School: The Classification of Their Works Based on Seals). *Kajima bijutsu zaidan nenpō* 11 (1994), pp. 363–71.

Yamamoto Yōko

1989 "Suigetsu Kannon zu no seiritsu ni kansuru ichi kōsatsu" (The Formation of the Moon and Water Guan-yin Image). *Bijutsushi*, no. 125 (March 1989), pp. 28–38.

Yamanaka and Company

1939 *Tōyō kobijutsu tenkan zuroku* (Catalogue of an Exhibition of Antiques). Sale cat. Tokyo: Tokyo Art Club, 1939.

Yamane Yūzō

1962a *Konishi-ke kyūzō Kōrin kankei shiryō to sono kenkyū* (The Life and Work of Kōrin: The Konishi Collection). Vol. 1, *Shiryō* (Documents). Tokyo: Chūōkōron Bijutsu Shuppan, 1962.

1962b *Sōtatsu.* Tokyo: Nihon Keizai Shinbunsha, 1962.

1974 "Den Sōtatsu hitsu Ise monogatari zu shikishi ni tsuite" (Study on the *Ise monogatari shikishi* Attributed to Sōtatsu). *Yamato bunka*, no. 59 (March 1974), pp. 1–27.

1975 "Tawaraya Sōtatsu to ihon Ise monogatari-e oyobi Shukongōshin engi-e: Shinshutsu no Ise monogatari zu byōbu

o chūshin ni" (Tawaraya Sōtatsu and Illustrated Scrolls of *Ise monogatari* and *Shukongōshin engi*). *Kokka*, no. 977 (February 1975), pp. 11–33.

1977– Editor. *Rinpa kaiga ʒenshū* (Paintings
1980 of Rinpa). 5 vols. Tokyo: Nihon Keizai Shinbunsha, 1977–80.

1979 Editor. *Rinpa* (Sōtatsu-Kōrin School). Zaigai Nihon no shihō (Japanese Art: Selections from Western Collections), 5. Tokyo: Mainichi Shinbunsha, 1979.

Yamane Yūzō et al.

1979 *Jinbutsuga: Yamato-e kei jinbutsu* (Figure Painting: *Yamato-e* Figure Paintings). Nihon byōbu-e shūsei (Collection of Japanese Screen Paintings), 5. Tokyo: Kōdansha, 1979.

1994 *Tokubetsu ten, Rinpa: Bi no keishō— Sōtatsu, Kōrin, Hōitsu, Kiitsu* (Special Exhibition, Rinpa: Succession of Beauty—Sōtatsu, Kōrin, Hōitsu, and Kiitsu). Nagoya: Nagoya City Museum, 1994.

Yamaoka Taizō

1978 *Kano Masanobu, Motonobu*. Nihon bijutsu kaiga zenshū (Survey of Japanese Painting), 7. Tokyo: Shūeisha, 1978.

Yamashita Yūji

1985 "Shikibu Terutada no kenkyū: Kantō suibokuga ni kansuru ichi kōsatsu" (A Study of Shikibu Terutada: An Observation about *suiboku* Painting in the Kantō District). *Kokka*, no. 1084 (1985), pp. 11–31.

1993 "Kakei to Muromachi suibokuga" (Xia Gui and Muromachi Ink Painting). In *Nihon bijutsushi no suimyaku* (Currents in Japanese Art History), edited by Tsuji Nobuo Sensei Kanreki Kinenkai. Tokyo: Perikansha, 1993.

Yamauchi Naosaburō

1918 Editor. *Kōrin ʒuroku* (Catalogue of Kōrin's Works). Kyoto: Unsōdō, 1918.

Yanagisawa Taka

1965 "Shōren'in denrai no hakubyō Kongōkai mandara shoson zuyō" (An Ink-Drawing Scroll Representing the Vajradhatu-Mandala Images in the Shōren'in Temple). *Bijutsu kenkyū*, no. 241 (July 1965), pp. 58–80 (pt. 1); no. 242 (September 1965), pp. 93–100 (pt. 2).

1980 Editor. *Bukkyō kaiga* (Buddhist Painting). Zaigai Nihon no shihō (Japanese Art: Selections from Western Collections), 1. Tokyo: Mainichi Shinbunsha, 1980.

1982 "A Study of the Painting Style of the Ryōkai Mandala at the Sai-in, Tōji, with Special Emphasis on Their Relationship to Late T'ang Painting." In *International Symposium on the Conservation and Restoration of Cultural Property: Interregional Influences in East Asian Art History, October 6 to 9, 1981, Tokyo, Japan*, pp. 123–33. Tokyo: Tokyo National Research Institute of Cultural Properties, 1982.

Yasuda, Ken

1948 *Poem Cards (The "Hyakunin isshu" in English)*. Tokyo: Kamakura-bunko, 1948.

Yasumura Toshinobu

1978 "Kano Tan'yū no denki shiryō ni tsuite: Fu Kano Tan'yū nenpu" (On the Historical Materials on Kano Tan'yū's Life, Supplemented by Kano Tan'yū Chronology). *Bunka* 42, nos. 1–2 (September 1978), pp. 17–36.

1993 *Hōitsu to Edo Rinpa* (Hōitsu and Rinpa in Edo). Rinpa Bijutsukan (Rinpa Museum), 3. Tokyo: Shūeisha, 1993.

1998 *Kano Tan'yū*. Shinchō Nihon bijutsu bunko (Shinchōsha Series on Japanese Art), 7. Tokyo: Shinchōsha, 1998.

Yiengpruksawan, Mimi Hall

1987 "One Millionth of a Buddha: The *Hyakumantō Darani* in the Scheide Library." *Princeton University Library Chronicle* 48 (spring 1987), pp. 225–38.

Yokota Tadashi

1976 "Shoki suiboku gaka no rakkan ni tsuite: Omoni zenrin no gaka o chūshin to shite" (Signatures of Early Ink Painters in Zen Circles). *Kobijutsu*, no. 50 (February 1976), pp. 33–40.

Yokoyama Kumiko

1994 "Suzuki Kiitsu kō: Denki oyobi zōkeijō no shomondai" (A Study of Kiitsu's Biography and Characteristics of His Painting). *Bijutsushi*, no. 136 (March 1994), pp. 193–216.

Yonezawa Yoshiho

1959 "Sekkyakushi hitsu Bokudō zu" ("A Cowboy"). *Kokka*, no. 802 (January 1959), pp. 17–18.

"Yosa Buson hitsu Kachō zu kai"

1930 "Yosa Buson hitsu Kachō zu kai" ("A Willow, a Peach-Tree, and Birds," by Buson Yosa). *Kokka*, no. 477 (August 1930), pp. 233–34.

Yoshimura Motoo

1976 *Maki-e*. Vol. 1. Kyoto: Kyoto Shoin, 1976.

Yoshinaga Kuniharu

1983 *Hiten: Indo kara Nihon e* (Flying Angels: From India to Japan). Tokyo: Genryū-sha, 1983.

Yoshioka Yukio

1985 Editor. *Fuji, yanagi, haru, natsu, kusa* (Wisteria, Willow, and Grasses of Spring and Summer). Nihon no ishō (Japanese Design in Art), 9. Kyoto: Kyoto Shoin, 1985.

Yoshizawa Chū

1959 "Ike Taiga ni okeru yōshiki tenkan: Nijūdai, sanjūdai no sakuhin o chūshin to shite" (On the Development of the Pictorial Style of Taiga Ikeno). *Kokka*, no. 811 (October 1959), pp. 359–66.

1974 "Nyoi Dōjin shūshū shogajō ni tsuite" (About the Album of Painting and Calligraphy Collected by Nyoi Dōjin). *Kokka*, no. 975 (November 1974), pp. 9–14.

1975 *Gyokudō, Mokubei*. Suiboku bijutsu taikei (Art of Ink Painting), 13. Tokyo: Kōdansha, 1975.

1978 *Tanomura Chikuden*. Exh. cat. Tokyo: Idemitsu Museum of Arts, 1978.

1986 "Onaji zu no aru Ike Taiga hitsu Rantei kyokusui zu byōbu ni tsuite" (The Screen of the Lan-ting Gathering, by Ikeno Taiga, and Its Duplicate). *Kokka*, no. 1096 (1986), pp. 33–35.

Young, Martie W., and Robert J. Smith

1966 *Japanese Painters of the Floating World*. Exh. cat., Andrew Dickson White Museum of Art, Cornell University. Ithaca, N.Y.: Office of University Publications, Cornell University, 1966.

Zolbrod, Leon M.

1967 *Takiʒawa Bakin*. Twayne's World Authors Series, 20. New York: Twayne Publishers, 1967.

Zōtei kojitsu sōsho

1929 Imaizumi Teisuke, editor. *Zōtei kojitsu sōsho* (Revised and Enlarged Edition of Books on Old Matters). Vol. 21. Tokyo: Yoshikawa Kōbunkan, 1929.

Selected Readings

General

Deutsch, Sanna Saks, and Howard A. Link. *The Feminine Image: Women of Japan*. Exh. cat. Honolulu: Honolulu Academy of Arts, 1985.

Fister, Patricia. *Japanese Women Artists, 1600–1900*. Exh. cat. Lawrence: Spencer Museum of Art, University of Kansas, 1988.

Guth, Christine. *Art of Edo Japan: The Artist and the City, 1615–1868*. Perspectives. New York: Harry N. Abrams, 1996.

The Heibonsha Survey of Japanese Art. 31 vols. Tokyo and New York: Weatherhill and Heibonsha, 1971–80.

Hempel, Rose. *The Golden Age of Japan, 794–1192*. Translated by Katherine Watson. New York: Rizzoli, 1983.

Hirayama Ikuo and Kobayashi Tadashi, editors. *Hizō Nihon bijutsu taikan* (Japanese Art: The Great European Collections). 12 vols. Tokyo: Kōdansha, 1992–94.

Japan Society and Suntory Museum of Art, Tokyo. *From the Suntory Museum of Art: Autumn Grasses and Water. Motifs in Japanese Art*. Exh. cat. New York: Japan Society, 1983.

Japan und Europa, 1543–1929: Eine Austellung der "43. Berliner Festwochen" im Martin-Gropius-Bau, Berlin. Edited by Doris Croissant et al. Exh. cat. Berlin: Berliner Festspiele and Argon, 1993.

Kidder, Edward J. *The Art of Japan*. New York: Park Lane, 1985.

Lee, Sherman E., editor. *Reflections of Reality in Japanese Art*. Exh. cat. Cleveland: Cleveland Museum of Art, 1977.

————. *A History of Far Eastern Art*. 5th ed. New York: Harry N. Abrams, 1994.

Mason, Penelope. *History of Japanese Art*. New York: Harry N. Abrams, 1993.

The Metropolitan Museum of Art. *Momoyama: Japanese Art in the Age of Grandeur*. Exh. cat. New York: The Metropolitan Museum of Art, 1975.

Murase, Miyeko. *Japanese Art: Selections from the Mary and Jackson Burke Collection*. Exh. cat. New York: The Metropolitan Museum of Art, 1975.

————. *Jewel Rivers: Japanese Art from the Burke Collection*. Exh. cat. Richmond: Virginia Museum of Fine Arts, 1993.

Museum of Fine Arts. *Courtly Splendor: Twelve Centuries of Treasures from Japan*. Exh. cat. Boston: Museum of Fine Arts, 1990.

Nihon bijutsu zenshū (Survey of Japanese Art). 26 vols. Tokyo: Kōdansha, 1990–94.

Nihon bijutsukan (The Art Museum of Japan). Tokyo: Shōgakkan, 1997.

Nihon no bijutsu (Arts of Japan), no. 1–. Tokyo: Shibundō, 1966–.

Noma Seiroku. *The Arts of Japan*. 2 vols. Translated and adapted by John M. Rosenfield and Glenn T. Webb. Tokyo and New York: Kōdansha International, 1978.

Paine, Robert Treat, and Alexander C. Soper. *The Art and Architecture of Japan*. 3rd ed. The Pelican History of Art. New Haven, Conn.: Yale University Press, 1981.

Piggott, Juliet. *Japanese Mythology*. Rev. ed. Library of the World's Myths and Legends. New York: Peter Bedrick Books, 1983.

Roberts, Laurance P. *A Dictionary of Japanese Artists: Painting, Sculpture, Ceramics, Prints, Lacquer*. New York: Weatherhill, 1990.

Rosenfield, John M., Fumiko E. Cranston, and Edwin A. Cranston. *The Courtly Tradition in Japanese Art and Literature: Selections from the Hofer and Hyde Collections*. Cambridge, Mass.: Fogg Art Museum, Harvard University, 1973.

Rosenfield, John M., and Shimada Shūjirō. *Traditions of Japanese Art: Selections from the Kimiko and John Powers Collection*. Exh. cat. Cambridge, Mass.: Fogg Art Museum, Harvard University, 1970.

Shimada Shūjirō, editor. *Zaigai hihō: Ōbei shuzō Nihon kaiga shūsei* (Japanese Paintings in Western Collections). Vol. 1, *Bukkyō kaiga, yamato-e, suibokuga* (Buddhist Painting, *yamato-e*, and Ink Painting). Vol. 2, *Shōbyōga, Rinpa, bunjinga* (Screen Paintings, Rinpa, and Literati Painting). Tokyo: Gakken, 1969.

Shimizu, Yoshiaki, editor. *Japan: The Shaping of Daimyo Culture, 1185–1868*. Exh. cat. Washington, D.C.: National Gallery of Art, 1988.

Singer, Robert T., et al. *Edo: Art in Japan, 1615–1868*. Exh. cat. Washington, D.C.: National Gallery of Art, 1998.

Stanley-Baker, Joan. *Japanese Art*. New York: Thames and Hudson, 1984.

Tokyo National Museum. *Muromachi jidai no bijutsu* (Art of the Muromachi Period). Tokyo: Tokyo National Museum, 1989.

Tsuji Nobuo. *Nihon bijutsushi* (A Concise History of Japanese Art). Tokyo: Bijutsu Shuppan-sha, 1991.

Varley, Paul, and Kumakura Isao, editors. *Tea in Japan: Essays on the History of Chanoyu*.

Honolulu: University of Hawaii Press, 1984.

Watson, William, editor. *The Great Japan Exhibition: Art of the Edo Period, 1600–1868.* Exh. cat. London: Royal Academy of Arts, 1981.

Yamane Yūzō and Yonezawa Yoshiho, editors. *Shōgakkan Gallery: Shinpen meihō Nihon no bijutsu* (Shōgakkan Gallery: Masterpieces of Japanese Art. New Edition). 33 vols. Tokyo: Shōgakkan, 1991–93.

Zaigai Nihon no shihō (Japanese Art: Selections from Western Collections). 10 vols. Tokyo: Mainichi Shinbunsha, 1979–81.

Archeology

Aikens, C. Melvin, and Higuchi Takayasu. *Prehistory of Japan.* Studies in Archaeology. New York: Academic Press, 1982.

Ishino Hironobu, editors. *Kofun jidai no kenkyū* (Study of the Kofun Period). 13 vols. Tokyo: Yūzankaku, 1990–93.

Kanazeki Hiroshi and Sahara Makoto, editors. *Yayoi bunka no kenkyū* (Study of Yayoi Culture). 10 vols. Tokyo: Yūzankaku, 1985.

Pearson, Richard J., et al. *The Rise of a Great Tradition: Japanese Archaeological Ceramics from the Jōmon through Heian Periods (10,500 B.C.–A.D. 1185).* Exh. cat., IBM Gallery of Science and Art. [Tokyo]: Agency for Cultural Affairs, Government of Japan; New York: Japan Society, 1991.

———. *Ancient Japan.* Exh. cat. Washington, D.C.: Arthur M. Sackler Gallery; New York: George Braziller, 1992.

———, editors. *Windows on the Japanese Past: Studies in Archaeology and Prehistory.* Ann Arbor: Center for Japanese Studies, University of Michigan, 1986.

Tanabe Shōzō, editor. *Sueki taisei* (Collection of Sue Ware). Tokyo: Kadokawa Shoten, 1981.

Tanaka Migaku. *Kodai Nihon o hakkutsu suru* (Excavating Ancient Japan). 6 vols. Tokyo: Iwanami Shoten, 1984–91.

Tanaka Migaku and Sahara Makoto, editors. *Kodaishi fukugen* (Restoration of Ancient Japan). 10 vols. Tokyo: Kōdansha, 1988–90.

Tsuboi Kiyotari. *Nihon no genshi bijutsu* (Early Arts of Japan). Tokyo: Kōdansha, 1977–79.

Shinto and Buddhist Art

Art Institute of Chicago. *The Great Eastern Temple: Treasures of Japanese Buddhist Art from Tōdai-ji.* Exh. cat. Chicago: Art Institute of Chicago, 1986.

Chingen. *Miraculous Tales of the Lotus Sutra from Ancient Japan: The "Dainihonkoku hokekyōkenki" of Priest Chingen.* Translated by Dykstra Yoshiko Kurata. Honolulu: University of Hawaii Press, 1987.

Cunningham, Michael R., John M. Rosenfield, and Mimi Hall Yiengpruksawan. *Buddhist Treasures from Nara.* Exh. cat. Cleveland: Cleveland Museum of Art, 1998.

Fukuyama Toshio. *Heian Temples: Byōdō-in and Chūson-ji.* Translated by Ronald K. Jones. The Heibonsha Survey of Japanese Art, 9. New York: Weatherhill, 1976.

Goepper, Roger. *Aizen-Myōō: The Esoteric King of Lust. An Iconological Study.* Artibus Asiae, Supplementum, 39. Zurich: Artibus Asiae, 1993.

Grotenhuis, Elizabeth ten. *Japanese Mandalas: Representations of Sacred Geography.* Honolulu: University of Hawaii Press, 1999.

Hamada Takashi and Nishikawa Kyōtarō, editors. *Bukkyō bijutsu nyūmon* (Survey of Buddhist Art). 6 vols. Tokyo: Heibonsha, 1989–92.

Harris, Victor, and Matsushima Ken. *Kamakura: The Renaissance of Japanese Sculpture, 1185–1333.* Exh. cat. London: Trustees of the British Museum, 1991.

Ishida Ichirō. *Jōdokyō bijutsu: Bunkashigaku-teki kenkyū joron* (The Art of Pure Land Buddhism: A Study in Cultural History). Rev. ed. Tokyo: Perikansha, 1991.

Kageyama Haruki and Christine Guth Kanda. *Shinto Arts: Nature, Gods, and Man in Japan.* Exh. cat. New York: Japan Society, 1976.

Kanda, Christine Guth. *Shinzō: Hachiman Imagery and Its Development.* Harvard East Asian Monographs, 119. Cambridge, Mass.: Council on East Asian Studies, Harvard University, 1985.

Kurata Bunsaku. *Hōryū-ji: Temple of the Exalted Law. Early Buddhist Art from Japan.* Translated by W. Chie Ishibashi. Exh. cat. New York: Japan Society, 1981.

Kurata Bunsaku and Tamura Yoshirō. *Art of the Lotus Sutra: Japanese Masterpieces.* Translated by Edna B. Crawford. Tokyo: Kōsei Publishing Company, 1987.

Kyoto National Museum. *Kami gami no bijutsu* (The Arts of Japanese Gods). Exh. cat. Kyoto: Kyoto National Museum, 1974.

LaFleur, William. *The Karma of Words: Buddhism and the Literary Arts in Medieval Japan.* Berkeley: University of California Press, 1983.

Mikkyō bijutsu taikan (Survey of the Art of Esoteric Buddhism). 4 vols. Tokyo: Asahi Shinbunsha, 1983–84.

Mizuno Kōgen. *Buddhist Sutras: Origin, Development, Transmission.* Tokyo: Kōseisha, 1982.

Morse, Anne Nishimura, and Samuel Crowell Morse. *Object as Insight: Japanese Buddhist Art and Ritual.* Exh. cat. Katonah, N.Y.: Katonah Museum of Art, 1995.

Nara National Museum. *Suijaku bijutsu* (Shinto Art). Tokyo: Kadokawa Shoten, 1964.

Nishikawa Kyōtarō and Emily J. Sano. *The Great Age of Japanese Buddhist Sculpture, A.D. 600–1300.* Exh. cat. Fort Worth, Tex.: Kimbell Art Museum; New York: Japan Society, 1982.

Ōta Hirotarō, Nakamura Hajime, and Hamada Takashi. *Zusetsu Nihon no Bukkyō* (Illustrated History of Japanese Buddhism). 6 vols. Tokyo: Shinchōsha, 1988–90.

Pal, Pratapaditya, and Julia Meech-Pekarik. *Buddhist Book Illuminations.* New York: Ravi Kumar, 1988.

Pal, Pratapaditya, et al. *Light of Asia: Buddha Sakyamuni in Asian Art.* Exh. cat. Los Angeles: Los Angeles County Museum of Art, 1984.

Rosenfield, John M., and Elizabeth ten Grotenhuis. *Journey of the Three Jewels: Japanese Buddhist Paintings from Western Collections.* Exh. cat. New York: Asia Society, 1979.

Saunders, Ernest Dale. *Mudra: A Study of Symbolic Gestures in Japanese Buddhist Sculpture.* Bollingen Series, 58. New York, 1960. Reprint. Princeton: Princeton University Press, 1985.

Snellgrove, David L. *The Image of the Buddha.* Tokyo and New York: Kōdansha International, 1978.

Tanabe, W. J. *Paintings of the Lotus Sutra.* New York: Weatherhill, 1988.

Tyler, Susan C. *The Cult of Kasuga Seen through Its Art.* Michigan Monograph Series in Japanese Studies, 8. Ann Arbor: Center for Japanese Studies, University of Michigan, 1992.

Painting

Akiyama Ken and Taguchi Eiichi. *Gōka "Genji-e" no sekai: Genji monogatari* (Splendor in the World of Genji Illustrations: The Tale of Genji). Tokyo: Gakken, 1988.

Akiyama Terukazu. *Heian jidai sezokuga no kenkyū* (Secular Painting in Early Medieval Japan). Tokyo: Yoshikawa Kōbunkan, 1964.

———. *Japanese Painting.* Translated by J. Emmons. Treasures of Asia. Geneva: Skira; New York: Rizzoli, 1990.

Brown, Kendall H. *The Politics of Reclusion: Painting and Power in Momoyama Japan.* Honolulu: University of Hawaii Press, 1997.

Cunningham, Michael R., et al. *The Triumph of Japanese Style: Sixteenth-Century Art in Japan.* Exh. cat. Cleveland: Cleveland Museum of Art, 1991.

Doi Tsugiyoshi. *Kinsei Nihon kaiga no kenkyū* (Study of the Painting of Recent Times in Japan). Tokyo: Bijutsu Shuppansha, 1970.

———. *Momoyama Decorative Painting.* Translated by Edna B. Crawford. The Heibonsha Survey of Japanese Art, 14. New York: Weatherhill, 1977.

Doi Tsugiyoshi, Tanaka Ichimatsu, and Yamane Yūzō, editors. *Shōhekiga zenshū* (Collection of Sliding Screens). 10 vols. Tokyo: Bijutsu Shuppansha, 1966–72.

Gitter, Kurt A., and Pat Fister. *Japanese Fan Paintings from Western Collections.* Exh. cat. New Orleans: New Orleans Museum of Art, 1985.

Hickman, Money L., and Satō Yasuhiro. *The Paintings of Jakuchū.* Exh. cat. New York: Asia Society Galleries, 1989.

Hickman, Money L., et al. *Japan's Golden Age: Momoyama.* Exh. cat., Dallas Museum of Art. New Haven, Conn.: Yale University Press, 1996.

Kano Hiroyuki. *Jakuchū.* Kyoto: Shikōsha, 1993.

Kinsei fūzoku zufu (Genre Painting of the Recent Period). 13 vols. Tokyo: Shōgakkan, 1982–84.

Klein, Bettina. *Japanese kinbyōbu: The Gold-Leafed Folding Screens of the Muromachi Period (1333–1573).* Adapted and expanded by Carolyn Wheelwright. Ascona, Switzerland: Artibus Asiae, 1984.

Komatsu Shigemi, editor. *Nihon emaki taisei* (Collection of Japanese Handscroll Paintings). 27 vols. Tokyo: Chūōkōronsha, 1977–79.

———. *Zoku Nihon emaki taisei* (Collection of Japanese Handscroll Paintings: Supplement). 20 vols. Tokyo: Chūōkōronsha, 1981–85.

———. *Zoku zoku Nihon emaki taisei* (Collection of Japanese Handscroll Paintings: Second Supplement). 8 vols. Tokyo: Chūōkōronsha, 1994–95.

Kyoto National Museum. *Chūsei shōbyōga* (Screen Paintings of the Medieval Period). Kyoto: Benridō, 1970.

———. *Ōgon no toki, yume no jidai: Momoyama kaiga sanka* (The Age of Gold, the Days of Dreams: In Praise of the Paintings in the Momoyama Period). Exh. cat. Kyoto: Kyoto National Museum, 1997.

Murase, Miyeko. *Byōbu: Japanese Screens from New York Collections.* Exh. cat. New York: Asia Society, 1971.

———. *Emaki: Narrative Scrolls from Japan.* Exh. cat. New York: Asia Society, 1983.

———. *Iconography of the Tale of Genji: Genji monogatari ekotoba.* New York and Tokyo: Weatherhill, 1983.

———. *Tales of Japan: Scrolls and Prints from the New York Public Library.* Exh. cat. Oxford and New York: Oxford University Press, 1986.

———. *Masterpieces of Japanese Screen Painting: The American Collections.* New York: George Braziller, 1990.

Osaka Municipal Museum of Art. *Chūsei byōbu-e* (Folding Screen Paintings of Medieval Japan). Kyoto: Kyoto Shoin, 1979.

Pekarik, Andrew J. *The Thirty-six Immortal Women Poets: A Poetry Album with Illustrations by Chobunsai Eishi.* New York: George Braziller, 1991.

Rathbun, William J., and Sasaki Jōhei. *Ōkyo and the Maruyama-Shijō School of Japanese Painting.* Exh. cat. Saint Louis: Saint Louis Art Museum, 1980.

Rosenfield, John M. *Extraordinary Persons: Japanese Artists (1580–1860) in the Kimiko and John Powers Collection. A Portfolio of Screen Paintings.* Exh. cat. Cambridge, Mass.: Harvard University Art Museums, 1988.

———, editor. *Song of the Brush: Japanese Paintings from the Sansō Collection.* Exh. cat. Seattle: Seattle Art Museum, 1979.

Sasaki Jōhei and Sasaki Masako. *Maruyama Ōkyo kenkyū* (Study of Maruyama Ōkyo). Tokyo: Chūōkōron Bijutsu Shuppan, 1996.

Shimizu, Yoshiaki, and Susan E. Nelson. *Genji: The World of a Prince.* Exh. cat. Bloomington: Indiana University Art Museum, 1982.

Takeda Tsuneo and Tsuji Nobuo, editors. *Kachōga no sekai* (The World of Bird-and-Flower Painting). 11 vols. Tokyo: Gakken, 1981–83.

Tanaka Ichimatsu, editor. *Nihon bijutsu kaiga zenshū* (Survey of Japanese Painting). 25 vols. Tokyo: Shūeisha, 1976–80.

———. *Shinshū Nihon emakimono zenshū* (Collection of Japanese Handscroll Paintings: New Edition). 30 vols. Tokyo: Kadokawa Shoten, 1976–81.

———. *Nihon byōbu-e shūsei* (Collection of Japanese Screen Paintings). 18 vols. Tokyo: Kōdansha, 1977–81.

Tokyo National Museum. *Kano ha no kaiga* (Painting of the Kano School). Exh. cat. Tokyo: Tokyo National Museum, 1981.

———. *Muromachi jidai no byōbu-e* (Screen Paintings of the Muromachi Period). Exh. cat. Tokyo: Tokyo National Museum, 1989.

———. *Yamato-e: Miyabi no keifu* (*Yamato-e*: Japanese Painting in the Tradition of Courtly Elegance). Exh. cat. Tokyo: Tokyo National Museum, 1993.

Tsuji Nobuo. *Jakuchū* (The Life and Works of Jakuchū Itō). Tokyo: Bijutsu Shuppansha, 1974.

Weidner, Marsha, editor. *Flowering in the Shadows: Women in the History of Chinese and Japanese Painting.* Honolulu: University of Hawaii Press, 1990.

Wheelwright, Carolyn, editor. *Word in Flower: The Visualization of Classical Literature in Seventeenth-Century Japan.* Exh. cat.

New Haven: Yale University Art Gallery, 1989.

Yamane Yūzō. *Momoyama Genre Painting.* Translated by John Shields. The Heibonsha Survey of Japanese Art, 17. New York: Weatherhill, 1973.

Calligraphy

Fu, Shen, Glenn D. Lowry, and Ann Yonemura. *From Concept to Context: Approaches to Asian and Islamic Calligraphy.* Exh. cat. Washington, D.C.: Freer Gallery of Art, Smithsonian Institution, 1986.

Komatsu Shigemi, editor. *Nihon meiseki sōkan* (Collection of Famous Calligraphies of Japan). 100 vols. Tokyo: Nigensha, 1976–86.

———. *Nihon shoseki taikan* (Japanese Calligraphy). 25 vols. Tokyo: Kōdansha, 1978–80.

Shodō geijutsu (Art of Calligraphy). 24 vols. Tokyo: Chūōkōronsha, 1970–73.

Shimizu, Yoshiaki, and John M. Rosenfield. *Masters of Japanese Calligraphy, 8th–19th Century.* Exh. cat. New York: Asia Society Galleries and Japan House Gallery, 1984.

Ink Painting

Barnet, Sylvan, and William Burto. *Zen Ink Paintings.* Great Japanese Art. Tokyo and New York: Kōdansha International, 1982.

Brinker, Helmut. *Zen in the Art of Painting.* Translated by George Campbell. London: Arkana, 1987.

Brinker, Helmut, and Kanazawa Hiroshi. *Zen: Masters of Meditation in Images and Writings.* Translated by Andreas Leisinger. Artibus Asiae, Supplementum, 40. Zurich: Artibus Asiae, 1996.

Etō Shun, editor. *Sesson Shūkei zen gashū* (The Complete Works of Sesson Shūkei). Tokyo: Kōdansha, 1982.

Fontein, Jan, and Money L. Hickman. *Zen Painting and Calligraphy.* Exh. cat. Boston: Museum of Fine Arts, 1970.

Kōno Motoaki et al., editors. *Nihon suiboku meihin zufu* (Masterpieces of Japanese Ink Painting). 5 vols. Tokyo: Mainichi Shinbunsha, 1992–95.

Matsushita Takaaki. *Ink Painting.* Translated and adapted by Martin Collcutt. Arts of Japan, 7. New York: Weatherhill, 1974.

Miyajima Shin'ichi and Satō Yasuhiro. *Japanese Ink Painting.* Exh. cat. Los Angeles: Los Angeles County Museum of Art, 1985.

Shimada Shūjirō and Iriya Yoshitaka, editors. *Zenrin gasan: Chūsei suibokuga o yomu* (Inscriptions by Zen Monks on Ink Monochrome Paintings). Tokyo: Mainichi Shinbunsha, 1987.

Shimizu, Yoshiaki, and Carolyn Wheelwright, editors. *Japanese Ink Paintings from American Collections: The Muromachi*

Period. An Exhibition in Honor of Shūjirō Shimada. Exh. cat. Princeton: The Art Museum, Princeton University, 1976.

Tanaka Ichimatsu and Yonezawa Yoshiho, editors. *Suiboku bijutsu taikei* (Art of Ink Painting). 17 vols. Tokyo: Kōdansha, 1973–77.

Tochigi Prefectural Museum and Kanagawa Prefectural Museum of Cultural History. *Kantō suibokuga no nihyakunen: Chūsei ni miru kata to image no keifu* (Two Hundred Years of Ink-Painting in the Kantō Region: Lineage of Stylistic Models and Themes in Fifteenth and Sixteenth Century Japan). Exh. cat. Utsunomiya: Tochigi Prefectural Museum; Yokohama: Kanagawa Prefectural Museum of Cultural History, 1998.

Tokyo National Museum. *Nihon no suibokuga* (Japanese Ink Painting). Exh. cat. Tokyo: Tokyo National Museum, 1989.

Watanabe Akiyoshi. *Of Water and Ink: Muromachi-Period Paintings from Japan, 1392–1568.* Exh. cat. Detroit: Founders Society, The Detroit Institute of Arts, 1986.

Nanga

Addiss, Stephen. *Zenga and Nanga: Paintings by Japanese Monks and Scholars. Selections from the Kurt and Millie Gitter Collection.* Exh. cat. New Orleans: New Orleans Museum of Art, 1976.

———. *The World of Kameda Bōsai: The Calligraphy, Poetry, Painting, and Artistic Circle of a Japanese Literatus.* Exh. cat. New Orleans: New Orleans Museum of Art; Lawrence: University Press of Kansas, 1984.

———. *Tall Mountains and Flowing Waters: The Arts of Uragami Gyokudō.* Honolulu: University of Hawaii Press, 1987.

Addiss, Stephen, and G. Cameron Hurst III. *Samurai Painters.* Great Japanese Art. Tokyo and New York: Kōdansha International, 1983.

Addiss, Stephen, et al. *Japanese Quest for a New Vision: The Impact of Visiting Chinese Painters, 1600–1900. Selections from the Hutchinson Collection at the Spencer Museum of Art.* Exh. cat. Lawrence: Spencer Museum of Art, University of Kansas, 1986.

Cahill, James. *Scholar Painters of Japan: The Nanga School.* Exh. cat. New York: Asia Society, 1972.

———. *Yosa Buson and Chinese Painting.* Berkeley: Institute of East Asian Studies, University of California, 1982.

———. *Sakaki Hyakusen and Early Nanga Painting.* Japan Research Monograph, 3.

Berkeley: Institute of East Asian Studies, University of California, 1983.

French, Calvin L. *The Poet-Painters: Buson and His Followers.* Exh. cat. Ann Arbor: University of Michigan Museum of Art, 1974.

Hayakawa Monta and Yamamoto Kenkichi. *Buson gafu* (Paintings by Yosa Buson). Tokyo: Mainichi Shinbunsha, 1984.

Kanda Kiichirō et al., editors. *Bunjinga suihen* (Masterpieces of Literati Painting). 24 vols. Tokyo: Chūōkōronsha, 1974–79.

Miyake Kyūnosuke. *Uragami Gyokudō shinseki-shū* (The Authentic Works of Uragami Gyokudō). Tokyo: Bijutsu Shuppansha, 1955.

Okayama Art Museum. *Uragami Gyokudō to sono jidai* (Uragami Gyokudō and His Time). Okayama: Okayama Art Museum, 1970.

Suzuki Susumu. *Chikuden.* Tokyo: Nihon Keizai Shinbunsha, 1963.

Takeuchi, Melinda. *Taiga's True Views: The Language of Landscape Painting in Eighteenth-Century Japan.* Stanford, Calif.: Stanford University Press, 1992.

Tanaka Ichimatsu et al., editors. *Ike Taiga sakuhinshū* (The Works of Ike Taiga). Tokyo: Chūōkōron Bijutsu Shuppan, 1957–59.

Tokyo National Museum. *Nihon no bunjinga ten* (Exhibition of Japanese Literati Painting). Exh. cat. Tokyo: Tokyo National Museum, 1965.

Zolbrod, Leon M. *Haiku Painting.* Great Japanese Art. Tokyo and New York: Kōdansha International, 1982.

Rinpa

Kokkasha, editor. *Kōetsu sho Sōtatsu kingindei-e* (Kōetsu's Calligraphy and Sōtatsu's Silver and Gold Underpaintings). Tokyo: Asahi Shinbunsha, 1978.

Link, Howard A., and Shinbo Tōru. *Exquisite Visions: Rinpa Paintings from Japan.* Exh. cat. Honolulu: Honolulu Academy of Arts, 1980.

Murashige Yasushi, editor. *Rinpa.* 5 vols. Kyoto: Shikōsha, 1989–93.

Nakamura Tanio, editor. *Hōitsu ha kachōga fu* (Edo: Rinpa and Artists Surrounding Sakai Hōitsu). 6 vols. Kyoto: Shikōsha, 1978–80.

Okudaira Shunroku et al., editors. *Rinpa bijutsukan* (Rinpa Museum). 4 vols. Tokyo: Shūeisha, 1993.

Tanaka Ichimatsu, editor. *Kōrin* (The Art of Kōrin). Rev. ed. Tokyo: Nihon Keizai Shinbunsha, 1965.

Uemura Masurō. *Kōrin.* Tokyo: Takamizawa Mokuhansha, 1940.

Yamane Yūzō. *Sōtatsu.* Tokyo: Nihon Keizai Shinbunsha, 1962.

———, editor. *Rinpa kaiga zenshū* (Paintings of Rinpa). 5 vols. Tokyo: Nihon Keizai Shinbunsha, 1977–80.

Yamane Yūzō et al. *Tokubetsu ten, Rinpa: Bi no keishō—Sōtatsu, Kōrin, Hōitsu, Kiitsu* (Special Exhibition, Rinpa: Succession of Beauty—Sōtatsu, Kōrin, Hōitsu, and Kiitsu). Nagoya: Nagoya City Museum, 1994.

Ukiyo-e

Chibbett, David G. *The History of Japanese Printing and Book Illustration.* Tokyo and New York: Kōdansha International, 1977.

Hillier, Jack Ronald. *The Art of the Japanese Book.* 2 vols. London: Sotheby's Publications, 1987.

Hillier, Jack Ronald, and Lawrence Smith. *Japanese Prints: Three Hundred Years of Albums and Books.* London: Trustees of the British Museum, 1980.

Jenkins, Donald. *Ukiyo-e Prints and Paintings: The Primitive Period, 1680–1745.* Exh. cat. Chicago: Art Institute of Chicago, 1971.

———. *The Floating World Revisited.* Exh. cat. Portland, Oreg.: Portland Art Museum, 1993.

Kobayashi Tadashi and Kitamura Tetsurō. *Edo no bijinga: Kan'ei, Kanbun-ki no niku-hitsuga* (Paintings of the Beautiful Women of the Edo Period: Kan'ei and Kanbun Periods). Tokyo: Gakken, 1982.

Lane, Richard. *Images of the Floating World: The Japanese Print.* New York: G. P. Putnam's Sons, 1978.

Narazaki, Muneshige. *Early Paintings.* Masterworks of *ukiyo-e*, 1. Tokyo and Palo Alto, Calif.: Kōdansha International, 1968.

———, editor. *Nikuhitsu ukiyo-e* (Ukiyo-e Paintings). Vol. 3 of *Zaigai hihō: Ōbei shūzō Nihon kaiga shūsei* (Japanese Paintings in Western Collections). Tokyo: Gakken, 1969.

———. *Ukiyo-e taikei* (The Complete Works of *ukiyo-e*). 17 vols. Tokyo: Shūeisha, 1974.

———. *Ukiyo-e Masterpieces in European Collections.* 13 vols. Tokyo: Kōdansha International, 1988–91.

Narazaki Muneshige and Yoshida Teruji. *Nikuhitsu ukiyo-e* (Ukiyo-e Paintings). 2 vols. Tokyo: Kōdansha, 1970.

Nihon Ukiyo-e Museum, Matsumoto. *Nikuhitsu ukiyo-e senshū* (Selected *ukiyo-e* Paintings). 3 vols. Tokyo: Gakken, 1985.

Nikuhitsu ukiyo-e (Ukiyo-e Paintings). 10 vols. Tokyo: Shūeisha, 1983.

Thompson, Sarah E., and Harry D. Harootunian. *Undercurrents in the Floating World: Censorship and Japanese Prints.* Exh. cat. New York: Asia Society Galleries, 1991.

Decorative Arts

Becker, Johanna Lucille. *Karatsu Ware: A Tradition of Diversity.* Tokyo and New York: Kōdansha International, 1986.

Cort, Louise Allison. *Shigaraki: Potters' Valley.* Tokyo and New York: Kōdansha International, 1979.

Ford, Barbara Brennan, and Oliver R. Impey. *Japanese Art from the Gerry Collection in The Metropolitan Museum of Art.* Exh. cat. New York: The Metropolitan Museum of Art, 1989.

Gōke Tadaomi, editor. *Shibata Zeshin meihinshū: Bakumatsu kaikaki no shikkō kaiga* (Masterpieces by Shibata Zeshin: Painting and Lacquerware from the Late Edo Period). 2 vols. Tokyo: Gakken, 1981.

Hayashiya Seizō, editor. *Nihon no tōji* (Japanese Ceramics). 14 vols. Tokyo: Chūōkōronsha, 1971–90.

Kawahara Masahiko. *The Ceramic Art of Ogata Kenzan.* Translated and adapted by Richard L. Wilson. Japanese Arts Library, 13. Tokyo and New York: Kōdansha International, 1985.

Kōgei Shuppan Henshūbu, editor. *Urushi kōgei jiten* (Dictionary of Lacquer Arts and Crafts). Tokyo: Kōgei Shuppan, 1978.

Kyoto National Museum. *Momoyama jidai no kōgei* (Handicrafts of the Momoyama Period). Kyoto: Tankōsha, 1977.

Mikami Tsugio. *The Art of Japanese Ceramics.* Translated by Ann Herring. The Heibonsha Survey of Japanese Art, 29. New York: Weatherhill, 1972.

Narasaki Shōichi, editor. *Nihon no tōji: Kodai, chūsei hen* (Japanese Ceramics: Ancient and Medieval). 6 vols. Tokyo: Chūōkōronsha, 1971–76.

Nihon tōji taikei (Collection of Japanese Ceramics). 28 vols. Tokyo: Heibonsha, 1989–90.

Nihon tōji zenshū (Compendium of Japanese Ceramics). 30 vols. Tokyo: Chūōkōronsha, 1976–83.

Okada Jō, Matsuda Gonroku, and Arakawa Hirokazu, editors. *Nihon no shitsugei* (Japanese Lacquer Art). 6 vols. Tokyo: Chūōkōronsha, 1978–79.

Pekarik, Andrew J. *Japanese Lacquer, 1600–1900: Selections from the Charles A. Greenfield Collection.* Exh. cat. New York: The Metropolitan Museum of Art, 1980.

Ragué, Beatrix von. *A History of Japanese Lacquerwork.* Translated by Annie R. de Wasserman. Toronto: University of Toronto Press, 1976.

Seattle Art Museum. *International Symposium on Japanese Ceramics, Seattle Art Museum, Volunteer Park, Washington, U.S.A., September 11–13, 1972, in Conjunction with the Opening of the Exhibition, "Ceramic Art of Japan: One Hundred Masterpieces from Japanese Collections."* Seattle: Seattle Art Museum, 1972.

Sekai tōji zenshū (Compendium of Ceramics). 23 vols. Tokyo: Shōgakkan, 1978–79.

Tokyo National Museum. *Tokubetsu ten zuroku Nihon no tōji* (Commemorative Catalogue of the Special Exhibition "Japanese Ceramics"). Tokyo: Tokyo National Museum, 1987.

Watt, James C. Y., and Barbara Brennan Ford. *East Asian Lacquer: The Florence and Herbert Irving Collection.* Exh. cat. New York: The Metropolitan Museum of Art, 1991.

Wilson, Richard L. *The Art of Ogata Kenzan: Persona and Production in Japanese Ceramics.* New York: Weatherhill, 1991.

Yonemura, Ann. *Japanese Lacquer.* Washington, D.C.: Freer Gallery of Art, Smithsonian Institution, 1979.

Yoshimura Motoo. *Maki-e.* Vol. 1. Kyoto: Kyoto Shoin, 1976.

Index

Catalogue items are indicated by their numbers. Page references to illustrations are in *italics*. Titles given as main entries denote works by unidentified artists; all other titles appear under the name of the artist.

Photograph Credits